The Free-Standing Sculptures
of the Mausoleum at Halicarnassus
in the British Museum

A Catalogue

The Free-Standing Sculptures
of the Mausoleum at Halicarnassus
in the British Museum

A CATALOGUE BY G. B. WAYWELL

Lecturer in Classics at King's College, University of London

Published for The Trustees of the British Museum
by British Museum Publications

© 1978, The Trustees of The British Museum

ISBN 0 7141 1258 5

Published by British Museum Publications Ltd
6 Bedford Square, London WC1B 3RA

British Library Cataloguing in Publication Data
───

British Museum
 The free-standing sculptures of the Mausoleum
 at Halicarnassus in the British Museum.
 1. British Museum. Department of Greek and
 Roman Antiquities 2. Sculpture, Carian
 3. Halicarnassus. Mausoleum
 I. Title II. Waywell, G B
 732'.9'24 NB130.C/

Designed by Bernard Crossland
Plates printed by Vivian Ridler, Printer to the University,
University Press, Walton Street, Oxford
Text set in Linotron Caledonia 10/12 pt
and printed in Great Britain
by J. W. Arrowsmith, Bristol BS3 2NT

FOR ELISABETH

Contents

Catalogue

List of Figures

Preface

This volume publishes in full for the first time the fragments of free-standing sculpture discovered during excavations conducted on the site of the Mausoleum at Halicarnassus in the last century by Sir Charles Newton and G. M. A. Biliotti. It includes all the fragments of sculptures in the round that were found on the site in the excavations and brought back to England, as well as the lions and the leopard that were removed from the walls of the Castle of St. Peter at Bodrum. The lioness from the Castle walls, which was presented by Newton to the Ottoman authorities of the day, and is now in the Istanbul Museum, is excluded as it does not form part of the British Museum collections. Excluded also are the fragments of sculptures in the round discovered since 1966 during Professor K. Jeppesen's re-excavation of the site of the Mausoleum. These are now housed in the Bodrum Museum, and are extensive enough to merit separate publication. Through the kindness of Professor Jeppesen, who has generously offered me publication rights, I have been able to see this new material, and take some account of it in the preparation of the text and in the notes to the Plates Appendix, p. 245.

The principal aim of this book has been to produce a new and complete catalogue of the sculptures in the round to supersede the partial accounts of the material given previously by C. T. Newton and A. H. Smith. Owing to the fragmentary nature of much of the sculpture, however, it has seemed necessary and desirable to offer an analysis and discussion of the sculptures in order to provide some sort of overall picture of the building from the sculptural point of view. This I have attempted to do in the first part of the book, beginning with a re-examination

of the excavations of Newton and Biliotti, and dealing in turn thereafter with each of the principal groups of sculpture. Because the conclusions drawn in the discussion section are personal ones which may appear controversial to some, I have tried not to let them impose themselves on the order of the catalogue itself, which broadly follows the divisions adopted previously by C. T. Newton and A. H. Smith, although in greatly enlarged form.

It must be emphasised that this volume, restricted as it is to the free-standing sculptures, constitutes only one part of a large-scale programme of research on the Mausoleum that is being undertaken by a number of scholars. Other volumes which are currently in the course of preparation include those on the relief sculptures by Professor B. Ashmole and Mr B. F. Cook, and on the architecture and the new excavations at Bodrum by Professor K. Jeppesen and Mr J. Zahle. Until these several publications of the extant material evidence appear, no final pronouncements on the overall form of the Mausoleum can be made, if indeed it will even then be possible. The observations on the general appearance of the Mausoleum which are made in this volume should be regarded as provisional. The restoration which is offered is one which is based on what seems to me to be the evidence of the sculptures in the round, and it is one which at the time of writing appeared not to be invalidated by the architectural evidence available. In my brief excursion into the field of architecture, I fully acknowledge the debt which I owe to the work of Professor Jeppesen, although the conclusions, and doubtless the errors, are my own. Out of the vast previous literature on the Mausoleum, I have profited particularly from Jeppesen's *Paradeigmata* (1958), and also from H. Riemann's article in Pauly-Wissowa, *Real-Encyclopädie*, vol. xxiv (1963) s.v. *Pytheos*, which gives an exhaustive bibliography up to the date of its publication.

My own research, which has taken ten years, would never have begun and would certainly not have been completed without the encouragement and assistance of many people.

Above all I must express my warmest thanks to Professor K. Jeppesen for his active encouragement to me to undertake the work initially, and also to the Carlsberg Foundation whose generous grants greatly assisted progress in the early years. Other scholars whose encouragement I have much appreciated at different times include Professor B. Ashmole, Mr P. A. Clayton, Mr B. F. Cook, Professor R. M. Cook, Professor A. W. Lawrence, and the late Professor D. E. Strong.

Invaluable assistance has been provided by the officers and staff of the Department of Greek and Roman Antiquities at the British Museum, in particular

by the then Keeper, Mr D. E. L. Haynes, Mr B. F. Cook, Mrs B. Miller, and not least by Mr W. Cole, to whom credit for some of the identifications is due.

Information on specific points has been kindly given by Professor B. Ashmole, Mr D. Bailey, Mr S. Hornblower, Professor K. Jeppesen, Professor A. W. Lawrence, Dr A. F. Stewart, Mr A. G. Woodhead, and Mr J. Zahle.

The views of the re-excavated site at Bodrum, plates 2–4, and the important architectural stones, plates appendix 45–6, are published by kind permission of Professor K. Jeppesen. Photographs on plates 14 and 15 are by courtesy of Professor B. Ashmole. The other photographs have been taken by staff of the British Museum Photographic Department, to whom my thanks are due.

The plan of the site, fig. 1, and the reconstructed elevations, figs. 8, 9, include architectural evidence from preliminary drawings generously supplied by Professor K. Jeppesen.

Extracts from Lt R. M. Smith's diary are published by kind permission of Lt-Col H. M. Harvey-Jamieson.

In addition to the grants made initially by the Carlsberg Foundation, I am grateful also to the Central Research Fund of London University for making a contribution at a later date towards travelling expenses.

During my visits to Turkey all possible assistance has been provided by the Turkish Archaeological Service and by the British Institute of Archaeology in Ankara.

Finally I offer my warmest thanks to Miss Carey Miller for her draughtsmanship, and to Mr Peter A. Clayton and the staff of British Museum Publications for the friendly efficiency with which they have seen the volume into print.

Abbreviations

AA	*Archäologischer Anzeiger*
AAA	*Athens Annals of Archaeology*
Abh. Akad.	*Abhandlungen der königlichen preussischen Akademie der Wissenschaften*
Adam, *TGS*	S. Adam, *The Technique of Greek Sculpture* (1966)
AJA	*American Journal of Archaeology*
AM	*Mitteilungen des deutschen archäologischen Instituts: athenische Abteilung*
AP	*Antike Plastik*
*ARV*²	J. D. Beazley, *Attic Red-Figure Vase-Painters,* 2nd ed (1963)
AZ	*Archäologische Zeitung*
BaBesch	*Bulletin antieke Beschaving*
BM	British Museum
van Breen, *Reconstructieplan*	J. van Breen, *Het Reconstructieplan voor het Mausoleum te Halikarnassos* (1942)
Brown, *Anticlassicism*	B. Brown, *Anticlassicism in Greek Sculpture of the Fourth Century BC* (1973)
BrBr	Brunn-Bruckmann, *Denkmäler griechischer und römischer Sculptur* (from 1897)
BSA	*Annual of the British School at Athens*
Buschor, *MuA*	Buschor, *Maussollos und Alexander* (1950)
CRAI	*Comptes Rendus de l'Académie des Inscriptions*
EA	Arndt-Amelung, *Photographische Einzelaufnahmen antiker Skulpturen* (from 1893)
FdD	*Fouilles de Delphes*
FdX	*Fouilles de Xanthos*
GGA	*Göttingische gelehrte Anzeigen*

GHI	See Tod
Gr. Pl.	See Lippold
Hamdy Bey-Reinach	Hamdy Bey-Reinach, *Une Nécropole Royale à Sidon* (1892)
Ist. Mitt.	*Istanbuler Mitteilungen*
JdI	*Jahrbuch des deutschen archäologischen Instituts*
Jeppesen, *Paradeigmata*	K. Jeppesen, *Paradeigmata: Three Mid-Fourth Century Main Works of Hellenic Architecture Reconsidered* (1958)
JHS	*Journal of Hellenic Studies*
KiB	*Kunstgeschichte in Bildern*
Lawrence, *GRS*	A. W. Lawrence, *Greek and Roman Sculpture* (1972)
Lawrence, *LGS*	A. W. Lawrence, *Later Greek Sculpture* (1927)
Lippold, *Gr. Pl.*	G. Lippold, *Griechische Plastik* (1951)
MAAR	*Memoirs of the American Academy in Rome*
MuZ	Pfuhl, *Malerei und Zeichnung* (1923)
MRG	See Newton
Newton, *HD*	C. T. Newton, *A History of Discoveries at Halicarnassus, Cnidus and Branchidae* (1862)
Newton, *MRG*	C. T. Newton, *A Guide to the Mausoleum Room* (1886)
Newton, *Papers*, i	C. T. Newton, *Papers Respecting the Excavations at Budrum* (1858)
Newton, *Papers*, ii	C. T. Newton, *Further Papers Respecting the Excavations at Budrum and Cnidus* (1859)
NH	See Pliny
NJb	*Neue Jahrbücher*
NM	National Museum, Athens
ÖJh	*Jahreshefte des österreichischen archäologischen Institutes*
Picard, *Manuel*, iv	C. Picard, *Manuel d'Archéologie Grecque*, iv (1954–63)
Pliny, *NH*	Pliny, *Naturalis Historia*
Reg.	Registration number
Riemann, P-W	H. Riemann, Pauly-Wissowa, *Real-Encyclopädie der Classischen Altertumswissenschaft,* xxiv (1963) s.v. *Pytheos,* cols 372–459
RM	*Mitteilungen des deutschen archäologischen Instituts: römische Abteilung*
SEG	*Supplementum Epigraphicum Graecum*
Smith, *BM Cat.* ii	A. H. Smith, *Catalogue of Sculpture in the Department of Greek and Roman Antiquities of the British Museum,* vol. ii (1900)
TGS	See Adam
Tod, *GHI*	M. Tod, *A Selection of Greek Historical Inscriptions,* vol. ii (1948)

INTRODUCTION

Excavations of C. T. Newton and G. M. A. Biliotti

The sculptures in the round which form the subject of this catalogue were discovered in the course of two excavations carried out on the site of the Mausoleum at Halicarnassus in the last century. The first, and by far the more important, excavation was that conducted by Sir Charles Newton between November 1856 and February 1858. Newton determined for the first time the precise location of the Mausoleum, and after considerable difficulties succeeded in exploring the rock-cut foundations (the so-called Quadrangle) and most of the surrounding ground on all four sides of the building. It is from Newton's excavations that the greater part of the sculptures in this catalogue come (1). The second excavation was carried out by G. M. A. Biliotti with the assistance of Salzmann between March and August 1865. This campaign was of a supplementary nature, being concerned with the acquisition and demolition of houses Newton had been unable to acquire, mostly on the south side of the Mausoleum, but also to the east and west, followed by the excavation of the ground on which they stood. Few of the sculptures found by Biliotti (rather more than 130 in number) came from the soil. Most were extracted from the walls of later structures, with the result that their condition is generally poorer than that of the sculptures found by Newton (2).

Sure recognition of the sculptures found in each of these two excavations is possible as a result of various numbering or lettering systems employed either by the excavators themselves or by the Museum authorities of

Notes and References begin on p. 247.

the day. Since these numbers and letters are important not only for the recognition of the Mausoleum sculptures but also as evidence regarding finding-places, they are set out in full below.

EXCAVATIONS OF C. T. NEWTON

Reg. no. 1857.12–20.1 ff. Only the most important sculptures from Newton's excavations received an official registration number (see list at end). For those which did, the last element in the registration number is generally the same as the number given to the sculptures by Newton in Bodrum, and used by him in his description of them in *HD*. The great majority of the fragments were painted with one or a combination of the following:

(i) *Number in red between 1 and 285.* Many fragments bear the same number. Reference is to the packing cases in which the fragments were dispatched to London, invoices of which were published in *Papers,* i and ii (1858/9), and are reproduced here (see Appendix I, below). The correlation of the numbers painted in red with these invoices provides the only scanty evidence for the finding-places of the minor fragments.

(ii) *Initials C.T.N. in red.* An alternative to (i), used presumably where the packing case number was either

not known or not deemed important. It is almost certain by inference, although nowhere specifically stated, that the initials C.T.N. were used only on sculptures from the site of the Mausoleum and not on those from Cnidus, which received a number in red somewhat higher than 285.

(iii) *Number in black between 145 and 468.* Often used together with (i) or (ii), but sometimes by itself. These numbers, which are also found on the relief sculptures of the Mausoleum, make up a sequence which probably represents an early series of display numbers, given to sculptures from the Mausoleum considered to be of secondary importance. They must have been painted on before 1865, since they are not found on any of Biliotti's fragments. The fact that 797 and 798, from Cos, received numbers in black, is presumably an error.

(iv) *Capital M followed by number (highest 12).* Significance uncertain. An ancillary number found only on a few minor fragments, mostly of drapery. The appearance of M 9 on a foot, 229, found by Biliotti, proves these numbers to belong to a time somewhat later than Newton's excavations.

(v) *C.T.N.3 (black).* Painted on a fragmentary statuette from Cos, 796, which does not belong to the Mausoleum. Significance uncertain, but probably belongs to a time considerably later than the excavations, since C.T.N.7 is painted (presumably in error) on a lion's paw from Lanuvium (Reg. 1893.7–13.11).

(vi) *No number.* A few fragments have no number at all, but are certainly from the Mausoleum either because they are mentioned in *HD* (e.g. 362, 367), or because of their style (e.g. 368, 419). Accordingly, a few fragments without numbers which have always been stored with the Mausoleum sculptures have been included in the catalogue (in particular 753–763).

EXCAVATIONS OF G. M. A. BILIOTTI

No sculptures from Biliotti's excavations were officially registered at the time. Instead each received one of five different numberings, painted in black: B.66; B.66.1; B.66.2; B.66.3; B.66.4. The precise significance of these different numberings is not certain. They appear to bear little relation to the invoice of packing cases included at the end of Biliotti's diary (see Appendix III, below),

according to which there were thirty-two casks and cases of sculpture from the Mausoleum. Probably therefore they were painted on upon receipt of the sculptures in London. The numbers 1 to 4 which follow the B.66 may have referred to different consignments, or may have been intended as a rough initial classification of the sculptures, which divide up broadly as follows: the fifty-nine fragments which have B.66.1 are lions and miscellaneous; five with B.66.2 are from human statues; forty-eight with B.66.3 are from draped human statues; while twelve with B.66.4 are connected with, or may have been thought to have been connected with, the chariot group. Seven fragments with B.66 are a random collection.

Whether or not this is so, one may be fairly confident that all the fragments with a B.66 numbering came from the site of the Mausoleum. Sculptures excavated by Biliotti on a cape at Bargylia while the Mausoleum excavations were in progress (Diary, 2 May and 1 June 1865) were given a B.65 number, followed by another number between 1 and 50, to avoid confusion with the sculptures from the Mausoleum. These sculptures have been excluded from the present catalogue. Amongst the sculptures from Bargylia were fragments of the massive figure of Scylla (BM 1542; Reg. 1865.12–12.1 ff.) which apparently occupied the summit of a Hellenistic funerary monument. Other sculptures purchased or acquired by Biliotti in Bodrum at this time were either registered, or were too large to be confused.[1]

Reg. 1868.4–5.1 ff. A few sculptures, registered in April 1868, are stated as coming from 'the excavations of G. M. A. Biliotti, Bodrum'. These sculptures include some which definitely belong to the Mausoleum (e.g. 420), others which probably do (e.g. 118, 154), but also others which clearly do not belong (e.g. 789, 790). Whether these sculptures are a random group from the 1865 excavations whose dispatch to London was delayed,[2] or whether they represent the fruits of some small supplementary excavation at the site of the Mausoleum in 1868, is hard to say. Probably the former is more likely,

1. Concerning the purity of Biliotti's sculpture from the site of the Mausoleum, there exists a somewhat disturbing letter from Newton to Biliotti dated 23 December 1868, which includes the following: 'I have received about three days ago your letter of Nov. 28. We have had great difficulty in identifying your marbles, which got mixed up with Wood's from Ephesus on board ship, in consequence of your cases having given way from not being properly made.'
I am grateful to D. M. Bailey for drawing my attention to this letter.

2. Alternatively they may have been sent in advance of the main batch of sculptures. Newton's letter to Biliotti, part of which is quoted in the previous footnote, seems to suggest that the main body of Biliotti's marbles did not arrive at the Museum until late in 1868.

despite the fact that their receipt of a registration number seems to set them apart from the rest of the 1865 sculptures. Biliotti certainly visited Bodrum in 1868 (see letter in Biliotti papers dated 1 June 1868), but he does not appear to have carried out any excavations. He acquired some fragmentary inscriptions that were found on the demolition of 'ruined houses which encumbered the interior of the castle', and delayed his departure on account of a rumour that 'in the castle there were more fragments of sculpture than what I had been shown (a statement which I subsequently ascertained to be incorrect)'. There is no mention of the further acquisition of sculptures from the Mausoleum, nor, in his accounts for antiquities, 1860–72, are there records of an excavation at Bodrum, other than that of 1865, the cost of which was £1,250 (3).

All the fragments from the excavations of Newton and Biliotti not previously registered received a registration number in 1972.

FINDING-PLACES OF SCULPTURES IN THE ROUND (fig. 1)

The finding-places of the sculptures in the round constitute important evidence for a reconstruction of the Mausoleum. Fortunately it has proved possible to recreate a relatively clear picture of this evidence from the various sources available.

Newton's account of his excavations in *HD* (1862) is adequate for the finding-places of the larger and more important fragments. Contradictions between one part of *HD* and another (as for example in the case of statue 29) can usually be resolved by reference to the earlier *Papers*, i or ii (1858, 1859), which are publications of official letters written by Newton from Bodrum at the time of the excavations about once a month to his parliamentary sponsors in London. These letters, which appear to have formed the basis for the account in *HD*, often contain information supplementary to that found in *HD*. Additional information relating to the finding-places of the major sculptures in the round is also to be found in two later publications by Newton, *Travels and Discoveries in the Levant* (1865), and *Guide to the Mausoleum Room* (*MRG*, 1886).

Concerning the smaller fragments of sculpture found by Newton there is far less information. He appears to have kept no day-book or diary of the excavations, or, if he did so, it has not survived. There is therefore no record of when and where each fragment turned up. An unpublished diary kept by Lieutenant R. Murdoch

Smith, who was in charge of the team of Sappers employed on the excavation, is of no great help in this respect (4). The only evidence for the finding-places of the minor fragments from Newton's excavations, therefore, is the references to location which accompany some of the entries in the invoice of packing cases, published in *Papers*, i and ii (reprinted in Appendix I, below), with which the numbers in red painted on the majority of Newton's sculptures may be correlated. These references to location are imprecise, generally referring only to a side of the building, are infrequent in the earlier part of the invoice, and mostly refer not to individual fragments, but to whole cases of fragments. I have assumed that all the contents of a particular case came from the side or location indicated in the invoice, but it is possible that this was not always so.[1] The invoice of packing cases is a valuable source of evidence, but the picture which emerges from it is incomplete. One cannot avoid the fact that for very many of the smaller fragments from Newton's excavations there is simply no finding-place recorded.[2]

Biliotti's diary of his excavations of 1865 contains frequent references to sculptures found. The extracts relevant to sculptures in the round are given in Appendix III, below. These references are generally of the briefest kind, so that often it is impossible to be certain to which fragment he is referring. Nevertheless, it has been possible to ascertain the finding-places of thirteen of the more important fragments found by him. For the remaining 119 fragments, no certain finding-place can be given, although no doubt most, if not all, of them were extracted from the walls of later structures, so that the loss of information is not as serious as it might seem.

From these various sources of information, the following deposits of sculpture in the round may be reconstructed, beginning with the north side, whence came most of the larger fragments:

1. Newton states in *Papers*, i. 24 (letter dated 24 June 1857) that an attempt was made to maintain homogeneity in the packing-cases which contained material from the Imam's field. The letter is reproduced below in Appendix I at the head of Newton's Invoice.
2. It is clear however from a comparison of Newton's *Papers* and R. M. Smith's diary with the list of packing-cases (Appendix I) that the sequence of case numbers does reflect the general course of the excavation: that is to say, the cases were packed as the excavation proceeded. From this observation the following inference may be drawn: cases numbered 61–144 contained material from the early part of the excavation, mostly random fragments of sculpture found out of context within the area of the Quadrangle, and in particular from the south-west corner, the west side, and the north-west corner (in that sequence). Cases numbered 145 ff. contained material from the north side, firstly from Mahomet's field, then from the Imam's field. The first reference to the Imam's field is for case 150. Thereafter references to location are reasonably good.

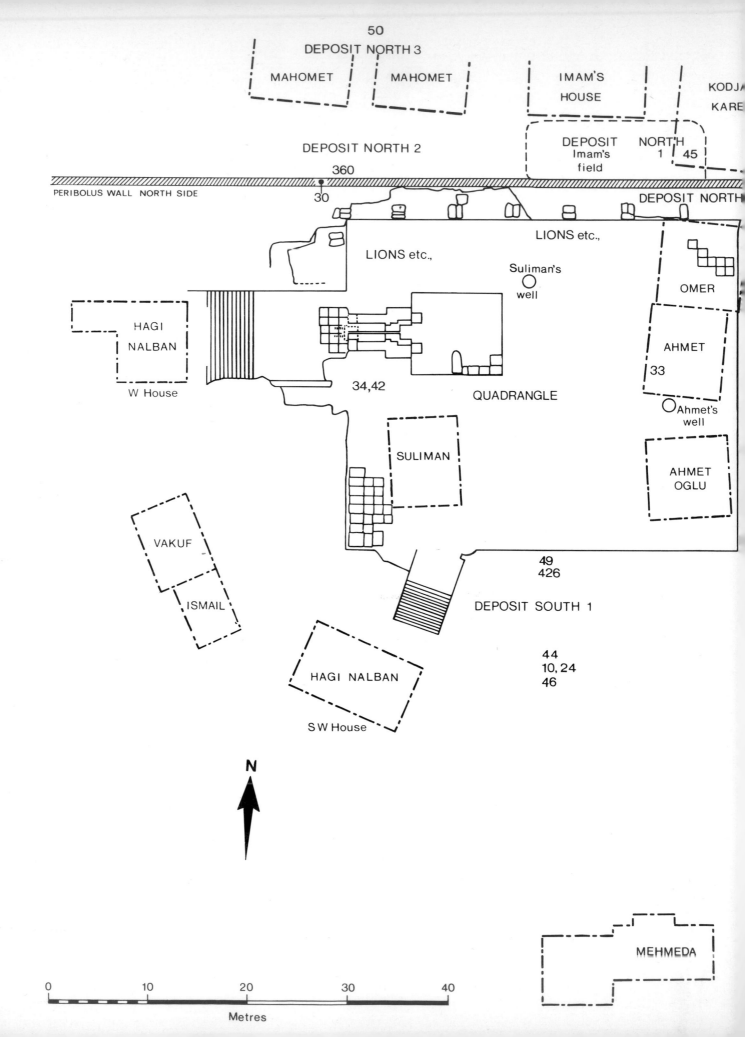

50

DEPOSIT NORTH 3

MAHOMET MAHOMET

IMAM'S
HOUSE

KODJA
KARE

DEPOSIT NORTH 2

DEPOSIT NORTH
Imam's 1 45
field

360

PERIBOLUS WALL NORTH SIDE

30

DEPOSIT NORTH

LIONS etc.,

LIONS etc.,

LIONS etc.,

Suliman's
well

OMER

HAGI
NALBAN

AHMET

33

W House

34,42

QUADRANGLE

Ahmet's
well

SULIMAN

AHMET
OGLU

VAKUF

49
426

DEPOSIT SOUTH 1

ISMAIL

44
10, 24
46

HAGI NALBAN

S W House

N

MEHMEDA

0 10 20 30 40

Metres

MEHEMET
ALI

DEPOSIT NORTH 5

HAGI
IMAM

GI NALBAN

S E House

?PROPYLON

PERIBOLUS WALL EAST SIDE

1 Plan of site

North side: 1. The Imam's field

(Newton, *Papers*, i. 14; *HD* 102–9)

Cat. no.	Description	Ref. to Newton	Case no.
	CHARIOT GROUP		
1	Forehand of horse (pl. 5)	*HD* 102–3	216–217
2	Hindpart of horse (pl. 6)	*HD* 103	216–217
6	Left forehoof and leg (pl. 8)	*HD* 103	189
8	Hoof (pl. 9)	*HD* 103	200
15	Knee of foreleg (pl. 10)		200
16	Lower foreleg (pl. 10)		189, 141
23	Support for horse (pl. 11)	*HD* 106	226
24	Spokes of chariot wheel	*HD* 106	207
25	(?) Drum of support for chariot (pl. 12)	*MRG* 36g	226

Fragments 18 and 20 may also have come from this deposit, since they have the same case number, 141, as one of the two adjoining fragments of 16.

Cat. no.	Description	Ref. to Newton	Case no.
	MAIN STATUARY		
26	'Maussollos' (pls 13–15)		Cases: 165, 170, 171, 173, 179, 180
27	'Artemisia' (pl. 13)		Cases: 150, 172, 185
28	Toe, probably of 27		179
31	Female head (built into chimney of house) (pl. 17)		237
43	Draped figure (pl. 19)		235
45	Male head (pl. 20)		211
48	Head of Apollo (pl. 22)		176
	FRAGMENTS OF STATUES		
74	Draped shoulder		161 or 191
78	Draped shoulder		171
116	Forearm		150
136	Draped arm		202
142	Colossal right hand (pl. 29)		206
149	Right hand		195
166	Draped leg		206
172	Lower left leg		206
199	Bare right foot (fig. 22)		189
208	Female foot in slipper	*MRG* 88	177
211	Colossal male right foot (pl. 31; fig. 31)		206

Cat. no.	Description	Ref. to Newton	Case no.
	FRAGMENTS OF DRAPERY		
232	(?) From seated rider		150
245	Drapery		173
257	Drapery		161
271	Drapery		173
280	Drapery		175
287	Drapery		165
288	Drapery		165
312	Drapery		180(?)
329	Drapery		237
332	Drapery		171
342	Drapery		199
	ACCESSORY		
358	Helmet on base (pl. 33)	*HD* 105, 228–9	206
	ANIMALS FROM SCULPTURAL GROUPS		
363	Fragment of head of bull		206
	FRAGMENTS OF LIONS		
401	Lion (pl. 37)		
402	Forepart (pl. 37)		
406	Forepart (pl. 39) (5)		
428	Paw (fig. 50)		199
432	Paw (fig. 54)		189
439	Paw (fig. 61)		189
447	Paw		176
452	Left hind leg		207
453	Hind leg		207
456	Hind leg		199
464	Hind leg		189
466	Foreleg (pl. 41)		174
472	Foreleg		200
474	Foreleg		161 or 191
484	Foreleg		200
525	Body		190
554	Mane		150
562	Body and mane		189
594	Tail		186
615	Tail		175
616	Tail		190
625	Tail		198
	FRAGMENTS, MISCELLANEOUS, UNIDENTIFIED		
674	Limb		206
684	Limb		195
707	Limb		186

This deposit of sculptures, numbering sixty-seven in all, is the largest and by far the most important of all those found in the excavations of Newton and Biliotti, since it is the only one where one can be sure that the sculptures had been undisturbed since their fall from the building. Newton appreciated the importance of the deposit (*HD* 102–9), but unfortunately did not keep a complete list of the sculptures found in it.

The part of the Imam's field in which the sculptures were found lay immediately to the north of the north wall of the *peribolus*, which here runs very close to the northern limit of the foundations of the Mausoleum (6). The sculptures came from a strip of ground measuring *c.* 60 by 20 ft (*HD* 107), which extended from a point roughly opposite the centre of the north side of the building towards the east. They were found 'piled one on another' (*HD* 107), and with them were 'intermixed' (*HD* 102) large numbers of marble slabs, many of which were steps from the pyramidal roof, while others were blocks from the upper courses of the *peribolus* wall (*HD* 102, 109). The sculptures and architectural marbles were covered to a considerable depth by soil washed down from the acropolis to the north, described by Newton (*HD* 107) as 'a fine sand, evidently deposited by the action of water'. It was no doubt this deep covering of soil, as well as the fact that the sculptures lay outside the *peribolus* wall, which caused the Knights of St John to overlook the deposit when searching for building material.

From the archaeological context of the deposit Newton concluded (*HD* 107) that the marbles in it had not been disturbed since their fall from the building, and in this he was undoubtedly correct (cf. also *HD* 197). He then suggested (*HD* 109) that the sculptures and architectural stones had come to occupy a position beyond the *peribolus* wall as a result of being hurled there by 'an earthquake or equivalent force'. This interpretation has been modified, probably correctly, by Jeppesen (*Paradeigmata*, 21), who has suggested from the evidence of the photograph, *HD*, pl. XI. 1, and another account of the excavation of this deposit by Newton in *Travels and Discoveries*, ii. 109, that the architectural marbles were not really 'intermixed' with the sculptures, as described in *HD*, but formed an upper layer on top of them, and that the pile of sculptures had gradually accumulated before the final collapse of the building, first filling up the gap between the building and the *peribolus* wall and then spilling over beyond the wall to form this deposit in the Imam's field. The sculptures which fell between the *peribolus* wall and the north face of the building would of course have been discovered

by the Knights, if they had not been removed earlier. The supposition of a gradually accumulated pile of sculptures, part of which was then removed, would explain how the almost complete lion, 401, could have been found lying on top of the *peribolus* wall.

The location of this deposit in the Imam's field is sufficiently far towards the centre of the north side of the Mausoleum to make it reasonably certain that the sculptures found in it belonged to the north side of the building (7). These sculptures therefore must represent some sort of cross-section of one of the longer sides of the Mausoleum, and as such they provide an important control on any reconstruction of the decoration of the building. This is confirmed by the contents of the deposit, as reconstructed above, which include substantial fragments of most of the main sculptural groups of the Mausoleum: the chariot group, the lions, the human figures of both colossal and heroic scales. The only major absence appears to be of the life-size scale of human figures (199 is an exception), but this may not be without significance, as will be explained below.

Included in the list is the colossal female head, 31, which in fact was extracted from the chimney of the Imam's house. It seems more likely than otherwise that, if it was built into his house, it would have been found on his property. Such was the case with the tail belonging to the hindpart of the chariot horse, 2, which came from a rubble wall on the Imam's property, while the horse was found in the main deposit.

leg'. These have not been positively identified. Possible candidates for the bent arms, although not certainly from female statues, are 111 (case no. 181) and 113 (case no. 117). There appears to be no candidate for a 'colossal male leg', but if the leg was of heroic size there are a number of possibilities among fragments 170 ff.—for example 176, also sent in case no. 117.

Mahomet's field lay immediately to the west of the Imam's. The sculptures from this deposit occupied a similar position to those in the Imam's field, lying just to the north of the *peribolus* wall, but in this case opposite the west end of the north side of the Mausoleum. The colossal head, 30, is marked on the plan in *HD*, pls III/IV, as lying directly on top of the *peribolus* wall (cf. lion 401 in the Imam's field). The ram 360 was found 'about three feet from the head' (*HD* 105). Probably these sculptures represent the remnants of a deposit built up in a similar fashion to that in the Imam's field. Architectural stones, including column drums and capitals (one of them a corner capital), turned up in this area also, apparently 'lying near the spot where they had originally fallen' (*HD* 112). It is clear, however, from Newton's account at *HD* 111 that the sculptures in Mahomet's field were found much closer to the surface than those in the Imam's field, and while he may very well be correct in his assumption that they were found where they had fallen, minor disturbance by later stone robbers cannot be entirely discounted.

North side: 2. Mahomet's field, west end of north side
(Newton, *Papers,* i. 32–33; *HD* 111–12)

Cat. no.	Description	Ref. to Newton	Case no.
30	Colossal female head (pl. 16)	*HD* 104, 111, 224	145
244	Fragment of drapery		250
360	Colossal ram (pl. 33)	*HD* 105, 111, 233	244
411	Lion (pl. 39)	*HD* 231	75, 100, 134
412	Lion (pl. 39),	*HD* 111	245
578	Tail of lion on base		253.9
579–590	Fragments of lions' tails		253.9

Newton, *Papers,* i. 33, and after it *HD* 111, also mentions as having been found in this deposit 'two bent arms from a female statue' and 'part of a colossal male

North side: 3. Mahomet's field, northern area
(Newton, *Papers,* i. 44–45; *HD* 112–16)

Cat. no.	Description	Ref. to Newton	Case no.
50	Head in Phrygian cap (pl. 23)	*Papers,* i. 45; *HD* 116, 227	256.2
764	Lid of funerary urn(?) (pl. 44)	*Papers,* i 44; *HD* 112, 263	262
765	Lid of funerary urn(?) (pl. 44).	*HD* 112, 263	262
770	Marble dish		262
771	Marble dish		262
772	Marble bowl		262

The head, 50, was found in the soil in Mahomet's field some way to the north of deposit 2, close to the line of an

ancient wall that ran east–west, parallel to the north wall of the *peribolus*, at a distance of 49 ft to the north (*HD* 114). Stylistically it appears to belong to the sculptures of the Mausoleum, but it can hardly have been in an undisturbed position, and is not necessarily connected with the sculptures from deposit 2. It is not certain from *HD* how close the deposit of marble bowls, dishes and urns was found to the head. According to *HD* 112 the marble vessels were found to the north of the column drums, which were themselves north of deposit 2 (the column drums were 24 ft north of the north-west corner of the Quadrangle). At *HD* 116, however, Newton states that he 'advanced further north' before coming upon the head, 50. Probably then the vessels were found *c.* 30 to 40 ft north of the *peribolus* wall. Very likely they are not connected with the head, 50, and should be considered a separate deposit. Newton (*HD* 112) considered them to be the remnants of funerary vessels from within the Mausoleum itself, but they could just as easily have come from one of the other tombs in the area.

North side: 4. Omer's field, east end of north side

Cat. no.	Description	Ref. to Newton	Case no.
29	Colossal draped figure (pl. 16)	*Papers,* i. 13; *HD* 223	136
67	Draped left shoulder		213
106	Draped arm		136
416	Hind part of lion (pl. 40)		76

It is not clear that these sculptures formed anything that may be termed a deposit, or that they were even found in close proximity to one another. Omer's house occupied the north-east corner of the Quadrangle of the Mausoleum (the area of the foundations, cf. *HD*, pl. IV). His field, in which 29 and 416 are stated to have been found, presumably consisted of the ground to the west, north, and east of the house (Ahmet's house adjoined to the south). Therefore it probably included ground just to the north and east of the cutting for the foundations. According to the invoice for case 136, statue 29 was found near Omer's well, but unfortunately this is not marked on *HD*, pl. IV; there is no precise reference for the finding-place of the lion, 416 (other than 'north side, Omer's field'); 67 is one of several fragments found, according to the invoice for case 213, at the east end of

the north side, which presumably brings us into Omer's field (the other fragments from this case have not been identified); 106 is included here on the possibly doubtful presumption that, having been dispatched in the same case as 29, it was found in the same area.

In all four instances, it is not clear whether the fragments came from within the area of the Quadrangle or from the narrow strip of ground between it and the north wall of the *peribolus*. Since the fragments certainly came from south of the peribolus wall, their positions must have been disturbed when the foundations of the Mausoleum were robbed and the finding-places are perhaps no more significant than are those of the fragments definitely found within the Quadrangle.

North side: 5. Mehemet Ali's field, north-east angle of *peribolus*

(Newton, *Papers,* ii. 8–9; *HD* 117–18; R. M. Smith in Dickson, op. cit. 106)

Cat. no.	Description	Ref. to Newton	Case no.
24(c)	Chariot wheel, felloe		256.8
53	Neck (pl. 24)	*HD* 117	261
228	Left foot of female (pl. 33)	*HD* 117	261
364	Body of bull (pl. 34)		283
403	Lion's head and neck (pl. 37)	*HD* 117	283
435	Lion's left rear paw on base (fig. 57)	*HD* 117	283
458	Lion's left hind leg	*HD* 117	261

Mehemet Ali's house stood 'nearly at the north-east angle of the *peribolus*, and on its northern side' (*HD* 117). Beneath it were found two necks from statues and a lion's leg. Only one of the necks has been positively identified, no. 53. The other, if not lost, may perhaps be 54, since all the other necks extant bear different case numbers (nos. 52, 55), or were found by Biliotti (no. 56). The lion's leg is likely to be 458, since this is the only one to bear the painted number 261.

A few feet to the east (presumably of the house) were found, according to *HD* 117, the left foot of a colossal male figure and part of a lion's paw, both with a fragment of base attached. The lion's paw is undoubtedly 435 (confirmed by case number), and the left foot is likely to be 228, despite the fact that it is not colossal and belongs to a female figure. The only other possible candidate would be the fragment of a colossal male foot,

212, but this is not certainly a left foot, and has no base attached to it.

Close to these fragments were found, in rich black vegetable soil, the head and neck of a lion, 403, as well as two architectural stones that were apparently steps from the pyramidal roof. The bull's body, 364, shares the same case number as the lion's head and must have come from the same place, although it is not mentioned by Newton in *HD*. Probably it was taken to be part of a lion.

Clearly these fragments formed a minor deposit of sculptures. The presence of two architectural stones led Newton to speculate whether these fragments might have been hurled to the spot at which they were found by the collapse of the Mausoleum (their positions being, therefore, undisturbed). They were so far from the building, however (not less than 170 ft from its centre, by Newton's estimate) that it is difficult to believe that this could be so. More likely this deposit is the fragmentary remnants of a heap of sculptures and architectural stones piled up by later stone robbers. The rich black soil in which these fragments were found, apparently covered the Quadrangle and the eastern side, and is presumably therefore later than the destruction of the Mausoleum by the Knights (cf. *HD* 117, 120, 123). But the sculptures from this deposit are perhaps more likely to have come from the north or east sides of the building than from the south or west.

North side: 6. Miscellaneous

A few other sculptures are stated as having come from various parts of the north side. One of these is the lion, 410 (pl. 39), which, according to *HD* 231, is from the north side, although no other details are given. The lion's head, 414 (pl. 40), was built into a stone wall a good distance to the north of the north wall of the *peribolus* (*HD* 116). The lion's foreleg, 496, is probably the fragment described in the invoice for case 195 as a 'piece of Lion, from road north of north-est (*sic*) corner of Mausoleum', and the fragment of tail, 617, which has the same case number, may also be from there. Other fragments, which all bear the same painted number 261, and are stated in the invoice for case 261 as having come 'chiefly from the north side', are as follows: 129 (wrist); 301 (drapery); 333 (drapery); 346 (drapery); 565 (lion's mane); 663 (hair); 664 (hair); 668 (mane?); 671 (limb); and 685 (limb).

East side of Mausoleum

Newton found very few fragments of sculpture in his excavation of the ground to the east of the Mausoleum foundations (*HD* 118–27). The only one mentioned in *HD* (122) as coming from this area, is a fragment of a lion's shoulder, which has not been identified (possible candidates include 514, 518, 519). In the invoice of cases, five fragments are stated as having been found on the east side and Biliotti added a further two:

Cat. no.	Description	Ref.	Case no.
7	Hoof of chariot horse (pl. 8; fig. 12)	B's diary, 20–23 June	B.66.4
19	Tail of chariot horse (pl. 10)	B's diary, 19 May	B.66.4
64	Colossal draped figure		285
124	Lower arm		203
132	Fragment of arm		203
143	Colossal left hand (pl. 29)		203
203	Bare foot on base (fig. 26)		285

No. 84, a draped shoulder, may also have come from the east side, since it was dispatched in case 149, which contained a frieze slab, stated to have come from there.

In addition, the following fragments may have come from the east side, since they were included in cases whose contents are stated to have come from the east and north sides of the Mausoleum:

202	Heel of foot on base (fig. 25)	208
357	Fragment of drapery	208
434	Right paw of lion on base (fig. 56)	208
455	Right hindleg of lion	209
626	Fragment of tail of lion	208

It is unfortunate that one cannot ascertain the precise finding-places of the above fragments, particularly since the fragments of colossal figures, 64 and 143, are of considerable importance for a reconstruction of the Mausoleum. Since, however, at *HD* 122, Newton specifically states that the unidentified lion's shoulder was the only sculpture to come from the lower soil, one may assume that these sculptures came from the upper level of soil, i.e. from the layer of black wash, which had been deposited later than the robbing of the foundations, and which was apparently 6 to 8 ft thick to the east

of the foundations (*HD* 120) (8). If this was the case, then it is unlikely that the finding-places of any of these sculptures would have been undisturbed. But even if disturbed, the sculptures may still have originally belonged to the east side.

The two fragments of the chariot group found by Biliotti both came from later structures. The hoof, 7, had been built into the walls of the house of Hagi Imam, which stood within the *peribolus,* close to the eastern wall, at a point opposite the centre of the east side of the Mausoleum. The tail, 19, came from a garden wall further east, outside the area of the *peribolus.*

South side of Mausoleum:
1. Hagi Nalban's field

(Newton, *Papers,* i. 32, 46–47; *HD* 127–36)

The following fragments of sculpture were found by Newton in the field owned by Hagi Nalban on the south side of the Mausoleum Quadrangle:

Cat. no.	Description	Ref.	Case no.
10	Hind leg of chariot horse (pl. 9)	*HD* 129	254.3
24a, b, d, e, f, g	Fragments of chariot wheel (pl. 11; figs. 14–17)	*Papers,* i. 46; *HD* 129	254.1–2
32	Fragment of colossal female head (pl. 17)	*Papers,* i. 47; *HD* 129, no. 5	
44	Male statue in Persian dress (pl. 19)	*Papers,* i. 46, *HD* 128–9, no. 1	249
46	Youthful male head (pl. 21)	*Papers,* i. 47, *HD* 129, no. 2	255
49	Head of Persian (pl. 23)	*Papers,* i. 32, *HD* 129, no. 4	238
57	Left eye and cheek (pl. 25)		254.12
58	Chin and neck		262
426	Right paw of lion (pl. 41)	*Papers,* i. 32; *HD* 129	238

A neck of a statue, mentioned in the invoice for case 256.3, as having been found in 'Hadji Nalban's field, South side', has not been identified.

Hagi Nalban owned two houses on the south side of the Mausoleum, one near the south-east corner of the cutting for the foundations, the other near the south-west corner. His field appears to have run from one to the other, so that it occupied all the ground immediately to the south of the Mausoleum. The sculptures listed above were all found by Newton in this field, perhaps closer to the south-west house than to the south-east one (both houses were later demolished by Biliotti). Although the sculptures are listed at *HD* 128–9 as if they had formed a deposit, it appears from the fuller account in *Papers,* i. 32, 46–47, that this was not strictly true. The head of a Persian, 49, and the lion's paw, 426, were found in the soil just outside the south edge of the Mausoleum Quadrangle (i.e. to the south of it) (*Papers,* i. 32). The statue, 44, however, was found 32 ft south of the edge of the Quadrangle, and at a depth of nearly 2 ft below the surface. Close to this figure (according to *Papers,* i. 46), or 'a little further to the south' (according to *HD* 129) were found the fragments of the chariot group, 10 and 24. Then according to *Papers,* i. 47, 'a few feet to the south' of where the fragments of chariot wheel were found, came the youthful male head, 46. The important fragment of a colossal female head, 32, came not from the soil, but from among the rubbish lying on the surface of the field (*Papers,* i. 47).

It is difficult to know how significant the finding-places of these sculptures are. On the south side of the Mausoleum the native rock rises closer to the surface, and the soil covering before the time of Newton's excavation was shallower. He describes it (*HD* 127) as 'a recent black soil, averaging in depth from 4 ft to 6 ft', and he appears to equate it with the black soil which covered much of the eastern side of the Mausoleum and the Quadrangle. If this is so (and one wonders if the soil levels at the site of the Mausoleum were really so simple as Newton maintains), then it is hard to see how the finding-places of the sculptures were other than disturbed.

On the other hand, the nature of the sculptures from this area allows some confidence that they may be the remnants of an original deposit of sculptures from the south side of the building. For although few in number the sculptures are not random scraps; they are substantial, important fragments which between them represent nearly all the major sculptural groups of the Mausoleum, in a way which is otherwise found only in the main deposit in the Imam's field (North: 1). Apart

from substantial remains of the chariot group there are fragments of a colossal female, 32, an heroic male, 44, and more fragments of the life-size scale of human figures than from any other location on the site (nos. 46, 49, 58), as well as a fragment of lion, 426. Differences between the working of some of these fragments (in particular 32 and 426) and comparable fragments from elsewhere, tend to confirm that here we are dealing with sculptures from a separate side of the building. The severe weathering which all the sculptures show may have resulted from their having lain on the surface for long after their fall from the building, or it may be added confirmation that the statues to which they belonged stood on the more exposed southern side of the building (see below, weathering).

South side of the Mausoleum:
2. Fragments from structures
The following fragments were retrieved by Biliotti from the walls and foundations of houses on the south side of the Mausoleum, which Newton had been unable to acquire:

Cat. no.	Description	Ref.	No.
13	Foreleg of chariot horse (pl. 10)	Mehmeda's house	B.66.4
17	Fetlock of chariot horse (pl. 10)	Mehmeda's house	B.66.4
56	Neck	Wall nr south-west corner of Quadrangle	B.66.3
110	Left elbow	Hagi Nalban's house south-west of Mausoleum	B.66.3
165	Leg of Persian (pl. 30)	Mehmeda's house	B.66.3
229	Foot in sandal	Mehmeda's house	B.66.2
451	Hind leg of lion (pl. 41)	Hagi Nalban's house south-east of Mausoleum	B.66.1

The nature and identity of some of these fragments, particularly those from Mehmeda's house, suggest that they may have been removed from an original deposit of sculptures in Hagi Nalban's field nearby. Mehmeda's property lay immediately to the south of Hagi Nalban's. If this was so, there would once have been a fairly substantial deposit of the chariot group on the south side (nos. 10, 13, 17, 24), as well as numerous fragments of the life-sized scale of figures, which included Persians.[1]

South side of the Mausoleum:
3. Upper gallery
In the Upper gallery, beneath Hagi Nalban's house at the south-west corner of the Mausoleum, Newton found the male head, 47. He excluded it from the sculptural decoration of the Mausoleum (*HD* 153), and was probably correct to do so, but because the wall of the gallery was breached at the point at which it was found, some doubt has remained, and so the head has been included in the catalogue.

West side of the Mausoleum
Very little at all was found to the west of the Mausoleum Quadrangle. Newton records at *HD* 136 that 'the soil, in most places, was not above three feet in depth over the native rock, which was here cut irregularly into shallow beds and steps'. The following fragments of sculpture are all that are recorded for the west side:

Cat. no.	Description	Ref.	Case no.
5	Fragment of body of chariot horse (pl. 7)		B.66.4
200	Right foot on base (pl. 31; fig. 23)	Vakuf's house	B.66.3
201	Right foot on base (fig. 24)	Vakuf's house	B.66.3
386	Fragment of horse's leg	Ismail's house	69
576	Lower jaw of lion	Vakuf's house	B.66.1

Other fragments, included in case 69, which may also have come from the walls of Ismail's house are: 221 (left

1. To judge from his diary, the majority of the fragments found by Biliotti came from the walls and foundations of Mehmeda's house. There is a good chance therefore that many of the fragments found by him belonged to the south side of the Mausoleum.

foot in sandal) (pl. 32; fig. 38); 299 (drapery); 385 (boar's tail?); 601 (lion's tail); 675 (leg); 717 (limb).

All but one of these sculptures were built into later structures: 386 came from the corner of Ismail's house, which was demolished by Newton (*HD* 136–7), while 200, 201 and 576 came from the foundations of the Vakuf's house, which was later demolished by Biliotti (Diary, 13 and 15 March 1865). These two houses, which adjoined one another, were located just to the west of the south-west corner of the Mausoleum (see fig. 1, and cf. *HD*, pl. IV). The important fragment of chariot horse, 5, was found, according to Biliotti's diary (14 March 1865), in the soil just above bedrock, near the south-west corner of the Vakuf's house. Whether or not its position was undisturbed there is no way of telling, but it may be that it was more or less in the position it had fallen from the building, bearing in mind that 386 may be part of a chariot horse, and that, according to Newton's account (*HD* 137), the walls of Ismail's house 'were chiefly composed of fragments of pyramid steps, similar to those found on the north side beyond the *peribolus* wall'. Newton noted the proximity of this house to the deposit of sculptures from the chariot group in Hagi Nalban's field (see above, South: 1), and concluded (*HD* 137): 'The position of these fragments relatively to the more massive remains from the Pyramid discovered on the north, would rather lead to the inference that, if the Mausoleum was thrown down by an earthquake, the rocking motion must have been from north-east to south-west.' Weight has been lent to this conclusion by the additional fragments of the chariot group found subsequently by Biliotti to the south and south-west of the Mausoleum. It looks as if there was originally a substantial deposit of sculptures from the chariot group in this area, of which the remnants are: 5, 10, 13, 17, 24a, b, d, e, f, g, and possibly 386.

The life-size bare feet, 200 and 201, are also similar to fragments found to the south of the Quadrangle, to which side they may have belonged, if not to the west.

THE QUADRANGLE OF THE MAUSOLEUM

The sculptures in the round, for which finding-places are recorded on one or other of the sides of the Mausoleum, number about 150. Of these, 110 came from the north side. There remain rather more than 500 fragments found by Newton, and about 120 found by Biliotti, for which no precise finding-place is given (for the few exceptions, see below). It is possible that some of the fragments found by Newton came from one of the sculptural deposits listed above, and that no record remains, but it is likely that the vast majority came from within the quadrangular cutting for the foundations of the Mausoleum, into which they had fallen or been thrown after the Knights of St John had removed as much squared stone as they required. Newton, *HD* 99, records that

> The whole of the Quadrangle was filled with remains of architecture and sculpture. The quantity of these fragments was so great that it would have been impossible to specify their exact position on the Plan, nor would such information be of any value in reference to the majority of the marbles, which had evidently been rolled and pitched out of the way by the spoilers of the tomb, as they removed successive courses of masonry.[1]

Only for the large fragments are rough indications of position within the Quadrangle given. From about the middle of the west side, close to the edge of the cutting, came the colossal Persian rider, 34 (pl. 18), and the standing male figure, 42 (pl. 19), (*HD* 90, 99). From 'the eastern part of the Mausoleum, near the point where the bed of the foundations is shallowest' (*HD* 99) came the colossal seated male figure, 33 (pl. 17), while fragments of the bodies and hindquarters of lions were found within the south-west corner (*HD* 89, 99), and 'towards the northern margin' (*HD* 100: amongst the latter were, apparently, 407 and 408, marked with a Π and a Λ). Also near the south-west corner were 'some portions of large statues in the round' (*HD* 90). In the southern area of the Quadrangle, 'we met with but little sculpture, and that in bad condition' (*HD* 100).

Newton is undoubtedly correct in his assessment that the finding-places of these fragments were of no significance. It may be felt likely that the very large fragments belonged originally to the sides nearest to which they were found, but even if likely, there can be no certainty of it, even for 34 and 42, which lay very close to the line

1. Cf. the description in *Papers*, i. 11: 'The whole of the quadrangular area is strewn with frusta of columns, fragments of marble, building stones and rubble. It is from these ruins that I have obtained nearly all the fragments of statues and friezes which have been discovered.' From a letter dated 3 April 1857, written shortly before the discovery of the deposit in the Imam's field.

For a suggestion that the fragmentary sculptures from the Quadrangle were dispatched in the cases numbered 61–144, see above, p. 3, n. 2.

of the cutting. The two lions 407 and 408, for instance, both of which were found towards the north margin, are likely, from the different letters which they have on their backs, to belong to different sides of the building (probably one from the north, the other from the west) (9).

The fragments of sculpture found by Biliotti, for which no finding-place is given, are likely to have been removed from the walls of the various houses he demolished. The three houses from which most of the sculptures came were located on the south side (two owned by Hagi Nalban, one by Mehmeda), but there were others to the east (Hagi Imam) and to the west (Vakuf, Hagi Nalban's third house). A few sculptures came from garden walls in the vicinity. A full record of which fragments came from which walls would undoubtedly have been useful, but there appears to be no way now to reconstruct this information. So far as one can judge from Biliotti's diary, the greatest number of fragments by far came from the walls and foundations of Mehmeda's house on the south side.

The Marble

All but a few of the free-standing sculptures of the Mausoleum are carved from the same kind of high-quality marble. This marble is white in colour, is generally of fine to very fine crystal, has occasional micaceous seams in it, and weathers to a patina whose colour ranges from orange-yellow to brown. In all probability it is Pentelic marble. It seems to be the same as is used for the chariot frieze, but it differs from that used for the architectural stones, which is of larger crystal and corresponds with what is generally thought to be Parian marble. The difference between these two marbles, one used for sculpture in the round, the other for architecture, is very clear. It is possible, for instance, to distinguish the fragments of the free-standing lions from the fragments of the lions'-head waterspouts solely through differences in the marble used, the standing lions being carved from 'Pentelic', the lions'-head waterspouts from the 'Parian' employed for the architecture (10).

A few fragments of sculpture, mostly heads, are carved from a white marble of slightly broader crystal, best described as fine to medium. These are 30, 52, 53, 54, 55, 56, and possibly also 48, 49, 50, and 51. Whether this is a different marble, for example, an island marble, or simply represents an inferior vein of 'Pentelic' is hard to say (11). It is used so rarely that the latter is perhaps likely. The head 46 (pl. 21) is carved from a greyish-blue, crystalline marble that appears to be the same as that used for the Amazon frieze, which may perhaps be Proconnesian or Thasian. This marble is also used for the fragment of uncertain identity, 656 (pl. 43). These two instances of the use of an inferior marble, if not simply an accident, are probably to be attributed to a shortage for some reason of the better quality.

There can be no doubt that these few fragments, whose marble varies slightly from the norm, belonged to the sculptural decoration of the Mausoleum. There might have been some doubt about 656, were it not for the fact that it duplicates stone 655 (pl. 43), which is carved from the high-quality marble that is typical for the sculptures in the round. Because of the existence of these minor variations in marble among sculptures known to be from the Mausoleum, one has to be wary of excluding other fragments from the Mausoleum on grounds of marble alone.

Those fragments which have been rejected on grounds of marble are carved from a white or greyish-white variety of large crystal, for the use of which on the Mausoleum there is no other evidence. Some of these fragments were found by Newton (e.g. no. 777), but most came from Biliotti's excavation, and so were presumably built into later walls (e.g. nos. 776, 779, 780, 781, 783, 784, 785, 788). Usually the style of the carving of these fragments is at variance also with that of the rest of the sculptures.

WEATHERING

All the fragments of sculpture in the round from the Mausoleum exhibit weathering in one degree or

another, and it looks as if all were placed on the building in positions that were at least partially exposed to the elements; that is to say, they were *externally placed*. The significance of the degree of weathering exhibited by particular fragments is not easy to assess. The amount of weathering of a marble sculpture can vary very much according to one or a combination of the following: (*a*) the orientation of the part of the building on which it was set; (*b*) the partial protection it may have enjoyed; (*c*) the size of the sculpture (larger areas of marble generally weather more slowly than do small areas) (12); (*d*) the quality of the marble; (*e*) the protective capacity of the colouring over the marble (for the colouring of the sculptures, see below); (*f*) the chance exposure to drips, especially from the roof, over a long period of time; (*g*) the fate of a sculpture after its fall from the building.

From the location and orientation of the Mausoleum, one would expect the sculptures from the most exposed side, the seaward-facing south side, to be the most weathered, and this indeed looks as if it may have been the case. The sculptures found to the south of the Mausoleum (see above, p. 10), to which side they probably belonged, all had severely worn front surfaces. Some of this may have been due to exposure after the destruction of the building, but because in some cases, e.g. 44, the backs and sides are quite well preserved, it is likely that the severe weathering of the fronts was the result of natural exposure on the building over a period of perhaps fifteen hundred years.

If the south side of the Mausoleum was the most exposed, the north side is likely to have been the most protected, being sheltered from sea winds, and partly protected from north winds also by the acropolis to the north. Since it is from the north side that most of the extant large fragments of sculpture come, it is understandable that in many instances the degree of weathering does not seem particularly severe.

The sculptures from the deposits in the fields of the Imam and Mahomet (see above, North: 1 and 2) probably give the safest indication of weathering suffered before the sculptures fell from the building. The major fragments of the chariot group are not unduly weathered, considering that they were probably exposed to the elements for 1,500 years or more (on the assumption that they finally fell in the thirteenth century AD, perhaps in the severe earthquake of 1222), but there is general weathering on the bodies and on the outer surfaces of the legs. The mild degree of weathering is perhaps partly to be explained by the great size of the sculptures and also by the fact that the fragments from the Imam's field are likely to be from the northernmost

horse or horses of the group, which would have been protected to some extent from the sea winds.

The lions from the north side also exhibit general weathering, e.g. 401, but usually there is severer weathering on the top of the statue and on the outward facing side towards which the head was turned, e.g. 410. This is also very noticeable on the colossal ram, 360, from Mahomet's field. The lions found in the excavations (which means those mostly from the north side) were far less weathered than those extracted from the walls of the castle. This must be partly because the lions in the castle had been exposed to sea winds for another three hundred years or more, but is also likely to be partly due to the fact that these lions originally stood on more exposed sides of the Mausoleum, including the south side.

The weathering of four heads of human statues from the deposit in the Imam's field, nos 26, 27, 45, 48, is important. On all these four there is quite severe weathering on the forehead and on the hair on top of the head. On 26 and 48 the rainwater has been conducted by the deep grooves of hair to the back of the head, and on 26 has then run on to the back of the shoulder of the statue, where it has caused considerable weathering of the surface. On 27 this has been prevented by the veiling of the hair. The lower parts of the statues 26 and 27 are not excessively weathered at either front or back (the upper edge of the bunched drapery around the waist of 27 is weathered however). The weathering of these sculptures appears to have come mainly from above, and is likely to have been caused partly by direct exposure to rain, and partly by dripping from above, for example, from a sima.

THE SCULPTURAL GROUPS

The Chariot Group

The four-horse chariot is the only sculptural group whose position on the Mausoleum, on the summit of the pyramidal roof, is known for certain (13).

Fragments 1–24 certainly belonged to it; 25 almost certainly did so; while other fragments which may have belonged are: 386, 388, 655, 656, 657, 658, 689, and 690.

Fragments 1, 2, 6, 8, 15, 16, 23, 24, and 25 were found in the deposit in the Imam's field on the north side (14), while fragments 18 and 20 may also have been (15). Fragments 10 and 24a, b, d, e, f, g, came from the south side, and with them are probably to be associated 5, 13, 17, and 386 (if it belongs), which were built into structures nearby (16). Both deposits were associated with large numbers of pyramid steps. Probably therefore Newton was correct to conclude (*HD* 137) that when the upper part of the building collapsed (probably as the result of an earthquake), the chariot group was split in two, part falling to the north-north-east and part to the south-south-west.

RECONSTRUCTION OF HORSES

Sufficient fragments of the four horses remain to permit a fairly full reconstruction to be made (fig. 2). The fragments which are juxtaposed in the drawing may not originally have belonged to the same horse but it is reasonable to assume that all four horses were constructed in the same way and to similar dimensions.

Notes and References begin on p. 247.

The hindpart 2 (pl. 6) provides important evidence that the horses were each carved in two halves, with a join just behind the shoulder. The front surface of 2, which has been worked for a join, has a smooth margin for *anathyrosis*, and a more roughly hollowed centre (fig. 10). It was attached to the forepart by three large clamps, one on top of the back, and one at each side, while beneath the belly was a necessary marble support of which 23 (pl. 11) is a remnant. The working of 23 shows that it was a half-support only, and must have abutted on a similar half-support beneath the forepart.

The forepart 1 (pl. 5) is broken behind, but its position in the reconstruction is controlled by two factors. First, there are no signs of cuttings for clamps, which must have attached it to its hindpart and are likely to have been of the same size as those of hindpart 2 (24 cm on top of the back, and 19 cm at the sides). Nor is there any trace on the underside of a worked area, probably a low protrusion, to receive the top of the half-support. From the evidence of the depression on the underside of 2, this is likely to have been *c.* 22 to 25 cm long. From this it is clear that at least 20–25 cm of marble is missing from behind forepart 1. The second factor is that the base on which the forehoof, 6 (pl. 8), rests must have abutted against the base from which the half-support, 23, rises. This confirms that about 20–25 cm is missing from behind 1, for when that amount is added, the upper foreleg of 1 comes precisely over the axis of the leg belonging to 6 (both legs being more or less straight).

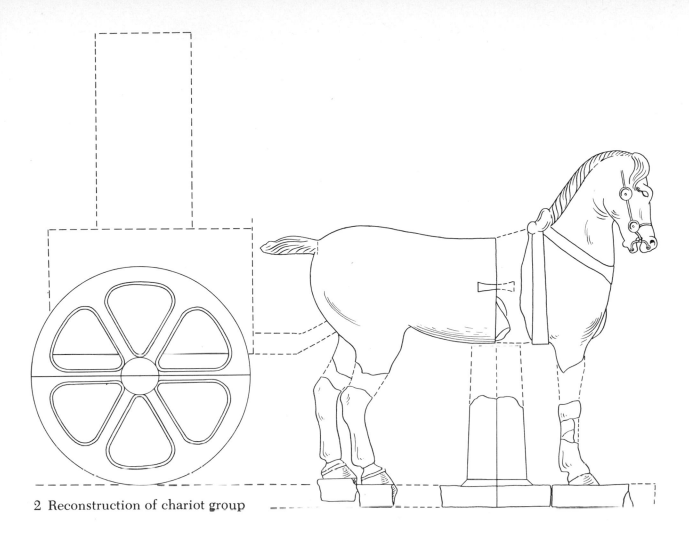

2 Reconstruction of chariot group

Evidence that the horses were standing, and not galloping or prancing, is provided by the three hooves on bases (nos. 6, 7, and 8; figs 11–13), and by the upper legs attached to forepart 1, the positions of which make it plain that the horse was standing still or, at the very most, walking slowly forward. Spirited action by the team must have been ruled out by structural considerations. The carving of the horses in two halves, with supports beneath the belly, must have required at least one of the forelegs to have rested squarely on the ground, and very likely both. The only slight evidence that a hoof may have been raised is the drill hole preserved in the break of 16 (pl. 10), but this may be connected rather with an ancient repair.

For constructional reasons, also, it is likely that both forehooves, and both hind hooves, stood on single plinths. That this was so is nearly confirmed by the large amount of base on which 6 stands, which extends two-thirds of the way across the width of one horse.

It is probable, then, that each horse of the chariot group was carved from two huge blocks of marble, one serving for the forehand, the forelegs, and the plinth on which the hooves rested, the other for the hindpart and the plinth on which the hindlegs rested. Each part was supported beneath the belly by a pillar, the base of which must have fitted closely against the bases on which the hooves rested, so that when the horse was placed in position on top of the building and the two parts were finally clamped together there emerged a single, solid, rigid construction.

The only other part of the horse to be carved separately was the tail. This, as is clear from the large fragment which adjoins 2 (pl. 6), was attached to the hindquarters by means of a dowel, which was fixed in position by lead. Three other fragments of the tail survive, 18, 19, 20 (pl. 10); these are large enough to make it plain that here we have fragments of all four horses of the team. The character of the tails is somewhat peculiar, in that they did not hang down at all, but stuck straight out for some 60 cm or more, the only droop being suggested by the curving of the upper contour, and by the lines of the hairs on the sides. A secondary division of hair towards the rear, which is found on three of the four fragments preserved, 2, 18, and 20, was probably meant to indicate that the tails were clipped and the end tied up, and so provide some explanation for their appearance. The reason for their being represented in this fashion was no doubt due in

the main to the technical difficulties involved in sus-
pending a deadweight of marble from a single dowel
(the hollowing out of the undersides shows that the
sculptors wanted to reduce weight to a minimum), but it
may also have been connected with the need for the tails
to have cleared the front rail of the chariot. Alternatively
clipped tails may have been an indication of mourning
(17).

It is pointed out in the catalogue that differences in
the carving of the hair of the four tails suggest that two
different sculptors worked on the chariot horses. Two of
the tails have hairs indicated by means of concave
grooves, 2 and 18, which recall the treatment of the
mane of 1; the hairs of the other two fragments, 19 and
20, are in the form of convex ridges. As 1 is likely to be a
northernmost horse it is perhaps also likely that 2 and 18
belonged to that side of the group. Tails 19 and 20, then,
would have belonged to the southernmost horses of the
team, the more exposed position of which may account
in part for the extremely severe weathering which these
two fragments show (18).

Allocation of other fragments to particular horses
cannot be made with any certainty. It is likely, however,
that the fragments found in the Imam's field belonged
in the main to the northernmost horses, and conversely
that the fragments found on the south side, and in
particular hind leg 10 (pl. 9), belonged to the southern-
most horses. The considerably thinner base beneath
hoof 8, as compared with that beneath hooves 6 and 7
(17 cm as against 24–25 cm), is also likely to indicate
that it belonged to a different horse, or at the very least, a
different half-horse, from those fragments.

The overall dimensions of the horses, as recon-
structed, are as follows: length, including head but
excluding tail, 3·60 m; when the tail is added the
over-all length comes to c. 4·20 m; width, 90 cm (evi-
dence of fragments 1 and 2; cf. also the base from which
the pillar, 23, rises); height from hoof to top of head,
c. 3·60 m. There is no evidence directly controlling the
height. The sides of the pillar, 23, taper upwards, but
the depression on the underside of 2 is too irregular in
shape to enable one to reconstruct with any accuracy the
dimensions of the top of the pillar. On the other hand,
the height of the horse can hardly have been much less
than that suggested here, or it would have seemed too
squat in relation to its length.

From these dimensions it is clear that the horses of the
chariot group were massive in appearance, with sturdy
legs, and a long, deep-bellied body. At the same time the
body was rather narrow in proportion to its length, and
the head was also small. A comparison with the horse

ridden by the Persian rider, 34 (pl. 18), shows them to be
constructed according to a different system of propor-
tions (19). Probably, therefore, the horses of the chariot
group were intended to be a large breed of draught
horse, of Asiatic or possibly even Nisaean stock, such as
must have been required to pull a chariot of the size
suggested by the extant wheel from the Mausoleum
(20). Chariot horses of closely similar proportions are
found on several fifth- and fourth-century BC reliefs
from Lycia and east Greece (21). The size of the breed
of horse has to be borne in mind when assessing the
scale of the statue or statues which occupied the
chariot (22).

RECONSTRUCTION OF CHARIOT

Less remains from the chariot than from the horses, and
no full reconstruction is possible. The only sure evi-
dence we have consists of the fragments of wheels, of
which the hub block 24a and the rim 24b are the most
important (figs 14–17). These provide the information
that the wheel was 2·30 m in diameter, that it had six
rather thick spokes, and that it was carved in two parts
which were joined by clamps.

The wheels are strikingly large compared with those
of the normal Greek chariot. This has been interpreted
by some as Persian influence, since Persian chariots
generally had much larger wheels than Greek ones. On
the other hand, the use of six spokes is a feature of
Ionian chariots, and it may well be, as von Lorentz has
argued (23), that the chariot was of largely Ionian type
and that the wheels were enlarged to counteract
foreshortening caused by the height of the group above
the ground, and to give extra prominence to the occu-
pant or occupants of the chariot.

The unusual thickness of wheel rims and spokes may
be due, in part, to the difficulty of carving them from
marble, but it must also have resulted from the decision
to carve the wheels in two halves, for this meant that the
spokes had to be broad enough to allow two of them, the
central horizontal pair, to be sliced down the middle.
Even so, strengtheners were required to reinforce these
half-spokes. Fragments 24a and 24b belong to the upper
halves of the wheels. We have no sure evidence as to the
form the lower halves took, other than that they were
separately carved. However, in view of the difficulties
caused by carving the wheels in two parts, both as
regards the thickness of the spokes required and the
need for unsightly strengtheners for the half-spokes, it

is likely that it was done only for compelling constructional reasons, in order to give greater strength to the chariot as a whole. One may reasonably assume, therefore, that the lower half of each wheel served as a support for the floor of the chariot. This being the case, it is likely that the lower halves of the wheels would have taken the form of solid blocks, on the outer faces of which the spokes, rim, and hub would have been carved in relief, perhaps to the depth of the horizontal strengtheners on the upper half (9·5 cm). The upper half of each wheel would have been clamped to the lower wheel block (evidence of fragment 24b), and the inner hub would presumably have abutted on the edge of the block which formed the floor of the chariot, so leaving a gap of 20 cm between the upper wheels and the sides of the chariot. Extra support would have been given to the chariot floor by pillars made up of drums of which stone 25 is likely to be an example. Probably these were positioned directly underneath the figure or figures which stood in the chariot, where they would have been effectively hidden from view by the solid lower wheel blocks. A system of construction of this kind would have given the chariot a strength and rigidity equal to that of the horses, and would have been no more unsightly than were the belly-supports which were beneath the horses.

Jeppesen has suggested (24) that the upper line of the strengtheners in the top half of the wheel may have coincided with the bottom of the chariot. This might seem desirable in that it would raise the whole of the chariot frame *c.* 23 cm higher, so that it would appear to clear the axle or the line of the axle (the axle normally passed beneath the floor of the chariot). It would also raise the chariot floor high above the presumed lower wheel blocks, which would therefore no longer support it, unless one assumed that the inner part of the blocks was cut 23 cm higher in order to do so, as indeed it could have been. There is, however, no reason why one should suppose that the strengtheners had relevance for anything other than the wheel itself. They do not project beyond the inner face of the wheel, and so cannot have had any structural significance for the chariot frame. They were necessary reinforcements for the weak half-spokes, and the height at which they terminate was probably chosen because it coincides with the top of the inner wheel hub.

There is no direct evidence for the form taken by the chariot frame, but the size and character of the wheels show that it cannot have been of light, mainland Greek type. In all probability it was of the general Greco-Persian type found on the grave stelae from Daskyleion and other related relief sculptures (25). Von Lorentz argued from the evidence of the six-spoked wheels that it was of Ionian type, and that it would therefore have had a rounded front, projecting in front of the wheels, in contrast to the square fronts of the chariots of mainland Greece (26). Van Breen also assumed a rounded front for the chariot, and claimed as evidence for it a slightly curved stone that came from Newton's excavations (27). This stone[1] (pl. 12) certainly seems to have formed part of a curving balustrade, since it is worked for *anathyrosis* on either end with other presumably similar stones, but there is no special reason to connect it with the chariot. A worn graffito on the upper edge of the stone includes the word NIKH, which van Breen assumed referred to the occupant of the chariot. Since, however, the word NIKH certainly occurs twice, and possibly three times, and there are traces of another word perhaps ending in the genitive, it is more likely that we are dealing here with a Nike inscription of much later date, and probably of agonistic or gymnastic significance (28). If this interpretation is correct, the stone may safely be excluded from the chariot group, where it would have been wholly inaccessible to a later writer of graffiti. Probably it formed part of an exedra.

All one can say concerning the dimensions of the chariot is that the length is unlikely to have been much

1. Reg. 1857.12–20.331. Finding-place not recorded. Blue-grey marble with brown patina in places, differing from the white marble employed for the chariot horses and wheels, and for all the sculptures in the round from the Mausoleum. H 0·865 m. L. 0·75 m. Th. 0·35 m.

The convex outer surface is smoothly finished except for the lower 10 cm which projects 2 cm and is dressed with the claw chisel as if for insertion into a base. The top is also smoothly finished, except for some point marks near the inscription, but the concave inner surface is more roughly worked, and is divided into zones. The upper 50 cm is relatively neatly finished with the claw chisel. Below this is a horizontal band 2 cm wide and slightly recessed because rendered with the point, and below this again a further 6 cm of clawed surface. The bottom 28·5 cm is more coarsely pointed, and it looks as if a horizontal stone may once have abutted here. The underside is roughly pointed. In the right-hand end (looking from the inner side) there is a cutting for a clamp, extending 4 cm inwards, and measuring 4 cm wide and 4·5 cm deep in the inner part where the tooth of the clamp gripped. In the centre of the inner face is another cutting 7 cm L. × 3 cm W. × 1 cm D.

The inscription is in the inner left-hand corner of the top side (looking from the outer side), carved so as to be read from the outer side. It reads as follows (see pl. 12):

1. N I K H Heights of letters: line 1, 2·25 cm;
2. K OPP ^ line 2, 1·5 cm; line 3, 2 cm; lines 4–6,
3. NI KH 2·7 cm.
4. N I K H
5. Ш
6. V 3 Nike inscription

less than the diameter of the wheel (2·30 m), and may have been slightly more if the front was rounded, perhaps up to 2·80 m. The width is unlikely to have been greater than the over-all width of the four horses of the team (*c.* 4·50 m, as each horse was 90 cm wide, and room must have been left between them for the chariot pole or poles), and may have been rather less, possibly even as little as 3 m. The width would obviously have been determined to a considerable extent by the size and number of the figures which occupied the chariot.

Of the chariot pole or poles nothing is known (29). If the chariot was of Greek type there is likely to have been only a single pole running between the central yoke-horses, in which case there would probably have been a wider gap here than between the yoke-horses and the outer trace-horses. If the chariot was of non-Greek type there could have been two poles (as in van Breen's reconstruction) or possibly even three (as in Jeppesen's reconstruction in *Paradeigmata*) (30). Presumably the pole or poles would have been of marble, like the rest of the chariot group. There is no evidence that bronze was used on the group for anything other than the bridles, and possibly also for the reins, although these could have been of lead.

OVER-ALL DIMENSIONS AND APPEARANCE

The over-all length of the chariot group must have been *c.* 6·50 m. This is the length of the horses, *c.* 4·20 m, plus the diameter of the wheel, 2·30 m. If the chariot had a rounded front, this must have been accommodated beneath the horses' tails, and may even have been responsible for the form of their carving (see above). The over-all width must have been *c.* 4·50 m. The total height of the group depends on the height of the figure or figures in the chariot, about which there has been much controversy in the past. Considering, however, that each horse was *c.* 3·60 m high, and making allowance for their being a larger breed of draught horse, it is difficult to believe that a figure in the chariot, if it was in scale with the horses, could have been less than 3·25 m high. The top of the head of a figure of this height would come roughly to the horses' eye-level (31).

Assuming a height of 3·25 m for the figure or figures in the chariot, the total height of the group would have been between 4·75 m and 5 m, depending on how high the figure(s) stood above the centre of the wheel.

For the precise way in which the chariot group was accommodated to the top of the pyramidal roof there is no certain evidence. Newton found a stone (32) with a large cutting in it, 18–19 cm deep, which would be suitable to receive the bases beneath the horses' hooves, although there are other statues which would have fitted into it (e.g. the Persian rider, 34 ff.). This stone is of the same thickness as the steps of the pyramid, so that it could theoretically have formed the top step of the pyramid, on which the chariot group might have been set. Alternatively there could have been a low podium beneath the chariot group, rising from the top step of the pyramidal roof, the effect of which would have been to make the group more easily visible from the ground (33).

It is obvious from those fragments of the group which remain that its over-all appearance must have been extremely impressive. This impressiveness must have resulted at least as much from the engineering and technical skills involved in assembling the group on the building as from the artistic beauty of the design and execution. It was an incredible achievement to erect a chariot group of this size, in a material as heavy as marble, on top of a monument as high as the Mausoleum. But the difficulties involved in the undertaking imposed limitations on the design of the group, which, from an artistic point of view, cannot have been wholly satisfactory. However powerful and massive in appearance the group may have been, it must also have been rather square and static, and there is a degree of stylisation similar to that apparent in the lions. In this respect the chariot group, like the lions, appears to have been conceived more as an element of the architectural design of the building than as an individual sculptural work of art.

Such shortcomings as there are in the design and execution of the group probably result from the difficulties of working in marble. Marble was of course the material normally employed for architectural sculpture, and it may be considered natural enough that marble should have been used for the chariot group of the Mausoleum. Nevertheless, free-standing four-horse chariots, executed in marble, must have been very rare in earlier Greek architectural sculpture, if indeed any existed at all, and it is probable that the sculptors of the Mausoleum can have had little experience at carving such a group (34). This may explain why the design was undertaken by Pytheos, the constructional difficulties being considered too great for anyone but an architect and engineer.

Because the group was of marble, the horses had to be carved in two halves, in order to make lifting possible;

they had to have unsightly supports beneath the belly, to take the weight;[1] and the hooves had to rest flat on the ground, again for reasons of weight, whether or not this was desirable for the significance of the group. The use of marble was probably also responsible for the somewhat unconvincing tails and the massive solidity of the chariot wheels.

Some of these difficulties would undoubtedly have been eliminated had the sculptors broken with architectural convention and used bronze instead of marble. On the other hand, it is possible that the size of the group is such that, even if bronze had been used, there would still have been constructional problems which could only have been solved by some external system of support, as on the marble group.

ORIENTATION

Since the longest axis of the Mausoleum ran roughly from east to west, and the base of the chariot group was rectangular, it follows that the group must have faced either to east or west. Beyond this there is no sure evidence which might enable one to determine in which of these two directions the group faced. The finding-places of the fragments are of no help, since fragments of the foreparts and hindparts of the horses, and of the chariot wheels, were found on both north and south sides of the building. There may, however, be a clue to the orientation in the leftward turn of the head on the forepart, 1, which was found in the Imam's field on the north side. It was conventional in earlier representations of Greek quadrigas for the heads of the inner yoke-horses to look towards one another, and for those of the outer trace-horses to look outwards (35). If this convention applied to the Mausoleum group, forepart 1, with its leftward turned head, can only have belonged to the right-hand yoke-horse or to the left-hand trace-horse (viewing from the position of the charioteer, to the first or third horses from the left). Now these two horses would be set nearer to the north side of the building on

an eastward-facing group than they would on a westward-facing group, and it may be felt more likely therefore that the chariot group faced to the east. The east was in any case the more important side of Greek temples, and it is probable that this also applied to the Mausoleum. Jeppesen's excavations at the site of the Mausoleum have proved that the propylon, or main entrance, into the precinct surrounding the Mausoleum, was in the east *peribolus* wall, so that a visitor to the building would have approached it from the east, and his first view of the monument would have been of the east and south sides (36). It is likely therefore that the principal sculptural group of the Mausoleum would have been orientated in such a way that it faced a visitor as he approached the building. The whole of the chariot group would not have been visible from within the *peribolus* to the east of the building, of course, but it would have been from just outside the propylon (37).

THE OCCUPANT OR OCCUPANTS OF THE CHARIOT

Much of the controversy surrounding the Mausoleum and its reconstruction has centred on the question of who occupied the chariot, and in particular whether statues 26 and 27 (pls 13–15), supposedly 'Maussollos' and 'Artemisia', stood in this position. Before coming to the question of the attribution of individual statues, it is as well to consider first who the occupants might have been, judging from such archaeological and art-historical evidence as we have.

The possible identifications of the occupants of the chariot are controlled by three main factors:

(*a*) Their size and number, as may be determined from the evidence of the fragments of horses and chariot.

(*b*) The extent to which the group conformed to Greek or non-Greek artistic conventions.

(*c*) The significance of the chariot group on top of a tomb—closely linked with (*b*).

The possibilities as regards numbers of figures are, at the most, four. There may have been no occupant at all, as has been suggested by some; there may have been one or two figures; or there may even have been three. The number of figures possible depends on the size of the figures, and the width of the chariot, neither of which is known for certain. It has been concluded above (38), however, that in order to have been in scale with the horses the figures in the chariot must have been at least 3·25 m high, and may have been higher, perhaps as

1. It is perhaps a debatable point to what extent the Greeks felt necessary external supports to be unsightly. They seem to have used them regularly in marble sculpture, for example beneath the rearing horses on the west pediment of the Parthenon, and beneath the bellies of the marble horses from the Anticythera shipwreck (Bol, *Die Skulpturen des Schiffsfundes von Antikythera* (1972), 84–91, pls 50–55). In neither of these groups, however, are the supports beneath the horses so substantial as on the Mausoleum chariot group, and both are partially disguised, those on the Parthenon pediment as rocks, those from the Anticythera shipwreck as acanthus columns.

much as 3·60 m. Assuming 3·25 m to be the correct height, such a figure would have had a maximum width of *c.* 1·25 m (by analogy with 26, the height of which is 3 m, and the maximum width 1·12 m). If one supposes that the minimum likely width for the chariot is 3 m (as suggested above, p. 20), there would just have been room for two figures of this size standing side by side. If, however, as seems probable, the chariot was wider than 3 m, then clearly there would have been ample room for two such figures. Three figures of this scale could only have stood side by side, however, if one supposes, with van Breen, that the chariot was as wide as the four horses of the team, i.e. *c.* 4·50 m. Obviously the chariot could have been made this width, if the designer had wanted to include three figures. Alternatively, if three figures stood in the chariot, one could have been placed behind the other two, the chariot probably having had sufficient depth to permit this.

The possible identities of these various numbers of figures depend on whether the four-horse chariot conformed to Greek or non-Greek artistic conventions, or was a combination of the two (by non-Greek one means Carian, Lycian, Persian, or Phrygian). Here we have only the general evidence of the horse types and the chariot wheels. The horses are definitely not of mainland Greek type. They are strong, solid draught horses of Asiatic or perhaps even Nisaean breed. It seems quite possible, as Preedy has suggested (39), that they were intended to evoke a favourite team from Maussollos' own stable, although this need not necessarily mean that Maussollos himself stood in the chariot.

The large chariot wheels appear to be of general Persian type, although the number of spokes may reflect east Greek practice. In any case, the size and solidity, the general character, agrees with that of the horses, and rules out the possibility of the chariot having been of the light racing type common in mainland Greece (40).

The general evidence of the extant sculptures, therefore, suggests that the chariot group had a marked Asiatic or Asiatic–Ionic character, though to what extent this may reflect the identity of the charioteer rather than the artistic origins of the designer is impossible to say.

Another factor to be borne in mind, which may or may not be significant for the interpretation of the group, is the absence of rapid movement in the representation of the horses. They appear to have been standing quietly, or, at the most, walking slowly forward. It might be felt that this favours a funerary interpretation, the slow-moving or static horses being intended to evoke the pomp and solemnity of a funeral procession. It is possible also that the curious tails may be intended to be clipped to denote mourning (41). On the other hand, the lack of movement in the horses may have been imposed to a considerable extent by structural considerations, and need not be significant.

In the light of this let us consider who the occupant or occupants of the chariot may have been, and the meaning of the chariot group in relation to the tomb.

The possibility that the chariot may have been empty and that it represented an offering to the dead Maussollos has met with a considerable amount of support from some eminent authorities (42). The theory seems to have started as something of a reaction to attempts to attribute statues 26 and 27 to the chariot, and it gained ground as support for the attribution of those statues diminished. Some of the evidence adduced in support of an empty chariot has been of a negative kind: that Pliny does not mention any figures in the chariot in his brief allusion to the group, and that no suitable fragments of possible figures were found in the excavations on the site. Neither of these points carries much weight (43).

It is known, however, that offerings of four-horse chariots were made to dead rulers in outlying areas of the Greek world. There is a striking illustration of just such a scene on the wall-paintings of the late fourth-century tholos tomb at Kazanlak in Bulgaria (44), where a groom leads an empty four-horse chariot forward as one of various rich offerings being made to the dead prince, who receives them seated on a throne with his consort. Four-horse chariots, empty of human beings, also take part in funeral processions on the lid of the Mourning Women sarcophagus, and on grave stelae of Greco-Persian type (45), though here they are escorted either by mourners who go on foot, or by other chariots that are occupied.

These examples, while certainly allowing the possibility that the Mausoleum chariot may have been empty, do not provide precise artistic parallels for it. In all of them the empty chariot forms part of a larger composition, and the reason for the emptiness is immediately apparent from the actions or presence of other figures around it. An empty chariot and four on the summit of the Mausoleum would, by contrast, have stood in total isolation. There can have been no groom to lead it forward or seated lord to receive it, as on the Kazanlak tomb, nor can it have formed part of a ceremonial procession, as on the Mourning Women sarcophagus or the grave stelae. The emphasis in such a group would have been on the absence of a charioteer, and therefore on the death of the ruler, rather than on the chariot as an offering to the dead.

It may be doubted therefore whether an empty chariot conveying so hopeless a message would be likely on the summit of so self-assertive a building as the Mausoleum. If it were so, it would seem to have been unparalleled in antiquity. No other chariots on the summits of buildings are known to have been unoccupied (46).

There may also be technical reasons for rejecting such an interpretation. It has been suggested above that the wheels of the chariot were carved in two parts in order to strengthen the construction of the chariot frame, and that there were underfloor supports made up of stones like 25. There would be no reason for resorting to these measures unless some figure was going to stand in the chariot.

Another possibility for the interpretation of the Mausoleum chariot is that it was a satrapal chariot, symbolising Maussollos' authority and rule. This is the opinion of Hafner (47), which is followed by Riemann (48). Such an interpretation would certainly satisfactorily account for the types of the horses and chariot. Necessary occupants would be Maussollos himself, and also a charioteer, since it is extremely unlikely that the satrap would have driven himself.[1]

If the chariot was of satrapal type, it is theoretically possible that Maussollos and Artemisia might have occupied the chariot, which would therefore have symbolised the joint sway of the brother–sister/husband–wife. But it is extremely unlikely that this was so, for they too would have needed a charioteer, which would mean three statues in the chariot. Although it is just possible that three statues could have been accommodated, there would undoubtedly have been difficulty over their relative placing, and the over-all appearance would have been extremely awkward. Since it is clear that statues 26 and 27, traditionally identified as Maussollos and Artemisia, cannot have belonged to the chariot (see below), there is no longer any reason for giving serious consideration to the possibility of their joint presence.

A third possible interpretation for the chariot group on the summit of the Mausoleum is that it represented the apotheosis of Maussollos (49). If this was the case the occupants may have been either Nike by herself or Nike and Maussollos.

The possibility that the charioteer was a solo Nike, or Victory personified, was suggested by Pfuhl (50) and, after him, by van Breen (51). Nike regularly appears by herself in a four-horse chariot in Greek art symbolising victory. Often the victory is an agonistic one, but sometimes it is of a more general nature which might include apotheosis. Plutarch (52) mentions a painting by Melanthios of Sicyon, which showed Aristratos, tyrant of Sicyon in the time of Philip, standing by a chariot which bore Nike. And, according to Pliny, *NH*, xxxv.108, Nicomachos of the Attic school painted 'Victory hurrying aloft in a quadriga' (53). A solo Nike must therefore be counted a possibility for the Mausoleum chariot, although it is perhaps not a likely one (54). The supposed evidence of the stone inscribed Nike, cited by van Breen, must certainly be rejected (55).

The other possibility for an interpretation as apotheosis is that there were two occupants, Nike and Maussollos. This would be analogous to the apotheosis of Heracles, as represented on numerous Attic red-figure vases of the late fifth and early fourth centuries BC, where Heracles is driven aloft by Nike in a quadriga to join the ranks of the gods (56).

Such a theme might be felt, perhaps, to be in keeping with the over-all design of the building. The chariot, being set high on the top of a tapering pyramid, would seem to be flying through the air, or preferably, as the horses were shown standing or walking and in a high state of nervous energy (cf. frag. 1), to have arrived already at its destination. The Asiatic character of the horses and chariot would not necessarily be out of place in this essentially Greek theme, for it would be natural enough that the apotheosis of Maussollos should take place in his own chariot pulled by his own team of horses. Such a group on the summit of the Mausoleum would have provided a fitting backdrop for Theodektes' tragedy *Maussollos*, which must have received its first performance in the theatre at Halicarnassus, and which, no doubt, would have culminated in the apotheosis of its hero. It would also furnish the prototype for similar scenes which are found later in Roman Imperial funerary art (57).

This interpretation of the chariot group is the one originally favoured by Newton (58), who suggested that statue 27 was a goddess driving the chariot. It was only when faced by arguments that the female figure was far too small in relation to statue 26, 'Maussollos', to be a

1. The Kings of Assyria and Persia were regularly driven by charioteers, and so too is the Lycian ruler on the relief, BM B.313 (Pryce, *BM Cat.* i. 1 (1928), 145, pl. XXX; Bernard, *Syria*, 42 (1965), 276–9, pl. 18). Here the lord is seated while the charioteer stands. Jeppesen's ingenious suggestion, founded on this relief, that the seated statue 33 may have occupied the Mausoleum chariot, is precluded by the scale of the figure (which is too small), and perhaps also by the pose (a sceptre held in the left hand). On this latter point, however, Diodorus, xviii. 27.1, describes a picture displayed on Alexander's funeral carriage, which showed Alexander seated in a chariot, holding a sceptre.

goddess, that he changed his identification of the figures to 'Maussollos and Artemisia', thereby radically altering the significance of the group for the tomb.

Oldfield (59) objected strongly to the interpretation of the chariot as representing the apotheosis of Maussollos on the grounds that it would have been highly irreverent of Maussollos (or Artemisia) to set up such a group, this being about a generation earlier than Alexander the Great, who was reputedly the first dynast in the Greek world to be formally deified. One may doubt, however, whether the apotheosis of Maussollos would have been any more irreverent than the conception and construction of a tomb monument as lavish as the Mausoleum. The marriage customs of the fourth-century Carian dynasty, whereby brother married sister, as in the Egyptian royal family, suggest that the children of Hecatomnos considered themselves as something rather more than mere mortals (60). It is entirely possible, indeed, that the later apotheosis of Alexander may have been inspired by an earlier example such as that of Maussollos. Alexander had strong emotional ties with Halicarnassus,[1] and much of the official iconography of his reign seems to have been directly inspired by the architecture and sculpture of the Mausoleum, the form and size of which is likely to have appealed to his own sense of megalomania.[2]

Another possibility is that the chariot may have been occupied by a deity who had close connections with the Hecatomnid dynasty. This was the opinion of von Lorentz (61), who suggested that the charioteer was Apollo, whose head appears on the Carian coins issued by Maussollos and his successors, and who is the only deity known for certain to have been represented on the Mausoleum, from the evidence of head 48 (pl. 22).[3] It seems more likely, however, that if Apollo was the occupant of the Mausoleum chariot, he would have appeared in his more solar aspect as Helios or Helios-Apollo (62).

There are some tenuous grounds for supposing that Maussollos may have closely associated himself with Helios, even to the extent of considering himself his son. Pseudo-Plutarch, *De Fluviis*, 25.1, makes a curious reference to Maussollos, son of Helios, which is held to be a former name of the river Indus in India (63). Maussollos as an alternative name for the Indian river Indus does not appear to make much sense, but it is possible that the compiler of the *De Fluviis* may have misused his source and that the reference should have been to the Carian Indus (64). If Maussollos, apart from being styled 'Son of Helios', really was at some time an alternative name for the Carian Indus, it would suggest that he assumed for himself a divine or semi-divine character, whose chief aspects, sun and river, were those of a fertility deity. That such a link is quite plausible is shown by the Greek text of the trilingual inscription from the Letoon at Xanthos (65), in which Pixodaros, the younger brother of Maussollos, and satrap of Lycia, is cited in close proximity with, and apparently as the avenging agent of, Leto, the children of Leto (Apollo and Artemis), and the *Nymphs* (66).

Seen against this background it seems possible that the chariot on the summit of the Mausoleum was occupied by a statue of Helios-Apollo. Such a figure would not necessarily represent Maussollos in divine form, although it could do so. It would, however, stress his and the dynasty's close links with the deity, particularly if Helios drove a chariot and four that was recognisably Maussollos' own.

This interpretation, moreover, might satisfactorily account for the form and iconography of the Mausoleum. The upper part in particular, consisting of chariot group, pyramid, and lions, seems especially appropriate for a ruler associated with sun-worship. Pyramids are closely connected with the sun (67), while lions are frequently linked both with Helios (68) and with Apollo (69). There is evidence too that Apollo was worshipped at Halicarnassus as Agyieus (70), the *agyieus* being a pointed or conical pillar, sometimes an obelisk, which approximates to the over-all form of the Mausoleum (71).

Helios or Helios-Apollo in a chariot on the summit of the Mausoleum might also have served as a prototype for other late classical sculptures with this subject-matter, in particular for the Helios in a quadriga made for the Rhodians by Lysippus (72). A Helios in a quadriga may possibly have stood on the summit of the Mausoleum at Belevi, which was closely influenced by the Mausoleum at Halicarnassus (73). Compare in addition the metope from Ilium with Helios in a chariot (74).

1. Ada, the younger sister of Maussollos, became his adoptive mother and eventually bequeathed to him the Carian dynasty. Cf. R. L. Fox, *Alexander the Great* (1973), 136; P. Green, *Alexander of Macedon* (1974), 193.

2. The pyre of Hephaestion (Diodorus, xvii, 115. 1–5), which was in the form of a stepped pyramid with lavish sculptures on each level, was undoubtedly modelled on the Mausoleum. Alexander's own funeral car (Diodorus, xviii. 27. 1) was also probably loosely based on it. And the realistic portraiture favoured by the Macedonian royal family may very well have been inspired by the earlier portraiture of the Carian dynasts, including that which appeared on the Mausoleum.

3. This head is far too small to have belonged to a figure in the chariot. The head of Apollo introduced on the Carian coins by Maussollos is based on the Rhodian type which later becomes Helios. The coins of Hecatomnos have a lion, which has links with Apollo.

Possible objections to the presence of Helios in the Mausoleum chariot are that the horses do not move at speed, as one normally finds with Helios, and that the group probably faced east, in the opposite direction to the sun's path across the sky. On the other hand, the tranquillity of the horses may be imposed by structural considerations, and the orientation of the group may have been dictated by the requirements of the site, especially by the need for a group to face the entrance in the east *peribolus* wall. An east-facing chariot driven by Helios would at least have had the merit of facing the rising sun.

Which of these possible occupants of the chariot on the summit of the Mausoleum one finally accepts depends largely on personal preference. There are arguments for and against all of them. In the present writer's opinion, it is unlikely that the chariot would have been empty, and probable that however many occupants there may have been (75), one would have been Maussollos, whether in human or divine form.

The two statues, 26 and 27, which Newton assigned to the chariot group, and which rapidly came to be identified as Maussollos and Artemisia (although originally Maussollos and a goddess) certainly formed no part of it (76). Leaving aside the question whether the statues are large enough (and from conclusions previously reached they undoubtedly are not) (77), there is no evidence in favour of their attribution to the chariot group, and overwhelming evidence against.

Points which at various times have been considered to favour attribution of the statues to the group, but which do not really constitute evidence at all, are:

1. The supposed significance of the finding-places of the statues in the Imam's field, together with many fragments of the chariot group. Reference to the deposit of sculptures found in the Imam's field (above, p. 5 ff.) shows that it contained fragments of almost all the free-standing sculptural groups of the Mausoleum, and that the sculptures found in it could have come from any part of one side of the building. There is no reason to suppose that the discovery of 26 and 27 in proximity to the fragments of chariot horses is of any greater significance than, say, the discovery in equal proximity of 43, 45, or 48.

2. The identities of the statues. There is no particular reason to suppose that statues 26 and 27 portray Maussollos and Artemisia. The supposed evidence of the coins of Cos has been misleading.

3. The cutting on the lower left side of 26, supposedly to adjust it to the chariot (fig. 18). The recutting, possibly on more than one occasion, certainly requires explanation, but there is no reason why one should think that it is connected with the chariot group, rather than with any other part of the building. The recutting could have been done at a much later date, and need not have been at all connected with the fitting into place of statues.

Points against the attribution of the statues to the chariot group are:

1. Neither statue could have held the reins: 26, it is now clear, held a scabbard in the left hand, while the arms of 27 are in the gesture of a mourning woman. For these two statues to have stood in the chariot therefore, one would have to postulate a third statue (lost) to have held the reins.

2. The composition of the statues, the detailed working of their front surfaces, and the rather more summary finish of their backs, are such as one commonly finds in the fourth century BC on statues that were to be placed against walls, or in some other position where they would have been readily visible only from the front. The finish of the fronts of 26 and 27 is much finer than the surface of the chariot horses, and suggests that they were not set at nearly so great a distance from the spectator.

3. The existence of numerous similar figures, both male and female, of equal scale, designed and carved in the same way, with which 26 and 27 are naturally to be classified (see below, Group IA).

If statues 26 and 27 are rejected from the chariot group, as they surely must be, then much of the support for the suggestion that the occupants of the chariot were Maussollos and Artemisia disappears. There is no good art-historical reason why Maussollos and Artemisia should have appeared by themselves in the chariot. The suggestion finds favour only for so long as there seem to be external grounds for attributing the two statues to the chariot. As the evidence all points to the rejection of the statues from the chariot, it is reasonable to conclude that the occupant was one of the other possibilities previously discussed.

Of the statue or statues which stood in the chariot no trace remains, except possibly among the broken fragments of drapery; 306, for example, is very broadly worked, and appears to be from a statue sufficiently large to have stood in the chariot (pl. 33). All possible occupants, whether Maussollos, a charioteer, Nike, or Helios, are likely to have been draped.

THE SCULPTOR OF THE CHARIOT GROUP

Pliny, *NH*, xxxvi. 31, states explicitly that the marble quadriga on top of the Mausoleum was made by Pytis (78). The form Pytis is usually transcribed Pythis, and is taken to be a corruption of Pythius (or Pytheus: i.e. the Latin forms of Pythios or Pytheos), who is mentioned by Vitruvius, vii, *Praef.* 12, as co-author with Satyrus, of a book about the Mausoleum, the two presumably being jointly responsible for the over-all design of the building (79). Other references to Pytheus by Vitruvius (80) make it plain that he was renowned as an architect rather than as a sculptor, and an Alexandrian papyrus seems to confirm that he was architect of the Mausoleum (81). No other sculptural works by him are recorded.

Satyrus, on the other hand, is nowhere else mentioned as an architect. It is tempting to suppose that he may be identical with the Satyros, son of Isotimos, from Paros, whose signature appears on a statue base at Delphi, which once supported figures of Ada and Idrieus, younger sister and brother, and successors, to Maussollos and Artemisia (82). If so, he would seem to have been a sculptor rather than an architect.

It has been suggested therefore that, of the two co-authors mentioned by Vitruvius, Pytheus may have been responsible for the architectural design of the Mausoleum, while Satyrus was responsible for the over-all sculptural decoration. Satyrus would thus gain charge of the chariot group, while Pliny's attribution of the group to Pythi(u)s would have to be explained as a misunderstanding of, or a mistake in, his sources (83).

This complex question, and others concerning the authorship of the sculptures of the Mausoleum, is discussed in greater length below (84). For the moment it is worth noting that at least two different sculptors were involved in the actual carving of the chariot group. This is apparent from variations in the carving of the four extant fragments of the horses' tails (85). It would seem that whoever the designer of the group may have been, he had at least one assistant working with him on the carving. Or possibly the carving was left entirely in the hands of subordinate sculptors, the master-sculptor being responsible only for the design of the group and the supervision of its execution.

The Lions

THE STANDING LIONS

The standing lions (catalogue nos 401–649) are the best-preserved group of free-standing sculpture from the Mausoleum. Their heraldic character caught the eye of the Knights of St John when they demolished the ruins, and ensured the preservation of some of their number through their being built into the walls of the castle at Bodrum. Many more fragments, both large and small, and generally in better condition, were found by Newton in the course of his excavations.

SCALE

Newton distinguished three different scales among the lions (*HD* 229–30), but almost certainly they should be regarded as belonging to a single scale. No two lions are of precisely similar dimensions, as the accompanying table of comparative measurements shows.

The smallest lion is 401, which is 1·53 m long and some 44 cm wide in the body. The largest is 410, which is 1·60 m long, as preserved (very little is missing), and 50 cm wide. The other lions fall somewhere between these two extremes, with the exception of the body widths of 415 (51 cm) and of the lioness in Istanbul (42 cm), if she belongs to this series, as she probably

Notes and References begin on page 249.

Cat. no.	Total extant L. m	L. from end of fur to tail m	W. of body at shoulders m	W. of face at eyes m	W. of eye cm
401 (pl. 37)	1·53	0·405	0·44	0·34	4·2
402 (pl. 37)	0·61	—	0·48	0·335	4·9
403 (pl. 37)	—	—	—	0·32	4·6
404 (pl. 38)	1·26	—	0·50	0·34	4·6
405 (pl. 38)	1·34	—	0·47	0·33	4·9
406 (pl. 39)	0·87	—	—	0·325	3·7
407	1·095	c. 0·24	—	—	—
408	0·59	c. 0·25	—	—	—
409	0·79	—	—	—	—
410 (pl. 39)	1·60	0·335	0·50	—	—
411 (pl. 39)	1·57	0·34	0·495	—	—
412 (pl. 39)	0·75	—	c. 0·48 (incl. cast)	0·33	4·1
413 (pl. 39)	1·01	—	0·48	0·305	4·25
414 (pl. 40)	—	—	—	0·335	4·1
415 (pl. 40)	1·46	—	0·51	0·325	4·3
416 (pl. 40)	1·015	0·135	—	—	—
417	0·57	0·26	—	—	—
Lioness in Istanbul	1·18	no fur on back	0·42	—	5

does (see below). That too much should not be made of these discrepancies is suggested by the fact that the lion which is narrowest in body, 401, has the widest face (34 cm), while the lion which is widest in body, 415, has a face width of only 32·5 cm. There are also quite broad

variations in the widths of the eyes, between only 3·7 cm for 406 and 4·9 cm for 402 and 405. The widest eye of all, 5 cm, belongs, appropriately enough, to the lioness in Istanbul, whose body width is the narrowest.

It is clear that the original lengths of the lions, including the heads, must have ranged between c. 1·55 m and 1·65 m (86). The original height, excluding the base, must have been c.1·60–1·65 m; 401 is 1·50 m high, as restored, to which the height of a paw, c. 10–15 cm, has to be added.

The variations in size probably result from the litheness or squareness of design of the particular lion. The smallest lion, 401, is squarely built, stands upright, and is somewhat dog-like in appearance; 410, on the other hand, is much lither, particularly in the hindquarters, and is consequently somewhat longer. The differences, in any case, are not great, and would certainly not have been noticeable from a distance.

Cat. no.	Maximum width of paw cm	Th. of base cm
418 (pl. 40; fig. 40)	16·5	12·5–16
419 (fig. 41)	21·5	10–17·5
420 (pl. 41; fig. 42)	21	12–15
421 (fig. 43)	half is c. 11	8 as preserved
422 (fig. 44)	19·5 as preserved	10
423 (fig. 45)	half is c. 10·5	6·5–7·5
424 (fig. 46)	half is c. 10	12–13
425 (fig. 47)	20	15–16·5
426 (pl. 41; fig. 48)	18	4·5
427 (fig. 49)	half is c. 8·5	9·5 as preserved
428 (fig. 50)	half is c. 10·5	9 as preserved
429 (fig. 51)	half is c. 10·5	13
430 (fig. 52)	half is c. 11	11·5–12
431 (fig. 53)	half is c. 9·5	9·5 as preserved
432 (fig. 54)	—	7·5 as preserved
433 (fig. 55)	—	6 as preserved
434 (fig. 56)	19·5 as preserved	14·5–15
435 (fig. 57)	18·5	10–12
436 (fig. 58)	21	11–12·5
437 (fig. 59)	half is c. 11	13
438 (fig. 60)	half is c. 10	8·5–15·5
439 (fig. 61)	18·5	12·5 as preserved
440 (fig. 62)	14·5	9·5–10
441	15 as preserved	—
442	half is c. 10	—
443	half is c. 10	—
577	tip of tail	9·5

Similar discrepancies in size are noticeable also amongst the paws, as the accompanying table shows.

The paws vary for the most part between 18·5 and 21 cm in width, although by far the majority seem to have been c. 20–21 cm wide. The smaller size of a few paws is unlikely to be significant. The variation depends to some extent on whether the paw took weight or not. If it did, the toes are splayed more, and the paw is wider: so, for instance, nos. 419, 420; 418, on the other hand, a right rear paw which is set back, and which took little weight, is only 16·5 cm wide at the toes, although in other respects it is not noticeably smaller than the other paws, and the tail which is preserved on the same fragment is of standard width. The only paw which might perhaps be excluded from the main series on grounds of size is 440, which is only 14·5 cm wide, or two-thirds the size of the largest, 419. But even this is not certain, since the break above the paw may be large enough for a lion's leg of standard size. Obviously a considerable degree of latitude has to be allowed for variations in carving between individual sculptors.

COMPOSITION

The composition of the lions emerges clearly from the larger fragments, and an accurate reconstruction is possible (fig. 4). They stood quietly on all four legs, their heads turned to one side, their tails curling between their hind legs. The type of lion appears to be non-Greek in origin (87). All the larger fragments in the British Museum are male, but it is likely that the lioness which Newton removed from the castle walls and presented to the Istanbul Museum (88) also belongs to the series. Möbius (89) preferred to exclude the lioness from the main series of standing lions, but her general composition conforms to that of the male lions, and her scale is the same, the narrower body and wider eye being perhaps concessions to her female sex. She seems ill-suited for a hunting group, to which she can only otherwise have belonged. Quite what the significance may have been of the inclusion of a lioness among the lions is hard to say. She may not have been alone, however. Fragment 374, which preserves some of the hindpart of a lioness, including udders identical to those of the Istanbul lioness, may also have belonged to the main series of standing lions, if the scale is large enough (90).

There are two main types: one intended to be seen laterally from its right side (type I), the other to be seen

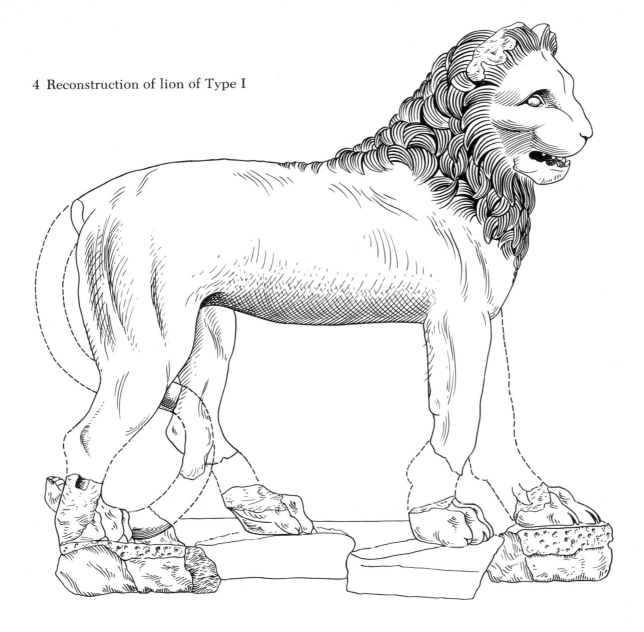

4 Reconstruction of lion of Type I

laterally from its left side (type II). In both types the head is turned towards the side from which the lion was to be seen, usually at an angle of *c*. 45 degrees, and on this side both foreleg and rear leg are set back. The existence in roughly equal numbers of these two types, one the reverse of the other, makes it certain that the lions confronted one another in heraldic fashion, either in confronting pairs (as has been assumed in most earlier reconstructions) or, more likely, in confronting rows. Evidence favouring an arrangement of the lions in confronting rows comes from the finding-places on the north side. The two large fragments, found in the Imam's field, opposite the eastern half of the north side, 401 and 402, are both of type I; while the two lions from Mahomet's field, opposite the western end of the north

side, 411 and 412, are both of type II. This suggests that the lions were arranged in two rows that met at the centre of each side.

An important variation occurs in three lions of type I, 404, 405, and 406, where the head is turned more sharply than in the other lions, at *c*. 90 degrees instead of *c*. 45 degrees. It must be considered only chance that no lions of type II with sharply turned heads have been preserved. If, as seems likely, the lions stood in confronting rows, these lions with sharply turned heads would probably have been the central lions on each side who actually confronted one another. If, however, the lions were arranged in confronting pairs, these lions would presumably have faced outwards at the four corners of the building. In either case there would be

four lions of type I on the building with heads turned at 90 degrees, and four of type II. Since we have three of type I, it follows that these must belong to three different sides of the building.

THE POSITION OF THE LIONS ON THE BUILDING

The evidence for the composition of the lions, and the large number of fragments preserved, suggest that the lions were ranged along all four sides of the Mausoleum. The degree of weathering, often severe, proves that the position occupied was an exposed one. There are really, therefore, only two positions which the lions might have occupied. One is on some part of the podium (91), the other is on the roof (92). They cannot have been placed between the columns of the pteron, as has been suggested by Krischen and others: their design precludes their having been placed frontally in this position, and Jeppesen's important discovery of the length of the axial intercolumniation (93) (3 m, with 1·50 m clear space between the column bases) means that there was not enough room for them to have been placed laterally here.

It seems fairly certain now that the lions were placed on the roof at the base of the pyramid. The upper steps of the pyramid were of insufficient width to have accommodated them (c. 43 cm on the long sides, c. 54 cm on the short sides, as compared with the 50 cm width of the lions), but there is evidence that the lowest step of the pyramid was widened to c. 60 cm and that it had cuttings to receive sculptures into which the lions can be reasonably fitted. One such pyramid step was brought back by Newton (94). Others have been found in the recent excavations by Jeppesen, who now agrees with Möbius's theory (95). The cutting in the pyramid step in the British Museum is 31 cm wide and 8 cm deep. From its closeness to the front edge of the step, it can only have contained a left hind paw (probably with tail attached) of a lion of type II, the equivalent, that is to say, of 418, which belonged to a lion of type I (the width of the base of this fragment, which bears both paw and tail, is 28 cm, which would ideally suit the cutting in the pyramid step).

Fragments of the bases on which the lions stood are, in fact, preserved beneath most of the paws which are extant (418–440; see list, above, p. 28), and these clearly constitute important evidence for the way in which the lions were set up on the building. The bases are rough hewn, and vary considerably in height: 419, for instance, varies in height between 10 and 17·5 cm; 418

between 12·5 and 16 cm; 438 between 8·5 and 15·5 cm. Generally, however, they provide a median height of c. 10–13 cm. Two paws only are of noticeably thinner base: 423 is 6·5–7·5 cm thick, while the base of 426 is only 4·5 cm. The latter may be significant: 426 is the only paw definitely found on the south side of the Mausoleum (see above, pp. 10–11); its character differs from that of most of the others, and it may be that the thin base indicates different workshop conventions.

Not all the base was let into the cutting which received it (probably in the pyramid step). Most fragments of bases which are at all well preserved have horizontal grooves or lines running along the edges, indicating the amount let in: usually c. 7·5–10 cm, although on 422 and 430 it is only c. 5·5–6·5 cm. This, again, is in general agreement with the depth of the cutting in the pyramid step in the British Museum. The edge of the base above this line is generally much more weathered than that below it. On most bases there are also horizontal recesses, the bottoms of which coincide with the level of the grooves or lines on the edges. These exist on 419, 420, 422, 424, 436, and 437, and there are traces also on 427 and 428. They are sometimes in front of the paw (nos. 419, 420, 436, 437), sometimes in the edge to the side of it (nos. 422, 424, 427, 428). Compare also the recesses behind the tails 577 and 578. The dimensions are roughly similar: L. 8·5–10 cm; H. 3 cm; D. 2·5–3 cm. The position of these recesses, just above the amount of base let into the step, suggests that they were connected with the setting up of the lions on the building. They do not seem to have been clamp holes, nor do they seem to have been used for lifting, since they are too shallow, and in some cases, e.g. 420, too awkwardly placed. Probably, therefore, they are pry-holes into which crowbars could be inserted in order to lever the lions into position once they have been lifted on to the roof (96). Some of the bases have chamfered edges to further ease their setting in place (nos. 418, 425, 431, 437).

The shape of the lions' bases is not known for certain. The extant fragments tend to be small and to show no great consistency. Some have fairly straight sides meeting roughly at right angles (nos. 418–424), others have rounded edges running close to the paw (nos. 425–434), while others are simply irregular in shape (nos. 435, 436, 438). It seems fairly certain that all four paws stood on a single plinth, since the lions were carved from single blocks of marble without supports under the belly, so that the carving of individual bases for each paw must have weakened the legs of the animals. That this was so is confirmed by the few larger fragments,

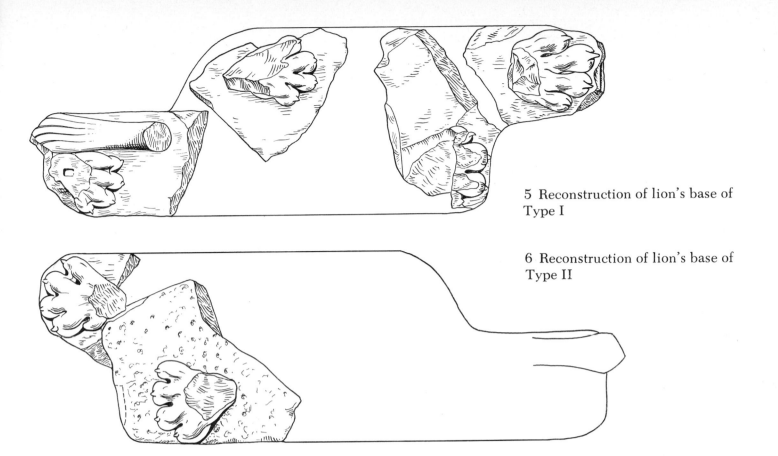

5 Reconstruction of lion's base of Type I

6 Reconstruction of lion's base of Type II

such as 419, 435, and 438, where enough base remains beside the extant paw to show that it must have extended across the full width of the lion, so that here at least two paws must have stood on the same base. Even from these fragments no great consistency of shape emerges for the original base. The base of 419, supposing it to be a left hind paw belonging to a lion of type I, may perhaps have been H-clamp shaped; that of 435 (left hind paw?) is highly irregular, the edge having been apparently hastily trimmed for fitting (there seems to have been a similar recutting of the edge of 426); while 438 (a right forepaw?) has an edge which curves around the paw, and then seems to veer forwards, presumably to pick up with the edge of the other forepaw, which must have been set forward.

Of these three examples, the picture presented by 438 is likely to be truest and most typical. Most of the other bases below paws which are extant have original edges on two or three sides, running very close to the paw. Bases which preserve edges on three sides (in front or behind, and on both sides) are: 418, 420, 425, 426, 427, and 429. Bases which have edges to two sides, as preserved, are: 421, 423, 424, 428, 430, 431, 432, 436. To judge from this evidence, it is likely that in most, if not all, cases the forepaw which was set forward, and the hind paw which was set back, had bases beneath them which projected forward or backward from the main part of the plinth. That beneath the forepaws would

have been c. 25 cm in width, to judge from the examples of 420 and 425, and would have projected forward at least 25 cm. That beneath the hind paw that was set back would have been slightly wider, probably c. 28–30 cm, as it also included the tail. The only extant large fragment we have of such a base beneath a hind paw is 418, which is 28 cm wide and must have projected backwards at least 40 cm.[1] Such a projection of the base beneath one forepaw and one hind paw on each lion would agree well with the dimensions and position of the cutting, probably for a lion, in the pyramid step A.19 in the British Museum. One would imagine that the edge of the base ran from the projecting forepaw across to and around the other forepaw (this would account for the line of the edge on fragments 433, 436, and 438), and that likewise it ran forward from the hind paw that was set back, across and around the other hind paw. If 419 is a hind paw, one must suppose that one lion's base at least had an indentation in the edge between forepaw and hind paw. For the sake of uniformity it is perhaps preferable to take 419 to be a forepaw, in which case the difficulty disappears, and bases of broadly similar shape emerge for each of the two types of lions. Composite reconstructions of the likeliest shapes of the bases are given in figs 5, 6.

1. However, 418 may not be typical: a square dowel hole in the broken surface of the leg appears to be ancient, and the whole of this fragment may constitute an ancient repair. See below, pp, 64, 189.

The lack of precision evident in the carving of the lions' bases suggests that they occupied a position on the building where they could not have been seen close at hand, and it seems most likely that this was on the roof, at the base of the pyramid. In this position, because of the projection of the sima, the lions would only have been wholly visible at a considerable distance from the building (97), and the bases could never have been seen at all from the ground.

Whether the lions were fixed in place with dowels, or simply rested in the cuttings made to receive them, there is no way of telling. None of the extant fragments of base has any dowel hole. On the other hand, it is noticeable that no central part of a lion's base has survived (i.e. between forelegs and hindlegs), and it may be that this part was dowelled to the building, where it would have tended to remain when the lion fell to the ground.

APPORTIONMENT OF EXTANT LIONS TO SIDES

It has been concluded above (pp. 29–30) that the lions stood on all four sides of the Mausoleum. For the question of the distribution of individual lions to particular sides, there is a variety of evidence: (a) the finding-places; (b) the letters carved on some of the larger fragments; (c) stylistic similarities discernible in the larger fragments, from which one may recognise the hands of different sculptors.

(a) Finding-places are summarised below:

North side
The Imam's field. 401 (type I) Π (pl. 37); 402 (I) (pl. 37); 406? (I) (pl. 39).
Mahomet's field. 411 (type II) Π (pl. 39); 412 (II) (pl. 39).
Mehemet Ali's field. 403 (I) (pl. 37).
Omer's field. 416 (II) Λ (pl. 40).
Built into wall some way to north. 414 (II) (pl. 40).
'From north side'. 410 (II) Π (pl. 39).

Within Quadrangle
405 (part) (I) (pl. 38); 407 (I) Π; 408 (I) Λ; 409 (I); 417 (II)? >.

From walls of castle
404 (I) (pl. 38); 405 (part) (I) (pl. 38); 413 (II) (pl. 39); 415 (II) Λ (pl. 40).

Most of the major fragments of lions recovered by excavation came from the north side. In the case of the two lions from the Imam's field, 401 and 402, and the two from Mahomet's field at the west end of the north side, 411 and 412, there is every chance that the lions were found where they had fallen from the building. It has been suggested above that, since 401 and 402 are of type I whereas 411 and 412 are of type II, the lions probably formed two confronting rows meeting at the centre of each side. There can be less certainty about the other fragments from the north, 403, 416, 414, and 410, although for all except 414 there must be some chance of their finding-places having been relatively undisturbed.

The other, generally more battered fragments, found within the Quadrangle (nos. 405, 407–409, 417), were clearly disturbed, and could have come from any of the four sides of the building.

For the lions, unlike for the other sculptures in the round, there is an additional source of evidence, namely those lions which came not from the excavations, but from the walls of Bodrum castle, into which they had been built by the Knights of St John: 404, 405 (part), 413, 415 (98). The Knights, when destroying the Mausoleum, missed at least one major deposit of sculptures and stones on the north side; there is therefore a good chance that the lions which they built into the castle came originally not from the north side of the Mausoleum but from one of the other sides.

(b) Letters. Four of the extant lions have the capital letter Π carved on their rumps: 401, 407, 410, 411; two have Λ: 408, 415; another appears to have Α (Α), 416, while another may have traces of a fourth letter, 417. Since these letters do not distinguish between the two types of lions (of the four lions with Π, two are of type I and two of type II), it is probable that they refer to the different sides of the building. This seems to be confirmed by the finding-places of the Π lions. Three definitely came from the north side: 401, 410, 411; while the fourth, 407, was found within the Quadrangle, and could have done so. None came from the walls of the castle. One may reasonably therefore attribute the Π lions to the north side. Of the lions with Λ, one, 408, came from within the Quadrangle, the other, 415, from the walls of the castle. On the grounds of finding-place alone, it is not possible to attribute them to a particular side. The lion with Α, 416, came from Omer's field at the east end of the north side. It is unlikely to have been found exactly where it had fallen (99), but if it had not been unduly disturbed, this would tend to suggest that

the 'A' lions may have belonged to the east side of the building, since we already have the Π lions at the north.

The reasons which dictated the choice of these letters for the lions have been much discussed, but no satisfactory conclusions have been reached (100). If we proceed on the assumption that the 'A' lions occupied the east side of the Mausoleum at roof level, and that the Π lions were on the north side at the same level, and if we bear in mind the existence of Λ lions which are likely to have belonged to another side, it is possible to construct a plausible hypothesis concerning the significance of the letters.

A, Λ, and Π are the first, eleventh, and sixteenth letters of the classical Attic and Ionic Greek alphabet. If there is any logic governing their choice, as there appears to be, the missing fourth letter which completes the sequence is the sixth letter of the alphabet, Z. It is just possible that traces of this letter remain on the fragmentary hindquarters, 417. Originally, therefore, the lions of the Mausoleum may have borne one of the letters, A, Z, Λ, Π, referring to the particular side on which each lion stood. If Λ referred to the east side and Π to the north, it is probable that Z lions would have been placed at the south, and Λ lions at the west. There would then be a progression from what was arguably the most important side of the building, the east (facing the propylon), to the next most important side, the south (the side that a visitor would have seen when approaching Halicarnassus from the sea), to the west, and finally to the north. According to this theory, the letters on the lions would be explained not as necessarily referring to particular workshops, but as representing part of a lettering system which applied to the over-all decorative scheme of the Mausoleum (101). Each part of the sculptural decoration on each side of the building would have received an identifying letter, in the case of the lions, A, Z, Λ, Π, and the work could then have been apportioned to the various sculptural workshops concerned in roughly equal amounts (102).

(c) **Stylistic similarities.** Individual sculptors' hands are discernible within the two basic types of lions. These extend the attribution of lions to sides. The following different hands seem evident:

Sculptor 1. 401, 402 (pl. 37). Both from the Imam's field, north side, and of type I, 401 being a Π lion. This sculptor may also have carved 403 (pl. 37). The treatment of the mane is in all cases very similar. The locks lie flat on the neck and on top of the back, and the carving is rather sharp. The eyes are deep sunk, the flews at the corner of the mouth rounded. The pose is square and stiff, and somewhat dog-like.

Sculptor 2. 411, 412 (pl. 39). Both from Mahomet's field at the west end of the north side, and both of type II; 411 is a Π lion. The style is fairly close to that of sculptor 1 with regard to pose and treatment of mane, but is if anything harder. There are harsh, angular flews at the corner of the mouth. Probably from the same workshop as 1.

Sculptor 3. 407, 410 (pl. 39). Both Π lions, one from the Quadrangle, one from the north side, one of type I, the other of type II. The treatment of the mane of 410 is fairly close to the styles of sculptors 1 and 2, but the pose is much lither, as is particularly evident in the hindquarters. There is less anatomical detail on the surface of the body.

Sculptor 4. 404, 415 (pls 38, 40). Both from the walls of the castle. 415 a Λ lion of type II, 404 of type I with a 90 degree turn of the head. The treatment of the mane is spikier than on the lions of sculptors 1–3. The proportions are more massive, the eyes less deep-set, the nostrils deeply drilled.

Sculptor 5. 405, 413 (pls 38–39). Both from the walls of the castle, of types I and II respectively, no letters preserved; 405 with a sharply turned head. Despite damage, both lions are evidently of leaner, bonier type. The eyes are round, the head is upturned, and the gaze is pathetic. The mane and the fur on the back are much tuftier than on other lions.

Sculptor 6. 414, 416 (pl. 40). Both of type II, 416 with A on its back, from Omer's field. The sculptor of each piece is an individualist. The triple row of locks on the back of 416 is unparalleled, as is the protruding tongue of 414. Both pieces exhibit certain horselike characteristics.

Based on the foregoing evidence and deductions, the distribution of the main fragments of lions is suggested in fig. 7, overleaf.

The attribution of 405 and 413 to the south side is not based on the evidence of letters, but rather on a process of elimination. Number 406, a lion of type I, with a 90 degree turn of head, could belong to either the north or the east sides, but the relative completeness (despite the extensive damage) perhaps favours the north (103).

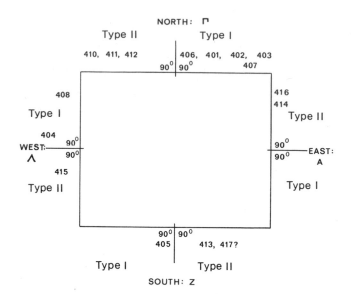

NORTH: ⌐

Type II Type I

410, 411, 412 406, 401, 402, 403
 90° 90° 407

408 416
 414
Type I Type II

404
WEST:— 90° 90°
Λ 90° 90° —EAST:
415 A

Type II Type I

 90° 90°
 405 413, 417?

Type I Type II

SOUTH: Z

7 Diagram of distribution of lions to sides

RECLINING LION

A fragment of a lion's paw exists, 650, that evidently belonged to a reclining rather than a standing lion. The fragment was found by Newton, and is carved from the same type of marble as the standing lions. One must assume therefore that it formed part of the sculptural decoration of the Mausoleum. It is conceivable that other fragments, particularly of body and mane, attributed in the catalogue to the standing lions, could have belonged to this or another reclining lion. The likeliest position for one or more reclining lions on the monument is perhaps flanking a doorway, false or real, into the building.

The precise number of lions which occupied each side remains uncertain, depending on the length of each side at roof level and the spacing between lions. The length of each side is now fairly surely known: probably 32 × 26 m (100 × 81¼ ft, assuming a 32 cm foot length) (104). But the spacing between lions is not known. If, however, the lions were arranged in confronting rows, a close spacing would seem to be indicated (105).

The likeliest number of lions is perhaps sixteen on each of the longer sides in two confronting rows of eight, and twelve on each of the shorter sides in two rows of six, making fifty-six in all. The effect produced by this number can be gauged from the reconstruction (figs 8–9). A greater number of lions is theoretically possible, up to a maximum of seventy-two (twenty by sixteen), but the over-all appearance created by this quantity is likely to have been too close-packed. It seems unlikely that there would have been fewer lions than fifty-six, in view of the large number of fragments preserved, and in view of the formal composition of the lions, which seems to require a close spacing.

In any case, the leading lions of each row would have confronted directly above the axis of the central column of each side.[1]

1. For the colouring of the lions, see below, p. 66; for the relationship to other fourth-century lions, see p. 68.

Human Sculptural Groups: Scales

HUMAN STATUARY

The fragments of human statuary belong to three different scales of figures.[1] This is made clear in particular by the numerous fragments of feet which remain, 193–230, and is confirmed by the many other fragments of legs, arms, hands, bodies, and heads. These three scales are as follows:

Scale I. Colossal: *c.* $1\frac{2}{3}$ × lifesize. Statue H. 2·70–3 m

The dimensions of the male figures of scale I are given by 26 (the so-called 'Maussollos'): H. *c.* 3 m; a maximum W. of *c.* 1·15 m (after the addition of the scabbard), and a thickness of just less than 0·70 m; 29, which is also likely to be male, must originally have been the same size as 26. To its existing height of 1·42 m must be added *c.* 1·10 m for the portion from base to mid-thigh, and *c.* 45 cm for the head and neck (these dimensions after 26), making 2·97 m in all. The width and thickness would also have roughly equalled those of 26, since the extant dimensions take no account of the projection of arms or knees. Other male figures whose dimensions are equal to those of 26 are 63 (from a statue very similar to 29), the seated figure 33, and the Persian rider, 34, who may be, if anything, slightly larger than 26 (the width of his left hand is 17 cm, as compared with the 14·5 cm width of

Notes and References begin on page 250.

1. For fragments possibly from a fourth scale, see below, p. 53.

the hand 142, which may have belonged to 26). The dimensions of the right foot of 26, and the thickness of the sandal sole, are paralleled by the other fragmentary male feet, 211 and 212 (cf. also the feet of colossal mounted figures, 40 and 41).

The only complete standing female is 27 (the so-called 'Artemisia'), who is some 30 cm shorter than 26. The two statues are in the ratio, therefore, of 9 : 10. That she belongs to the colossal scale is shown by her width and thickness, which are almost equal to those of 26. The 9 cm extra thickness of 26 is almost entirely attributable to the fact that its left knee protrudes farther forward through the drapery. Some discrepancy between the heights of male and female figures is to be expected, particularly since it is evident from the sculpting that the male and female standing figures of this scale are intended as portrait statues.

Whether all the female statues were of the height of 27 there is no way of telling. Of the other female heads preserved, 30 is slightly larger than 27, and comes very close to 26, while 31 is slightly smaller. Number 32, if the dimensions of the ear are a guide, may have been the largest female head of all.[2] Too much should not be made of these discrepancies in dimensions of facial features between different statues. A safer guide to scale is given by the over-all heights of head and neck, which for the statues 26, 27, 30, and 31, all come within the narrow range of *c.* 42·5–44 cm.

2. The ear of 32 is 10·8 cm high and 6 cm wide, compared with 9 cm H. and 4·5 cm W. for 30, and 7 cm H. and 5 cm W. for 27.

The female foot is also shorter than the male's (41 cm for 27), but not much narrower (16 cm as compared with 18 cm). The sandal sole is thicker, being 4 cm or more (nos. 27, 28, 209, 210).

Tables of comparative measurements
OVER-ALL DIMENSIONS M—male; F—female

Cat. no.	Height m	Width m	Thickness m
26 (pls 13–15)	3	1·12 (excl. scabbard)	0·68
27 (pl. 13)	2·67	1·09	0·59
29 (pl. 16)	1·42	0·99	0·60
33 (pl. 17)	1·95	1·10 (excl. seat)	
34 (pl. 18)	1·16	(ankles to waist)	
63 (pl. 25)	0·61	0·65	0·23
64	0·52	0·47	0·37
65 (pl. 26)	0·40	0·30	0·18
98 (pl. 28)	0·31	0·155	0·15
104 (pl. 28)	0·39	0·32	0·175
231 (pl. 33)	0·33	0·42	0·14

HEADS
Height

Cat. no.	Head plus neck cm	Chin to crown cm	Chin to lips cm	Lips to bridge of nose cm	Bridge to hairline cm
26 (pl. 14)	c. 44	39	8	13·5	9·5
27 (pl 13)	c. 42·5	36·5 (originally)	—	—	9·5
30 (pl. 16)	c. 43	38	7·5	11	11
31 (pl. 17)	c. 42·5	35	7	10	—

Width

Cat. no.	Max. W. cm	Face at eyes cm	Eye cm	Mouth cm
26 (pl. 14)	—	26	6	9
27 (pl. 13)	33	23	4·5	—
30 (pl. 16)	31	21·5	4·5	6·3
31 (pl. 17)	27 (excl. hair)	20	—	5·5?

FEET

Cat. no.	Length cm	Width cm	H. of sandal sole cm
26 M (pl. 15)	48	18	2·5
27 F	41	16	4
28 F	—	—	4
40 M	28·5	15	—

FEET

Cat. no.	Length cm	Width cm	H. of sandal sole cm
209 F (pl. 31; fig. 30)	17	14	4·6
210 F	11·5	3·7	4·7
211 M (pl. 31; fig. 31)	12·5	15	2·2
212 M (pl. 31)	16	10·5	2·5

Scale II. Heroic: c. $1\frac{1}{3}$ × lifesize. Statue H. c. 2·40 m

Tables of comparative measurements
OVER-ALL DIMENSIONS

Cat. no.	Height m	Width m	Thickness m
42 M (pl. 19)	1·06	0·58 (complete)	0·38 (complete)
43 M (pl. 19)	1·01	0·56 (complete)	0·43 (complete)
44 M (pl. 19)	0·94	0·50 (complete)	0·40 (complete)
66 M (pl. 26)	0·36	0·34	0·37 (almost complete)
67 M	0·38	0·30	0·10
68 M (pl. 26)	0·505	0·32	0·405 (complete)
69	0·30	0·34	0·24
70 M	0·45	0·25	0·40 (complete)
71 M (pl. 26)	0·52	0·23	0·23
85A M (pl. 27)	0·57	0·475 (almost complete)	0·27
90 F (pl. 27)	0·325	0·57 (complete)	0·36 (complete)
91 F (pl. 28)	0·66	0·62 (complete)	0·32
92 F	0·495	0·33	0·28
216 M (pl 32; fig. 34)	Statue base W. 0·32		—

HEADS
Height

Cat. no.	Chin to crown cm	Chin to lips cm	Lips to bridge of nose cm	Bridge of nose to hairline cm
45 (pl. 20)	30	7·5	7·9	6·5
58	—	6	—	—
48 (pl. 22)	34	5·8	8·7	11

Width

Cat. no.	Max. W. cm	Face at eyes cm	Eye cm	Mouth cm
45 (pl. 20)	15·5	—	3·6	4·75
57 (pl. 25)	—	—	3·5	—
58	—	—	—	4·5
48 (pl. 22)	26·5	16·5	4	5·5

FEET

Cat. no.	Length cm	Width cm	Height of sandal sole cm
213 M (pl. 32; fig. 32)	31	13 (complete)	1·4
214 M (pl.32)	15	10	1·5
215 M (fig.33)	23	12	1·4
216 M (pl. 32; fig. 34)	13·5	12	—
217 M (pl. 32; fig. 35)	16	—	1·1
90 F (pl. 27)	—	—	3
93 F	14	—	1·5
208 F	10	10	1·2 (slipper)
228 F (pl. 33)	8·3	10	3

No complete male statue of scale II survives intact, but there are numerous large fragments from which it is possible to reconstruct the original height. The head and neck, 45 (35 cm), plus the upper body 68 (50·5 cm), plus the lower body 42 (1·06 m), plus the lower leg 171 (31 cm), plus the foot and ankle 214 (19 cm), gives a total height of 2·415 m. Making allowance for slight overlaps or gaps between fragments, an average height for male figures of scale II of *c.* 2·40 m is likely. These figures were, therefore, in the ratio of 8:10 to the male figures of the colossal scale I.

The three torsos 42, 43, and 44 give a width for the male statues ranging between 50 and 58 cm, excluding arms, while the same three torsos, taken with 66, 68, and 70, give an average thickness of 40 cm.

No complete height is available for the female statues of this scale, as no heads or upper parts remain. One may surmise that, as was probably the case with the female statues of scale I, they may have been slightly smaller than the males, with an original height of perhaps *c.* 2·20 cm. The two lower parts of female statues that are relatively complete, 90 and 91, are both slightly wider than the male statues, perhaps on account of the fuller drapery, and not much thinner in depth.

No complete foot remains for either male or female figure of scale II. However, the length of 213 which only

has the heel missing, 31 cm, means that the male foot must have been *c.* 37–38 cm long, and 13 cm wide, dimensions which find confirmation in fragments 214–217. The sandals of the male figures again tend to have thinner soles than those of the females.

Scale III. Life-size: Statue H. *c.* 1·80 m

No complete statues of scale III remain or are reconstructible, but since it is clear that all the fragments are life-size, an original height of *c.* 1·80 m must be likely. Two torsos, 72 and 85, suggest an original width for the statues of *c.* 40 cm, excluding arms, and a thickness of perhaps 25 cm. The outlines of two complete feet remain, 199 and 201, which give a length of 29·5–30 cm, and a width of between 11 and 12 cm. These dimensions are confirmed by the other smaller fragments of feet, both bare and sandalled. The sandal soles vary in thickness between 1 and 1·4 cm.

Tables of comparative measurements
BODIES

Cat. no.	Height cm	Width cm	Thickness cm
72	34·5	40	22
85 (nude); (pl.27)	41	35	21

HEADS
Height

Cat. no.	Chin to crown cm	Chin to lips cm	Lips to bridge of nose cm	Bridge of nose to hairline cm
46 (pl. 21)	25	5·2	7·5	7·3
49 (pl. 23)	25	[—13·8—]		5·5
51 (pl. 24)	24 (at back)	—	—	—
59	—	5	—	—
[47 (pl. 22)	21·5 (incl. neck)	6	7·7	—]

Width

Cat. no.	Max. W. cm	Face at eyes cm	Eye cm	Mouth cm
46 (pl. 21)	20	—	3·3	4·3
49 (pl. 23)	21	14·2	3	—
51 (pl. 24)	21	—	—	—
59	—	—	—	*c.* 4
[47(pl. 22)	*c.* 20	14	3	—]

FEET

Cat. no.	Length cm	Width cm	Thickness of sandal sole cm
193 (pl. 31; fig. 20)	18	10	—
198 (fig. 21)	16	11	—
199 (fig. 22)	29·5 (complete)	11 (complete)	— —
200 (pl. 31; fig. 23)	27	12	—
201 (fig. 24)	30 (almost complete)	12	—
203 (fig. 26)	18	11	—
204 (fig. 27)	10	12	—
207	16	8	1
218 (pl. 32; fig. 36)	—	—	1·3
219 (fig. 37)	—	—	1·4
220	—	—	—
221 (pl. 32; fig. 38)	18	9 (complete at heel)	1·4
222 (fig. 39)	16	9 (complete at heel)	1·4
223	7·5	7·5	—
225	13	9	—
226	11	11·5	1·25
165 (pl. 30)	—	9 (complete at heel)	—

The three scales of human statuary, III, II, and I, are in the proportion one to another of 3:4:5, or perhaps one should say, more correctly, 6:8:10, since they are compounds of a unit of measurement almost exactly equivalent to 30 cm, which runs through much of the sculpture and architecture of the Mausoleum. Whether this unit represents the full Ionian foot length employed, or whether it is fifteen dactyls of a 32 cm foot length is debatable.[1] What is certain is that these three scales of sculpture must be considered separately as regards subject-matter, since Greek sculptural rules concerning isocephaly mean that they must have occupied different parts of the monument, there being a strong likelihood that the larger scales I and II were placed higher than the smallest scale III.

1. The former might be thought likely since the life-size feet of the sculptures of scale III are *c.* 30 cm long. On the other hand, Jeppesen suggests that a 32 cm foot seems more likely from the evidence of the architecture and the cutting for the foundations of the basement. Cf. *Paradeigmata*, 58; *AJA*, 79 (1975), 78.

ANIMALS FROM HUMAN SCULPTURAL GROUPS

Tables of comparative measurements
HORSES
Chariot horses (fig. 2)

Length from head to hind quarters	3·60 m
Length, shoulder to hind quarters	*c.* 3 m
Height, excluding base	*c.* 3·60 m
Width of body	0·90 m
Length of hoof (e.g. 6, 7, 8)	0·34 m
Width of hoof (e.g. 6, 7, 8)	0·28 m

Horse of Persian rider 34 (pl. 18)

Length, shoulder to hind quarters	*c.* 2·10 m
Width of body	0·87 m
Length of forehoof, 36	0·215 m
Width of forehoof, 36 (as preserved)	0·125 m
Length of hind hoof, 37	0·29 m
Width of hind hoof, 37 (as preserved)	0·16 m

Life-size horses, fragments 390 ff. (pl. 36)
 Leg fragments only preserved; no over-all dimensions reconstructible.

Ratio of horse of Persian rider to chariot horses

Body length	7:10
Body width	almost 1:1
Hoof length, 37 and 6	*c.* 10:12
Hoof length, 36 and 6	2:3

SACRIFICIAL AND HUNTING ANIMALS
Ram, 360 (pl. 33): L. 1·50 m (excluding head); H. 0·84 m; W. 0·555 m. About the same size as the standing lions.

Bull, 362, 363, 364 (pl. 34): Width of 364 is 0·29 m, originally *c.* 0·58–0·60 m. Therefore larger than lions.

Boar's body, 365 (pl. 34): L. 0·72 m; H. 0·55 m; Th. 0·35 m (complete).

Boar's body, 366: L. 0·61 m; H. 0·475 m; Th. 0·35 m (complete).

Boar's head, 367 (pl. 34): L. 0·48 m; H. 0·24 m; Th. (*c.* half) 0·12 m.

Boar's head, 368 (pl. 34): L. 0·27 m; H. 0·255 m; Th. 0·23 m (complete).

Length of 365 plus 367 equals 1·20 m.

Leopards: 371 (pl. 35): L. (incl. head) 1 m; H. 0·59 m; Th. 0·39 m.

373 (pl. 35): L. (hind part) 0·66 m.

Total length of leopard *c.* 1·70 m, including lowered head. The scale is the same as for the standing lions.

Fragments of horses of three different scales exist. The largest are those of the chariot group, with a length of 3·60 m, and a height of about the same or slightly more. The next in scale is the horse of the Persian rider, 34, which is important because the rider is clearly to be equated with the colossal scale I of the human statuary. A comparison of this horse with a reconstruction of one of the chariot horses proves it to be somewhat smaller in scale, but also shows that the two horses were composed according to widely divergent systems of proportion. Whereas the body length of the chariot horse is considerably greater than that of the Persian rider's horse (in the ratio of 10:7), the body width is almost the same (90 cm as compared with 87 cm). The explanation for this apparent contradiction probably lies partly in the fact that the chariot horses are intended to be a larger breed of draught horse (106) and partly that the width of the chariot horses was reduced in order to accommodate them to the summit of the building. There is some variation also in the ratios of the different hooves. The raised forehoof of the Persian rider's horse, 36, is in the proportion 2:3 with forehoof 6 of the chariot group, which, however, rested on the ground. On the other hand hind hoof 37, which supported the prancing horse and which may therefore have been lengthened to provide extra purchase, is in the proportion of 29:34, or rather more than 10:12, with the chariot horse hoof 6 (or indeed hoof 7 or 8, one of which may have been a hind hoof). Bearing in mind that, for technical reasons, the length of hind hoof 37 may have been increased, and the widths of the bodies of the chariot horses reduced, and bearing in mind also that the chariot horses are likely to have been a larger breed of horse, it is reasonable to assess the true ratio between the scales of the Persian rider's horse and the chariot horses as being 10:12.

Therefore, if the three scales of human figures are in the proportion 6:8:10, the chariot group was in the ratio of 12, or, in other words, was twice life-size. This would suggest that any figure or figures which stood in the chariot ought to be larger than the standing figures of scale I, even allowing for a difference in breed between the chariot horses and the horse of the Persian rider (107).

The third scale of horse was about life-size. Numerous fragments of legs remain, 390–399, but none is sufficiently large to permit a reconstruction of over-all dimensions. The riders of these horses, however, must have been equal to the scale III of human figures, and if they had the same proportion to the horses as the Persian rider, 34, has to his, then the third scale of horses would have been *c.* 1·80 m long, including prancing forehooves, or 1·50 m from the shoulder to the hindquarters.

Most, if not all, of the other animals extant, 360–385, must, from their size relative to the Persian rider's horse, have been grouped with human figures of the colossal scale I. Thus the ram, 360, is 1·50 m long, excluding the head (not far short of 2 m with it), and 55 cm wide. The bull, 364, was *c.* 60 cm wide, and probably at least 2 m in length. The fragments of boar, 365 and 367, add up to a length of 1·20 m, to which the hindquarters have to be added, while the width was 35 cm; and the two fragments of leopard, 371 and 373, make up *c.* 1·70 m in length, including the lowered head, and have a maximum width of 39 cm. The mastiff (?) 376 is of similar scale. These sizes are all about equal to, or larger than, the average size of the standing lions.

Human Sculptural Groups: Subject-matter

SCALE I. COLOSSAL FIGURES

Within the colossal scale I it is possible to distinguish at least three different series of figures:

A. Colossal standing figures: dynastic portraits

NORTH SIDE

No. of frags	Minimum no. of statues		
3	3	Male:	26 ('Maussollos'), Imam's field (pls 13–15); 211 (right foot), Imam's field (pl. 31; fig. 31); 29 (male statue), Omer's field (pl. 16).
4	3	Female:	27, 28 ('Artemisia'), Imam's field (pl. 13); 30 (head), Mahomet's field (pl. 16); 31 (head), Imam's house (pl. 17).
1		Either:	142 (right hand), Imam's field (pl. 29)

EAST SIDE

2	1	Either:	64 (lower body); 143 (left hand) (pl. 29)

SOUTH SIDE

1	1	Female:	32 (head), Hagi Nalban's field (pl. 17)

OTHER FRAGMENTS, FINDING-PLACE UNKNOWN

7	2	Male:	63 (upper back) (pl. 25);
	(prob.)		73 (shoulder);
			95 (drapery over right arm);
			96 (drapery over left fore-arm);
			104 (torso) (pl. 28);
			212 (sandalled foot) (pl. 31);
			231 (drapery) (pl. 33).
9	1	Female:	62 (head);
			65 (body) (pl. 26); 97 (arm);
			98 (arm) (pl. 28);
			99 (arm);
			100 (arm);
			102 (arm);
			209 (sandalled foot) (pl. 31; fig. 30);
			210 (sandalled foot).
8		Either:	110 (elbow);
			112 (arm);
			114 (arm); 126 (wrist);
			144 (hand) (pl. 29);
			151 (finger); 152 (finger);
			153 (finger).

FRAGMENTS OF DRAPERY, PROBABLY FROM COLOSSAL FIGURES

9			237; 242; 253; 262; 263; 268; 269; 271; 279.
—	—		
44	11	Total	

The forty-four fragments listed here belong to at least eleven different statues, and in all probability to many more. They are roughly equally divided between the sexes, and include the controversial statues 26 and 27, traditionally identified as 'Maussollos' and 'Artemisia'. The relative completeness of these two figures is important for the over-all interpretation of the series, and it is necessary to establish that they belong to it. Reasons against attributing them to the chariot group have been given above (108), and the scale of the statues, which is in no way unique, has also been discussed (109).

Much more important positive evidence for considering 26 and 27 as only two surviving statues from a whole series of colossal portraits, is the existence of numerous other fragments, which, in scale, conception and execution, are closely similar and in some cases identical to them. Fragments of male statues that are similar to 26 are: 29, 63, a fragment of a draped chest in Bodrum (110), and especially 211, the tip of a colossal right foot wearing a sandal identical to that of 26, which was also found in the Imam's field. Fragments of female statues closely similar to 27 include: the heads, 30, 31, 32, and 62, and several fragments of drapery, notably the draped upper arm, 98. The unusually good state of preservation of 26 and 27, as compared with the other fragments, must be attributed to the fortuitous way in which they fell and rolled beyond the north *peribolus* wall, where they were rapidly covered by earth and so protected from the attentions of later stone robbers (111).

The facial features of 26, the hairstyle of 27 and the other female heads, and the portly forms of 26, 27, and 29, suggest that both male and female figures were intended as portrait statues.

The male statues wear what one might call 'Carian' dress, consisting of a very large, Greek-style himation, beneath which is worn, in non-Greek fashion, a tunic of fairly thick material, which covers what would otherwise be on a Greek the bare upper torso and right shoulder: so 26, 29, 63, and the fragment in Bodrum; cf. the seated figure, 33. On the feet are worn elaborate sandals, within which is an inner shoe, or possibly a leather sock, that conceals the toes: 26, 211, 212. The only bare parts of the body, therefore, were the heads, the hands, and possibly the lower parts of the arms. No doubt many of the arms were, like the left arm of 26, almost completely swathed in drapery (cf. frags 95 ff.), while others may have been partially sleeved, if one may judge from the right shoulder of 26, where there is no edge or limit indicated for the under-tunic (112). There is no evidence for the male heads other than that

of 26. This is a fine portrait of an Asiatic male type, generic rather than individualistic, with the long hair that seems to have been fashionable for princes east of the Aegean in the fourth century BC (113). That the male figures are intended as dynastic portraits is suggested by the sword scabbard held in the left hand of 26 (114).

The female statues wear the regular fourth-century east Greek dress, consisting of a fine chiton with buttoned sleeves that reach to the elbow (nos. 27, 98), over which is a capacious himation, similar to that worn by the male figures. Sandals are worn, but the straps seem to have been painted on feet that are otherwise bare (nos. 27, 28, 209, 210). The female heads which remain do not appear to have had distinctive portrait features like those of 26, but their relationship to one another is indicated by the ornate hairstyle and the close-fitting cap, or *sakkos* (nos. 27, 30, 31, 32, 62). The decorative hairstyle, with its triple row of tight curls, is one which is found also on later fourth-century BC female heads from Priene, where the influence is likely to be from the Mausoleum (115). Some have wanted to see Persian influence in the tightly rolled curls, but it is more likely an archaising Greek style that lingered on in Caria, or was readopted by the Carian court at the time of Artemisia. The ornate hairstyle, with three rows of snail-shell curls, was common enough in late Archaic times, and also turns up on later fifth-century archaising sculpture, such as the Hermes of Alcamenes. The use of the *sakkos* to confine the hair may well be an archaism, since it was commonly worn in the later Archaic and early Classical periods (116). Probably the ornate hairstyle and the *sakkos* should be regarded as courtly attributes, indicating that the women are members, past or present, of the ruling Carian dynasty. And it may be that the adoption of such an archaistic hairstyle by the ladies of the fourth-century BC Carian court is a conscious echo of the time of the earlier great queen Artemisia, who fought with such distinction on the side of the Persians at the battle of Salamis.[1]

The veiling of two of the female heads, 27 and 31, is presumably indicative of mourning, but need have no particular significance for their identities. On the sarcophagus of the Mourning Women, some of the female

1. There is no historical evidence for a family link between the dynasty of Hecatomnos and the earlier dynasty that ruled Halicarnassus in late Archaic times, but the fact that Hecatomnos chose the name Artemisia for his eldest daughter suggests that, whether the blood-tie was strong or not, there was a clear attempt to associate the fourth-century dynasty with the earlier one. For the known members of the dynasties, see Bockisch, *Klio*, 51 (1969), 117–75; cf. J. Crampa, *Labraunda*, vol. iii. 2 (1972), 5–9.

figures between the columns are veiled, others are not, the distinction being apparently simply for the sake of variety.

The pose adopted by the female statues seems to have been that of the so-called *femina orans* statue type, in which both forearms are raised in a gesture of reverence, supplication or grief: so 27, 97, 98, 99, 100, 102. It is a pose which is common in the fourth-century BC and one which seems to have been particularly employed for official Carian sculpture (117). The standing female figures of the sarcophagus of the Mourning Women give a good idea of the variations possible in the positions of the lower arms.

For the position which this range of colossal male and female portrait statues occupied on the building there is some general evidence in the finding-places and in the working of the individual statues. Of the fragments whose finding-place is known, eight were found along the north side of the building, two to the east, and one to the south. Although one cannot be sure that these finding-places were in all cases undisturbed, the distribution of the fragments around the building, taken together with the large total number of fragments in existence, makes it more likely than otherwise that this series of colossal figures stood on all four sides of the Mausoleum. Furthermore, the finding-places of the fragments from the north side, which are most likely to be undisturbed, suggest that the statues were ranged along the whole length of the building, not clustered together. The eight fragments from the north must belong to at least six different statues, three male, three female. Of these one, 30 (female), came from the west end of the north side; three, 26, 27, 211 (two male, one female), came from the central part; and one, 29 (male), came from the east end of the north side. The sixth fragment, 31 (female), was built into the Imam's house, and could have come from any part of the side.

The discovery of the almost complete statues, 26 and 27, within the deposit in the Imam's field, may also be significant. The only other fairly complete statues from this deposit are of the chariot horses and lions, both of which groups were set high on the building, and, indeed, it seems likely that statues could only have fallen wholly outside the *peribolus* wall from a fairly high position on the building.[1] If this is so, then the series to which 26 and 27 belong must have been placed

quite high, probably on the upper half of the building. A high position seems also to be required by the working of the female head, 30, where the rough pointwork on top of the cap, and the lewis-hole for lifting the statue on to the building, are reminiscent of similar features on hind part 2 of the chariot horses.

The working and condition of the individual statues provide three further pieces of evidence regarding position. First, the severe weathering of the heads and shoulders of 26 and 27 proves that they stood on the outside of the building (118). Second, the fact that all the extant statues have inferior carving on their backs, compared with their fronts and sides (nos. 26, 27, 29, 63, 73), shows that they must have had their backs to the building, from which they therefore looked outward, presumably ranged side by side. Finally, the unnatural fall of the drapery below the scabbard, on the lower left side of 26, suggests that this statue may have been confined quite closely at the side.[2]

Bearing in mind this evidence of the finding-places, and the carving of the statues, the likeliest position on the building for this series of colossal portraits is between the columns of the Ionic peristyle, one statue occupying each intercolumniation. The length of the axial intercolumniation, recently discovered (119), 3 m, with 1·50 m clear space between the column bases, means that statues of this design and scale could have been nicely accommodated, one in each intercolumniation. Assuming the maximum width of any of the statues to have been 1·20 m (26 was probably 1·15 m, but 29 could have been a little more), there would have been c. 15 cm clear space on either side between the widest part of the statue and the line of the column base. This would be sufficient to prevent the statues from seeming too crowded in, but clearly would mean that the drapery at the sides of the statues could not be allowed to fall too far outwards (hence perhaps the unnatural fall of the drapery on the side of 26).

There is of course no proof that any sculptures occupied the intercolumniations, but in view of the large amount of sculpture that has to be accommodated to the building, it is unlikely that these positions would be left empty. There is nothing particularly innovative about figures placed between columns. They are found earlier on the Nereid Monument, as well as on the roughly contemporary sarcophagus of the Mourning Women, and they are found also between the columns of Roman mausolea and sarcophagi, some of which, at

1. The more fragmentary sculptures from this deposit, generally of smaller scale, and including, for example, the heads 45 and 48, look as if they may have been split off by stones falling from above, and so propelled beyond the *peribolus* wall. For the contents of the deposit see above, pp. 5–7.

2. The cutting on the lower left side of 26 cannot be regarded as confirmatory evidence of lateral confinement, as we do not know when, or for what reason, the recutting was done.

least, are likely to have been influenced by the Mausoleum at Halicarnassus (120). The evidence of these monuments, indeed, suggests that it was the more important sculptures which were placed between the columns, and, on the Mausoleum, it is arguable that, after the chariot group on the summit, the next most important group of sculptures was this series of colossal portrait statues. A position for them between the columns of the pteron would seem to be highly appropriate. Furthermore, if we assume that some sculpture occupied the intercolumniations, it is difficult to find another suitable candidate amongst the extant groups. The lions, it is now known (121), are too large to fit into the space available, the groups IA, IC, and III have too much interaction between figures for them to have been placed between columns (see below). The only other possible candidate would seem to be the standing figures of scale II, and against these the smaller scale must militate.

It now seems fairly certain that the thirty-six columns which Pliny says the Mausoleum had were arranged 11 × 9. If there was a colossal statue in each intercolumniation, it follows that there would have been thirty-six statues in all: ten on each of the longer north and south sides, and eight on the shorter east and west sides. Of the ten from the north side we have fragments certainly of six, and as these are equally divided between male and female it is reasonable to suppose that an equal division between sexes applied over-all to the series. There would therefore originally have been eighteen male statues and eighteen female statues placed probably alternately in the intercolumniations. Such an alternation between male and female statues would be in keeping with a dynasty in which brother married sister, and male and female ruled conjointly. It would also have the practical effect of evening out any necessary discrepancies in height between male and female statues (as for example between 26 and 27).

The supposition that there were thirty-six statues in the series agrees with the relatively large number of extant fragments. Fragments of almost a third of them survive, and it is not impossible that a fragment of each of the thirty-six statues is extant. This is about the same proportion of sculpture surviving as in the case of the chariot group.

It looks therefore as if the spaces between the columns of Maussollos' tomb were occupied by portraits of his ancestors, the male members striking solemn or regal poses, the females in attitudes of mourning. It is possible that still living members of the family were included in their number, such as Artemisia, Ada, and Idrieus (122), but it seems more likely that the portraits would have been of dead and heroised ancestors, who would thus be honouring the achievements, and mourning the death of their most celebrated descendant (123).

There is no reason to suppose that there would have been any difficulty in finding sufficient numbers of ancestors to fill all the intercolumniations. A ruler of Caria named Maussollos is recorded for the late sixth century BC (124), who is likely to have been a direct ancestor of the fourth-century Maussollos, and no doubt the dynasty could have been traced back much further than that. And from a similarity of names (Artemisia, Pixodaros), it is likely that the fourth-century dynasty also linked itself with the rulers of Halicarnassus in late Archaic times. It is quite possible, therefore, that the elder Artemisia may have numbered amongst this series of portrait statues. Other more recent members of the dynasty, whose presence one might also expect, include Maussollos' father Hecatomnos, Hecatomnos' wife (name unknown), and Hecatomnos' father Hyssaldomos. The one person who is unlikely to have appeared in this series is Maussollos himself, and even if he did appear, it is unlikely that he would have been placed on the north side. The identification of statue 26 as Maussollos, therefore, can hardly be correct.

The technique of carving these colossal figures varies. Two statues at least, 27 and probably also 30, were carved from a single block of marble. Most of the others were carved in separate portions which were then clamped together: 26, 29, 31, 63, 65, 73, 96, 97, 98, 100, 102, 104, and the Bodrum fragment. Generally it seems to have been the heads and the arms, or lower arms, that were carved separately.

Stylistic variations are hard to assess accurately when dealing with such fragmentary material. But there do seem to be stylistic differences between 26 and 29, and between the foot of 26 and 211; also between the female heads 27, 30 and 32, and between the drapery of 27 and 98. On the other hand the styles of 29 and 63 are reminiscent of one another. As some of these variations occur within statues that seem to come from the same side of the building it is preferable to regard them as differences between individual craftsmen rather than between workshops (125).

B. Colossal sacrificial group

Cat.
no.

33 Colossal seated figure (pl. 17)
360 Body of ram (pl. 33)
361 Hind leg of ram
362 Hoof of bull (pl. 34)
363 Head of bull
364 Shoulder and neck of bull (pl. 34)
365 Body of boar (pl. 34)
368 Head of boar (pl. 34)

The fragments of ram and bull, 360–364, make it plain that at least one sacrificial group of colossal scale formed part of the sculptural decoration of the Mausoleum. The sacrifice represented was probably of threefold type, or τρίττοια, which normally consisted of ram, bull, and boar, or a multiple of these animals. It may be, therefore, that the fragments of boar, 365 and 368, belong to this group rather than to the hunting group IC. The plumpness of these fragments, and the positions of the legs of 365, which suggest the animal was standing or walking, favour this attribution, but certain compositional requirements are involved, which will be discussed below.

The threefold sacrifice was not uncommonly offered to gods and heroes (126). A sacrificial scene of this type is represented in relief on the Nereid Monument (BM 904–905), where the animals involved are bulls and goats, and there are other examples in Attic votive relief sculpture of the fourth century BC (127). The threefold sacrifice, or *suovetaurilia,* is common also in Roman religious art (128).

A sacrificial scene of this kind may have had a recipient, who is likely to have formed part, indeed was probably the focal point, of the group. Such a figure could possibly have been seated; if so an obvious candidate for it among the extant sculpture is the colossal seated male figure, 33. There is no proof that this figure formed part of a sacrificial scene, but such an association seems more plausible than a connection with the colossal standing figures IA, which has previously been suggested (129), as it satisfactorily accounts for the seated pose.[1] If 33 did belong to a sacrificial group, it is probable that it should be identified as Maussollos, since a sacrifice represented on the Mausoleum must have been intended to honour the occupant of the tomb. The male figure, 33, has all the appearance of being a dynastic figure, since he wears the Carian dress of the male figures of IA, together with a fine pair of high boots. The pose, too, is that of a prince or hero or god-like figure (130). If the purple deposit on the surface of the statue, noted by Newton when it was discovered, is the remains of paint, this would tend to confirm a royal identity (131).

Composition of group or groups, and position on building

Of the fragments whose finding-place is known, the body of the ram, 360, was found in Mahomet's field, at the west end of the north side; the head of the bull, 363, came from the Imam's field, roughly opposite the eastern half of the north side; while the shoulder and neck of a bull, 364, turned up at the north-east angle of the *peribolus* wall. The colossal seated figure, 33, was found within the Quadrangle, at a point closer to the east side, than to any of the others. Its position, however, was clearly disturbed, so that it could have belonged originally to any of the four sides. From this evidence of the finding-places it looks as if there was probably a sacrificial group on the north side of the building, to which the fragments 360 and 363 belonged, and to which 364 and 33 could have belonged (the style of the drapery of 33 is quite close to that of other statues from the north side, such as 26 and 43). It is quite conceivable, however, that there may have been more than one such group on the Mausoleum; 364 and 33 could, from their finding-places, just as easily have belonged to a sacrificial group on the east side of the building, where one might have expected a solemn ceremony of this nature to be represented.

For the composition of the group or groups, apart from the finding-places on the north side, which suggest the figures were ranged along the building, there is a certain amount of evidence from the carving of the individual statues. The ram, 360, was carved to be seen laterally from its left side, while there is a worked surface on the inner, right side for abutment against another figure, in all probability an attendant, who would have been leading it forward. The iron dowel in the top of the ram's head, found by Jeppesen and now in Bodrum, is likely to be for the attachment of the arm of the attendant, who would thus appear to be leading the animal forward by the horns, rather than to be the base of a spike to deter birds. Since the finding-place of the ram, near the north-west corner of the building, was probably not much disturbed, it must have been placed

1. Alternatively the statue might have formed part of a scene of audience, as for example on the Nereid Monument, BM 879; or on the long west side of the Payava tomb: Demargne, *FdX*, v (1974), 78–82, pls 42–43.

against the west end of the north side of the building, so that it appeared to be moving towards the middle of the north side.

The boar's head, 368, was carved to be seen from its right side. Supposing that it belongs to a sacrificial group, it can only have been placed satisfactorily in the left-hand half of a side (the eastern half of the north side, or the southern half of the east side), where it too would be moving towards the centre of the side. The colossal seated figure, 33, was sculpted to be seen from a frontal view, and would naturally fill the focal point in the centre of a side, on which the animals appear to have been converging. For the intended viewpoint of the fragments of bull there is no sure evidence.

A composition for the group or groups, such as the working of the fragments seems to suggest, with a centrally placed recipient to whom the sacrificial animals were led from either side, would seem to be quite plausible. It would not differ much from the sacrificial scene on the Nereid Monument (BM 904–905), where animals are led from either side towards a large central altar. On the Nereid Monument there are five animals: a bull and a goat on the left, and a bull and two goats on the right. It is perhaps likely that on the Mausoleum also the sacrificial animals were numerous. The fragments of bull could have belonged to two or even three different animals, and the same applies to the fragments of boar and ram.

For the position of the sacrificial group or groups on the building there is a fair amount of evidence of various kinds, which allows some specific conclusions to be drawn. The noticeably severer weathering of the left side of the ram, 360, the side that was certainly turned outward from the building, proves that the position was an external one, exposed to the elements. This is confirmed by the severe weathering of the front of the fragment of a bull, 364. The fact that the animals were clearly designed to be seen laterally, and that a sacrificial group must necessarily have involved interaction between figures, means that the group or groups can hardly have been set anywhere other than against some part of the podium, whose masonry would have served as a background to the figures. The strip of rough pointwork on top of the back of the ram, 360 (similar to the rough pointwork on top of the female head, 30, and the chariot horse 2), and the absence of legs on the seat of 33, suggest a fairly high position on the building, where these features would not be noticed. A high position is suggested also by the colossal scale at which the fragments are worked, and by the fact that, when the building was destroyed, two

statues at least, 360 and 363, could have fallen to the north of the north *peribolus* wall.

In order to satisfy these criteria, one can hardly conclude otherwise than that there must have been a ledge or step quite high up on the podium, probably not far below the peristyle, of sufficient depth to accommodate these statues. The maximum depth of 33 is 1·12 m, so that the step is not likely to have been less than 1·25 m in depth.[1] The step or ledge almost certainly ran on all four sides of the podium, so providing room for four groups. It is unlikely that there were four sacrificial groups (see below, group IC), but there could well have been two, placed on the same level on different sides, the north and perhaps also the east, as suggested above.

C. Colossal hunting group

Cat.
no.

34	Persian rider (pl. 18)
35	Nose of horse (pl. 18)
36	Raised forehoof (pl. 18)
37	Hind hoof (pl. 18)
38	Raised foreleg
39	Upper hind leg (pl. 19)
40	Foot of rider
41	Foot of rider
232	Waist of draped rider?
233	Body of draped rider?
234	Body of draped rider?
317	Arm of Persian
387	Hind leg of horse
388	Hind leg of horse
389	Raised foreleg of horse
366	Rear part of boar
367	Head of boar (pl. 34)
369	Leg and hoof of boar (pl. 35)
370	Hoof of boar (pl. 35)
371	Forepart of leopard (pl. 35)
372	Head of leopard
373	Hind part of leopard (pl. 35)
374	Hindquarters of leopard or lioness
376	Hunting dog? (pl. 36)
377	Head of dog[2]
385	Fragment of boar's tail

1. Confirmatory architectural evidence for the existence of at least one step of this kind has been found in Jeppesen's excavations, and recognised in the basements of the British Museum. See below, pp. 57, 245, and pl. 46.

2. The 'bodies of two dogs', mentioned in the Invoice for case 119 have not been identified.

The colossal rider in Persian dress who is seated on a prancing horse, 34, may reasonably be associated with a number of fragments of animals of large scale, which must have belonged to a hunting group or groups. The pose of 34 would be equally suitable for a battle group (132), but as no other fragments of such a group on a colossal scale exist, he is better classified with the animals. The scale of these animals is equal to, or slightly larger than, that of the series of standing lions, and seems to be in correct proportion to the horse of 34 (133).

The fragments of horse, 35–39, in all probability belong to statue 34, but fragments of other similar figures may be preserved in the feet, 40 and 41, which wear riding boots, in the draped fragments from about waist level, 232–234, in the draped arm, 317, and in the horses' legs of large scale which do not obviously belong to the chariot group, 387–389 (134). The animals from the group or groups appear to have been fairly numerous. The four fragments of leopard must belong to at least two different animals, the four fragments of boar (these are in addition to the two fragments allotted to the sacrificial group) in all probability belonged to more than one animal, and there was a hunting dog, 377, and perhaps also a mastiff, 376.

The only one of these fragments whose finding-place is known for sure is 34. This was discovered within the Quadrangle, close to its western margin. Clearly, therefore, its position had been disturbed. Since, however, the fragments 35–39 which probably belong to it were found built into walls nearby, it may be that 34 had not been moved far from its position, and that there was originally a hunting group to which it belonged on the west side of the Mausoleum. The fact that none of the fairly substantial sculptures of this group are recorded as having been found in the deposits on the north side would tend to suggest that, wherever the hunting group or groups were placed on the Mausoleum, it was not on the north side.[1]

It is clear from the composition of 34 and 371 that both statues were designed to be seen laterally from their right sides, and since the pose of both statues involves a good deal of action, the horse of 34 being shown prancing, the leopard, 371, running along with head down in desperation, it is likely that the over-all composition of the hunting group or groups was lateral in nature, and that the statues were ranged along the side of the building, like those of the sacrificial group, IB. That the figures were somewhat removed from the spectator is suggested by a certain roughness in the carving, particularly of the drapery at the waist and the left hand of the rider of 34, and also by the point marks on the muzzle of 371. These criteria for location of the group are the same as for the sacrificial group, IB, and as the scales of the two groups are equal it is probable that the position on the building was similar. One may reasonably conclude that the hunting group was also placed close against the wall of the upper part of the podium, and that it occupied, on a different side or sides of the building, the same ledge or step as has been inferred for the sacrificial group, IB. The minimum depth of this step suggested above, 1·25 m, would easily accommodate 34, which is 1·025 m wide as preserved, and would provide sufficient room for the overlapping of some of the animals, the maximum width of which seems to have been c. 40 cm.

If, as seems likely, there was a sacrificial group at the north and a hunting group at the west, it is perhaps likely that there would have been other similar groups on the other two sides, perhaps a sacrifice at the east (as was suggested above), and a hunting scene at the south, so that a longer and a shorter side were devoted to each of the two themes. The relatively large number of animals preserved may favour two hunting groups rather than one.

It is probable that the composition of the hunting group or groups would have been similar to that which occurs on one of the long sides of the Alexander sarcophagus (135) where two animals of different kinds (one lion, one deer) are hunted by three horsemen and five men on foot, accompanied by three hounds. This is the number of figures of colossal scale, about twelve or thirteen, which could have been accommodated on one of the shorter sides of the Mausoleum, in the position suggested (136).

Hunting scenes of this type, involving one or more animals hunted, are common in Greek or Greek-influenced relief sculptures produced for non-Greek patrons east of the Aegean in the fifth and fourth centuries BC (137).

1. Although Newton's recording system was far from complete, one feels that had any of the larger fragments of animals been found on the north side he would have indicated as much, either in *Papers*, i, or in the Invoice of packing-cases. The fact that the leopard, 371, was built into Bodrum castle by the Knights, may also indicate an original provenance from some side other than the north. Cf. above, p. 32.

SCALE II. HEROIC STANDING FIGURES

A. Male: Greek or Carian dress
Fragments of body. 42, west side of Quadrangle (pl.19); 43, Imam's field, north side (pl.19); 68, upper body (pl. 26); 70, upper body; 71, upper body (pl.26); 85A, lower body (pl.27).

Heads. 45, Imam's field, north side (pl. 20); 53, neck, north-east angle of *peribolus* (pl. 24); 57, left eye and cheek, south side (pl.25); 58, chin and neck, south side.

Draped legs. 160, knee; 164, lower leg.

Bare legs. 162, left knee; 169, leg with sandal ribbons (pl.30); 170, right leg (pl.31); 171, right leg; 172, left leg, Imam's field, north side; 173, right leg; 174, left leg; 175, (?) left leg; 176, right leg; 177, left leg; 178, right leg (pl.31); 179, left leg; 180, 181, 182, 183.

Sandalled feet. 213, right (pl.32; fig.32); 214, left (pl. 32); 215, right (fig.33); 216, left (pl.32).

Total number of fragments of group A: 32.

B. Male: Persian dress
44, body, south side (pl.19) 66, right shoulder (pl.26); 67, left shoulder; 86, right thigh; 87, left thigh (pl.27); 101, right arm and sleeve; 136, draped arm, Imam's field; 137, draped lower arm; 139, wrist in sleeve (pl. 28); 166, trousered leg, Imam's field, north side; 167, trousered leg in boot; 168, trousered leg in boot (pl.30); 217, left foot in sandal, (?) of Persian (pl.32; fig.35).

Total number of fragments of group B: 13.

C. Deity
48, Head of Apollo, Imam's field, north side (pl.22).

D. Female: Greek or Carian dress
90, lower part on base (pl.27); 91, lower part (pl.28); 92, lower part; 93, lower right part; 208, left foot in slipper, Imam's field, north side; 228, left foot in sandal, north-east angle of *peribolus* (pl.33).

Total number of fragments of group D: 6.

E. Male or female
Shoulders. 69; 74, Imam's field, north side; 75; 77; 78, Imam's field, north side; 79; 80; 82.

Lower back. 94 (if not scale I).

Arms. 111 (pl.28); 115; 116; 117; 121; 127; 128; 129.

Hands. 145, right (pl.29); 146, right; 147, right; 148, right; 149, right; 150, left; 154, finger; 155, finger (pl. 30); 157, finger; 158, finger.

Total number of fragments of group E: 27.

F. Accessory
359, sword scabbard.

Total number of fragments of scale II: 80.

The fragments listed above seem to have belonged to a series of standing figures that were similar to the colossal dynastic portrait statues, IA, but were of smaller scale and probably also of greater number (138).

The general similarity with series IA is demonstrated by the presence of both male figures (groups A, B) and female figures (group D), by the motionless stance and upright bearing of all the figures, by the identical sandals worn by the males (nos. 213–216), and by the fact that, to judge from the finding places, the statues stood on all four sides of the building. Substantial numbers of these figures of scale II were found in the important deposit in the Imam's field on the north side: 43, 45, 48, 74, 78, 136, 166, 172, 208; others were found on the south side: 44, 57, 58; the neck 53 and the foot 228 came from the deposit close to the north-east angle of the *peribolus*; the torso 42 was discovered close to the western margin of the Quadrangle.

There are, however, some differences between this series of figures and the colossal series IA, particularly as regards details of dress. The male figures are divided between Greco–Carian dress and Persian dress. Those who wear Greco–Carian dress (group A) have lighter and less grandiose garments than the dynastic male figures of series IA. They seem in general to have worn tunics that descended only to about knee-level: 42, 164; but cf. the draped knee, 160. In one instance the tunic hangs loose, 43 (cf. also 85A), but it would seem that more often it was confined at the waist by a belt: 42, 68, 70. A himation was sometimes worn, 68, sometimes not, 42, 43. The knee-length tunics left the lower legs bare: 42, 169, 170–183, but the feet wore sandals, as is shown by the fragment of bare leg around which sandal ribbons are wrapped, 169, and by the fragments of feet in sandals: 213–216. It is noteworthy also that no bare feet of scale II survive.

Lower arms and hands are likely to have been exposed (cf. the fragments in group E), and some of the hands at least held objects, 145, 146, 147, perhaps including the fragment of sword scabbard, 359, although it is possible that this may have belonged to a figure from the life-size group of scale III (see below). The general aspect of these male figures of group A must have been very similar to that of the draped statues of the Daochos group at Delphi (139).

The only head of this group to be well preserved, 45, has none of the individuality to be seen in the head of 26, and it is, in fact, composed according to a different system of proportions, more akin to that used for conventional portraits in mainland Greece in the fourth century BC. Its bland, neutral features have something in common with the female heads of the colossal series IA, although it lacks their depth. The beard (one feature which it shares with 26), suggests maturity of age. Rather more realistic is the treatment of the body of 43, whose somewhat unflattering corpulence recalls that of statues 26 and 27.

There is no reason to suppose that the male figures who wear Persian dress (group B) did not also belong to this series of standing figures. Like the male figures of group A they were found on both north and south sides of the building (136 and 166 from the north, 44 from the south), and they appear to have had static poses, designed to be seen frontally (cf. especially 44, 168). The forward movement of the upper arm of 66 could have belonged to a figure in motion, but could equally be accommodated to a standing figure.

The dress seems to have been the regular Persian one, consisting of a tunic bunching over a belt, 44, and descending to just above the knee, 86, with close-fitting sleeves that covered the arms down to the wrist: 66, 101, 136, 137, 139. *Anaxyrides*, or trousers, were worn over the legs, 86?, 166–168, and were tucked into boots, 167, 168. The left foot, 217, may also have belonged to a figure in Persian dress, since mesh sandals of this type are worn by Persians of scale III (cf. esp. the leg, 165). Thick cloaks, probably the *kandys*, are worn by 66 and 67, but not apparently by 44. Although no heads remain, there can be little doubt that they would have been swathed in the normal Persian headdress, the *kyrbasia*. A *kyrbasia* is required by the material which remains behind the right shoulder of 66, whose head was added separately.[1]

Fragments of the lower parts of at least four female statues remain of this scale (group D). The finding-

places of the larger fragments are not known, but the foot in a slipper, 208, if it belongs to this series, came from the deposit in the Imam's field on the north side, while the foot, 228, was found close to the north-east angle of the *peribolus* wall. Three of these female figures, at least, 90, 91, and 93, were composed in the same way as the female figures of scale I. They wear the standard Ionic female dress, consisting of a very fine chiton, visible around the ankles, over which is a large himation that falls in heavy folds behind the figure, where the carving is of a more summary character.[2] Sandals are worn by 90, 93, and 228. Those of 90 and 228 are of identical style, although they belong to different statues.

The fine head of Apollo, 48, has been tentatively grouped with this scale of figure. Its actual size comes midway between scales I and II, but since one may be sure that a deity would have been represented larger than accompanying mortals or heroes, classification with scale I is obviously out of the question. An attribution to scale II would seem quite suitable, but the possibility must remain that it may have belonged to the groups of life-sized figures of scale III.[3]

A point in favour of attributing the head of Apollo to scale II may also be its finding-place in the deposit in the Imam's field on the north side. From this deposit came numerous fragments of scale II, but only a single one of scale III.[4]

The energetic, turning pose of the head might be thought more suited to the vigorous action of a battle group, but could equally have been accommodated to a standing figure.[5]

Position on building, composition, and identification

The discovery of fragments of scale II in most of the sculptural deposits on the site of the Mausoleum, and

1. It is possible that the fragment of head, 57, may preserve traces of a *kyrbasia*.

2. Cf. also 92 for this.

3. If, as seems likely, the average height of the male figures of scale II was 2·40 m, the height of Apollo, judging from the relative dimensions of his head (above pp. 36–7), may be estimated at *c.* 2·60 m. From this, classification with scale II would seem more probable, since, if placed with the figures of scale III, he would have towered over them by about 80 cm, or almost half as much again as their presumed height of 1·80 m. But the latter must remain a possibility.

4. For a discussion of the reasons for the absence of fragments of scale III from the deposit of sculptures in the Imam's field, see below p. 52.

5. The turn of the head 48 is similar to that of the colossal female head, 30, which must have belonged to a standing figure. See below, p. 119.

the relatively large total number of fragments preserved, make it likely that statues of scale II appeared on all four sides of the Mausoleum.

Most of the larger fragments are carved in such a way as to suggest that they were intended to be seen from a frontal viewpoint only. Their backs and sides have more schematic designs, and are much less well finished than their fronts: 42, 43, 44, 67, 68, 70, 74. Like the colossal standing figures IA, therefore, they must have faced outward from the building. The smaller, 'heroic' scale on which they are worked, however, suggests that they were set closer to the spectator, hence lower down on the building, than the statues and groups of colossal scale, IA, B, and C. This being so, it is hard to see that they could have been placed anywhere other than against the podium of the Mausoleum, at a lower level than groups IB and C, but still some way above ground-level. If they had been set at ground-level, it is doubtful if any fragments could have been found to the north of the north *peribolus* wall in the Imam's field.

One must suppose, therefore, that there was a second step or ledge to the basement, running round the building on all four sides, and of sufficient depth to accommodate the statues of this scale. Since the maximum thickness of the extant statues is 43 cm, and the average thickness is 40 cm (140), the depth of the step need not have been greater than 75 cm (about half the depth of the step suggested for groups IA and B).[1] On this ledge the figures would have been set with their backs to the building, and ranged side by side.

The statues would probably have been let into cuttings made to receive them in the surface of the step, which is likely to have been of blue limestone (141). To judge from the thickness of bases preserved beneath some of the extant fragments, these cuttings are likely to have been *c.* 7–7·5 cm deep.[2] Two fragments, one male, one female, 215 and 92, with much thicker bases of 13 cm or more, may have belonged to a different side of the building, or at least have been produced by a different workshop.[3]

It might be felt that the proposed position of this scale of figures on the building, whereby large numbers of isolated standing statues were ranged laterally close against a back wall, would not make an effective com-

position. Judged by modern notions of aesthetics it is quite possible that this may be so; nonetheless there is ample evidence to show that laterally arranged groups of this nature were very much favoured by Greek sculptors of the late fifth and fourth centuries BC.

Some of the best examples, and the best parallels for the Mausoleum, come from Delphi. There the votive monument of Lysander (405 BC) and the monument of the Arcadians (369–362 BC) consisted of rows of standing figures, set side by side in straight lines, but clearly intended as groups. Similar too was the Argive monument (369–362 BC), whose component statues were placed side by side around a semicircle. Closest of all to the proposed arrangement for the Mausoleum is the Daochos group (338–334 BC), whose statues were set in a straight line against a high back wall (142). Such articulation as these groups possessed seems to have been achieved by an over-all counterpoint in the positions of limbs, and by slight variations in the spaces between statues, in order to break the lines down into smaller groupings.

The Delphi groups cited here all consisted of heroised mortals or ancestral figures being honoured by, or in the presence of, deities. In the case of the Arcadian monument, and probably also the Daochos monument, the deity was Apollo. In view of this it must be considered very likely indeed that the head of Apollo, 48, does belong to the series of standing figures of scale II. Apollo was evidently the protecting deity of the Hecatomnid dynasty as he appears on the coins of Maussollos and his successors (143). One might envisage him, therefore, as having been placed on the north side of the podium of the Mausoleum in the company of male and female figures, who represented dynastic heroes. There can be little doubt, in any case, from the presence of female statues and from the types of dress and footwear, that the statues of scale II, like those of IA, represented members, past or present, of the ruling dynasty of Halicarnassus and Caria. The presence of male figures in Persian dress in this series would suggest that Maussollos stressed his ancestral links with Persia, as well as with Greece and Caria.

The precise number of figures of scale II is hard to assess, but it may have been as many as seventy-two (144). If so, then taking groups IA and II together, more than one hundred of Maussollos' ancestors may have been represented on the Mausoleum, honouring him, and themselves being honoured, by their presence.

The statues of scale II, like most of those of the other scales, were carved in several portions, heads and arms at least generally being worked separately. Fragments

1. That the sculptors did not have much spare room to work with is suggested by the treatment of the crossed legs of 42, where the two limbs are fused into one at the point at which they overlap.

2. Bases of this thickness remain on 213, 216, and 217; cf. also 90, 93, and 94.

3. Similar variations in thicknesses of bases are found with the standing lions, above p. 30, and the fragments of scale III, below p. 52.

of shoulders with cuttings to receive heads are: 66, 68, 69, 70, 74, 75; fragments which have surfaces for the attachment of arms are: 68, 70, 77, 78.

Stylistic similarities or differences within the series are not easy to assess because of the fragmentary nature of the material, but the following observations may perhaps be made: 42 and 68 are of very similar style, but belong to different statues. With them should be classed the lower leg, 164. Fairly close in style also is 43, from the north side, a torso which has much in common with the colossal statue, 26; likewise the head of Apollo, 48, has much in common with the colossal female head, 30; 44, from the south side, differs considerably from both 42 and 43. These similarities and differences probably reflect the hands of individual sculptors or craftsmen rather than workshops.

SCALE III. LIFE-SIZE FIGURES

Total frags

Heads. 46, male head, south side (pl. 21); 49, head of Persian, south side (pl. 23); 51, back of head (pl. 24); 52, neck (pl. 24); 54, neck; 55, neck (pl. 25); 56, neck and hair; 59, chin and neck; 60, cheek and eye; 61, top of head. Cf. 47, male portrait head, south side (pl. 22). 10 (11)

Bodies. 72, draped upper torso; 85, upper body of nude male (pl. 27); 235, draped upper body of rider (?); 105, drapery with arm-joint. Cf. 80, draped shoulder. 5

Arms. 113, right elbow; 119, lower arm; 124, lower arm; 135, arm and drapery. 4

Hands. 156, thumb; cf. 150, hand, 155 (pl. 30) and 158, fingers. 4

Legs. 159, left thigh and knee (pl. 30); 161, draped left knee; 163, bare left knee; 165, lower right leg of Persian in trousers and sandal, south side? (pl. 30); 184, bare lower right leg; 185, bare lower right leg; 186, bare leg; 187, bare leg; 188, bare leg; 189, bare leg. 10

Bare feet. 193, left foot (pl 31; fig. 20); 194, ankle; 195, right ankle; 197, ankle; 198, left foot (fig. 21); 199, right foot, Imam's field, north side (fig. 22); 200, right foot, west side (pl. 31; fig. 23); 201, right foot, west side (fig. 24); 202, heel, east or north sides (fig. 25); 203, left foot, east side (fig. 26); 204, left foot (fig. 27); 205, toe of left foot (fig. 28); 206, left foot (fig. 29). *Total frags* 13

Feet in sandals. 207, left foot; 218, left foot (pl. 32; fig. 36); 219, right foot (fig. 37); 220; 221, left foot (pl. 32; fig. 38); 222, right foot (fig. 39); 223; 224, leg with sandal strap; 225; 226, left foot in boot; 227, heel; 229. Cf. also 165, above (pl. 30). 12

Accessory. 358, helmet on base, Imam's field, north side (pl. 33). 1

Fragments of horses. 390; 391; 392 (pl. 36); 393; 394; 395; 396; 397; 398; 399; 400? (tail, possibly of larger scale). 11

Total number of fragments 70
(including no. 47 71)

The fragments listed above of the life-size figures of scale III appear to have belonged mainly, if not entirely, to a group or groups representing battles between Greek and Persian warriors. The head of a Greek combatant may be considered to be preserved in the complete, but worn, head, 46. Its pose is vigorous and active, and a cutting on top of the back of the head is likely to have been for the addition of a raised right arm, that was either making or warding off a blow. Fragment 51, from the back of a head, must have belonged to a closely similar figure, while other fragments from the heads of Greek combatants are perhaps preserved in 59, which has a clean-shaven chin, and the necks, 52, 54, and 55, which, like 46, were worked separately from the bodies to which they belonged.

A fragment of a Persian adversary remains in the complete head, 49, which has a searching, upward gaze that complements that of 46. The head is swathed in a *kyrbasia* which leaves only the upper face bare, while a drill-hole in the left side of the head may have been for the attachment of a weapon. Close parallels for this head, and for the Greek-type heads, are to be found among the Greek and Persian warriors who fight with one another on the Alexander sarcophagus (145). There is no trace of individuality in the features of either 46 or 49. Both appear to be heads of standard mid-fourth-century type.

Bodies and arms are in short supply for this scale of figure, but an important fragment remains in the nude upper torso, 85, which must have belonged to a Greek warrior. This is the only certain evidence for the appearance of totally or predominantly nude figures amongst

the sculptures in the round of the Mausoleum. The head which belonged to this torso was worked separately, for part of a socket remains. This is fairly unusual for a nude figure, but is in agreement with the separate working of the heads of Greek figures, mentioned above.

Relatively large numbers of fragments of legs and feet remain, which serve to confirm the identity of the group or groups. Fragment 159, a left knee and thigh, over which is part of a short chiton, must have belonged to a lightly clad warrior, presumably therefore a Greek, who appears to have been striding forward; 161 and 163 probably belonged to similar figures.

The fragments of bare legs and bare feet are all likely to have belonged to Greek warriors (these are the only completely bare feet amongst the extant sculptures in the round from the Mausoleum. There are none of scales I or II.). The Persian warriors, by contrast, wore sandals, if one may judge from the evidence of fragment 165. This is the lower right leg of a Persian, clad in trousers, over which is worn a sandal made up of a meshwork of criss-crossing straps, pulled together by laces tied just above the ankle. Several other fragments of feet that wear sandals of identical type (nos. 218–224, 229) may reasonably also be attributed to Persians; 226, a foot that appears to wear a boot, could also have belonged to a figure in Persian dress. Other sandalled feet such as 225 and 227, could have belonged to either Greeks or Persians. That some of the Greeks may have worn sandals is suggested by the bare foot that rests on a sandal sole, 207. This foot can hardly have belonged to a Persian, nor is it likely to be of a female, for the existence of which in scale III there is otherwise no evidence.

Altogether there are twenty-five fragments of feet surviving from figures of scale III. These must have belonged, at the very least, to twelve different figures, six bare-footed and six in sandals, and in all probability to many more. The figures to which these feet belonged were all, of course, represented on foot.

There is evidence to suggest, however, that a number of the combatants of this group or groups were mounted on horseback. A relatively large number of fragments of horses' legs are extant (ten in all), which are of much smaller scale than the legs of the horses of the chariot group or those of the Persian rider's horse of group IC, and which cannot reasonably be attributed to any other group than this battle between Greeks and Persians. It is possible that 235 could be part of the draped upper body of a mounted Persian, who would have been constructed in a similar fashion to his colossal counterpart, 34.

The fighting of this group or groups must have been vigorously represented, and there is likely to have been considerable interaction between figures. Apart from the evidence of heads 46 and 49 for this, which have already been mentioned, there are also a number of fragments of legs and feet that can only have belonged to figures that were striding forward, starting back, or otherwise engaged in energetic movement: 159, 198, 203, 205. High action is also implied by the prancing forelegs of horses: 390, 391, 392, 393, 394, 395, 396, 397.

It is possible that fragment 358, which preserves part of a helmet resting on a base, also belongs to the battle group. Helmets resting on rocky groundlines are found in various battle groups of the fourth century BC (146), but the curious form the helmet takes, with its mixture of archaistic and dramatic elements, still requires explanation. Perhaps the archaism which the helmet shows (an archaism only too evident from the fact that the closest parallels for the lower part of the 'helmet' are to be found in the heads from the Aeginetan pedimental sculptures) should be considered in the same light as the similar archaism evident in the hairstyles of the colossal standing female figures, namely that it is an attempt to evoke an earlier glorious period in the history of the ruling dynasty of Halicarnassus. If this is so, and if the helmet does belong to a life-size battle group, it might suggest that the battle between Greeks and Persians was not intended to represent a contemporary event from Maussollos' own lifetime, but was a reference back to the great Persian wars of the early fifth century, in which Artemisia of Halicarnassus had played a prominent part, fighting on the side of Xerxes.

For the way in which the battle group or groups were placed on the building there is important evidence in the carving of three of the fragments of horses' forelegs, 391, 392, and 393. These three fragments of legs have been carefully finished only on one side, and the animals to which they belonged were evidently intended to be viewed laterally from their right sides. This strongly suggests that the battle group or groups of scale III, like the colossal groups IB and C, were set close to the building and ranged along the sides of it, so that the sculptures could only have been seen from a single viewpoint. One would also expect, therefore, that the battle groups of scale III may have occupied a position similar to that of groups IB and C, that is, against some part of the podium.

If the battle group or groups were placed against the podium, it is difficult to believe that they were set anywhere other than at or about ground-level. The smaller scale suggests they were closer to a spectator

than the sculptures of scales I and II, and if the positions on the podium suggested for the sculptures of IB, IC, and II be accepted, the position for scale III, if it is to be placed lower than II, must come close to ground-level. A position at or about ground-level is favoured also by the distribution of the finding-places of the fragments of scale III, where they are known. Scale III is the only one of the scales and groups of sculptures on the Mausoleum, of which the majority of the fragments whose finding-place is known did *not* come from the large deposit of sculptures in the Imam's field on the north side.

Of the fragments whose finding-place is known, the two important heads, 46 and 49, came from the south side, as did also probably the leg, 165. Two feet, 200 and 201, came from the west side, close to the south-west corner of the building, while the foot 221, and the neck 56, were extracted from walls in this vicinity. Foot 203 came from the east side, while 202 came from the east or the north side. The only two fragments that seem to have come from the Imam's field are the foot 199, and the helmet on a base, 358, which may or may not have belonged to this group. Considering the richness of the deposit in the Imam's field, and the fact that all the other major groups of sculpture are well represented there, the chariot group, the lions, scales IA and II, the presence of only a single certain fragment of scale III there is quite remarkable. It could be only chance, but the likelihood is that it is not. If this under-representation is not chance, the only reasonable explanation is that the sculptures of scale III were set at a place on the building from which they could not have fallen or been knocked north of the north *peribolus* wall, that is to say at ground-level, where they would have been lower than the top of the wall, or at least low enough on the building to ensure that when it collapsed they could not have spanned the short gap between it and the wall.

To judge from the other known finding-places, it looks as if there may have been a battle group between Greeks and Persians of scale III on the south side of the building at ground-level. Whether or not there were other similar groups on the east, west, and north sides is impossible to say. From the number of fragments preserved it is perhaps likely that there was more than one such group, and it is also likely that if there were sculptures at ground-level on the south side, there would also have been sculptures of some kind at this level on the other sides. This probably applies also to the north side, where on account of the proximity of the building to the *peribolus* wall, the composition of sculptures set at ground-level could hardly have been appreciated by a spectator, since the maximum distance at which he could have stood back from the building to view them was 10 or 11 ft (3·35 m).[1]

It has been suggested above (p. 34) that the paw of a reclining lion which survives, may have belonged to an animal that flanked a doorway into the building. If this was so, then at least one side of the building at ground-level must have been interrupted, so that it would not have been available for a full-length battle group. In view of this it may be felt likely that battles between Greeks and Persians did not occupy all four sides of the Mausoleum at ground-level.

There may have been other groups of scale III, of a quieter, more reverential character, similar to those which appear to have alternated with hunting groups in the colossal scale I. The life-size male portrait head, 47, if it is part of the sculptures of the Mausoleum, could have belonged to a sacrificial or reverential group, since the hair is confined by a fillet. Fragment 61 could be part of a similar head, and the sandalled feet, 225 and 227, might also conceivably have belonged to figures of this type. But the evidence is insufficient to prove beyond doubt the existence of such groups amongst the life-size scale of sculptures.

For the way in which the sculptures of scale III were fitted on to the building, some slight evidence remains in the fragments of bases which remain beneath a number of the feet. These suggest that the figures were let into cuttings which must have been made in the surface of the ledge which accommodated them. The bases beneath the feet vary in thickness. Some are only *c.* 6–7 cm: 200, 206, 218, 219. Others are considerably thicker, and more rugged, varying between 10 and 16 cm: 198, 199, 201, 202, 205, 226. The foot, 203, whose base ranges between 7·5 and 10 cm, and the helmet, 358, whose base ranges between 5·5 and 13 cm, span the two extremes. Similar variations in the thicknesses of bases are to be found among the lions and the human figures of scale II (147). It is possible that these represent differences between workshops.

1. The sculptures placed higher up on the north side of the building would have been even more difficult to see from within the *peribolus*, but these at least would have been easily visible from outside the *peribolus* wall, as would not have been the case with sculptures set at ground-level.
Even so it is hard to believe that, if there were sculptures at ground-level on the other sides of the building, they would not also have existed at the north. There must have been as much room on the north side of the building to receive sculptures as on the other sides, and their absence would have created an imbalance in the over-all decoration of the building which would have been more serious than any problems of visibility caused by their presence.

Concerning the position of the ledge which accommodated the sculptures of scale III, and its dimensions, one can only conjecture. It is likely to have been placed close to ground-level, but to have been above any crepidoma which may have existed at the base of the building. There is no sure evidence for the depth of the ledge, but 75 cm would easily have accommodated figures of life-size, and would have left room for some overlapping.[1]

'SCALE IV'

Cat.
no.
50 Head in Phrygian cap (pl. 23)
76 Draped shoulder
89 Lower body of Persian (pl. 27)

Three fragments exist which appear to have belonged to a figure or figures of some three-quarters life-size. Two of the fragments, the head, 50, and the lower body, 89, definitely wear Persian or Phrygian dress; the third, 76, probably does so. If these fragments represent adults, then we certainly have a fourth scale of sculptures in the round, although it does not appear to have been a very important one. Alternatively, the fragments may have belonged to boys or youths, who would therefore be of life-size, and may have been involved in the battle group of scale III, or some other life-size group.

The only one of these fragments whose finding-place is known is the head, 50, which was found some way to the north of the north wall of the *peribolus*, in a position which is likely to have been disturbed (148).

FURTHER SCULPTURES BELONGING TO SCALES I–III

In the above discussion of the differing scales and subject-matter of the human statuary, only those fragments have been attributed to each scale or group which can be supposed with reasonable certainty to have belonged to it. The number of fragments which have been attributed are as follows: for scale I, groups A, B, and C, 78; for scale II, 80; for scale III, 74 (including the head, 47, and the three fragments of 'scale IV'); making a total of 232 fragments for all three scales.

There remain about 225 further fragments of drapery and miscellaneous sculptures (mainly of limbs or bodies), which, although they cannot be attributed to a particular scale or group, must have belonged to one or other of the three main scales of human statuary.

If these further fragments are apportioned equally to the three scales (and in ratio to the surviving fragments of each scale), then *c.* 70–80 would have belonged to scale I, *c.* 70 to scale II, and *c.* 70 to scale III. This would bring the extant fragments of each scale to *c.* 150 in number, which is a considerable quantity, and one which lends confidence to the large numbers of original sculptures which have been assessed for each scale.

1. The fragmentary stone published by Jeppesen and Zahle, *AJA*, 79 (1975), 75, fig. 4, looks as if it may have supported a statue of this scale. See below, p. 245, pl. 46, 1–2.

Sculptural Evidence for a Reconstruction of the Mausoleum

The sculptures in the round constitute important evidence for a reconstruction of the Mausoleum. In order to appreciate the significance of this evidence it is necessary to say something briefly about the general architectural form of the Mausoleum.[1]

Any reconstruction of the Mausoleum must take into account the description of the building given by Pliny, *NH*, xxxvi. 30–31, a passage which, to judge from the facts and figures included in it, looks as if it may derive ultimately from an authoritative source. I follow the text of Mayhoff's Teubner edition, except that I prefer the manuscript reading 'altitudine' to the emendation, 'altitudinem', in line 17.

1 Scopas habuit aemulos eadem aetate Bryaxim et Timotheum et Leocharen, de quibus simul dicendum est, quoniam pariter caelavere Mausoleum. sepulchrum hoc est ab uxore Artemisia factum Mausolo, 5 Cariae regulo, qui obiit olympiadis CVII anno secundo. opus id ut esset inter septem miracula, hi maxime fecere artifices. patet ab austro et septentrione sexagenos ternos pedes, brevius a frontibus, toto circumitu pedes CCCCXXXX, attollitur in altitudinem XXV cubitis, 10 cingitur columnis XXXVI. pteron vocavere circumitum. ab oriente caelavit Scopas, a septentrione Bryaxis, a meridie Timotheus, ab occasu Leochares, priusque

Notes and References begin on page 251.

1. A full publication of the architectural remains of the Mausoleum, and a detailed reconstruction based on this, is being undertaken by Professor K. Jeppesen. I am grateful to him for discussing problems of reconstruction with me over a long period of time. He does not necessarily agree with the solution outlined here.

quam peragerent, regina obiit. non tamen recesserunt nisi absoluto, iam id gloriae ipsorum artisque monimentum iudicantes; hodieque certant manus. 15 accessit et quintus artifex. namque supra pteron pyramis altitudine inferiorem aequat, viginti quattuor gradibus in metae cacumen se contrahens; in summo est quadriga marmorea, quam fecit Pythis. haec adiecta CXXXX pedum altitudine totum opus includit (149). 20

The likeliest picture of the Mausoleum which may be drawn from this passage, and which seems to fit best the most recent archaeological evidence, is as follows:

The Mausoleum was a four-sided building, rectangular in plan, with a maximum circumference of 440 ft, and a total height of 140 ft, including the quadriga. It consisted of three main elements: a lower part (*inferiorem*, line 17) which must have been some kind of podium (cf. *circumitum*, lines 8, 10, which according to the *Oxford Latin Dictionary*, can mean a walled surface); a pteron or colonnade of thirty-six columns; and above this, a pyramid of twenty-four steps, on top of which stood the quadriga.

The height of 25 cubits ($37\frac{1}{2}$ ft), mentioned in line 9, since it is clearly not the total height of the building, is likely to be the height of one of the three main parts of it: $37\frac{1}{2}$ ft is too high for twenty-four pyramid steps (the height of each of which is known to have been 30 cm), and too low for a podium, if the total height of 140 ft is to be retained. Probably it refers to the height of the pteron or order.

The somewhat obscure sentence beginning, 'namque supra pteron . . .' (line 16), suggests an equality in height

between the lower part of the building (whatever word has to be understood with *inferiorem*, whether it be *circumitum*, *partem*, or *pyramidem*), and some part of the upper building, ostensibly the pyramid. The pyramid by itself must have been too low to be equal in height either to the pteron or the podium, and in order to make any sense of the passage it is perhaps necessary to suppose that, in the original source from which Pliny's account derives, it was the pyramid plus the pteron which equalled the height of the lower part of the building.

So far Pliny's description of the Mausoleum seems coherent, or at least explicable. There is, however, one dimension which seems to be at variance with the rest, and that is the length of 63 ft attributed in line 7 to the longer north and south sides of the building (probably at the level of the pteron, to which this part of Pliny's account seems generally to refer). This length appears to conflict with the figures for the total circumference, 440 ft, and the number of columns, thirty-six (unless there was a considerable reduction in size between the base of the Mausoleum and the pteron, and the columns were arranged in some sort of dipteral order); and it certainly conflicts with the number twenty-four for the pyramid steps, since the width of the treads of these is known (cf. *Paradeigmata*, and below), and twenty-four make up far too large a roof for a building with a 63-ft side.

One has a choice, therefore, between accepting 63 ft, and rejecting most of the other figures in the text, or accepting the other figures, which at least seem consistent, and rejecting or emending 63.[1] The latter of these alternatives seems the more reasonable course. Working backwards from the most recent architectural evidence (see below), it seems possible that the original reading for the length of the north and south sides was *centenos pedes*, but how *sexagenos ternos* could have supplanted *centenos* is not easy to see.

The recent excavations of Jeppesen at Bodrum have produced some new, crucial pieces of information, which, when taken together with evidence previously known, and with Pliny's account, allow a reconstruc-

tion of the order and pyramidal roof which must be substantially correct, and furnish maximum dimensions for other parts of the building (150) (figs 8, 9).

The new evidence is as follows:

(a) **Maximum dimensions of base of building.** Jeppesen's re-excavation of the cutting for the foundations (151) shows them to be quadrangular, measuring *c.* 39 m by *c.* 33 m, with longer sides on the north and south (so Pliny).[2] Foundation slabs which remain *in situ* in the south-west and north-east corners show that a slight gap of up to *c.* 50 cm was left within the rock cutting, so that the maximum lower dimensions of the Mausoleum within the Quadrangle were *c.* 38 × *c.* 32 m. If the foot length employed on the Mausoleum was 32 cm (and this is one of the two most likely possibilities) (152), the dimensions 38·40 × 32 m would give sides of 120 × 100 ft, thus confirming the 440 ft for the total circumference given by the text of Pliny. If the foot length used was 32 cm, then the 30-cm unit or module, which manifestly runs through much of the sculpture and architecture, would be 15 dactyls of a 32-cm foot.

(b) **Axial intercolumniation.** The discovery of a complete architrave beam from the walls of the cella, built into the castle at Bodrum (153), has made possible the calculation of the all-important axial intercolumniation of the order, which turns out to be almost exactly 3 m, or 10 units of 30 cm.[3]

This hitherto unknown measurement, when combined with the thirty-six columns and twenty-four pyramid steps mentioned by Pliny, and with other previously known dimensions, produces a reconstruction for the upper part of the Mausoleum which, in its external appearance, seems wholly convincing (figs 8, 9). The dimensions which are known, apart from the intercolumniation, are: the height of each pyramid step, 30 cm; the widths of the treads of the pyramid steps: 60 cm for the bottom one on each side, to accommodate the lions; otherwise 43 cm on the longer sides, and 54 cm on the shorter sides; the tread of the top step was probably only 24 cm. Twenty-four pyramid steps of these dimensions, when set above a colonnade arranged

1. From the acceptance or rejection of the 63-ft long side has arisen the dichotomy between small-type and large-type reconstructions. For general surveys, see van Breen, *Reconstructieplan*, 44–117; Riemann, P-W, 383–415. The best known large-type reconstruction is by Krischen (*Weltwunder der Baukunst in Babylonien und Ionien* (1956), figs 31–32), who arbitrarily emended 63 ft to 63 cubits. The most recent small-type reconstruction, based on the assumption that *sexagenos ternos* is correct, is by Jeppesen in *Paradeigmata*. He now, however, favours the large-type Mausoleum, as do most other scholars. Cf. *AJA*, 79 (1975), 75 n.33.

2. According to Jeppesen and Zahle, *AJA*, 79 (1975), 75 n.31, the precise dimensions of the Quadrangle vary between 38·15 m and 38·40 m for the longer sides, and between 32·50 m and 32·75 m for the shorter sides. These dimensions confirm the general accuracy of the outline of Newton's Quadrangle: he gave the dimensions as 127 × 108 English feet, or *c.* 38·71 × 32·92 m.

3. This is 15 cm shorter than Krischen had supposed in his reconstruction.

11 by 9, with an inter-axial of 3 m, reduce to a platform measuring *c.* 6·50 × 4·75 m, which nicely accommodates the chariot group. The arrangement of the columns, 11 by 9, is the only one to suit the dimensions of a twenty-four-stepped pyramidal roof, and the proportions of the sides of the foundation cutting.

The height of the order, from stylobate to sima, seems likely, from the extant evidence, to have been the 25 cubits (37½ ft) mentioned by Pliny: 37½ ft, on the basis of a 32-cm foot length, gives a height of 12 m for the order, which is four times the inter-axial.

The likely employment of a 32-cm foot length has further implications for the over-all proportions of the Mausoleum. The twenty-four steps of the pyramid, each of which was 30 cm high, would make a total height of 22½ ft, which, when added to the 37½ ft of the order, makes a total of 60 ft for the pyramid plus pteron. If we accept Pliny's total height for the building of 140 ft, this leaves 80 ft still to be distributed. Of this amount, it seems most likely that 60 ft would have belonged to the podium, and 20 ft to the chariot group and any pedestal it may have stood on.[1] There would thus be an equality in height between the pyramid plus pteron and the lower part of the Mausoleum, such as may originally have been intended by the source of Pliny.

The total height of the Mausoleum, on the basis of a 32-cm foot, would have been 44·80 m.

An arrangement of columns, 11 by 9, with an inter-axial of 3 m, gives important dimensions for the stylobate of 32 m on each long side, and 26 m on each short side, or 100 × 81¼ ft, on the basis of a 32-cm foot.

A comparison of these figures for the dimensions of the stylobate with those for the base of the building, viz. 38·40 × 32 m, or 120 × 100 ft, shows that the podium contracted between its base and summit by 6·40 m on each long side, and by 6 m on each short side, or 10 and 9⅜ ft. The contraction was probably equally distributed, so that each end of each side reduced by 3 m, the extra few centimetres being taken up by the inclination of the sides. For the way in which this occurred, the evidence of the sculpture in the round is crucial.

It may be taken as certain now that the sculptures in the round which are extant must have stood on the main structure of the Mausoleum. There have been suggestions in the past that some of the sculptures may have been displayed away from the tomb building elsewhere within the *peribolus* (154). Jeppesen's excavations,

however, have shown that the *peribolus* was not finished, so that this cannot have been the case (155). Only the north wall of the *peribolus* seems to have been completed. The east wall and the propylon were left in an unfinished state, while the south and west walls of the *peribolus* were planned but never built. The area within the *peribolus* walls does not even seem to have been levelled, much less paved. Furthermore, the evidence of the sculptures themselves, their design and execution for a single lateral viewpoint, and the weathering they display, shows that they must have stood externally on the building.

Now we know that the chariot group stood on the summit of the pyramidal roof, and it is fairly certain that the lions were ranged on the lowest step of the pyramid, at the base of the roof. The only other external positions on the Mausoleum higher than the podium that could have been occupied by sculpture in the round are the intercolumniations, to which the colossal series of dynastic portrait statues has been allotted with fair likelihood.

Assuming these groups of sculpture to be correctly placed, the remaining sculptures in the round can only have been placed on or against the podium, and one must suppose, therefore, that this had ledges or steps that were sufficiently broad to accommodate them. Now the sculptures that are to be attributed to the decoration of the podium are of three different scales (they are the sacrificial and hunting groups of scale I, the standing figures of scale II, and the fighting figures of scale III), and it would be wholly contrary to one of the fundamental principles of Greek sculpture, that of isocephaly, if they were not set on different levels. If one of the scales of sculpture was placed on a ledge at or about ground-level (most probably the smallest scale III), then one must postulate two further steps or ledges higher on the podium, to accommodate the sculptures of scales I and II.

The podium assumes the form, therefore, of a three-stepped pyramid, which may perhaps be the 'lower pyramid' that has always seemed to be required by the text of Pliny (156). Such a shape would also well suit the famous account preserved by Guichard of the destruction of the podium of the Mausoleum by the Knights of St John, early in the sixteenth century. In particular, the sentence 'for in a short time they perceived that the deeper they went, the more the structure was enlarged at the base, supplying them not only with stone for making lime, but also for building' suggests a gradual enlarging of the podium downwards (that is, by more than one step) (157).

1. The total height calculated above, p. 20, for the chariot and occupants, *c.* 5 m, amounts to 15 or 16 ft, so that a pedestal would have been perhaps 1·50 m high.

These arguments for the shape of the podium, based originally on the evidence of the sculptures in the round, have found at least partial confirmation in the recent discovery by Jeppesen on the site of the Mausoleum of very many fragments of a moulded course of dark-blue limestone with cuttings on its upper surface for sculptures, which must have run round the podium (158). Recognition by Jeppesen of a corner piece of this course in the British Museum proves that the step to which it belonged ran round all four sides of the building. Whether these fragments belong to a single course, as Jeppesen has initially concluded, is uncertain. But in view of the numbers and different scales of the sculptures that have to be attributed to the podium, it seems probable that they may belong to more than one course.

The height of each of the steps of the podium remains conjectural. In the tentative reconstruction given below (figs 8, 9), where it is assumed that the total height of the podium was 60 ft, or 19·20 m, it is suggested that the life-size sculptures were set on a base 1·10 m above ground-level, and that the podium above this was divided into steps in the ratio of 3 : 4 : 5, giving heights of 4·50 m, 6 m, and 7·50 m, to agree with the sculptures with which they were most likely connected, and to provide some optical correction for a spectator on the ground looking up.

The precise projection of each step on which the sculptures rested is not certain at present. Eventually it may emerge from a full examination of the fragments of the blue limestone courses in Bodrum. In the meantime, the sculptures themselves provide some evidence, when taken with the fact that each side of the building contracted by 3 m between base and top of podium. The widths of the steps are unlikely to have been much greater than the maximum width of the sculptures placed on them, for the sake of visibility from below. The maximum thicknesses of the sculptures of scale I are 1·12 m for 33 and 1·025 m for 34. The projection of the uppermost step, therefore, on which these sculptures are likely to have rested need have been no more than c. 1·25 m, and is unlikely to have been more than 1·50 m. The thickness of the sculptures of scale II is only some 40 cm, so that a minimum width of 60 cm and a maximum of perhaps 1 m is likely (159). A width of 75 cm seems the maximum necessary for the figures of scale III set at or about ground-level. This in fact appears to be the width of the fragment of moulded base recently published by Jeppesen (160), which, to judge from the dimensions of the cutting for the statue, and its diagonal placing relative to the front of the block, looks as if it may have supported one of the figures in motion of scale III (161).

The figures suggested for the projection of these three steps, 1·25 m, 1 m, and 75 cm (or alternatively, 1·50 m, 75 cm, and 75 cm), total 3 m. This would mean that there can have been very little in the way of a crepidoma at the foot of the podium. Possibly there was only a single step, such as there is evidence for in *MRG* A23 (162), on the upper edge of which is a setting line 11 cm in from the face, which roughly equals the projection of the moulding on the statue base mentioned above. Clearly the moulded statue base cannot have rested directly on a euthynteria course of blocks like *MRG* A23. There must have been at least another course of blocks between the two, and, assuming the blocks of the Mausoleum to have been carved in multiples of 30 cm, this would mean that the lowest level of sculptures on the podium was raised at least 60 cm above ground-level (not including the thickness of the statue base, which is c. 20 cm), and quite possibly more, perhaps up to 90 cm (or 1·10 m, including the thickness of the statue base), as suggested in the conjectural reconstruction of the podium (figs 8, 9).

According to the reconstruction suggested, therefore, the Mausoleum was decorated with sculpture in the round on six levels, including the summit, each side having a similar scheme of decoration. The details of this over-all scheme, with an assessment of the total number of statues on each level, are as follows:

		Total statues
I.	Chariot group on summit	5 or 6
II.	Lions at base of roof	56 or 72
III.	Portraits between columns	36
IV.	Colossal groups on upper step of podium	56
V.	Heroic portraits on middle step of podium	72
VI.	Life-size groups at base	88
	Total number of statues	314 *or* 330

Obviously this assessment can only be a rough one, but it seems a valid exercise because it gives some impression of the incredible lavishness of the sculptural decoration of the Mausoleum, a lavishness presupposed by the fame which the tomb building and its sculptures enjoyed in antiquity as one of the seven wonders of the world.

The total numbers of statues assessed for the higher placed groups, the quadriga, the lions, and the dynastic portraits, cannot be far out and may be entirely correct. Most doubt concerns the lions, which may not have been as numerous as the seventy-two suggested. A

8 Reconstruction of long side of
Mausoleum

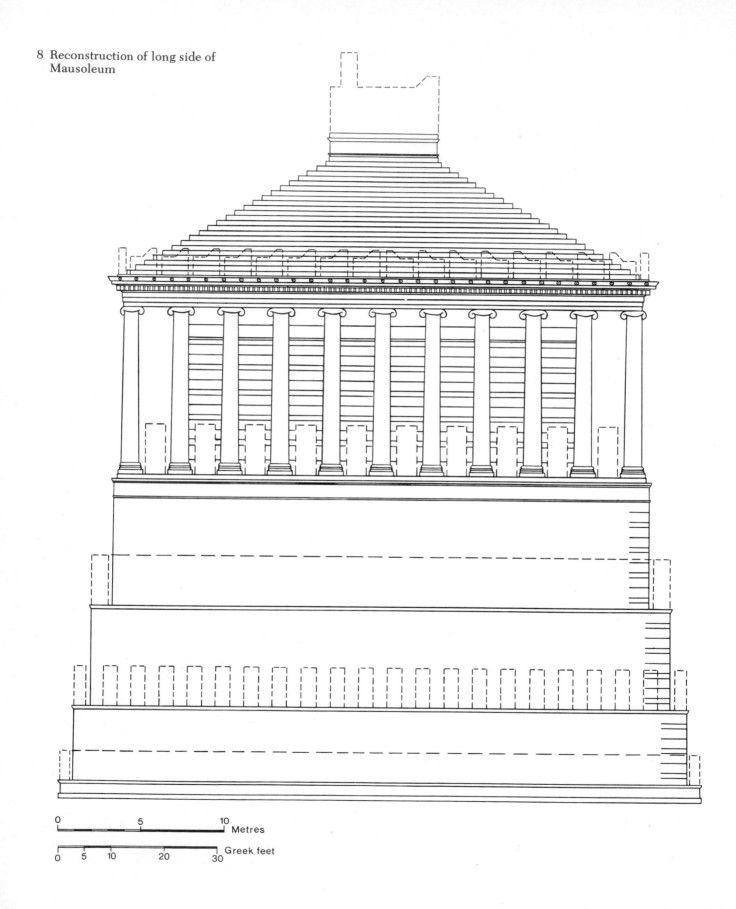

0 5 10 Metres

0 5 10 20 30 Greek feet

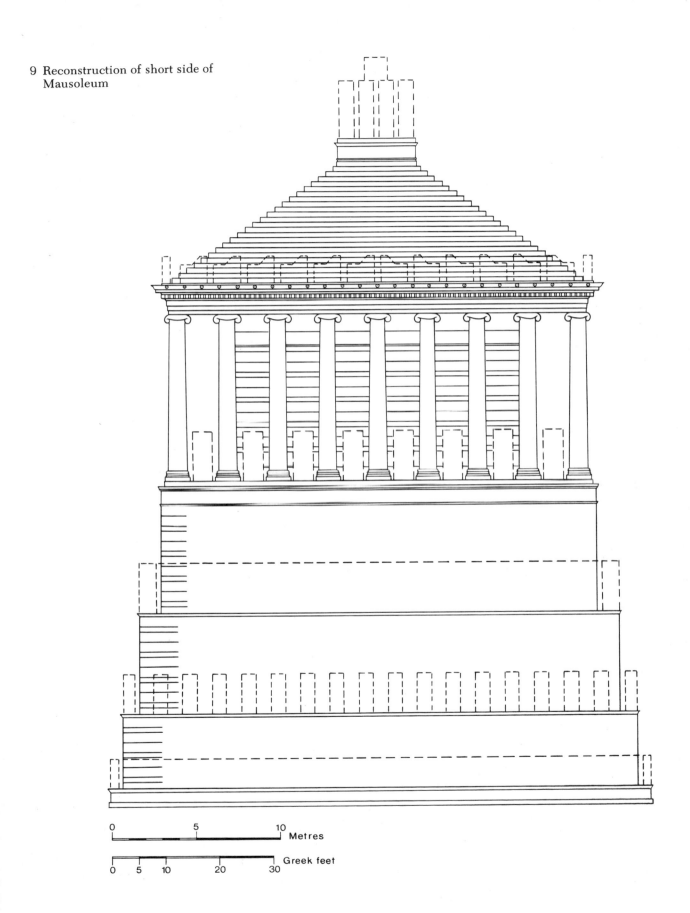

9 Reconstruction of short side of
Mausoleum

0 5 10 Metres

0 5 10 20 30 Greek feet

minimum number of fifty-six seems likely, however (163), so that these three upper groups would in any case have required about a hundred colossal statues (counting the lions as colossal). The substantial number of large fragments of these sculptural groups found in the important deposits north of the north *peribolus* wall, and the many other smaller fragments from elsewhere on the site of the Mausoleum, appears to confirm this total figure for the upper part of the building, viz. either 98 or 114.

The assessment of the number of sculptures on the podium is much more open to doubt. For one thing, much less material evidence remains, and the sculptures which do survive are generally smaller and more damaged than those from higher on the building. The reason for this, no doubt, is that many of the statues still stood on the podium, or lay around its base, when it was discovered and dismantled by the Knights, and consequently these would be among the first to be burnt for lime (164).

The only really large fragments surviving from the sculpture on the podium are the mutilated colossal statues, 33 and 34, which were left behind in the Quadrangle by the Knights. These do furnish dimensions which, when taken with the known lengths of the wall of the podium against which the groups were set, and with the evidence of the dark limestone angle-piece that the groups stood on all four sides of the building, allow some conclusions of a general nature to be drawn.

The length of the Persian rider's horse, 34, must originally have been 3 m, including raised forehooves. The width of the seated statue, 33, is now 1·28 m, but must have been at least 1·50 m originally, including the extended left arm. The animals from the groups, ram, bull, leopard, boar, each require a length of *c.* 2 m in a composition. The length of the wall of the podium against which the figures of scale I were set was 32 m on each long side, and 26 m on each short side. Assuming an average length for each figure involved of 2 m, this means that if each side were completely filled with figures, as it is likely to have been, there would have been fifteen or sixteen figures on each long side, and twelve or thirteen on each short side, say sixteen by twelve, making a total of fifty-six.

For the heroic standing figures of scale II, the background of the podium provided lengths of probably 34·60 m on each long side, and 28·60 m on each short side. The average width of the figures preserved is *c.* 60 cm, excluding arms. Including arms and any falling drapery, it may perhaps have been *c.* 80–85 cm. The spacing between such standing figures is, of course, not known, but assuming it to be about equal to the width of each statue, then one statue and one space would make 1·70 m, on which reckoning there would have been twenty statues on each long side, and sixteen on each short side, making seventy-two altogether.[1] This would be twice the number of the similar portrait statues of scale I, which they appear to echo. The extant fragments of this scale of statue do not make such an assessment wholly out of the question (165).

There is rather more doubt concerning the likely number of statues of scale III, because it cannot be taken as certain that figures of this scale were placed on all four sides of the Mausoleum, in similar fashion. One side at least is likely to have been interrupted by a doorway, and there may also have been problems in the visibility of sculpture placed at ground-level on the north side, where the building ran close to the *peribolus* wall (166).

Taking the south side, however, where there is likely to have been a battle scene involving combatants in Greek and Persian dress, some of them mounted on horseback, the wall of the podium is likely here to have been 36·60 m long (as compared with 30·60 m long on each of the shorter sides). A horse of scale III, assuming it to be in the same proportion to its rider as the horse of 34 is to *its* rider, would have been *c.* 1·80 m in length, including any prancing hooves. If the horses occupied about half the composition, then they may have been nine or ten in number. Into the remaining 18·30 m may be fitted perhaps fifteen or sixteen warriors at most (possibly fewer, since many seem to have been engaged in vigorous action that required more room). At the most, then, there are likely to have been twenty-four figures on the south side (counting horse and rider as one). If such groups existed on the shorter sides they may have included twenty figures. If on the north side as well, there would have been eighty-eight statues of scale III altogether.

However the third scale of sculpture was arranged, it seems reasonable to conclude that the statues that decorated the podium numbered 200, if not more. That is to say, there were twice as many statues on the podium as on the upper half of the building, although the scale of many was not nearly so large, so that the quantity of marble and carving must have been about the same. The assessment may seem an inordinately large one, particularly since so many of the statues have

1. On the Daochos base at Delphi the spacing between statues is roughly equal to the width of one statue. See Will, *BCH*, 62 (1938), pl. XXX.

conveniently disappeared into lime-kilns. On the other hand, the statues and fragments of IB, IC, II, and III number, at a conservative estimate, about 180, and it is apparent from their mutilated condition that these represent only a small broken remnant of a very much larger body of material. There are in addition c. 225 other fragments, mostly of drapery or limbs, the vast majority of which are likely to have belonged to the sculptural groups of the podium (167). The sculptures from the podium have survived less well than those placed higher mainly because there was much less chance of their being thrown beyond the *peribolus* wall at the north, where they might have been spared the devastation of the Knights. The lime-kilns into which the greater part of the sculpture from the podium disappeared are an unfortunate fact, as is clear from Guichard's account.

It seems likely, in any case, that the bulk of the sculptural decoration of the Mausoleum would have been placed on the podium, since here it was much closer to the spectator and would be much more easily seen.

The following is a list of the likely heights at which the sculptures were set, and the shortest distance away from the building on level ground at which they would be visible:

Sculpture	H. at which set (Gk ft)	Shortest distance visible (metres) Top	Whole statue
Chariot group (incl. podium)	120–40	c. 30	c. 44·5
Lions	97½	c. 9	c. 90
Statues between columns	60–70	c. 1·50	c. 4·50
Podium groups I	c. 35–45	wholly visible	
Podium groups II	17½–25	wholly visible	
Podium groups III	ground-level	wholly visible	

These figures apply to a spectator viewing one of the longer sides from level ground. In fact the ground rises steeply to the north of the Mausoleum, so that the visibility of the higher groups would have been much improved on that side. To the south the ground falls away towards the harbour, and the visibility of the higher sculptures would have been correspondingly poorer.

The figures for the podium are based on the assumption that there were three steps of 4·50 m, 6 m, and 7·50 m in height, above a step c. 1·10 m high for the scale III sculptures.

It is apparent from this list that the only statues that could not be seen with ease by a spectator standing at the base of the monument were the lions at the base of the pyramidal roof and the chariot group at the summit. The groups of colossal scale I that were set highest on the podium were at no higher level than the average Greek pedimental composition, and would have been at least as easily visible. Similarly the statues between the columns would have been not much higher than certain temple acroteria. The unusually large distance for complete visibility of the lions results from their position on the lowest step of the pyramid behind the sima, the lip of which masked them. This may have been somewhat countered by allowing the bases of the lions to rise several centimetres proud of their cuttings in the steps in which they were set.

Apart from the occupant(s) of the chariot, therefore, all the human statuary would have been fairly easily visible to a spectator standing on the ground. If, as is possible, the chariot group was intended to signify the apotheosis of Maussollos, its invisibility from the spectator immediately below would not matter, and might even be of significance.

If the arrangement of the sculptures on the podium as proposed here be accepted, then it is clear that these groups of statues were closely similar in conception to earlier Greek pedimental sculpture. They were carved in the round, but were designed with only a single viewpoint in mind, and were set close against a back wall, so that from a distance they would have had the appearance of relief sculpture.[1] The major difference is that the constraining raking cornices of pedimental composition were absent, so that the effect would have been that of an Ionic frieze in deep relief. The original appearance of painted figures set against a white marble background finds striking parallels in the colour schemes of the sarcophagus of the Mourning Women and the Alexander sarcophagus (168).

There are two further points which seem to favour a reconstruction such as that suggested here. Firstly in the over-all scheme of decoration there is a nice alternation between horizontally and vertically composed groups, and, at the same time, between moving and static figures, of the kind that one might reasonably have expected to find in such a late Classical composition.

Taking the long south side of the building as an example, and working from the base to the summit

1. This may explain why, in Pliny's account, the word used for the carving of the Mausoleum sculptures is *caelare*, which is a term normally used for sculpture in relief. See above, p. 54: *caelavere*, line 3; *caelavit*, line 11. Cf. Jeppesen, *Paradeigmata*, 8.

according to the reconstruction proposed here, the sculptures consisted of: a battle group involving movement and interaction between figures, with a basically horizontal line of composition (scale III); above this, motionless, isolated figures of vertical composition (scale II); above this, a horizontally composed group of either hunting or sacrificial type, involving movement and interaction (scale I); and above this, motionless statues placed in isolation between the columns, emphasising the verticality of the pteron. Finally the horizontal lines of the steps of the pyramidal roof were accentuated at their base by horizontally composed lines of lions in somewhat stylised motion, and at the summit by a horizontally composed chariot group, which appears to have been motionless. In such a design the sculptural decoration would possess over-all unity, while the more violent scenes of movement would be kept to the lower part of the building.

A neat, almost over-precise, counterpoint of this kind seems to fit in with the architectural character of Pytheos as evinced by the temple of Athena at Priene, and indeed by the relatively simple scales and proportions of the architecture and sculpture of the Mausoleum.

The second point favouring the reconstruction proposed here is as follows. It is clear that a building such as the Mausoleum, which had a large amount of sculptural decoration of a similar nature on each of its four sides, must have employed an elaborate numbering or lettering system to ensure that the correct sculptures were placed in the correct places. This was the more necessary if, as the literary sources maintain, and as seems likely from the material evidence, responsibility for carving the sculptures was divided up between different workshops. The remnants of such a numbering system seem to be preserved on the rumps of the lion statues, where the letters A, Λ, and Π remain (169). Now these letters preserved on the lions fit in perfectly with the reconstruction suggested, if it is assumed that the chariot group had no letter (not necessary), and that each level of sculpture on each side of the building received a different letter of identification, working from roof level to ground level, and beginning with the east side and working via the south and west sides to finish at the north.

The system would then originally have been as follows:[1]

	East side	South side	West side	North side
Lions	A	Z	Λ	Π
Statues between columns	B	H	M	P
Podium groups I	Γ	Θ	N	Σ
Podium groups II	Δ	I	Ξ	T
Podium groups III	E	K	O	Y

This system cannot be regarded as proven unless the appropriate letter can be found on one of the other groups of statues. So far none has appeared. The letters, however, are faint enough on some of the lions, and it is likely that on the lower placed statues they would have been less conspicuous originally, possibly having been placed, for example, on the bases of the statues. Newton reported, oddly enough, on the discovery of the Persian rider, 34, that 'the crupper of the horse is marked with the letter Σ' (170). If this is so, I have been unable to find any conclusive traces of it. There are some raised zig-zag lines on the inside of the upper right hind leg, which could conceivably be read as a kind of sigma or nu (which would be preferable, if the colossal hunting group was placed at the west), but it cannot be taken as certain or even likely that these marks represent a letter at all.

Biliotti is equally tantalising. In his diary for 14 June 1865 he makes the following entry:

> From the garden wall dividing Mehmeda's property from Ahmed Bey's: *Statue*: Heel under which is inscribed the letter Σ.

This fragment, which might have settled the matter, has not been identified and must be presumed lost. It is hard to believe, however, that there was not some reason for Biliotti's remark.

1. There would be no need for letters for the relief sculptures, for these would have been built into the structure as work progressed, and may even, in part at least, have been carved *in situ*. The sculptures in the round, however, can only have been set in place on the building when all the architectural work was completed, commencing with the chariot group on the summit and working downwards to the base of the podium. Large numbers of sculptures must therefore have been stored on the site of the Mausoleum possibly for many years, and letters of identification would undoubtedly have been necessary.

One may conjecture that it was the task of lifting the sculptures on to the building that was not completed when Artemisia died in 351 BC. This being so, it is conceivable that the sculptors involved may have agreed to complete the installation of statues already carved under the terms of their previous contract (cf. Pliny, *NH*, xxxvi. 31).

Technique

PIECING OF STATUES

Most of the statues from the Mausoleum were carved in more than one piece, the separate portions being joined together by sockets, dowels or clamps, often secured by lead. The horses and wheels of the chariot group were carved in this way, as were most of the human statues. Exceptions to this practice on the Mausoleum include, most notably, the lion statues, which were carved from large single blocks of marble, and, amongst the human statuary, 27 ('Artemisia') (pl. 13), 33 (pl. 17), and perhaps also the statue to which the female head, 30 (pl. 16), belonged.

Piecing of statues is found in all periods of Greek sculpture, but it becomes prevalent in the fourth century BC, and extremely common in the Hellenistic period (171). There were normally two main reasons for the adoption of this practice, both of which had an economical basis: first, the saving of marble, the ability to use smaller blocks and so cut wastage to a minimum; second, the saving of time. By carving a statue in separate portions, several masons could work on it simultaneously. Since the sculptors of the Mausoleum do not seem to have been at all short of marble, piecing was probably adopted for the second of these reasons, namely the saving of time. The Mausoleum, for all its bulk and lavishness of decoration, was constructed in a remarkably short space of time, probably twenty years at the most (between, say 368 and 348 BC), which

would make the relative progress of work much faster than, for example, on the Parthenon at Athens, which was itself famed in antiquity for the speed of its construction. This could only have been achieved by the employment of a large labour force (including four sculptural workshops and their attendant masons), and by the adoption of quicker methods of carving, such as the piecing of statues.

SEPARATE CARVING OF UPPER BODIES

The upper half of the Persian rider, 34 (pl. 18), was carved separately and joined to the lower part by means of a massive, wedge-shaped dowel, secured in position by lead, the pour-hole for which remains. It may have been the regular practice on the Mausoleum to carve the upper parts of mounted figures separately; cf. frags 232, 233, 234, 235. Wedge-shaped dowels were used also on 26 (left forearm), 65, and 112. Other instances of pour-holes for lead are to be found on 2 (for joining tail), 25, 26 (tenon of head), and 405.

An example of a colossal standing figure, joined at the waist, may exist in fragment 104 (172). If this was the case, then the upper body would have had a deep tenon which fitted into a mortise in the lower half of the body.

Notes and References begin on page 251.

ATTACHMENT OF SEPARATELY CARVED HEADS

In general on the human statuary it was the heads and arms that were carved separately.[1] Heads were fitted to bodies by the mortise and tenon method that was usual in Greek sculpture. Larger heads, like 26 and 31, were additionally secured by means of substantial dowels, but this seems to have been considered unnecessary for heroic or life-sized heads. Cf. the tenons of 46 (pl. 21), 52 (pl. 24), 53 (pl. 24), 54, 55 (pl. 25); and the mortises of 68 (pl. 26), 69, 70, 72, 75, 76, 85 (pl. 27). The life-size head 47 (pl. 22) is exceptional in having a large dowel-hole, but it is possible that this may not have belonged to the Mausoleum. In addition to having a dowel, the tenon of the head of 26 (pl. 15) was further secured by cross-pinning through the wall of the socket in the body of the statue, a practice which is found later in the fourth century on the statue of Sisyphos from the Daochos group at Delphi (173). The tenons generally taper below the neck and have a flat underside, oval in shape, but there are examples of the alternative type with rounded underside in 53 and 55 (pls 24, 25). This variation *may* represent different workshop conventions. Tenons with rounded undersides are employed, for example, on the Scopaic pedimental sculptures from the temple of Athena at Tegea (174), and on the head of the Demeter of Cnidus, which has been ascribed to Leochares (175).

Fragment 85 (pl. 27), it should be noted, is an unusual example of a nude torso whose head was worked separately and added by means of a mortise and tenon joint.

ATTACHMENT OF SEPARATELY CARVED ARMS

Arms joined at the shoulder were usually fixed by means of large square or rectangular dowels that were sometimes cross-pinned for extra security, so 26 (right arm), 70, and 77 (where part of the iron cross-pin remains).[2] There is also cross-pinning of the forearm joint, 100, and possibly also of the hand, 144 (pl. 29).

There are instances of a second, supplementary dowel being used, smaller than the main one, to provide added strength: 63 (pl. 25), 68 (pl. 26), 77, 78. These second dowels may have helped to prevent arms from

1. There are two fragments extant, 66 and 85, where the heads were carved separately but the arms were not.
2. Compare the cross-pinning of the right arms of Daochos I from Delphi and Asclepios at Eleusis: Adam, *TGS*, 104.

slipping out of line before the lead hardened around the dowel.

On the worked surface of the shoulder of 77 there is a lip to provide extra purchase for a raised arm.

Forearms that were worked separately were usually attached by a single dowel without cross-pinning: 97, 98 (pl. 28), 102, 104 (pl. 28), 105, 106, 107, 109, 131, 132, 133, 135, 314; but a few had double dowels: 96, 101, 312 (?). Dowels were mostly square or rectangular in section (176), but some were round: 107, 135. Where there are remains of dowels sufficiently large to test, the material employed seems to have been mostly iron: 77, 83, 87 (pl. 27), 100, 144 (pl. 29), 405 (pl. 38) (177).

SEPARATE WORKING OF FEET AND HANDS

There are two examples of parts of feet and hands being carved separately, although it is possible that these may have been ancient repairs. The forepart of the bare foot, 193 (pl. 31; fig. 20), was worked separately and attached by means of two circular dowels. And the middle finger of the colossal hand, 144 (pl. 29), was attached by a dowel.

Some hands have grooves in their palms as evidence that separately worked objects were held: so 143 (pl. 29), 145 (pl. 29), 146, 147; and in one case, 145, there is also a small dowel hole for further security.

ANCIENT REPAIRS

Certain or probable examples of ancient repairs are to be found on the following fragments: 16, foreleg of chariot horse with dowel hole (pl. 10); 26, right nostril of 'Maussollos' (pl. 14) (178); 27, top of drapery fold to left of left knee (pl. 13); 87, top of drapery fold, repaired by means of large iron dowel and four supplementary dowels (pl. 27); 405, lower jaw of lion (pl. 38); 416, tail of lion, fixed by dowel into socket; 418, right rear paw and tail of lion, on base (pl. 40; fig 40). The outermost of the two cuttings on the lower left side of 26 may also originally have been a repair (pl. 15; fig 18).

ANCIENT RECUTTING

There is an example of recutting on the inner fold of the lower left side of 26, where the uneven edge through the fold was clearly not carved for a repair (pl. 15; fig. 18)

(179). The reasons for this recutting cannot now be determined.

Some of the bases beneath lions' paws look as if they may have been hastily trimmed in order to be fitted into position: so 426 (pl. 41; fig. 48) and perhaps 435 (fig. 57).

CUTTINGS FOR LIFTING AND LEVERING

There are two examples of lewis-holes which must have been cut to facilitate the lifting of the statues on to the building. One is on top of the back of the hindpart of the chariot horse, 2; the other on top of the female head, 30. Two deeply scored grooves running across the line of the hairs on the tail that belongs to 2 (pl. 6), which are certainly ancient since they show signs of weathering, may have been caused by ropes or hawsers used to lift the chariot horses on to the roof.[1]

Horizontal cuttings found on the edges of most of the lions' bases were probably to facilitate their levering into place by means of crowbars. For the same reason many of the lions' bases have chamfered edges (180).

FINISH OF SURFACE

The quality of the surface finish of statues from the Mausoleum varies considerably, depending on how far from the spectator the statue or group of statues was set, and which side would be visible when the statue was set in position. As on many fourth-century sculptures, parts deemed by the sculptor to be likely to be invisible when the statue was set in place received much sketchier treatment.

The carving of the chariot group, the farthest removed from the spectator, was broad, and the finish is generally rough. On parts that would have been completely invisible from below rough pointwork was left: on top of the back of 2, on the undersides of the tails, and on the surfaces of the bases. Elsewhere the surface seems to have been considered smooth enough after the use of the claw chisel: for example on the chariot wheels, on the sides of the body of 2, on the hooves, especially 6, 7, and 9, and on the insides of many of the fragments of legs. Greater effort appears to have been expended on smoothing some of the outer visible surfaces, particularly of the leg fragments 6, 11, 13, 14, 15; while other leg fragments, 10, 16, and 17, have a smooth finish both inside and outside. The differences between the finish of outer and inner surfaces may in some cases have been exaggerated by the effects of weathering. This may explain the apparently smoother surface of the forepart 1 compared with the hindpart 2.

Although weathering makes judgement difficult, the lions appear to have been more finely finished than the chariot horses, except for the bases which, in some cases, are extremely rough and irregular. Outward surfaces seem generally to have been finished with the fine rasp, although heavy rasp marks often remain on the insides of legs, such as 454, 464, 466, 470, 473, so that there results a differentiation between inner and outer surfaces similar to that noted on the legs of the chariot horses.

The fronts and sides of the colossal portrait statues IA, that may have stood in the intercolumniations, are finely carved and finished, with an attempt to suggest texture and crumpling of material, but the backs are much more schematic in design and are less carefully finished. Compare in this respect, 26, 27, 29, 63, 73. The top of the cap of the colossal female head, 30, has a strip of rough pointwork, similar to that on top of the hindpart of the chariot horse 2. Compare also the top of the back of the ram, 360, for this.

The smaller scale (II) of standing figures, who were probably placed lower on the building, appear to have been similarly worked, with backs much less carefully designed and finished than fronts: 42, 43, 44, 67, 68, 70, 74. The legs, which are well preserved below the drapery of 42, provide important evidence that the bare limbs of this scale of figure at least were originally highly polished. Compare also the fragment of leg, 174, for this.

Statues from colossal groups placed against the podium, such as 33, 34, 360, show a broadness of concept similar to that of the chariot group, although the finish is generally a little finer. The ram, 360, however, has a strip on top of the back that was not taken beyond the stage of the point, while the Persian rider's horse, 34, exhibits traces of the flat chisel, particularly on the left side. The rider's left hand is also sketchily worked. Some of the statues of animals, both of scale I and scale III, were carved in detail only on the side that was turned outward from the building towards the spectator. Cf. the head of a boar, 368, where the left side has been only roughly finished with the flat chisel (pl. 34),

1. One might have expected the tails not to have been fitted until the bodies had been positioned on the roof, but it is difficult to find any other explanation for these score-marks.

and the prancing hooves of life-size horses, 391, 392, and 393. The inner side of 391 has been worked with the flat chisel, the inner side of 393 with the point (with marks of the flat on the underside), while 392 is smoothed but has no detail.

Statue bases are generally finished more or less roughly with the point, but there is sometimes a smooth band running around the outline of a foot: cf. 199 (fig. 22), 201 (fig. 24), 216 (fig. 34), 218 (fig. 36), 219 (fig. 37) (181). In one case, 200 (pl. 31; fig. 23), a drilled groove, made by the running drill, divides foot from base. The running drill is also used on occasion on bare flesh in the angle of elbows, for example, 111 (pl. 28) (182).

PAINT

There is sufficient evidence to show that all the free-standing sculptures of the Mausoleum were more or less fully painted.

Red paint remains on the harness strap beneath the forepart, 1, of the horses of the chariot group, and there was red paint on the tongue of the head of 1 when it was discovered by Newton. A brown patina on the body of 1, and also on the fragments of leg, 10 and 12, may be the remnants of brown paint which is likely to have been applied to at least some of the horses of the chariot group.

The lions were painted a yellow-brown or yellow-ochre colour, traces of which are still to be seen on the face and mane of 402, generally on 407, on the left flank and, in one place, on the right flank of 411, on the right flank of 413, on the inside of the right rear thigh of 416, and on the fragments of legs, 460 and 466. Red paint remained on the tongue of 401 when it was unearthed by Newton.

Random traces of paint which are preserved on the human statues permit the reasonable inference that these too were quite fully painted. There was colour in the corner of the eye and in the nostril of 26 when it was discovered. Purple on the surface of 33 is likely to be the remains of paint, and this colour was also seen by Newton on the back of 42. Lightish blue paint remains on the inner surface of the drapery fragment, 244, which is probably part of a billowing cloak, and the same colour is to be found within a fold on fragment 303. Another fragment of drapery, 245, which lies over a limb or body, is coloured rose-red.

Red-brown paint remains on the hair and beard of 47, on the female slipper 208, and perhaps also on the boar's head, 367.

Recent cleaning has revealed traces of a painted saddle cloth on 34, close to the line of the right leg of the Persian rider. It had a fringed edge, painted blue within a finely drawn red outline (fig. 19).

There are also a number of feet wearing sandals, generally female, where one must assume that the sandal straps were added in paint: 27 (plus 28), 207, 228.

The Relationship to other Sculptures of the Fourth Century BC

CHARIOT GROUP

Free-standing four-horse chariot groups in marble were very rare in Greek sculpture, and at the time it was carved the massive marble quadriga on the summit of the Mausoleum may have been unique (183). The usual medium for chariot groups, which were a frequent agonistic dedication, was bronze. One of the earliest groups in bronze must have been that made by Ageladas to celebrate Kleosthenes' victory at Olympia in 516 BC (184), while numerous other references in Pausanias and Pliny attest their popularity in the fifth and fourth centuries BC (185).

The only other marble group mentioned by Pliny, *NH*, xxxvi. 36, is a quadriga and chariot in which stood Apollo and Diana, by a sculptor named Lysias; this was reputedly carved from a single block of stone. It was famous enough to be rededicated by Augustus at Rome on top of an arch on the Palatine. The date of Lysias is not known, but the practice of sculpting large-scale groups from single blocks of stone is elsewhere attributed by Pliny to Rhodians of Hellenistic times (186), and it is perhaps likely therefore that Lysias was a Hellenistic sculptor. By carving his group in one piece Lysias may have avoided the awkward supports beneath the bellies of the horses which characterise the Mausoleum group.

Marble horses from a chariot group, recovered from the Anticythera shipwreck, appear also to be of Hellenistic date (187). They are life-size, their heads and

necks worked separately, their bodies carved from a single block, which still however required a marble support beneath the belly. In style they seem to be influenced by contemporary bronze working rather than by earlier marble groups such as that on the Mausoleum.

It has been suggested that a marble chariot and four stood on the summit of the pyramidal roof of the Mausoleum at Belevi (188), which is probably to be dated to the third century BC. If this was so (and the evidence for it is not strong), it would presumably have been a direct inspiration from the Mausoleum at Halicarnassus.[1]

Marble chariots are regularly found earlier than the time of the Mausoleum in Greek pedimental sculpture, but these are usually carved in relief. Even when actually sculpted in the round, as on the east pediment of the temple of Zeus at Olympia, or on the west pediment of the Parthenon, they have none of the constructional problems of a truly three-dimensional group. The rearing horses on the west pediment of the Parthenon do however require belly supports (189), as indeed do the standing Olympia teams (190).

The horses of the Mausoleum chariot group are of a type not normally encountered in the art of mainland Greece. Probably they are intended to represent an

1. Recent excavations at Ephesus suggest that a life-size marble four-horse chariot may have formed part of the sculptural decoration of the late-Classical altar. Cf. Bammer, *AA* 1968, 420, fig. 40 and Fleischer, *ÖJh* 50 (1972–75) cols 462–8, figs 40–1. In particular, the horse's head which is preserved, bears a marked similarity to that of the Mausoleum chariot-horse.

Asiatic breed of draught horse, if not actually the Nisaean breed that was the special preserve of the Persian king and his satraps (191). Horses of closely similar type are found on fifth-century reliefs from Lycia (192), in the procession of chariots from the roof of the Mourning Women sarcophagus (193), in the Kazanlak tomb paintings, probably of the late fourth century BC (194), and on a frieze from Persepolis (195).

The large, six-spoked chariot wheel is also not normally found in the art of the Greek mainland, and probably represents a combination of Ionian and Asiatic types (196).

From the evidence of the character of the horses and wheels of the Mausoleum chariot group, one may justifiably conclude that the designer of the group did not belong to the Greek mainland. This must support Pliny's attribution of the group to the Ionian architect of the Mausoleum, Pytheos.

LIONS

The stylised standing or walking pose of the lions is one which is almost wholly, if not entirely, absent from the sculpture of the Greek mainland at all periods. Mainland lions, which become quite common in the fourth century as grave monuments, are usually reclining, crouching or springing (197). Of the standing or striding lions listed by Willemsen (198), only the pair in Rhodes castle from Ialysos (199) seem at all comparable with those of the Mausoleum, although to judge from the treatment of the mane they are probably earlier than the Mausoleum.

The only certain example of a standing lion from Attica is that which, according to Möbius, was found in the old necropolis of Salamis in 1956 (now in NM, Athens) (200). This isolated example is not sufficient to upset Möbius's suggestion that the type of the Mausoleum lions is oriental in origin, although perhaps soon adopted by Ionia.

It derives from the same type which inspired the prowling lions and panthers of seventh-century Greek orientalising painted pottery, a sculptural example of which is to be found in the standing lions of the early Archaic lintel from Prinias in Crete, where strong oriental influence is normally inferred (201). The formal arrangement of the lions of the Prinias lintel in confronting rows gives a good impression of the way in which the lions of the Mausoleum were probably arranged on each side. An interesting later example of the Mausoleum type is the star-spangled lion on the

relief from Commagene (202). A similarly stylised pose is employed also for the sphinxes from the Mausoleum at Belevi (203). One should note also that golden lions alternated with bulls on the fifth level of the pyre of Hephaestion (204).

For the general style of the Mausoleum lions, one may compare the lion at Ecbatana that probably dates from the time of Alexander the Great (205), and the lion that is being hunted on the west long side of the Alexander sarcophagus (206). The head of the latter, in particular, comes very close to those of the Mausoleum lions, and the tail curls in similar fashion between the hindlegs (207).

COLOSSAL STANDING PORTRAITS: MALE FIGURES

Several original fourth-century portrait statues, some of them colossal, can be closely related to the colossal male series from the Mausoleum of which 26 ('Maussollos') and 29 are the best preserved examples (pls 13–16).

One such is the colossal male portrait statue from Kerch, now in the Hermitage, Leningrad (208). Apart from the bare chest, which probably results from close connections with Attic sculpture, the statue in its composition and drapery comes close to 26, and in its pose perhaps even closer to 29, of whose pose it is a mirror reverse (209).

The Kerch statue is likely to be the portrait of one of the fourth-century kings of the Cimmerian Bosporos, either Leukon, who reigned 389/8–349/8 BC, or one of his sons, Pairisades I (349/8–310/9), Spartokos, who ruled jointly with Pairisades until his death in 342 BC, or Apollonios the youngest.

Portraits of these three sons appear on the relief, NM 1471, which illustrates a decree set up in the Piraeus in 347/6 BC, which records the honours decreed to them upon their renewal of the corn agreement between the Cimmerian Bosporos and Athens after the death of their father Leukon (210).

The joint rulers, Spartokos and Pairisades, are shown seated on identical thrones, very much in the manner of the seated statue 33 from the Mausoleum, while the third prince, Apollonios, stands on the right, in a pose identical to that of the Kerch statue, and close to that of 26 as regards build and arrangement of drapery. All three have bare chests in the Greek fashion, but they seem to have had beards and long hair, very much in the manner of 26.

Another very important parallel for 26 is the lower half of a colossal male portrait statue in the Vatican, Belvedere 9 (211). The upper half was worked separately and is lost, but the height of the lower half, 1·50 m, shows that it must have been of the scale of 26 originally. The stance, the drapery and the overfold are almost identical to those of 26. Fuchs, in Helbig[4], suggests a date of *c.* 300 BC for the statue, but there seems no reason why it could not belong to the second half of the fourth century. Fuchs's description of the marble appears to disqualify it from being an actual fragment of the Mausoleum statuary.

Other original portrait statues which come close to 26 in pose and arrangement of drapery, though simplified in detail, are: the portrait, supposedly of a philosopher from the temenos of Neoptolemos, Delphi (212), which, though sometimes dated to the early third century BC, should be considered as belonging to the second half of the fourth century BC, in view of the close links with the Mausoleum (cf. also the female statue found with it, below); the life-size statue in Budapest from an Attic grave monument (213); and the standing male figure from the recently discovered Heroon at Kallithea, near Piraeus, which in its architectural form and decoration appears to have been modelled on the Mausoleum (214).

For a later, heavier, Pergamene version of the type of 26, cf. the colossal statue of a ruler from Pergamon in Istanbul Museum (215).

Apart from the general similarity of types, the statues mentioned so far are closely linked to Mausoleum 26 by two important points of detail:

1. Sandal types. The elaborate and luxurious sandals or shoes worn by 26 ('Maussollos'), and by the fragmentary feet 211 and 213–216, although otherwise very rare in extant Greek sculpture, are found in almost identical fashion on the Delphi philosopher, on the Vatican statue, and apparently also on the statue from the Kallithea Heroon. The only major difference is that, whereas the feet of these statues are bare within the sandal, on the Mausoleum an extra sock is worn inside the leather inner to conceal the toes; but this probably reflects the Carian horror of exposing bare male flesh. On the Vatican statue there is an added cross-bar on the strap-work, just above the toes, but in other respects the sandals are identical to those of 26.

A development of this type of sandal, with more open toecap, is worn by the Copenhagen and Vatican copies of the statue of Demosthenes (216). If this sandal represents the style of the early third century, then the Delphi philosopher and the Vatican statue, whose sandals come much closer to those of the Mausoleum, should certainly be regarded as fourth-century work.

2. Crease-folds or 'Liegefalten'. The crease-folds which enliven the drapery of 26, 27, and 64 from the Mausoleum (but not 29), are found also on the Kerch statue, on the Vatican statue, and on the Delphi philosopher. They appear to be a device which originates, probably in mainland Greek art, around the middle of the fourth century BC, perhaps not appreciably earlier than the time of the Mausoleum sculptures.

Other statues on which they are to be seen, apart from those already mentioned, are: the colossal Apollo in the Agora Museum, supposedly by Euphranor (217); and two statues from Delphi, the female, inv. 1817, and the draped male, inv. 1820, which were found together with the Delphi philosopher in the temenos of Neoptolemos (218).

Crease-folds, as a device for enlivening the texture of drapery, also appear in Attic grave relief sculpture in the second half of the fourth century. Examples include: Athens, NM, Conze no. 145, pl. 44. NM 870: Conze no. 320, pl. 78; Diepolder, pl. 47; Adam, *TGS*, 117–20. Athens, NM, Conze no. 1228, pl. 262; Studniczka, *Art. u. Iph.* (1926), 108, fig. 86. New York, Met. Mus. 65.11.11: B. F. Cook, *AP*, ix. 66, n. 11. New York, Mitchell Coll.: B. F. Cook, *AP*, ix. 65, n. 4, fig. 3. New York, Met. Mus.: Richter, *Catalogue* (1954), no. 94, pls 76–77. BM 1910. 7–12.1: A. H. Smith, *JHS*, 36 (1916), 78, pl. III, 1.

One feature which the portrait statues so far mentioned do *not* have in common with the male portraits from the Mausoleum, is the wearing of a sleeved undergarment beneath the himation, which completely covers the chest. Long undergarments of this kind, which must ultimately reflect Persian taste in dress, seem to have been widely worn by males east of the Aegean in the fourth century BC, and perhaps particularly in Caria. Other examples include: Zeus Labrandeus on the coins of Hecatomnos and Maussollos (219); Zeus Stratios and Idrieus on the relief from Tegea (220); the priest on the south side of a grave monument at Limyra in Lycia (221); the seated prince on the Kazanlak tomb paintings (222); the figure on a grave stele from Smyrna (223); and the Sarapis of Bryaxis (224). Compare also the statuette of Hades on Cos, who could conceivably derive directly from the male portrait statues of the Mausoleum (225), and the representation of Zeus Hypsistos on BM 817 from the area of Cyzicus (226).

The random appearance of the sleeved undergarment

beneath the himation in mainland sculpture of the second half of the fourth century should probably be regarded as oriental influence, brought about by the impact of east Greek sculptures on mainland art, and perhaps also later by the conquests of Alexander and his subsequent aping of oriental fashion. The earliest appearance in Attic sculpture seems to be on the relief to the Mother of the Gods, Piraeus 1165 (227) of *c.* 360–350 BC, where an undergarment is worn by the male suppliant, whose dress is otherwise close to that of the Delphi philosopher. Cf. also the figure on the Kerameikos relief, Svoronos, pl. 122.

Sleeved undergarments are worn also by a number of Attic portrait statues, dating in their original form from the late fourth or early third centuries BC: for example the Arundel 'Homer' (228), which is probably original Greek work; the copy of a portrait statue in Naples, tentatively identified as the orator Hypereides, whose dress is arranged much in the manner of Mausoleum 26 (229); and the statue of Aeschines (230).

An example from Delphi is the draped male statue, inv. 1820 (231), found together with the philosopher and the female in the type of 'Artemisia' in the temenos of Neoptolemos. Pouilloux (232) separates this statue from the philosopher and the female figure, and dates it to the first century BC. But there seems no reason why it too should not be later fourth-century work. In style it does not seem appreciably different from, for example, the female figure on the grave relief from Rhamnous, NM 833, of *c.* 330/320 BC (233).

The long hair worn by 26 ('Maussollos') is another oriental fashion that was popular east of the Aegean in the fourth century BC. Heads with long hair, moustaches, and beards are to be found earlier than the time of the Mausoleum in Lycia.

Nereid Monument (*c.* 400–375 BC): seated male figure on east pedimental relief, BM 924; elders surrendering on small base frieze, BM 879; warrior on corner block of large base frieze, BM 854 (hair protrudes below helmet).

Tomb of Payava, *c.* 370–350 BC (234). Short north side, A. H. Smith, *BM Cat* ii. 950. 6, pl. X; Demargne, *FdX*, v, pl. 45.1. Long west side: Smith, 950.7, pl. XI; *FdX*, v, pls 42–43. Short south side: Smith, 950.8, pl. XII; *FdX*, v, pl. 44.

Grave monument at Limyra. Priest on south side, Borchhardt, *Ist. Mitt.* 19/20 (1969/70), 204–5, pl. 39.2. Old men: op. cit. 189 ff., pls 34.1, 36.1.

Long hair is worn by the sons of Leukon from the Bosporos on NM 1471 of 347/6 BC (235), and by some

colossal heads from the later fourth century, such as the Asclepios of Melos (236), Zeus of Otricoli (237), and the Sarapis (238), whose more luxuriant style is often thought to lie in the sculptural vicinity of Bryaxis. These latter heads have a facial structure similar to that of 'Maussollos', although they lack his individuality of feature.

A head often compared to that of 26 is the one from Nemi in Nottingham (239). It has long hair, moustaches, and beard, and the treatment of forehead, eyebrows, eyes, and lips is much like that of 26, but the bust shape appears to be of Trajanic date at the earliest.

Long hair does appear on Attic grave reliefs, but it is normally reserved for old men. Examples which come fairly close to the head of 26 include: Berlin K 46, Blümel, *Die kl. gr. Sk.* no. 10, fig. 15; BM 1907.10–25.1, Smith, *JHS*, 36 (1916), 78–79, fig. 10; BM 1915.4–16.1, Smith, op. cit. 80, fig. 11; grave stele of Prokleides, NM Athens, Diepolder 54, pl. 46; Stele of Hippon, Copenhagen, Diepolder 48, pl. 45.1; stele of Korallion, Kerameikos, Diepolder 49 ff., pl. 45.2; cf. also the old man on the Ilissos stele type, esp. NM 869, Conze 1055, and NM 871, Conze 1054.

Long hair similar to that of 26 is also to be found on the Triton in Berlin, Blümel, op. cit. no. 103, figs 142–5, which has been associated with Scopas.

For the corpulence which is another feature of 26, compare the Lateran Sophocles type (240), and the Charon grave relief from the Kerameikos (241).

Of the statues and reliefs adduced here as comparative evidence, few can be dated earlier than the time of the Mausoleum (*c.* 368–348 BC), and those few are from Lycia, whose tombs are likely to have provided the spark of inspiration for the general form and decoration of the Mausoleum. The most important parallels in Greek sculpture belong to the second half of the fourth century, and must certainly be considered later than the Mausoleum (this probably includes also the Kerch statue in Leningrad). This may be taken as an accurate reflection both of the originality of conception of the colossal male portraits from the Mausoleum, and of their influence in the development of Greek portrait sculpture.

COLOSSAL STANDING PORTRAITS: FEMALE FIGURES

Mausoleum 27 ('Artemisia') preserves the type, while 30 is the best version of the head (pls 13, 16).

Numerous female figures from the middle and second half of the fourth century BC conform closely to the 'Artemisia' type. Cf. in general Kabus-Jahn, *Studien zu Frauenfiguren*, 23–29. The following may be noted:

From a specifically Carian context: Ada on the Tegea relief, BM 1914.7–14.1, A. H. Smith, *JHS*, 36 (1916), 65 ff.; Female figure on a relief from Halicarnassus in the American Academy at Rome: Bieber, *Anthemon* (1955), 70, pl. 3, 2; Laumonier, *Cultes Indigènes en Carie* (1958), 627, 636, pl. 16, 1–2.

Most of the standing females between the columns of the Mourning Women sarcophagus are related to the type of the 'Artemisia', and two come very close indeed: long north side, first corner figure, and fourth figure from left. Cf. Hamdy Bey-Reinach, op. cit., pl. 8, 1; Mendel, *Catalogue*, i. 70; Picard, *Manuel*, iv. 1 (1954) 70, n.1, 206 ff.

Close parallels among free-standing statuary include:

1. Female statue from temenos of Neoptolemos at Delphi. Inv. 1817; *FdD*, iv, pl. 72; Pouilloux, *FdD*, ii, 'La Région nord du Sanctuaire' (1960), 49, 52–53, 86; Kabus-Jahn 46–48. Found side by side with the philosopher and the draped male statue, mentioned above. The close similarity between these three statues and those of the Mausoleum is intriguing. Comparable features include figure types, arrangement of drapery, wearing of a non-Greek undergarment, sandal types, crease-folds. Possibly the Delphi statues were executed by sculptors who had worked on the Mausoleum.

2. Headless statue, New York, Met. Mus. Richter, *Catalogue* (1954), no. 126, p. 75, pl. 96; Kabus-Jahn 43–46.

3. Several female statues from Cyrene. Rosenbaum, *Catalogue of Cyrenaican Portrait Sculpture* (1960), nos 22, 39, 43, 141–7.

4. Fairly close are statues of Demeter and Kore, also from Cyrene. Rosenbaum, op. cit., nos 45, 148–51. These have been thought to derive from fourth-century originals by Praxiteles (Kabus-Jahn 30).

5. Related to these, but at a greater distance from 'Artemisia', are the female statues from Thasos in Istanbul, inv. nos 2149, 2150, 2151, 2154 (242).

Where precisely the Mausoleum colossal female type stands in this series is hard to say, but it is quite possible that it stands at the head, and that all the statues here are influenced by it. Kabus-Jahn places it in the middle of the series, and sees an Attic origin of the type, deriving from Praxiteles. Her dating of 'Artemisia' to 350/340 BC, however, is perhaps too late, and although the drapery

schema of the type was certainly utilised by the Praxitelean school, the derivation of the original from Praxiteles himself seems little more than an assumption. The problem could be resolved, I suppose, by accepting with Vitruvius that Praxiteles was one of the sculptors engaged on the Mausoleum. In this way both Praxiteles and the Mausoleum could be seen as the source of the type (243).

A possible forerunner for the 'Artemisia' type may exist in the Praying Woman type, preserved in several copies (244). The original of this type, however, which some think may have been the bronze Praying Woman of Euphranor, recorded by Pliny (*NH*, xxxiv. 78), may not have been much earlier than the time of the Mausoleum.

The plain-soled sandals worn by 27 and 28 are unexceptional, but the more elaborate female sandal type, represented by fragments 209 (pl. 31; fig. 30) and 210 from the Mausoleum, finds a parallel in Attic sculpture, in the sandals worn by Damasistrate on her grave stele (245). Cf. also the sandals worn by the female of 'Artemisia' type from Delphi (above).

For the crease-folds on the drapery which the Delphi statue shares with Mausoleum 27, see above p. 69.

There are a number of close fourth-century parallels from Priene for the head type and hairstyle of the colossal female standing statues from the Mausoleum.

BM 1151. From Sanctuary of Athena. Smith, *BM Cat.* ii; Buschor, *MuA* 24; Schede, *Die Ruinen von Priene*[2] (1964), 44, fig. 56. Found in pronaos of temple of Athena Polias. The head type precisely as on the Mausoleum, with a triple row of curls framing the forehead, and the rest of the hair confined in a cap.

BM 1153. *MRG* P.3; Smith, *BM Cat.* ii. A smaller head of the same type as BM 1151, and probably from the same location. Triple row of spiralling curls, and close-fitting cap.

Berlin 1535. Blümel, *Die kl. gr. Sk.* no. 105, figs 140–1. From north-east corner of cella of temple of Demeter. Half life-size with four rows of spiralling locks around forehead, and the rest of the hair wound round by ribbons. Strands of hair emerge at back of head and on neck.

Berlin 1536. Blümel, op. cit. no. 104, figs 138–9. Head of statuette from same location as Berlin 1535. Triple row of spiralling curls, hair confined in cap.

There can be little doubt that these four heads belong to the second half of the fourth century BC, and that they were influenced by the Mausoleum female type. When

Pytheos moved to Priene to work on the temple of Athena Polias, after the completion of the Mausoleum, he must have taken many masons and sculptors with him, who should perhaps be regarded as the authors of these heads.

There is nothing precisely similar in Attic sculpture, but a fragment of a grave relief from Aghia Triada, datable to the later fourth century BC, comes quite close (Conze, no. 861, pl. 164; in NM, Athens). This preserves the life-size portrait head of an old woman, with wrinkled forehead and chin, her hair dressed in a double or triple row of snail-shell curls. The hairstyle of this fragment, if it does not directly reflect that of the Mausoleum females, may have been intended as an indication of mature age on a portrait head, the equivalent of long hair on elderly men (see above).

The reason for the adoption of an archaistic hairstyle for the colossal female portraits of the Mausoleum is not certain, but it may be for the sake of venerability, perhaps through association with extant earlier portraits of famous members of the dynasty.[1] A late Archaic marble statue of Artemisia I, which throughout antiquity stood at Sparta, where it served as a caryatid for the Persian stoa (246), could theoretically have provided the model for the hairstyle of the Mausoleum female statues.

For the cap which encloses the hair (*sakkos*), compare the portraits of Sappho (247), the head of a Nike from the Nike parapet at Athens (248), and, in a fourth-century funerary context, the head of the servant girl on the grave relief, BM 671 (249).

1. Some think the hairstyle to be of Persian origin: so Rodenwaldt, *Griechische Reliefs in Lykien* (1933), 13 n. 6; Riemann, P-W, cols 444, 498; Schlörb, *Timotheos* (1965), 72, n. 216; S. Haynes, *Land of the Chimaera* (1974), 30; but I know of no representations in Persian art of women who wear it.
Perhaps a clue to the significance of the hairstyle lies in the relief sculptures of a mid-fourth-century grave monument at Limyra in Lycia, where a naked youth with hair dressed in snail-shell curls stands between two seated old men with long hair and beards, in a scene which has been explained as the judgement of a soul in the Underworld. Cf. Borchhardt, *Ist. Mitt.* 19/20 (1969/70), 189 ff., pls 34,1; 36,1.
Of considerable interest also is the silver head-vase from Lycia, where the two heads set back to back, one male, one female, have the hair over their foreheads dressed in double rows of snail-shell curls, less formally arranged than those of the Mausoleum. Cf. D. E. Strong, *BMQ* (1964) 95–102; R. D. Barnett, *Mélanges Mansel* (1974) 893–903, pls 319–20; J. Borchhardt, *Ist. Forsch.* 32 (1976) 47, pls 18,3 and 19,3–4.

COLOSSAL SACRIFICIAL GROUP: SEATED FIGURE 33
(pl. 17)

This figure wears the same dress as the colossal standing male statues. Comparable seated figures of fourth or early third century BC date are as follows:

Nereid Monument. Seated hero in east pedimental relief, BM 924 (chest bare); seated commander in Persian headdress on BM 879.

Tomb of Payava. Seated Persian satrap on long west side, BM 950.7, pl. XI; Demargne, *FdX*, v (1974), 78 ff., pls 42.2, 43.1.

Spartokos and Pairisades on the Attic decree relief, NM 1471 of 347/6 BC (see n. 210).

Kazanlak tomb. Seated prince or lord receiving funerary offerings (see n. 44). This ruler wears a short-sleeved undergarment of white material, like that worn by 33.

Sarapis of Bryaxis type (see n. 224), whose pose and arrangement of drapery was probably originally much like that of 33.

Seated statue of Dionysos from monument of Thrasyllos. BM 432; Br. Br. 119; Lawrence, *LGS*, 106–7.

COLOSSAL SACRIFICIAL GROUP: RAM
Frags 360 (pl. 33); 361; head in Bodrum

The scale of the ram from the Mausoleum appears to be unparalleled in extant sculpture. Free-standing rams were probably always rare, although sacrifices involving sheep or rams are fairly frequent in votive relief sculpture.

The fine ram's head in Boston, which is likely to be fourth-century work, probably came from a statue in the round (250), but the reclining bronze ram in Palermo Museum is later work (251).

Pliny, *NH*, xxxiv. 80, records a free-standing bronze group by Naucydes of a man slaying a ram, perhaps to be identified as Phrixos (252).

For examples of rams in relief sculpture of a votive nature, note the following:

Architectural reliefs

Parthenon frieze, north side, slab IV, A. H. Smith, *Sculptures of the Parthenon* (1910), pl. 41; C. M. Robertson, *The Parthenon Frieze* (1975).

Sculptured pier from Artemision at Ephesos, BM 1212. On one side is a ram led to sacrifice by a Victory, on the other a bull. Cf. also the ram's head, BM 1216, probably from another pier.

Votive reliefs

NM 1404, ram with bull, Svoronos, pl. 60; NM 2390, ram with bull, Svoronos, pl. 140; NM 1395, ram with boar, Svoronos, pl. 59; NM 1333, Svoronos, pl. 36; NM 1407, Svoronos, pl. 65; NM 1436, Svoronos, pl. 71; Kerameikos relief, Svoronos, pl. 122; NM 2401, Svoronos, pl. 147; NM 3078, Svoronos, pl. 201.

Acr. Mus. 2496, Walter, *Beschreibung*, no. 231, has a threefold sacrifice, with a ram or sheep in the company of a bull and boar, such as is likely to have been represented on the Mausoleum. The relative scales of the animals on this relief are instructive, the boar being about half the height of the ram. For other rams on reliefs in the Acropolis Museum, cf. Walter, *Beschreibung*, nos 101, 193, 228, 229, 313A.

Decree reliefs

IG, ii.² 28, Svoronos, pl. 208, Tod, *GHI* ii, no. 114, 387 BC. Two rams facing (not bulls as stated by Tod). NM 2806, Svoronos, pl. 222, ram and bull facing. NM 2781, Svoronos, pl. 228.

Although these examples are mostly too small for any direct comparison with the Mausoleum ram, it is clear from the rams on the Parthenon frieze and on some of the better votive reliefs that the impressionistic carving of the fleece had long been conventional.

COLOSSAL SACRIFICIAL GROUP: BULL

Frags 362–364 (pl. 34)

Two marble statues of bulls from Attic funerary monuments of fourth-century date are extant (253): Dipylon bull from Kerameikos (Richter, *Animals,* fig. 103; Picard, *Manuel*, iv. 2 (1963), 1421–2, figs. 542–3); Copenhagen no. 238, Billedtavler, pl. XVII. Both animals are carved in an active pose, with head lowered. Cf. also the bull on the fourth-century Attic relief in Rome, Museo Barracco, 136, for this (254).

To judge from the fragment of neck and leg, 364, the Mausoleum bull or bulls walked more peaceably in procession, as would be fitting in a votive context. Closer comparisons are probably offered, therefore, by the following reliefs on which bulls or heifers are led to sacrifice:

Parthenon frieze, south and north sides; frieze of the Nike Temple Parapet (Carpenter, *The Sculptures of the Nike Temple Parapet* (1929), *passim*).

Votive reliefs

Apart from those already mentioned, on which a bull appears with a ram (NM 1404, NM 2390, NM 2806, Acr. Mus. 2496), note: NM 1429, Svoronos, pl. 37; NM decree relief, Svoronos, pl. 215; Acr. Mus., Walter, *Beschreibung*, no. 295; and the reliefs to Heracles, Agora S. 1249, *Hesperia*, 17 (1948), 137, pl. 34; Eretria 631 (unpublished); Venice, Museo Archeologico 118, Frickenhaus, op. cit. 122, no. 4, Linfert, *AA* 1966, 496, fig. 1.

Two bulls are offered in sacrifice on the Nereid Monument, BM 904–905, a bull is sacrificed by a priest on the tomb monument at Limyra in Lycia (255), and there is a bull at one end of the animal frieze on the Heroon from Kallithea in Piraeus Museum.

Bulls alternated with lions on the fifth level of the pyre of Hephaestion, which in its pyramidal form was probably inspired by the Mausoleum (256).

COLOSSAL SACRIFICIAL GROUP: BOAR

Frags 365, 368 (pl. 34)

The relative scales of the boar, sheep and bull offered in sacrifice on Acr. Mus. 2496 (Walter, *Beschreibung*, no. 231), favour the inclusion of Mausoleum 365 in a colossal sacrificial group.

For other examples of boars or pigs offered in sacrifice on Attic votive reliefs, cf.: NM 1395, Svoronos, pl. 59; NM 1330, Svoronos, pl. 35; NM 1402, Svoronos, pl. 35; NM 1334, Svoronos, pl. 38; NM 2398, Svoronos, pl. 146; NM 1016, Svoronos, pl. 183; NM 953, Svoronos, pl. 185; Acr. Mus., Walter, *Beschreibung*, nos 102, 315 A, B.

COLOSSAL HUNTING GROUP: MOUNTED PERSIAN RIDER

34, 35–41. 232–234. Cf. 317 (pls 18–19)

The pose of the prancing horse and rider, 34, is one that is common in Greek sculpture of the late fifth and fourth centuries BC, both on the mainland and in east Greece. Examples from the mainland include the type of the

Dexileos stele (394/3 BC), and the horsemen of the Oxford relief of *c.* 320 BC (257), which belongs to the same frieze from the Acropolis as Walter, *Beschreibung*, nos 409–409C.

For parallels from hunting contexts, where the rider wears Persian dress, note:

1. Satrap sarcophagus (*c.* 430–420 BC). Long east side. Two horsemen who attack leopard. Hamdy Bey-Reinach, pls XX, XXII, 1.

2. Grave stele from Çavuşköy, Istanbul Museum 1502 (*c.* 420–400 BC). Hasluck, *JHS*, 26 (1906), 26–27, pl. VI; Borchhardt, *Ist. Mitt.* 18 (1968), 206–8, pl. 53, 1.

3. Lycian sarcophagus (*c.* 375–350 BC). Long east side. Two horsemen in Persian dress amongst five who hunt boar. Hamdy Bey-Reinach, pl. XVI.

4. Mourning Women sarcophagus (*c.* 350–340 BC), base frieze. One horseman on long south side, attacking boar; two on long north side. Hamdy Bey-Reinach, pl. X.

5. Alexander sarcophagus (*c.* 325–300 BC). Long west side. Horseman attacking lion. His horse has a fringed saddle cloth like that of Mausoleum 34. Hamdy Bey-Reinach, pls XXVII, 1; XXXI, 1; XXXIV; Schefold, *Der Alexandersarkophag*, figs 32, 33, 40.

Cf. also similarly mounted Persian horsemen from battle groups on this sarcophagus: north short side, Hamdy Bey-Reinach, pls XXVI, 1; XXIX; XXXVII, 2; Schefold, op. cit. pls 16, 18, 28, 29, 30. South gable: central mounted horseman, Hamdy Bey-Reinach, pls XXVI, 2; XXXVI. This horse also has a fringed saddle cloth. Schefold, op cit., figs 2, 3, 4, 5.

For reliefs from Attica with horsemen, not in Persian dress, hunting animals, cf. NM 2965 with a boar hunt, and NM 2966 with a lion hunt (Svoronos, pl. 194). Both belong to the second half of the fourth century.

No original statues in the round like Mausoleum 34 are extant. The nearest is the mounted Amazon from the west pediment of the temple of Asclepius at Epidaurus (258). Statues of this kind in marble must have been rare in the fourth century, and were probably nonexistent outside an architectural context. Bronze was the normal medium for horsemen from free-standing groups, such as, for example, the lion-hunt group of Crateros at Delphi by Leochares and Lysippus (259), or the Squadron of Alexander by Lysippus, which consisted of twenty-five statues of Alexander's cavalry hetairoi who fell at the Granicus in 334 BC (260).

COLOSSAL HUNTING GROUPS: LEOPARDS AND BOARS

Frags 371–374 (pl. 35); and frags 366–367, 369–370, 385 (pls 34–35)

Numerous examples of hunting scenes, involving the pursuit of leopards and boars, are to be found in the Greek or Greek-influenced relief sculptures produced for non-Greek patrons east of the Aegean in the fifth and fourth centuries BC.

Leopards and boars are hunted together on the upper frieze of the north wall of the Heroon at Gjölbaschi-Trysa (261) and also on the base frieze of the sarcophagus of the Mourning Women (262).

Leopards are hunted separately on the following:

1. Satrap sarcophagus (*c.* 430–420 BC): Borchhardt, *Ist. Mitt.* 18 (1968), pl. 54, 1.

2. Relief from Seleucia on Kalykadnos (*c.* 400 BC): Borchhardt, op. cit. 163–5, pl. 54, 2.

3. Sarcophagus of Merehi (*c.* 370–350 BC): Demargne, *FdX*, v (1974), 95, pls 50, 1; 51, 1. BM 951.

4. Bellerophon grave of Tlos (*c.* 350–325 BC): Fellows, *Discoveries in Lycia* (1841), pl. between pp. 136 and 137.

5. Centaur sarcophagus in Limyra (*c.* 350–320 BC): Borchhardt, op. cit., pl. 55, 2.

6. Alexander sarcophagus (*c.* 325–300 BC): Schefold, *Der Alexandersarkophag* (1968), figs 2, 3, 6, 10, 14; von Graeve, *Der Alexandersarkophag und seine Werkstatt* (1970), pls 42–45.

Boars are hunted separately on the following:

1. Grave stele from Çavuşköy, Istanbul Museum, no. 1502 (*c.* 420–400 BC): Hasluck, *JHS*, 26 (1906), 26–27, pl. VI; Borchhardt, op. cit. 206–8, pl. 53, 1; *Museum Guide* (1968), 46, pl. IVA. There is a deer in the background.

2. Nereid Monument (*c.* 400–375 BC): Frieze 3, BM 887.

3. Lycian sarcophagus (*c.* 375–350 BC): Long side A. Mendel, *Catalogue*, i, no. 63, p. 161. Hamdy Bey-Reinach, pl. XVI.

4. Tomb of Payava (*c.* 370–350 BC): BM 950, 2; Demargne, *FdX*, v (1974), pl. 34.

5. Sarcophagus of Dancing Women (*c.* 350–325 BC): Demargne, *FdX*, v (1974), 100–1, pls XXXIII; 56.

Compare also the boar hunted on the fourth-century Attic relief, NM 2965 (Svoronos, pl. 194).

In Attica in the fourth century free-standing marble leopards were used on occasion as tomb monuments. Two fine female leopards, found in the Kerameikos and now in Munich, served this purpose (263). If they belonged to the same grave monument as the stele of Mnesarete with which they were found, then they should be dated to *c.* 375 BC, that is to say, slightly earlier than the Mausoleum leopards, to which they are closely similar. There are also recumbent leopards in Athens and Piraeus, and a springing leopard in Basel, which probably belonged to funerary monuments (264).

A free-standing marble boar formed part of the sculptures of the east pediment of Scopas' temple of Athena Alea at Tegea, where the subject was the Calydonian boar hunt, but all that remains is a fragment of the head (265). This head, which is probably slightly later than the Mausoleum, belonging to the decade 350–340 BC (266), exhibits a pictorial treatment that differs from that of the Mausoleum boars' heads. On the Tegea head the bristles are minutely carved. On the Mausoleum heads, the surface is left smooth and rounded, and any detail of hair must have been rendered in paint.

For an example of an earlier free-standing boar, presumably from a hunting group, there is the fine bronze animal in Istanbul Museum.

SCALE II: HEROIC STANDING FIGURES

The male standing figures in Greek or Carian dress of this scale (pl. 19) find their closest typological parallels in the draped statues of the Daochos group at Delphi, datable to 338–334 BC (267), and in other statues of Thessalian rulers.

From the Daochos group: Aknonios: Adam, *TGS*, 97 ff., pls 44–45; Dohrn, *AP*, viii (1968), figs 6–7, pls 26–28. Sisyphos I: Adam, *TGS*, pls 47–49; Dohrn, op. cit., pls 30–32; this statue is especially close in its arrangement of drapery to Mausoleum 42 and 68. Daochos I: Adam, *TGS*, pl. 46c; Dohrn, op. cit., figs 8–9, pl. 29. Daochos II was also probably draped, but only the feet remain: Dohrn, op. cit., figs 10–11.

Cf. the statue of a ruler in Chalcis Museum: Dohrn, op. cit. 46, pls 36–37; and a similar figure on the mid-fourth-century stele of a Thessalian warrior from Kalojeri near Trikkala: Biesantz, *Die thessalischen Grabreliefs*, K 33, pls 14–15; Dohrn, op. cit. 47–48. fig. 32.

These statues, like those of the Mausoleum, scale II, wear knee-length tunics, with or without a cloak or himation over them (the tunic of Daochos I is completely obscured by the heavy cloak which is drawn closely round it). The lower legs are bare, but sandals are worn on the feet with leather socks within them.

The sandals are of a meshwork variety which seems to have been worn by some of the statues of scale II on the Mausoleum, to judge from 169 (pl. 30) and 217 (pl. 32; fig. 35), and which predominates amongst the life-size scale of figure: 165, 218–224, 229 (pls 30, 32; figs 36–9); cf. the somewhat broader mesh of 212 (scale I) (pl. 31) and 225. This is a type of sandal that seems often to have been worn by ephebes and by men of military age and dress (268).

In stance, the Mausoleum statues of this series were probably much like those of the Daochos group, with one leg taking more of the weight, the other set back to balance the figure.

The more extreme cross-legged pose of Mausoleum 42 (pl. 19) finds parallels in Attic grave and votive relief sculpture, mostly of a date in the second half of the fourth century BC. In grave reliefs note: NM 869 (Ilissos stele), Conze, no. 1055, pl. 211; Diepolder 51, pl. 48. NM 871 (similar type), Conze, no. 1054, pl. 210; cf. also Conze, no. 1033, pl. 205. NM 833, Conze no. 1084; Diepolder, pl. 54; Lippold 271, pl. 87.4. NM 834, Conze no. 1023, pl. 201; Diepolder 53; Karouzou, *Cat.* (1968), 117–18. NM 2574, Diepolder, pl. 53; Fuchs, *Die Skulptur*, fig. 581.

One of the standing females on the Mourning Women sarcophagus has her free leg crossed over her supporting leg (269), and so too do several male and female figures on Attic votive reliefs, for example, NM 1345, Svoronos, pl. 35; NM 1334, Svoronos, pl. 38; NM 1383, Svoronos, pl. 38; NM 1361, Svoronos, pl. 50; NM 1397, Svoronos pl. 58; NM 2010, Svoronos, pl. 100; NM 1478, Svoronos, pl. 109; NM 2416, Svoronos, pl. 150; NM 2508, Svoronos, pl. 154; NM 2522, Svoronos, pl. 155; NM 2484, Svoronos, pl. 157; NM 2557, Svoronos, pl. 171; NM 2926, Svoronos, pl. 186.

A cross-legged stance is also employed for the Pothos type (270), for the Artemis on the Sorrento base, thought to reflect an original by Timotheos (271), and for the later classicising Boy from Tralles (272).

Links between the statuary of the Mausoleum and the Daochos group extend beyond figure types into details of carving and technique.

The hinted projection of the male genitalia through the garments of Mausoleum 43 and 85A (pls 19, 27), is found also on Sisyphos I (273).

The highly polished bare limbs of Mausoleum 42 (pl. 19) and 174 are found also on the statues of Daochos I, Sisyphos I, and Aknonios, where there is a contrast with the rougher finish of the drapery (274).

The statues of the Daochos group are pieced in the same manner as those of the Mausoleum. There is cross-pinning of the inset head of Sisyphos I, as on Mausoleum 26; and the right arm of Daochos I was fitted by a cross-pinned rectangular dowel, as on Mausoleum 70.

The smooth border which is left round the feet of statues on bases on some of the Mausoleum fragments, 216, 218, 219 (pl. 32; figs 34, 36, 37), is found also on the base of Aknonios (275).

It is clear that the statues of the Daochos group, datable to 338–334 BC, have much in common, both in design and execution, with the earlier statuary of the Mausoleum. If, as seems probable, the Daochos group was the product of Argive–Sicyonian sculptors (276), this would strongly suggest that sculptors from Peloponnesian workshops were engaged earlier in the carving of the sculptures of the Mausoleum.

Head, 45 (pl. 20)

Parallels for this portrait are to be found amongst bearded male heads on Attic grave reliefs. Cf. for example, Berlin, K.46: Blümel, *Die Kl. gr. Sk.* no. 10, fig. 15; and the bearded male who shakes hands with Damasistrate on NM 743: Conze, no. 410, pl. 97; Diepolder 49; F. Johannsen 46 ff., fig. 24.

But closest of all to it, as regards structure of face and treatment of eyes, nose, lips, and hair, is the colossal head of Zeus from Mylasa in Caria, now in Boston (277). In view of the close correspondence between these two heads, particularly evident in the profiles, it seems certain that the Boston Zeus is from the same Mausoleum workshop which produced 45, and may well be from the hand of the same sculptor.

Head of Apollo, 48 (pl. 22)

Of the fourth-century representations of Apollo preserved in copies, that which has generally been compared with the Mausoleum head is the Apollo from Anzio type (278). While there are certainly affinities between the two as regards facial structure and, particularly, hairstyle, there are differences of pose. The Apollo of Anzio stands tranquilly, and his head is lowered, whereas the head of the Mausoleum Apollo is turned alertly to one side and raised slightly. Much closer to the poise of the Mausoleum head is that of the Apollo Belvedere, whose hairstyle is also similar (279). This might suggest that the Mausoleum Apollo was of the same energetic bow-shooting type as the Belvedere.[1] But for an equally lively Apollo of Citharoedos type, there is the statue which has been thought to reproduce the Palatine Apollo of Scopas, and which Gardner has compared with the Mausoleum head (280).

Another head which comes close to the Mausoleum Apollo in its poise, treatment of face and hair is that of the so-called Pothos type, which has been associated with both Scopas and Praxiteles (281).

Persian figures (pls 19, 26, 27, 28, 30)

Free-standing statues of Persians were probably never very common in Greek art of the Classical period, although one has references in literature to the portraits of Persian military leaders, wearing barbarian dress, who supported the roof of the Persian stoa in Sparta (282). Representations of Persians in relief sculpture become common in Attica from the time of the Athena Nike frieze onwards, that is from the 420s BC. A good example of a standing figure in Persian-type dress of the fourth century BC from the workshop of Praxiteles, is the Scythian slave on one of the slabs of the Mantineia base (283). Figures in Persian dress turn up regularly on the series of sarcophagi from Sidon, ranging from the Satrap sarcophagus (*c.* 430–420 BC) to the Alexander sarcophagus (*c.* 325–300 BC).

There is a life-size statue of a standing Persian in a mourning pose from the Mausoleum at Belevi, probably of Hellenistic date (284).

Female figures of scale II

So far as one can tell from the small fragments which remain, these were of the same general type as the females of scale I, for the parallels with which, see above (p. 71).

1. The Apollo by Pausanias which formed part of the Monument of the Arcadians at Delphi (369–362 BC) seems also to have been an energetically striding figure. Cf. Arnold, *Polykletnachfolge*, 192.

SCALE III: LIFE-SIZE BATTLE GROUP

The closest parallels to the fragments of this group, and particularly to the heads 46 and 49, are to be found on the various friezes of the Alexander sarcophagus. For the head of Greek type, 46 (pl. 21), compare Schefold, op. cit., figs. 19, 21–22, 35, 60. For the Persian head, 49 (pl. 23), compare op. cit., figs. 25–26, 33, 35–36, 46.

Comparable to the type of the Greek head, 46, are also two heads in the round from Rhodes, one in New York (285), the other in Copenhagen (286). On the basis of the similarity between these heads and some from the Alexander sarcophagus, Frel has recently argued for Rhodian authorship for the Alexander sarcophagus. It would seem, however, that both the Rhodian heads and those of the Alexander sarcophagus lie strongly under the influence of the life-size statuary of the Mausoleum, which could as easily imply a mainland Greek origin for the type.

Battle groups between Greeks and Persians occur also on earlier sarcophagi, such as that of the Mourning Women (287).

For the striding poses adopted by many of the figures from the Mausoleum group, one should compare, apart from the above-mentioned sarcophagi, the grave stele of Aristonautes (288), and the grave relief in Bucharest (289).

The sandals of close meshwork worn by many of the statues of this group find parallels in those worn by the draped statues of the Daochos group at Delphi (290).

GENERAL ASSESSMENT

The origins of much of the sculptural decoration of the Mausoleum lie east of the Aegean in the funerary art of Ionia and western Asia Minor. From this art derive the types of the chariot horses and standing lions; the hunting and sacrificial groups; the presence of many figures in Persian dress, some of whom fight with Greeks; and the hairstyles and dress-styles of many of the portrait statues.

An important source of influence is Lycia. The Heroon at Gjölbaschi-Trysa, the Nereid Monument at Xanthos, the tomb of Payava, and other lesser funerary monuments already display themes and sculptural details which are found subsequently on the Mausoleum.

Another source of influence is the series of sarcophagi carved by Greek sculptors for non-Greek patrons in the late fifth and fourth centuries BC, of which the most outstanding examples are those from Sidon. Some of these sarcophagi, which are certainly earlier than the Mausoleum, such as the Satrap and Lycian sarcophagi, include themes that anticipate the sculptural decoration of the Mausoleum. Others which are roughly contemporary with the Mausoleum, such as the Mourning Women sarcophagus, or definitely later, such as the Alexander sarcophagus, are likely themselves to have been directly influenced by the sculptures of the Mausoleum. This applies particularly to the Alexander sarcophagus, whose elaborate relief sculptures show many points of contact with the Mausoleum sculptures.

The sculptures of the Mausoleum, therefore, appear to belong very much to the same tradition as those of the Sidon sarcophagi, although they are worked on a much grander scale. The choice of subject-matter and the themes of the sculptures must reflect the essentially non-Greek taste and traditions of the patron (in the case of the Mausoleum, Maussollos and Artemisia), but the design of the sculptures and their execution is Greek work of the highest order. The Greek designer, however, must have been one who had intimate knowledge of Asiatic art and taste, which in effect is likely to mean an Ionian Greek. For the choice of theme on the Mausoleum, one need probably look no further than the Ionian architect of the building, Pytheos, perhaps in conjunction with his colleague, Satyrus (291).

One feature of the sculptural decoration which seems to set the Mausoleum apart from other Asiatic funerary monuments is the series of portrait statues, some of them undoubtedly dynastic, the effect of which was to transform a funerary monument into a 'Syngenikon', or a monument for the glorification of a ruling family in the presence of its ancestors. Although some details of hairstyles and dress are understandably Asiatic (or probably more accurately Carian), the general concept seems a Greek one, and the degree of realism in the portraiture must certainly be so. Whether the influence is from mainland Greece or from east Greece is hard to say, so poor is our knowledge of the development of portraiture in the first half of the fourth century BC (292), but east Greece is perhaps the more likely. There appears to have been a flourishing school of Ionian portraiture in the fourth century, much of it in the service of non-Greek patrons. The Hecatomnid dynasty in particular seems to have had a predilection for

portraits of its members, some of which may antedate the Mausoleum.[1]

It may be that the demands of non-Greek patrons such as the Hecatomnids for portraits stimulated Greek sculptors towards a greater realism in portrayal (such as there is evidence for in Mausoleum 26) than they would ever have achieved (or possibly ever did achieve) within the confines of mainland Greece. However this may be, there can be no doubt that the portrait statues were the most original feature of the Mausoleum, and it was they and the character of a 'Syngenikon' which they gave to the building which had the strongest influence on Greek sculpture in the second half of the fourth century BC.

The types of both the male and female figures of the colossal series were widely adopted throughout the Greek world for portrait statuary, while some of the male statues of scale II seem to have served as prototypes for portraits of minor dynasts set up at Delphi and in Thessaly.

The various kinds of family monuments or groups of family portraits which proliferate in the second half of the fourth century BC, are likely to draw their inspiration directly from the example of the Mausoleum. This is certainly the case with regard to the family shrine complete with portrait statues recently found at Kallithea, near Piraeus, whose entire form is broadly modelled on its more famous counterpart in Halicarnassus. And it is likely to apply also to family groups such as the Daochos group at Delphi and the family portraits of Philip of Macedon by Leochares in the Philippeion at Olympia, since both the sculptors of the Daochos group and Leochares were probably directly involved in the carving of the Mausoleum sculptures. One might compare also the family group of five from the Athenian acropolis whose bases survive, signed by Sthennis and Leochares (293). And the tomb monument of Theodektes himself, Maussollos' poet, which was built beside the road from Athens to Eleusis, presumably c. 334 BC, appears to have been a kind of poetical

'Syngenikon', with a portrait of Theodektes standing amid earlier famous poets, including Homer (293a).

If many of the themes and types of the Mausoleum sculptures are of east Greek or Asiatic origin, the carving of the statues seems to have been entirely in the hands of Greek sculptors. Some of these no doubt were Ionian Greeks, or even Greek-trained Carians or Lycians (cf. head 45), but very many must have come from mainland Greece.

There are numerous points of contact with Attic sculptures, not only with the relief sculptures which survive in such large numbers, but also with the few statues in the round which are extant, such as the Asclepios from Eleusis and the Apollo from the Agora.

Links are perhaps even closer with extant marble sculptures from Delphi, notably the statues of the Daochos group, and the portraits from the temenos of Neoptolemos. Similarities extend here from figure types and sandal types to details of carving, such as crease-folds, and technique. The principles of composition and methods of construction of fourth-century sculptural groups at Delphi, including the Daochos group, and, earlier, the Arcadian and Argive monuments, according to which statues were set in lateral lines on dark limestone bases, also correspond closely to those used for the sculptural groups on the lower part of the Mausoleum.

If, as is likely, much of the official sculpture at Delphi in the fourth century BC was in the hands of Peloponnesian-trained sculptors, then it would seem extremely likely that Peloponnesian sculptors were engaged also on the Mausoleum. Another link between the Mausoleum and Delphi in the mid-fourth century may be Satyros, if the sculptor of that name who made the statues of Ada and Idrieus at Delphi is the same as the Satyrus named as joint author of a book about the Mausoleum by Vitruvius.

The picture which emerges from this survey, of a building belonging in the main to Ionic–Asiatic funerary traditions, whose sculptures were carved by a mixture of mainland Greek sculptors, is one which broadly agrees with the ancient literary evidence concerning the architects and sculptors of the Mausoleum.

1. Bases for statues of Hecatomnos and Maussollos set up by the Caunians have been found near Caunus, dating perhaps from earlier than 357 BC (Bean, *JHS*, 73 (1953), 20; *SEG*, xii. 470–1); a bronze statue of Maussollos and a stone one of Artemisia were set up at Erythrae in 357–355 BC (Tod, *GHI*, no. 155); a statue base in Istanbul inscribed ΑΒΑ ΥΣΣΑΛΔΩΜΟΥ may possibly have been for a portrait of a sister of Hecatomnos (Robert, *Le Sanctuaire de Sinuri* (1945), 100, pl. VII); and statues of Ada and Idrieus made by Satyros were set up by the Milesians at Delphi perhaps c. 346–344 BC (Tod, *GHI*, no. 161). Cf. also the heads of satraps and dynasts of Asia Minor on coins from the late fifth century onwards (Kraay, *Greek Coins* (1966), nos 621–3, pl. 184; Demargne, *FdX*, v (1974), 83 n. 63).

The Sculptors of the Mausoleum

Names of seven architects and sculptors are associated by ancient sources with the construction and decoration of the Mausoleum.

According to Vitruvius, vii *Praef.* 12–13, Pytheos and Satyrus wrote a book about the Mausoleum. He does not actually state that they were architects, but he implies that they were responsible for the over-all form of the building.[1]

Pytheos is confirmed as architect by the second-century BC Alexandrian papyrus (294).

No architect is named by Pliny, *NH*, xxxvi. 30–31 (for text see above, p. 54), but the *quintus artifex* who, according to him, made the chariot group, and whose name in the manuscript appears as Pyt(h)is, is almost certainly to be equated with Pytheos. There is no reference at all in Pliny to Satyrus.

According to the slightly divergent traditions in Pliny and Vitruvius, the sculptural decoration was divided between four famous Greek sculptors, each of whom was responsible for one side of the building, so that an element of competitiveness entered into the work.

The names of the sculptors and the sides they carved are given by Pliny as: Scopas, east side; Bryaxis, north side; Timotheos, south side; Leochares, west side.

Vitruvius also names Leochares, Bryaxis and Scopas as sculptors (in that order), but the fourth sculptor is given as Praxiteles, Timotheos appearing only in a parenthetical remark as a possible additional sculptor (*nonnulli etiam putant Timotheum*). Although he states that individual sculptors took one side each, he does not attribute sculptors to sides.

Most commentators have accepted the truth of these ancient statements and have assumed that the sculptural decoration of the Mausoleum was in the hands of the four sculptors named by Pliny, and that each carved the side allotted to him. The name of Timotheos as fourth sculptor has generally been preferred to that of Praxiteles, who appears only in the version of Vitruvius.

Attempts made to apportion extant sculptures, particularly slabs of the Amazon frieze, but also sculptures in the round, to one or other of these four sculptors, have not been particularly convincing. There has been over-reliance on theoretical notions of style, a tendency to disregard even such archaeological evidence as does exist, and a reluctance to admit the possibility that much of the extant sculpture came not from the hands of one of the master sculptors, but from sculptural assistants, to whom the work was delegated. Yet, if Pliny's division of the sculptors is correct, only an explanation such as this can account for the fact that heads as obviously different as 45, 48 (pls 20, 22), and those of statues 26 and 27 (pls 13–15), which from their finding-places

1. The text of Vitruvius reads as follows (ed. Krohn, 1912): 'de Mausoleo Satyrus et Pytheos (*sc.* volumen ediderunt). quibus vero felicitas maximum summumque contulit munus; quorum enim artes aevo perpetuo nobilissimas laudes et sempiterno florentes habere iudicantur, et cogitatis egregias operas praestiterunt. namque singulis frontibus singuli artifices sumpserunt certatim partes ad ornandum et probandum Leochares, Bryaxis, Scopas, Praxiteles, nonnulli etiam putant Timotheum, quorum artis eminens excellentia coegit ad septem spectaculorum eius operis pervenire famam.'

must have belonged to the same side of the building, could have been produced by the workshop of a single master sculptor, in this case Bryaxis (295).

More recently doubt has been cast on the validity of the accounts in Vitruvius and Pliny. It has been suggested, from similarities in phraseology and a certain naivety of approach, that both accounts derive from the local guides at Halicarnassus, Vitruvius' directly, Pliny's via Mucianus, and that the story, as we have it, of the work of four famous sculptors on the Mausoleum is a romanticisation, if not a complete fabrication (296). Renewed attention has been paid to the possibility that there may have been a single over-all supervisor of the sculptural decoration of the Mausoleum in Satyrus, who is named by Vitruvius as co-author of the book about the Mausoleum. If the Satyrus mentioned by Vitruvius is the same man as the Satyros, son of Isotimos, of Paros, whose signature is preserved on a statue base at Delphi which once supported statues of Ada and Idrieus (351–344 BC), successors to Maussollos and Artemisia, then clearly this man, who was apparently Carian court sculptor immediately after the death of Artemisia, would be an ideal candidate for general designer and supervisor of the sculptural decoration of the Mausoleum. The link is conjectural, but is tempting, and Satyrus has recently received much of the credit for the sculptural decoration of the building (297).

In the light of the new evidence put forward in earlier chapters for the free-standing sculptures of the Mausoleum, and the conclusions drawn from it concerning the form of the building, it is worth taking a fresh look at the question of the sculptors of the Mausoleum, considering in particular the following points:

1. Were the four sculptors named by Pliny, Scopas, Bryaxis, Timotheos, Leochares (with the possible addition of Praxiteles) involved in the sculptural decoration of the Mausoleum?

2. If so, was each responsible for a single side? How otherwise might the work have been divided up?

3. What part, if any, is Satyrus likely to have played in the sculptural decoration of the building?

For the participation of Scopas at least on the sculptures of the Mausoleum, there is strong circumstantial evidence from the fourth century BC in the relief found at Tegea dedicated to Zeus Stratios, Ada and Idrieus, which must be dated between 351 and 344 BC (298). Although the contents of the decree or dedication which the relief headed are lost, the relief itself provides tangible evidence of a connection between Halicarnassus and Tegea, two places at which according to literary sources Scopas received important sculptural and architectural commissions, namely the Mausoleum, and the temple of Athena Alea at Tegea. The most reasonable explanation for the presence of the relief in Tegea is to suppose that it was set up either by Scopas himself or, perhaps more likely, by a Carian mason, recruited into his workshop at Halicarnassus, and later brought with him to the Peloponnese to assist in the construction and decoration of the temple of Athena at Tegea.[1]

It does not positively prove Scopas' presence at Halicarnassus, for the possibility must remain that a Carian came of his own accord to Tegea, but when taken with the literary evidence of Vitruvius and Pliny it comes very close to doing so.

There is further literary evidence for Scopas having worked in the vicinity of Halicarnassus at some time. Pausanias, viii. 45. 5, tells us that Scopas made statues in Ionia and Caria, while Pliny, *NH*, xxxvi. 22, records marble statues of Dionysus and Athena by him at Cnidus. According to Strabo xiv. 640, statues of Leto and Ortygia at Ephesus were by Scopas, while his large-scale marble group of Poseidon, Achilles, Thetis, and sea thiasos, removed to Rome by Domitius Ahenobarbus (Pliny, *NH*, xxxvi. 26), probably originally stood in Bithynia.

Similar references are preserved for the other Mausoleum sculptors mentioned by Vitruvius and Pliny, suggesting that they too worked in Caria at some time in their careers.

Bryaxis, whose name suggests he may have been of Carian origin, made statues of Zeus and Apollo accompanied by Lions at Patara in Lycia (299); a marble Dionysus at Cnidus (300); and five colossal statues of deities in Rhodes (301).

An Ares which stood in Halicarnassus itself was, according to Vitruvius, ii. 8. 11, from the hand of either Leochares or Timotheos; although, since the statue evidently was not signed, there must be a suspicion that these names were chosen because they were two of the sculptors associated with the Mausoleum nearby. It may be felt disquieting, perhaps, that Vitruvius or his authority could not distinguish between the work of Leochares and Timotheos. Leochares has been associated by Ashmole (302) and others with the

1. The date of this temple should probably be placed later than the Mausoleum, in the 340s, rather than before it. So Picard, *Manuel*, iv. 1 (1954), 150 ff.; A. W. Lawrence, *Greek Architecture*[3] (1974), 191. Brown, *Anticlassicism* (1973), 29–31, still prefers the earlier dating.

Demeter from Cnidus, although there is no literary reference to support it.

Praxiteles made statues of Aphrodite for Cnidus and Cos (303), and apparently also another for Alexandreia in Caria (304).

The sculptures in the round from the Mausoleum and the style and technique which they show tend to confirm that a multiplicity of workshops from mainland Greece was involved in the carving. The presence of several workshops, working simultaneously, is required in the first place by the enormous amount of sculpting that had to be done in a limited time.

It has been suggested above that more than three hundred statues in the round stood on the Mausoleum, of which most were larger than life-size. If, as seems likely, it normally took about a year for one skilled mason to carve a life-size statue from start to finish (305), then the number of years it would have taken one man to carve the Mausoleum sculptures in the round may be roughly calculated as follows, bearing in mind that the surface area of a statue larger than life-size increases by geometric progression.[1]

Group	No. of statues	Scale	No. of years carving
Chariot	6	twice life-size	48
Lions	56	life-size	56
Portraits I	36	$1\frac{2}{3}$ × life-size	144
Hunting/Sacrificial groups	56	$1\frac{2}{3}$ × life-size	224
Portraits II	72	$1\frac{1}{3}$ × life-size	144
Groups III	88?	life-size	88
		Total	704

If it would have taken one man about seven hundred years to do the work, then clearly it would have taken seventy men ten years, thirty-five men twenty years, and so on. We do not know for sure how long it took to build the Mausoleum, but the maximum time available is likely to have been twenty years, or perhaps slightly less than this: say seventeen or eighteen years, between 367 and 350 BC.[2]

Taking eighteen years as the time-scale for the building of the Mausoleum, the number of skilled craftsmen who would have been required to carve all the sculptures in the round, working continuously, is forty. Now although we do not know the average size of a fourth-century master sculptor's workshop, it is unlikely to have been very large: perhaps six or seven skilled sculptors, who could be increased in number by recruitment when the commission required it. Even if one supposes that a workshop may have had as many as twelve or fifteen skilled sculptors (by which time, with all the necessary additional semiskilled and manual labour, it would be approaching the size of a small factory), it is clear that at least four such workshops would have been required to produce the sculptural decoration of the Mausoleum in the available time. Our assessment has only been for the sculptures in the round. There were in addition several hundred feet of relief sculptures, and countless architectural blocks and mouldings, which had to be produced simultaneously.

It looks therefore as if the traditions recounted by Vitruvius and Pliny, according to which the sculptural decoration of the Mausoleum was divided between four famous Greek sculptors, rest on a foundation of truth. The individual sculptors concerned, however, may not have been chosen so much for their artistic excellence, as for the amount of skilled labour which they would have brought with them. Possibly the only way to ensure an adequate supply of highly skilled craftsmen over a long period of time was to bring in entire workshops from mainland Greece, complete with their master sculptors. In addition it is likely that every other available skilled mason and sculptor would have been recruited, and it is not inconceivable that some of these could have come, for example, from the workshop of Praxiteles, who may well have been working at Cnidus nearby around 360 BC.

In summary, the evidence which supports the statements of Vitruvius and Pliny is as follows: the immense amount of sculpting to be done requires a multiplicity of workshops; the extant sculptures suggest that these workshops came from or had strong links with mainland Greece; the Tegea relief suggests that Scopas was

1. A statue twice life-size has a surface area eight times greater than a life-size figure; a statue $1\frac{2}{3}$ times life-size has a surface area 4·6 times greater; and a statue $1\frac{1}{3}$ times life-size a surface area 2·37 times greater.

2. That is, from the probable date of the new town plan of Halicarnassus to one year after the death of Artemisia. The completion of the Mausoleum is unlikely to have extended far into the reign of Ada and Idrieus. If the Tegea relief is linked with Scopas, then he would seem to have already been working there before 344 BC, and if the Satyros of the Delphi statue base is the Mausoleum Satyrus, then

he would have been working at Delphi, probably c. 346–344 BC. Pytheos too must have moved on to Priene in the 340s for the temple of Athena there to be ready for dedication by Alexander in 334 BC.

For a similar computation, see Brown, *Anticlassicism*, 33–34. Jeppesen, *Mélanges Mansel* (1974), 735–48, follows most of the ancient authorities in assuming that the Mausoleum was begun by Artemisia in 353 BC, and argues the necessary corollary that much of the construction took place under Ada and Idrieus, possibly down to 340 BC.

indeed one of the sculptors involved. If the presence of Scopas is confirmed by external evidence, then there is no reason to doubt that the other sculptors involved were those mentioned by both Vitruvius and Pliny: Bryaxis, Timotheos, and Leochares (although allowance has to be made for the participation of Praxiteles).

Was each sculptor and his workshop responsible for a single side of the building?

It was certainly believed in the first century BC and later that each of the Mausoleum sculptors took responsibility for one side of the building, since the story is found in slightly different forms in both Vitruvius and Pliny (the main difference being that Pliny attributes sculptors to sides, while Vitruvius, perhaps because he has five possible sculptors, does not). The question to be decided is whether this division of labour is a simplistic invention of the local guides at Halicarnassus, or whether it goes back to the fourth century BC.

Even if the story originated with the guides at Halicarnassus, it must have been plausible, and suited to the form of the building, or it would never have gained currency at all. It further confirms that the Mausoleum was of the general form suggested above: a four-sided building, the smaller sides not much shorter than the longer, with closely similar if not identical sculptural decoration on each side. If four sculptors were involved in the decoration of a building of this type, one sculptor would naturally tend to be attributed to each side, whether or not it had been so originally.

That there may be some substance in Pliny's attribution of sculptors to sides is suggested by the fact that, of the four sculptors named by him, it is the elder pair, Scopas and Timotheos, who in the middle of the fourth century are likely to have been considered the more eminent, who are credited with the two more important sides of the building, Scopas the east and Timotheos the south, while the younger pair, Leochares and Bryaxis, take the west and the north sides respectively. That the east and the south were the more important sides has been shown by Jeppesen's discovery of the propylon midway along the east side of the *peribolus* wall. It was evidently the intention of the architect that the visitor should enter the *peribolus* at a point south-east of the tomb building, from where he would have oblique views of the east and south sides.

It might be argued that this appropriateness in attribution of sculptors to sides could also be the work of first-century AD guides. On the other hand, by Roman times Timotheos very possibly was not considered so important a sculptor as Leochares or Bryaxis. Certainly there are fewer references to his works in literature

compared with the other Mausoleum sculptors, and in Vitruvius' account his name appears last in the list of sculptors, in a parenthetical remark. Therefore one might not expect a guide to attribute to him the longer of the two more important sides, the side indeed which faced the harbour and the sea, from which direction most visitors must have approached Halicarnassus, unless there were good traditional reasons for doing so (306).

We know too of at least one building earlier than the Mausoleum, where the sculptural decoration was divided according to sides, and where the sculpture on the more visible sides was placed in the hands of better sculptors. On the Siphnian treasury at Delphi of *c.* 525 BC, the east and north sides of the frieze, which were readily visible to a visitor walking up the Sacred Way, are far superior in both design and execution to the south and west sides (307).

The extant sculptures of the Mausoleum provide evidence which in part confirms and in part contradicts the tradition of the division of sculpting by sides. It suggests that while there is some truth in the remarks of Vitruvius and Pliny, the position is more complex than appears there. To some degree we are forced to distinguish between the design and execution of the sculptures in the round.

Letters which remain on the backs of some of the lion statues, A, Λ, Π, suggest that the carving of these sculptures at least was divided according to sides, for the Π lions certainly belong to the north side (308). If the explanation, put forward above (309), for the intervals between these letters be accepted, namely that they are the remnants of a comprehensive numbering system for the entire sculptural decoration of the Mausoleum, then we can go further and say that, as far as the execution of the sculptures is concerned, the numbering of the sculptures was done according to sides, working from roof to ground-level, beginning at the east, continuing at the south and then the west, and ending at the north.

There appears to be a broad correspondence between this numbering system and the tradition recounted by Vitruvius and Pliny, in that the numbering of the sculptures for the purposes of carving and setting in place on the building does seem to have been done according to sides, beginning at the east, and followed by the south.

This does not necessarily mean that one workshop carved all the sculptures on one side of the building, although it could mean that, and one might be tempted to take it that way. One of the difficulties of simple attribution of sculptors to sides has always been that the

sculptors of the shorter sides, Scopas and Leochares, would have had considerably less sculpture to produce than those of the longer sides, Timotheos and Bryaxis (although it is conceivable that the latter may in fact have had larger workshops). If, however, a lettering system for groups of sculptures on each side were employed, as suggested here, it would have been perfectly easy to effect an equal distribution of work between workshops by apportioning to each workshop some groups from a longer side, others from a shorter side. Such a division of labour, one workshop being responsible for parts of a longer and a shorter side, would also have had the practical advantage of creating greater blending and homogeneity of style in the sculptural decoration as a whole.

Turning from the execution of the sculptures to their design, it is clear that in this respect there was no simple division between one side of the building and another. The subject-matter, and consequently the over-all design, of the sculpture of the Mausoleum tends to change according to level rather than side. The subject-matter at any given level tends to run round all four sides of the building, and can have had only one basic designer, although details could in some cases have been left to the sculptor whose workshop was responsible for carving a particular side at that level. This applies particularly to the sculpture from the upper half of the building. Groups or subjects which are found on all four sides of the building are: the lions from the roof, the portraits I from the intercolumniations, the portraits II from the podium, and the three friezes in relief. On some parts of the podium it is likely that different groups existed at the same level, for example, the hunting and sacrificial groups of Podium level I. These could well have had different designers, and it is possible that there may even have been a different designer for each of the four sides.

Who was responsible for the design at each level? Was it one sculptor or several? Is it just chance that the names of six possible sculptors (excluding Praxiteles) are associated with the Mausoleum: Pytheos, Satyrus, Scopas, Bryaxis, Timotheos, Leochares; and that the sculptural decoration in the round existed on six levels, including the chariot group?

Before attempting to answer these questions, one point seems fairly certain. There must have been a single sculptor who had charge of and responsibility for the entire sculptural decoration of the Mausoleum. This is required by the over-all unity of design which the sculptures possess (310), by the complex practice of carving by sides and designing by levels, and by the sheer volume of the work which had to be distributed by someone amongst several workshops. This general sculptural overseer is unlikely to have been one of the four sculptors whose workshops carved the sculptures. He could have been the architect, Pytheos, but far more likely is it that he was the Satyrus mentioned by Vitruvius as co-author with Pytheus of a book about the Mausoleum. If this Satyrus is the Satyros of the Delphi statue base, as is likely, then his candidacy for the position of overseer would seem certain. A man who was court sculptor for the Hecatomnids soon after the death of Artemisia is likely to have occupied a sufficiently influential position under Maussollos for him to be made overseer of sculptors who, in artistic terms, may have been his superiors.

As to the extent to which Satyrus or one of the other sculptors may have been responsible for the designs of the various groups of sculptures, one can only indulge in informed speculation, bearing in mind the sculptural affinities of the designs as discussed in the previous chapter.

Pliny tells us that the chariot group on the summit was made (and therefore designed) by Pythis, who is usually identified with the architect Pytheos. There is no reason to doubt his word for it. The size and material of the group involved problems of construction and engineering which could probably only have been tackled by an architect, while the types of the horses and chariot suggest that the sculptor was thoroughly acquainted with Ionic-Asiatic art, which probably effectively excludes the four mainland Greek sculptors.

The lions employ only a single design, which is reversed to produce the two basic types, and can therefore have had only one designer although they were placed on all four sides of the building. Since they are as thoroughly Asiatic in character as the horses of the chariot group, it seems extremely probable that they had the same designer, namely Pytheos. Certainly these sculptures which decorated the pyramidal roof of the Mausoleum have a stylised, more decorative, architectural character about them, which seems to set their design apart from that of the sculptures from lower on the monument. If the Centaur frieze decorated the base of the chariot group, as Jeppesen has suggested, that too may have been the design of Pytheos.

The colossal male and female portraits of Hecatomnids from between the columns of the order, which include 26 and 27, must have been designed (although not necessarily carved) by one who was well acquainted with the taste in statuary of rulers and dynasts in outlying areas of the Greek world, mostly east and north

of the Aegean in the fourth century BC. An obvious candidate is Satyrus himself, particularly if he made statues of Ada and Idrieus at Delphi. Otherwise Bryaxis might be a possibility. The female statues seem to have conformed to a single basic type, but there may have been scope for minor variations in design amongst the male statues by the executant sculptors.

If the four sculptors, Bryaxis, Scopas, Leochares and Timotheos, took a major part in the design of any of the groups it can only have been those of the podium. Even here some of the statues seem to betray an Ionic-Asiatic quality, (e.g. nos. 33 and 34), although hunting groups are known to have been designed subsequently by Leochares at Delphi and Scopas at Tegea, and sacrificial groups abound in Attic relief sculpture.

A mainland designer seems quite possible for some of the male statues of the portraits of scale II from the podium, perhaps one who had connections with the Peloponnese, such as Timotheos or Scopas. Beyond this it is impossible to go, so fragmentary are the groups from the lower part of the building.

Two main possibilities suggest themselves concerning the design of the sculptures. Either all were entirely the work of Pytheos and Satyrus, hence the predominantly Ionic–Asiatic character of them; or the design was divided into three main sections, according to level: Pytheos designed the sculptures on the roof; Satyrus the sculptures from the colonnade; and the four mainland Greek sculptors the pedimental-type sculptures which decorated the podium.

CATALOGUE

The Chariot Group

FRAGMENTS OF HORSES

1. Forepart of a horse (pl. 5)

BM 1002; *MRG* 36; Reg. 1857.12–20.238.

Reconstructed from several smaller fragments consisting of:

(*a*) Neck and shoulders, including upper parts of both forelegs.

(*b*) Central part of head, including the right eye and part of the bridle, adjoining (*a*) at throat.

(*c*) Upper part of head at front, now joined to (*b*) by bronze bridle.

(*d*) Lower part of head, now joined to (*b*) by bronze bridle.

(*e*) Several fragments (at least four) of the upper head and mane, set in plaster between (*a*) and (*b*).

(*f*) Fragment of collar uniting the two parts of the harness on the right side of the body.

(*g*) Additional piece of upper left foreleg.

According to Newton (*Papers*, i. 14, 21; *HD* 102–3, 217) the large fragment of body (*a*), and the central part of the head (*b*), were found by him underneath large marble slabs north of the *peribolus* wall on the north side of the Mausoleum. The lower part of the head (*d*), with bronze bit and bridle attached, was found underneath a house, a little to the east.

Dimensions as reconstructed. H. 2·33 m. W. (across front) 0·90 m. L. (including head) *c.* 1·40 m. L. of head from crown to nostril *c.* 1·05 m. W. of right eye 9 cm. W. of girth behind right leg 16·8 cm. Projection of girth above body, 8 mm at sides; 1 mm underneath.

Marble. White, fine-crystalled. The surface is weathered on the right side of the body and neck, but is well preserved on the left side of the neck.

Restoration. Plaster has been used to smooth the joins between the fragments listed above; also to reconstruct the upper left part of the head and part of the right eyebrow. The left nostril is damaged but not restored. A drill-hole in the break of the right foreleg appears to be modern.

Some 25-30 cm of body is missing from behind the present break at the shoulders up to the original division between the front and rear parts of the horse. It would appear that, when this horse fell from the building, the clamped joint between the two halves proved stronger than the marble itself, so that the forepart was snapped off just in front of the marble support underneath the belly (see reconstruction, fig. 2).

The horse is represented standing quietly with its head held down and turned to its left. From the positions of the upper legs it is probable that neither foreleg was raised from the ground. This quiet stance is in strong contrast with the vigorous treatment of the form. Bulging muscles, flaring nostrils, open mouth, prominent veins, and bulbous right eye all impart a feeling of great energy and vitality, suggesting that the horse has just finished a tremendous exertion.

Around the body are two bands of harness which are joined at the crest by a collar. The strap which passes

around the body just behind the legs is the μασχαλιστήρ; that which runs around the lower part of the neck is the λέπαδνον. This is the regular type of harness for a four-horse chariot. Traces of red paint are visible on the strap under the belly.

The treatment of the mane and the lock of hair that flops over the right eye is broad and schematic. A parting divides the two sides of the mane, running up the nape of the neck, and the hair which falls in waves on either side to a uniform length is rendered by sharp and angular chiselling. In the lock over the eye, where there is a greater depth of hair, the running drill has also been used to cut deep, irregular furrows.

Incised lines indicate creases at the throat where the head is held down, and there are others at the base of the mane on the right-hand side. This incision seems rather crude compared with the competent volumetric modelling of the rest of the body.

The head itself is magnificently carved. In order to create an impression of animation and power, the sculptor has exaggerated the eye socket and given extra prominence to the network of veins and to the nostril, and in so doing he has lent great character to the horse.

In the open mouth the teeth are carved, and within them the tongue is outlined with the running drill. Newton reports (*Papers*, i. 21) that when the head was unearthed red paint remained on the tongue, but this is no longer visible.

One of the most remarkable features is the elaborate bronze bridle and bit which is still attached to the head. It should be noted, however, that considerable repair work must have been done to the bridle by Newton, since it was originally found in two parts, as is apparent from the illustration in *HD* 103. The bronze wire on the forehead and the bronze wire linking the two discs on the right side would appear to have been re-attached. The bit passes through a hole drilled through the tongue and is riveted on either side to curving cheek-pieces of Corinthian type, which are attached to the bridle by means of hooks (for an example of a similar cheek-piece from Olympia see Anderson, *Ancient Greek Horsemanship*, 74, pl. 33a; for Corinthian cheek-pieces, see Herrmann, *JdI*, lxxxiii [1968], 10–11). The bridle itself is fixed to the head by means of bronze pins which run through the centre of the bronze discs that mask the joins between the bridle straps. The drill-holes in the head to receive these pins were originally wrongly aligned and new holes had to be made. This at least is the likeliest explanation for several spare drill-holes which are preserved. On the right-hand side of the head there is an extra hole partly hidden by the lower disc,

and two extra holes near the upper disc, one of which is hidden by the disc, the other clearly visible. On the left-hand side of the head, where the bridle is missing, two holes mark the positions of both upper and lower discs, although one of the lower holes is in a restored area and may simply be an invention of the restorer. On the right-hand side the bronze wire of the bridle forks in two in the region of where the right ear would have been.

In general the workmanship of this piece is broad and massive, and in places the finish is rather rough. Clear traces of the point remain on the back of the collar that unites the harness, marks of the claw chisel are visible on top of the collar, on the girth under the belly and below the right nostril, and the grooves of the running drill can be seen in the hair, around the tongue, and also on either side of the girth where it passes under the belly.

Newton, *Papers*, i (1858), 14, 21; *HD* 102–3, 217; *MRG* 36; Smith, *BM Cat.* 1002; Preedy, *JHS*, xxx (1910), 145 ff.; von Lorentz, *Maussollos u. die Quadriga auf dem Maussolleion zu Halikarnass* (1930), 11–18; Markman, *The Horse in Greek Art* (1943), 190; Picard, *Manuel*, iv. 1 (1954), 72; Jeppesen, *Paradeigmata* (1958), 36–39; Riemann, P–W, 437–9; Müller–Ammon, *The Seven Wonders of the World* (1969), 234.

2. Rear part of a horse (pl. 6; fig. 10)
BM 1003; *MRG* 36a; Reg. 1857.12–20.239.

Found by Newton in the large deposit of sculptures north of the north wall of the *peribolus*. The tail, which belongs, was discovered built into a rubble wall immediately above the *peribolus* wall (Invoice, case no. 101; *HD* 102).

Dimensions. L. from front join to area for attachment of tail 1·98 m. Projection of fragment from front half 0·18 m. Total H. 1·56 m. H. of body at join 1·12 m. W. 0·90 m.

Marble. White, fine-crystalled, good quality. The same as for 1. Deep cracks in the marble on both sides of the body have necessitated the insertion of a long nut and bolt, running the entire length of the body, to clamp the pieces together. The bolt emerges in the centre of a deep depression (*c.* 15 cm deep) that has been gouged in the worked surface at the front. Although one might not think so from the harsh nature of the tool marks, this depression is undoubtedly ancient, for it is described by R. M. Smith in a letter dated 2 May 1857 (W. K. Dickson, *The Life of Major-General Sir Robert Murdoch Smith* [1901], 60). He interprets it as part of a mortise and tenon joint, but it is perhaps rather a deep and crude

form of *anathyrosis*, which, from its appearance, may have been executed hastily on the building. In the top of the back towards the rear is a large lewis hole which also seems to be ancient, having been made no doubt to facilitate the lifting of the horse on to the building. Farther towards the rear there is a plaster knob, the significance of which is not clear, but it is probably connected with the Victorian repair work.

Preserved is the entire rear half of the body of one of the chariot horses, including the join for the attachment of the front half, and a flat surface at the rear for the attachment of the tail. The upper parts of both hind legs remain, being broken off just above the hock. The right leg is set slightly farther forward than the left. A small part of the front section of this horse has been rejoined to the lower left part of the abdomen, the correct position being assured by the correspondence of a large vein. The genitals show the horse to be a stallion.

The carving, like that of 1, is broad and massive. The muscles are convincingly modelled, but detail is scant except for the veins which are carved on the left side of the abdomen. The finish is generally rather rough. Clear traces of the claw chisel remain on the right side of the body. They are rather less clear on the left side, but this could be due to weathering. On the top of the back, which has been only roughly finished, harsh point marks remain.

At the front of this fragment is a vertical plane surface, dressed with the claw chisel, where the two halves of the horse were joined together. Although much of the original surface has been destroyed by the depression which has been hacked out, traces still remain around the edges of a grid system of lightly scored lines, which were no doubt intended to facilitate the carving of the cross-section of the body at this point, and to ensure a close correspondence with the front half (see fig. 10). There are three horizontal lines remaining, A, B, C, and one vertical line, X. The distances between them are: from top of back to A, 28·5 cm; from A to B, 26 cm; from B to C, 27·2 cm; and from C to the underside of the belly, 28·5 cm. Line X cuts line B *c.* 16·5 cm in from the left flank. No corresponding vertical line is visible on the opposite side.

The two halves of the horse were originally held together by clamps, for which three wedge-shaped cuttings remain, one in the middle of the back at the top, the other midway down either side of the body, the bottom of the cutting aligned exactly on line B of the grid system. Of these cuttings, that on top of the back is the largest, being 24 cm long, widening from 5 cm to 8 cm, and increasing in depth from 3·5 cm to at least

Fig. 10

7 cm (the depth at the broader end may be greater, for the cutting here is filled with plaster). The cuttings on the sides are slightly smaller, being 19 cm in length, extending in width from 3 to 10 cm, and increasing in depth from 2·5 to 7 cm where the tooth of the clamp gripped.

It has previously been reported that under the belly there is a cutting for a support (so Newton, *HD* 106–7 and, after him, Smith, *BM Cat.*; von Lorentz, *Maussollos*, 17; Jeppesen, *Paradeigmata*, 38). This is not so. An area of marble measuring 35 cm wide by between 22 and 26 cm long has been torn away, and in the middle of this is the tip of an iron dowel, still *in situ* and measuring 3·5 × 2 cm. It seems likely from this that there was originally a low marble protrusion under the horse, as on the Persian rider, 34, to provide a flat surface for the join with the support, and that the support was so well fastened to this protrusion that it tore it away when the horse fell from the building, leaving only the tip of the dowel stuck in the horse's body.

At the rear of the horse's body there is a vertical, plane surface, dressed with the claw chisel and measuring *c.* 24 cm wide by 23 cm high, to receive the tail which was carved separately. Part of the iron dowel which fixed the tail to the body remains *in situ*, as does also the

lead which was poured in to seal the join. The lead has spread out in a gap between tail and body, and it also fills the semicircular pour-hole right to the top. The 4 cm square cutting immediately below the original dowel was made in modern times in order to refit the tail.

The tail (pl. 6)
Reg. 1972.3–30.1.

Found close to 2, and certainly belonging to it. L. 0·62 m. H. 0·23 m. W. 0·23 m.

Marble. Identical to that of 2. At one end is a flat vertical surface, worked with the claw chisel, which originally measured *c.* 20 × 20 cm, and in which there are the remains of a dowel hole measuring 5·5 × 4 cm, which exactly corresponds with the dimensions of the dowel in the rear of the horse. A modern dowel has been added which partly occupies the ancient cutting. Apart from small fragments missing at front and rear, most of this tail seems to be preserved. It was apparently short and stubby, and stuck straight out from the horse's body. It does not seem particularly convincing when seen close to, but no doubt it was satisfactory enough from a distance. The carving of the strands of hair is sharp and angular, and is very similar to the treatment of the mane of 1. An extra bunch of hair towards the rear would seem to indicate that the tail was tied up. The underside is hollowed out to reduce weight, and harsh point marks remain. There is severe weathering on top, as well as two heavily scored lines that cut across the grooves of the hairs near the join with the body.

Since the time of Newton it has been assumed that the forepart 1 and the rear part 2 belong to two different chariot horses, although the reasons for this assumption have never been fully expounded. Newton, *HD* 103, says: 'At first I supposed the two portions of horse to belong to the same animal; but, on comparing them since their arrival in the British Museum, it has been decided by competent authorities that they are portions of two different horses.' Later in *MRG* 36a he says of the rear part 2: 'Action of hind legs shows to have belonged to a different horse in the team.' Newton's decision therefore seems to be based upon the positions of the legs (he is echoed later by von Lorentz, *Maussollos*, 17: '. . . von zwei verschiedenen Tieren, wie aus der Stellung der Beine hervorgeht'). The positions of the legs are not absolutely certain, but it does seem likely that on the forepart both legs were more or less together on the ground with the right perhaps set slightly forward, while on the rear part the right hind leg was

slightly in advance of the left. Is it really impossible for a horse to stand in this position? On the face of it there would seem to be no firm evidence to allow one to state categorically that these two large fragments belong to different horses. The reconstruction shows that the fragment of forepart which adjoins 2 does not completely fill the gap missing behind 1, and so could come from the same forepart as 1. The question must remain open.

Newton, *HD* 103 ff., 217; *MRG* 36a; Smith, *BM Cat.* 1003; von Lorentz, *Maussollos*, 11–18; Jeppesen, *Paradeigmata*, 36–38; Riemann, P-W, 437–8.

3. Fragment of forepart of body (pl. 7)
Reg. 1972.3–30.2. Numbered B.66.4 (black).

Found by Biliotti, but not mentioned in his diary.

Dimensions. H. 0·50 m. W. (L.) 0·18 m. Th. 0·30 m.

Marble. White, fine-crystalled.

Preserved is a portion of the right side of the body, above and behind the right foreleg, part of the break for which remains. Close behind the leg, running along the rear break, is a vertical groove, representing the edge of a girth which ran around the body, proving this to be from a chariot horse. On the underside of the fragment, behind the leg, the girth is preserved to a width of 3 cm.

The body has broadly worked, muscular undulations, the surface finished with the claw chisel, the marks of which have been softened by weathering. An area on the underside, between the girth and the leg, is rather roughly worked.

Marble, scale, broad working, finish, and girth around body make the attribution to the chariot group certain. Obviously from a different horse to 1. About one-third of the width of the body is preserved, and almost half the height.

4. Fragment of forepart of body (pl. 7)
Reg. 1972.4–17.30. Numbered B.66.4 (black).

Found by Biliotti, but not mentioned in his diary.

Dimensions. H. 0·27 m. W. (L.) 0·16 m. Th. 0·24 m.

Marble. White, fine-crystalled.

A fragment from the lower belly behind the forelegs, the underside rather flattened, as on 1. On one edge of the fragment is a raised ridge, 4·3 cm wide, as preserved, and projecting 8 mm above the body. This ridge runs down the side and across the underside which remains,

and is almost certainly part of a girth, proving this to be part of one of the chariot horses. The projection of the girth above the body is exactly the same as on 1. Probably this fragment comes from the lower left side of a forepart, including some of the body from behind the girth.

5. Fragment of forepart of body (pl. 7)
Reg. 1972.3–30.3. Numbered B.66.4 (black).

This is probably the fragment found by Biliotti on 14 March 1865. According to his diary it was excavated from the soil just above bedrock near the south-west corner of the Vakuf's house on the west side of the Mausoleum Quadrangle.

Dimensions. H. 0·64 m. W. 0·47 m. Th. 0·36 m.

Marble. White, fine-crystalled.

A large fragment of body, with the surface preserved on three sides. From the huge dimensions, from the type of marble, from the broad and emphatic modelling of the musculation, and from the rather coarse finish where there are clear traces of claw work, it is certain that this fragment belongs to one of the chariot horses. A comparison with 1 shows that it comes from the lower right side of the chest of a forepart, just above the join of the right foreleg.

Biliotti diary, 14 March 1865.

6. Left hoof and lower foreleg on base
(pl. 8; fig. 11)

BM 1005, 1; *MRG* 36b; Reg. 1857.12–20.283.

Found by Newton north of the north wall of the *peribolus* together with fragments 1 and 2.

Dimensions. Base: L. (front to back) 0·88 m. W. 0·70 m. Th. 0·25 m (maximum). Hoof: L. 0·34 m. W. 0·28 m. Height of leg as restored 0·70 m. Total H. of leg and base 0·95 m.

Marble. White, fine-crystalled.

A large piece of base on which stands a left hoof, to which have been added three adjoining pieces of foreleg from below the knee. The original edge of the base is preserved on the left-hand side and behind the hoof. Rough pointwork covers the edges and the top surface, with the exception of a higher, smoother area in front of and to the right of the hoof. Around the sides of the hoof the base is depressed slightly in a band that

11 Hoof no. 6

varies in width from 2 to 6 cm. It is still rendered with the point, but less roughly than the rest of the base.

The axis of the hoof is set at a slight angle to the left side of the base, pointing outwards, proving that this hoof belongs to a left leg. It is well modelled, but the finish is somewhat rough, and the marks of the claw chisel are clearly visible. Most of the coronet above the hoof is preserved on this fragment, and is similarly worked. A separate fragment of coronet, however, has been added to the left side towards the back. Above the hoof and coronet has been fitted a large fragment comprising pastern, fetlock, and part of the cannon bone of the lower foreleg. It does not join absolutely flushly to the hoof, but certainly belongs here. Plaster fills the gaps between the fragments. The left, outer side of this fragment of foreleg is broadly carved and its surface is smoothly finished. The inner surface exhibits the claw work which is a common feature of many of the fragments of the chariot group.

On top of this fragment is added another piece of the cannon bone from just below the knee. It is broken at the front, and adjoins the lower fragment closely only at the back. It too is smoothed on the left outer side, while rougher claw work remains on the inner side.

Newton, *HD* 103, 217; *MRG* 36b; Smith, *BM Cat.* 1005, 1; Jeppesen, *Paradeigmata*, 25, fig. 13F; Riemann, P-W, 437.

7. Right hoof on base (pl. 8; fig. 12)

BM 1005, 2; *MRG* 36c. Reg. 1972.3–30.4. Numbered B.66.4 (black).

Found by Biliotti between 20 and 23 June 1865 when he demolished a house belonging to Hagi Imam, east of the Mausoleum Quadrangle.

Dimensions. L. 0·43 m. W. 0·335 m. Th. of base 0·24 m. H. of hoof above base 0·175 m.

Marble. White, fine-crystalled.

The hoof is broken at the back but is otherwise well preserved. Its surface is finished with the claw chisel, as on fragment 6. A small part only of the coronet remains, its surface showing traces of the point.

The base, which is preserved to its original thickness, is broken to the left of the hoof, and in front of it, but the right edge remains running close beside the hoof, its surface heavily pointed, and there seems also to be part of the rear edge preserved, at a distance of only 4 cm from the back of the hoof. The axis of the hoof is set at an angle to the right side, suggesting that it belongs to a right leg. Newton assumed it to be from a foreleg, but this is not certain.

This fragment differs from 6 in that the hoof is set much closer to the edges of the base, and the surface of the base is more smoothly worked.

Biliotti diary, 20–23 June 1865; Newton, *MRG*, 36c; Smith, *BM Cat.* 1005, 2; Dinsmoor, *AJA*, xii (1908), 156, fig. 4; Jeppesen, *Paradeigmata*, 25, fig. 13G; Riemann, P-W, 437–8.

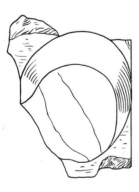

12 Hoof no. 7

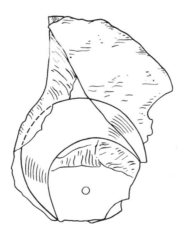

13 Hoof no. 8

8. Fragment of hoof on base (pl. 9; fig. 13)

BM 1005, 5; *MRG* 36f; Reg. 1857.12–20.284.

Found by Newton in the large deposit of sculptures north of the north *peribolus* wall.

Dimensions. L. 0·49 m. W. 0·49 m. Th. of base 0·17 m. H. of hoof above base 0·165 m.

Marble. White, fine-crystalled.

Two closely adjoining fragments, one of which consists mostly of base. The hoof is broken at the back, but is otherwise quite well preserved. The finish is somewhat smoother than on fragments 6 and 7. At the front part of the coronet remains, its surface showing traces of the point.

A fair amount of the base is preserved in front of and to the right of the hoof, and there is a slight trace on the left of the hoof also, but no original edge remains. Consequently it is difficult to tell which way the hoof was aligned, and therefore whether it belongs to a left or a right leg. The surface of the base is roughly pointed, and there is a depression running around the hoof, as on fragment 6. Much of the underside of the base is broken, but the original thickness seems to be preserved on the right side, where it measures 17 cm. This is somewhat thinner than the other two fragments of base, but there can be no doubt that this hoof belongs to one of the chariot horses. Newton confidently assigned it to a rear leg, but there seems no reason why it could not equally have come from a foreleg. A hole 2 cm diameter drilled into the broken surface on top of the hoof is likely to be modern.

Newton, *HD* 103, 217; *MRG* 36f; Smith, *BM Cat.* 1005, 5; Jeppesen, *Paradeigmata*, 25, fig. 13H; Riemann, P-W, 437–8.

9. Fragment of hoof and coronet (pl. 9)

Reg. 1972.4–8.27. Numbered B.66.4 (black).

Found by Biliotti, but not mentioned in his diary.

Dimensions. H. 0·17 m. W. 0·135 m. Th. 0·075 m.

Marble. White, fine-crystalled. Incrustation on breaks.

A fragment preserving the upper part of a hoof and a section through the bulging coronet above it. The surface is finished with the claw chisel, the marks of which have been softened by weathering. A comparison with fragment 6 shows the attribution to the chariot group to be certain.

10. Hind leg from hock to fetlock (pl. 9)

BM 1005, 4; *MRG* 36e; Reg. 1857.12–20.286.

Reconstructed from three fragments consisting of: (*a*) hock; (*b*) upper part of cannon bone; (*c*) lower part of cannon bone and fetlock. The hock fragment (*a*) is numbered 254 (red). According to the invoice of packing cases (no. 254), it was found by Newton in Hadji Nalban's field on the south side of the Mausoleum Quadrangle with fragments of the chariot wheels. This is confirmed by *HD* 129. The gaps between the fragments are filled with plaster.

Dimensions as reconstructed. H. 0·86 m. W. (side) 0·30 m. Th. 0·23 m.

Marble. White, fine-crystalled with yellow-brown patina.

The modelling of the over-all structure of the leg is highly competent and similar in style to that of the two large fragments of body, 1 and 2, where the general proportions are skilfully rendered, but scant attention is given to detail. The finish of this leg is good. Both sides have been well smoothed, and it is difficult to tell which was the inner and which the outer surface, and consequently whether this is part of a right or left leg.

Newton, *HD* 129; *MRG* 36e; Smith, *BM Cat.* 1005, 4; Jeppesen, *Paradeigmata*, 40–41, fig. 26; Riemann, P-W, 437–8.

11. Hock from hind leg (pl. 9)

MRG 36h. Reg. 1972.3–30.5. Two adjoining fragments numbered 105 (red) and 139 (red).

Found by Newton, but finding-place not given.[1]

Dimensions. H. 0·37 m. W. (side) 0·30 m. Th. 0·20 m.

Marble. White, fine-crystalled with silvery veins.

The two fragments make up most of the hock joint from a hind leg similar to 10. From the working of the surface it was probably a left leg. The surface of the left side, which is better preserved, is smoothly finished, although traces of the claw chisel are just visible in places. At the back of the leg the treatment changes abruptly to a rougher finish where the claw marks are clearly visible, and as much of the inner right surface as remains is similarly treated. The smoother finish of the outer surface may in part be due to weathering.

Newton, *MRG* 36h.

1. Although the finding-places of many of the smaller fragments from Newton's excavations must be recorded as not known, there is a strong likelihood that the fragments numbered in red between 61 and 144 came from the so-called Quadrangle, or foundation cutting, of the Mausoleum. See above, p. 3, n. 2.

12. Fragment of pastern and fetlock from hind leg (pl. 9)

MRG 36o; Reg. 1972.3–30.6. Numbered 152 (red).

Found by Newton, but precisely where is not recorded.

Dimensions. H. 0·26 m. W. 0·25 m. Th. 0·18 m.

Marble. White, fine-crystalled.

A comparison with the hind leg 10 shows that this fragment comes from just above the hoof. It is in a somewhat mutilated condition, being broken at the back (although it is preserved to its original width), and chipped at the front. Much of the original surface has flaked away. That which remains has a deep brown patina. The right-hand surface appears to be well smoothed, while the left side and the front are rougher and show the marks of the flat chisel. If this differentiation between the working of the two sides is a safe indicator, this fragment would belong to a right hind leg.

Newton, *MRG* 36o.

13. Fragment of upper foreleg (pl. 10)

MRG 36p. Reg. 1972.3–30.7. Numbered B.66.4 (black).

Found by Biliotti on 19 May 1865 when demolishing Mehmeda's house on the south side of the Mausoleum Quadrangle. It was built into the chimney and is blackened on one side.

Dimensions. H. 0·56 m. W. 0·31 m. Th. 0·27 m.

Marble. White, fine-crystalled.

A massive fragment from the upper foreleg of one of the horses close to its juncture with the shoulder, as is shown by the diagonal break on top of the leg and the longer outer face. The leg is not preserved to its original width: some 5–6 cm is missing on the left edge as viewed from the outer side. The muscles and general structure of the leg are broadly modelled on both inside and outside, but the quality of the finish varies as it does on some other fragments. On the outer side the surface is fairly well smoothed, but as one progresses around the edge which is preserved, harsher claw marks appear, and these cover most of the inner surface. Whether this is part of a right or left leg is hard to say. It does not belong to forepart 1.

Biliotti diary, 19 May 1865; Newton, *MRG* 36p.

14. Fragment of upper foreleg (pl. 10)
MRG 36l. Reg. 1972.3–30.8.

No invoice number. Finding-place not known.

Dimensions. H. 0·40 m. W. 0·33 m. Th. 0·23 m.

Marble. White, fine-crystalled.

A much-battered fragment from the upper foreleg of one of the chariot horses, as is clear from the width. The upper foreleg attached to 1 measures 37 cm at its widest point near the body, and rapidly diminishes. This fragment therefore must come from just below the shoulder. To judge from the curving contours of the edges, the leg is likely to have been set slightly forward (or backward). The side on which the surface remains exhibits the usual claw marks. Most of the other side is now broken, but as much of the surface as exists is more smoothly finished, and may therefore have been the outer surface. The hole drilled in the break is for mounting on a base.

Newton, *MRG* 36l.

15. Fragment of foreleg (pl. 10)
MRG 36m. Reg. 1972.3–30.9. Numbered 200 (red).

According to the invoice of cases (no. 200) it was found by Newton together with other fragments of the chariot horses in the Imam's field, in the main sculptural deposit to the north of the north wall of the *peribolus.*

Dimensions. H. 0·30 m. W. (side view) 0·23 m. Th. (front view) 0·15 m.

Marble. White, fine-crystalled with silvery veins.

To judge from the dimensions, which are smaller than those of fragments 13 and 14, and from the rather bulbous contours, this is probably a knee of a foreleg. One side is much better preserved than the other and exhibits the usual clawed surface. In a depression towards the back there are also some harsh point marks. The claw marks extend to about halfway around the front edge, where they give way to a smoother surface, now somewhat pocked by weathering. The smoother face was perhaps the outer one.

Newton, *MRG* 36m.

16. Fragment of lower foreleg (pl. 10)
MRG 36n. Reg. 1972.3–30.10.

Two adjoining fragments from the cannon bone of a lower foreleg. The upper fragment is numbered 141

(red) and is of unknown provenance. The lower fragment is numbered 189 (red), and according to Newton's invoice was found in the Imam's field, on the north side of the north wall of the *peribolus.*

Dimensions. H. 0·28 m. W. 0·205 m. Th. 0·135 m.

Marble. White, fine-crystalled.

The lower fragment provides a complete section through the foreleg. The surface is well smoothed on both sides, but there are some rough point marks at the back. In the break of the upper fragment is the bottom of a drill-hole which appears to be ancient: 1·7 cm diameter × 5 cm deep, as preserved. This must be either for an ancient repair, or else for the separate attachment of the lower foreleg, which might imply that it was raised from the ground.

Newton, *MRG* 36n.

17. Fragment of fetlock (pl. 10)
Reg. 1972.3–30.11. Numbered B.66.4 (black).

Found on 20 May 1865 by Biliotti when demolishing Mehmeda's house on the south side of the Mausoleum Quadrangle.

Dimensions. H. 0·305 m. W. 0·145 m. Th. 0·16 m.

Marble. White, fine-crystalled.

Preserved is the rear part of the fetlock, known as the ergot. A comparison with fragments 6 and 10 shows that it could come from either a foreleg or a hind leg, although it is perhaps slightly closer in style to that of the foreleg 6. The finish is smooth on either side, but at the back are the rough marks of a point or heavy rasp.

Biliotti diary, 20 May 1865.

18. Fragment of tail (pl. 10)
MRG 36k. Reg. 1972.3–30.12. Numbered 141 (red).

Found by Newton, but precise finding-place not recorded.

Dimensions. L. 0·32 m. H. 0·21 m. Th. 0·20 m.

Marble. White, fine-crystalled.

The fragment appears to come from the rear part of the tail, since there are two principal divisions of hair, the upper one of which commences at the forward break,

and also since the U-shaped hollow on the underside begins to flatten out towards the rear break. The treatment of the hair corresponds with that of the large fragment of tail which adjoins 2. Parallel strands run along the length of the tail and are cut in sharp and angular grooves with the flat chisel. Weathering is severer on top than at the sides. Rough pointwork remains on the underside.

Newton, *MRG* 36k.

19. Fragment of tail (pl. 10)

MRG 36i. Reg. 1972.3–30.13. Numbered B.66.4 (black).

The circumstances of the discovery are recorded by Biliotti in his diary for 19 May 1865: 'In walking with Mr Newton in the gardens occupying the lower ground east of the Mausoleum platform, we found a sculptural fragment, which Mr Newton recognized at once to be part of a horse's tail.'

Dimensions. L. 0·41 m. H. 0·21 m. Th. 0·18 m.

Marble. White, fine-crystalled.

Only the left side is reasonably preserved. The top, right side, and underside are battered and much weathered, and the fragment is broken at both ends. It appears to be the central part of the tail which is preserved.

The treatment of the hair differs considerably from that of fragments 2 and 18, and seems to be the work of another sculptor. Whereas the other fragments have concave grooves to represent the hair, here the strands are shown as high, convex ridges with lower bands in between that are themselves slightly convex. The finish is also smoother. There are no traces of an additional division of hair on top, but the underside is hollowed out with the point in the same way as on fragments 2 and 18.

Biliotti diary, 19 May 1865; Newton, *MRG* 36i.

20. Fragment of tail (pl. 10)

Reg. 1972.3–30.14. Numbered 141 (red).

Found by Newton, but precise finding-place not recorded. Cf. fragments 16 and 18 which were dispatched in the same case. Possibly all are from the Imam's field on the north side, since 16 adjoins a fragment which came from there.

Dimensions. L. 0·38 m. H. 0·195 m. Th. 0·205 m.

Marble. White, fine-crystalled.

Extremely worn on all sides, and broken at both ends. The underside is hollowed out with the point. On top towards the rear are traces of an extra bunch of hair, as on fragments 2 and 18. The hair where it is preserved on the right side is ridged rather than grooved, a treatment which corresponds to that of 19. In the broken front end of the tail there remains the bottom of a dowel hole, 3·5 cm square, for the attachment of the tail to the body. Cf. tail belonging to 2.

21. Fragment of genitals (pl. 11)

Reg. 1972.3–30.15. Numbered 152 (red).

Found by Newton, but finding-place not recorded.

Dimensions. H. 0·18 m. W. 0·21 m. Th. 0·115 m.

Marble. White, fine-crystalled.

A semispherical fragment, partly broken on the edges and behind, bearing traces of the rasp on the surface. A comparison with fragment 2 shows it to be half of one of the testicles of a chariot horse.

22. Fragment of bronze bridle (pl. 11)

Reg. 1972.3–30.16.

Finding-place not recorded.

Dimensions. L. 0·11 m. H. 0·035 m. W. 0·025 m.

Preserved is most of the hook which joins the bit and cheek-piece to the bridle. All that is missing is part of the circular surround to the hole through which one end of the bit passed. It may belong to the bridle of fragment 1, where this particular element is missing on the left side of the horse's head.

23. Half of marble support for horse (pl. 11; fig. 2)

BM 1005, 3; *MRG* 36d; Reg. 1857.12–20.285. Numbered 226 (red).

Found by Newton among the pile of sculptures and pyramid steps to the north of the north wall of the *peribolus* in the Imam's field (Invoice of cases, no. 226; *HD* 106).

Dimensions. Max. H. 1·17 m. W. of base 0·68 m. L. of base at side 0·59 m. W. of pillar at base 0·375 m. W. of pillar at upper break 0·365 m. L. of pillar at base

0·322 m. L. of pillar at upper break 0·285 m. Th. of base varies from 0·22 to 0·32 m.

Marble. White, fine-crystalled. Identical to that of fragments of horses.

There remains a large portion of base from which a rectangular shaft rises up, its sides tapering gradually.

One side of the base is preserved to its original length, 0·59 m. It is roughly worked with the point, as is also the surface of the base, which is very irregular. The original width of the base is not preserved, but it may be calculated as *c*. 0·86 m by doubling the distance from the preserved edge to the central axis of the pillar. This is almost equal to the width of one of the horses (0·90 m, see above, nos 1 and 2).

Three sides of the rectangular shaft are carefully dressed with the claw chisel, and they taper gradually upwards. The fourth side is perpendicular and is flush with the back of the base. Here the surface of both shaft and base has been worked for *anathyrosis*, to provide a close join with the other half of the support, now lost. An outer margin, *c*. 11 cm in width, has been dressed with the claw chisel, while the inner area has been cut slightly lower and shows heavy score marks of the point.

The upper part of the shaft is missing, but its original height may be calculated as *c*. 1·80 m: that is to say, *c*. 63 cm is missing. At this height, assuming the taper to be constant, the shaft would have reduced to the dimensions of the depression beneath horse 2 (*c*. 35 × 22–26 cm), which was caused when a support of this type was wrenched from its position.

It is clear that each horse originally had two such half-supports, one beneath the rear edge of the forepart, the other beneath the front edge of the hind part. Whether the two half-supports were themselves clamped together is not certain. No clamp cuttings remain in the portion preserved. Possibly it was considered unnecessary, since each support was fixed to half of the horse with a strong dowel, and the two halves of the horse were then securely clamped together.

Newton, *HD* 106, pl. XXV, figs 11–12; *MRG* 36d; Smith, *BM Cat.* 1005, 3; Jeppesen, *Paradeigmata*, 25, fig. 13D; Riemann, P-W, 437.

FRAGMENTS OF CHARIOT

24. Fragments of chariot wheels (pl. 11)

BM 1004; *MRG* 37; Reg. 1857.12–20.327–329 (327, nave; 328, three portions of circumference; 329, spokes).

Newton discovered several fragments which he correctly assigned to the wheels of the colossal chariot. These were incorporated in a stone reconstruction of one of the wheels which has now been dismantled. Since the fragments were found in different locations on the site of the Mausoleum, it is probable that they belong to two wheels.

Most of the fragments were found on the south side of the Quadrangle together with the hock fragment 10 (Newton, *HD* 129; *Papers*, i. 46: they were found at a depth of nearly 2 ft below the surface). One or two pieces of spoke were discovered in the main deposit of sculptures north of the north *peribolus* wall (*HD* 106), and at least one other fragment came to light at the north-east angle of the *peribolus* wall (Invoice of cases). The entry, *MRG* 37, written by Newton at a later date, which states that all the fragments were found north of the north *peribolus* wall, must be regarded as incorrect. This is followed by Smith, *BM Cat.* 1004.

The fragments which survive are as follows:

(a) **Half of a nave,** worked separately, with inner and outer hubs preserved (figs 14, 15). The outer hub is smaller and is flanged. Radiating from the hub are the

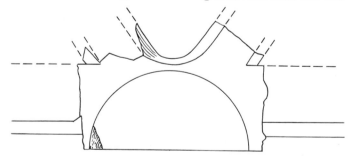

14 Nave of chariot wheel, 24a

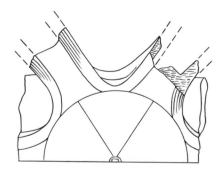

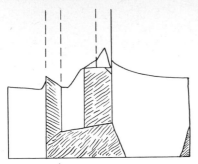

15 Nave of chariot wheel, 24a

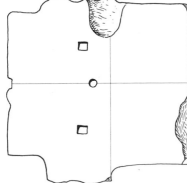

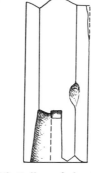

16 Felloe of chariot
wheel, 24b

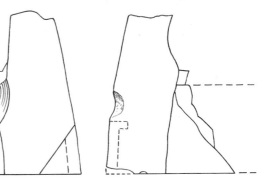

17 Felloe of chariot wheel, 24b

remains of two whole spokes with chamfered corners, and two horizontal half-spokes, at the back of which are strengtheners. The outer hub has been finished with the point, but its surface is now weathered. On it are traces of guidelines, scored at intervals of 60 degrees, which correspond with the centres of the lines of the complete spokes. At the base of the outer hub there is a cutting (L. 2 cm, H. 1 cm, D. 1·1 cm), which was probably for the tooth of a clamp or a small dowel which fixed the upper half of the wheel to the lower half.

The underside has been neatly dressed with the claw chisel. Two scored guidelines remain here also, one running along the line of the back of the horizontal half-spokes, the other intersecting it at right angles, and running from the centre of the inner hub to the centre of the outer hub (see fig. 15). Cf. similar guidelines on 2 and 25. Two dowel holes on the underside, measuring 2·5 cm square × 5 cm deep, are almost certainly ancient, and would have served to fix this half hub-block to its counterpart. A round dowel hole between them is modern.

From the south side of the Mausoleum.

(b) **Part of felloe with worked lower edge** (figs 16, 17). Preserved are the chamfered edges of the wheel rim, and part of a half-spoke, together with the end of a strengthener behind it. In the tyre is a cutting for a clamp (H. 0·14 m; W. 0·03 m; D. 0·05 m [tooth]), which once fixed the upper half of the wheel to the lower half. Numbered 254 (red). From south side of Mausoleum.

(c) **Part of felloe from midway between spokes.** Numbered 256.8 (red). According to the Invoice of cases, found at the 'north-east angle of the Peribolus'.

(d) **Part of felloe.** Numbered 254 (red). From south side of Mausoleum.

(e) **Fragment of spoke.** Numbered 254 (red). From south side of Mausoleum.

(f) **Fragment of spoke.** Numbered 254 (red). From south side of Mausoleum.

(g) **Fragment of spoke from close to join with felloe.** Numbered 254 (red). From south side of Mausoleum.

(h) **Large fragment of horizontal half-spoke from close to join with felloe.** Front and back edges are preserved, but the inner strengthener is broken away. The underside has been neatly dressed with the claw chisel. No number. Finding-place not known.

(i) **Large fragment of spoke.** No number. Finding-place not known.

(j) **Fragment of spoke** with original surface preserved on one side only. No number. Finding-place not known.

(k) **Small fragment of spoke** with original surface preserved on one side only. Numbered 207 (red). According to the invoice of cases, from the Imam's field on the north side.

Fragments (a), (b), (d), (e), (f), and (g), which were all found on the south side, may have belonged to the same wheel or half-wheel. Some of the fragments which have no number are likely to have come from the Imam's field on the north side, since it is clear from HD that more than one fragment of spoke was found there.

Dimensions. Over-all diameter 2·30 m. Diameter of hub, outside 0·38 m; inside 0·42 m. Projection of hub from spokes, outside 0·095 m; inside 0·20 m. Th. of hub block 0·47 m. Width of rim including chamfered edge 0·195 m. Th. of rim 0·17 m. Th. of tyre 0·10 m. Width of spokes varies between 0·13 and 0·15 m. Th. of spokes *c.* 16–17 cm. Th. of strengtheners 0·075 m. H. of top of strengtheners above diameter of wheel 0·23 m. H. of top of strengtheners above top of half-spokes 0·16 m.

Marble. The same as that used for the horses, white, fine-crystalled with streaks of schist. All surfaces have been finished with the claw chisel except where otherwise noted. The outer hub of the chariot wheel is considerably more weathered than the inner hub.

Fragments (*a*) and (*b*) are of the greatest importance for the reconstruction of the wheels. They show that the wheels were carved in two halves, which were clamped together, and that they had six spokes with chamfered edges. The over-all diameter of 2·30 m is provided by the outer curve of the rim of fragments (*b*), (*c*), and (*d*).

The only features which Newton failed to interpret correctly are the marble strengtheners which ran at about the height of the inner hub on the inside of the wheel to give extra support to the horizontal half-spokes that were the unavoidable consequence of carving the wheel in two parts. Newton noted the protrusions on fragments (*a*) and (*b*), but suggested in *HD* 130 that alternate intervals between each pair of spokes were entirely closed with marble to give greater strength. When he came to reconstruct the wheel, he was obviously unconvinced by his own suggestion, and he took no account of the protrusions at all. The first correct interpretation was made by von Lorentz, *Maussollos*, 18–19, and he was followed by Jeppesen, *Paradeigmata*, 41.

One can only speculate about why the wheels were carved in two halves. It was hardly done for ease of sculpting, because, as has been noted, the division into two parts necessitated the use of unsightly strengtheners. The more likely explanation, for which it must be admitted there is no direct evidence, is that the lower half of each wheel was probably left solid in order to take the weight of the chariot, the individual spokes being carved in relief, perhaps to the depth of the strengtheners on the upper part (*c*. 9·5 cm). Solid lower wheels could have served as supports for the floor of the chariot, and would have had the advantage of masking any other supports that might have been necessary underneath the floor of the chariot (for example, fragment 25, below).

If the lower half of each wheel was left solid, then we certainly have fragments of both chariot wheels extant, as seems likely in any case, because there are too many spoke fragments preserved to fit into a single upper half.

Newton, *Papers*, i, 46; Newton, *HD* 106, 129; *MRG* 37; Smith, *BM Cat.* 1004; von Lorentz, *Maussollos*, 18–21; Jeppesen, *Paradeigmata*, 39–41; Riemann, P-W, 437–8; Müller-Ammon, *The Seven Wonders of the World* (1969), pl. on p. 240.

25. Drum probably from support for chariot

(pl. 12)

BM 1005, 6; *MRG* 36g; Reg. 1857.12–20.288.

Found by Newton in the large sculptural deposit to the north of the north wall of the *peribolus* (Invoice of cases, no. 226). An oval stone with smoothly dressed surfaces and more roughly worked sides which taper slightly. According to Newton, *MRG* 36g, several other similar stones were discovered which fitted together to form a tapering pillar. This stone was the largest and was the only one brought to England. Some of those left behind were found by Jeppesen in 1972.

Dimensions. Lower side: L. 0·64 m. W. 0·49 m. Upper side: L. 0·60 m. W. 0·475 m. Th. 0·245 m.

Marble. White, medium-crystalled.

Each face is laid out in a grid system similar to that on the end of fragment 2, consisting of one line scored along the length, intersected by two lines across the width.

The underside is dressed all over with the claw chisel, and has two dowel holes into which run V-shaped channels, through which lead was poured to seal the joins. In one of the cuttings lead still remains, but there is no trace of the dowel itself. The other empty cutting measures 6 × 3 cm. Around the point where two lines of the grid intersect, there is a shallow rectangular cutting made up of V-shaped grooves. Since it is of similar dimensions to the dowel hole nearby, it may be a false start on the part of the mason, or it may simply be a mason's mark.

The upper surface has been dressed for *anathyrosis*, an oval area in the centre being slightly recessed and more roughly worked. There is a grid system like that of the underside, except that one of the cross-lines was wrongly aligned and had to be rescored. Again there are two cuttings for dowels, in both of which lead remains. The dowels however have disappeared, leaving narrow slits measuring 3 × 1 cm.

There is no proof that this drum was part of a support for the chariot, but the style of carving, with rough outer surfaces, clawed faces and use of grid system, makes it likely that it belongs to the chariot group. Since we know what the supports for the horses were like, it is difficult to see what else it could have supported if not some part of the chariot.

Newton, *MRG* 36g; Smith, *BM Cat.* 1005, 6.

Main Fragments of Statuary

26. Colossal standing male figure, so-called 'Maussollos' (pls 13–15)

BM 1000; *MRG* 34. Reg. 1857.12–20.232.

Reconstructed from numerous fragments found by Newton in the main sculptural deposit north of the north wall of the *peribolus*. The head was found a few feet to the east of the body (*HD* 104, 214, pl. XI). Sixty-three fragments were initially recognised, eleven more being added later on closer inspection of the smaller fragments in London (*RM*, i [1886], 188). Three further fragments which belong have since been identified (see below), bringing the total so far to seventy-seven.

Dimensions. Over-all H. 3 m, excluding the base. The height has been variously given by previous writers as 2·99 m, 3 m, 3·015 m or 3·03 m. The discrepancy is of no significance for a statue which has been reconstructed from so many fragments. For what it is worth, the present writer measured the height as exactly 3 m, after the head had been removed and reset in its present position in summer 1968. Th. of base not known for certain; it has not been fully exposed since the last century. According to van Breen, *Het Reconstructieplan* (1942), 310, it is 12 cm. Max W. of statue (not including fragment of scabbard) 1·12 m. W. of statue at feet (as preserved) 0·74 m. Max. Th. (from left knee to back) 0·68 m.

Marble. After thorough cleaning of the statue in the early summer of 1969 the marble was found to be white, fine-crystalled with a yellow-brown patina in places. It looks as if it may be Pentelic: this was the opinion of Furtwängler, *AZ*, xxxix (1881), 306. According to J. Watson, *Marbles* (1916), 158, and, after him, Riemann, P-W, 439, the marble is Parian, but this does not seem at all likely. See above, p. 14.

Head. The head, which was carved separately, is reconstructed from four fragments:

(*a*) Base with tapering sides, which was let into body, and lower part of neck.

(*b*) Left side of neck and bearded left jaw, up to level of left ear.

(*c*) Most of the face, together with the hair above the forehead and on the right side. The back of the head is almost entirely missing.

(*d*) Piece of hair from the lower right side of the head, one end adjoining the hair of fragment (*c*), the other worked so as to rest on the shoulder of the torso.

Restoration. Plaster has been used to fill the gaps between the fragments of face and neck. Restored between fragments (*b*) and (*c*) are: left part of forehead; left corner of left eye; most of left cheek; tip of left part of moustache; and part of chin. Much of the right side of the neck between fragments (*a*) and (*c*) also consists of plaster, which continues round to fill the slight gap at the front between fragments (*a*) and (*b*). The hair on the left side of the head was once restored in plaster, but this has now been removed.

Dimensions of head. Max. H. (including base) 61 cm. Max W. (including base and hair) 41 cm. Max. Th. 40 cm. *Face.* Chin to crown of head 39 cm; chin to top of

forehead 31 cm; chin to centre of lips 8 cm; centre of lips to base of nose 3·5 cm; base of nose to bridge of nose 10 cm; bridge of nose to hairline 9·5 cm. W. of mouth 9 cm; W. of right eye 6 cm; W. from centre of nose to right side of face 13 cm. Therefore total width of face at eye-level probably originally c. 26 cm.

Treatment of head. The proportions of the face, strongly carved features, and treatment of hair give the head a marked Asiatic character. The forehead is low in relation to its width, but it has a pronounced bulge above the eyebrows (in the fourth-century fashion). The nose, narrow at the bridge, broadens considerably towards the nostrils. The left nostril is drilled, the right one broken, although the break has been smoothed, apparently for an ancient repair. According to Adam, *Technique of Greek Sculpture* (1966), 81, the new nostril must have been fixed with cement or mortar. The eyebrows diverge sharply, almost at right angles, from the nose, and then sweep up into high, wide curves which are emphasised still more by the bulge of the forehead. Beneath them the eyes are deep-set and rather small, the upper lids sharply carved, tear ducts clearly marked. Faint undulations below the eyes suggest the loose skin over the lower eye socket. The cheeks are full and fleshy, and are delineated from the nostrils by strong creases. The lips are closed, the lower one short, but full and protruding, the upper one wider, but 'curled' to give an arrogant if not slightly cruel expression. Over the upper lip is a short moustache, the hairs of which are only lightly carved, and this merges on either side of the mouth with the close-trimmed beard, which covers all the chin and lower jaws, but not so as to obscure the strong and powerful structure of the face. The hair of the beard is rendered by short, curling, triangular locks, within each of which are two or three schematic lines representing the individual strands of hair.

The hair of the head is worn long, in the prevailing fourth-century Asiatic fashion. It sweeps up from the forehead, and then falls in deep waves down by the right side of the face, obscuring the right ear, to rest on the shoulders. Traces of the running drill can still be seen in some of the deeper grooves. None of the hair is preserved on the left side of the head, but a groove remains on the neck, showing where the line of the hair was. A drill-hole, in about the position of where the left ear would have come, is perhaps modern, having possibly served to secure the plaster locks which were once attached to the left side of the head.

According to Newton, *Papers*, i. 22, traces of colour were visible in the corner of the eye and in the nostril when the fragments of head were first uncovered. Which colour is not specified, but presumably it was red or rose.

The weathering on the top and back of the hair is much severer than on the face (although that too is weathered), a fact which suggests that the statue stood in an exposed position on the building.

Base of head. The head was joined securely to the body by means of a base or tenon, roughly oval in plan, with tapering sides, which fitted into a corresponding socket cut in the torso. The upper edges of the tenon are somewhat battered, but the underside is quite well preserved.

Dimensions. W. at shoulder level 34 cm; W. (underside) 29 cm; D. (underside) 21 cm. H. of tenon let into body, below neck at front, 10 cm; rather more at back. The sides of the tenon are tolerably smooth, but the underside is roughly worked with the point.

In the middle of the underside is a cutting for a dowel, measuring $6·5 \times 5 \times 10$ cm deep, the sides tapering slightly. A duct for the lead which was poured in to seal the join runs across the underside, and originally came out in the region of the left shoulder. It measures 2 cm W × 1 cm D. The surfaces of this duct and much of the underside of the tenon are covered with a red deposit of oxidised lead, which extends 3 cm within the dowel hole, indicating the limit of the penetration of the lead around the dowel. The deposit of lead appears to have been considerably more substantial when first found than it is today. Cf. Newton, *HD*, 214 n. *b*: 'another fragment, on the lower edge of which are the remains of the lead originally used to secure it in its socket, and still presenting an impression of the marble surface immediately below it'; quoting E. Hawkins, *Further Paper respecting the Excavations at Budrum* (London, 26 March 1858). This original deposit is apparently still visible on the photograph taken by Ashmole just before the last war (pl. 15).[1]

The axis of the base is at an angle to the front of the face, so that when the head is set on the body it is turned to the right.

Socket in body. The socket cut in the body to receive the head is quite well preserved except at the front, where the edge is broken.

1. Substantial fragments of lead from the Mausoleum excavations, which evidently secured the heads of statues in sockets, are still preserved in the British Museum, Reg. 1976.1–5.1–9. These may include portions of the lead which held the head of 26 in place, since some fragments retain impressions of roughly carved marble sockets, which correspond with the description of Hawkins.

Dimensions. W. of longest axis between shoulders: 36 cm at top, 30·5 cm at bottom; Th. at bottom 23 cm; D. of socket by right shoulder 13 cm; by left shoulder, which is held higher, 19 cm.

In the middle of the socket is a dowel hole, 8·5 cm square and at least 8 cm deep (true depth not ascertained). Around the upper edge of the socket at the back of the statue is a flat, smoothly worked band, on which rested the underside of the long tresses of hair.

The base of the head does not fit tightly into the socket, and considerable variations in the relationship of head to body would be possible were it not for two controlling factors:

(i) A hole drilled in the back of the base of the head, towards the right side, 11 cm up from the bottom, and measuring 1·5 cm in diameter by 6·5 cm deep, clearly has to coincide with a similar hole drilled into the socket from the back of the statue. This hole (first noted by Newton, *RM,* i (1886), 188; cf. Adam *TGS,* 80) must have been drilled after the head had been set in position with lead, in order to further secure it with a metal pin.

(ii) Since a strip on the back of the socket has been worked smooth to receive the hair, it is obviously desirable that the small piece of hair on the right side of the head, whose underside is preserved, should rest on this. It should perhaps be noted that, in the present battered state of the head, wedges have had to be used to make the hair adjoin the shoulder cutting.

When both these conditions are observed, as they have been in the present reconstruction, the head is not only turned to the right, but is also inclined towards the right shoulder, and lowered slightly in the direction of where the right hand may have been.

Body. Reconstructed from the seventy-three remaining fragments. Most of these are smaller portions of drapery, whose position is ascertained by the general lines of the folds. The bulk of the body consists of three large fragments which fit together quite well.

Restoration. The whole statue, as reconstructed, rests on a stone 'shoe', which fills the gap between the feet, and extends from the front to the back of the statue, where the drapery once reached the ground, but is now broken. Other areas restored in plaster are: the edge of a major drapery fold which runs from the outside of the right calf muscle up to the inside of the left thigh; the outer part of the right thigh just below the hip; the right buttock and small of the back; several small areas of the bunched himation around the waist.

Pose. The pose is easy and relaxed. Most of the weight is taken on the right leg, and the right foot rests flat on the ground. The body is balanced by the left foot, the toe of which once touched the ground. The left leg, although free, is not set back or to the side (as tended to be the case in late fifth-century sculpture), but is set forward, so that the left knee pushes through the garment, and the toe of the raised left foot would have come roughly as far forward as that of the right foot. This rather more rhythmic stance became popular in the earlier part of the fourth century. The effect of the stance is to raise the right hip, and thus push it through the drapery, and lower the left hip, which is obscured by the drapery. This pattern is reversed in the upper half of the figure, the right shoulder being lowered, while the left is raised considerably higher, with the result that the frontal line of the statue is a gentle S-shape.

Drapery. Two garments are worn: (i) a ground-length tunic of thickish material—hardly a chiton, perhaps rather an Asiatic *surma.* This is visible only over the upper body at the front, around the right shoulder (and perhaps once over the upper right arm, if the garment was sleeved), and below the himation at the back of the statue, where the folds are rendered in the most schematic way. (ii) A large himation. Two of the corner tassels (or weights) are preserved, one in a deep fold beside the left hip, the other underneath a fold close to and just above the left knee. The other two tassels must have been on the portion of drapery removed from the lower left side, as von Lorentz has suggested (*Maussollos,* p. 40). The himation runs from beneath the left armpit, around the body just below the breasts, where the upper edge is folded over and tightly bunched. It then passes under the right armpit and diagonally up across the back in sweeping folds to the left shoulder, from where it falls over and around the left arm to the ground.

Treatment of drapery. The folds of the tunic are represented as sharp ridges, broadly and evenly spaced. Rather unimaginative, but perhaps intended to contrast with the more elaborate himation. Flabby breasts, modelled through the folds of the tunic, and a considerable paunch, which is partly obscured by the bunched folds of the himation, are an attempt to express maturity of age.

The himation is composed in such a way as to accentuate the rhythm of the pose. The line of the shoulders is picked up by the top of the bunch of the himation and by the bottom edge of the himation around the ankles, while the line of the hips and knees is paralleled by the bottom edge of the overfold of the

himation. The overfold of the himation thus forms the important transition from the lower to the upper part of the figure. The carving of the himation shows a high degree of skill. Strong rounded folds model the form, while avoiding transparency, and are contrasted with one another in line, direction and depth. For example, the heavy bunching of the upper overfold contrasts with the smooth area of the lower overfold; the deep twisting folds over the right leg contrast with the broad spaces over the left leg, particularly below the left knee. In design this is formal, classic drapery, in the traditions of the fifth century, where the major lines and folds are subordinate to the overall concept of the form. The formalism of the composition is relieved, however, by a certain amount of realistic detail in the treatment of the texture of the drapery. This is of two particular kinds:

(i) Creases resulting from the folding or pressing of the himation prior to its being worn. These run roughly horizontally across the upward pull of the formal folds (they are parallel, in fact, to the line of the upper edge of the bunched himation, and to the line of the shoulders). Four creases are visible: (*a*) from left knee to right calf; (*b*) from left thigh to right knee; (*c*) on overfold, from area of left hip towards right hip; (*d*) on front and side of drapery below left arm—here quite horizontal; crease (*d*) is possibly a continuation of crease (*b*). With one exception these creases occur only on the front and sides of the statue; the one exception is to be found on the lower left side of the himation at the back, otherwise there are no creases on the main sweep of the himation at the back, suggesting that the finish here is less careful than on the rest of the statue. Transverse creases of this kind are a sophistication first employed by fourth-century sculptors (see above, p. 69).

(ii) Random creases caused by the wearing of the garment. These are numerous. They are to be found, for example, on the lower triangle of drapery between the left knee and right ankle; on the overfold of the himation; on the drapery below the left arm.

There is a seam on the lower edge of the overfold, where it is preserved, and another on the lower edge of the himation which runs round to the left side.

Feet. Elaborate sandals are worn on the feet. Little remains of the left one, but that on the right foot is well preserved except for a small part missing where the front part of the foot has been broken and rejoined.

Dimensions of right foot. L. 48 cm. W. 18 cm. Th. of sole of sandal 2·5 cm. The sandal consists of a fairly thick sole, a toe cap of elaborately worked straps, and a leather upper which starts within the toecap where the two sides of the upper do not nearly meet and passes behind the heel. Within the leather upper is worn, presumably, another soft leather slipper or sock, since no toes or bare flesh are carved. A broad ribbon laces the two sides of the upper together, commencing from the straps of the toecap, crossing to pass through eye-holes in the uppers, and then crossing again to pass through large rings on the outside of the upper. The two ends of the ribbon were then tied in a bow, one part of which hangs below the drapery on the outer right side of the foot. The ribbon may have passed around the back of the ankle, although this is not visible here because of the drapery. For fragments of similar sandals, see below, nos 211, 213–216; and cf. above, p. 69.

Left arm. Fragments adjoining the left shoulder and upper left side of the body show that the upper left arm was held down close to the body, and that the lower arm was extended. It is certain now too that a sword scabbard was held in the left hand. Two adjoining fragments consisting of the lower end of a scabbard and a portion of drapery, were found to join flushly to the himation on the lower left side (pl. 15). The attribution of these fragments was first made by Koch, *Leipz. Winckelm.– Blatt* (1929), figs 1–2, and he was followed by von Lorentz, *Maussollos*, 49–50, figs. 4–5, but it was not thought the fragments fitted exactly (they were able to use casts only in their experiments). Riemann, P-W, 439, after von Lorentz, claimed a gap of 'nur 0·01 m'. This was sufficient for the attribution to be disputed (for example by Jeppesen, *Paradeigmata*, 50; and Borchhardt, *AA* 1968, 202). There is now no doubt that the fragments belong. The area of the join measures *c.* 10·75 × 7·75 cm, although some of this area on the scabbard fragment has been destroyed by a square cutting, made to mount it on a base.

Details of fragments. MRG 38d (there attributed by Newton to the Persian rider). Lower fragment, scabbard and drapery, numbered 260 (red) and 414 (black). Upper fragment, drapery only, initialled C.T.N. (red).

Dimensions. Max. H. 39 cm. W. 14 cm. Th. 17 cm.

Marble. White, fine-crystalled. The drapery is preserved on all four sides—the only break is at the back (4 cm W.). The outer surfaces are well finished, but the inner surface is rough and was obviously difficult to reach. A deep groove cut by the running drill is a continuation of a more carefully finished groove on the lower drapery of the main statue. There are light rasp marks on the inner drapery, and particularly heavy rasp marks on the back of the scabbard which is preserved.

The lower end of the scabbard is rounded and measures 12 cm H. × 15 cm W. × 3 cm Th. Above it is a fillet, 2 cm H., and above this remnants of the blade casing, which has a pitched front, the total width being c. 11–11·5 cm. Scabbards of a similar type occur on the Amazon frieze (slabs BM 1008, 1010, 1012, 1018, 1019, 1022), and on the column drum from the later Artemision at Ephesos (BM 1206; worn by Thanatos. Smith, *BM Cat.,* pl. xxiii).

The sword scabbard was held diagonally inwards towards the body at an angle of c. 70 degrees to the horizontal, the lower end pushing into the drapery. This explains the outward diversion of the drapery folds on the himation of the main statue. But the drapery here is not logical. If the scabbard pushes into the drapery, then the drapery ought not to run inwards again underneath it, unless of course the width of the lower part of the statue had to be reduced.

It is clear that most of the scabbard was carved in the round. Part of this upper, free-standing scabbard is almost certainly preserved in a fragment not hitherto recognised as such (pl. 15): Reg. 1972.4–4.113. Numbered 206 (red). According to Invoice of cases, found in the Imam's field, on the north side in the same area as 26. A fragment of sword scabbard, with pitch at front and back. Max. H. 18·5 cm. W. 11·5 cm. Th. 7 cm (Th. of blade 6 cm). The front is smoothly finished, but the back has rasp marks similar to those at the back of the scabbard on the other fragments. At the lower part of the back of this fragment there is also a bulge where the scabbard has diverged from some other object. The thickness of the break here, 1·5 cm, matches the thickness of the break at the highest point on the inside of the other fragment. And the grain of the marble of this fragment runs vertically when the scabbard is set at an angle of c. 70 degrees. Although there is no join, there can be little doubt that this fragment also belongs to 26.

Judging from the dimensions of the preserved portions of the scabbard, and from the proportions of the scabbards on the Amazon frieze and Artemision column drum, the complete scabbard is likely to have been c. 84 cm long, if empty, or c. 98 cm long, if it had a sword in it. Taking into account the 70 degree tilt, a scabbard of this length would have terminated close to the left breast of the figure (see von Lorentz's fig. 4, which is correct in this respect). As this is somewhat higher than the top of the drapery over the left forearm, which is preserved on a single fragment from the region of the elbow, it is likely that the left hand grasped the scabbard about two-thirds of the way up the blade.

In all probability the left hand and lower arm, and the upper part of the scabbard above the hand, would have been carved separately, perhaps in two pieces (one consisting of lower arm and hand, the other being the upper scabbard, fixed by a dowel through the hand to the lower scabbard). The reasons for this supposition are as follows:

(i) The upper part of the scabbard must have come close to the drapery of the torso, particularly the bunched overfold and tunic on the left side of the body. This area of drapery could not have been well finished, as it is, if the upper scabbard had been carved from the same piece of marble as the body of the statue.

(ii) That the forearm was carved separately is verified by a cutting on the underside of the fragment which preserves the drapery from over the left arm. This cutting, which is of dovetail shape, and runs horizontally from the front to the back of the statue must be for the attachment of a forearm (for other examples of dovetail cuttings, see above, p. 63). Since the front of this cutting is not preserved, it is impossible to say how much of the left forearm was separately worked.

It may be concluded that the left arm was held close to the body, with the forearm extended, and that the left hand held a sword scabbard at an angle, the lower end of which pushed out the himation on the lower left side.

Right arm. The right arm, which was worked separately and is now lost, was attached at the shoulder by means of a dowel. The lower part of a plane surface for the attachment of the arm remains (H. 9 cm. W. 18 cm, as preserved), angled downwards, but the upper part has been broken away with the arm. In this broken area is the remains of the dowel hole, 7 cm H. × 3 cm W. × 4 cm D. (depth much greater originally). Running into the dowel hole from the front of the statue is a round hole, 10 cm long by 1·5 cm diameter, now half broken away. This may have been a pour-hole for the lead which would have secured the arm dowel in position, but is more likely to have been for a transverse metal pin into the dowel. Such a cross-pinning of the dowel would explain why so much of the shoulder, and precisely one-half of the hole in question, was torn away with the arm.

To judge from the sinking of the right shoulder, the angle of the joint for the attachment of the arm, and the cross-pinning of the dowel, the right arm was almost certainly lowered, but its pose cannot be determined with any accuracy. There are a limited number of possibilities, however, bearing in mind that a scabbard was held in the left hand:

(i) The right hand could have held the sword from the scabbard, if the scabbard was empty.

(ii) The right arm could have passed across the body to clasp the sword within the scabbard. (This is unlikely, as it is doubtful if the right shoulder is turned sufficiently to allow it.)

(iii) The lower right arm could have been raised or stretched out, resting on a sceptre. (It may however be contrary to the principles of Greek sculpture to have the sceptre on the same side of the figure as the supporting leg.)

(iv) The arm could have been completely lowered and stretched forward, holding a patera.

It is possible that the colossal right hand, 142, may belong to this statue, since it was found in the same sculptural deposit in the Imam's field (see below, ad loc.). If so, possibility no. (iv) would be most likely.

Cutting in drapery on lower left side (pl. 15; fig. 18). The cutting in the drapery on the lower left side has been the most controversial feature of the statue, particularly as regards its positioning on the building.

When the statue was originally carved, the end of the himation on the left side fell from over the arm and beside the left leg as far as the ankle, in two principal folds. Subsequently, although when is not certain, both these folds were cut away at differing heights in the region of the left knee, inwards almost as far as the left leg.

There appear, in fact, to be two different cuttings:

(i) A cutting in the outer fold of the himation at a point exactly 1 m above the base, and c. 50 cm below the point where the fragment of scabbard adjoins. The cutting, whose edge is neat and well squared, penetrates c. 7·5 cm, i.e. as far as the inner fold of the himation, which is not cut away here. The exposed surface of the inner fold is carefully finished with the claw chisel. Another part of this first cutting is probably to be recognised in a patch of neat claw work at a point c. 60 cm above the base. Elsewhere it has been largely obliterated by cutting (ii).

(ii) A cutting in the inner fold of the himation at a height varying from 82 to 92 cm above the base. The point was used to remove the marble, and the coarseness and roughness of the chiselling is surprising. Whereas the cutting (i) in the outer fold was neatly squared off, the inner fold has been hacked away, the edge of the cutting not being chiselled level across the fold, and varying in height by up to 10 cm. The removal of the inner fold has also revealed the coarse working of the himation over the lower left leg, which was once concealed by the deep drapery fold. Where the inner fold adjoined the main bulk of the statue, a strip about 9 cm

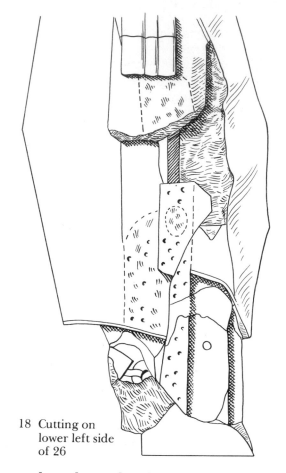

18 Cutting on
lower left side
of 26

wide, and extending from 72 cm above the base down to 10 cm above the base (but, no doubt, once from 82 cm down to ground-level), has been levelled with harsh strokes of the point. Towards the bottom of the statue, no more than a centimetre or two in depth of marble has been removed below cutting (i), and in one place the claw work of cutting (i) remains.

Behind cutting (ii), at a height of 29 cm above the base, is a drill-hole, 2 cm in diameter, filled now with plaster. Almost certainly this is modern work. It cannot, in any case, have had any significance for the cuttings, as it is 5 cm behind the pointed strip.

Interpretation of cuttings. There have been two main interpretations:

(a) That the statue was found to be too wide for the place where it was intended to stand (most people thought in the chariot), and so the lower drapery was removed to fit it in position: firstly cutting (i), carefully and perhaps in the workshop; then cutting (ii), hastily and crudely, when it was found that still more marble had to go—perhaps carried out on the building (Krischen, and others).

(b) That the drapery was damaged during carving, or the block was of insufficient size, and that the cuttings are simply for the attachment of a separately worked piece of drapery. See von Lorentz, *Maussollos,* 40 ff. (he notes the differences in the chiselling, but ascribes them to one and the same cutting).

The difficulties of view (b) are that:

It does not take sufficient account of the differences in the chiselling.

There are no dowel holes in the statue. It is unlikely that so large a piece of drapery could or would have been simply cemented in position (A. v. Gerkan, *GGA,* ccxiv [1960], 6, 12; cf. Riemann, *Gnomon,* xxxiii [1961], 71).

It is difficult to see how an extra piece of drapery could have fitted. The edge of the outer fold has been neatly squared, but the edge of the inner fold goes almost to a point, and has clearly not been worked for the attachment of a separate piece.

It looks as if view (a) is nearer the mark, although it is impossible to come to any firm conclusion.

The difficulty is that the two cuttings are at odds with each other. Cutting (i) looks as if it could have been intended for a join, while cutting (ii) has all the appearance of hasty hack-work, the need to remove an area of marble in the quickest possible time.

If the statue did have to be cut down in order to fit it in position, it says little for the coordination between the architectural and the sculptural planning of the building, but there are precedents. That the statue was, in any case, intended to stand in a confined space may be suggested by the unnatural fall of the drapery below the bottom of the scabbard (see above).

Identity of statue. The size and bearing of the statue, the portraiture apparent in the head, the non-Greek use of the under-tunic, and, particularly, the sword scabbard held in the hand, suggest that the statue is of a heroised ruler or lord. This means that almost certainly he belongs to the Hecatomnid dynasty. Which member of the dynasty, however, is impossible to say. There is no evidence that it is Maussollos who is here represented. Attempts which have been made to recognise 'Maussollos" features in heads of Heracles on Coan coins possibly issued under Carian domination have not been particularly convincing. It is true that the features of Heracles on the coins of Cos do change in the fourth century BC, but precisely when this change occurred is not known, other than that it was some time between 366 and 330 BC. In reality the new features on the coins probably do nothing more than reflect general changes

in fourth-century heads as compared with earlier classical profiles. It is too much to recognise in them the features of this statue. Cf. Six, *RM,* xiv (1899), 81 ff.; G. F. Hill, *Anatolian Studies presented to Sir W. M. Ramsay* (1923), 207 ff.; Riemann, P-W, 442; Richter, *Portraits,* ii, fig. 898.

Similar figures. See above, pp. 68–70.

Position on building. The severe weathering on the face, hair, and shoulders shows that the statue stood in an exposed position on the building. For further discussion, see above, pp. 14–15.

Scale. I.

Newton, *Papers,* i. 15, 22; *HD* 104, 214, pl. XI; *MRG* 34; Smith, *BM Cat.* 1000; Preedy, *JHS,* xxx (1910), 133; Krischen, *JdI,* xl (1925), 22; von Lorentz, *Maussollos,* 22 ff.; Neugebauer, *JdI,* lviii (1943), 49 ff.; Buschor, *MuA* (1950), 21 ff.; Lippold, *Gr. Pl.* (1951), 255; Picard, *Manuel,* iv 1 (1954), 84 ff.; Bieber, *Scritti in Onore di Carlo Anti* (1955), 67–71; Jeppesen, *Paradeigmata* (1958), 48–50; Carpenter, *Greek Sculpture* (1960), 214–16; Riemann, P-W, 439–42; Kabus-Jahn, *Studien zu Frauenfiguren* (1963), 70–72, pl. 12; Richter, *Portraits of the Greeks* (1965), ii, 161–2, figs 899, 900, 902; C. M. Havelock, *Hellenistic Art* (1971), 35–36, pl. 18.

27. Colossal standing female figure, so-called 'Artemisia' (pl. 13)

BM 1001; *MRG* 35; Reg. 1857.12–20.233 (body), 1857.12–20.260 (head).

Found in the main sculptural deposit north of the north wall of the *peribolus* (Newton, *HD* 103, no. 3; 216). Whether the head was found here is not explicitly stated. It was not recognised at first as belonging to the body (*HD* 225, no. 260).

The statue was carved from a single block of marble, unlike 26. The body now consists of two main fragments, united around knee-level by a restored area of lighter-coloured marble. The head, reconstructed from nine fragments, joins flushly to the body at the base of the neck.

Missing. Much of face; right forearm; some of left forearm; tip of left foot (for fragment of left big toe, probably belonging to this statue, see below, 28); area of drapery from front at knee-level; another area from back at similar level; drapery behind upper right arm; upper edges of veil; back of left shoulder; much of himation where it falls below arm on left side.

Dimensions. H. 2·67 m, excluding base. H. of base not known. Max. W. 1·09 m. W. at feet 0·78 m. Max. Th. 0·59 m.

Marble. The same as for 26, white, fine-crystalled.

Head. *Dimensions.* H. from break at bottom of neck 42 cm. W. 33 cm. D. 42 cm. H. of hair 5 cm. Hair extends backwards 3–4 cm, beyond which it is covered by cap; W. of left eye 4·5 cm; distance between tear ducts 5 cm; H. from line between tear ducts to top of forehead 9·5 cm. Left ear: H. 7 × W. 5 cm.

Most of the lower part of the face is missing, including chin, mouth, nose, some of the right eye, left eye-ball, and much of the right ear. The hair consists of three superimposed rows of curls, of a style which is found on other heads, except that here the individual curls are globular and have no hairs carved on them. Most of the hair is covered by a tight cap or *sakkos*, over which the upper edge of the himation has been drawn as a veil, passing just behind the ears. At the back the pointed end of the cap protrudes through the veil, whose folds are only summarily rendered here, except for a zigzag fold just below the join between head and body.

Forehead and hair are considerably weathered.

Body. The form is heavily built and rather corpulent. The protruding stomach and full, sagging breasts are suggestive of mature age (cf. statue 26). The weight of the figure is taken fully on the left leg, while the right leg is at ease, the heel of the right foot being raised slightly from the ground, but not set back. The upper part of the body is set square, shoulders level, head upright, and gaze straight forward. Both upper arms are held close to the body, while both lower arms were once extended, the left being held somewhat higher than the right. (Dimensions of breaks of arms: Right arm at elbow, H. 18·5 cm. W. 18 cm; left arm at mid-forearm, H. 13·5 cm. W. 13 cm.)

Drapery. Two garments are worn: (i) A ground-length chiton, with elbow-length sleeves fastened by buttons, which is visible only over the upper part of the body at the front, and around the ankles at front and back. (ii) A large himation which envelops the form, running from the left side around the right leg, and then up across the back to the left shoulder, whence it falls over and around the left arm to the ground. The upper edge of the himation at the front is thickly bunched around the waist. At the back it is drawn up over the head to serve as a veil.

Treatment of drapery. Over the upper body the chiton is rendered by a series of shallow folds, slightly tautened over the breasts and deeper between them, executed for the most part by means of the running drill,

clear traces of which remain at the bottom of the grooves. The sharpness and the multitude of small folds well convey the light texture of the material, but the arrangement of folds is somewhat dull and unimaginative. Much more effective is the treatment of the chiton around the ankles, where deep folds of the garment that cast shadows contrast with shallow, angular, twisting folds on the surface, which suggest the crisp, light texture of the material—this is almost overdone where the chiton flounces over the left foot. There is a rather harsh transition where the chiton passes over the right foot. Here the direction of the folds changes suddenly from vertical to horizontal, and the contrast between depth and shallowness vanishes. This style of treatment of the lower chiton is perhaps Praxitelean in origin, although it was widely applied in Greek sculpture in the later fourth century. At the back the chiton is only very summarily worked (cf. Preedy, *JHS,* xxx [1910], 156–7).

The treatment of the himation is similar in conception to that of statue 26, but is perhaps slightly inferior in execution. Again there is parallelism between the main cross-lines of the drapery (i.e. bunched folds of himation are roughly parallel to lower edge of himation), but these lines do not agree with the shoulders (as on statue 26), which are here square. The pose is more static, and there is less harmony between drapery and form.

There is, however, much the same surface detail as on statue 26. Creases resulting from folding or pressing the garment prior to its being worn: three of these are visible running horizontally across the himation, around the lower right leg, just above the right knee, and over the upper right thigh.

Random creases caused by the wearing of the garment are also common, especially in the plain area above the lower edge of the himation (they are found in a similar place on statue 26). There is also a convincing crumpling of the garment below the left arm (cf. drapery on support of Hermes of Olympia).

The carving of the himation at the back is rather more summary than at the front, particularly on the upper left side and at the back of the head. Cf. *JHS,* xxx (1910), 155.

Feet. *Dimensions.* L. of right foot 41 cm; W. 16 cm. Thick-soled sandals are worn, the soles 4 cm high, but there are no traces of straps, which therefore must have been represented in paint. A gap appears to have been left for the painted strap between the big toe and the second toe of the right foot.

Technique. The finish is generally good. When harsh tool marks are left it seems to be to achieve a special effect—so with the sharply drilled grooves in the chiton. A broken drapery fold to the left of the left knee appears to have been repaired in antiquity. The break has been smoothed and two holes drilled for the addition of a new piece. The small area of base which is preserved to the left of the left foot has a smooth surface.

Scale. Slightly smaller than statue 26, to which it is in the ratio of 9:10, but the difference is perhaps no more than that between a tall man and a woman of medium height. See above, pp. 35–6.

Identity. Probably one of the female members of the Hecatomnid family. Apart from the fact that she is shown to be of mature age there is no clue as to who she is. There is no reason to identify her specifically as Artemisia.

As with 'Maussollos', so too the features of 'Artemisia' have been recognised in heads of Demeter on coins of Cos (cf. B. V. Head, *Cat. of Greek Coins of Caria, Cos, Rhodes etc.* (1897), pl. 30, no. 11). Since, however, the facial features of this statue are almost wholly destroyed, it is difficult to see how such an identification can be considered. The formal curls over the forehead, which are the one certain feature of the head, do not occur on the coin type.

Similar figures. The figure type is a fairly common one in the mid-fourth century. For examples, see above pp. 70–71.

For the hairstyle of this statue, compare the other female heads from the Mausoleum, 30, 31, 32 (below); also the fourth-century heads from Priene, BM 1151, 1153; Berlin 1535, 1536. Cf. above, pp. 71–2.

Newton, *HD* 103, 216, 225; *MRG* 35; Smith, *BM Cat.* 1001; Preedy, *JHS*, xxx (1910), 154 ff.; von Lorentz, *Maussollos*, 22 ff.; Buschor, *MuA* (1950), 22; Riemann, P-W, 442–5; Kabus-Jahn, *Studien zur Gewandfiguren des 4 Jht. v. Chr.* (1963), 23–29, 70–72; Richter, *Portraits of the Greeks* (1965) ii, 161–2, fig. 901.

28. Fragment of a left big toe on sandal sole, probably belonging to 27

Reg. 1972.7–14.60. Numbered 179 (red).

According to the Invoice of cases, 179 contained a piece of statue no. 2 (i.e. 'Maussollos'), from the Imam's field.

Dimensions. L. 0·095 m. H. 0·10 m. W. 0·05 m. H. of sandal sole, 4 cm.

Marble. White, fine-crystalled.

A fragment of bare big toe resting on a sandal sole, the edge of which is preserved to the right of the toe, showing it to belong to a left foot. There remains also a crease across a joint, and the very edge of the cutting for the toe-nail. The scale is colossal, and the fragment is certainly from one of the colossal standing female figures, for whom bare toes are appropriate. A comparison with 27 ('Artemisia') suggests that it almost certainly belongs to that statue (the left foot is missing). Similarities include the scale, style of working of toe and sandal sole, height of sandal sole, and marble. There is however no join, since the instep of the left foot of 27 is still missing, so that the attribution is not wholly conclusive.

29. Colossal standing figure, probably male
(pl. 16)

MRG 39; Reg. 1857.12–20.236.

Found near the well in Omer's field, towards the east end of the north side of the Mausoleum (Newton, *Papers*, i. 13, Invoice of cases, no. 136; *HD* 223). Newton's remark, *HD* 101, that it was found 'about the middle of the west side' (of the Quadrangle), must be regarded as incorrect.

Reconstructed from three adjoining fragments, which preserve parts ranging from the left shoulder to midway down the left thigh. The fragments are as follows:

(i) Largest part, extending from above the waist to about mid-thigh on the left side. Both front and back are preserved.

(ii) Portion of upper body on left side, preserved only at the front.

(iii) A small part of the bunched himation folds between (i) and (ii). On either side of this fragment the line of the folds has been restored in plaster.

Dimensions as reconstructed. H. 1·42 m. W. 0·99 m. Th. 0·60 m.

Marble. White, fine-crystalled. The same as for 26 and 27.

The sex of the figure remains in dispute. The dress (chiton, or undergarment, and himation) is unhelpful, since it is worn by both male and female figures on the Mausoleum. Newton at first thought it to be female (Invoice of cases, no. 136), but later described it as male (*HD* 223; *MRG* 39). Jeppesen (*Paradeigmata*, 51 n. 58) thinks the form of the right hip female, and he has been followed by Riemann (P-W, 447). On the other hand, the thick material of the undergarment corresponds more

nearly with the tunic of the male statue, 26, than it does with the flimsy chiton of the female statue, 27; and there is no trace of a female breast on fragment (ii) from the upper body.

Pose. The weight of the figure seems to have rested mostly on the right leg, the hip of which is pushed prominently through the undergarment. The part of the upper left thigh which remains protrudes through the drapery, confirming that this leg was relaxed. Probably the stance was similar to that of statue 26.

Drapery. The chiton (or undergarment), which is preserved over the right flank, the stomach, and on the upper left part of the body, has a thick texture and is close-fitting. No surface folds at all are carved over the right hip, but there are some small cross-folds at waist-level. On fragment (ii) two folds radiate downwards from the left shoulder where there appear to be traces of a clasp. The himation, which covers the legs and the left side of the body, has a bunched upper edge that runs from the left shoulder, down across the belly to the right hip, and then around the hip (where it is now broken), up across the back, and over the left shoulder, where it disappears beneath the top of the diagonal bunch. At the right hip there is a protrusion of crumpled folds above the line of the bunch, similar to the crumpled himation beneath the left arm of 27, and behind this are the remains of some vertical folds. Below the diagonal bunch at the front, the folds of the himation gradually fan out over the protruding left thigh until they fall in heavy verticals beside the left leg.

Arms. The positions of the arms are not known for certain, but there is some evidence:

At a point on the right side towards the back, just above the hip, there is a rectangular cutting which runs horizontally into the figure: W. 2·5 cm; H. 4 cm (top of cutting not preserved); D. 8 cm (since the original surface is now missing at this point, the depth must once have been *c.* 12 cm). Within it are traces of the metal (probably iron) dowel. This cutting is likely to be for the addition of the right arm. One may infer, therefore, that the right arm was lowered, and that it may have been set akimbo, the hand resting on the back of the hip (a pose which became common in the mid-fourth century).

If one may judge from the broad mass of himation folds which fall outside the line of the left leg, and which in all probability represent the end of the diagonal bunch of the himation after it has passed over

the left shoulder, the left arm was probably extended sideways for some distance, and may perhaps have been resting on a sceptre.

Workmanship. So far as one can judge from so worn and damaged a statue, the carving is of a high standard, although it seems different in style to that of statues 26 and 27. It comes closer to the working of some of the smaller fragments of colossal statues which are preserved. At the front the drapery is deeply worked with the running drill, and well finished, although the arrangement lacks inspiration. At the back the drapery folds are shallower and more schematic, although there is a degree of broad modelling (perhaps less well worked at the back than statues 26 and 27). As with 26, and some of the other colossal figures (but not 27), the statue was carved in more than one piece.

Scale. About the same as that of 26.

Newton, *Papers,* i. 13; *HD* 101, 223; *MRG* 39; Neugebauer, *NJb* (1942), 60, pl. 2,2; Buschor, *MuA* (1950), 22, fig. 19; Jeppesen, *Paradeigmata,* 47, 51, fig. 22R; Riemann, P-W, 447.

30. Colossal female head from statue
(pl. 16)

BM 1051; *MRG* 44; Reg. 1857.12–20.259.

Found in Mahomet's field, immediately to the north of the north wall of the *peribolus,* and close to the north-west corner of the Mausoleum Quadrangle (Newton, *Papers,* i. 15; Invoice of cases, no. 145; *HD* 104, 111, 224). Cf. *HD* 104: 'a little to the west of the house on the extreme left in pl. XI'; and *HD,* pl. IV, where 'female head' is written on the *peribolus* wall in this position.

Dimensions. Max. H. 0·48 m. Max. W. 0·31 m. Max. D. 0·43 m. *Head.* H. chin to hairline 30 cm; chin to division between lips 7·5 cm; lips to nostrils 2·5 cm; nostrils to line between tear ducts 8·5 cm; line between tear ducts to hairline 11 cm. W. of face at eye-level 21·5 cm; of each eye 4·5 cm; of nose at nostrils 6 cm; of lips 6·3 cm. H. of each ear 9 cm, W. 4·5 cm; *Hair:* H. 6·2 cm; projects from cap 4·7 cm. Diam. of each curl 2·2 cm.

Marble. White, fine-medium crystal.

The best-preserved female head from the Mausoleum. Broken off at the base of the neck. There is damage to the chin, lips, nose, right eye, curls on right of forehead, upper forehead and hair and cap above it. Elsewhere the surface is in generally good condition.

Proportions of face. Seen from the front the face is oval, chin narrowing but rounded, forehead broad and semicircular where it is confined by the formal curls. The cheeks are full, smooth, and fleshy. No wrinkles or creases are indicated, but the contours are well modelled. The forehead recedes slightly and has a low bulge over the eyebrows. The eyes are quite deeply set, wide open, eyelids not over-emphatic, tear ducts marked. The nose was fairly broad at the base, nostrils drilled. Lips (now broken) were slightly parted, the division being made by a fine running drill.

In profile the head is squarish and deep-sided, a feature which is exaggerated by the pointed cap which projects some way behind the back of the neck. The ears are smallish and set flat against the sides of the head, although their inner parts are deeply carved (2·5 cm).

Hair. The hair is exposed only at the front, where a triple row of formal curls runs above the forehead, terminating in front of each ear. The individual rows of curls are stepped back one from another. On the front of each curl spiralling hairs are neatly chiselled, and between the curls are shallow drill-holes. This is in contrast to the treatment of the curls of statue 27, where the locks are globular and no spiralling strands of hair are indicated. The topmost row of curls is exposed for 4·7 cm in depth. Beyond this the rest of the hair is confined by a close-fitting cap or *sakkos,* which is pulled tightly over the forehead and behind the ears. On the lower edge of the cap at the back of the neck there is crimping. The surface of the cap is very smooth, the only undulations in the material being two slight folds above the ear on each side of the head.

The treatment of the hair and the style of the cap give the head something of an archaistic appearance.

Pose of head. The head is not held erect, nor is it fully frontal. The neck which is preserved runs diagonally upwards from the left shoulder, and the head is twisted back to the left and is tilted upward. As a result there are three light crease marks on the left side of the neck. For this pose, compare the head of Apollo, below 48. The twisting upward angle of the head, squarish profile, deep-set eyes, broad nostrils, and lightly parted lips are all features generally held to characterise the style of Scopas. But such an attribution is not confirmed by the finding-place. No doubt these features were soon employed by other fourth-century sculptors.

Workmanship. The features of the face are very finely finished. The sides and back of the neck are slightly rougher, showing rasp marks. There are rasp marks too on the sides of the cap. A strip on top of the cap is very coarsely worked, and shows clear traces of the point and flat. In the middle of this area, there is a sizeable lewis-hole (L. 4·7 cm; W. 1·2 cm; D. 5 cm; the sloping edge of the hole towards the back of the head), which was presumably for hoisting the statue into position. This might suggest that the head was not worked separately and fitted into a body, for it is not so heavy by itself as to require a lewis-hole to lift it. Cf. the lewis-hole in the roughly pointed area on top of the back of the hind part of the chariot horse 2, above. The presence of a lewis-hole on this head might suggest that the statue was set fairly high on the building.

Scale. Slightly smaller than the head of 26, and slightly larger than that of 27. The facial features are markedly smaller than those of 26, but the forehead is higher (i.e. the over-all proportions of the heads conform to different systems). The eye is the same width as 27's (4·5 cm), and the width and depth of the head are similar. The forehead, however, is slightly higher than that of 27. See above, pp. 35–6.

Comparison with head of 27. The two heads are sculpted to the same general design, but differ in details. This head is not draped, and is rather more oval in frontal view; the hair is here treated differently, although it matches the dimensions of 27; the ears of this head are larger. One would ascribe it to a different, and perhaps superior, sculptor, working to the same orders.

Identity. Because of the similarity with the head of 27, and the common hairstyle, one must suppose this to be another member of the same family. Beyond this, there is no evidence.

Newton, *Papers,* i. 15, no. 5; *HD* 104, 111, 224; *MRG* 44; Smith, *BM Cat.* 1051; Jongkees, *JHS*, 68 (1948), 35, fig. 7; Buschor, *MuA*, 24, fig. 27; Picard, *Manuel*, iv. 1 (1954), fig. 45; Jeppesen, *Paradeigmata*, 37, 47, 51, figs 22R, 36; Riemann, P-W, 448.

31. Colossal female head (pl. 17)
BM 1052; *MRG* 45; Reg. 1857.12–20.261.

Found built into the chimney of the Imam's house, just to the north of the north wall of the *peribolus*, and close to the main deposit of sculptures (Newton, *Papers*, i. 30; Invoice of cases, no. 237; *HD* 111, 225).

Dimensions. Max. H. as restored 0·58 m; Max. W. 0·27 m; Max. D. 0·32 m.

H. from chin to crown 35 cm; chin to lips 7 cm; lips to line between tear ducts *c.* 10 cm; W. of face at eyes, *c.* 20 cm; W. of mouth, to judge from the drill-holes at the corners which vaguely remain, 5·5 cm. The positions of lips, nose, eyes, and ears are discernible from depressions or protrusions, but there are no details remaining.

Marble. Probably the same as that used for the other sculptures, but blackened by smoke and fire. On the right cheek, where a little of the original surface remains, the marble has a warm, brown patina. Generally in extremely poor condition.

A colossal female head, wearing a cap and partly veiled, in the manner of 27. The lower part has been worked for insertion into a separately carved body. Reconstructed from three large fragments:
 (i) Tenon and lower neck.
 (ii) Upper neck, face, and most of back of head.
 (iii) Large fragment of crown of head.

Restoration. Much of the neck at the front and sides is restored in plaster. Some plaster also smooths the join at the back between fragments (i) and (ii).

The shape of the head, seen from the front, is oval, roughly corresponding to 30. It is also deep in profile. Much of the forehead is missing, but there can be little doubt that the hair originally arched over the forehead from in front of the ears, as on heads 27 and 30. The lower edges of snail-shell curls are just visible on the left side of the forehead, and there is another remnant of a curl in front of the right ear. Traces of the cap which was worn are also to be seen behind the left ear and at the back of the neck on the right, where the veil adjoins.

Parts of the veil—probably, in fact, the upper edge of an himation—remain at the back and on the right side, although no details are preserved. It does not seem to have been pulled as far over the head as that of 27, because there are no traces of it at the right of the neck where the surface is quite well preserved.

Tenon. This is the best-preserved part of the head. It is broken only on the left at the front. The sides taper and are dressed with the claw chisel. H. at back 18 cm; H. at front 7 cm. The underside measures 23 cm L. × 19 cm across, and is roughly pointed. In the centre is a square dowel hole measuring 2 × 2 × 8 cm deep. For this method of fitting head to body, cf. statue 26.

Pose. As it is at present restored, the head is turned a little to its right, and is also inclined slightly in that direction. But because the joins between fragments at the neck are so ragged, this pose is not trustworthy.

Scale. About the same as 27 and 30 (i.e. I).

Newton, *Papers*, i. 30; *HD* 111, 225; *MRG* 45; Smith, *BM Cat.* 1052; Neugebauer, *JdI*, lviii (1943), 40 ff.; Buschor, *MuA* (1950), 41, fig. 59; Jeppesen, *Paradeigmata*, 47, 51, figs 22a, 37; Riemann, P-W, 448.

32. Fragment of colossal female head (pl. 17)
BM 1053; *MRG* 46; Reg. 1972.3–30.17.

Found by Newton on the south side of the Mausoleum Quadrangle among the rubbish lying on the surface of Hagi Nalban's field (*Papers*, i. 47; *HD* 129, 225).

Dimensions. Max. H. 0·35 m. W. 0·27 m. D. 0·20 m.

Marble. White, fine-crystalled. Brown incrustation on most of surface, which is in poor condition.

Preserved is part of the left side and top of a female head that wears a close-fitting cap in the manner of 27 and 30. The details which remain are: the left ear (H. 10·8 cm; W. 6 cm), some of the left side of the neck, the cap on the left side of the head, and also a small part of the cap from the top of the head, which runs down on the right side to a point somewhere above the right ear.

There are shallow undulations in the surface of the cap where it is pulled taut over and behind the ear (cf. cap of 30). The head does not appear to have been veiled.

Scale. Certainly as large as the heads 27 and 30 (I). The ear, which is the only comparable detail that remains, is slightly larger than that of 30 (H. 9 cm), and considerably larger than the ear of 27 (H. 7 cm). This variation in proportions is perhaps to be attributed to differences between workshops.

Newton, *Papers*, i. 47; *HD* 129, 225; *MRG* 46; Smith, *BM Cat.* 1053; Jeppesen, *Paradeigmata*, 47, 51; Riemann, P-W, 448 (n); Schlörb, *Timotheos* (1965), 75–76.

33. Colossal seated male figure (pl. 17)
BM 1047; *MRG* 40; Reg. 1857.12–20.235.

Found by Newton 'in the eastern part of the Mausoleum Quadrangle, near the point where the bed of the foundations is shallowest . . . lying with back uppermost' (*HD* 99). In *HD* 223 the finding-place is given more precisely as 'under the wall of one of the two houses marked in the Plan as Ahmet's'. This refers to the more northerly of the two houses shown on *HD*, pls III and IV.

Part of the lower right leg was found by Biliotti in 1865 (it is numbered B.66.3 in black), and this has been joined to the figure. Its position is assured by the correspondence of the drapery folds.

Dimensions as preserved. H. not including base 1·95 m. W. 1·28 m. D. 1·12 m. The thickness of the base is not known for certain, but is at least 7 cm.

Marble. White, fine-crystalled. Much of the surface has a dark-brown patina, with purple tinges in places. Newton, *HD* 222–3, interpreted these tinges as traces of the original paint: 'The statue has been painted; and the folds of the drapery are still coated with an artificial surface of a purple colour. I am inclined to think that this is the original pigment chemically united with a deposit from water.... On its first discovery, two colours seemed blended on the surface, which, by exposure to air, rapidly faded. It is possible that this effect was caused by the decomposition of a portion of the purple in the ground.' The colour is not now so well preserved as it would appear to have been in Newton's day.

The statue is badly battered and broken, particularly at the front. Missing are: the upper part of the body and the head, the left arm, upper right arm, lower right forearm and hand, lower right leg and foot, left foot, the drapery over the lower left leg and left thigh, and many other smaller areas of drapery.

Pose. Seen from the side, the body is straight and erect, but seen from the front, it leans slightly to its left. This movement, and the direction of the drapery folds over the torso, suggest that the left shoulder was higher, and that the left arm was probably raised, perhaps resting on a sceptre. The right arm was held down, and the forearm rested on the thigh. It is clear from the rather summary finish of the drapery over the right thigh that the lower forearm, which is now missing, must have been raised just above the surface of the leg, and that it was apparently not worked separately. One or two slight protrusions (now very worn) from the drapery over the thigh, just inside the line of the arm, may have been supporting struts either for the right hand or for the object possibly held in it (for example a patera). The left thigh is raised higher than the right, and the left lower leg is drawn back under the seat, the heel of the foot being raised from the ground, although the toe would probably have just reached the groundline, which rises slightly at this point. The lower right leg is set forward, and the right foot would probably have been set flat on the ground. In general the pose is not dissimilar to that already used in the fifth century for the seated goddes-

ses from the east pediment of the Parthenon, although it is somewhat stiffer and heavier.

Drapery. The figure, although male, wears a tunic or undergarment and himation. The tunic, which is visible over the upper body at the front, and in a triangular area behind the right arm, clings closer to the form than the himation, but is nevertheless of thickish material, and is not at all transparent. No sleeves remain over that part of the right arm which is preserved. On the front of the body the folds tend to run from the right side of the waist towards the left shoulder, emphasising the pull of the body in this direction. The running drill was used in the deeper folds. In the area of tunic visible behind the right arm, the folds are the best preserved of any on the statue, and provide a clear example of the use of the running drill. The folds here run in rather schematic fashion, parallel to the outline of the arm, and have no relation to the pull of the tunic folds on the other side of the arm, a fact which illustrates the somewhat four-sided conception of the statue.

The large himation once hung from the shoulders. It covers the back of the figure, where the arrangement of the folds is rather more summary than on the other sides, and falls in strong vertical folds on either side of the body. On the right side, a heavy fold falls behind and outside the upper right arm, before curving up again from the cushion and passing over the right thigh, below the forearm, and into the lap. On the left side of the body, a severely straight fold abruptly obscures the tunic, and another heavy fold, further to the left of this and deeper, sweeps down in a broad curve and falls on to the cushion, where its crinkled ends can be seen. There is no sign of the left arm having been attached here, and so this part of the himation must be considered to be falling from a raised left arm.

At the front, the himation covers all but the lowest parts of the legs. Around the waist and in the lap it lies in a heavy bunch of deeply carved and complexly arranged folds, which spread out towards the left thigh and knee to merge with the other end of the himation which falls from the left arm. Folds pull more tautly around the right thigh and calf, to model the limb through the drapery. From here heavy catenaries once passed across to the left thigh and knee, which were set higher, but most of this area of drapery is now broken.

The bottom edge of the himation remains behind the lower legs of the figure, running from just below the front right corner of the seat, across the support, to a point just above the raised heel of the left foot. The surface of the drapery here is smooth, but there are no

individually carved folds. Another part of the lower edge of the himation seems to be preserved on the front of the additional fragment of lower right leg, found by Biliotti.

Lower legs. The lower legs were bare, and the feet wore high boots with scalloped tops and with soles. Jeppesen, *Paradeigmata*, 50–51, seems to have mistaken these for close-fitting trousers. The fancy top of the boot is preserved on the front and side of the lower left leg, and the thickness of the sole is also just preserved at the back (c. 3·5 cm). Some of the top of the boot also remains on the back of the lower right leg.

Right arm. Treatment very muscular. Diameter of arm at elbow, 15 cm. Dimensions of lower break: H. 13·5 cm. W. 12 cm.

Seat. The figure is seated on a draped stool on top of which is a cushion. Beneath the seat is a large square support to take the weight of the statue.

Cushion. Broken at right rear corner, and on left side. The cushion is well-filled and has few creases in it. It is flush with the front of the seat, but projects on either side (between 7 cm and 11 cm). Th. of cushion at front right corner 18 cm; as much as 22 cm where it projects beyond the seat.

Seat. Right rear corner and front left corner missing; lower drapery on left side damaged. The drapery takes the form of rather dull catenaries, one main chain on each face. H. of seat at front right corner 23 cm; at front left corner 31 cm. A curious feature of the seat is that it appears to have had no legs. On the underside of the front right corner, which is well preserved, there is no trace of any cutting for the attachment of a leg. The pointwork is perhaps finer here than elsewhere on the underside, but is hardly smooth enough for the abutment of another piece of marble. One can only presume that the lower part of the statue was not readily visible.

Support. Beneath the seat is a roughly worked support, the sides of which have been dressed with the claw chisel. H. at front right corner 68 cm. W. of front at top 63 cm; at bottom 60 cm (the taper is on the right side only). Th. at top 56 cm; at bottom 54 cm, as preserved. The support is not set quite square with the seat above, although the front of it is flush with the front of the seat and cushion. The projection of the seat over the support at the sides varies between 15 and 26 cm; at the back it is c. 7 cm.

In front of the support beneath the feet of the statue is an irregular groundline, carved with the point. As preserved it rises up 14·5 cm, and projects 12 cm in front of the support (much more than this originally). This groundline does not seem to have existed at the sides or back of the statue.

Scale. The dimensions of the right arm are about equal to those of statue 27 (I).

Identity. Perhaps to be associated with some of the fragments of colossal animals, and to be interpreted as part of a sacrificial group. See above, pp. 44–5.

Style. The general style of the drapery is not dissimilar to that of statue 26, in so far as it is possible to judge from so battered a figure.

Newton, *Papers*, i. 13; *HD* 99, 221–3; *MRG* 40; Smith, *BM Cat.* 1047; Six, *JHS*, xxv (1905), 2, fig. 1; Buschor, *MuA*, 38, fig. 52; Picard, *Manuel*, iv. 1 (1954), fig. 49; Jeppesen, *Paradeigmata* (1958), 37, fig. 22S, 50–51; Riemann, *P-W*, 446(e). Havelock, *Studies presented to G.M.A. Hanfmann* (1971), 61, pl. 25e.

34. **Colossal Persian rider** (pl. 18)
 BM 1045; *MRG* 38; Reg. 1857. 12–20.234.

Found by Newton roughly in the middle of the west side of the Mausoleum Quadrangle (*Papers*, i. 8; *HD* 90, 218–21; position marked on *HD*, pls III–IV). Several pieces of the hindquarters, now reattached, were found built into a garden wall a few feet from where the main part of the statue was discovered (*HD* 221). A fragment rejoined to the inside of the right hind leg is numbered 181 (red).

Dimensions as preserved. L. 2·15 m. H. 1·16 m. W. 1·025 m. W. of body of horse 87 cm. Dimensions of right foreleg at break: H. 19·3 cm. W. 16 cm. L. of thigh of rider 61 cm; L. of lower leg c. 65 cm; W. of left hand 17 cm.

Marble. White, fine-crystalled, with streaks of mica. Brown patina in places, especially on left side of horse.

The statue has suffered much wanton damage through lying exposed after abandonment by stone robbers. The extremities of the horse and the left leg of the rider appear to have been removed by blows of a sledgehammer, no doubt to provide building material. Some of these fragments have been found and refitted, including most of the hindquarters, part of the upper right shoulder of the horse, and some of the upper right foreleg. Pock marks on the left side of the horse suggest the statue has at some time been used for target practice.

Missing. Of the horse: both hind legs, some of hind-quarters, tail, both forelegs except for upper forearms, neck, and head. Of the rider: left leg, both feet (but see below), upper body above waist, which was worked separately, including head, right arm, and all but the lowest part of the left arm.

The horse. The horse is shown prancing. The right hindleg is set forward and takes much of the weight, as is apparent from the bulging muscles of the hindquarters. The position of the left hindleg is not certain. Both forelegs are raised and stretched out in the air, the left one being somewhat higher than the right. Corresponding with this pose the shoulders and forehand of the horse are twisted round to its right, towards a spectator viewing from the right side.

Beneath the belly of the horse there are the remnants of a protrusion, which once received a support (cf. hind part of chariot horse 2). Only the right edge of the protrusion remains; elsewhere it has been torn away with the support, leaving a slight hollow within the rectangular area of attachment. No trace of the dowel remains.

Dimensions. L. 36 cm; W. 29 cm; Protrusion at front 4 cm (back merges with belly of horse). The angle of the horse's body may be calculated as *c.* 1 in 9, or about 10 degrees above the horizontal. The horse is perhaps galloping therefore as much as prancing.

The general treatment of the horse is similar to that of the chariot horses: the body is broad and powerful, musculation massive and somewhat accentuated, and there are prominent veins on the lower flanks. The proportions, however, differ from those of the chariot horses. This horse, although almost as wide as those—87 as against 90 cm—is very much shorter (see above, pp. 38–9). The surface finish is variable, being extremely rough in places. On the right rear flank, behind the rider, the surface is quite well smoothed, although rasp marks remain. On the right side of the forehand, and more particularly along the left flank, harsh strokes of the flat chisel remain, which in some places have hardly erased the marks of the claw chisel (cf. Adam, *TGS* 33). It may be seen from this that the general carving of the horse, while still broad, has been taken a step further than that of the chariot horses, which were in many places only taken to the stage of the claw chisel.

The rider sits easily on the horse, gripping the flanks with his knees and bending his lower legs back (the break on the left side shows that the left leg was in a similar position to the right). The left hand, which is held close to the waist, no doubt held the reins.

He wears Persian or Asiatic dress, consisting of a tunic which descends to just above the knees, and close-fitting trousers or *anaxyrides.* The carving of the trousers over the right leg and the lower part of the tunic is of the very highest order, the garments appearing to billow back in the wind as the rider speeds along. Over the lower body however, the drapery is more static and rather less convincing. There are harsh drill grooves in the bunched overfold that protrudes at the front below a narrow belt, and on the left side of the tunic clear traces of the flat chisel remain.

The clenched left hand which probably held the reins is also carved only in a broad and sketchy fashion: again the carving has not been taken beyond the stage of the flat chisel. There are prominent veins on the back of the hand. The marble between thumb and forefinger has not been removed, and still has point marks on the surface.

Part of the creased Persian sleeve is visible on the lower left arm. Most of this arm was worked separately together with the rest of the upper part of the body.

About half of the worked surface to receive the upper body remains, level with the top of the belt. It has been worked as if for *anathyrosis,* with a smooth outer margin (8 cm W. at front; 17 cm at left side), and a coarsely pointed, recessed inner circle, *c.* 12 cm radius. In the centre, partly preserved, is a massive wedge-shaped dowel hole: L. 12 cm; W. 4·5 cm at top, widening to 7 cm at bottom; D. 15 cm. The sides are roughly pointed. Running into this cutting from the left side of the body is the remains of a channel for lead, which was poured in to seal the dowel into its correct position, L. 26 cm.

On the right flank of the horse, close to the lower right leg of the rider, are preserved traces of red and blue paint which form a faint pattern. Delicate, curving red lines, 1·5 mm in width, seem to have enclosed in jagged or scalloped fashion a blue-painted area, the two colours being separated by a reserved strip, also 1·5 mm in width (fig. 19). From the position on the horse's body, this is likely to be the remnant of a saddle-cloth that was represented only in paint. The traces that remain have been protected from the weather by the rider's leg. A painted saddle-cloth with fringed edge is to be seen on the horse of a Persian rider on the Alexander sarcophagus, the central figure of the right-hand pediment (Schefold, *Der Alexandersarkophag,* figs 2, 4, 5; cf. also Anderson, *Ancient Greek Horsemanship* [1961], 79–82).

19 Painted saddle cloth
on 34

Newton remarks in *Papers,* i. 13 that 'in the great equestrian statue, the crupper of the horse is marked with the letter Σ'. No certain traces of any such letter are now to be seen on the rear part of the horse. It is possible, however, that Newton may have been referring to some raised zigzag lines on the inside of the upper right hindleg, which could conceivably be read as a three-bar sigma or a nu. But it must be considered extremely doubtful whether these lines were ever intended to represent a letter. For the possible significance of such letters, see above, pp. 36–7, 62, 82–3.

This statue is of outstanding work as regards the composition and the broad lines of horse and rider and the treatment of drapery. The finish is less satisfactory in places (but cf. chariot group). The smoother finish of the right side, and the turn of the horse in this direction, suggest that this was the principal viewpoint.

Probably the rider was part of a free-standing group, perhaps set against a wall. From the high action, either a hunt or a battle must have formed the subject-matter. In either case the horseman is likely to have been aiming a blow with his right arm, either at man or beast.

Scale. The rider is of the same scale as 26 (colossal, I). For the scale of the horse, see above, pp. 38–9.

Newton, *Papers,* i. 8, 13; *HD* 90, 218–21; *MRG* 38; Smith, *BM Cat.* 1045; Preedy, *JHS,* xxx (1910), 150, fig. 6; A. W. Lawrence, *Classical Sculpture* pl. 87; Buschor, *MuA,* fig. 55; Picard, *Manuel,* iv. 1 (1954), fig. 47; Jeppesen, *Paradeigmata* (1958), 48, 51–52, fig. 22; Riemann, P-W, 445-6.

FRAGMENTS PROBABLY BELONGING TO PERSIAN RIDER (Nos 35–41)

The following seven fragments are likely to belong to statue 34, but as no join is possible, some doubt must remain, and they are therefore numbered separately. They could, for instance, have come from similar mounted figures which may have existed. Other fragments, attributed to the statue by Newton, are much more doubtful, and will be found amongst the fragments of horses, below nos. 386 ff. Fragment *MRG* 38d, which Newton thought belonged to the rider, has been found to adjoin statue 26 (see above).

35. Nose and upper jaw of horse (pl. 18)
BM 1046, 1; *MRG* 38a; Reg. 1972.3–30.18. Numbered 158 (red).

According to Newton (*Papers,* i. 10; *HD* 219), this fragment was found close to the main statue 34, and so is likely to belong. The separate fragment, described as 'part of chin and lower jaw' in *MRG* 38a, belongs in fact to a lion. See below, no. 576.

Dimensions as mounted. H. 0·22 m. W. (nostril to nostril) 0·15 m. L. 0·20 m.

Marble. White, fine-crystalled.

Preserved are the right nostril, inner part of left nostril, tip of nose, upper edge of mouth on right side, and front teeth of upper jaw.

The flaring nostrils and open mouth suggest that the horse to which they belonged was involved in energetic action. Rough pointwork remains on the underside of the upper jaw; and concave grooves left by the flat chisel are to be seen on the right side. Similar in finish to 34.

Newton, *Papers,* i. 10; *HD* 219; *MRG* 38a; Smith, *BM Cat.* 1046, 1.

36. Fragment of forehoof (pl. 18)
BM 1046, 2; *MRG* 38b; Reg. 1972.3–30.19. Numbered 150 (red).

According to Newton, *Papers,* i. 10, found in close proximity to the Persian rider.

Dimensions. H. 0·19 m. L. 0·215 m. W. 0·125 m.

Marble. White, fine-crystalled.

Preserved is the right half of a forehoof, broken just above the coronet. The lower edge of the right side, which is chipped, has been restored in plaster.

The underside has not been attached to a base, but has been worked flat with a point. A drill-hole is modern, for mounting on a base. Clearly the hoof belonged to a raised foreleg.

The surface of hoof and pastern is not badly weathered, and exhibits traces of the flat chisel (cf. working of 34). Whether from a right or left foreleg is not certain.

Newton, *Papers,* i. 10; *HD* 219; *MRG* 38b; Smith, *BM Cat.* 1046, 2.

37. Fragment of hind hoof on base (pl. 18)
BM 1046, 3; *MRG* 38c; Reg. 1972.3–30.20.

According to Newton, *Papers*, i. 10, found in close proximity to the Persian rider, 34.

Dimensions. Max. L. 0·37 m. W. 0·16 m. H. 0·29 m. Dimensions of hoof: L. 0·29 m. W. 0·16 m. H. above base 0·12 m. Th. of base 0·17 m.

Marble. White, fine-crystalled.

Preserved is the left half of a hind hoof on a thick base. Broken above the coronet.

The shallow angle of the front of the hoof, the considerable length attached to the ground, and the long, flat top to the coronet, show this to be one of the hind hooves of a prancing horse. Whether from a right or left leg is not certain. The surface is rather coarsely finished with the flat chisel (cf. 34).

The base has no original edge preserved, although a roughly pointed underside remains. In front of the hoof the surface of the base is smooth; to the left and behind, it is roughly worked.

The scale is the same as 36, and is suitable for 34.

Newton, *Papers*, i. 10; *MRG* 38c; Smith, *BM Cat.* 1046, 3.

38. Fragment of raised foreleg
MRG 38h. Reg. 1972.3–30.23. Initialled C.T.N. (red).

This is probably the 'forearm' which, according to Newton, *Papers*, i. 10, was found close to the Persian rider.

Dimensions. L. 0·35 m. H. (W.) 0·22 m. Th. 0·18 m.

Marble. White, fine-crystalled.

A fragment of a horse's foreleg, broadly worked. The direction of the grain of the marble suggests the leg was raised above the horizontal. Scale, marble, and style confirm the attribution to the Persian rider.

Newton, *Papers*, i. 10; *MRG* 38h.

39. Fragment of upper hind leg (pl. 19)
Reg. 1972.3–30.24. Initialled C.T.N. (red).

Probably to be identified with the fragment described in *Papers*, i. 10 as 'part of thigh of one of hind legs', which was discovered close to the main fragment, 34.

Dimensions. H. 0·36 m. W. 0·19 m. Th. 0·13 m.

Marble. White, fine-crystalled. Surface worn.

Part of one side of a colossal hind leg of a horse. There is a clearly marked division in the surface, probably representing the two bones of a horse's leg. At the top is part of a projection, perhaps where the leg joined the underside of the body, while towards the lower edge is a depression, which may represent the chestnut(?).

Scale, marble, and general style favour the attribution to the Persian rider.

40. Fragment of colossal left foot wearing boot
Reg. 1972.3–30.21. Numbered 111 (red).

Finding-place not given.

Dimensions. L. 0·285 m. W. 0·15 m. H. 0·13 m.

Marble. White, fine-crystalled.

Missing are the heel, part of the instep, and the tips of the toes.

The foot was not attached to a base, its underside being as well smoothed as the top. In all probability it belongs to a mounted figure. The soft boot without a sole is of the type worn by horsemen in Asiatic dress on the Alexander sarcophagus (Schefold, *Der Alexander-sarkophag* [1968], figs 5, 18, 33, 67). It is quite likely to belong to statue 34, with which the scale and the marble correspond, but since the left leg of the rider is completely missing no join is possible.

41. Fragment of colossal foot wearing boot
Reg. 1972.3–30.22. Numbered 127 (red), 351 (black).

Finding-place not given.

Dimensions. L. 0·14 m. H. 0·08 m. W. 0·075 m.

Marble. White, fine-crystalled.

A small fragment of the right side of a foot of similar type to 40, and probably also from a horseman, since it was not attached to a base. There is a slight crease across the toe. It could be part of the right foot of statue 34, for which the scale is suitable. If not, it must have belonged to a similar mounted figure.

42. Lower part of draped, standing male figure (pl. 19)
BM 1048; *MRG* 41; Reg. 1857.12–20.237.

Found by Newton on the west side of the Mausoleum Quadrangle (*Papers*, i. 8; *HD* 90, 223). Position marked on *HD*, pl. III, where it is described as 'Female Statue'.

Dimensions. H. 1·06 m. W. 0·58 m. Th. 0·38 m.

Marble. White, fine-crystalled. Surface worn, brown patina in places. Newton reported (*HD* 223) a streak of

purple colour in one of the folds at the back, but this is no longer very apparent.

The statue is preserved from just below the waist to below the knee. That the figure is male is suggested by the easy stance and the type of dress worn.

Pose. The stance is a relaxed one, the weight of the figure being taken entirely by the left leg, while the right is crossed over in front of the supporting leg, with the toe of the right foot probably once resting on the ground. The protruding left hip and the line of the right leg are both clearly modelled through the drapery.

The garment is a male chiton or tunic which reaches to some way below the knee, and which was confined at the waist by a belt. Traces of this belt remain on the left rear side of the statue, and crumpled folds from just beneath it are to be seen at the front. The material of the tunic is of a thick texture, and there is a seam which runs around the irregular lower edge. The arrangement of the folds at the front of the statue is simple, but effective. Strong vertical folds hang beside and over the supporting leg, while other major folds pull from the inner contour of the right leg diagonally towards the left hip. In style, there are affinities with the drapery of 26, especially as regards the texture of material, irregular lower edge with seam, and smooth area of garment below knee. At the back the folds are rather schematic in line, running vertically for the most part, but the finish is reasonably good.

Beneath the garment parts of both legs remain. They are bare and still retain the sheen of a surface which was once very highly polished. The lower right leg has not been fully separated from the left at the point where it crosses in front of it. This, and the treatment of the drapery, suggests that the principal viewpoint was from the front.

Scale. Heroic (II): considerably smaller than statues 26, 27 and some others, but still over life-size.

Newton, *Papers*, i. (1858), 8; *HD* 90, 223; *MRG* 41; Smith, *BM Cat.* 1048; Amelung, *Ausonia*, iii (1908), 131, fig. 23; van Breen, *Reconstructieplan* (1942), fig. 77; Buschor, *MuA* (1950), fig. 61; Jeppesen, *Paradeigmata* (1958), 47, 52, fig. 22U; Riemann, P-W, 446 (f).

43. Part of draped, standing male figure (pl. 19)
BM 1050; *MRG* 43; Reg. 1857.12–20.281. Numbered 235 (red).

According to the Invoice of cases, no. 235, this statue was found on the north side in the Imam's field; and this finding-place is confirmed by *Papers*, i. 30 and *MRG* 43,

where the descriptions and dimensions clearly refer to this figure. Confusion over the finding-place, however, has arisen from apparent inconsistencies in *HD*. When discussing statue no. 281 at *HD* 128–9 and 224, which one might suppose referred to this statue, Newton says it was found on the south side. Almost certainly he is referring here to the following statue 44 (BM 1049; Reg. 1857.12–20.279), which is likely to have come from there. The likeliest explanation of this confusion is that when the two statues reached London, the wrong registration numbers were painted on them, so that the statue numbered 281 in Newton's notes (from which he wrote *HD*) emerged as 1857.12–20.279, while his statue no. 279 is now 1857.12–20.281, i.e. this statue. Newton's discussion of his statue no. 279, *HD* 111 and 224, confirms that it came from the north side, being found outside the *peribolus* wall, underneath the foundations of the Imam's house.

Dimensions. H. 1·01 m. W. 0·56 m. Th. 0·43 m.

Marble. White, fine-crystalled, with silvery veins.

Preserved from the breast to the upper thigh. Most of the back is broken, although a fold of drapery exists at the base of the back which gives the original thickness of the statue. A separate fragment of the upper left thigh (bearing the initials C.T.N. in red) has been added, its position being ascertained by the correspondence of the folds.

The figure is shown to be male by the flat left breast, by the garment worn (cf. statue 26), and by the slight protrusion of the genitals through the drapery.

The body is rendered in realistic and somewhat unflattering fashion through the clinging garment. The chest is flat while the stomach protrudes (cf. 26 and 27). The weight of the figure was on the right leg, the relaxed left leg being set forward.

The drapery consists of a long, ungirdled tunic, similar to the undergarment of statue 26, although worn apparently without a himation. It seems to have covered the whole of the upper part of the body. Although the garment adheres closely to the form, a thick texture is suggested by the bold and broadly spaced drapery folds, which are carved as rather sharp ridges (cf. folds of undergarment of 26). Heavy vertical folds frame the body on either side.

For a fragment from a similar statue, see below, 85A. For the style, cf. 26 and 42.

Scale. Heroic (II).

Newton, *Papers*, i. 30; *HD* 111, 224 no. 279; *Travels*, ii (1865), 112; *MRG* 43; Smith, *BM Cat.* 1050; van Breen, *Reconstructieplan* (1942), fig. 75; Neugebauer, *JdI*, lviii (1943), 49, fig. 4; Buschor, *MuA*, fig. 18;

Jeppesen, *Paradeigmata* (1958), fig. 22X; Riemann, P-W, 447 (h); Schlörb, *Timotheos* (1965), 76–77, fig. 56 (attributes to Timotheos through confusion over finding-place).

44. Part of draped, standing figure (pl. 19)
BM 1049; *MRG* 42; Reg. 1857.12–20.279.

Found on the south side of the Mausoleum: Newton, *Papers*, i. 46; *MRG* 42; *HD* 128–9, 224, no. 281 (see above, statue 43, for confusion in *HD* between Newton's statues 279 and 281: the description at *HD* 128, 'The surface has suffered a good deal', clearly refers to this statue). According to the entry in the BM register, this statue was dispatched to England in case 249. The invoice for case 249 reads: 'Part of Draped Female Figure, Hadji Nalban's field, north side of Mausoleum'. This in fact confirms the finding-place, 'north' here being an unfortunate misprint for south! (Hadji Nalban's houses and fields were on the south side of the Mausoleum: cf. *HD passim*, and Invoice of cases, no. 262).

Dimensions. H. 0·94 m. W. 0·50 m. Th. 0·40 m.

Marble. White, fine-crystalled, rotting to a powdery white in places. Surface badly worn at front, better preserved at right side and back.

The figure is preserved from the waist to just above the knees. Its sex depends on the interpretation of the drapery (see below).

Pose. The weight is on the right leg, the hip of which protrudes. The left leg is set slightly forward.

Drapery. A garment of thick material is worn, through which both legs are modelled.. Between the legs are deeply drilled vertical folds. At about the level of the hips is a bunched overfold, falling over a belt, part of which remains at the back where there is no bunch. (L. remaining 11 cm; W. of belt 4 cm. It is broken on the left, but disappears under the overfold on the right side.) The overfold is carved in naturalistic fashion, with crumpled, irregular pouches of drapery. On the front left side of the statue, near the upper break are traces of a second belt, this time running over the garment, from which catenaries of drapery hang down over the abdomen.

No himation is worn. Severe, vertical folds on the side of each leg belong to the main garment, and mark the division between the rather summary arrangement of drapery at the back and the more varied composition at the front.

Although this figure has generally been considered to be a female wearing a peplos, it should undoubtedly be interpreted rather as a male wearing Persian dress, for the presence of which on the Mausoleum there is ample evidence (see above, pp. 73–7). None of the other extant female figures from the Mausoleum wears the peplos, there being a marked preference for the fine Ionian chiton and himation (so 27, 91, 93, 98).

The working of the drapery suggests the figure was intended to be seen from the front.

Scale. Heroic (II).

Newton, *Papers*, i. 46; *HD* 128/9, 224; *Travels*, ii (1865), 206; *MRG* 42; Smith, *BM Cat.* 1049; Amelung, *Ausonia*, iii (1908), 104, fig. 9; van Breen, *Reconstructieplan* (1942), fig. 76; Buschor, *MuA* (1950), 34, fig. 42; Jeppesen, *Paradeigmata*, 47, fig. 22V; Riemann, P-W, 446 (g); Schlörb, *Timotheos* (1965), 76.

45. Part of bearded male head (pl. 20)
BM 1054; *MRG* 47; Reg. 1857.12–20.267.

Found by Newton in the main sculptural deposit to the north of the north *peribolus* wall, 'with the head of Mausolus, a few feet to the east of the horse' (*HD* 104–5; cf. *Papers*, i. 22; Invoice of cases, no. 211).

Dimensions. Max. H. 0·35 m. Max. W. 0·155 m. Max. Th. 0·22 m. H. chin to crown 30 cm; chin to hairline 22 cm; chin to centre of lips 7·5 cm; lips to nostrils 2·2 cm; nostrils to line between tear ducts 5·7 cm; line between tear ducts to hairline 6·5 cm. W. of left eye 3·6 cm; W. of mouth (i.e. drill groove between lips) 4·75 cm; W. of nose at eye-level 2·25 cm, at nostrils 4·25 cm. H. of left ear 6·8 cm.

Marble. White, fine-crystalled, weathered to a somewhat granular surface with an orange patina in places, and especially on the left temple, cheek, and neck, where the surface is better preserved.

Missing. Right side of head, including some of right eye, back of head, and most of neck, except for a portion below the chin.

Pose. The pose of the head appears to have been.fully frontal, its expression neutral. The features are very finely worked: the forehead is low, with a pronounced bulge over the eyebrows; the nose has a slight bulge in profile, and is somewhat asymmetrical in frontal view, the left nostril being considerably larger than the right (this could be interpreted as an optical correction, cf. Gardner, *New Chapters in Greek Art* [1926], 104); the eyes are fairly deeply set, eyelids not over emphatic; the

cheeks are rather flat, and the chin is large and firm; the mouth is similar in style to those of other Mausoleum heads, with a wide thin upper lip, and a narrow full lower lip, the two lips being lightly parted by a drill groove (3·5 mm wide). The ear is quite large (almost the same as 27's), and correctly placed. In profile the head is not nearly so deep as other Mausoleum heads.

The hair on top of the head is severely weathered, but it is well preserved on the left side, where the treatment can be seen to have been broad and bold, with only schematic representation of individual locks. Yet there is a remarkable symmetry in the arrangement of some of the locks, this being particularly noticeable in the short locks that rise up from the forehead and fall to either side from a point above the centre of the nose. Compare the arrangement of locks above the foreheads of the lions, below. Cf. also the hairstyles of the portraits of Alexander the Great.

The hair of the beard and moustache is treated similarly to that of the head, but the locks are smaller. There is, again, a basic symmetry in the arrangement of the locks, one half of the beard mirroring the other half on either side of a line projected below the centre of the nose. The rough finish of hair and beard seems intended to contrast with the very smooth finish of the facial features.

Scale. Over life-size. Probably to be equated with the scale of bodies 42, 43 and 44 (Heroic, II).

The fifth-century style classicising features of this head, in particular the mild, dignified countenance and the symmetrical arrangement of the hair, have been noted since the time of Newton (*HD* 225). Cf. Jeppesen, *Paradeigmata*, 54, who criticises the head on this score. Nevertheless the regularity of hair and features is not much greater than that of other Mausoleum heads, and the carving is of a very high standard.

There is a very close stylistic relationship between this head and the colossal head of Zeus in Boston, from Mylasa, which is not far from ancient Halicarnassus (cf. Caskey, *Boston Catalogue* [1925], no. 25, pp. 59–61; Pollitt, *Art and Experience in Classical Greece* [1972], p. 100, fig. 44). If the two heads are not from the hand of the same sculptor, they are certainly the product of the same workshop.

Newton, *Papers*, i. 22; *HD* 104–5, 225; *MRG* 47; Smith, *BM Cat.* 1054; Gardner, *New Chapters in Greek Art* (1926), 103–4; Buschor, *MuA* 18–19, figs 9, 10; Bieber, *The Sculpture of the Hellenistic Age*[2] (1961), fig. 73; Jeppesen, *Paradeigmata* (1958), 54, figs 22γ, 44–45; Riemann, P-W, 448–9(o).

46. Youthful male head (pl. 21)

BM 1056; *MRG* 48; Reg. 1857.12–20.265. Numbered 255 (red).

Found by Newton on the south side of the Mausoleum (*Papers*, i. 47; *HD* 129, 227).

The head is worked separately, for insertion into a body. It consists of two fragments which adjoin closely: (*a*) tenon and lower part of neck; (*b*) upper neck and remainder of head.

Dimensions. Max. H. 0·38 m. W. (top of tenon) 0·20 m. Th. 0·26 m. Head: H. from chin to crown 25 cm; chin to lips 5·2 cm; lips to line between tear ducts 7·5 cm; line between tear ducts to hairline 7·3 cm; W. of each eye 3·3 cm; distance between tear ducts 4 cm; W. of mouth 4·3 cm.

Marble. Grey-white, crystalline variety, the surface weathered to a granular texture, grey-brown in colour. This marble appears to differ from that used for the majority of the fragments. It is perhaps the same as that used for the Amazon frieze.

The head is in so worn a condition that the details are no longer clear, with the exception of the hair at the back of the head. The nose is missing.

Pose. The pose is an active one. The head is twisted energetically to its right at an angle of about 45 degrees to a line through the shoulders. It is also tilted slightly to the right, and the gaze is directed downwards.

All the finer details of the face are worn away, but much can still be said. Seen from the front, the face is oval, the chin pointed. There is a pronounced bulge in the forehead over the eyebrows, the eyes are deeply set so as to cast dark shadows, the lower part of the nose was once quite broad, and the lips were slightly parted. The expression, therefore, was (and still is to some extent) intense and passionate, if not fearful. There is no beard, which suggests that this is a fairly youthful figure. The ears are now almost completely missing, except for the deeply drilled inner parts. The hair is short and curly. At the back, where it is still well preserved, the rendering is somewhat schematic, but not untidy.

The tenon has tapering sides, dressed with the claw chisel: H. at front 4 cm; at back 11·5 cm. The underside is oval, measuring 15·5 cm L. by 13 cm W.

A shallow rectangular depression, measuring 3 × 2 × 1 cm deep (as preserved), which remains in a flattened area on the rear part of the crown of the head, probably indicates the place at which the hand of a raised right arm adjoined. Compare the struts for the

attachment of a raised right arm in a similar position on the marble copies of the head of Harmodios (Brunn-såker, *The Tyrant-Slayers of Kritios and Nesiotes*[2] [1971], 70–72). If so, the statue to which 46 belonged may have been making or warding off a blow.

Style. The energetic pose and pathetic expression are so-called Scopaic elements, and recall the heads 30 and 48. The gaze, however, is directed downwards and not upwards, as in those heads.

Scale: Life-size (III). Smaller than head 45: cf. heights of chin to crown; although the details of the two heads conform to differing systems of proportions.

Newton, *Papers*, i. 47; *HD* 129, 227; *MRG* 48; Smith, *BM Cat.* 1056; Buschor, *MuA* (1950), 29 ff., figs 36, 39; Jeppesen, *Paradeigmata*, 48, fig. 22β; Riemann, P-W, 450 (q.); Schlörb, *Timotheos* (1965), 76.

47. Bearded male head (pl. 22)
BM 1055; *MRG* 152; Reg. 1857.12–20.266. Numbered 141 (black).

Found by Newton amongst rubble in a breach in the wall of the Upper gallery on the south side of the Mausoleum, beneath Hadji Nalban's house (i.e. close to the south-west corner): *HD* 153. Thought by Newton not to belong to the sculptures of the Mausoleum.

Dimensions. Max. H. 0·345 m. Max. W. (top of tenon) 0·21 m. Max. Th. 0·22 m. H. chin to lips (now) 6 cm; originally perhaps *c.* 8 cm; lips to nostrils 1·7 cm; nostrils to eyebrows 6 cm; W. of face at eyes 14 cm; W. of right eye 3 cm. H. of right ear 5·2 cm.

Marble. Milky white, very fine crystal, reddish-brown patina in places, heavy incrustation on beard. The marble is apparently not the same as that which was used for the majority of the sculptural fragments. Some traces of red paint remain on the beard, and there is red-brown paint on the hair at the back.

The head, which has been worked for insertion into a separately carved body, is reconstructed from two fragments consisting of: (*a*) tenon and front of neck up to chin; (*b*) head, and back of neck.

Missing. Tip of beard, lower part of nose, and most of the head above eye-level, including part of the left eye, part of the left ear, all the forehead and most of the hair. Some of the upper part of the head appears to have been worked separately (see below).

Pose. The pose of the head is fully frontal, but the gaze is directed upwards slightly. The head itself is squarish, with flat cheeks, and eyes that are rather small and narrow. The upper lip is concealed by a moustache, the lower lip is full and narrow, but does not curl forward in the way that one finds on other heads. The division between the lips is deeply drilled with the running drill, and the groove continues down beyond the right side of the mouth, dividing the moustache from the beard. The rendering of the beard is rather impressionistic: there is little attempt to indicate hairs within the individual locks.

The hair of the head is well preserved at the back, where it is short and bound by a fillet, the groove for which (1·5 cm wide) still remains, running from above the right ear round the back of the head to just short of where the left ear would have been. The fillet itself may perhaps have been added in metal. Beneath the fillet, the arrangement of the hair is somewhat dull and symmetrical.

In the top of the head, where the surface is otherwise broken, there are the remains of a drill-hole and a rectangular cutting, which must have served for the attachment of the separately worked upper part of the head. The drill-hole, which is situated towards the front right part of the head, is 1·2 cm diameter, and now only 1 cm deep. The rectangular cutting, set more towards the left rear part, is 4 cm long (more originally) × 3·5 cm wide × 6 cm deep, as preserved. No traces of any levelled surfaces for the addition of the hair remain.

The treatment of the neck is quite realistic. Three creases run from the front round to each side, although these are not the result of the pose of the head, as are the creases on the neck of 30. They are perhaps an attempt to suggest maturity of age. There is also a realistic depression at the base of the neck at the front.

The sides of the tenon taper slightly, and vary in height from almost nothing at the front to *c.* 13 cm by the right shoulder. The underside is almost circular, in contrast to the oval bases of the other preserved heads, diameter 20 cm. In the centre is a dowel-hole 2·5 cm square × 9 cm deep. There is no sign of any lead which might have secured the dowel. The underside is finished with the point, while the sides have been smoothed with the claw chisel, which has not completely eradicated the earlier strokes of the point.

Technique. The areas of bare flesh on the face, neck, and shoulders have been finely finished, and were perhaps once highly polished. The beard and hair exhibit sharp chisel marks, probably of the flat or a fine point.

Identity. The head has many of the characteristics of fourth-century Greek portrait heads, for example a

squarish structure, beard, realistic details such as the creases in the neck (Buschor, *MuA* 15–16, sets it stylistically between the Plato portrait and the Lycurgan Sophocles). The fillet in the hair and the upward gaze suggest that the figure was in an attitude of reverence, supplication or prayer.

Scale. Life-size (III); about the same as 46, although the proportions of details differ. The structural proportions of this head are closer to those of 45.

Does it belong to the Mausoleum? Although certainly of fourth-century BC workmanship, there are some doubts as to whether this head really formed part of the sculptures of the Mausoleum. The finding-place in a rock-cut gallery of earlier date than the Mausoleum is not conclusive, because it is clear from Newton's description (*HD* 153) that the wall of the gallery was breached at the point where the head was found, so that the material was not uncontaminated. There are, however, a number of stylistic differences between this head and the other well-preserved heads from the Mausoleum: (*a*) marble different; (*b*) top of head separately worked; (*c*) treatment of mouth different: lower lip does not curl, and drill groove is prolonged beyond corners of mouth; (*d*) underside of tenon circular; (*e*) impressionistic working of hair not specifically matched by any other head, where the locks tend to be clearer; (*f*) treatment of eyes differs.

These differences do not constitute sufficient grounds for the rejection of the head from the Mausoleum: it does appear to be fourth-century work, and it was found on the site of the Mausoleum. On the other hand, in view of the numerous stylistic peculiarities, it cannot be accepted without reserve.

Although Neugebauer, *AA*, xxxix (1924), 113, rejected the head on stylistic grounds, considering it to be older, modern opinion has tended to accept it, attributing it to the workshop of the oldest of the sculptors who are supposed to have worked on the Mausoleum, Timotheos (so Buschor, *MuA* 15–16; Riemann, P-W 449; and Schlörb, *Timotheos* [1965], 74–75).

Newton, *HD* 153–4; *MRG* 152; Smith, *BM Cat.* 1055; Jongkees, *JHS*, lxviii (1948), 35, fig. 10; Buschor, *MuA* (1950), 15–16, fig. 1; Picard, *Manuel*, iv. 1 (1954), fig. 51; Jeppesen, *Paradeigmata* (1958), 48; Riemann, P-W 449 (p); Schlörb, *Timotheos* (1965), 47, 74–75, pl. 21a.

48. Head of Apollo (pl. 22)
 BM 1058; *MRG* 50 + 51 f.; Reg. 1857.12–20.264.

Found by Newton among the pyramid steps in the main sculptural deposit to the north of the north *peribolus*

wall (*Papers*, i. 15; Invoice of cases, no. 176; *HD* 104, 225). Only the three fragments making up the face were united by Newton. The back of the head, catalogued separately as *MRG* 51 f, was recognised as belonging by P. Gardner (*JHS*, xxiii [1903], 121 ff.; *New Chapters in Greek Art* [1926], 99–116).

Dimensions as reconstructed. Max. H. 0·42 m. Max. W. 0·265 m. Max. Th. 0·29 m. H. from chin to hairline 25·5 cm; chin to centre of lips 5·8 cm; lips to base of nose 2 cm; base of nose to line between tear ducts 6·7 cm; line between tear ducts to hairline 11 cm. W. of face at eyes 16·5 cm; of left eye 4 cm; of mouth 5·5 cm. H. of left ear 5·5 cm. Diameter of neck at lower break 16 cm. Circumference of neck 55 cm.

Marble. When the head was cleaned in the early summer of 1969, the marble was shown to be white, medium-crystalled, somewhat micaceous, with an orange patina in places. As to whether it is Pentelic, note the judgement of A. H. Smith in Gardner, *New Chapters*, 103: 'The marble, as Mr A. H. Smith kindly informs me, is neither Pentelic nor Parian, but a crystalline and micaceous stone, used for other Mausoleum sculptures, but not for the masonry.' See above, p. 14 for further discussion.

The four fragments from which the head has been reconstructed are:

(*a*) Lower right part of face, including right cheek, lower part of nose, mouth, and chin.

(*b*) Upper part of head at front, including hair, forehead, upper part of nose, part of right eye, left eye, part of left cheek, upper tip of left ear.

(*c*) Front part of neck, including a sliver on right side up to right ear lobe, lower left cheek, and jaw.

(*d*) Much of back of head, including bun of hair, most of rear part of left ear, and some of the neck at the back and on the left side.

Plaster fills the gaps between fragments (*a*), (*b*), and (*c*) on the front of the head, and also between (*b*) + (*c*) and (*d*) on the left side. This is, however, only surface restoration, and the various fragments seem correctly related to one another in their present reconstruction.

Still missing. A large slice from the right side of the head, *c.* 10–12 cm wide, including the hair, most of the right ear, and some of the neck. The lower edge of the neck is broken; therefore it is not certain that the head was worked separately from the body, as has been asserted by some (so Riemann, P-W 450). There is considerable damage to the right eyebrow, right eye, nose, lips, chin, and left ear.

The hair on the top and back of the head is much weathered, suggesting that the statue stood in an exposed position on the building (cf. statue 26).

Proportions and treatment. Seen from the front the face is oval, but in profile it is square and deep-sided. The forehead is triangular with a pronounced bulge above the eyebrows. The eyes are fairly deeply set, rather narrow, with a high lower lid, sharply cut, arching upper lid, and well-marked tear ducts. The right cheek is full and fleshy, with no wrinkles or creases. The nostrils were probably once quite broad, and slightly flared (some of the left nostril remains). The lips are lightly parted, their division drilled, the lower lip short and full. The chin is small, somewhat pointed, but firm. There is no beard. The expression is pleasant and smiling. The left ear is rather small, not deeply modelled, and adheres flatly to the side of the head.

The hair is long, and is carved in a flowing, restless style of considerable individuality. There is a parting in the middle of the forehead, from which strands of hair sweep sideways and upwards in unruly waves, which form deeply carved masses higher on the head. At the back, the treatment is less deep, and more schematic. On top at the back, there are the remains of a bun or top-knot, the details of which are now worn away. There may also have been a bow of hair at the front, as on for example the Apollo Belvedere.

Pose. The pose of the head is not frontal. The line of the neck, as preserved, runs diagonally to the figure's right from its left shoulder, and the head is then twisted back to its left, and the gaze directed upwards. In profile the neck also leans forward, and the Adam's apple is clearly marked. For the pose cf. the colossal female head 30. The best viewpoint is three-quarters from the right, seeing the whole of the left cheek and the left side of the head.

Technical points. Flesh finely finished; hair left rougher to provide contrast. Some use of running drill in hair, but considerable care exerted, especially at the front.

The carving of this head is of the very highest quality. Stylistically there is much in common with the female head 30—cf. proportions of face, treatment of individual details, pose of head—and it does not seem too much to attribute both heads to the same workshop, if not actually to the same sculptor.

Identity. There can be no doubt that the head represents a youthful Apollo, as it conforms closely to the fourth century BC Apollo type: cf. Apollo Lykeios, Apollo Sauroktonos, Apollo Belvedere, and the Apollo of the Sala delle Muse in the Vatican. To judge from the lively pose and gaze, the figure to which this head belonged is likely to have been in motion (cf. Belvedere and Vatican Apollos). In what guise Apollo appeared on the Mausoleum, whether as Citharoedus (and therefore draped), or as Bow-shooter (and so nude, but for chlamys), there is no way of telling. Gardner, *New Chapters,* favoured the former interpretation, Deubner, *Hellenistische Apollongestalten* (1934), 53 ff., the latter.

The fragment of draped shoulder (66 below), which Gardner associated with this head, cannot belong. It is clear from the working of it that the head which belonged to it was draped at the back, as this head of Apollo certainly was not.

Scale. Smaller than the heads of the colossal series of figures, 26–32, but slightly larger than the next series (II: heroic), 42–45. Since a deity would be larger than the figures of mortals with whom he may have been grouped, this head may be reasonably classed as being of scale II. It is not impossible, however, that it may have been grouped with mortal figures of life-size: it depends on how much larger a deity was represented than a mortal at this time. See above, pp. 36–7, 51.

Newton, *Papers,* i. 15; *HD* 104, 225; *MRG* 50 (+ 51 f); Smith, *BM Cat.* 1058; P. Gardner, *JHS,* xxiii (1903), 121 ff.; *New Chapters in Greek Art* (1926), 99–116; Deubner, *Hellenistische Apollongestalten* (1934), 53 ff.; Neugebauer, *NJb,* cxvii (1942), pl. 2, 4; K. A. Pfeiff, *Apollon* (1943), 126, pl. 51b; Buschor, *MuA* (1950), 35, fig. 58; Arias, *Skopas* (1952), pl. 16, fig. 56; Picard, *Manuel,* iv. 1 (1954), fig. 46; Jeppesen, *Paradeigmata* (1958), 48, 52, 53, 54, figs 46–47; Riemann, *P-W* 450–1; von Graeve, *AM,* 89 (1974), 238, pl. 86.2.

49. Head of Persian (pl. 23)
BM 1057; *MRG* 49; Reg. 1857.12–20.263.

Found by Newton in Hadji Nalban's field on the south side of the Mausoleum Quadrangle (*Papers,* i. 32; Invoice of cases, no. 238; *HD* 129 no. 4, 226).

Dimensions. Max. H. 0·36 m. Max. W. 0·21 m. Max. Th. 0·25 m. H. chin to hairline 19·3 cm; chin to base of nose 8·3 cm; base of nose to line between tear ducts 5·5 cm; line between tear ducts to hairline 5·5 cm. W. of face at eye-level 14·2 cm; of left eye 3 cm. H. chin to crown 25 cm.

Marble. White, micaceous, weathered to a coarse texture.

The head and upper part of the neck are preserved in one piece, but the surface is extremely weathered, and few details of the facial features remain.

The head is swathed in a Persian head-dress or *kyrbasia,* which covers both sides of the face, and is also drawn up over the mouth at the front. On top of the head, the loose upper part of the cap flops forward (the tip of it now broken), and is divided from the lower part of the head-dress on each side by rather harsh grooves made by the running drill. There is otherwise little detail in the carving of the *kyrbasia.*

Of the facial features, the eyes are wide-open, and seem to have had a searching, intense gaze. The forehead is rather low, and above it are traces of hair, carved in vertical grooves but now much worn.

Pose. So far as one can tell, the neck ran at an angle diagonally from the left shoulder, and the head was turned back slightly to the left, and directed upwards a little. Cf. heads 30, 48.

In the left side of the head-dress, at the level of the left eyebrow, is an ancient drill-hole, 8 mm in diameter and 2 cm deep, which may have served for the attachment of a weapon.

Scale. Life-size (III). Cf. head 46.

Newton, *Papers,* i. 32; *HD* 129, 226; *MRG* 49; Smith, *BM Cat.* 1057; Buschor, *MuA* 30, 34, figs 46, 49; Picard, *Manuel,* iv. 1 (1954), fig. 48; Jeppesen, *Paradeigmata* (1958), 48, fig. 22; Riemann, P-W 450 (r); Schlörb, *Timotheos* (1965), 76. pl. 21b.

the lower jaw or chin. It also comes lower over the forehead, and covers the upper half of each ear.

Pose of head. The neck seems to run diagonally upwards from the right shoulder, and the head is turned back slightly to the right, the gaze perhaps directed downwards.

Little can be said of the facial features, so damaged are they.

Scale. About three-quarters life-size if of an adult. The smallest head, by some way, of those found at the site of the Mausoleum. There is no reason, however, to suppose that it comes from a relief, as Newton tentatively suggested (*HD* 227), presumably with the break on the back of the head in mind; its finding-place, some way distant from the north *peribolus* wall, may possibly cast doubt on its attribution to the Mausoleum, although the marble is the same as that used for the majority of the other sculptures. There are also two fragments of draped bodies of similar scale, probably from Persian figures; see 76 and 89 below.

Newton, *Papers,* i. 45; *HD* 116, 227; *MRG* 51; Smith, *BM Cat.* 1060; Buschor, *MuA* 41 ff., figs 63–64; Picard, *Manuel* iv. 1 (1954), fig. 52; Jeppesen, *Paradeigmata* (1958), fig. 22; Riemann, P-W, 451 (u).

50. Head in Phrygian cap (pl. 23)
BM 1060; *MRG* 51; Reg. 1857.12–20.262.

Found by Newton some way (*c.* 50 ft) to the north of the north *peribolus* wall, close to the line of an ancient wall in Mahomet's field (*Papers,* i. 45; Invoice of cases, no. 256. 2; *HD* 116, 227: described by Newton as Amazon). Not from the south side, as claimed by Riemann.

Dimensions. Max. H. 0·315 m. Max. W. 0·21 m. Max. Th. 0·20 m. H. from chin to line of cap 15 cm; chin to centre of lips 3·5 cm; lips to bridge of nose 6·5 cm. W. of face at eyes 13 cm; W. of each eye *c.* 2·8 cm; W. of mouth *c.* 4 cm.

Marble: White, weathered to a gritty texture.

The head and upper neck are preserved in a single fragment, the surface of which, however, is much damaged and exceedingly worn. Part of the back of the head has been split off.

A small head, somewhat less than life-size, probably male, wearing a cap of Phrygian type, different in style to that of 49. It is higher in the crown, with a smaller point, wider at the side of the head, and it does not cover

Other Fragments of Statues

FRAGMENTS OF HEADS

51. Back of male head (pl 24)
MRG 51a. Reg. 1972.4–2.1. Numbered 157 (black).

Finding-place unknown.

Dimensions. H. 0·24 m. W. 0·21 m. D. 0·19 m. H. of ear (as preserved) 6·5 cm.

Marble. White, fine-medium crystal, with brown patina.

Preserved from behind the left ear, around the back of the head to the right ear, the rear half of which remains. The top of the head extends farther forward to a point that cannot have been far short of the forehead.

Mostly it is hair which remains. This is short and curly, its treatment rather rough, revealing much use of the point. A small portion of the neck, which is preserved behind the right ear, is however well smoothed.

In proportion the head appears to have been broad and square.

Scale. About life-size (III). For the treatment of the hair, cf. head 46.

Newton, *MRG* 51a.

52. Neck and tenon (pl. 24)
MRG 51b. Reg. 1972.4–2.2. Numbered 253.22 (red).

Found by Newton, but precise finding-place unknown. Briefly mentioned, *HD* 227.

Dimensions. H. 0·22 m. W. 0·205 m. D. 0·20 m.

Marble. White, fine-medium crystal.

Two adjoining fragments which make up the lower part of a neck and a tenon for insertion into a separately carved body.

The sides of the neck are well smoothed, but at the base the marks of the point and claw chisel remain. At the base of the neck in the front is a deep hollow (cf. head 47). Because of this apparently 'muscular' treatment, Newton judged the head to be from a male figure, but there is really no proof one way or the other.

The tenon is well preserved and has tapering sides: H. at front 4 cm; at back 11 cm. The roughly picked underside is oval and measures 17 × 14 cm.

Scale. About life-size (III).

Newton, *HD* 227; *MRG* 51b.

53. Neck (pl. 24)
MRG 51c. Reg. 1972.4–2.3. Numbered 261 (red), 149 (black).

According to the Invoice of cases, no. 261, this is one of two necks found under Mehemet Ali's house at the north-east angle of the *peribolus* (cf. Newton, *HD* 117). The other neck found there has not been identified.

Dimensions. H. 0·23 m. W. 0·21 m. Th. 0·23 m.

Marble. White, fine-medium crystal, with brown patina.

Preserved is a large neck of a statue, with a broad, rounded lower end for insertion into a separately carved body. It is not really a tenon in the manner of 52. This lower end, which is now damaged on the left side, has been roughly pointed.

The treatment of the neck is realistic: there is a prominent Adam's apple, a deep recess at the base of the neck in front, and two creases on the front. Rough pointwork remains at the back of the neck.

Scale. Over life-size; perhaps scale II, possibly even colossal.

Newton, *MRG* 51c; *HD* 117.

54. Base of neck and tenon

MRG 51d. Reg. 1972.4–2.4. Numbered 142 (black).

Finding-place not given, but perhaps from north-east angle of *peribolus*. See no. 53, and above p. 8.

Dimensions. H. 0·13 m. W. 0·22 m. Th. 0·21 m.

Marble. White, fine-medium crystal, with brown patina. The surface is much weathered and somewhat incrusted.

Preserved is a tenon for insertion into a statue, and the lowest part of a neck. The tenon has sharply tapering sides, ranging in height from 3 cm at the front, to 9·5 cm at the back. The underside which is oval and measures 18 × 15 cm has been dressed with the claw chisel.

Scale. About life-size (III).

Newton, *MRG* 51d.

55. Lower neck and tenon (pl. 25)

MRG 51e. Reg. 1972.4–2.5. Numbered 256.5 (red).

Finding-place not given in Invoice of cases.

Dimensions. H. 0·25 m. W. 0·22 m. D. 0·17 m.

Marble. White, fine-medium crystal, with brown patina.

Preserved is a tenon for insertion into a statue, and part of the neck, broken at the front, but rising to a considerable height at the back. The tenon is rounded underneath (cf. 53), and varies in height from 7 cm at the front to 13 cm at the back. It is roughly worked with the point, as is also the flesh at the base of the neck. The recess at the base of the neck in front is clearly indicated.

Scale. Life-size (III).

Newton, *MRG* 51e.

56. Fragment of neck

Reg. 1972.4–2.6. Numbered B.66.3 (black).

Probably the fragment found by Biliotti on 29 March 1865, on which date in his diary he describes finding 'in a garden wall near the SW angle of the quadrangle: a head larger than life-size, but so defaced it can hardly be recognised as such'.

Dimensions. H. 0·13 m. W. 0·14 m. Th. 0·185 m.

Marble. White, medium-crystalled.

Broken above, below, and at both sides. At the front, part of the surface of the neck is preserved, and the beginnings of the underside of the chin. There is a crease in the neck. At the back, there remains a small area of neck, and, above it, a few locks of short, curly hair like that of 46 and 51, which show the head to have been male.

Scale. About life-size (III).

57. Fragment with left eye and cheek (pl. 25)

Reg. 1972.4–2.7. Numbered 254.12 (red), 228 (black).

According to the Invoice of cases, no. 254.12, found on the south side of the Mausoleum Quadrangle. Probably one of the fragments mentioned by Newton, *HD* 227.

Dimensions. H. 0·145 m. W. 0·10 m. Th. 0·09 m.

Marble. White, fine-crystalled.

A small fragment of a head, which preserves the upper part of the left cheek, most of the left eye (W. as it remains 3·5 cm), and some of the forehead. A raised, regular line which seems to run across the forehead close to the upper break suggests the head may have worn a cap or helmet.

Scale. Over life-size (probably II). The width of the eye, which is not quite complete, is almost equal to that of the bearded head, 45 (3·6 cm), and is not much smaller than that of Apollo, 48 (4 cm). Could be from a helmeted warrior, or a Persian in a cap, or even from a figure of Athena.

58. Fragment of chin, lower lip, and neck

Reg. 1972.4–2.8. Numbered 262 (red), 229 (black).

According to the Invoice of cases, no. 262, found in Hadji Nalban's field on the south side of the Mausoleum.

Dimensions. H. 0·095 m. W. 0·13 m. D. 0·15 m. W. of lower lip 4·5 cm. H. from chin to top of lip 6 cm.

Marble. White, fine-crystalled. The upper break shows signs of severe burning.

Preserved is a rounded, beardless chin, the lower left side of the jaw, and the upper part of the neck. Above the chin is a short but full lower lip, of the sort to be found on other Mausoleum heads; cf. 30, 45, 48.

Scale. A comparison with other beardless heads suggests it is of scale II (heroic), and perhaps even equal to the scale of the head of Apollo, 48 (there, chin to lips 5·5 cm; W. of mouth 5·5 cm, but lower lip not as wide as full mouth). It may well be part of the same head as 57, above, which is of similar marble, scale and style, and which was also found on the south side of the Mausoleum. There is, however, no join.

59. Fragment of chin, mouth, and neck

Reg. 1972.4–2.9. Numbered 118 (red), 221 (black).

Finding-place not given.

Dimensions. H. 0·065 m. W. 0·105 m. D. 0·15 m. W. of mouth perhaps *c.* 4 cm. H. from chin to centre of lips 5 cm.

Marble. White, fine-crystalled.

A fragment of a head which preserves the chin, left part of the mouth, lower left jaw, and some of the left side of the neck. There is damage to the chin and lips.

Scale. About life-size. Cf. head 46 of scale III (chin to lips 5·2 cm; W. of mouth 4·3 cm).

60. Fragment of cheek and eye

Reg. 1972.4–2.10. Numbered 120 (red), 220 (black).

Finding-place not known.

Dimensions. H. 0·165 m. W. 0·085 m. Th. 0·09 m.

Marble. White, fine-medium crystal.

A fragment of a head which preserves part of the left cheek, down nearly as far as the jaw, half of the left eye, and some of the left temple. The eyelid was once quite sharply cut, but is now rather damaged.

Scale. About life-size (III).

61. Fragment of top of head

Reg. 1972.4–17.11. Initialled C.T.N. (red), numbered 227 (black).

Finding-place not known.

Dimensions. H. 0·075 m. W. 0·125 m. D. 0·20 m.

Marble. White, fine-crystalled.

A fragment with a convex surface, on which are carved wavy grooves of hair. The hair is parted, and there are traces of what appears to be a fillet. In all probability from the top of a human head. Cf. head 47.

Scale. About life-size (III).

62. Fragment of cap of colossal female head

Reg. 1972.4–2.11. Numbered 105 (red).

Finding-place not known.

Dimensions. H. 0·20 m. L. 0·22 m. Th. 0·06 m.

Marble. White, fine-crystalled.

A convex, smoothly worked fragment, which is almost certainly part of the left side of the cap (*sakkos*) of a colossal female head of the type of 30. The uneven curves (steep on top, shallower towards back), rasped surface, grain of marble and scale all agree with 30.

FRAGMENTS OF BODIES

63. Part of upper back of colossal draped figure (pl. 25)

MRG 55. Reg. 1972.4–2.12. Four adjoining fragments, one of which (on right of back) is numbered 253.22 (red).

Finding-place not known.

Dimensions as restored. H. 0·61 m. W. 0·65 m. Th. 0·23 m.

Marble. White, fine-crystalled.

The four fragments make up much of the upper part of the back, including some of the left shoulder and a cutting to receive the left arm.

The drapery consists of a himation, worked for the most part in shallow vertical folds. Towards the right shoulder there is part of the diagonal bunch, whose working is equally shallow. Much better is the carving of the few folds of himation which fall below the attachment for the left arm, and which would, no doubt, have been visible from the front of the statue.

At the left shoulder is part of a vertical plane surface, dressed with the claw chisel, which received the left arm. *Dimensions as preserved.* H. 0·29 m; W. 0·105 m; recessed 6·5 cm inwards from the outermost drapery fold on the left side. On the broken front edge one side of the dowel hole for attaching the arm is preserved: D. 10·5 cm; H. at shoulder 4 cm, within 3 cm. A small fragment of the metal dowel still remains, adhering to the marble. The dowel hole ran upwards slightly. Below the dowel hole, and set farther back, there is most of a drill-hole, 3 cm in diameter and 2 cm deep.

Scale. Colossal (I). Cf. statues 26, 27, 29. The arrangement of the drapery at the back is similar to that of 29, but these fragments cannot have belonged to that figure because the direction of the bunched folds does not correspond. The bunching on 29 is nearly vertical, here it is more oblique.

Newton, *MRG* 55.

64. Fragment of colossal draped figure
Reg. 1972.4–17.1. Numbered 285 (red).

According to the Invoice of cases, no. 285, found on the east side of the Mausoleum.

Dimensions. H. 0·52 m. W. 0·47 m. Th. 0·37 m.

Marble. White, fine-crystalled.

A fragment probably from the lower part of the side of a colossal draped figure. On the small area of original surface which is preserved, there are sweeping folds of a himation, which pull up and around the body. Running horizontally across the line of these folds is a shallow groove representing a long crease of the kind to be found on the lower parts of the himatia of statues 26 and 27. In style, therefore, this figure would appear to have been very similar to statues 26 and 27.

Scale. I.

65. Fragment of colossal draped figure (pl. 26)
MRG 53. Reg. 1972.4–2.13. Initialled C.T.N. (red).

Finding-place unknown.

Dimensions. H. (as mounted at present) 0·40 m. W. 0·30 m. Th. 0·18 m.

Marble. White, fine-crystalled, with brown patina.

The underlying form of the figure is well rounded, and the drapery adheres closely to it, being finely wrought in numerous narrow folds. Shallower folds on the right of the fragment (as mounted) could be part of a chiton, while more deeply bunched folds on the left may belong to a himation. Alternatively the folds could all be part of a sweeping himation of fine material, pulled more tautly in one place than another. The deeper folds are drilled, while between them sharply chiselled folds spiral slightly. In the middle of this fragment is a drill-hole, 1·3 cm in diameter and 4 cm deep.

The fineness of the drapery suggests that this is part of a female figure rather than a male figure, but precisely which portion is preserved is hard to say. The constant curve of the form and the fine quality of the finish favour the side of a figure rather than some part of the back or shoulders. A point which ought to be significant is that on one edge of the back of this fragment, which is otherwise broken, there is slightly more than half of a dovetailed clamp cutting (L. of half of dovetail 4·5 cm; D. of side, as preserved, 1 cm). This must be for the attachment of another piece of the statue, and one thinks of a lower arm rather than a shoulder. Cf. the dovetailed cutting for the attachment of the left forearm of 26.

Possibly, therefore, this is part of a colossal female figure, at about hip or waist level. The style differs from that of 27, the arrangement of the folds being more varied, and the carving of a higher quality.

Scale. I.

Newton, *MRG* 53.

66. Right shoulder of draped figure (pl. 26)
BM 1061; *MRG* 52. Reg. 1972.4–2.14. Numbered 96 (red).

Finding-place unknown.

Dimensions. H. 0·36 m. W. 0·34 m: Th. 0·37 m.

Marble. White, fine-crystalled, with brown patina.

Preserved are the right shoulder, upper right arm, and part of a socket to receive a separately worked head. The arm is draped in a close-fitting sleeve of the type normally worn by Persians. Over the chest and shoulder is a garment, probably a cloak, of thick material, which hangs in heavy folds on either side of the arm. At the back of the shoulder is a still heavier mass of drapery, which terminates at the edge of the socket for the head in a smooth margin. The head which belonged to this body must, therefore, have been draped at the back. In all probability it wore a Persian helmet (*kyrbasia*).

Only the right side of the socket for the head remains, and none of the base. It was at least 9 cm deep at the

front of the figure, and 12 cm at the back. The inside is heavily picked.

Rasp marks remain on the surface of the drapery.

Scale. Over life-size (II).

Gardner's suggestion that this is part of the statue of Apollo, to which the head 48 belonged, is almost certainly incorrect (*New Chapters in Greek Art* [1926], 102–3). Apollo's head is undraped at the back, whereas the head which belonged to this body must have been at least partially draped at the back and sides. Probably this fragment belongs to a statue that wore Persian dress, of which there are several other examples from the Mausoleum.

Newton, *MRG* 52; Smith, *BM Cat.* 1061; P. Gardner, *JHS* xxiii (1903), 125 ff., fig. 4; *New Chapters in Greek Art* (1926), 102–3, fig. 11; Riemann, P-W, 451 (v).

67. Part of back and left shoulder of draped figure

MRG 56. Reg. 1972.4–2.15. Numbered 213 (red).

According to the Invoice of cases, no. 213, this is one of several fragments from the 'east end, north side of Mausoleum'.

Dimensions. H. 0·38 m. W. 0·30 m. Th. 0·10 m.

Marble. White, fine-crystalled, with brown patina.

The drapery consists of a heavy cloak, whose vertical folds are bunched quite deeply on the right side, but are pulled tauter on the rounded left edge, which is probably part of the back of the left shoulder. The finish is somewhat summary.

This fragment could well have belonged to the same statue as 66. The dimensions, type of marble, type of drapery, and style of carving closely correspond. No join is possible, however, and this piece is not thick enough to have preserved traces of a socket for a head.

Scale. Over life-size (II).

Newton, *MRG* 56.

68. Upper left part of draped male figure
(pl. 26)

MRG 59 (?). Reg. 1857.12–20.282. Numbered 73 (red).

Finding-place not known.

Dimensions. H. 0·505 m. W. 0·32 m. D. 0·405 m.

Marble. White, fine-crystalled. Surface weathered.

Preserved is the left side of the upper part of a draped figure, in the top of which there is the left part of a socket to receive a separately worked head: L. (as preserved) 11 cm; W. 17·3 cm; D. (max) 12 cm. The sides and base of the socket are roughly pointed.

At the left shoulder is most of a plane surface, dressed with the claw chisel, for the attachment of a separately worked left arm. The surface of the lower half is broken, but the original extent is clear. *Dimensions as preserved.* W. 18 cm (original); H. (now) 11 cm; original H. *c.* 20–22 cm.

Most of the cutting for a dowel remains: H. 4·2 cm; W. 3·1 cm; D. 9·3 cm. To the left of the cutting is another drill hole, 1·5 cm in diameter and 1·7 cm deep.

The upturned angle of the plane surface, and the downward course of the dowel hole, which is at right-angles to the surface, suggest that the left arm was raised.

The figure wears a close-fitting chiton, confined by a belt, the upper part of which remains below the left arm. Although the surface is much worn, it can be seen that the folds at the front pull up from the belt to the left shoulder, confirming that the left arm was raised.

Running diagonally across the shoulder and down over the back is a thick wedge of drapery, never finished in detail, which is presumably the edge of a cloak or himation. This garment terminates at the point where the left arm was attached, and may have been continued on the separately worked arm, perhaps falling below it. There is, in any case, no sign of a himation on the front of the figure.

This fragment is identical in scale, and very similar in style, to the lower part of a male statue, 42. It cannot, however, have belonged to the same statue as that fragment, because the pose is wrong (the stance of 42 suggests that its upper body would have leaned to its right, whereas this upper body leans to its left). Clearly, though, it must belong to the same series as 42.

Scale. Over life-size (II).

Newton, *MRG* 59 (?).

69. Upper part of draped statue

MRG 58 (?) (mounted on a base numbered 59, but suiting better the description of 58). Reg. 1972.4–2.16. Numbered 154 (red).

Finding-place not known.

Dimensions. H. 0·30 m. W. 0·34 m. Th. 0·24 m.

Marble. White, fine-crystalled, with brown patina.

A fragment from the upper part of a statue, preserving much of a socket for the insertion of a head, and part of a shoulder. The sides of the socket (max. D. 12 cm) are neatly finished with the point. Whether it is the left or right shoulder which is preserved is not certain, since both the front and back of the body are broken. Slight traces of drapery remain over the shoulder, and on the lowest part of one side.

Scale. Over life-size (II); for size of cavity, cf. 68.

Newton, *MRG* 58 (?).

70. Upper right part of draped figure

MRG 60 (?) (description there does not correspond closely). Reg. 1972.4–2.17. Initialled C.T.N. (red).

Finding-place not known.

Dimensions. H. 0·45 m. W. 0·25 m. Th. 0·40 m.

Marble. White, fine-crystalled; exceedingly worn and weathered. Condition generally very poor.

Preserved is the right side of the upper part of a large draped figure, including part of a socket to receive a head. *Dimensions of socket, as preserved.* L. 7·5 cm; W. 21 cm; D. 11 cm. The sides and base are roughly pointed.

On the right shoulder, the front part of which is broken away, are traces of cuttings for the attachment of the arm. Some of a plane surface remains, angled downwards, and above this, in a broken area, there appears to be the bottom of a dowel hole, H. 7 cm × W. 1·5 cm, through which runs at right angles a drill-hole for a pin to secure the dowel, 1 cm in diameter × 6 cm long (as preserved). Cf. statue 26. The pin appears to have been inserted from the front of the figure as on 26. In all probability the arm was held down.

Drapery remains on the front, side and back of the fragment. At the front the folds are in the form of well-defined, broadly spaced, sharp ridges, that seem to fall from a right male pectoral, and then curve to the right at the bottom of the fragment, as if hanging loose over a belt. The garment appears to be a male chiton (cf. 26, 42, 43, 68). At the back shallower, broader folds run diagonally from the left side of the figure up to the back of the right shoulder. This may be part of a himation. The working of the drapery at the back seems to have been more schematic than at the front.

Scale. Over life-size (II). Similar in style to 68, but unlikely to belong to the same statue as that fragment, because the arrangement of drapery does not well correspond.

Newton, *MRG* 60 (?).

71. Part of upper body and shoulder of draped figure (pl. 26)

MRG 54. Reg. 1972.4–2.18.

Finding-place not known.

Dimensions. H. 0·52 m. W. 0·23 m. Th. 0·23 m.

Marble. White, fine-crystalled, with brown patina.

Preserved is a fragment from a draped torso, the upper part of which curves over sharply, and is clearly from a shoulder. No trace of cuttings for head or arm remains. Attributed by Newton (*MRG* 54) to the back of a figure, but the deep working and fine finish of the drapery suggest that it comes from the front of a statue, in which case it must be part of the left side of the breast and shoulder.

The garment appears to be a thickish chiton like that worn by 26 and other statues. Strong folds radiate from the area of the shoulder and begin to pull around the side of the figure at the bottom of this fragment.

Scale. Over life-size (II). Similar in style to 70. It is not impossible that both fragments may have belonged to the same statue.

Newton, *MRG* 54.

72. Upper part of draped figure

Reg. 1972.4–2.19. Numbered B.66.3 (black).

Found by Biliotti, but finding-place not given.

Dimensions. H. 0·345 m. W. 0·40 m. Th. 0·22 m.

Marble. White, fine-crystalled, with orange patina. Surface much damaged and weathered.

Preserved is the upper part of a statue with drapery at the front and on the right side. The back is broken, as are the upper edges. On top, however, is part of the bottom of a socket to receive a head, oval in shape, worked with the point. *Dimensions as preserved.* L. 16 cm; W. 11 cm.

The drapery is a close-fitting chiton, rendered in rather uninteresting straight folds which converge towards the waist, where the garment was probably belted. If this is the front which is preserved (and it is not absolutely certain), the figure is male, since the breasts are not full.

Perhaps from a figure of the type of 68, but smaller in scale.

Scale. About life-size (III).

73. Fragment of shoulder
Reg. 1972.4–17.2. Initialled C.T.N. (red).

Finding-place not known.

Dimensions. H. 0·34 m. W. 0·37 m. Th. *c*. 0·15 m.

Marble. White, fine-crystalled. A deposit of mortar adheres to the top of the shoulder.

A fragment with curving outer surface from the upper back of a draped statue. The surface at the back is only roughly finished with the claw chisel, but it becomes smoother towards the right break, where creases of drapery begin to appear. On the back, part of the side of a socket to receive a head remains, worked with a point. At the top, which appears not to be broken, the thickness of the wall between drapery and socket is *c*. 6–6·5 cm.

Scale. Colossal (I). Cf. upper back of statue 26.

74. Fragment of draped shoulder
Reg. 1972.4–2.20. Numbered 191 or 161 (red).

In either case probably from the Imam's field on the north side of the Mausoleum (see Invoice of cases, nos 161, 191).

Dimensions. H. 0·24 m. W. 0·195 m. Th. 0·115 m.

Marble. White, fine-crystalled. Surface weathered.

A fragment from the upper part of a draped figure, probably from behind the right shoulder. The drapery, which is perhaps a himation, falls in vertical folds, that are worked in shallow and schematic fashion. Part of the side of a socket to receive a head remains: D. at least 9·5 cm; worked with the point.

Scale. Probably over life-size (II).

75. Fragment of upper back of draped figure
Reg. 1972.4–2.21. Numbered B.66.1 (black).

Found by Biliotti, but finding-place not known.

Dimensions. H. 0·24 m. W. 0·24 m. Th. 0·12 m.

Marble. White, fine-crystalled; surface considerably worn.

A fragment from the back of the shoulders of a draped figure, preserving a small part of a socket to receive the head. Long marks of the point remain on the sides of the socket. *Dimensions as preserved*: D. 10 cm; L. 8 cm; W. 5·5 cm. Three very light drapery folds remain on the back, the upper two running almost horizontally across the shoulders, the lower one rather more diagonally from the left down towards the right side. Probably from the right side of the back, to judge from the relation of the socket to the outer contour.

Scale. Probably over life-size (II).

76. Part of upper body of draped figure
Reg. 1972.4–2.22.

Unnumbered, but previously displayed with other fragments from the Mausoleum.

Dimensions. H. 0·16 m. W. 0·18 m. Th. 0·15 m.

Marble. White, fine-crystalled.

A fragment from the shoulder of a small draped statue, on which is preserved part of a socket for a head, and some of a worked surface for the attachment of an arm. *Dimensions of socket, as preserved.* L. 9 cm; D. at side 8·5 cm; sides and base pointed. *Dimensions of surface for attachment of arm.* H. 11 cm; surface dressed with claw chisel. Part of a drill hole for the dowel remains: 1·5 cm diameter and 5·5 cm deep. A single heavy fold of drapery remains on one side of the figure, the other side being broken. If this drapery belongs to the front of the statue, as seems likely since it is well finished, then this is the left shoulder which is preserved. The garment may perhaps have been a Persian cloak. Cf. 66. Neat work.

Scale. From a figure rather less than life-size, and probably the same scale as the Phrygian head 50 (IV). Cf. also the fragment of a small Persian figure below, 89.

77. Fragment of draped shoulder
Reg. 1972.4–2.23. Numbered B.66.3 (black).

From Biliotti's excavations, but finding-place unknown.

Dimensions. H. 0·20 m. W. 0·19 m. D. 0·15 m.

Marble. White, fine-crystalled, with orange patina in places.

A fragment probably from the back of a right shoulder, with a flat surface worked for the attachment of the arm. The drapery, which is most likely a himation, is

smoothly finished except on the right, where a raised edge runs over the upper arm. About half of the surface for the attachment of the arm remains, dressed with the claw chisel (diameter originally *c*. 15·5 cm). On one side of it, close to where the edge of the drapery approaches, is a protruding lip to give further purchase to the arm. There also remain parts of two dowel holes. The lower one measures: L. 3 cm; W. 1·25 cm; little of the depth remains. Into this dowel hole ran a transverse drill-hole, in order to cross-pin the arm dowel, as on 26. Half of this hole is preserved on the break; it is 10 cm long. Traces of the iron pin remain within it. Although little of the second dowel hole remains, it was probably of the same dimensions as the first: W. 1·5 cm; L. (now) 0·5 cm.

The cross-pinning of the dowel may suggest the arm was held down.

Scale. Over life-size (II).

78. Fragment of right shoulder of draped figure
Reg. 1972.4–2.24. Numbered 171 (red).

According to Newton's invoice, case no. 171 contained 'seven pieces from Statue No. 2 (i.e. "Maussollos"), Imaum's field, north side'. It looks as if this fragment was found in the main deposit of sculptures in the Imam's field, and was at first thought to belong to 'Maussollos'.

Dimensions. H. 0·20 m. W. 0·155 m. Th. 0·083 m.

Marble. White, fine-crystalled.

Preserved is part of a himation from behind and over a right shoulder, and a vertical plane surface, dressed with the claw chisel, for the attachment of the arm. Two sides of a dowel hole remain: H. 2·2 cm; W. 1·25 cm; D. 8·1 cm (these dimensions all original). Above and behind the dowel hole is a supplementary drill-hole: 1·1 cm in diameter and 4·5 cm deep. The dowel hole runs downwards in relation to the worked surface. Adhering to the sides of the cutting are traces of the iron dowel.

The folds of the drapery at the back are vertical and are carved only in the shallowest concave undulations. Over the shoulder itself they give way to a rougher pocked surface (owing to pointwork or weathering or both). The style of the drapery is close to that of 74, and it is possible that both fragments belonged to the same statue, although there is no join.

Scale. Over life-size (II).

79. Fragment of draped shoulder
Reg. 1972.4–2.25. Numbered B.66.3 (black).

From Biliotti's excavations. Finding-place not known.

Dimensions. H. 0·235 m. W. 0·17 m. Th. 0·17 m.

Marble. White, fine-crystalled; surface much worn and weathered.

A fragment of a shoulder with drapery on one main side, and a flat surface on the end, dressed with the point, for the attachment of an arm. The drapery appears to have been quite heavy, for traces of deep, long grooves remain, but the condition is too poor to be certain whether this belongs to the front or back of a figure, and, consequently, whether this is part of a right or a left shoulder.

Scale. Over life-size (II).

80. Shoulder of draped figure
Reg. 1972.4–2.26. Initialled C.T.N. (red).

Finding-place not known.

Dimensions. H. 0·21 m. W. 0·17 m. Th. 0·235 m.

Marble. White, fine-crystalled; surface quite well preserved.

Probably, though not certainly, a right shoulder. The drapery at the 'back' is smooth and foldless, except for a broad fold which runs obliquely close to the break, and which is perhaps the edge of a himation. The drapery at the 'front' is more deeply worked in concave grooves, and the folds run horizontally towards where the arm may have been raised. The upper part of a worked surface is preserved, for the attachment of the arm, smoothly finished except for a few point marks. *Dimensions*. W. 14·5 cm; H. (now) 8 cm.

The inner part of a dowel hole also remains: H. 4 cm; W. 1·7 cm; D. (to worked surface, i.e. original) 8·5 cm.

Scale. Not much over life-size (II or III).

81. Fragment of draped shoulder (?)
Reg. 1972.4–2.27. Numbered 126 (red).

Finding-place not known.

Dimensions. H. 0·255 m. W. 0·165 m. Th. 0·065 m.

Marble. White, fine-crystalled with streaks of mica. Surface badly weathered.

A fragment of a draped figure, one end of which is worked smooth as if for the attachment of an arm at the

shoulder. A protruding fold runs around what may have been part of a socket to receive a head. The drapery, although worn, seems to have been very finely carved.

Scale. Life-size or slightly less.

82. Fragment of shoulder of draped figure
Reg. 1972.4–2.28. Numbered 146 (red), 550 (black).

Finding-place not known.

Dimensions. H. 0·33 m. W. 0·19 m. Th. 0·14 m.

Marble. White, fine-crystalled.

A fragment from the back of the right shoulder of a draped figure. The garment, probably a himation, hangs in long vertical folds. At the top it curves over the shoulder, and a heavier fold falls over the right side of the shoulder. Cf. fragments 66 and 67.

Scale. Probably over life-size (II).

83. Fragment of shoulder (?)
Reg. 1972.4–2.30. Initialled C.T.N. (red).

Finding-place not known.

Dimensions. H. 0·40 m. W. 0·15 m. D. 0·32 m.

Marble. White, fine-crystalled, with orange patina.

A slice from a statue, preserving only a small and narrow area of the original surface. This undulates slightly and is smoothly finished. Within the broken inner area, there is part of a cutting for a large dowel. One side only remains, to which fragments of the iron dowel adhere: H. 5·8 cm; L. as preserved 7·3 cm. The presence of this dowel hole suggests the fragment may be from the shoulder of a human statue, in which case it would probably be part of a left shoulder. The preserved surface could be drapery.

Scale. Hard to assess, perhaps even colossal (I).

84. Fragment of shoulder of draped figure
Reg. 1972.4–2.29. Numbered 149 (red).

Finding-place not certain, but dispatched with a frieze slab from the east side of the Mausoleum.

Dimensions. H. 0·22 m. W. 0·095 m. Th. 0·145 m.

Marble. White, medium-crystalled.

A fragment of a draped figure, whose upper edge curves over, as if from the back of a shoulder. The edge of a

heavy cloak appears to be preserved, hanging vertically. For the style cf. 66, 67, 82.

Scale. Uncertain.

85. Left shoulder and breast of nude male figure (pl. 27)
BM 1065; *MRG* 71*. Reg. 1972.4–2.31.

Finding-place not known.

Dimensions. H. 0·41 m. W. 0·35 m. Th. 0·21 m.

Marble. White, fine-crystalled, with brown patina. Surface much worn.

Preserved is a portion of the bare left breast, and some of the left shoulder, of a male figure. The right breast and the back are missing. On top of the fragment are the remains of a socket to receive a separately worked head. Most of the bottom is preserved, but the upper edges are damaged. *Dimensions as preserved*: L. 10·5 cm; W. 14 cm; surface worked with point. There is an unsightly rim, projecting above the shoulder, where the head adjoined the torso on the left side. The upper left arm seems not to have been separately worked.

Scale. Life-size (III).

This fragment is of considerable importance, since it is the only sure evidence that nude figures as well as draped ones formed part of the free-standing sculptures of the Mausoleum.

Newton, *MRG* 71*; Smith, *BM Cat.* 1065; Riemann, P-W, 451 (w).

85A. Fragment of draped, male standing figure (pl. 27)
Reg. 1972.4–2.178. Numbered B.66.3 (black).

From Biliotti's excavations, but finding-place not known.

Dimensions. H. 0·57 m. W. 0·475 m. Th. 0·27 m.

Marble. White, fine-crystalled with silvery grains of mica. Surface weathered.

Preserved is a portion from the front of a statue, from just below the waist to the region of the upper thighs. Broad folds of drapery curve around the stomach and over the genitals which protrude slightly through the garment. Drapery folds remain at both sides of the fragment, but the back is broken. The upper right thigh appears to have been set forward, in which case the weight would have been on the left leg.

From a standing male statue who wore a long tunic, closely comparable with 43 in scale and style.

Scale. Over life-size (II).

86. Right thigh of draped male figure
BM 1062; *MRG* 61. Reg. 1972.4–2.32.

Finding-place not known.

Dimensions. H. 0·58 m. W. 0·33 m. Th. 0·21 m.

Marble. White, fine-crystalled, with yellow-brown patina in places. Surface much worn.

Preserved is part of the front of the right thigh of a figure, almost certainly male, who wore a knee-length chiton. Some of the lower edge of the chiton remains over the leg, and there is also a small amount of the leg itself preserved on the right side. It is not clear whether the leg was bare or draped. The garment adheres closely to the rounded form of the limb, and apparently had only a few, shallow, vertical folds. A heavier fold behind the leg on the right side may have belonged to a himation. For the garment cf. 42. It is not impossible, however, that this is from a figure in Persian dress.

Scale. Over life-size (II).

Newton, *MRG* 61; Smith, *BM Cat.* 1062; Riemann, P-W, 451 (w).

87. Fragment of lower left side of draped figure (pl. 27)
BM 1063; *MRG* 63; Reg. 1972.4–2.33.

Finding-place not known.

Dimensions. H. 0·50 m. W. 0·405 m. Th. 0·20 m.

Marble. White, fine-crystalled, with yellowish patina.

A large fragment from the left side of a draped figure, perhaps from over the left thigh. The drapery has a thick texture, and hangs in broad vertical folds, one of which has been repaired in antiquity. Its surface has been levelled with light strokes of the point, and four holes have been drilled, each 5 mm in diameter and 1·5 cm deep, for the attachment of the new piece of drapery. Beyond them is part of an iron dowel, *in situ*, which fixed the same piece of drapery.

Scale. Over life-size (II). For the style, cf. 86. It is possible that both fragments belonged to the same statue.

Newton, *MRG* 63; Smith, *BM Cat.* 1063; Riemann, P-W, 451 (w).

88. Fragment of lower left side of draped figure
Reg. 1972.4–2.34. Numbered B.66.3 (black).

From Biliotti's excavations, but finding-place not known.

Dimensions. H. 0·42 m. W. 0·255 m. Th. 0·19 m.

Marble. White, fine-crystalled.

A much-damaged fragment, broken to the right, behind, above and below, which is probably from the lower left side of a draped statue. At the front are some deeply drilled folds, whose coarsely worked surfaces may have been hidden by an overlapping himation at the side, part of which seems to remain. On the left side itself, however, is a vertical plane surface, dressed with the claw chisel, as if for the addition of a separately worked fragment of drapery. Cf. the cutting on the lower left side of 26; also the repair on 87.

Scale. Hard to assess; at least life-size (III), possibly even colossal (I).

89. Part of small male figure in Persian dress (pl. 27)
BM 1064; *MRG* 65; Reg. 1972.4–2.36.

Finding-place not known.

Dimensions. H. 0·32 m. W. 0·26 m. Th. 0·12 m.

Marble. White, fine-crystalled; surface much weathered and damaged.

A fragment from the front of a figure in Persian dress, preserved from the waist to the knees. The left side and back are broken, but the right side remains except for damage to folds. The figure wears close-fitting trousers, a knee-length tunic, and probably also a cloak, part of which may remain on the right side. The tunic is confined at the waist by a broad belt, in which, on the right of the front, is a ring, through which an end of the belt passes, hanging in a double loop across the abdomen.

Scale. Somewhat less than life-size; perhaps the same scale as fragments 50 and 76, above (IV).

Newton, *MRG* 65; Smith, *BM Cat.* 1064; Riemann, P-W, 451 (w).

90. Lower part of draped female figure on base (pl. 27)
MRG 64. Reg. 1857.12–20.280. Numbered 154 (red).

Finding-place not known.

Dimensions. H. 0·325 m. W. 0·57 m. Th. 0·36 m. Th. of base: 7 cm (front); 8 cm at side.

Marble. White, fine-crystalled; chocolate-brown patina in folds at rear. Surface badly weathered.

Reconstructed from three closely adjoining fragments, which make up most of the base on which stood a female figure. The left half of the front of the base is missing, as is also a small part of the left side. At the back and on the right side, drapery hangs in heavy, vertical folds, regularly but deeply carved. The garment is probably a himation. The right foot, which emerges from the drapery at the front, rests on a sandal, the sole of which was *c.* 3 cm high (it may have had decorative beading around the edges of the sole). Cf. 228, below. Little of the sandal, and no details of the foot remain. The lower edge of the garment is divided from the base by a drilled groove.

The surface of the base is roughly finished with the point, but the underside has a more regular finish.

Scale. Over life-size (II). For similar figures, see 91–93.

Newton, *MRG* 64.

91. Lower part of draped female figure (pl. 28)
MRG 70. Reg. 1972.4–2.42. Numbered 73 (red-black).

Finding-place not known.

Dimensions. H. 0·66 m. W. 0·62 m. Th. 0·32 m.

Marble. White, fine-crystalled.

A large fragment, much battered, from the lower part of a female figure wearing chiton and himation. Despite the poor condition, it can be seen that the weight of the figure was on the right leg, while the left leg was at rest. The chiton is visible at the front, between the legs and over the left calf. At the back and on the right side there are further folds of the chiton, rendered in schematic fashion, over which falls a himation, whose surface is more expansively worked. No traces of the feet remain.

Scale. Over life-size (II).

Newton, *MRG* 70.

92. Lower part of draped female figure on base
Reg. 1972.4–2.43. Numbered B.66.3 (black).

From Biliotti's excavations, but finding-place unknown.

Dimensions. H. 0·495 m. W. 0·33 m. Th. 0·28 m. Th. of base: 13 cm.

Marble. White, fine-crystalled.

Preserved is part of the back and right side of a draped statue, probably female, set on a base. The drapery, which is most likely a himation, hangs in heavy vertical folds, divided one from another by the running drill. The drill has also been used to separate the hem of the garment from the base. The edges and underside of the base have been finished with the point.

Scale. Over life-size (II).

93. Fragment of lower right part of draped female figure
Reg. 1972.4–2.44. Initialled C.T.N. (red); numbered 215* (black).

Finding-place not known.

Dimensions. H. 0·17 m. W. 0·29 m. Th. 0·14 m.

Marble. White, fine-crystalled.

Preserved is the rear part of a right foot wearing a sandal, the sole of which is 1–1·5 cm thick. Over the sandal is a chiton, which pulls in deep, horizontal folds around the ankle, but hangs in more summary, vertical folds at the back. The foot rests on a base 6·5 cm thick, the top of which is irregular, but not roughly finished, while the underside is lightly pointed.

Scale. Over life-size (II).

94. Fragment of lower part of back of draped statue
Reg. 1972.4–2.45.

Unnumbered, but previously displayed with other fragments from the Mausoleum.

Dimensions. H. 0·235 m. W. 0·23 m. Th. 0·11 m.

Marble. White, fine-crystalled, with bluish veins.

A fragment on which are preserved some broadly carved drapery folds from the lowest part of the back of a statue, and some of the base on which it stood. The edge of the base is broken, but its original thickness is preserved: 7·5 cm, or 9 cm including the drilled groove which separates base from drapery. Similar in style to the lower backs of 26, 27, and 90–93.

Scale. Over life-size, possibly even colossal.

FRAGMENTS OF DRAPED ARMS OR ATTACHMENTS FOR ARMS

95. Fragment of draped right arm from colossal statue

Reg. 1972.4–2.47. Numbered 162 (red).

Finding-place not known.

Dimensions. H. 0·305 m. W. 0·18 m. Th. 0·165 m.

Marble. White, fine-crystalled, with dark brown patina in places. Surface now much broken and worn.

Closely bunched folds of a himation fall over a right forearm that was probably slightly lowered, to judge from the way the folds are stepped downwards. Part of the surface of the arm remains on the underside, where it is separated from the drapery by a groove cut by the running drill. Similar to the drapery over the left arm of 26, and clearly from a colossal figure of that type, although whether from a male or female is hard to say (but perhaps rather male; cf. fragments of female figures, below, 98–100). The diameter of the arm at the front break, *c.* 12·5 cm, is roughly equal to the break on the left forearm of 27.

96. Drapery from left arm of colossal statue

Reg. 1972.4–2.48. Numbered 118 (red).

Finding-place not known.

Dimensions. H. 0·215 m. W. 0·13 m. Th. 0·085 m.

Marble. White, fine-crystalled.

Preserved are some heavy folds of a himation where they fall over a left arm, and part of a vertical plane surface with cuttings for the attachment of a separately worked forearm. The part of a dowel hole which remains measures 3 cm H. and 6 cm D., and runs upwards relative to the dressed surface which received the arm. There is another smaller cutting in the drapery fold immediately above where the forearm was attached: H. 2 cm; W. 1·75 cm; D. 1·75 cm.

Apparently from a statue similar in style and dimensions to 26.

97. Drapery and arm-joint from colossal statue

Reg. 1972.4–2.49. Initialled C.T.N. (red).

Finding-place not known.

Dimensions. H. 0·19 m. W. 0·12 m. Th. 0·08 m.

Marble. White, fine-crystalled.

A fragment from the region of the elbow of a right arm, which has a plane surface, dressed with the point, and part of a dowel hole to receive a separately worked forearm. *Dimensions of cutting*: H. 3·2 cm; W. 1·1 cm; D. 2·7 cm (more originally). A himation is drawn tightly around the arm, just behind the worked surface on the right side, but projecting in front of it underneath, where it might have served as a ledge to give extra support to the separate forearm.

Probably from a colossal female figure of the type of 27, where the cloak is drawn tightly around the elbow, before passing under the arm and across the waist.

98. Fragment of upper right arm and elbow of colossal draped female figure (pl. 28)

Reg. 1972.4–2.50. Numbered B.66.2 (black).

From Biliotti's excavations, but finding-place not known.

Dimensions. H. 0·31 m. W. 0·155 m. Th. 0·15 m.

Marble. White, fine-crystalled, with orange patina.

A fragment from the upper right arm and elbow of a female figure of the type of 27, who wears a sleeved chiton, and a closely drawn himation. Parts of a vertical surface, dressed with the claw chisel, and a dowel hole remain for the attachment of a separately worked forearm, which ran at right angles to the upper arm. *Dimensions of surface of attachment, as preserved.* H. 5 cm; W. 8 cm. *Dimensions of dowel hole.* H. 7 cm; W. 1 cm; D. 6 cm. The folds of the chiton sleeve are well varied, and have been finely wrought with the running drill. Traces remain of at least two buttons which fastened the sleeve. The himation, visible on the right side, is more smoothly worked, and has a seam at the edge. The way in which the edge of the himation passes from the elbow around to the front of the arm suggests that the himation was pulled up over the head and shoulders to serve as a veil, as on 27.

From a statue of the highest quality carving, of similar basic type to 27, but of different, and perhaps superior, style: the chiton is more effectively rendered; and the statue was worked in more than one part, as 27 was not. The colossal veiled female head, 31, could have belonged to this fragment.

Scale. I.

99. Fragment of draped right arm

Reg. 1972.4–2.51. Initialled C.T.N. (red).

Finding-place not known.

Dimensions. H. 0·145 m. W. 0·095 m. D. 0·15 m.

Marble. White, fine-crystalled.

Part of the upper forearm of a statue, probably female, with an himation drawn tightly around it. To judge from the line of the edge of the garment, the arm may have been raised slightly. The running drill has been used to divide the garment from the upper side of the arm. Diameter of break of arm, *c.* 12 cm.

Scale. Over life-size (I or II).

100. Fragment of draped arm and arm-joint

Reg. 1972.4–2.52. Initialled C.T.N. (red).

Finding-place not known.

Dimensions. H. 0·15 m. W. 0·16 m. D. 0·15 m.

Marble. White, fine-crystalled.

A fragment from the underside of an arm, around which is a tightly drawn himation. The arm appears to have been slightly raised. Cf. 99. Just beyond the point at which the arm emerges from the himation, there are the remains of a flat surface to receive the lower arm, part of the bottom of a cutting for a dowel (now mostly broken away), and the tip of a transverse pin-hole, 1·2 cm in diameter, to secure the dowel in position. Fragments of the iron pin still remain in this hole. Probably from a female statue.

Scale. Over life-size (I or II).

101. Fragment of draped right arm and arm-joint

Reg. 1972.4–2.53. Numbered 156 (red).

Finding-place not known.

Dimensions. H. 0·22 m. W. 0·15 m. D. 0·256 m.

Marble. White, fine-crystalled.

A fragment from a draped right arm, around and under which sweep the heavily bunched folds of an himation. Most of a worked surface remains for the attachment of the lower arm (H. 12·5 cm; W. 10·5 cm), within which is a dowel hole: H. 3·5 cm; W. 1·3 cm; D. 5 cm, as preserved. On the upper edge of the worked surface is a small drill-hole, 6 mm in diameter and 1·5 cm deep. Cf.

similar feature on 96. The style of the sleeve over the upper arm suggests that this fragment belongs to a figure wearing Persian dress, rather than to a female.

Scale. Over life-size (probably II).

102. Fragment of drapery and arm-joint

Reg. 1972.4–2.54. Numbered 164 (red).

Finding-place not known.

Dimensions. H. 0·33 m. W. 0·20 m. D. 0·135 m.

Marble. White, fine-crystalled; surface damaged and worn.

Preserved is part of an arm, swathed in the heavily bunched folds of a himation. About half of a worked surface remains for the attachment of a lower arm: H. 14·3 cm; W. (as preserved) 6·5 cm; also half a dowel hole: H. 2·5 cm; W. 0·75 cm; D. 6 cm.

In the broken rear surface are two drill-holes, at right angles to one another, which seem to have formed the side and base of another cutting, the significance of which is uncertain, although it was apparently unconnected with the forearm joint.

Probably from a female figure.

Scale. Over life-size (I or II).

103. Fragment of drapery and arm-joint

Reg. 1972.4–2.55. Numbered B.66.3 (black).

From Biliotti's excavations, but finding-place not known.

Dimensions. H. 0·19 m. W. 0·115 m. D. 0·14 m.

Marble. White, fine-crystalled.

A fragment of a bunched himation, falling over the left arm of a statue, close to the elbow. Part of a cutting for the attachment of the forearm remains: H. 5 cm; W. (as preserved) 2·5 cm; D. 1·5 cm.

Scale. Over life-size (I or II).

104. Fragment of draped torso with arm-joint (pl. 28)

Reg. 1972.4–17.3. Numbered 164 (red).

Finding-place not known.

Dimensions. H. 0·39 m. W. 0·32 m. Th. 0·175 m.

Marble. White, fine-crystalled.

A fragment from the front of a draped figure, on which is most of an oval area for the attachment of an arm: H.

21 cm; W. 18·5 cm. In the middle is a dowel hole: H. 3·6 cm; W. 1 cm; D. 5·5 cm. The worked surface of this area does not appear to be preserved. Running from the right side of the figure and falling over the arm, is a heavy drapery fold, the surface of which is not well preserved, although the direction is clear enough. The line of this fold suggests that it was a forearm which was attached. There is, however, in the back of this fragment part of a deeply carved recess, as if to receive a head. *Dimensions as preserved.* H. (D.) 15–16 cm; W. 12 cm; Th. 8·5 cm. If this cutting were for the insertion of a head, then the area on the front would have to be a shoulder-joint. The cutting on the back, however, seems rather deep for the addition of a head, and it may be that the whole of the upper part of the body was carved separately. The upward pull of the drapery folds above the arm-joint is not suited to a shoulder.

Scale. Whatever the interpretation, this is likely to be from a colossal figure (I).

105. Fragment of draped figure with arm-joint
Reg. 1972.4–2.56. Numbered 125 (red).

Finding-place not given.

Dimensions. H. 0·205 m. W. 0·135 m. Th. 0·13 m.

Marble. White, fine-crystalled.

The drapery is of a thickish texture, and runs in fairly deep, horizontal folds towards one side, where there is a vertical dressed surface for a join, with the remains of a dowel hole: H. 2 cm; W. 2 cm (more originally); D., as preserved, 5·5 cm. Whether the join is for a forearm or an upper arm (i.e. this is a shoulder) is not certain. Perhaps rather a shoulder. The style of the drapery and the scale are similar to those of fragment 80, which is a right shoulder.

Scale. Perhaps slightly over life-size (II or III).

106. Fragment of himation with joint for right arm
Reg. 1972.4–2.57. Numbered 136 (red).

Finding-place uncertain, but dispatched in same crate as statue 29, which came from the north-east area of the Quadrangle.

Dimensions. H. 0·165 m. W. 0·13 m. Th. 0·08 m.

Marble. White, fine-crystalled.

A fragment of himation that hung beside and below a right arm. Part of a worked surface remains for the attachment of a forearm at right angles to the drapery. One side of a dowel hole is preserved: H. 3·5 cm; D. 5·8 cm. The top of this fragment is also straight and smooth. This too may have been part of a joining surface, or it may simply have been sawn at a later date.

Scale. Uncertain.

107. Fragment of drapery with joint for arm
Reg. 1972.4–2.58. Numbered 253.7 (red).

Finding-place not known.

Dimensions. H. 0·13 m. W. 0·08 m. D. 0·09 m.

Marble. White, fine-crystalled.

A fragment of crumpled drapery from the region of the elbow, on which is part of a surface, dressed with the claw chisel, for the attachment of a forearm. A drill-hole for the dowel remains, *c.* 1·5 cm in diameter and 6 cm deep, as preserved. The drapery projects slightly around the edges of the worked surface to conceal the join.

Scale. Over life-size, perhaps colossal (I). Could be from female figure.

108. Fragment of drapery with joint for arm
Reg. 1972.4–2.59. Numbered 78–84 (red).

Finding-place not known.

Dimensions. H. 0·115 m. W. 0·08 m. Th. 0·045 m.

Marble. White, fine-crystalled.

A fragment of himation that curves over an arm. One end is smoothed, probably to receive a forearm. For the type cf. 96.

109. Fragment of drapery with joint for arm
Reg. 1972.4–2.60. Initialled C.T.N. (red).

Finding-place not known.

Dimensions. H. 0·15 m. W. 0·075 m. D. (L.) 0·08 m.

Marble. White, fine-crystalled.

A small fragment of a draped arm which has a dressed surface, slightly recessed, to receive a forearm. Traces of a dowel hole remain. For the type of joint, cf. 107.

FRAGMENTS OF ARMS

110. Elbow of left arm
Reg. 1972.4–2.61. Numbered B.66.3 (black).

Found by Biliotti on 4 April 1865, built into the walls of Hadji Nalban's house, south-west of the Mausoleum.

Dimensions. L. 0·27 m. H. 0·22 m. Th. 0·145 m.

Marble. White, fine-crystalled; surface much weathered.

Part of a bent left arm, broken just above the elbow and at mid-forearm. The lower arm was raised.

Scale. Over life-size, probably colossal (I).

111. Elbow of left arm (pl. 28)
Reg. 1972.4–2.62. Numbered 181 (red), 262 (black).

Finding-place not known.

Dimensions. L. 0·23 m. H. 0·185 m. Th. 0·12 m. *Dimensions of upper break.* 13 × 12 cm; of lower break: 9 × 9 cm.

Marble. White, fine-crystalled, with brown patina. Surface considerably weathered.

Broken just above the elbow and at mid-forearm. The fuller musculation of the left side and the coarser working of the right side (heavy rasp marks remain), suggest this is from a left arm. The lower arm was raised. The running drill has been used to delineate the internal angle of the elbow.

Scale. Over life-size (II).

112. Fragment of colossal lower arm
Reg. 1972.4–2.63. Initialled C.T.N. (red).

Finding-place uncertain; possibly not from the Mausoleum (see below).

Dimensions. L. 0·25 m. H. 0·165 m. Th. 0·115 m. *Dimensions of lower break.* H. 13·3 cm. Th. 10 cm.

Marble. White, medium-crystalled; weathered to a gritty surface. Perhaps island marble.

Part of a large forearm (probably right), the upper end of which is cut into a wedge-shaped tenon, for insertion into the body of a colossal statue. Tenon L. 9 cm × W. 6·5 cm at inner end; surface dressed with claw chisel. Within the tenon is a wedge-shaped dowel hole, for further securing the arm in place: L. 6·7 cm; W. 2·1–2·9 cm.

The rather coarse-grained marble may be against the attribution of this fragment to the Mausoleum. It is very similar to a number of fragmentary arms found by Newton in a wall in Cos, and later confused with the Mausoleum sculptures. See below, nos 797, 798, 799.

Technically, however, this arm could belong to the Mausoleum. Forearms were worked separately, and dovetailed dowels were used; cf. 26.

Scale. Colossal (? I).

113. Right elbow
Reg. 1972.4–2.64. Numbered 117 (red), 256 (black).

Finding-place not known.

Dimensions. H. 0·135 m. L. 0·135 m. Th. 0·105 m.

Marble. White, fine-crystalled.

Broken immediately above and below the elbow, and on the inner side. The lower arm was raised.

Scale. Not much over life-size (? III).

114. Fragment of lower arm
Reg. 1972.4–2.65. Initialled C.T.N. (red). Numbered 258 (black).

Finding-place not certain.

Dimensions. L. 0·255 m. Upper break: H. 15·5 cm; Th. 15 cm. Lower break: H. 12 cm; Th. 9·5 cm.

Marble. White, medium-crystalled; weathered to a gritty surface.

A forearm, similar in style to 112, and perhaps therefore not from the Mausoleum. Cf. below, nos 797–799.

Scale. Perhaps colossal (? I).

115. Forearm
Reg. 1972.4–2.66. Numbered 110 (red), 222 (black).

Finding-place not known.

Dimensions. L. 0·27 m. *Dimensions of upper break.* H. 12·1 cm; Th. 10 cm.

Marble. White, fine-crystalled; surface in poor condition.

Perhaps a left arm.

Scale. Over life-size (II).

116. Fragment of forearm

Reg. 1972.4–2.67. Numbered 150 (red), 257 (black).

Dispatched in crate containing part of statue no. 1 ('Artemisia'), from the Imam's field on the north side. Perhaps also from there.

Dimensions. L. 0·175 m. H. 0·115 m. Th. 0·10 m.

Marble. White, fine-crystalled, with brown patina.

A fragment from just below the elbow. Perhaps from a right arm (weathering severer on right side).

Scale. Over life-size (II).

117. Left forearm

Reg. 1972.4–2.68. Numbered 117 (red).

Finding-place not known.

Dimensions. L. 0·25 m. H. 0·095 m. Th. 0·108 m.

Marble. White, fine-crystalled.

Two adjoining fragments.

Scale. Over life-size (II).

118. Fragment of forearm

Reg. 1868.4–5.8.

From Biliotti's excavations at Bodrum.

Dimensions. L. 0·15 m. H. 0·105 m. Th. 0·085 m.

Marble. White, fine-crystalled, with brown patina.

A rounded tapering fragment, almost certainly from a forearm.

Scale. Uncertain.

119. Fragment of lower arm

Reg. 1972.4–2.69. Numbered 110 (red), 172 (black).

Finding-place not known.

Dimensions. L. 0·162 m. H. 0·102 m. Th. 0·106 m.

Marble. White, fine-crystalled.

A fragment of a tapering limb, almost certainly part of a forearm. Just possibly from a lower leg.

Scale. Perhaps over life-size (II or III).

120. Fragment of forearm

Reg. 1972.4–2.70. Initialled C.T.N. (red).

Finding-place not known.

Dimensions. L. 0·19 m. Upper break: H. 12·5 cm; Th. 11 cm. Lower break: H. 7·8 cm; Th. 6·8 cm.

Marble. White, medium-crystalled, weathered to a coarse texture.

Fragment of tapering limb, probably an arm.

121. Fragment of forearm

Reg. 1972.4–2.71. Numbered 83 (red), 239 (black).

Finding-place not known.

Dimensions. L. 0·12 m. Upper break: H. 11·5 cm; W. 12·5 cm. Lower break: H. 8·5 cm; W. 9·5 cm.

Marble. White, fine-crystalled with orange patina.

From the lower forearm.

Scale. Over life-size (II).

122. Fragment of forearm

Reg. 1972.4–2.72. Numbered 184 (red).

Finding-place not known.

Dimensions. L. 0·14 m. H. 0·073 m. W. 0·15 m.

Marble. White, fine-crystalled.

A fragment of a smoothly worked limb, probably an arm.

123. Fragment of lower arm

Reg. 1972.4–2.73. Numbered B.66.3 (black).

From Biliotti's excavations. Finding-place not known.

Dimensions. L. 0·105 m. W. 0·145 m. Th. 0·095 m.

Marble. White, fine-crystalled.

An oval section through an arm, close to the wrist.

Scale. Probably colossal (I).

124. Fragment of lower arm

Reg. 1972.4–2.74. Numbered 203 (red), 223 (black).

According to invoice of cases (no. 203), from the east side of the Mausoleum.

Dimensions. L. 0·10 m. Upper break: 10 × 8·7 cm. Lower break: 7·8 × 6·7 cm.

Marble. White, fine-crystalled.

A section through an arm, close to the wrist.

Scale. (? III).

125. Fragment of lower arm
Reg. 1972.4–2.75. Numbered 111 (red), 233 (black).

Finding-place not known.

Dimensions. L. 0·095 m. H. 0·10 m. Th. 0·075 m.

Marble. White, fine-crystalled.

126. Wrist
Reg. 1972.4–2.76. Numbered 117 (red), 254 (black).

Finding-place not known.

Dimensions. L. 0·14 m. W. 0·094 m. Th. 0·082 m.

Marble. White, fine-crystalled; much weathered.

Scale. I or II.

127. Left wrist
Reg. 1972.4–2.77. Numbered 64 (red).

Finding-place not known.

Dimensions. L. 0·11 m. W. 0·085 m. Th. 0·07 m.

Marble. White, fine-crystalled.

Creases near the hand and a slight depression below the thumb show this to be from a left arm.

Scale. Not much more than life-size (II or III). Cf. 145 below.

128. Wrist
Reg. 1972.4–2.78. Numbered 253.9 (red), 244 (black).

Finding-place not known.

Dimensions. L. 0·097 m. W. 0·087 m. Th. 0·065 m.

Marble. White, medium-crystalled.

Scale. As 127.

129. Wrist
Reg. 1972.4–2.79. Numbered 261 (red), 230 (black).

According to the invoice, the fragments in case 261 came chiefly from the north side.

Dimensions. L. 0·115 m. W. 0·08 m. Th. 0·065 m.

Marble. White, fine-crystalled.

Part of a crease on one side shows that this is from close to a hand.

Scale. As 127.

130. Right wrist
Reg. 1972.7–14.119. Numbered 245 (black).

Finding-place not known.

Dimensions. L. 0·085 m. W. 0·075 m. Th. 0·06 m.

Marble. White, fine-crystalled.

Sinews are carved on the inner side.

131. Fragment of arm
Reg. 1972.4–2.80. Numbered 163 (red).

Finding-place not known.

Dimensions. L. 0·115 m. H. 0·13 m. Th. 0·08 m.

Marble. White, fine-crystalled.

A curving fragment of a limb. There is a raised lip at one end, and the end itself has been dressed with fine strokes of the point. On the break is part of a dowel hole. Obviously worked for insertion into a socket, and almost certainly a forearm.

Scale. Over life-size, perhaps even colossal (II or I).

132. Fragment of arm
Reg. 1972.4–2.81. Numbered 203 (red), 234 (black).

According to the invoice of cases, from the east side of the Mausoleum.

Dimensions. L. 0·13 m. H. 0·08 m. Th. 0·095 m.

Marble. White, fine-crystalled.

A fragment from the upper end of a forearm where it was inserted into a body. Preserved is part of the surface of the arm, some of a worked end, and some of a cutting for a dowel. The dowel hole runs at an angle to the worked end (i.e. the arm was raised or lowered): L. 9 cm; W. 2·2 cm; Th. (as preserved) 1·2 cm.

Scale. The dimensions suggest the arm must have been a large one (I or II).

133. Fragment of arm
Reg. 1972.4–2.82. Numbered 127 (red).

Finding-place not known.

Dimensions. L. 0·08 m. H. 0·075 m. W. 0·144 m.

Marble. White, fine-crystalled.

A fragment probably of a lower arm, one end of which has been worked for attachment to a body. The surface is lightly pointed except for a smooth margin *c.* 1·5 cm wide, and there are the remains of a dowel hole: W. 1·25 cm; H. (now) 5 mm; D. 5·5 cm.

Scale. Uncertain.

134. Fragment of arm and drapery
Reg. 1972.4–2.83. Numbered 128 (red).

Finding-place not known.

Dimensions. L. 0·105 m. H. 0·165 m. Th. 0·125 m.

Marble. White, fine-crystalled.

A fragment of an arm, oval in section, emerging from a garment, probably a himation. Cf. 108.

135. Fragment of arm and drapery
Reg. 1972.4–2.84. Numbered B.66.2 (black).

From Biliotti's excavations, but finding-place not known.

Dimensions. L. 0·11 m. H. 0·125 m. Th. 0·065 m.

Marble. White, fine-crystalled.

A fragment of a lower arm, the end of which has been worked to fit on to a statue. Part of a dowel hole remains, 1·7 cm in diameter and 6 cm D. (more originally). The edge of a garment is carved on the outer side of the arm.

Scale. About life-size (III).

136. Fragment of draped arm
Reg. 1972.4–2.86. Numbered 202 (red).

According to the invoice of cases, found in the Imam's field, on the north side of the Mausoleum.

Dimensions. L. 0·17 m. H. 0·12 m. Th. 0·04 m.

Marble. White, fine-crystalled

The drapery is close-fitting, with shallow folds. Probably it is from a figure in Persian dress. In the break on the back is part of a groove, as if for a dowel, but running diagonally across the fragment instead of along the line of the arm.

137. Fragment of draped arm
Reg. 1972.4–2.87. Numbered 117 (red), 255 (black).

Finding-place not known.

Dimensions. L. 0·175 m. H. 0·11 m. Th. 0·09 m.

Marble. White, fine-crystalled.

The drapery is close-fitting and rumpled. Probably it is from quite close to the wrist of a figure in Persian dress. There appears to be part of a smooth cutting or groove on the broken surface at the back, W. 1·5 cm.

Scale. Over life-size (II).

138. Fragment of draped arm
Reg. 1972.4–2.88. Numbered B.66.1 (black).

From Biliotti's excavations, but finding-place unknown.

Dimensions. L. 0·125 m. H. 0·12 m. Th. 0·045 m.

Marble. White, fine-crystalled.

The drapery is close-fitting and has transverse folds, and is probably from a figure in Persian dress.

139. Wrist in sleeve (pl. 28)
Reg. 1972.4–2.89. Numbered 120 (red), 248 (black).

Finding-place not known.

Dimensions. L. 0·105 m. H. 0·10 m. Th. 0·07 m. Dimensions of lower break: 8·5 × 6·5 cm.

Marble. White, fine-crystalled.

A fragment of a wrist draped in a smoothly worked Persian sleeve, the lower edge of which is indicated by a light ridge.

Scale. As 127–129 (perhaps II rather than III).

140. Fragment of draped arm (?)
Reg. 1972.4–2.90. Initialled C.T.N. (red).

Finding-place not known.

Dimensions. L. 0·105 m. W. 0·07 m. Th. 0·015 m.

Marble. White, fine-crystalled.

A fragment of a limb wearing close-fitting drapery. Probably from an arm.

141. Fragment of draped arm (?)
Reg. 1972.4–2.91. Numbered B.66.1 (black).

From Biliotti's excavations, but finding-place unknown.

Dimensions. L. 0·165 m. W. 0·10 m. Th. 0·05 m.

Marble. White, fine-crystalled. Surface much weathered.

A fragment of a draped limb, probably an arm. The drapery has transverse folds, fairly deeply worked. Cf. 138.

FRAGMENTS OF HANDS AND FINGERS

142. Colossal right hand (pl. 29)
Reg. 1972.4–2.92. Numbered 206 (red), 252 (black).

According to the invoice of cases, found in the Imam's field, on the north side of the north *peribolus* wall.

Dimensions. L. 0·22 m. W. 0·145 m. Th. 0·095 m.

Marble. White, fine-crystalled.

Preserved from the wrist to the base of the fingers and thumb. The stubs of the thumb and second (middle) finger which remain, show that the thumb was held in towards the palm, while the fingers were extended, as if the hand held a patera. Dowel holes in the broken bases of fingers one (index) and three show that these fingers were added separately. *Dimensions of each dowel hole.* Diam. 6 mm; D. 1·5 cm.

Two creases are indicated in the palm of the hand.

The finding-place would suggest that this hand belonged to one of the colossal figures from the northern range of the building. It is not impossible that it may have belonged to 'Maussollos', no. 26.

Scale. Colossal (I), but cf. width of Persian rider's left hand: 17 cm.

143. Colossal left hand (pl. 29)
Reg. 1972.4–2.93. Numbered 203 (red), 251 (black).

According to the invoice of cases (no. 203), found on the east side of the Mausoleum.

Dimensions. L. 0·215 m. W. 0·145 m. Th. 0·095 m.

Marble. White, fine-crystalled.

Preserved from the wrist to the base of the thumb and fingers. The thumb is held in towards the palm of the hand, as on 142, but the fingers were rather more clenched, and once held an object, a groove for which runs diagonally across the palm (W. 2·5 cm).

Were it not for the finding place, this would be a suitable candidate for the left hand of 'Maussollos', no. 26, since, if the hand is held with the thumb uppermost, the groove across the palm runs at precisely the same angle as the sword scabbard held by 26.

144. Fragment of colossal left hand (pl. 29)
Reg. 1972.4–2.94. Numbered 181 (red), 238 (black).

Finding-place not known.

Dimensions. L. 0·155 m. W. 0·125 m. Th. 0·052 m.

Marble. White, fine-crystalled, with brown patina.

Preserved is part of the side of a left hand, including the stub of the little (fourth) finger, most of the third finger, which is held out straight, and the base of the middle (second) finger. The base of the middle finger has been smoothed, and the finger has been attached by a pin, the hole for which is partly preserved: diam. 6 mm; D. 5 cm. Traces of the iron pin adhere to the marble. Immediately below the middle finger, and cutting across its pin-hole, there is part of another hole preserved (diam. 6 mm; L. 5·2 cm), which runs from the palm through to the back of the hand. Here too there are traces of the iron pin remaining. This hole must either have been for cross-fixing the pin for the middle finger,

or else for the attachment of an object held in the palm of the hand (for example, a dish).

A small protrusion towards the end of the third finger may have been attached to the object held in the hand, or it may show where the little finger adjoined.

Scale. Colossal (I). L. of third finger 11·5 cm; diam. of base of middle finger 4 cm (diam. of fingers of 142–143, *c.* 3·5–4 cm).

145. Right hand (pl. 29)
Reg. 1972.4–2.95. Numbered 131 (red), 249 (black).

Finding-place not known.

Dimensions. L. 0·17 m. W. 0·125 m. Th. 0·08 m. Wrist at break: 8·5 × 6·5 cm.

Marble. White, medium-crystalled. Surface worn.

Preserved from wrist to knuckles. The hand held an object for which a deep groove remains in the palm, W. 3 cm. Within the groove is a shallow dowel hole, 5 mm deep, for securing the object in place.

Scale. Diameter of base of fingers *c.* 3 cm. Probably therefore over life-size (II rather than III). The dimensions of the wrist of this fragment suggest that the fragments of wrists, above nos 127–129 and 139, are also of scale II rather than III.

146. Right hand
Reg. 1972.4–2.96. Numbered 131 (red), 249 (black).

Finding-place not known.

Dimensions. L. 0·18 m. W. 0·12 m. Th. 0·075 m. Wrist at break: 8 × 6·5 cm.

Marble. White, medium-crystalled, with orange-brown patina. Surface much worn.

Preserved from the wrist to just short of the knuckles. A groove in the palm shows that an object was held, although there is no dowel hole to secure it, as on 145.

Scale. Over life-size (II), cf. 145.

147. Fragment of right hand and wrist
Reg. 1972.4–2.97. Numbered 111 (red), 247 (black).

Finding-place not known.

Dimensions. L. 0·17 m. W. 0·09 m. Th. 0·07 m. Wrist at break: 8 × 6 cm.

Marble. White, fine-crystalled.

Preserved are the wrist and the lower part of a right hand, including the base of the thumb and most of the palm. In the palm is a groove for the attachment of an object. This groove runs straight, along the line of the arm, and not diagonally, as on 145–146.

Scale. Over life-size (II).

148. Back of right hand
Reg. 1972.4–2.98. Numbered 126 (red).

Finding-place not known.

Dimensions. L. 0·19 m. W. 0·10 m. Th. 0·075 m.

Marble. White, medium-crystalled.

The back of a right hand, preserved from the wrist to the knuckles, including the stub of a thumb. The palm is broken.

Scale. Over life-size (II). Cf. 145–147.

149. Part of right hand and wrist
Reg. 1972.4–2.175. Numbered 195 (red), 246 (black).

Perhaps from the north side of the Mausoleum: case 195 contained fragments from there.

Dimensions. L. 0·15 m. W. of wrist 0·08 m. Th. of wrist 0·066 m.

Marble. White, fine-medium crystal.

Preserved is the wrist and the lower part of a right hand, including the stub of the thumb and some of the palm. The crease dividing wrist from hand is clearly marked on the inside of the arm.

Scale. Over life-size (II). Cf. 145–148.

150. Fragment of left hand
Reg. 1868.4–5.19.

From Biliotti's excavations at Bodrum.

Dimensions. L. 0·09 m. W. 0·10 m. Th. 0·08 m. Break at wrist: 7 × 6 cm.

Marble. White, fine-crystalled (finer than 145, 146, and 148).

Broken at the wrist. Preserved is the stub of the thumb and some of the palm. On the back of the hand two veins are carved.

Scale. Probably II rather than III. Could go with 147.

151. Finger

Reg. 1972.4–2.99. Numbered 181 (red), 236 (black).

Same case no. as 144, but finding-place not known.

Dimensions. L. 0·08 m. Diam. 3·5 cm.

Marble. White, fine-crystalled.

The middle part of a finger, preserving two joints, one of which is bent. Could be from the same hand as 144.

Scale. Colossal (I).

152. Finger

Reg. 1972.4–2.100. Numbered 253 (red).

Finding-place not known.

Dimensions. L. 0·06 m. H. 0·05 m. Diam. 3·5 cm.

Marble. White, fine-crystalled.

One joint remains, which is bent at a right angle.

Scale. Colossal (I).

153. Fragment of finger

Reg. 1972.4–2.101. Numbered 67 (red).

Finding-place not known.

Dimensions. L. 0·055 m. Diam. 3·5 cm.

Marble. White, fine-crystalled.

Scale. Colossal (I).

154. Fragment of finger

Reg. 1868.4–5.149.

From Biliotti's excavations at Bodrum.

Dimensions. L. 0·063 m. Diam. 2·7–3 cm.

Marble. White, fine-crystalled.

The tip of a finger, which is held straight out, including the nail. The carving is a little angular compared with other fragments.

Scale. Probably II.

155. Tip of finger (pl. 30)

Reg. 1868.4–5.148.

From Biliotti's excavations at Bodrum.

Dimensions. L. 0·055 m. Diam. 2·5–3 cm.

Marble. White, fine-crystalled, with brown patina.

Preserved from the tip to just below the first joint. The nail is neatly carved, and two creases indicate the joint.

Scale. II or III.

156. Thumb

Reg. 1972.4–2.102. Numbered B.66.3 (black).

From Biliotti's excavations, but finding-place not known.

Dimensions. L. 0·065 m. Diam. 2·5–2·8 cm.

Marble. White, fine-crystalled.

Most of a thumb, neatly carved. The top curves back noticeably in profile, as if it were pressed against an object.

Scale. About life-size (III).

157. Fragment of finger

Reg. 1868.4–5.150.

From Biliotti's excavations at Bodrum.

Dimensions. L. 0·045 m. Diam. 3·3 cm.

No joint preserved.

Scale. Over life-size (probably II).

158. Fragment of finger

Reg. 1972.4–2.103. Numbered 181 (red), 235 (black).

Same case no. as 144 and 151.

Dimensions. L. 0·06 m. Diam. 2·5–3 cm.

Marble. White, medium-crystalled.

Surface well smoothed.

Scale. II or III.

FRAGMENTS OF LEGS

159. Left thigh and knee of draped statue

(pl. 30)

MRG 62. Reg. 1972.4–2.104.

Dimensions. H. 0·30 m. L. from knee to break of thigh 0·26 m. Dimensions of leg at break below knee-cap, *c.* 11 × 11 cm.

Marble. White, fine-crystalled; surface much worn.

Preserved is a left leg from about mid-thigh to just below the knee. The left side of the knee is missing. The leg is bent, and the figure to which it belonged was clearly striding forward, or otherwise engaged in energetic action. A short chiton is worn, part of which billows back over the thigh, the folds boldly rendered and broadly spaced. Part of the lower edge of the garment remains on the left side.

Scale. About life-size (III). Perhaps from a figure in a battle-group.

Newton, *MRG* 62.

160. Knee of draped figure

MRG 62*. Reg. 1972.4–2.105. Numbered 256,6 (red).

Finding-place not known.

Dimensions. H. 0·24 m. W. 0·185 m. Th. 0·13 m.

Marble. White, fine-crystalled, with orange-brown patina.

Preserved from just above to just below the knee-cap. The leg was quite strongly bent; more so, for instance, than the free left leg of 26. The drapery has the thick texture of a himation. It is stretched taut over the thigh and knee-cap, but heavy folds begin to fall below the knee-cap, one on the right side obviously following the line of the lower leg, the other hanging farther out. Behind the knee on the right side there are shallower creases in the garment. No folds are to be seen on the left side of the knee. Probably a right knee.

Scale. Over life-size (II).

Newton, *MRG* 62*.

161. Fragment of draped knee

Reg. 1972.4–2.106. Numbered 120 (red).

Finding-place not known.

Dimensions. H. 0·10 m. W. 0·13 m. Th. 0·135 m.

Marble. White, fine-crystalled.

Preserved is the knee-cap of a left (?) knee. The leg was bent. On the left side, near the upper break, is a protrusion with a straight edge, which is most likely a drapery fold.

Scale. Life-size (III). Cf. 159.

162. Bare left knee

Reg. 1972.4–2.107. Initialled C.T.N. (red).

Finding-place not known.

Dimensions. H. 0·17 m. W. 0·155 m. Th. 0·133 m.

Marble. White, fine-crystalled; surface worn.

A fragment of the lower thigh and knee-cap of a left leg, broken behind. There is no sign of drapery. The modelling is competent. There is a pronounced bulge of the inner vastus muscle over the knee-cap, and a deep hollow below the outer vastus. This, and the fact that the leg is not much bent, suggests that this fragment comes from the supporting leg of a statue.

Scale. Over life-size (II).

163. Bare left knee

Reg. 1972.4–2.108. Numbered 112 (red).

Finding-place not known.

Dimensions. H. 0·15 m. W. 0·115 m. Th. 0·14 m. Diam. of leg below knee, *c.* 11 cm.

Marble. White, fine-crystalled.

A fragment of the lower thigh and knee-cap of a bent left leg, similar in pose to 159. Probably from a striding figure. No drapery remains, but a short chiton could have been worn.

Scale. Life-size (III).

164. Lower leg of draped male figure

Reg. 1972.4–2.109. Initialled C.T.N. (red).

Finding-place not known.

Dimensions. H. 0·32 m. W. 0·145 m. Th. (side) 0·19 m.

Marble. White, fine-crystalled.

Preserved is the lower part of a leg emerging from the heavy drapery of a himation, at the bottom of which is a seam. Drapery remains on both the front and side of the

leg, but there are no folds on the surface, which is worn. The line of the leg is at an angle to the lower edge of the drapery at the side. This fragment is likely, therefore, to be either from a seated figure of the type of 33, or else from a leg crossed over a supporting leg, as on 42. The seam of the garment is similar to that of 42.

Scale. Over life-size (II).

165. Draped right leg of Persian wearing sandal (pl. 30)

Reg. 1972.4–2.110. Numbered B.66.3 (black).

Found by Biliotti on 22 May 1865 in the foundations of Mehmeda's house on the south side of the Mausoleum.

Dimensions. H. 0·24 m. W. 0·09 m. D. (along line of foot) 0·145 m. Diam. of upper break, 9–10 cm.

Marble. White, fine-crystalled.

Preserved from about mid-calf down almost to the heel at the back, and to the upper part of the foot at the front. The levels of the malleoli show it to be a right leg. Close-fitting trousers of Persian type are worn, and on the foot is a shoe or sandal made up of an elaborate network of straps, terminating in a series of loops at the ankle, through which a ribbon or lace is threaded. The two ends of this lace are criss-crossed one over the other around the lower leg, on top of the trousers, and were clearly tied just below the calf muscle. For the type of sandal, see below nos 217–224.

Scale. Life-size (III).

166. Fragment of draped leg

Reg. 1972.4–2.111. Numbered 206 (red).

According to the invoice of cases, found in the Imam's field on the north side of the north *peribolus* wall.

Dimensions. H. 0·16 m. W. (front) 0·12 m. Th. 0·17 m.

Marble. White, medium-crystalled; weathered to a gritty texture.

A fragment of a lower leg, oval in section, that wears close-fitting drapery, probably trousers. The folds are much more elaborately worked on one side than on the other. Most likely from a figure in Persian dress.

Scale. Over life-size (II).

167. Fragment of draped leg wearing boot

Reg. 1972.4–2.112. Numbered B.66.3 (black).

From Biliotti's excavations, but finding-place not known.

Dimensions. H. 0·175 m. W. 0·12 m. Th. 0·135 m.

Marble. White, fine-crystalled.

A very worn fragment of a leg that wears trousers of Persian type, of which a few folds remain. A horizontal ridge running around the lower part of this fragment, and a tab at the back, look as if they are the top of a boot. Cf. 168, below.

Scale. Probably II.

168. Draped left leg wearing boot (pl. 30)

Reg. 1972.4–2.113. Numbered 110 (red).

Finding-place not known.

Dimensions. H. 0·43 m. W. (front) 0·142 m. Th. (as preserved) 0·125 m.

Marble. White, fine-crystalled; surface much worn.

Preserved from below the knee to the ankle. Much of the front and the left side are broken. A close-fitting high boot is worn, with a horizontal top that terminates just below the calf muscle. At the back is a tall wedge-shaped tab that comes up over the muscle.

Above the boot, on the inner side of the leg, there is a drapery fold, proving that close-fitting trousers were worn. From a figure in Persian dress.

Scale. Over life-size (II).

169. Fragment of leg with sandal ribbons (pl. 30)

Reg. 1972.4–2.114. Numbered 117 (red), 161 (black).

Finding-place not known.

Dimensions. H. 0·13 m. Dimensions of upper break, 13 × 12 cm.

Marble. White, fine-crystalled.

A fragment of a lower leg, around which are bound the ribbons or laces of a sandal, in horizontal bands. At one side, perhaps the back, the ribbons are tied in a knot or bow, from which the end of a ribbon hangs down.

Scale. II or III; perhaps rather II.

BARE LEGS

170. Right leg (pl. 31)

Reg. 1972.4–2.115. Numbered 110 (red), 177 (black).

Finding-place not known.

Dimensions. H. 0·30 m. W. (front) 0·15 m. Th. (side) 0·155 m.

Marble. White, fine-crystalled.

Preserved from immediately below the knee to about mid-shin (just below the calf muscle). The shin bone is much bowed, and the calf muscle is set off from it by a clearly marked groove.

Powerful work, from a statue over life-size.

Scale. II.

171. Lower right leg

Reg. 1972.4–2.116. Numbered B.66.3 (black).

From Biliotti's excavations, but finding-place uncertain.

Dimensions. H. 0·31 m. W. (front) 0·15 m. Th. 0·14 m.

Marble. White, fine-crystalled, with silvery veins.

Preserved from above the calf muscle at the back, to just above the ankle. The bulge of the muscle on the left side proves it to be from a right leg. The direction of the grain of the marble (diagonal in side view) suggests that the leg may have been set back, with only the toes touching the ground, i.e. was from a free-leg.

Scale. II.

172. Lower left leg

Reg. 1972.4–2.117. Numbered 206 (red), 174 (black).

According to the invoice of cases, found in the Imam's field on the north side.

Dimensions. H. 0·30 m. W. (front) 0·125 m. Th. 0·14 m.

Marble. White, fine-crystalled. Much weathered at front.

Preserved from just below the knee to some way above the ankle. The back is broken.

Scale. II.

173. Lower right leg

Reg. 1972.4–2.118. Numbered 124 (red), upper fragment; 105 (red), lower fragment.

Finding-places unknown.

Dimensions. H. 0·30 m. W. (front) 0·13 m. Th. 0·14 m.

Marble. White, fine-crystalled; surface flaked in places.

Two adjoining fragments of a lower right leg, the join smoothed with plaster. Much of the right side and some of the front are broken. The calf muscle is divided from the shin bone by an emphatic groove and ridge. Cf. 170. On the front of the lower part of the leg where the surface is well preserved, there are clear traces of the rasp.

Scale. II.

174. Left leg

Reg. 1972.4–2.119. Numbered 253 (red), 178 (black).

Finding-place not known.

Dimensions. H. 0·28 m. W. (front) 0·15 m. Th. 0·135 m.

Marble. White, fine-crystalled; surface much worn.

Two adjoining fragments of a left leg, preserved from just below the knee to about mid-calf. Plaster smooths the join between the fragments. An emphatic groove and ridge indicate the line of the shin bone. To judge from the diagonal grain of the marble on the upper break, the leg was probably bent at the knee, and the lower leg set back. The surface was once highly polished. Cf. 42.

Scale. II.

175. Lower left (?) leg

Reg. 1972.4–2.121. Numbered 86 (red) and 120 (red).

Finding-place not known.

Dimensions. H. 0·233 m. W. (front) 0·125 m. Th. 0·13 m.

Marble. White, fine-crystalled.

Two adjoining fragments of a lower leg. Most of the front and left side is missing. Probably a left leg, to judge from a groove representing the shin bone on the right side.

Scale. II.

176. Lower right leg
Reg. 1972.4–2.122. Numbered 117 (red), 181 (black).

Finding-place not known.

Dimensions. H. 0·145 m. W. (front) 0·125 m. Th. 0·16 m.

Marble. White, fine-crystalled.

A fragment of lower leg, including part of the calf muscle. Grooves on the left side of the front suggest it is part of a right leg. The diagonal grain of the marble may indicate that the leg was bent and set back.

Scale. II.

177. Lower left leg
Reg. 1972.4–2.123. Numbered 179 (black).

Finding-place not known.

Dimensions. H. 0·18 m. W. (front) 0·14 m. Th. 0·15 m.

Marble. White, fine-crystalled, with brown patina; weathered.

A groove indicating the division between shin-bone and muscle shows this to be part of a left leg.

Scale. II.

178. Lower right leg and ankle (pl. 31)
Reg. 1972.4–2.124. Numbered 82 (red), upper fragment; 110 (red), 173 (black), lower fragment.

Dimensions. H. 0·245 m. W. (front) 0·118 m. Th. 0·115 m.

Marble. White, fine-crystalled.

Two adjoining fragments of a lower right leg, including the malleoli of the ankle. Plaster smooths the join. The leg appears to have borne the weight of the figure, since it leans forward slightly. There are rasp marks on the outer side. The foot seems to have been bare.

Scale. II.

179. Lower left leg
Reg. 1972.4–2.125. Numbered 112 (red), 175 (black).

Finding-place not known.

Dimensions. H. 0·27 m. W. 0·13 m. Th. 0·13 m.

Marble. White, fine-crystalled; surface much weathered.

A fragment which preserves much of the shin and some of the calf muscle of a left leg.

Scale. II.

180. Fragment of lower leg
Reg. 1972.4–2.127. Numbered 110 (red), 241 (black).

Finding-place not known.

Dimensions. H. 0·15 m. W. (back) 0·14 m. Th. 0·08 m.

Marble. White, fine-crystalled, with brown patina.

A fragment of calf muscle from the back of a lower leg.

Scale. II.

181. Fragment of lower leg
Reg. 1972.4–2.128. Numbered 125 (red), 231 (black).

Finding-place not known.

Dimensions. H. 0·185 m. W. (back) 0·135 m. Th. 0·085 m.

Marble. White, fine-crystalled, with brown patina.

A fragment of calf muscle from a lower leg.

Scale. II.

182. Fragment of leg
Reg. 1972.4–2.129. Numbered 85 (red).

Finding-place not known.

Dimensions. H. 0·165 m. W. 0·135 m. Th. 0·055 m.

Marble. White, fine-crystalled, with orange-brown patina.

A fragment of a limb, almost certainly part of a calf muscle from a lower leg. Rasp marks remain on the surface.

Scale. II.

183. Fragment of leg
Reg. 1972.4–2.130. Numbered 121 (red).

Finding-place not known.

Dimensions. H. 0·15 m. W. 0·09 m. Th. 0·09 m.

Marble. White, fine-crystalled.

A fragment of a lower leg, including some of the calf muscle. Fine rasp marks remain on the surface.

Scale. II.

184. Lower right leg

Reg. 1972.4–2.120. Initialled C.T.N. (red), numbered 182 (black).

Finding-place not known.

Dimensions. H. 0·293 m. W. (front) 0·12 m. Th. 0·14 m.

Marble. White, fine-crystalled; surface weathered.

Preserved from about mid-calf down to just above the ankle.

Scale. Life-size (III).

185. Lower right leg

Reg. 1972.4–2.126. Numbered 243 (black).

Finding-place not known.

Dimensions. H. 0·125 m. W. (front) 0·11 m. Th. 0·12 m.

Marble. White, fine-crystalled.

A fragment of a lower leg, including part of the calf muscle. An indentation, representing the shin bone, on the left side of the front, suggests this is from a right leg.

Scale. III.

186. Fragment of leg

Reg. 1972.4–2.132. Numbered 117 (red).

Finding-place not known.

Dimensions. H. 0·09 m. W. (front) 0·08 m. Th. 0·10 m.

Marble. White, fine-crystalled.

A fragment of a leg from just below the calf muscle.

Scale. III.

187. Fragment of leg (?)

Reg. 1972.4–2.133. Numbered B.66.1 (black).

From Biliotti's excavations; finding-place unknown.

Dimensions. H. 0·125 m. Diam. *c.* 0·10 m.

Marble. White, fine-crystalled.

A fragment of a rounded limb, probably a leg, although it could just possibly be an upper arm.

Scale. III.

188. Fragment of leg (?)

Reg. 1972.4–2.134. Numbered 80 (red).

Finding-place not known.

Dimensions. H. 0·135 m. W. (front) 0·09 m. Th. 0·11 m.

Marble. White, fine-crystalled.

A fragment probably of a lower leg, just possibly of a wrist.

Scale. III.

189. Fragment of lower leg (?)

Reg. 1972.4–2.135. Numbered 117 (red).

Finding-place not known.

Dimensions. H. 0·11 m. W. (front) 0·115 m. Th. 0·13 m.

Marble. White, fine-crystalled.

A fragment probably of a lower leg.

Scale. III.

190. Fragment of leg (?)

Reg. 1972.4–2.136. Numbered 120 (red).

Finding-place not known.

Dimensions. H. 0·145 m. W. 0·14 m. Th. 0·06 m.

Marble. White, fine-crystalled.

A fragment of a large human limb, perhaps an upper leg. Rasp marks remain on the surface.

191. Fragment of leg (?)

Reg. 1972.4–2.137. Numbered 110 (red).

Finding-place not known.

Dimensions. H. 0·075 m. W. (front) .0·08 m. Th. 0·127 m.

Marble. White, fine-crystalled.

A small fragment of a limb, in all probability part of a lower leg.

192. Fragment of leg (?)

Reg. 1972.4–2.138. Initialled C.T.N. (red), numbered 162 (black).

Finding-place not known.

Dimensions. H. 0·17 m. W. 0·10 m. Th. 0·11 m.

Marble. White, fine-crystalled.

A worn fragment of a limb, most likely part of a lower leg.

FRAGMENTS OF BARE FEET

193. Bare left foot and ankle on base
(pl. 31; fig. 20)
MRG 78. Reg. 1972.4–2.139.
Numbered 120 (red), 169 (black).

Finding-place not known.

Dimensions. H. 0·19 m. L. 0·18 m. W. 0·10 m.
Th. of base, as preserved, 5 cm.

Marble. White, fine-crystalled.

20 Bare
foot, 193

Preserved from just above the ankle to the instep, where
there is a smooth vertical edge in which are two drill-
holes for the attachment of the front part of the foot,
which was worked separately. *Dimensions of upper
drill-hole.* 1 cm diam. × 3 cm deep; lower drill-hole:
1·5 cm diam. × 5 cm deep.

The foot rests flat on the ground, while the lower leg
appears to have been set forward. Most of the base is
broken away, but some of the right edge seems to be
preserved below the instep.

Scale. About life-size (III).

Newton, *MRG* 78.

194. Bare ankle
Reg. 1972.4–2.140. Numbered 253 (red).

Finding-place not known.

Dimensions. H. 0·13 m. W. (front) 0·055 m. Th. (side)
0·10 m.

Marble. White, fine-crystalled.

Left side only preserved. Whether from a right or left leg
is uncertain.

Scale. About life-size (III).

195. Right ankle and part of foot
Reg. 1972.4–2.141. Numbered B.66.1 (black).

From Biliotti's excavations, but finding-place not
known.

Dimensions. H. 0·155 m. L. 0·15 m. Th. 0·11 m.

Marble. White, weathered to a gritty texture; brown
patina.

A fragment of a bare foot preserved from just above the
ankle to just above the instep. The heel is missing.

Scale. Life-size (III).

196. Fragment of ankle (?)
Reg. 1972.4–2.142. Numbered 64 (red), 164
(black).

Finding-place not known.

Dimensions. H. 0·11 m. W. 0·105 m. Th. 0·08 m.

Marble. White, fine-crystalled; surface much weath-
ered.

The fragment seems to preserve part of a malleolus and
a portion of the lower leg. There is some rough chisel-
ling on the inner side.

197. Fragment of ankle (?)
Reg. 1972.4–2.143. Numbered 127 (red).

Finding-place not known.

Dimensions. H. 0·137 m. W. (L.) 0·105 m. Th. 0·09 m.

Marble. White, fine-crystalled.

A much damaged fragment which seems to preserve the
Achilles tendon and both malleoli of a right foot.

Scale. About life-size (III).

198. Fragment of bare left foot on base (fig. 21)
MRG 72. Reg. 1972.4–2.144. Numbered 90 (red).

Finding-place not known.

Dimensions. W. 0·53 m. D. 0·285 m. Max. H. 0·235 m.
Th. of base varies between 12 cm below foot and 16 cm
at right; dimensions of foot as preserved: L. 16 cm; W.
11 cm; H. above base 11·5 cm.

Marble. White, fine-crystalled.

The toes, heel, and left side of the foot are missing. A
wedge of stone beneath the raised instep shows that the
foot rested on its toes. Veins are carefully carved on the
upper surface of the foot.

A large part of the front edge of the base is preserved,
from which it is clear that the toes of this left foot must
have come right to the front of the base. Both the edge
and the top of the base are roughly finished with the
point. Towards the right the base becomes higher and
more rugged (cf. the base of the colossal horse's hoof, 6),
but there is no sign of the right foot. Probably therefore
this would have been set back, in which case the figure
would have been shown running or striding forward.

Scale. About life-size (III).

Newton, *MRG* 72.

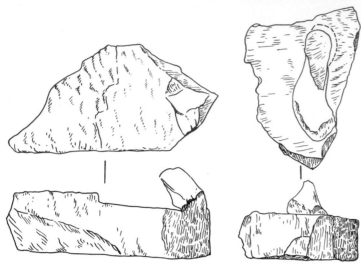

21 Bare foot on base, 198 22 Bare foot on base, 199

199. Fragment of bare right foot on base
(fig. 22)

MRG 73. Reg. 1972.4–2.145. Numbered 189 (red), 215 (black).

According to the invoice of cases (189), found in the Imam's field on the north side of the Mausoleum.

Dimensions. Base: W. 0·31 m. D. 0·38 m. Th. 0·115 m. Foot: L. as preserved 0·21 m; originally 0·295 m; W. 0·11 m.

Marble. White, fine-crystalled.

Preserved is a large fragment of statue-base, original edges of which remain to the right and in front, on which is a bare right foot, roughly life-size, of which the toes and heel remain only in outline. The instep is deeply under-drilled. The surface of the base is roughly finished with the point, except for a smooth strip, 1·5–2 cm wide, running around the heel. The foot appears to have rested flat on the ground.

Scale. III.

Newton, *MRG* 73.

200. Bare right foot on base (pl. 31; fig. 23)
Reg. 1972.4–2.177. Numbered B.66.3 (black).

Found by Biliotti on 13 March 1865 when excavating below the Vakuf's house, to the west of the Mausoleum. Cf. 201, below.

Dimensions. Base: W. 0·19 m; D. 0·29 m; Th. 0·07 m. Foot: L. as preserved 0·27 m; W. 0·12 m. Total H., base + foot, 0·14 m.

Marble. White, fine-crystalled.

A well-preserved bare right foot resting on a fragment of base. The heel is missing, and there is damage to the tips of the big toe and the two toes next to it. The foot rests flat on the ground. Veins are clearly marked above the toes and on the right side. Cf. 198. A drilled groove runs around the foot, dividing it from the base.

A small amount of the front edge of the base appears to be preserved in front of the little toe. All other edges are broken. The underside is heavily pointed, while the upper surface has been finished with lighter strokes of the point.

Scale. About life-size (III).

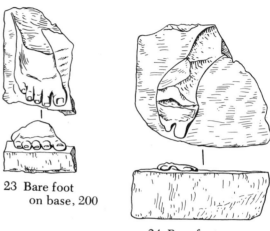

23 Bare foot
on base, 200

24 Bare foot
on base, 201

201. Statue base with remains of bare right foot (fig. 24)
Reg. 1972.4–2.146. Numbered B.66.3 (black).

Found by Biliotti on 15 March 1865 in the foundations of the Vakuf's house, west of the Mausoleum Quadrangle. Cf. 200, above, for finding-place.

Dimensions. Base: W. 0·36 m. D. 0·31 m. Th. 0·13 m. Foot: L. 0·30 m. W. at toes 0·12 m.

Marble. White, fine-crystalled.

Preserved is part of a statue base, including some of the front and right edges (with rounded corner), on which is the outline of most of a bare right foot. Only the tip of the heel is completely missing.

The edges and underside of the base are coarsely worked with the point. The surface is flatter, but still shows rough point marks. Running along the outer, right side of the foot, from the heel to little toe, is a smoother strip, 2 cm wide. The foot seems to have rested fully on the ground.

Scale. From a figure of life-size or slightly over (probably III).

202. Fragment of statue base with heel of bare foot (fig. 25)

Reg. 1972.4–2.147. Numbered 208 (red), 214* (black).

According to the invoice of cases, from either the east or the north side of the Mausoleum.

Dimensions. L. 0·275 m. W. 0·105 m. H. (max.) 0·20 m. Th. of base: 14·5–15 cm.

Marble. White, fine-crystalled.

Preserved is a narrow slice of a thick base, whose surface and underside are roughly finished with the point. A small part of the edge of the base may also remain behind the heel. The heel appears to be from a left foot, although this is not certain. It is bare, rests flat on the ground, and is of roughly life-size.

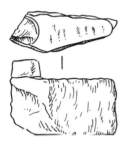

25 Bare heel on base, 202

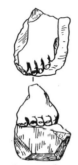

26 Bare foot on base, 203

203. Forepart of bare left foot on base (fig. 26)

MRG 74. Reg. 1972.4–2.148. Numbered 285 (red), 160 (black).

According to the invoice of cases (no. 285), found on the east side of the Mausoleum.

Dimensions. Max. H. 0·205 m. D. (= L. of foot) 0·18 m. W. 0·15 m. Th. of base: 7·5–10·5 cm.

Marble. White, fine-medium crystal.

Preserved is the forepart of a left foot, broken immediately behind the big toe, and mid-way along the left, outer side. The big toe, the toe next to it, and the outer part of the little toe are damaged, as is also the front edge of the base. The original edge of the base is preserved on the left side.

The heel of the foot was clearly raised, for a wedge of stone remains beneath the sole of the foot, and the little toe and the toe next to it are completely freed from the base. Perhaps therefore from a striding or running figure. Cf. 198.

Scale. About life-size (III).

Newton, *MRG* 74.

204. Forepart of bare left foot on base (fig. 27)

MRG 75. Reg. 1972.4–2.149. No other number.

Finding-place not known.

Dimensions. H. (max.) 0·135 m. D. (L.) 0·20 m. W. 0·14 m. Th. of base: 9 cm.

Marble. White, fine-crystalled; surface now in poor condition with thick brown incrustation in places.

Of the foot only the big toe and the next three toes remain. The big toe is stubby and rather short, and there is a gap between it and the second toe. The surface of the base is smooth, but much worn. No original edge seems to be preserved.

Scale. Life-size (III).

Newton, *MRG* 75.

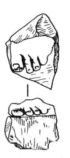

27 Bare foot on base, 204

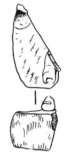

28 Bare foot on base, 205

205. Big toe of left foot on base (fig. 28)

MRG 76. Reg. 1972.4–2.150. Numbered 162 (red).

Finding-place not known.

Dimensions. H. (max.) 0·15 m. D. 0·22 m. W. 0·125 m. Th. of base: 10–10·5 cm.

Marble. White, fine-crystalled; surface weathered.

Preserved is a large portion of base, including the right and front edges. The surface is roughly finished with the point. On the break at the left is the big toe of a bare left foot, seemingly of life-size. Along the right edge of the base, towards the back, is a depression 5 cm long × 3·5 cm wide × 1·5 cm deep.

Since it is unlikely, for practical reasons, that the right foot of this statue stood on a separate base, one must assume either that it was set back, so that the figure was striding forward, or that it was crossed over the left supporting leg in the manner of 42.

Newton, *MRG* 76.

206. Fragment of bare left foot on base (fig. 29)

MRG 77. Reg. 1972.4–2.151.
No other number.

Finding-place not known.

Dimensions. H. 0·095 m. L. 0·10 m.
W. 0·14 m. Th. of base: 6 cm.

Marble. White, fine-crystalled.

Fig. 29

Preserved are the big toe and half of the next toe of a bare left foot, set on a fragment of base, the front edge of which is rounded. The edge and upper surface of the base are smoothly finished, the underside roughly picked. The missing toes appear to have been worked separately.

Scale. About life-size (III).

Newton, *MRG* 77.

FRAGMENTS OF FEET IN SANDALS

207. Rear part of left foot

MRG 79. Reg. 1972.4–2.152. Numbered 168
(black).

Finding-place not known.

Dimensions. H. 0·19 m. L. 0·16 m. W. 0·08 m.

Marble. White, fine-crystalled.

Broken just above the ankle and at the instep. The foot is bare, but rests on a sandal sole, 1 cm thick. The straps of the sandal must have been added in paint. Cf. sandals of 27. The foot rested on a base which is completely broken away, except for a protrusion below the sole.

Scale. About life-size (III).

Newton, *MRG* 79.

208. Tip of left foot of female in slipper

MRG 88. Reg. 1972.4–2.153. Numbered 177
(red), 201 (black).

According to Newton, *MRG* 88, this fragment was found in the 'same part of the diggings' as the statue *MRG* 35, no. 27 above, to the north of the north *peribolus* wall in the Imam's field.

Dimensions. L. 0·10 m. W. 0·10 m. H. 0·08 m.

Marble. White, fine-crystalled. A red-brown deposit on the surface may be paint.

Only the very tip of the foot is preserved. Near the break is the border of a garment, probably from a chiton worn

by a female. The slipper has a smooth, slightly creased surface, as if of leather, and rests on a sole, 1·2 cm thick. It has been broken from a base, no trace of which remains.

Newton, *MRG* 88, attributed this foot to the same colossal statue as the head, 30, but there is no strong reason for doing so; the head was found some way away from this fragment.

Scale. Over life-size, but perhaps no more than heroic scale (II). Newton considered it colossal.

Newton, *MRG* 88.

209. Forepart of left foot wearing sandal from colossal female figure (pl. 31; fig. 30)

MRG 89. Reg. 1972.4–2.154.
Numbered 118 (red), 206 (black).

Finding-place not known.

Dimensions. L. 0·17 m. W. 0·14 m.
H. 0·14 m. Th. of base: 5·7 cm.

Marble. White, fine-crystalled, with brownish patina.

Fig. 30

The foot was bare. Parts of four toes only remain, the little toe being missing. Much of the big toe and the second toe are broken, as is also the forepart of the third toe. The nail of the fourth toe is neatly sculpted. The foot rests on an elaborate sandal, with a squared-off toe and a very high sole which has delicate beading running around the upper and lower edges: total H. 4·6 cm; lower beading 1·15 cm; upper beading divided into two parts, 4·5 and 7·5 mm high respectively. The sandal stands on a fairly thin base, worked with the point, its front and left edges preserved, running close to the sandal.

Scale. Almost certainly from one of the colossal female figures (I). For a fragment of the other foot of this figure, see 210 below. For the sandal type, see above, p. 71.

Newton, *MRG* 89.

210. Fragment of right foot in sandal from colossal female figure

Reg. 1972.4–2.155. Numbered 118 (red), 208
(black).

The case number, 118, suggests it was found in the same part of the excavations as 209.

Dimensions. H. 0·112 m. L. 0·115 m. W. 0·037 m.

Marble. White, fine-crystalled.

There remains part of the big toe of a right foot, with neatly carved nail, resting on a thick-soled sandal of similar design and dimensions to that of 209: total H. 4·7 cm; single lower beading 1·1 cm H.; double upper beading, 5·5 and 7·5 mm high respectively. Part of the squared front of the sandal also remains.

Most of the foot above the toe-nail appears to have been covered by a trailing chiton, the lower edge of which remains, obscuring the side of the sandal also. A shallow drill groove divides the lower edge of the garment from the toe. The sandal has been broken away from a base.

Scale. The peculiar style of the sandal and the close similarity of dimensions suggest that this fragment is from the same colossal female statue as 209 (I).

211. Forepart of right foot in sandal from colossal male figure (pl. 31; fig. 31)
Reg. 1972.4–2.156. Numbered 206 (red), 209 (black).

According to the invoice of cases, no. 206, found in the main sculptural deposit in the Imam's field, on the north side of the north *peribolus* wall.

Dimensions. H. 0·083 m. L. 0·125 m. W. 0·15 m. Th. of sole 2·2 cm.

Marble. White, fine-crystalled.

Fig. 31

Preserved is the tip of a colossal right foot wearing a sandal identical in style to that of 'Maussollos', 26. It consists of a fairly thick sole, a toe-cap of intricate straps, within which is a leather upper, the edges of which remain as two ridges, and within this, presumably, a soft slipper or shoe, since no toes are carved. The foot appears not to have rested on a base, since the underside is smooth, except for a drill hole, which is likely to be modern. The carving is slightly sketchy compared with the sandal of 26. From a colossal male statue of the same scale and type as 26, and, to judge from the finding-place, from the same northern range of figures.

Scale. I.

212. Fragment of foot in sandal from colossal male figure (pl. 31)
Reg. 1972.4–2.157. Numbered 214 (black).

Finding-place not known.

Dimensions. H. 0·175 m. L. 0·16 m. W. 0·105 m. Th. of sole 2·5 cm.

Marble. White, fine-crystalled.

Preserved is part of the right side of a foot, between ankle and toe, wearing a sandal of different type to that worn by 26. It appears to have had a meshwork of criss-crossing straps around the ankle, the forward straps terminating in loops through which laces were threaded. Parts of two of these loops remain. For sandals of similar type, but smaller scale, see 217 ff. below, especially 225.

The marble below the sandal sole has been hollowed out with harsh strokes of the point, leaving an inner core of marble beneath the sole. It is possible, therefore, that the heel of this foot may have been raised from the ground. In the right side of the foot near the break at the front there is part of a smooth, diagonal cutting, the significance of which is uncertain.

Scale. I.

213. Right foot in sandal from male figure (pl. 32; fig. 32)
MRG 80. Reg. 1972.4–2.158. Initialled C.T.N. (red).

Finding-place not known.

Dimensions. H. 0·22 m. L. 0·31 m. W. 0·13 m. Th. of base 7 cm. Th. of sole 1·4 cm.

Marble. White, fine-crystalled.

Fig. 32

Two fragments are preserved which make up most of a right foot except for the heel. The join is not close, but there can be little doubt that the two fragments do belong to the same foot. A gap of *c.* 1·5 cm is filled with plaster. The surface of the marble is generally much worn.

The foot wears an elaborate sandal of the type worn by 26 and 211, but smaller in scale. There is a sole, and a network of toe straps terminating in a point above the toes and in a loop on either side of the foot. Within the toe-cap is a leather inner, and within this must be a soft slipper or shoe, since no toes are carved. A broad lace

passes through an eyelet in the point above the toes, and then is threaded under the leather inner on either side of the foot, and out through the loops at the back of the toe cap. From here the two ends of the lace cross over twice, each time passing under the leather inner, and out through an eyelet marked by a protrusion or stud, thus pulling the two sides of the inner firmly together. The ends of the lace probably passed around the back of the ankle, perhaps via a ring, as on 26, and were tied in a bow in front of the ankle. One loop of the bow hangs down on the right side of the foot.

Beneath the foremost of the two fragments, the base is preserved to its original thickness (7 cm), but there is no edge remaining. The sole of the sandal rests flat on the ground.

Scale. Heroic (II).

Newton, *MRG* 80.

214. Heel of left foot wearing sandal, from male figure (pl. 32)
MRG 80*. Reg. 1972.4–2.159. Numbered 61 (red), 219 (black).

Finding-place not known.

Dimensions. H. 0·20 m. L. 0·15 m. W. 0·10 m.

Marble. White, fine-crystalled; surface much worn.

Preserved are the heel and ankle of a left foot, wearing a sandal or shoe, probably of the same type as 213. There is a sole, 1–1·5 cm thick, and a leather upper which terminates in a point behind the heel. A broad strap, no doubt part of the lace, runs around the back of the ankle, holding the sandal in place. The part of the leg which is preserved above the ankle appears to be draped in close-fitting trousers of Persian type.

The foot rested on a base, which is now broken away except for 1 cm thickness below the sole.

Scale. Heroic (II). Could belong to the same statue as 213, but could equally have gone with 215 or 216.

Newton, *MRG* 80*.

215. Forepart of right foot in sandal from male figure (fig. 33)
MRG 82. Reg. 1972.4–2.160. Initialled C.T.N. (red), numbered 215 (black).

Finding-place not known.

Dimensions. H. 0·18 m. L. 0·23 m. W. 0·12 m. Th. of base, as preserved 12 cm; Th. of sole of sandal 1·4 cm.

Marble. White, fine-crystalled. Fig. 33

The foot, which is broken behind the instep, wears a sandal of the type worn by 26, 211, and 213. Most of the framework of the toe-cap is quite well preserved, and there are remains also of the lace and leather inner. The base is broken on all sides, including the underside. It was much thicker, however, than the bases of 213 and 214. The heel of this foot may have been raised slightly from the ground.

Scale. Heroic (II).

Newton, *MRG* 82.

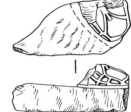

Fig. 34

216. Forepart of left male foot in sandal, set on base (pl. 32; fig. 34)
MRG 85. Reg. 1972.4–2.161. Numbered 236 (red), 2.. (black).

Finding-place not known.

Dimensions. Base: W. 0·32 m; D. 0·15 m; Th. 7 cm. Foot: L. 0·135 m; W. 0·12 m; H. 0·055 m.

Marble. White, fine-crystalled.

Preserved is a large fragment of statue base, including much of the front edge, its surface roughly finished with the point, except for a smooth, narrow strip, 1·4 cm wide, running around the sandal. The sandal is of the type worn by 26, 211, 213, and 215. Only the toe-cap remains. Undulations in the surface of the slipper between the straps of the toe-cap suggest the toes under the leather.

Scale. Heroic (II). Could perhaps belong to the same statue as 213, since the base of both fragments is of the same thickness. (Newton considered it life-size.)

Newton, *MRG* 85.

217. Tip of left foot in sandal, set on base
(pl. 32; fig. 35)

MRG 86. Reg. 1972.4–2.162.
Numbered 112 (red), 217 (black).

Finding-place not known.

Dimensions. H. 0·13 m. W. 0·16 m.
L. 0·16 m. Th. of base 7·5 cm.

Marble. White, fine-crystalled. Fig. 35

Preserved is the tip of a left foot wearing a sandal made up of an elaborate network of straps. There is a sole, 1·1 cm thick, fixed to which is a low zigzagging strap. From each apex of this strap a thong runs to a point above the toes, whence it loops back to the next apex. Through the loops which are thus formed above the toes there pass two thongs or laces, which would have secured the sandal over the foot. Since no toes are carved, a soft leather slipper or sock must be worn inside the sandal. For the type of sandal, see 218–224 below, and 165 above. This fragment, however, is of larger scale. Sandals of this type are also worn by some of the statues of the Daochos group at Delphi. See above, pp. 75, 77.

Scale. Heroic (II).

Newton, *MRG* 86.

218. Forepart of left foot in sandal, set on base
(pl. 32; fig. 36)

MRG 81. Reg. 1972.4–2.163.
Numbered 253 (red), 210 (black).

Finding-place not known.

Dimensions. H. 0·15 m. W. 0·15 m. L. 0·14 m. Th. of base 7·2 cm. Th. of sole of sandal 1·3–1·4 cm.

Marble. White, fine-crystalled. Fig. 36

Preserved is the left side of the tip of a left foot, set on a base, of which the left and front edges remain. The surface of the base is roughly finished with the point, although there is a plain strip running around the sandal. The sandal is of the type worn by 217: there is an inner leather shoe, over which is a network of straps, fixed to the sole, and converging to a point above the toes, where the loops are gathered by a single thong or lace. For another fragment which might belong to this foot, see 221 below.

Scale. Life-size (III).

Newton, *MRG* 81.

219. Forepart of right foot in sandal, set on base
(fig. 37)

MRG 83. Reg. 1972.4–2.164.
Numbered 164 (red), 218 (black).

Finding-place not known. Fig. 37

Dimensions. H. 0·135 m. W. 0·13 m. L. 0·125 m. Th. of base 7 cm. Th. of sole of sandal 1·4 cm.

Marble. White, fine-crystalled.

A fragment of a right foot similar in style and dimensions to 218, and wearing a sandal of identical type. The working of the base is also similar: the surface is pointed except for a smooth strip, *c.* 1 cm wide, left around the sandal. This foot is set farther back from the front edge of the base than 218. It is quite possible that both fragments belong to the same statue. For another fragment which could belong to this foot, see 222 below.

Scale. Life-size (III).

Newton, *MRG* 83.

220. Fragment of foot in sandal
Reg. 1972.4–2.176. Numbered 88 (red).

Finding-place not known.

Dimensions. H. 0·07 m. L. 0·095 m. W. 0·09 m.

Marble. White, fine-crystalled.

A fragment from above the toes of a foot wearing a sandal of the type worn by 218–219. Preserved are three looping ends of sandal straps, through which is threaded a leather thong or lace.

Scale. Probably life-size (III).

221. Left ankle and foot of male figure in sandal
(pl. 32; fig. 38)

MRG 84. Reg. 1972.4–2.165.
Numbered 69 (red), 203 (black).

Finding-place not known.

Dimensions. H. 0·16 m. L. 0·18 m. W. 0·09 m. Th. of sole of sandal 1·4 cm.

Marble. White, fine-crystalled. Fig. 38

Two adjoining fragments which make up the heel and rear part of a left foot and ankle, broken above the ankle and at the instep. The sandal consists of an intricate network of straps, running around the back of the heel and terminating in loops on either side of the ankle,

through which the lace is threaded. A soft under-slipper bulges out between the straps and between the criss-crossing lace. This is evidently the rear part of a sandal of the type to be found on fragments 217–220. It is possible that this fragment belongs to the same foot as 218, although there is no join. The foot has been broken away from a base.

Scale. Life-size (III).

Newton, *MRG* 84.

222. Right ankle and rear part of foot in sandal (fig. 39)

MRG 84*. Reg. 1972.4–2.166. No other number.

Finding-place not known.

Dimensions. H. 0·135 m. L. 0·16 m. W. 0·09 m. Th. of sole of sandal 1·2–1·4 cm.

Marble. White, fine-crystalled; surface much weathered.

Fig. 39

Broken at the ankle and the instep. The sandal worn is identical in type to that of 221, and is of precisely similar dimensions. Quite possibly it belongs to the same statue as 221, as Newton suggested (*MRG* 84*). It may also be from the same foot as 219. Therefore 218+221 and 219+222 could make up most of the two feet of a single statue. Other fragments of feet in sandals of this type exist, however: see above, 165, 220, and below, 223–224.

This foot has been broken away from a base.

Scale. Life-size (III).

Newton, *MRG* 84*.

223. Heel of foot in sandal

Reg. 1972.4–2.167. Numbered 195 (red), 205 (black).

Perhaps from the north side: case 195 included two fragments from there.

Dimensions. H. 0·133 m. L. 0·075 m. W. 0·075 m.

Marble. White, fine-crystalled; surface much weathered.

A fragment of a heel wearing a sandal of close mesh-work, of the type worn by nos 217–222. Part of a base remains below the heel.

Scale. Life-size (III).

224. Fragment of lower leg with sandal strap

Reg. 1972.4–2.168. Numbered 224 (black).

Finding-place not known.

Dimensions. H. 0·17 m. L. 0·09 m. W. 0·095 m.

Marble. White, fine-crystalled; surface much weathered.

A fragment of the back of a lower leg or upper ankle, with a looping sandal strap preserved on each side, through which a lace is threaded. From a sandal of the type worn by nos 217–223.

Scale. Life-size (III).

225. Fragment of foot in sandal

Reg. 1972.4–2.169. Numbered 207 (black).

Finding-place not known.

Dimensions. H. 0·09 m. L. 0·13 m. W. 0·09 m.

Marble. White, fine-crystalled.

A fragment of an ankle and upper foot wearing a sandal with a pointed back, and bold, looping straps at the right side, two of which remain. The type of sandal differs slightly from 217–224, and is similar to that of 212, although it is of smaller scale.

Scale. Life-size (III).

226. Tip of left foot in slipper or boot, set on base

MRG 90. Reg. 1972.4–2.170. Numbered B.66.3 (black).

Finding-place not known.

Dimensions. H. 0·19 m. W. of base 0·23 m. W. of foot 0·115 m. L. 0·11 m. Th. of base: 12 cm.

Marble. White, fine-crystalled; surface exceedingly worn.

Preserved is the front part of a left foot, wearing a slipper or boot with a sole 1·25 cm thick, set on a fragment of base, of which some of the left edge remains.

Scale. About life-size (III).

Newton, *MRG* 90.

227. Heel of foot in sandal

Reg. 1972.4–2.171. No other number (therefore not absolutely certainly from the Mausoleum).

Dimensions. H. 0·15 m. L. 0·092 m. W. 0·085 m.

Marble. White, fine-crystalled.

Preserved is the heel of a foot wearing a sandal consisting of a sole and a leather upper. On the right side is either a drapery fold hanging down over it, or else part of a strap. The foot has been broken from a base.

Scale. About life-size (III).

228. Toes of left foot on sandal (pl. 33)
Reg. 1972.4–2.172. Numbered 261 (red).

Found underneath Mehemet Ali's house near the northeast angle of the *peribolus* wall (*HD* 117). The invoice of case 261 confirms that it is from the north side.

Dimensions. L. 0·083 m. W. 0·10 m. H. 0·063 m. Th. of sandal sole: 3 cm.

Marble. White, fine-crystalled; surface very worn.

Preserved are the bare toes of a left foot resting on a sandal, the upper and lower edges of which have beading 1 cm high. There is a gap between the big toe and the second toe, as if for a sandal strap. The underside of the sandal is smoothly worked. Almost certainly from a female figure. The sandal is similar to that of the female figure, 90; but it does not belong to that statue. There is a slight indentation in the front of the sandal sole between the big toe and the second toe.

Scale. Over life-size (II).

229. Fragment of foot in sandal
Reg. 1972.4–2.173. Numbered B.66.2 (black) and M 9 (black).

Probably found by Biliotti on 30 May 1865 in the foundations of Mehmeda's house on the south side of the Mausoleum.

Dimensions. L. 0·103 m. W. 0·078 m. H. 0·035 m.

Marble. White, fine-crystalled.

A small fragment of an upper foot or ankle, on which are the remnants of a network of straps, probably from a sandal of the type of 217–224.

230. Fragment of leg with sandal straps
Reg. 1972.4–2.174. Numbered 127 (red). Number in black, 3.6, painted out.

Finding-place not known.

Dimensions. H. 0·14 m. W. 0·115 m. Th. 0·13 m.

Marble. Greyish-white, large-crystalled.

A fragment of a lower leg on which remain traces of sandal straps. There may also be drapery folds above, although this is not clear. The sandal does not correspond with any of the main types described above, and the marble differs from that used for the majority of the sculptures in the round. May perhaps not be from the Mausoleum.

FRAGMENTS OF DRAPERY

Fragments of draped torsos

231. Fragment of colossal draped figure
(pl. 33)
Reg. 1972.4–4.117. Numbered B.66.3 (black).

From Biliotti's excavations.

Dimensions. H. 0·33 m. W. 0·42 m. Th. 0·14 m.

Marble. White, fine-crystalled.

A fragment of a figure wearing a himation that bunches into deep folds. Perhaps from the region of the waist or lower abdomen. For the style, cf. 29.

Scale. I.

232. Fragment from waist of draped figure
Reg. 1972.4–2.37. Numbered 150 (red).

Perhaps from the Imam's field, north side.

Dimensions. H. 0·15 m. W. 0·315 m. Th. 0·12 m.

Marble. White, fine-crystalled; surface incrusted. There is a purple deposit on the base and lower sides. Cf. 33 and 42.

A fragment of the front of a draped figure from about waist-level. The underside has been worked for *anathyrosis*, with a smooth outer margin and a recessed inner area worked with the point, showing that this fragment comes from an upper part of a statue that was carved separately. The garment has numerous shallow folds, and is probably a Persian tunic. It is confined by a belt, through which a hole has been drilled to receive some object: diameter 2·5 cm; depth, as preserved, 7·5 cm.

This fragment may well be from the upper part of a rider similar to 34. It is unlikely to be from that statue, since the tunic of 34 already has a belt.

Scale. Probably colossal (I).

233. Fragment of upper part of draped figure

Reg. 1972.7–14.76. Numbered 67 (red).

Finding-place not known.

Dimensions. H. 0·057 m. W. 0·118 m. D. 0·085 m.

Marble. White, fine-crystalled.

The underside has been worked smooth, probably for *anathyrosis.* The drapery is carved in deep folds that run diagonally outwards, as if they had been confined above by a belt. Traces of the running drill remain in the bottom of two folds. Probably from the upper part of a mounted rider. Cf. 34, and especially 232, to which the style is similar.

Scale. ? I.

234. Fragment from upper part of draped figure

Reg. 1972.4–2.38. Numbered 162 (red).

Finding-place not known.

Dimensions. H. 0·175 m. W. 0·15 m. Th. 0·125 m.

Marble. White, fine-crystalled.

The underside of this fragment has been worked for *anathyrosis,* with a smooth margin and a rougher, recessed inner area, suggesting that it comes from just above the waist of a figure carved in two parts. On the front there are preserved several heavy folds of a thick garment, across which runs, at an oblique angle, a groove for a narrow belt, which must have been added separately. The carving of the folds is rather coarse, but no more so than, for example, the working of some of the folds on the rider, 34. Perhaps from a statue of a rider similar to 34.

Scale. Hard to assess; could be colossal (I).

235. Fragment from upper part of draped figure

Reg. 1972.4–2.39. Numbered 130 (red).

Finding-place not known.

Dimensions. H. 0·153 m. W. 0·21 m. Th. 0·125 m.

Marble. White, fine-crystalled.

Preserved is roughly a quadrant of a draped body, the lower side of which has been worked for *anathyrosis,* with a smooth margin, 2·5 cm wide, and an inner area recessed with the claw chisel. The working of the drapery is rather summary: traces of the flat chisel and

rasp remain. Perhaps from the back of a figure, who may have been seated. Cf. 232–234.

Scale. About life-size (III).

236. Fragment of draped figure

Reg. 1972.4–2.40. Initialled C.T.N. (red).

Finding-place not known.

Dimensions. H. 0·21 m. W. 0·20 m. Th. 0·10 m.

Marble. White, fine-crystalled.

The surface is convex, the drapery smooth except for two bold folds which run diagonally across one edge. Probably from an upper thigh at side or back. The working of the drapery is reminiscent of 26.

Scale. Hard to assess.

237. Fragment of female figure

Reg. 1972.4–4.1. Initialled C.T.N. (red).

Finding-place not known.

Dimensions. H. 0·23 m. W. 0·22 m. Th. 0·14 m.

Marble. White, fine-crystalled, with brown patina.

A fragment from the lower part of the front and side of a large female statue draped in chiton and himation. The vertical folds of the chiton are executed with the running drill, the treatment of the himation is broad and smooth, as on for example 26, although rasp marks remain on the surface. Probably from a statue similar to 'Artemisia', no. 27.

Scale. Probably colossal (I).

238. Fragment of female figure (?)

Reg. 1972.4–4.2. Initialled C.T.N. (red).

Finding-place not known.

Dimensions. H. 0·24 m. W. 0·22 m. Th. 0·07 m.

Marble. White, fine-crystalled; surface much worn.

A fragment on which a thinnish garment is stretched across a convex surface. Perhaps a chiton over a female breast.

239. Reg. 1972.4–4.3. Numbered B.66.3 (black).

From Biliotti's excavations, but finding-place not known.

Dimensions. H. 0·215 m. W. 0·18 m. Th. 0·085 m.
Marble. White, fine-crystalled.

Shallow folds fan out and are stretched taut over a protrusion which is perhaps a female breast. Cf. 238.

240. Reg. 1972.4–4.4. Initialled C.T.N. (red).
Finding-place not known.
Dimensions. H. 0·075 m. W. 0·18 m. Th. 0·075 m.
Marble. White, fine-crystalled.

A small fragment with a convex surface over which the drapery is stretched tight: from a breast or a limb.

241. Reg. 1972.4–4.5. Numbered 93 (red).
Finding-place not known.
Dimensions. H. 0·20 m. W. 0·195 m. Th. 0·06 m.
Marble. White, fine-crystalled.

Diverging folds suggest that this fragment comes from the upper part of a statue, near the shoulder, and the thick material looks like part of a cloak. Perhaps from a figure in Persian dress. Cf. 66 and 67.
Scale. Over life-size (probably II).

242. Reg. 1972.4–4.6. Initialled C.T.N. (red).
Finding-place not known.
Dimensions. H. 0·20 m. W. 0·23 m. Th. 0·06 m.
Marble. White, fine-crystalled.

A fragment of a himation on which are a few broad folds of drapery.
Scale. From a large, possibly colossal, statue.

243. Reg. 1972.4–4.7. Numbered B.66.3 (black).
From Biliotti's excavations. Finding-place not known.
Dimensions. H. 0·17 m. W. 0·21 m. Th. 0·12 m.
Marble. White, fine-crystalled.

A fragment of drapery with broadly worked folds, one of which runs obliquely across the line of the others. Perhaps from the breast of a figure in Persian dress.

244. Reg. 1972.4–4.8. Numbered 250 (red).
Finding-place not certain. Perhaps from Mahomet's field. Case 250 contained a capital from there.
Dimensions. H. 0·27 m. W. 0·17 m. Th. 0·11 m.
Marble. White, fine-crystalled.

A fragment of drapery with worked surfaces on three sides. The front is concave, and well finished. The back is convex, and is carved in more schematic fashion. One edge between back and front is also worked. Perhaps part of a billowing cloak. Clear traces of blue paint remain on the concave surface (front). Cf. 303.

245. Reg. 1972.4–4.9. Numbered 173 (red), 444 (black).
According to the Invoice of cases (no. 173), found in the Imam's field on the north side of the north *peribolus* wall.
Dimensions. H. 0·21 m. W. 0·08 m. Th. 0·115 m.
Marble. White, fine-medium crystal.

A fragment of a himation curving over a limb or body. In the hollows of the folds, which are quite deeply carved, there are clear traces of rose-red paint.

246. Reg. 1972.4–4.10. Initialled C.T.N. (red).
Finding-place not known.
Dimensions. H. 0·165 m. W. 0·14 m. Th. 0·09 m.
Marble. White fine-crystalled.

A fragment of a cloak or himation with broadly worked, curving folds.

247. Reg. 1972.4–4.11. Numbered 135 (red).
Finding-place not known.
Dimensions. H. 0·12 m. W. 0·12 m. Th. 0·08 m.
Marble. White, fine-crystalled.

A fragment of a cloak or himation with deeply carved folds.

248. Reg. 1972.4–4.12. Numbered B.66.3 (black).
From Biliotti's excavations. Finding-place not known.
Dimensions. H. 0·11 m. W. 0·12 m. Th. 0·05 m.
Marble. White, fine-crystalled.

A fragment of a cloak or himation with parts of two curving folds. Similar in style to 247.

249. Reg. 1972.4–4.13. Initialled C.T.N. (red).
Finding-place not known.
Dimensions. H. 0·065 m. W. 0·24 m. Th. 0·165 m.
Marble. White, fine-crystalled.

A fragment of himation from a large draped statue.

250. Reg. 1868.4–5.29.
From Biliotti's excavations at Bodrum.
Dimensions. H. 0·24 m. W. 0·155 m. Th. 0·093 m.
Marble. White, fine-crystalled.

A fragment of a draped figure, the surface of which is much damaged. Traces of two drapery folds remain. Perhaps from the chest or shoulder of a statue.

251. Reg. 1972.4–4.118. Numbered B.66.3 (black).
From Biliotti's excavations.
Dimensions. H. 0·24 m. W. 0·25 m. Th. 0·12 m.
Marble. White, fine-crystalled.

A fragment of drapery with broad, shallow folds, perhaps from the upper part of the back.

252. Reg. 1972.4–4.119. Numbered B.66.3 (black).
From Biliotti's excavations.
Dimensions. H. 0·095 m. W. 0·33 m. D. 0·23 m,
Marble. White, fine-crystalled.

A fragment sliced from a draped figure on which only a small area of drapery is preserved.

Fragments of bunched drapery

253. Reg. 1972.4–4.15. Numbered 130 (red).
Finding-place not known.
Dimensions. H. 0·19 m. W. 0·28 m. Th. 0·27 m.
Marble. White, fine-crystalled.

A fragment of a bunched himation, on which are the remains of five deeply carved folds. Whether from a bunch around the waist or over the shoulder is uncertain. Similar in style to the drapery of 26, and perhaps also from a colossal figure.

254. Reg. 1972.4–4.16. Numbered 254.10 (red), 186 (black), M 3 (black).
Finding-place not known.
Dimensions. H. 0·08 m. W. 0·14 m. Th. 0·055 m.
Marble. White, fine-crystalled.

A small fragment of a bunched himation.

255. Reg. 1972.4–4.19. Numbered 127 (red), 183 (black).
Finding-place not known.
Dimensions. H. 0·145 m. W. 0·09 m. Th. 0·095 m.
Marble. White, fine-crystalled; surface weathered.

A fragment of a bunched fold, perhaps from a himation.

256. Reg. 1972.4–4.17. Numbered 109 (red).
Finding-place not known.
Dimensions. H. 0·24 m. W. 0·14 m. Th. 0·16 m.
Marble. White, fine-crystalled.

A fragment of bunched drapery folds, probably from around the waist of a statue. The running drill was used in the deeper folds.

257. Reg. 1972.4–4.18. Numbered 161 (red).
Finding-place not certain. Dispatched in a case which contained a lion from the Imam's field, north side.
Dimensions. H. 0·10 m. W. 0·23 m. Th. 0·09 m.
Marble. White, fine-crystalled.

A twisting bunch of drapery, perhaps from the waist of a statue.

258. Reg. 1972.4–4.21. Initialled C.T.N. (red).
Finding-place not known.
Dimensions. H. 0·12 m. W. 0·145 m. Th. 0·15 m.
Marble. White, fine-crystalled; surface much worn.

A few folds of drapery remain. The underside is slightly concave, its surface finished with the point, as if for a join of some kind.

259. Reg. 1972.4–4.22. Numbered 262 (red).
Finding-place not known.

Dimensions. H. 0·125 m. W. 0·175 m. Th. 0·065 m.

Marble. White, medium-crystalled; surface weathered.

A fragment of a himation with deep, irregular folds. Perhaps from the lower part of a figure.

260. Reg. 1972.4–4.120. Initialled C.T.N. (red).
Dimensions. H. 0·175 m. W. 0·14 m. Th. 0·055 m.

Marble. White, fine-crystalled.

A fragment of drapery with lightly bunched folds.

Fragments of himatia hanging at the sides of figures

261. Reg. 1972.4–4.23. Numbered 158 (red).
Finding-place not known.

Dimensions. H. 0·21 m. W. 0·16 m. Th. 0·16 m.

Marble. White, fine-crystalled; surface much weathered.

A fragment of drapery, probably from a himation where it falls over and below the arm of a statue. Cf. 95, 96, 103, 106, 108, 109 above.

262. Reg. 1972.4–4.24. Numbered B.66.3 (black).
From Biliotti's excavations, but finding-place not known.

Dimensions. H. 0·30 m. W. 0·21 m. Th. 0·10 m.

Marble. White, fine-crystalled, with orange patina.

Two adjoining fragments of a himation that hung at the side of a figure. Worked surfaces of drapery remain on three sides. Probably from the lower left side of a figure that may have been colossal.

263. Reg. 1972.4–4.25. Numbered 141 (red).
Finding-place not known.

Dimensions. H. 0·59 m. W. 0·21 m. Th. 0·15 m.

Marble. White, fine-crystalled.

Three adjoining fragments of drapery from the lower left side of a statue, probably of colossal size. Both inner and outer surfaces are worked, as well as the front edge. There is a break only at the rear. The inner surface is only roughly carved, but on the outer side there are deeply drilled, well-finished folds.

264. Reg. 1972.4–4.26. Numbered 143 (red), 197 (black).
Finding-place not known.

Dimensions. H. 0·245 m. W. 0·12 m. Th. 0·075 m.

Marble. White, fine-crystalled.

Two adjoining fragments of drapery, the join smoothed with plaster, probably from a himation where it falls beside a figure. Both inner and outer surfaces and the front edge are worked. In the outer surface are two deeply drilled grooves.

265. Reg. 1972.4–4.48. Initialled C.T.N. (red).
Finding-place not known.

Dimensions. H. 0·15 m. W. 0·11 m. Th. 0·062 m.

Marble. White, fine-crystalled.

Two adjoining fragments of a himation that fell beside a figure. Drapery surfaces are preserved on both sides.

266. Reg. 1972.4–4.27. Numbered 75 (red), 192 (black).
Finding-place not known.

Dimensions. H. 0·14 m. W. 0·06 m. Th. 0·07 m.

Marble. White, fine-crystalled.

A fragment of drapery with surfaces preserved on three sides. Probably from a himation where it falls beside a figure.

267. Reg. 1972.4–4.28. Initialled C.T.N. (red).
Finding-place not known.

Dimensions. H. 0·24 m. W. 0·085 m. Th. 0·055 m.

Marble. White, fine-crystalled.

A fragment of a himation from the side of a figure, broken only on one edge.

268. Reg. 1972.4–4.29. Initialled C.T.N. (red).
Finding-place not known.

> *Dimensions.* H. 0·20 m. W. 0·085 m. Th. 0·085 m.
>
> *Marble.* White, fine-crystalled.

A fragment of a large fold of a himation from the side of
a large statue. The lower edge of the fold is preserved,
and has been undercut slightly.

269. Reg. 1972.4–4.30. Numbered 111 (red).
Finding-place not known.

> *Dimensions.* H. 0·18 m. W. 0·08 m. Th. 0·06 m.
>
> *Marble.* White, fine-crystalled.

A fragment of a large himation fold with worked sur-
faces on three sides. The inner side is concave and
heavily rasped. Similar in style to the drapery of 26.

270. Reg. 1972.4–4.31. Numbered 254 (red), 184
(black).
Finding-place not known.

> *Dimensions.* H. 0·105 m. W. 0·077 m. Th. 0·07 m.
>
> *Marble.* White, rather crystalline; perhaps island.

A fragment from the lower end of a hanging himation
fold. From a statue of large size.

271. Reg. 1972.4–4.32. Numbered 173 (red), 191
(black).

According to the invoice, case 173 contained 'fragments
of Statue no. 2 ('Maussollos'), Imaum's field, north
side'. Found therefore in the main sculptural deposit.

> *Dimensions.* H. 0·263 m. W. 0·117 m. Th. 0·05 m.
>
> *Marble.* White, fine-crystalled.

A fragment of well-carved drapery from the edge of a
himation. Worked surfaces remain on both inner and
outer sides, and on the front edge. Probably from the
side of a colossal statue.

272. Reg. 1972.4–4.33. Initialled C.T.N. (red),
numbered 200 (black).
Finding-place not known.

> *Dimensions.* H. 0·14 m. W. 0·13 m. Th. 0·06 m.
>
> *Marble.* White, fine-crystalled.

A fragment of a hanging himation fold, with surfaces
preserved on three sides.

273. Reg. 1972.4–4.34. Initialled C.T.N. (red),
numbered 312 (black).
Finding-place not known.

> *Dimensions.* H. 0·185 m. W. 0·08 m. Th. 0·105 m.
>
> *Marble.* White, fine-crystalled.

A fragment from the lower edge of a hanging himation
fold.

274. Reg. 1972.4–4.35. Numbered 120 (red), 412
(black).
Finding-place not known.

> *Dimensions.* H. 0·125 m. W. 0·115 m. Th. 0·083 m.
>
> *Marble.* White, fine-crystalled; surface much weath-
> ered.

A fragment of a himation where it falls beside a figure.
Surfaces are preserved on three sides.

275. Reg. 1972.4–4.36. Numbered 120 (red).
Finding-place not known.

> *Dimensions.* H. 0·172 m. W. 0·11 m. Th. 0·11 m.
>
> *Marble.* White, fine-crystalled.

Two adjoining fragments from the edge of a hanging
himation. Worked surfaces remain on three sides, and
on part of the fourth. There is only a very narrow break
at the back.

276. Reg. 1972.4–4.37. Numbered B.66.3 (black).
From Biliotti's excavations. Finding-place not known.

> *Dimensions.* H. 0·17 m. W. 0·13 m. Th. 0·11 m.
>
> *Marble.* White, fine-crystalled.

A worn fragment of drapery with worked surfaces on
both sides, probably from a free-hanging himation.

277. Reg. 1972.4–4.38. Numbered B.66.3 (black).

From Biliotti's excavations. Finding-place not known.

Dimensions. H. 0·135 m. W. 0·11 m. Th. 0·067 m.

Marble. White, fine-crystalled; condition rather rotten.

The tip of a fold from a free-hanging himation. All four sides and the underside are worked. Broken only above.

278. Reg. 1972.4–4.39. Numbered B.66.3 (black).

From Biliotti's excavations. Finding-place not known.

Dimensions. H. 0·15 m. W. 0·055 m. Th. 0·045 m.

Marble. White, fine-crystalled.

A fragment of a hanging himation, with worked surfaces preserved on both sides and one edge.

279. Reg 1972.4–4.40. Numbered 23 (red), M 1 (black).

Finding-place not known.

Dimensions. H. 0·25 m. W. 0·10 m. Th. 0·045 m.

Marble. White, fine-crystalled.

A large fold from the edge of a himation. The underside is hollowed out, where the garment is folded back in a U-shape. Probably from a colossal statue.

280. Reg. 1972.4–4.41. Numbered 175 (red).

According to the Invoice of cases (175), found in the Imam's field on the north side.

Dimensions. H. 0·21 m. W. 0·14 m. Th. 0·08 m.

Marble. White, fine-crystalled.

A fragment from the lower edge of a himation where it falls beside a figure.

281. Reg. 1868.4–5.4.

From Biliotti's excavations at Bodrum.

Dimensions. H. 0·205 m. W. 0·125 m. Th. 0·08 m.

Marble. White, fine-crystalled.

A fragment of a himation where it falls beside a figure, with worked surfaces on three sides.

282. Reg. 1868.4–5.28.

From Biliotti's excavations at Bodrum.

Dimensions. H. 0·125 m. W. 0·135 m. Th. 0·055 m.

Marble. White, fine-crystalled.

A fragment of a himation with a worked surface on each side.

283. Reg. 1972.4–4.129. Numbered 24 (red).

Dimensions. H. 0·115 m. W. 0·07 m. Th. 0·05 m.

Marble. White, fine-crystalled.

A fragment from the lower part of a himation where it hangs beside a figure. Three surfaces and the underside have been worked.

Other fragments probably of himatia

284. Reg. 1972.4–4.43. Numbered 83 (red).

Finding-place not known.

Dimensions. H. 0·215 m. W. 0·165 m. Th. 0·09 m.

Marble. White, fine-crystalled.

A fragment preserving parts of the front and side of a draped figure. The drapery is probably a himation.

285. Reg. 1972.4–4.44. Initialled C.T.N. (red).

Finding-place not known.

Dimensions. H. 0·19 m. W. 0·12 m. Th. 0·14 m.

Marble. White, fine-crystalled, with orange-brown patina.

A fragment of a draped figure, with two heavy himation folds which probably fell by the side. For the style of the drapery, cf. 29 above.

286. Reg. 1972.4–4.45. Initialled C.T.N. (red).

Finding-place not known.

Dimensions. H. 0·215 m. W. 0·135 m. Th. 0·10 m.

Marble. White, fine-crystalled.

A fragment of drapery with two heavy, straight folds. Probably from a himation hanging beside a figure. Cf. 285.

287. Reg. 1972.4–4.46. Numbered 165 (red).

According to the Invoice of cases (165), found in the Imam's field on the north side.

Dimensions. H. 0·20 m. W. 0·18 m. Th. 0·11 m.

Marble. White, fine-crystalled.

A fragment of a himation, with several deeply carved folds, probably from the side of a statue.

288. Reg. 1972.4–4.47. Numbered 165 (red).

According to the Invoice of cases (165), found in the Imam's field on the north side.

Dimensions. H. 0·23 m. W. 0·14 m. Th. 0·06 m.

Marble. White, fine-crystalled.

Fragment of a himation.

289. Reg. 1972.4–4.49. Initialled C.T.N. (red).

Finding-place not known.

Dimensions. H. 0·215 m. W. 0·062 m. Th. 0·023 m.

Marble. White, fine-crystalled.

Two adjoining fragments of drapery, with straight, parallel folds, probably from a himation.

290. Reg. 1972.4–4.121. Initialled C.T.N. (red), numbered 468 (black).

Finding-place not known.

Dimensions. H. 0·175 m. W. 0·115 m. Th. 0·085 m.

Marble. White, fine-crystalled.

A fragment of hanging drapery folds, probably from a himation.

291. Reg. 1972.4–4.50. Initialled C.T.N. (red), numbered 196 (black).

Finding-place not known.

Dimensions. H. 0·105 m. W. 0·065 m. Th. 0·055 m.

Marble. White, fine-crystalled.

Fragment of drapery.

292. Reg. 1972.4–4.51. Numbered B.66.3 (black).

From Biliotti's excavations. Finding-place not known.

Dimensions. H. 0·13 m. W. 0·09 m. Th. 0·06 m.

Marble. White, fine-crystalled.

Fragment of drapery.

293. Reg. 1972.4–4.52. Numbered B.66.3 (black).

From Biliotti's excavations. Finding-place not known.

Dimensions. H. 0·16 m. W. 0·09 m. Th. 0·09 m.

Marble. White, fine-crystalled.

Fragment of drapery.

294. Reg. 1972.4–4.53. Numbered B.66 (black).

From Biliotti's excavations. Finding-place not known.

Dimensions. H. 0·16 m. W. 0·12 m. Th. 0·185 m.

Marble. White, fine-crystalled; surface worn.

Fragment of drapery with broadly spaced folds.

295. Reg. 1972.4–4.54. Numbered B.66.2 (black).

From Biliotti's excavations. Finding-place not known.

Dimensions. H. 0·17 m. W. 0·145 m. Th. 0·21 m.

Marble. White, fine-crystalled.

A much battered fragment of drapery with coarsely drilled folds.

296. Reg. 1972.4–4.55. Initialled C.T.N. (red).

Finding-place not known.

Dimensions. H. 0·20 m. W. 0·09 m. Th. 0·08 m.

Marble. White, fine-crystalled.

A fragment of drapery, probably from a himation.

297. Reg. 1972.4–4.56. Initialled C.T.N. (red).

Finding-place not known.

Dimensions. H. 0·28 m. W. 0·095 m. Th. 0·075 m.

Marble. White, fine-crystalled; surface weathered.

A fragment of drapery, perhaps from the side of a statue.

298. Reg. 1972.4–4.57. Initialled C.T.N. (red).
Finding-place not known.
>*Dimensions.* H. 0·26 m. W. 0·12 m. Th. 0·09 m.
>*Marble.* White, fine-crystalled.

A fragment of drapery, the surface of which shows clear traces of the rasp.

299. Reg. 1972.4–4.58. Numbered 69 (red).
Finding-place not known.
>*Dimensions.* H. 0·23 m. W. 0·17 m. Th. 0·055 m.
>*Marble.* White, fine-crystalled.

A fragment of a himation.

300. Reg. 1972.4–4.59. Numbered 262 (red).
Finding-place not known.
>*Dimensions.* H. 0·19 m. W. 0·19 m. Th. 0·07 m.
>*Marble.* White, fine-crystalled, with brown patina.

A fragment of drapery. For the style cf. 43 above.

301. Reg. 1972.4–4.60. Numbered 261 (red).
Case 261 contained fragments 'chiefly from the north side'.
>*Dimensions.* H. 0·20 m. W. 0·165 m. Th. 0·08 m.
>*Marble.* White, fine-crystalled; surface much worn.

A fragment of drapery, probably from a himation.

302. Reg. 1972.4–4.61. Initialled C.T.N. (red)
Finding-place not known.
>*Dimensions.* H. 0·195 m. W. 0·14 m. Th. 0·085 m.
>*Marble.* White, fine-crystalled.

A fragment of drapery, probably from a himation.

303. Reg. 1972.4–4.62. Numbered B.66.3 (black).
From Biliotti's excavations. Finding-place not known.
>*Dimensions.* H. 0·355 m. W. 0·28 m. Th. 0·115 m.
>*Marble.* White, fine-crystalled.

A large, but much damaged fragment of drapery, with folds preserved on both sides. Probably from a free-hanging cloak or himation. Clear traces of blue paint remain within a drilled fold on one side. Cf. 244 above.

304. Reg. 1972.4–4.63. Initialled C.T.N. (red).
Finding-place not known.
>*Dimensions.* H. 0·16 m. W. 0·11 m. Th. 0·06 m.
>*Marble.* White, fine-crystalled, with silvery veins.

A fragment of a tautly drawn garment, whose shallow, concave folds radiate from a point now missing. There are coarse rasp marks on the surface. Perhaps from the back of a figure.

305. Reg. 1972.4–4.64. Numbered 109 (red).
Finding-place not known.
>*Dimensions.* H. 0·28 m. W. 0·15 m. Th. 0·11 m.
>*Marble.* White, fine-crystalled.

A large fragment of drapery with the remains of folds on three faces. Perhaps from the side of a figure.

Fragments of drapery, mostly from the backs of statues

306. Fragment from a large statue (pl. 33)
Reg. 1972.4–2.46. Initialled C.T.N. (red).
Finding-place not known.
>*Dimensions.* H. 0·355 m. W. 0·26 m. Th. 0·30 m.
>*Marble.* White, fine-crystalled, with yellow-brown patina.

A large fragment of drapery, three sides of which are worked. Two sides have broadly carved folds, as if from the back or side of a statue. The third side is concave, and has been finished with the point.
>*Scale.* From a statue of large size, probably colossal.

307. Reg. 1972.4–4.66. Numbered 105 (red), 194 (black).
Finding-place not known.
>*Dimensions.* H. 0·095 m. W. 0·185 m. Th. 0·185 m.
>*Marble.* White, fine-crystalled.

A fragment of deeply folded drapery, from the back or side of a figure.

308. Reg. 1972.4–4.67. Numbered 253.21 (red). Finding-place not given.

Dimensions. H. 0·16 m. W. 0·14 m. Th. 0·10 m.

Marble. White, fine-crystalled, with brown patina.

A fragment of drapery, probably from the lower part of a statue.

309. Reg. 1972.4–4.68. Numbered 118 (red). Finding-place not known.

Dimensions. H. 0·21 m. W. 0·135 m. Th. 0·11 m.

Marble. White, fine-crystalled.

A fragment of drapery with convex surface, on which are several folds that run diagonally across the grain of the marble. Perhaps therefore from the shoulder or upper back of a statue. Cf. 74, 75, 78, 82, 84 above.

310. Reg. 1972.4–4.69. Numbered B.66.3 (black). From Biliotti's excavations. Finding-place not known.

Dimensions. H. 0·10 m. W. 0·26 m. Th. 0·18 m.

Marble. White, medium-crystalled.

A fragment of drapery with two adjacent worked surfaces. One has lightly undulating folds, the other has been finished with the point. Cf. 306.

311. Reg. 1972.4–4.70. Numbered 157 (red). Finding-place not known.

Dimensions. H. 0·04 m. W. 0·10 m. Th. 0·05 m.

Marble. White, fine-crystalled.

A fragment of drapery with lightly undulating folds, perhaps from the back of a statue. Cf. 310.

312. Reg. 1972.4–4.71. Numbered 130 or 180 (red). If 180, it would be from the Imam's field, on the north side.

Dimensions. H. 0·07 m. W. 0·355 m. Th. 0·25 m.

Marble. White, fine-medium crystal.

A fragment of drapery from a large statue, with, on one side, traces of drapery folds, and a smooth area for a join, in which is a dowel hole, 7 mm in diameter; on the other side is part of a socket, finished with the point.

313. Reg. 1972.4–4.72. Initialled C.T.N. (red). Finding-place not known.

Dimensions. H. 0·23 m. W. 0·13 m. Th. 0·06 m.

Marble. White, fine-crystalled.

A fragment of broadly carved drapery.

314. Reg. 1972.4–4.73. Numbered 128 (red). Finding-place not known.

Dimensions. H. 0·175 m. W. 0·105 m. Th. 0·105 m.

Marble. White, fine-crystalled.

A fragment of drapery with the remains of a cutting, now measuring 3 × 4 × 11 cm deep. Perhaps for the attachment of an arm. Cf. 96–109 above.

Fragments of draped limbs

315. Reg. 1972.4–4.74. Numbered 115 (red). Finding-place not known.

Dimensions. H. 0·20 m. W. 0·27 m. Th. 0·20 m.

Marble. White, fine-crystalled.

A fragment of a rounded limb or body over which drapery is stretched taut.

316. Reg. 1972.4–4.75. Numbered 137 (red). Finding-place not known.

Dimensions. H. 0·182 m. W. 0·12 m. Th. 0·09 m.

Marble. White, fine-crystalled.

A fragment of a draped limb. The drapery is carved in a sophisticated, three-dimensional fashion.

317. Reg. 1972.4–4.76. Numbered 139 (red). Finding-place not known.

Dimensions. H. 0·205 m. W. 0·20 m. Th. 0·095 m.

Marble. White, fine-crystalled.

A fragment of a limb, probably an arm, covered in close-fitting drapery that is pulled in horizontal cross-folds, as on Persian sleeves. Cf. 136–141 above. If this is so, then the scale is colossal, and the arm may well have belonged to a Persian rider of the type of 34.

318. Reg. 1972.4–4.122. Initialled C.T.N. (red).
Dimensions. H. 0·17 m. W. 0·15 m. Th. 0·115 m.
Marble. White, fine-crystalled.

Fragment of limb or body, across which drapery is tightly drawn.

319. Reg. 1972.4–4.77. Numbered B.66.2 (black).
From Biliotti's excavations. Finding-place not known.
Dimensions. H. 0·105 m. W. 0·07 m. Th. 0·06 m.
Marble. White, fine-crystalled.

A small fragment of a draped limb or body.

320. Reg. 1972.4–4.78. Numbered 195 (red), 415 (black).
Finding-place not known.
Dimensions. H. 0·125 m. W. 0·14 m. Th. 0·075 m.
Marble. White, medium-crystalled.

A fragment of a draped limb, perhaps a thigh or a knee.

321. Reg. 1972.4–4.124. Numbered B.66.3 (black).
From Biliotti's excavations.
Dimensions. H. 0·05 m. W. 0·115 m. Th. 0·085 m.
Marble. White, fine-crystalled.

A fragment of draped limb or body.

322. Reg. 1972.4–4.79.
No other number, but previously stored with Mausoleum fragments.
Dimensions. H. 0·365 m. W. 0·22 m. Th. 0·17 m.
Marble. White, fine-crystalled.

A fragment of a draped figure with a protrusion which may be the knee of a bent leg.

Miscellaneous fragments of drapery

323. Reg. 1972.4–4.125. Numbered 130 (red).
Finding-place not known.
Dimensions. H. 0·155 m. W. 0·16 m. Th. 0·07 m.
Marble. White, fine-crystalled, with brown patina.

Fragment of finely worked drapery.

324. Reg. 1972.4–4.80. Initialled C.T.N. (red).
Finding-place not known.
Dimensions. H. 0·10 m. W. 0·07 m. Th. 0·025 m.
Marble. White, fine-crystalled.

A fragment of drapery.

325. Reg. 1972.4–4.81. Numbered B.66.3 (black).
From Biliotti's excavations. Finding-place not known.
Dimensions. H. 0·18 m. W. 0·095 m. Th. 0·053 m.
Marble. White, fine-crystalled.

A fragment of drapery with a few radiating folds.

326. Reg. 1868.4–5.27.
From Biliotti's excavations at Bodrum.
Dimensions. H. 0·185 m. W. 0·095 m. Th. 0·05 m.
Marble. White, fine-crystalled.

A fragment of drapery.

327. Reg. 1972.4–4.82. Numbered B.66.3 (black).
From Biliotti's excavations. Finding-place not known.
Dimensions. H. 0·13 m. W. 0·08 m. Th. 0·07 m.
Marble. White, fine-crystalled.

A fragment probably of drapery, although strands of hair are just possible. One edge is coarsely finished with the point.

328. Reg. 1972.4–4.83. Numbered B.66.3 (black).
From Biliotti's excavations. Finding-place not known.
Dintensions. H. 0·11 m. W. 0·057 m. Th. 0·055 m.
Marble. White, fine-crystalled.

A fragment of drapery.

329. Reg. 1972.4–4.84. Numbered 237 (red).
Perhaps from the Imam's field, north side.
 Dimensions. H. 0·145 m. W. 0·105 m. Th. 0·055 m.
 Marble. White, fine-crystalled.

A fragment of drapery.

330. Reg. 1972.4–4.85. Numbered 71 (red).
Finding-place not known.
 Dimensions. H. 0·15 m. W. 0·11 m. Th. 0·07 m.
 Marble. White, fine-crystalled, with orange patina.

A fragment of drapery.

331. Reg. 1972.4–4.87. Initialled C.T.N. (red), numbered 195 (black).
Finding-place not known.
 Dimensions. H. 0·12 m. W. 0·04 m. Th. 0·075 m.
 Marble. White, fine-crystalled.

A fragment of drapery.

332. Reg. 1972.4–4.88. Numbered 171 (red).
Case 171 contained 'seven pieces from statue no. 2 ('Maussollos'), Imaum's field, north side'.
 Dimensions. H. 0·097 m. W. 0·035 m. Th. 0·035 m.
 Marble. White, fine-crystalled.

A small fragment of drapery.

333. Reg. 1972.4–4.89. Numbered 261 (red).
Case 261 contained fragments 'chiefly from the north side'.
 Dimensions. H. 0·123 m. W. 0·10 m. Th. 0·04 m.
 Marble. White, fine-crystalled.

A fragment of drapery.

334. Reg. 1972.4–4.90. Initialled C.T.N. (red), numbered 189 (black).
Finding-place not known.
 Dimensions. H. 0·085 m. W. 0·04 m. Th. 0·045 m.
 Marble. White, fine-crystalled.

A small fragment of drapery.

335. Reg. 1972.4–4.91. Initialled C.T.N. (red).
Finding-place not known.
 Dimensions. H. 0·065 m. W. 0·05 m. Th. 0·027 m.
 Marble. White, fine-crystalled.

A small fragment of a large drapery fold.

336. Reg. 1972.4–4.92. Numbered 47 (red).
Finding-place not known.
 Dimensions. H. 0·06 m. W. 0·095 m. Th. 0·047 m.
 Marble. White, fine-crystalled.

A fragment of drapery.

337. Reg. 1972.4–4.93. Numbered 195 (red).
Finding-place not known.
 Dimensions. H. 0·08 m. W. 0·06 m. Th. 0·065 m.
 Marble. White, fine-crystalled.

A fragment of drapery.

338. Reg. 1972.4–4.94. Numbered 128 (red), M 4 (black).
Finding-place not known.
 Dimensions. H. 0·07 m. W. 0·085 m. Th. 0·06 m.
 Marble. White, fine-crystalled.

A fragment of drapery.

339. Reg. 1972.4–4.95. Numbered 125 (red), M 6 (black).
Finding-place not known.
 Dimensions. H. 0·12 m. W. 0·08 m. Th. 0·065 m.
 Marble. White, fine-crystalled.

A fragment of drapery.

340. Reg. 1972.4–4.96. Initialled C.T.N. (red), numbered 202 (black), M 8 (black).
Finding-place not known.
 Dimensions. H. 0·098 m. W. 0·065 m. Th. 0·05 m.
 Marble. White, fine-crystalled.

A fragment of drapery, with surfaces remaining on three sides.

341. Reg. 1972.4–4.126. Numbered 128 (red).
Finding-place not known.
> *Dimensions.* H. 0·113 m. W. 0·085 m. Th. 0·07 m.
> *Marble.* White, fine-crystalled.

A fragment of drapery.

342. Reg. 1972.4–4.127. Numbered 199 (red).
Perhaps from the Imam's field. Case 199 dittoes case
198, which contained fragments from there.
> *Dimensions.* H. 0·11 m. W. 0·07 m. Th. 0·045 m.
> *Marble.* White, fine-crystalled, with brown patina.

A fragment of a fold of a himation.

343. Reg. 1972.4–4.128. Numbered 14 (red).
Finding-place not known.
> *Dimensions.* H. 0·13 m. W. 0·065 m. Th. 0·087 m.
> *Marble.* White, fine-medium crystal.

A fragment of drapery, neatly carved.

344. Reg. 1972.4–4.130. Numbered 264 (red).
Finding-place not known.
> *Dimensions.* H. 0·09 m. W. 0·095 m. Th. 0·04 m.
> *Marble.* White, fine-crystalled, with brown patina.

A fragment of drapery.

345. Reg. 1972.4–4.131. Numbered 14 (red).
Finding-place not known.
> *Dimensions.* H. 0·095 m. W. 0·063 m. Th. 0·043 m.
> *Marble.* White, fine-crystalled.

A fragment of drapery.

346. Reg. 1972.4–4.97. Numbered 261 (red), M 10
(black).
Case 261 contained fragments 'chiefly from the north
side'.
> *Dimensions.* H. 0·105 m. W. 0·07 m. Th. 0·04 m.
> *Marble.* White, fine-crystalled.

A fragment of drapery.

347. Reg. 1972.4–4.123. Numbered B.66.1 (black).
From Biliotti's excavations.
> *Dimensions.* H. 0·07 m. W. 0·115 m. Th. 0·085 m.
> *Marble.* White, fine-crystalled.

A fragment of drapery.

348. Reg. 1972.4–4.98. Numbered B.66.3 (black).
From Biliotti's excavations. Finding-place not known.
> *Dimensions.* H. 0·14 m. W. 0·07 m. Th. 0·09 m.
> *Marble.* White, fine-crystalled.

A fragment of drapery.

349. Reg. 1972.4–4.99. Numbered B.66 (black).
From Biliotti's excavations. Finding-place not known.
> *Dimensions.* H. 0·10 m. W. 0·10 m. Th. 0·105 m.
> *Marble.* White, fine-crystalled.

A fragment of drapery with folds on the front, and
surfaces worked as if for joins at top and bottom. The
top is lightly picked, the bottom has been dressed with
the claw chisel.

350. Reg. 1972.4–4.100. Numbered B.66.3 (black).
From Biliotti's excavations. Finding-place not known.
> *Dimensions.* H. 0·08 m. W. 0·137 m. Th. 0·075 m.
> *Marble.* White, fine-crystalled.

A fragment of drapery.

351. Reg. 1972.4–4.101. Numbered B.66.3 (black).
From Biliotti's excavations. Finding-place not known.
> *Dimensions.* H. 0·13 m. W. 0·17 m. Th. 0·07 m.
> *Marble.* White, fine-crystalled.

A fragment of a drapery fold.

352. Reg. 1972.4–4.102. Numbered B.66.3 (black).
From Biliotti's excavations. Finding-place not known.
> *Dimensions.* H. 0·10 m. W. 0·075 m. Th. 0·065 m.
> *Marble.* White, fine-crystalled.

A fragment of drapery.

353. Reg. 1972.4–4.103. Numbered B.66 (black).
From Biliotti's excavations. Finding-place not known.
 Dimensions. H. 0·085 m. W. 0·105 m. Th. 0·07 m.
 Marble. White, fine-crystalled.

A very worn fragment of drapery.

354. Reg. 1972.4–4.104. Initialled C.T.N. (red).
Finding-place not known.
 Dimensions. H. 0·145 m. W. 0·095 m. Th. 0·09 m.
 Marble. White, fine-crystalled.

A fragment of drapery.

355. Reg. 1972.4–4.106.
No other number, but previously stored with the
Mausoleum sculptures.
 Dimensions. H. 0·127 m. W. 0·023 m. Th. 0·02 m.
 Marble. White, fine-crystalled.

The edge of a drapery fold, in the back of which are two
modern copper dowels. Perhaps added at some time to
'Artemisia', 27.

356. Reg. 1972.4–4.107. Numbered B.66.3 (black).
From Biliotti's excavations. Finding-place not known.
 Dimensions. H. 0·245 m. W. 0·24 m. Th. 0·145 m.
 Marble. White, fine-crystalled.

A fragment of deeply carved drapery, one side of which
has been worked level, as if for a join.

357. Reg. 1972.4–4.108. Numbered 208 (red).
Case 208 contained 'various fragments from east and
north sides of Mausoleum'.
 Dimensions. H. 0·13 m. W. 0·16 m. Th. 0·08 m.
 Marble. White, fine-crystalled.

A fragment of drapery, one side of which has been
dressed with the claw chisel as if for a join.

FRAGMENTS OF ACCESSORIES

358. Fragment of helmet on base (pl. 33)
 BM 1059; *MRG* 50*; Reg. 1857.12–20.330. Num-
 bered 206 (red), 156 (black).

Found in the main sculptural deposit on the north side
in the Imam's field, lying underneath the pyramid steps:
Newton, *Papers,* i. 22; *HD* 105, 228–9. Mistaken at first
for an archaic head.
 Dimensions. H. 0·24 m. W. 0·28 m. D. 0·41 m. Th. of
 base varies from 5·5 to 13 cm.
 Marble. White, fine-crystalled; surface weathered.

Preserved is the lower part of a helmet resting on an
irregular base. The helmet is of curious style. It seems to
have covered the whole face at the front, and itself to
have had features carved in relief. There is a pointed,
beard-like protrusion, above which is a wide, gaping
mouth, like that of a dramatic mask. Around the mouth
the lips are indicated, and falling on either side of it are
two thin, drooping moustaches. The cheeks appear to
have been rather prominent. At the back is a ridge which
evidently represents the base of the helmet at neck-
level. The helmet must have had a stylised, rather
archaistic look about it.

In the upper break of the helmet, just behind the
mouth, there remains the bottom of a socket worked
with the point. *Dimensions as preserved*: L. 12 cm; W.
8 cm; D. 5 cm. This must have been for the addition of a
fairly substantial fragment, perhaps including some of
the upper part of the helmet.

Two edges of the base are preserved, adjacent to each
other. Both are concave, so that the base has something
of a cushion-shape. The helmet seems to rest on a rocky
protrusion, which has a smooth surface, but the flat
corner of the base has coarse point marks.

Scale. Roughly life-size (III). Attributed by Newton
to the base of a statue. It could perhaps have formed part
of a sculptural group. The style of the helmet appears to
be unparalleled. It may however be a variant of the
Ionian helmet. Cf. Snodgrass, *Early Greek Armour and
Weapons* (1964) 32.

For examples of helmets resting on or against rocky
ground in fourth-century BC sculpture, note:
 (*a*) Athena relief, Acr. Mus. 1330: Casson, *Catalogue*,
231; Charitonides, *AE* 1957, 84–87.
 (*b*) South angle, west pediment of temple of
Asclepios, Epidauros: Crome, *Die Skulpturen* (1951),
43, no. 33, pl. 38.3.

(c) Alexander sarcophagus, pediment: *KiB* 337, 5–6; Schefold, *Der Alexandersarkophag* (1968), figs. 2–4; von Graeve, op. cit., colour pl. II, 2.

Newton, *Papers*, i. 22; *HD* 105, 228–9; *MRG* 50*; Smith, *BM Cat.* 1059; van Breen, op. cit. 254, fig. 69; Riemann, P-W, 451 (t).

359. Fragment of sword scabbard
Reg. 1972.4–4.114. Numbered 158 (red).

Finding-place not known.

Dimensions. H. 0·145 m. W. at top 8 cm; at bottom 7·3 cm. Th. at top 4·5 cm; at bottom 4 cm. Th. of sides 3 cm.

Marble. White, fine-crystalled.

A fragment from the tapering blade of a sword scabbard. The front is pitched, while the back is slightly concave. It is similar to the scabbard held by 'Maussollos', 26, but it is not so large.

Scale. Either II or III. It could be from either a portrait statue like 26, but of scale II, or from a figure in a battle-group, if of scale III.

For possible fragments of shields, see below, nos 764–765.

Fragments of Animals from Sculptural Groups

FRAGMENTS OF RAM

360. Body of colossal ram (pl. 33)
BM 1097; *MRG* 145; Reg. 1857.12–20.258.

Found to the north of the north *peribolus* wall, in Mahomet's field, towards the west end of the Quadrangle, 3 ft from the colossal female head, 30: Newton, *Papers*, i. 32; *HD* 105, 111, 233.

Dimensions. L. 1·50 m. H. 0·84 m. W. 0·555 m.

Marble. White, fine-crystalled; surface weathered, particularly on the left side.

Missing. All four legs from just below the body, the lower part of the tail, the right shoulder, and the head. The head is now in Bodrum (found by Jeppesen in 1970); and one of the hind legs may survive (361, below).

The ram was carved to be seen in side view, from its left side, facing towards the spectator's left. Its right legs were set forward slightly, while its left legs were set back (cf. the poses of the architectural lions, below), and creases in the woolly coat on the left side suggest that the shoulders and head were turned slightly to the animal's left, in the direction of the spectator.

The treatment is broad, the surface having been finished only with the point and claw chisel, while the wool is indicated by irregular grooves made by the running drill, or, in places, by the chisel. The grooves were originally shallower on the right side of the body (the back) than on the left, but are now better preserved there, since the left side has been weathered.

A strip *c.* 20 cm wide along the top of the back has no wool markings on it at all. Its surface has been only very roughly finished with the point. Cf. the top of the back of the colossal chariot horse, 2. This feature, taken together with the general broadness of the carving, suggests that the ram was placed fairly high up on the building at a considerable distance from the spectator.

On the right side of the body (the back), there is a protrusion emerging from the lower flank of the animal. The lower part of it is now broken, but it was once rectangular, H. 26·5 cm, W. 15 cm, its surface smooth and level with the widest part of the right side of the body. Although there are no clamp cuttings or dowel holes, it seems likely that this protrusion marks the point of abutment against another figure, perhaps an attendant who may have been leading the ram.

This ram must have formed part of a sacrificial group. Probably it is to be associated with the fragments of bull and boar below, the whole group to be interpreted as a threefold sacrifice (*trittoia* or *suovetaurilia*). The colossal seated figure, 33, could also have formed part of this group. See above, pp. 44–5.

Scale. I.

Newton, *Papers*, i. 32; *HD* 105, 111, 233; *MRG* 145; Smith, *BM Cat.* 1097; Six, *JHS*, xxv (1905), 4, fig. 4; Jeppesen, *Paradeigmata* (1958), 47, 51, figs 22θ, 39; Riemann, P-W 453 (aa).

361. Fragment of hind leg of ram(?)

MRG 147; Reg. 1972.4–8.1. Numbered 253.20 (red).

Finding-place not known.

Dimensions. H. 0·165 m. W. (side) 0·10 m. Th. 0·09 m.

Marble. White, fine-crystalled.

A delicately worked fragment from the lower part of an animal's leg. It has all the characteristics of a ram's leg, and, since the scale is about right for the colossal ram, 360, Newton's attribution of this leg to it may well be correct. There is no join, however.

Newton, *MRG* 147.

FRAGMENTS OF BULL OR OX

362. Large cloven hoof from bull or ox (pl. 34)
Reg. 1972.4–8.2.

No other number, but certainly from the Mausoleum, since it is mentioned by Newton, *HD* 234, although the finding-place is not given.

Dimensions. H. 0·13 m. L. 0·23 m. W. 0·12 m.

Marble. White, fine-crystalled.

The hoof has been broken from a base. It is preserved complete, with a small portion of leg above and behind it. It is much too large to have belonged to the ram, 360, or to a boar (see below). Almost certainly, therefore, it belonged to a bull or ox, which probably formed part of the same sacrificial group as the ram.

Newton, *HD* 234; Six, *JHS*, xxv (1905), 4; Jeppesen, *Paradeigmata*, 51; Riemann, P-W, 453 (bb).

363. Fragment of head of bull
Reg. 1972.4–8.3. Numbered 206 (red).

According to the Invoice of cases, 206, found in the Imam's field on the north side of the Mausoleum.

Dimensions. H. 0·225 m. W. 0·19 m. Th. 0·085 m.

Marble. White, fine-crystalled with yellow-brown patina; surface much weathered.

Preserved is a rounded fragment from the left side of the face or muzzle of a bull, including the left nostril. It is the working of the nostril which confirms the identification. It is carved like an eye-socket with a tail (or like a

comma), 2 cm deep, within which is a drill-hole, 8 mm in diameter, and a further 2 cm deep. This was the usual way of indicating bulls' nostrils in ancient sculpture (cf. parallels cited above, p. 73). The width of the drill-hole in the nostril is the same as that within the drilled nostrils of the leopard's head, 372, below. The surface of the muzzle below the nostril shows point marks, which suggests perhaps that it was not readily visible. Cf. the point marks on the muzzle of the leopard 371.

Scale. The same as for 362. Probably this is part of the same animal. Large enough for the fragment to be associated with the colossal ram. See above, pp. 44–5.

364. Fragment of right shoulder, foreleg and lower neck of bull (pl. 34)
Reg. 1972.4–8.4. Numbered 283 (red).

The inventory for case 283 reads: 'Lion's head; fragments of Lion; fragments of Frieze in panels, from Mehemet Ali's field, north-east angle of Mausoleum, Peribolus.' The wording is slightly ambiguous, but almost certainly this fragment was found at the north-east angle of the *peribolus*, and was taken by Newton to be part of a lion's body. Found, therefore, quite close to 363.

Dimensions. H. 0·51 m. L. 0·295 m. W. (about half) 0·29 m.

Marble. White, fine-crystalled.

A fragment from the right forepart of a large animal. It is too large to be from one of the architectural lions, and is without doubt from a bull or ox. The top of the right leg is stubby and fat, the skin creased and wrinkled, as of a bull's hide; the belly is deep, so that a large part of the upper leg is carved in strong relief against it (as is not the case with the lions); and there is a projecting breastbone hanging between the legs, representing the base of the neck or throat. Cf. the sacrificial heifers on the south side of the Parthenon frieze, slabs 38–41.

The condition of the surface is quite good. The finish of the right side is smooth, but behind and under the leg there are clear rasp marks. The projecting bone between the legs has been weathered into holes by rain water running down the front of the animal.

The scale is that of the other fragments of bull, 362–363, and is in keeping with the colossal ram, 360. Assuming the projection between the legs to be midway across the body, the original width of the animal must have been *c.* 58–60 cm. Cf. 55 cm in width of ram,

and 90 cm of colossal chariot horses. The height, allowing for the missing upper half of the body and head, and for the lower legs, must have been at least 1·50 m. Quite possibly from the same sacrificial group as the ram, 360.

FRAGMENTS OF BOARS

365. Forepart of a boar (pl. 34)
BM 1096, 2; *MRG* 142; Reg. 1857.12–20.287.

Finding-place not known.

Dimensions. H. 0·55 m. L. 0·72 m. W. 0·35 m.

Marble. White, fine-crystalled.

Preserved from the back of the neck to mid-way along the body. A second fragment of the body has been attached at the rear. It is characterized as a boar by the bristle along the spine, although there is no indication of coarse hair over the body, which is smooth and fat. The upper parts of both forelegs remain, carved in relief against the lower belly of the animal, and from the angle of these, it would seem that the animal was standing upright, rather than running or crouching, ready to spring. The stance and the rather flabby body might suggest that the boar belonged to a sacrificial rather than a hunting group, and it is perhaps to be associated with the ram, 360, and the bull, 362–364, in a *suovetaurilia*. The scale is probably in keeping, since the addition of the head and rear quarters would bring the total length to *c.* 1·40–1·50 m. One of the two boars' heads preserved could belong to this body.

Newton, *HD* 233; *MRG* 142; Smith, *BM Cat.* 1096, 2; Six, *JHS*, xxv (1905), 4; Riemann, P-W, 453 (z).

366. Rear part of a boar
MRG 139; Reg. 1972.4–8.5.

Finding-place not known.

Dimensions. L. 0·61 m. H. 0·475 m. W. 0·35 m.

Marble. White, fine-crystalled.

Reconstructed from two adjoining fragments consisting of:
(*a*) Right hindquarters, genitals, base of tail, and some of right flank. This fragment numbered 98 (red).
(*b*) Left hindquarters, top of left hindleg, bristle along spine and end of curly tail.
Newton considered the animal in question to be a panther, but the bristle along the spine, the curly tail

and the treatment of the genitals, which are enclosed in a bag, prove that it is in fact a boar. The scale is the same as for 365, but the treatment of the right flank is much leaner and more muscular, and it is probable that the animal formed part of a hunting group, where it was shown in energetic movement, either springing through the air, as the present mounting suggests, or, perhaps more likely, crouching forward with muscles tensed, ready to spring. The latter interpretation is favoured by the fragment of leg, 369 below, which may belong to this animal.

Newton, *MRG* 139.

367. Left side of head of boar (pl. 34)
BM 1096, 1; *MRG* 143; Reg. 1972.4–8.6.

No other number. Finding-place not known.

Dimensions. L. 0·48 m. H. 0·24 m. Th. 0·12 m.

Marble. White, fine-crystalled.

Two fragments, joined by plaster, which preserve:
(*a*) The upper jaw, including the left nostril, which is drilled to a depth of 2 cm, and the upper part of the tusk.
(*b*) The left side of the face, and the left eye, which is 6 cm wide.
A red-brown deposit below the eye on fragment (*b*) may be the remains of paint.
The scale is that of the two bodies 365 and 366. Although associated by Newton and Smith with 365, the head has a lean, sinewy character more in common with 366.

Newton, *MRG* 143; Smith, *BM Cat.* 1096, 1.

368. Head of boar seen from right (pl. 34)
Reg. 1972.4–8.7.

No other number, but previously displayed with the Mausoleum sculptures, and clearly from the Mausoleum stylistically.

Dimensions. L. 0·27 m. H. 0·255 m. Th. 0·23 m.

Marble. White, fine-crystalled.

Preserved from the snout to just behind the eye, where there is a vertical cutting. Whether this is ancient, for separate attachment of the head, or more modern, is hard to say. The head, although worked in the round, was never finished in detail on the left side. The lines of the mouth and the tusks, which are carved on the right

side, are not indicated on the left. Instead there are only rough, vertical striations made by the flat chisel. In the snout there are two shallow nostrils. The right eye is 6 cm wide.

The scale is identical to that of the head, 367, but the style is different. The head is fleshier and more smoothly worked. An association with the body 365 would seem possible, bearing in mind, however, that that body may have formed part of a *suovetaurilia*, some of which at least was seen from the left (ram, 360), whereas this head was definitely carved to be seen from the right.

369. Leg and hoof of boar on base (pl. 35)
BM 1096, 3; *MRG* 144; Reg. 1972.4–8.8. Numbered 162 (red), 344 (black).

Finding-place not known.

Dimensions. L. 0·35 m. H. 0·23 m. W. 0·18 m. Th. of base: 8–10 cm.

Marble. White, fine-crystalled.

Two adjoining fragments which make up the lower leg and cloven hoof of a boar, set on a roughly picked base. The leg is set forward at a shallow angle to the surface of the base, and a wedge of marble has been left immediately behind the hoof to strengthen it. Newton considered this to be a hindleg, which indeed it could be. It could however equally be a foreleg, since boars put their forelegs out in front of them when they are about to spring. Newton also supposed it to be a right leg, which again it might be. However, the left edge of the base appears to be preserved immediately below the hoof, while the base extends beyond the right side of the hoof and seems to rise. This might suggest that it is a left leg rather than a right.

The scale is the same as for the other fragments of boar. This fragment is perhaps from the same animal as the body 366.

Newton, *HD* 233; *MRG* 144; Smith, *BM Cat.* 1096, 3.

370. Hoof of boar on base (pl. 35)
MRG 146. Reg. 1972.4–8.9. Numbered 254.4 (red), 176 (black).

Finding-place not known.

Dimensions. L. 0·145 m. W. 0·125 m. H. 0·115 m. Th. of base 8 cm.

Marble. White, fine-crystalled.

Preserved is the tip of a cloven hoof, resting on a base, the surface of which is roughly worked. Original edges of the base appear to remain in front of and just to the left of the hoof, and again adjacently to the left; i.e. the front of the base was stepped back. The underside of the base is smooth.

Newton attributed this hoof to the ram, 360, but it seems too large for this. It is similar in scale and style to the boar's hoof, 369, and in all probability also belongs to a boar. It may be from the same animal as 369, since the bases of the two fragments are of the same thickness.

Newton, *HD* 234; *MRG* 146.

FRAGMENTS OF FELINES: LEOPARDS[1] AND LIONS

371. Forepart of a running leopard (pl. 35)
BM 1095; *MRG* 138. Reg. 1857.12–20.256.

Removed by Newton from over one of the gateways of the castle of St Peter at Bodrum. The close similarity with the other leopard's head (372 below), which was found in the Mausoleum excavations, proves that it is part of the sculptures of the Mausoleum.

Dimensions. L. 1·00 m. H. 0·59 m. W. (max.) 0·48 m. W. of body at shoulders 0·39 m; at rear break 0·37 m. W. of eye 3·4 cm.

Marble. White, fine-crystalled; surface considerably weathered.

Preserved are the head, neck, forepart of body, and upper right leg. There is damage to the nose and lower jaw.

The leopard was carved to be seen from its right side. It was portrayed running along to the right, its neck lowered, and its head turned at 90 degrees to the front. Clearly it was being hunted and was in some desperation. Coarse point marks on the left side of the neck confirm that this side was away from the spectator's view. There are traces of the flat chisel on the underside of the belly and neck, and there are point marks on the lower part of the muzzle (cf. bull's head, 363). The top of the back, neck, and head are much more weathered than the flanks or leg. Some of this weathering, however, must result from exposure in the castle for three hundred years or more.

1. Leopard is the correct term for these felines rather than panther, which has often been applied in the past. There were no true panthers in ancient Greece. See Hull, *Hounds and Hunting in Ancient Greece* (1964), 99–100; J. M. C. Toynbee, *Animals in Roman Art* (1973), 82.

Newton thought (*HD* 233) that some object was held in the mouth, but this seems to be an erroneous interpretation of the large flews or pads at the corners of the feline mouth. The general treatment of the head is not dissimilar to that of the heads of the architectural lions.

For similar leopards, see above, pp. 74–5.

Newton, *HD* 233; *MRG* 138; Smith, *BM Cat.* 1095; Six, *JHS*, xxv (1905), 3, fig. 3; Jeppesen, *Paradeigmata* (1958), 52, fig. 38; Riemann, P-W, 453 (y).

372. Part of head of leopard
Reg. 1972.4–8.10. Numbered 80 (red) and 98 (red).
Finding-place not known.

Dimensions. H. 0·18 m. L. 0·20 m. W. 0·16 m.

Marble. White, fine-crystalled, with brown patina.

Two adjoining fragments which make up the right side of a leopard's head. Preserved are the nose with both nostrils, the upper jaw, the right flew, right cheek, and the corner of the right eye (W. as preserved 1·7 cm). The nostrils have been drilled to a depth of 1 cm by a bit 8 mm in diameter. Cf. the drilled nostrils of the bull's head, 363. The surface of what remains is in much better condition than 371, and the nose in particular has been very neatly carved.

Scale and style are similar to 371.

373. Rear part of leopard (pl. 35)
Reg. 1972.4–8.11. Initialled C.T.N. (red).
Finding-place not known.

Dimensions. L. 0·66 m. H. 0·37 m. W. 0·35 m.

Marble. White, fine-crystalled with brown patina.

Preserved are the right side of the hindquarters, most of the top of the back, some of the underbelly, and the base of the tail of a feline animal. It cannot be from one of the architectural lions, for it is rather too small, differently proportioned, too lithe, and has no fur along the top of the back, or behind the right leg (all the architectural lions have fur on top of the back terminating *c.* 35 cm or less in front of the tail; here there are 55 cm of smooth back). The tail is also slightly smaller than those of the lions, being *c.* 9 × 8 cm at the break; it twists to the animal's left and is not straight, as are the lions'. Without doubt, therefore, this is part of a leopard. The right leg appears to have been set slightly further back

than the left, and the hindquarters were probably arched. Male genitals are roughly indicated below the belly in the same place as on the lions.

There is widespread use of the flat chisel on top of the back. This recalls the working of 371, and it is not impossible that the two fragments may belong to the same animal, since the scale is about the same. There does not appear to be a join.

374. Hind quarters of female leopard or lioness
MRG 140. Reg. 1972.4–8.12.

No other number, but mounted on a base inscribed: 'Part of panther, Mausoleum'. Mentioned by Newton (*HD* 233), and perhaps dispatched in case no. 129.

Dimensions. H. 0·46 m. L. 0·34 m. W. 0·275 m. W. of right leg 17·5 cm. This is about half of original width. Therefore original W. *c.* 35 cm.

Marble. White, fine-crystalled; surface weathered.

Two adjoining fragments which make up the right part of the back of a female feline animal, probably a leopard, although it could be a lioness. Preserved are the upper part of the right rear leg, the female genitals at the back, the inner part of the left rear leg, and at the front break two distended udders, set side by side. The right one is complete, but only about a third of the left one remains. These are identical in style to the udders of the lioness from the Mausoleum in Istanbul. The right leg appears to have been set back slightly, the left leg forward.

Scale. The same as for the other leopard fragments.

Newton, *HD* 233; *MRG* 140.

375. Left foreleg of feline(?) (pl. 35)
Reg. 1972.4-8.13. Numbered 111 (red).
Finding-place not known.

Dimensions. H. 0·20 m. L. 0·36 m. W. 0·20 m. Break of lower leg: 8·8 × 7·5 cm.

Marble. White, fine-crystalled.

Part of the left foreleg and body of an animal with fur at the back of its legs. Probably it is from a lion, although it could be from a leopard, or even from a Molossian hound (the Molossian hound in the Kerameikos has fur behind its legs). The fragment is on a smaller scale than

the architectural lions, and the leg was clearly set forward, as of an animal running or being hunted. There are marks of the claw chisel on the back of the leg, while the fragment of body that remains has only been roughly finished with the point. The upper side of the leg is considerably weathered.

FRAGMENTS OF DOGS AND OTHER ANIMALS

376. Forepart of muscular animal, perhaps a mastiff (pl. 36)
Reg. 1857.12–20.257.

In the register it is described as an 'animal'. Numbered 253.19 (red). According to the Invoice of cases it is a 'piece of lion's shoulder with mane'. Finding-place not known.

Dimensions. H. 0·51 m. L. 0·44 m. W. 0·335 m. W. of half front 20 cm.

Marble. White, fine-crystalled.

Two fragments, joined by plaster, from the forepart of an extremely muscular animal. Preserved are: the upper part of the left foreleg, whose muscles are very pronounced, just over half of the front, the shoulders, and the base of the neck, which seems to have been quite long and to have been offset from the muscles of the shoulder.

At the base of the neck in front, above the division of the legs, there are a few locks of fur, similar in treatment to those of the architectural lions. There is, however, no mane on top of the neck, nor is there any along the spine. The left leg appears to have been upright, the head was turned slightly to the animal's left, and there are heavy creases in the skin on the right side of the neck. The surface of the body is finished with the claw chisel, a feature which, together with the accentuated musculation, calls to mind the horses of the chariot group.

As for the identity of the animal, there seem to be only two possibilities: a lioness or a mastiff. A leopard is excluded by the fur at the throat, a lion by the absence of a mane. The scale, however, is equal to that of the leopard 371, with an original width at the shoulders of *c.* 40 cm. Of the two possibilities a large mastiff is the more likely. The heavy musculation would suit it better, and is in fact precisely paralleled by the musculation of the mastiff type in the Uffizi and elsewhere (Richter, *Animals,* fig. 174; Keller, *Die antike Tierwelt,* 112, fig.

43; Mansuelli, *Catalogue,* i, nos 48, 49). Large mastiffs of the Molossian type also appear to have had fur at the neck, although not as much as lions.

377. Fragment of head of dog
Reg. 1972.4–8.15. Numbered 115 (red), 490 (black).

Finding-place not known.

Dimensions. L. 0·155 m. H. 0·145 m. W. 0·075 m.

Marble. White, fine-crystalled.

Preserved is the right side of the muzzle of a dog, including upper and lower jaws, right nostril, and part of the tongue, the edge of which is drilled within the open mouth. The skin above the nose is wrinkled. That it is from a dog is shown by the very small flew at the corner of the mouth, which is much smaller than the flews of lions or panthers.

The dog was of square-nosed type, and was probably a Molossian or pseudo-Molossian (cf. Keller, op. cit. 91, 112; Richter, *Animals,* 33).

Scale. Slightly smaller than that of the leopards' heads. It may be large enough for the body 376, but the finish is much smoother than on that fragment.

378. Fragment of body of animal
Reg. 1972.4–8.16. Numbered 158 (red).

Finding-place not known.

Dimensions. H. 0·245 m. L. 0·33 m. Th. 0·17 m.

Marble. White, fine-crystalled.

A fragment of the body of an animal. It does not appear to be from one of the architectural lions, but looks more as if it were from a leopard or boar. Two holes drilled in the break on the underside are no doubt modern.

379. Leg of animal
Reg. 1972.4–8.17. Numbered 68 (red).

Finding-place not known.

Dimensions. H. 0·165 m. W. 0·15 m. Th. 0·06 m. W. of lower break 7 cm.

Marble. White, fine-crystalled.

A fragment of a small, sinewy foreleg, from close to the join with the body. Probably from a dog or boar.

380. Leg of animal
Reg. 1972.4–8.18. Numbered B.66.1 (black).

From Biliotti's excavations. Finding-place not known.

Dimensions. H. 0·10 m. W. 0·14 m. Th. 0·085 m.

Marble. White, fine-crystalled.

A fragment of an upper foreleg, from close to the join with the body. Probably from a dog or boar. Cf. 379.

381. Leg of animal
Reg. 1972.4–8.19. Numbered 120 (red).

Finding-place not known.

Dimensions. H. 0·21 m. W. 0·17 m. Th. 0·14 m.

Marble. White, fine-crystalled.

Two adjoining fragments which make up part of the leg of a fairly large animal. The outer surface shows traces of the flat chisel, while the inner surface has been finished only with the claw. Not from one of the architectural lions, whose musculation and finish differ. Perhaps from a leopard.

382. Fragment of tail
Reg. 1972. 4–8.20. Numbered B.66.1 (black).

From Biliotti's excavations. Finding-place not known.

Dimensions. H. 0·08 m. Diam. 5 × 6 cm.

Marble. White, fine-crystalled.

A round, straight-sided fragment, probably a tail. It is too small for the architectural lions, and is perhaps from a leopard or smaller-sized lion.

383. End of leopard's tail(?)
Reg. 1972.4–8.21. Numbered B.66.1 (black).

From Biliotti's excavations. Finding-place not known.

Dimensions. H. 0·125 m. Diam. 5·5 cm.

Marble. White, fine-crystalled.

A fragment of tail, broken at one end only. The other end is rounded. It is smaller than those of the architectural lions and differs in style. Perhaps from one of the leopards.

384. Fragment of tail
Reg. 1972.4–11.57. Numbered 66 or 99 (red).

Finding-place not known.

Dimensions. H. 0·085 m. Diam. 5·3 × 5·8 cm.

Marble. White, fine-crystalled.

There is a purple deposit on the inner surface. The fragment is too small for one of the architectural lions, and is perhaps from a leopard or smaller-sized lion.

385. Fragment of boar's tail (?)
Reg. 1972.4–8.22. Numbered 69 (red).

Finding-place not known.

Dimensions. H. 0·09 m. Diam. of upper break: 6 × 7·5 cm; lower break; 4 × 4 cm.

Marble. White, fine-crystalled.

A fragment of a small, curving tail, which a comparison with 366 suggests may be the upper part of a curly boar's tail, from close to the join with the body.

FRAGMENTS OF HORSES

For fragments of horses already mentioned, see above 1–23 (chariot group), and 34–41 (Persian rider).

386. Fragment of horse's leg
Reg. 1972.4–8.23. Numbered 69 (red).

This is probably the fragment described in the invoice for case 69 as: 'Piece of Horse, Mausoleum, south western side, corner of Ismail's house.'

Dimensions. H. 0·165 m. W. 0·145 m. Th. 0·04 m.

Marble. White, fine-crystalled.

A small fragment of a large limb with a low, oval protuberance which probably represents the chestnut on the hind leg of a horse. The grain of the marble suggests that the leg was upright rather than prancing, and the scale could be equal to that of the chariot group.

387. Fragment of hind leg of horse
Reg. 1972.4–8.24. Initialled C.T.N. (red).

Finding-place not known.

Dimensions. H. 0·24 m. W. (side view) 0·42 m. Th. 0·20 m.

Marble. White, fine-crystalled.

A large fragment with the original surface preserved only at one end. Here there is a bony protrusion strongly reminiscent of the hock of a horse's hind leg. The angle of the protrusion would suggest that the leg may have been bent, and the horse shown prancing. The surface has been finished with the rasp.

Scale. The scale (I) is at least equal to that of the Persian rider's horse, 34, to which this fragment could conceivably have belonged. (This may be one of the fragments listed in *MRG* 38, not all of which have been positively identified.)

388. Fragment of hind leg of horse
Reg. 1972.4–8.25. Initialled C.T.N. (red).

Finding-place not known.

Dimensions. H. 0·243 m. W. (side) 0·08 m. Th. 0·125 m.

Marble. White, fine-crystalled.

A fragment which is probably from the hind leg of a horse, in the region of the hock. The finish is generally smooth, except for a few light marks of the point on one side, and some deeper horizontal striations made by the same chisel at the back. The scale is large, and it is not impossible that this fragment might have belonged to the chariot group. Otherwise it could have belonged to a horse similar to the Persian rider's.

Scale. I.

389. Fragment of raised foreleg of horse
Reg. 1972.4–8.26. Numbered 183 (red).

Finding-place not known.

Dimensions. H. 0·27 m. W. 0·12 m. Th. 0·06 m. The cross-section of the upper break must have been *c.* 14 × 12 cm.

Marble. White, fine-crystalled.

A fragment which preserves about half the thickness of a horse's foreleg, from just above the hoof. The surface has been finished with the claw chisel, but is now weathered. The direction of the grain of the marble, diagonally across the leg, would suggest that the leg was raised from the ground. Although the style and the marble would allow an attribution to the chariot group, the scale appears to be too small.

390. Part of shoulder and foreleg of horse
(pl. 36)

MRG 141. Reg. 1972.4–8.28. Initialled C.T.N. (red).

Finding-place not known.

Dimensions. H. 0·33 m. L. 0·24 m. Th. 0·225 m.

Marble. White, fine-crystalled; surface weathered.

Two adjoining fragments which preserve the right side of the shoulder, and the upper part of the raised right foreleg of an animal. Newton described these fragments in *MRG* 141 as 'probably of a panther', but this is certainly wrong. The foreleg has a bone structure that is divided into two clear sections, as a leopard's is not (cf. 371), but as a horse's is. Near the upper break of the chest is a raised ridge curving across it, 1 cm high and 2·5 cm wide, roughly carved. It is difficult to see what this is, if not reins or some sort of harness(?). Since the surface of the animal skin continues beyond it, it cannot be the raised edge of a socket to receive a separately worked head and neck.

Scale. Considerably smaller than that of the Persian rider's horse (34), and probably no more than life-size (III).

Newton, *MRG* 141.

391. Fragment of raised right foreleg of horse
Reg. 1972.4–8.29. Numbered 80 (red).

Finding-place not known.

Dimensions. H. 0·155 m. L. 0·23 m. Th. 0·12 m.

Marble. White, fine-crystalled.

Part of the upper right foreleg of a prancing horse, from close to its join with the body, small portions of which remain. The outer right side of the leg has been well carved, and has a muscular appearance, but the inner left side has been only schematically worked with the flat chisel.

Scale. About life-size (III). Cf. 390.

392. Foreleg of prancing horse　(pl. 36)
Reg. 1972.4–8.31. Initialled C.T.N. (red).

Finding-place not known.

Dimensions. H. 0·24 m. W. 0·175 m. Th. 0·10 m. Upper break: 11 × 9 cm; lower break: 8·5 × 6 cm.

Marble. White, fine-crystalled.

Preserved are parts of the upper leg, knee and lower leg. Only the right side has been worked in detail, the left side being smooth (cf. boar's head, 368). It could be a left or a right foreleg, but it clearly belonged to a horse that was meant to be seen from its right side.

Scale. About life-size (III). Cf. 390–391.

393. Fragment of foreleg of prancing horse (?)
Reg. 1972.4–8.30. Initialled C.T.N. (red), numbered 358 (black).

Finding-place not known.

Dimensions. H. 0·11 m. L. 0·18 m. Th. 0·125 m.

Marble. White, fine-crystalled, with brown patina.

A fragment of a raised foreleg from close to the body. The right side is well finished, but there are marks of the flat chisel on the underside, and point marks on the left side. A comparison with 390–392 suggests that it is part of the foreleg of a horse, carved to be seen from the right side.

Scale. About life-size (III).

394. Knee of foreleg of prancing horse
Reg. 1972.4–8.32. Numbered 253 (red).

Finding-place not known.

Dimensions. H. 0·21 m. W. 0·21 m. Th. 0·09 m.

Marble. White, fine-crystalled.

A fragment that seems to be from the strongly bent knee of a horse's foreleg. Both sides are preserved, and there is a continuous edge running from the upper foreleg, over the knee, to the lower leg. The treatment of the surface is muscular and sinewy.

Scale. About life-size (III).

395. Fragment of hind leg of horse
Reg. 1972.4–8.33. Numbered 165 (black).

Finding-place not known.

Dimensions. H. 0·207 m. W. 0·13 m. Th. 0·09 m.

Marble. White, fine-crystalled.

A fragment of a horse's leg, including some of a joint, probably part of a hock from a hind leg. The leg appears to have been bent, as though the horse were prancing.

Scale. About life-size (III).

396. Fragment of horse's leg
Reg. 1972.4–8.34. Numbered 66 (red), 266 (black).

Finding-place not known.

Dimensions. H. 0·17 m. W. 0·14 m. Th. 0·075 m.

Marble. White, fine-crystalled.

Preserved is part of a horse's leg, including some of a joint, and also the cannon bone with its clear division into two parts. Most likely from the rear leg of a prancing horse.

Scale. About life-size (III).

397. Fragment of horse's leg
Reg. 1972.4–8.35. Numbered X (red), 310 (black).

Finding-place not known.

Dimensions. H. 0·195 m. W. 0·145 m. Th. 0·08 m.

Marble. White, fine-crystalled.

Preserved is about half of a section through a horse's leg, the surface of which has emphatically marked bones and sinews. Probably it is part of the cannon bone of the hindleg of a prancing horse. Cf. 396.

Scale. About life-size (III).

398. Knee of foreleg of horse
Reg. 1972.4–8.36. Numbered 345 (black).

Finding-place not known.

Dimensions. H. 0·233 m. W. 0·17 m. Th. 0·095 m.

Marble. White, fine-crystalled.

Preserved is most of the knee-joint from a horse's foreleg that was evidently straight.

Scale. Life-size or slightly larger (?III). Far too small for the chariot group.

399. Horse's foreleg (?)

Reg. 1972.4–8.37. Numbered 79 (red), 167 (black).

Finding-place not known.

Dimensions. H. 0·11 m. W. 0·085 m. Th. 0·046 m.

Marble. White, fine-crystalled.

A fragment that is probably from the lower leg of a horse, although it could just possibly be a human limb, for example, a wrist.

400. Fragment of horse's tail

Reg. 1972.4–8.38. Numbered 264 (red).

Finding-place not known.

Dimensions. L. 0·175 m. H. 0·15 m. Th. 0·075 m.

Marble. White, fine-crystalled.

A fragment of a horse's tail, one end of which has been levelled with the point, probably for attachment to a body. Around this end surface is a plain band, beyond which are strands of flowing hair, sharply chiselled. Towards one break, the strands of hair give way to a roughly pointed surface, which must have been either the underside or the topside (cf. top of back of colossal chariot horse 2, and colossal ram 360). The working differs from that of the tails of the chariot horses.

Scale. Difficult to assess; certainly life-size, and probably more. It may be large enough for the Persian rider, 34, but is unlikely from the case no. (264) to be the fragment of tail which, according to Newton, *Papers,* i. 10, was found close to the Persian rider.

Fragments of Lions

STANDING LIONS

LARGE FRAGMENTS

Type I. Head turned to right, left legs forward, right legs back

401. Statue of a lion (pl. 37; fig. 4)
BM 1075; *MRG* 100; Reg. 1857.12–20.240

According to Newton the lion was found lying on top of the north wall of the *peribolus,* 'resting apparently as he had fallen' (*HD* 102), at a point roughly opposite the centre of the north side of the Quadrangle. According to R. M. Smith's diary (23 April 1857) it was lying '*behind* the marble wall on the North side of the Mausoleum' (my italics). Whatever the truth of the matter, the lion should undoubtedly be considered as part of the sculptural deposit found close by in the Imam's field, just to the north of the north *peribolus* wall.

Dimensions. L. (max.) 1·53 m. H. 1·50 m. W. at top of forelegs 0·44 m. W. of face at eyes 34 cm; W. of each eye 4·2 cm; distance from end of fur on back to base of tail 40·5 cm.

Right rear leg: at top, W. 36 cm, Th. 20 cm: at stifle, W. 16 cm, Th. 12 cm; right foreleg: at top, W. 21 cm, Th. 17 cm; above paw, W. 14·5 cm, Th. 11·5 cm.

Break of tail at base: H. 11 cm, W. 10 cm.

Marble. White, fine-crystalled, with brown patina in places. Probably Pentelic. Surface considerably weathered on body and head, less so on front of mane.

Head and body are preserved in a single fragment which is generally in fine condition. Three of the legs have been completed down to points just above the paws by the addition of several large fragments: two to the right foreleg, two to the right rear leg, and one to the left rear leg. Gaps between these fragments, and most of the hock of the right rear leg, have been restored in plaster. The lowest fragment attached to the right hind leg probably does not belong.

Still missing. All four paws, and the base or bases on which they rested; the left foreleg from above the knee; all the tail except for a curving portion attached to the inside of the right rear leg; part of the mane in front of the right ear.

This is the best-preserved lion, and, apart from the fact that it is rather narrower in the body than average, it may be regarded as typical of type I: it stands with both left legs set forward, both right legs set back, while the head is turned to the right (i.e. the lion's right) at 45 degrees (a few lions have a more emphatic turn of the head of *c.* 90 degrees: see below).

The head is carved in broad and bold fashion (cf. head of chariot horse, 1). Round, deep-set eyes create an intense, passionate rather than ferocious expression. A groove runs from the centre of the forehead, down nearly to the tip of the muzzle. The nostrils are indicated by shallow drill-holes. At the corners of the opened mouth are large feline flews. Within the mouth, teeth and tongue are carved. Red paint, which remained on the tongue when the lion was first discovered (*HD* 102,

232), has now disappeared. The rough finish of the tongue, which Newton thought was meant to imitate the prickly nature of a lion's tongue (*HD* 232), is more likely owing to difficulty of access.

The face is framed by a rather stiff-looking mane, consisting in the first place of a series of formally arranged locks, which are parted in the centre of the forehead, and meet again in ruff-like fashion at the throat. There are fourteen locks on the right side of the head, but only eleven on the left side. Each lock has four or five hairs indicated by sharply chiselled V-shaped grooves (cf. carving of hairs of mane and tails of chariot horses). From behind the first row of locks, pointed ears protrude. The rest of the mane, which covers neck, upper shoulders, and chest, running down between the tops of the forelegs, has a more tousled arrangement of locks, but each lock has the same dully designed, sharply carved hairs, which produce a hard, somewhat lifeless appearance. A double row of locks runs from the shoulders along the top of the back, stopping some way short of the tail. Between them is a narrow parting which runs up the back of the neck to emerge opposite the groove in the centre of the forehead. A few hairs are also indicated on the upper backs of fore and rear legs, and at the top of the front of the rear legs, where they join the body.

The body and legs are thick-set and muscular. Generally the modelling is broad, and anatomical details scant. There is some indication of the spinal column and rib-cage on the right rear flank, and there is a large, forking vein on the underbelly (cf. chariot horse, 2). Some features of the anatomy seem dog-like or horse-like rather than lion-like. The position of the male genitals is that of a dog or horse, rather than a lion, and the rear of the body and upper rear legs have much in common structurally with the hind part of the chariot horse, 2.

The tail, which is now mostly missing, was originally S-shaped. It curved out from the body, curled in again between the rear legs, to both of which it was attached for added strength, and then turned outwards again to rest on the base just behind the hindmost rear paw (cf. 418, below). The curve of the tail may derive from Oriental prototypes, but was probably retained here for technical reasons as much as anything.

The lion was carved from a single huge block of marble, the grain of which ran vertically to give extra strength to the legs. There was no support added beneath the belly. Much of the squareness and massiveness of the composition may be caused by the need to give added strength to the statue (cf. the chariot group in this respect).

On the left side of the top of the back of the lion, at a point just to the rear of the last of the double row of locks, there is carved a letter Π, the bars of which measure 6·5 × 5 × 2 cm. The letter is carved so as to be read from the left side of the lion, that is from the back.

From the position of the letter and from the general design, it is clear that this lion, like the others of type I, was intended to be viewed laterally from its right side. Seen from this view, the positions of all four legs and the tail are readily visible, and so too is most of the head, while the letter Π is invisible.

Newton, *HD* 102, 231, 232; *Travels in the Levant*, ii. 109; *MRG* 100; Brunn-Bruckmann, no. 72; Smith, *BM Cat.* 1075; Jeppesen, *Paradeigmata*, 42, fig. 22F; Riemann, P-W, 451–2.

402. Forepart (pl. 37)
BM 1083; *MRG* 102; Reg. 1857.12–20.243.

Probably that described by Newton, *HD* 104, no. 7, as: 'head and shoulders of a lion, well preserved', in which case it was found in the main sculptural deposit in the Imam's field to the north of the north *peribolus* wall.

Dimensions. H. 0·92 m. W. (max.) 0·56 m. L. (max.) 0·61 m. W. at shoulders 0·48 m; of face at eyes 0·335 m; of left eye 4·9 cm.

Marble. White, fine-crystalled.

Missing. All the body behind the shoulders; all four legs; the upper jaw, right cheek and nose; tufts of mane above the forehead. The lower jaw has been broken off, but is rejoined. The condition of what remains is good. Traces of yellow-brown paint are preserved on face and mane.

The turn of the head to the right at 45 degrees shows that the lion is of type I. The treatment of the face and mane is very similar to that of 401, and it may be that the lion is from the same sculptor's hand. The halo of mane that frames the face has an identical arrangement of locks, with fourteen on the right of the face, and eleven on the left.

The rear parts which could theoretically belong to this piece are: 407, 408 or 409.

Newton, *HD* 104, no. 7; *MRG* 102; Smith, *BM Cat.* 1083.

403. Part of head and neck (pl. 37)
MRG 116; Reg. 1857.12–20.244. Numbered 283 (red).

According to the Invoice of cases (283), found near the north-east angle of the *peribolus* wall, in Mehemet Ali's

field. This is confirmed by *HD* 117, where Newton adds that they were 'at a distance of not less than 170 ft from the centre of the Mausoleum. Whether they (*sc.* fragments of lion, and two marbles supposed to be from the pyramid) were hurled to the spot where I found them on the fall of the building, or dragged thither subsequently, cannot now be ascertained.' Cf. *Papers,* ii. 9.

Dimensions. H. 0·64 m. W. of face at eyes 0·32 m; of each eye 4·6 cm.

Marble. White, fine-crystalled; surface weathered.

Preserved is the upper part of the head, to which has been added a piece of mane on the right side. The turn of the head to the animal's right at 45 degrees shows that it was of type I.

Forehead, eyes, mane, and right ear are in good condition. The nose is broken, but the inside of the upper jaw remains, its surface pointed. The cheeks and lower jaw are completely missing. Deep-set eyes and prominent brows give a pathetic expression.

Newton, *Papers,* ii. 9; *HD* 117; *Travels,* ii. 89; *MRG* 116.

404. Forepart (pl. 38)
BM 1077; *MRG* 104; Reg. 1857.12–20.242.

Removed by Newton from the walls of the castle of St Peter at Bodrum.

Dimensions. L. 1·26 m. H. 0·96 m. L. from right shoulder to rear break 0·92 m. W. of body at shoulders 0·50 m; of face at eyes 0·34 m; of each eye 4·6 cm.

Marble. White, fine-crystalled.

Missing. The hindquarters, rear legs, and forelegs, except for the upper stumps.

Condition. The right foreleg has been cut, probably when the lion was built into the castle. The head has been broken off at the neck, but rejoined. There is damage to the tip of the nose and to the left eye. The surface is much weathered because of exposure in the castle.

The lion is of type I, but differs slightly from 401–403 in that the head is turned more sharply to the right, at 90 degrees instead of 45 degrees. There are also differences in treatment of detail compared with 401. The eyes seem less deep-set, and the expression correspondingly less intense. The nostrils are more deeply cut, and the neck is thicker-set, although this may be the result of the sharper turn of the neck. The halo of locks around the

face is also equally divided, with thirteen locks on each side of the head, and the arrangement of the rest of the mane tends to be more subdued. The large vein on the lower right flank also differs from that on 401. Ribs are indicated on the right side of the body, just before the rear break. For another lion of similar style, see 415 below.

Newton, *MRG* 104; Smith, *BM Cat.* 1077; Jeppesen, *Paradeigmata* 42, fig. 22K; Willemsen, *Löwenkopf-Wasserspeier* (1959) 50, pl. 56.2.

405. Forepart and body (pl. 38)
BM 1080; *MRG* 107; Reg. 1857.12–20.241.

The forepart was removed by Newton from the walls of the castle at Bodrum. The body, according to *MRG*, was found in the excavations on the site of the Mausoleum.

Dimensions as reconstructed. L. 1·34 m. L. from shoulder to rear break 1·17 m. H. 1·01 m. W. at top of forelegs (shoulders) 0·47 m; of face at eyes 0·33 m; of each eye 4·9 cm.

Marble. White, fine-crystalled.

Missing. The hindquarters, rear legs, both forelegs from just below the body (the right one cut, cf. 404), the nose and lower jaw.

Condition. The two fragments do not closely adjoin, although they probably belong to the same animal, and there is a large area of plaster restoration between them on each flank.

There is damage to the mane on top of the head and neck, and also to the left ear. The surface of the marble is severely weathered, particularly on the right side.

The lion is of type I, with left foreleg advanced and head turned to the right at 90 degrees. For the sharp turn of the head cf. 404. A peculiarity of this lion is that the head, besides being sharply turned, is also tilted at an angle, so that it has something of a quizzical look. The eyes are deeply set, but the groove in the centre of the forehead is less emphatic than on other lions.

The lower jaw, now missing, was evidently broken and repaired in antiquity. Part of an iron dowel, set in lead, for the re-attachment of the jaw, remains *in situ,* and there is also half of a drill-hole running horizontally to the dowel from the flew at the right corner of the mouth. *Dimensions.* Dowel 1·25 cm diam.; drill-hole 4·3 cm long. If, as seems likely, the drill-hole is a pour-hole for the lead, the repair must have been made before the lion was set upright, probably during the initial carving in the fourth century BC.

The arrangement of the mane is less tousled than on 401, 402, and 404, particularly on the lower part of the shoulders, where the rows of locks are formal and regular. The carving of the individual locks is perhaps a little deeper, but weathering has blurred the sharpness of the edges.

As is usual, there is a double row of locks running along the top of the back. The individual tufts, however, are quite prominent, and differ markedly from the flat-lying locks of 401 and 404. Compared with those lions, too, the body and head seem less massive, and the proportions generally slimmer. In keeping with this, the rib-cage and spinal vertebrae are more prominently marked on both sides of the body, and there is a long vein on the lower right flank (cf. 404). For a lion similar in style, see below, 413.

Newton, *HD*, pl. XV, below, left side (forepart only); *MRG* 107; Smith, *BM Cat.* 1080; Jeppesen, *Paradeigmata*, fig. 31; Willemsen, *Löwenkopf-Wasserspeier* (1959), 50, pl. 56.4.

406. Fragmentary head and neck (pl. 39)
MRG 111, plus other fragments. Reg. 1972.4–10.1.

The largest fragment of head was found, according to *MRG*, on the site of the Mausoleum. A fragment of mane on the lower right side is numbered 80 (red).

It is possible that this lion may be from the deposit in the Imam's field. R. M. Smith's diary records three lions as having been found there: a complete lion (401) on 23 April; a lion's head and neck (402) on 9 May; and, on 27 April, 'a lion's head and some fragments', for which this lion is the likeliest candidate (all the other extant lions' heads can be accounted for).

Dimensions as assembled. H. 0·81 m. L. 0·87 m. W. 0·48 m. W. of face at eyes 0·325 m; of each eye 3·7 cm.

Marble. White, fine-crystalled.

Preserved is a large fragment of the upper head and neck (*MRG* 111), to which numerous small fragments have been added, so as to make up much of the left side of the shoulder and chest, back as far as the tufts of fur at the base of the neck. All the fragments are much mutilated, and in addition there is considerable weathering to the top of the head and neck.

The head is turned sharply to the right at *c.* 90 degrees, showing that the lion is of type I. For the sharp turn of the head, cf. 404–405. Of the face, only the forehead, two eyes, and the roof of the mouth remain. The eyes are unusual on account of their small size (W.

3·7 cm). They are round and pig-like, and widely spaced. The roof of the mouth has been worked with the point.

Although its condition is now very sad, this was once a well-carved lion, the mane being competently handled. There are prominent tufts of mane on top of the back at the base of the neck, as on 405.

Newton, *MRG* 111.

407. Hind part
BM 1086; *MRG* 110; Reg. 1857.12–20.245.

Described in *MRG* as having been found 'on the site of the Mausoleum'. Probably it is one of the 'several hind quarters of lions' mentioned in *HD* 100 as having been found towards the north margin of the Quadrangle.

Dimensions. L. 1·095 m. H. 0·88 m. W. at front break 0·44 m. L. from end of fur on top of back to base of tail 24 cm. H. of body at front break 0·535 m.

Marble. White, fine-crystalled.

The body has been reconstructed from seven fragments, which make up most of the rear part of the animal, from behind the shoulders. Much of the lower right flank is restored in plaster. Two additional fragments have been attached to the right rear leg, extending it down to the hock. The left rear leg is broken just below the body, and the tail is missing, although there are traces on the inside of the right rear leg, showing where it was attached. Traces of yellow-brown paint remain on much of the surface.

The lion is of type I, with right rear leg set back, leg rear leg set forward. The head would have been turned to the right, although there is no way of telling the angle of the turn. On top of the back are the remains of the double row of locks, which lie rather flat. At the point where they terminate, on the left side of the top of the back, there is part of an inscribed letter: Γ, so far as it is preserved (there is a break between fragments here). The vertical bar is 4·3 cm long, the horizontal cross-stroke 2 cm now, probably more originally. It is either a Γ (cf. *HD* 100, which probably refers to this lion), or, perhaps more likely, the remains of a Π. Cf. 401, 410 and 411, which also have this letter.

The foreparts which could theoretically belong are: 402, 403.

Newton, *HD*, pl. XV, below, fifth from left (hindquarters only); *MRG* 110; Smith, *BM Cat.* 1086; Jeppesen, *Paradeigmata*, 42.

408. Hind quarters
MRG 114. Reg. 1857.12–20.246

According to the base on which the lion is mounted it was 'discovered on the site of the Mausoleum'. Probably it is one of the pieces found within the Quadrangle itself (*HD* 100 mentions a fragment from the north margin of the Quadrangle with Λ on its back).

Dimensions. L. 0·59 m. H. 0·66 m. W. 0·50 m. L. from end of mane on top of back to base of tail 25 cm. W. of body at front break 0·41 m. Dimensions of break of tail: H. 11 cm. W. 10 cm.

Marble. White, fine-crystalled.

Reconstructed from several fragments, the largest of which preserves the top of the back, the rump, and the front of the upper right rear leg. To this fragment have been joined: the back of the upper right rear leg, numbered 253.18 (red); the back of the upper left rear leg; two fragments from the left flank, including the bottom of the rib-cage. Still missing are: all the body in front of the pelvic area, the lower rear legs, and the tail.

The lion is of type I, with left leg set forward, right leg set back, and prominent right hip-bone. On top of the back is preserved the end of the two rows of locks of mane. They lie fairly flat, and there is a broad parting. Close to the end of these locks on the left side of the top of the back, there is a letter Λ, carved so as to be read from the back of the animal. The left stroke measures 5·6 cm in length, the right stroke 4·6 cm. It was misread in *MRG* as B (?).

The foreparts which could belong are: 402, 403, or even 404 (?).

Newton, *HD*, pl. XV, below, sixth from left; *MRG* 114; Jeppesen, *Paradeigmata*, fig. 22 I.

409. Body
MRG 112. Reg. 1972.4–10.2.

According to the base on which it is mounted, it was 'discovered on the site of the Mausoleum'. Perhaps from the Quadrangle (cf. *HD* 89, 100).

Dimensions. L. 0·79 m. H. of front break 0·61 m; of rear break 0·42 m. W. of front break 0·44 m.

Marble. White, fine-crystalled.

Two closely adjoining fragments which preserve the body from just behind the forelegs to just in front of the hindquarters. Rather more of the right flank remains than the left. Although all four legs are missing, the prominent right hip-bone might suggest that the right rear leg was set back (cf. 408, above), and therefore that the lion was of type I. This cannot be regarded as certain.

On top of the back is the usual double row of locks, broad at the front, but narrowing considerably towards the rear. The hair lies fairly flat. Although the end of the two rows is preserved, there is no sign of a carved letter on either side of the rump. It may possibly have been worn away by weathering.

Newton, *MRG* 112.

Type II. Head turned to left, right legs forward, left legs back

410. Statue of a lion (pl. 39)
BM 1081; *MRG* 108; Reg. 1857.12–20.248.

According to Newton, *HD* 231, no. 248, found on the north side of the Mausoleum.

Dimensions. L. 1·60 m. H. 0·99 m. W. at shoulder 0·50 m. Fur on top of back stops 33·5 cm in front of tail. H. of body at base of neck 0·69 m. H. of body in front of rear legs 0·42 m. Break of tail: H. 11 cm. W. 15 cm.

Marble. White, fine-crystalled; weathering particularly severe on the left side.

Reconstructed from several fragments. The largest of these are the hindquarters, to which two fragments of the upper left rear leg have been added, and the forepart, to which has been joined a fragment of the upper left foreleg. Hindquarters and forepart adjoin on the right side, but on the left side there is a large gap, which has been restored in plaster.

Missing. The head and upper neck, both forelegs, the right rear leg from just below the body, the left rear leg from below the hock, and the tail.

The lion exemplifies type II; both left legs are set back, both right legs set forward, and the head was turned to the lion's left. Although the head is missing, the line of the neck on the left side would suggest that the turn of the head was not sharp, but was probably *c.* 45 degrees. The arrangement of the mane is rather formal, and the carving of the individual locks somewhat schematic. The locks which run in a double row along the spine are low-lying. For the treatment of the mane, cf. 404 above.

The proportions of the shoulders seem quite massive, but the hindquarters are lithe and fall away more sharply than on other lions, and the whole design seems less square, and generally better conceived. On the

other hand, anatomical details are sparse, there being no indication of the rib-cage on either side. There is, however, a large vein on the lower left flank. On the lowest fragment adjoining the left rear leg, there are traces of the tail, showing that on lions of type II, as on those of type I, the S-shaped tail was attached to the inside of the hind legs.

On top of the back, just to the rear and to the right of the double row of locks, is the letter Π, carved so as to be read from the right side (back) of the lion. The lengths of the strokes are: $7 \cdot 3 \times 5 \cdot 3 \times 2 \cdot 2$ cm. It is certainly *pi* and not *gamma*. Cf. lions 401, 407, and 411.

The modelling of the left side of the hindquarters of this lion is reminiscent of the right side of the hindquarters of 407.

Newton, *HD* 231; *MRG* 108; Smith, *BM Cat.* 1081; Jeppesen, *Paradeigmata*, 42, fig. 22 H.

411. Statue of a lion (pl. 39)
BM 1084; *MRG* 103; Reg. 1857.12–20.249.

According to *HD* 231, found on the north side of the Mausoleum. If this is the lion that was reassembled from the fragments sent to England in cases 75, 100, and 134, as it probably is, then the finding-place can be given more accurately as Mahomet's field, north side of Mausoleum (Invoice of cases, no. 75). Cf. *Papers*, i. 13.

Dimensions. L. (max.) $1 \cdot 57$ m. H. $1 \cdot 24$ m. W. at shoulders $0 \cdot 495$ m. Distance from end of fur on back to base of tail 34 cm. H. of body at base of neck $0 \cdot 65$ m. H. of body in front of rear legs $0 \cdot 40$ m. Break of tail: H. $10 \cdot 5$ cm. W. 13 cm.

Marble. White, fine-crystalled.

Reconstructed from several fragments, including two large pieces of body: (*a*) the hind part, to which have been added the left side of the rump and the base of the tail; (*b*) the forepart, to which have been joined a fragment of neck and mane on the right, the right side of the face and muzzle, a fragment of the upper right foreleg, and three fragments of the left foreleg.

Missing. The upper part of the head and neck, including both eyes and much of the nose; both rear legs; the right foreleg from below the knee; the left foreleg from just above the paw; the tail.

There is considerable weathering on the top of the back and the flanks, but the chest is in very fine condition. Yellow-brown paint remains on the left flank, and particularly in a patch on the right flank.

The lion is of type II, with right foreleg advanced, left foreleg set back, and head turned to the left at 45 degrees. Although all the upper part of the head has been sheared away, the right side of the jaw remains in good condition, and the teeth are well preserved within the mouth. The carving, particularly of the right flew, is harsh and angular. This may be why Newton, *HD* 231, thought the lion seemed in an 'unfinished state'. More likely, however, it is an indication of mechanical workmanship. There is a similar stiffness and formality in the arrangement and execution of the mane. Two rather flat-lying rows of locks run along the top of the back, in the usual fashion. There is some shallow indication of the rib-cage on both sides of the rear flank, and a large vein on each side of the lower belly.

On top of the right side of the rump, carved so as to be read from the back of the lion, is the letter Π, the lengths of the strokes measuring $6 \cdot 3 \times 4 \times 2 \cdot 8$ cm. Cf. 401, 407, and 410.

For the general style, particularly the angularity of the flews, cf. 412 below.

Newton, *HD* 231; *MRG* 103; Smith, *BM Cat.* 1084; Jeppesen, *Paradeigmata*, 42, figs. 22 G, 34.

412. Head and shoulder (pl. 39)
BM 1076; *MRG* 101; Reg. 1857.12–20.252.

Found on the north side of the Mausoleum (*MRG* 101), and probably the 'head of a lion broken off at the shoulder' mentioned by Newton, *HD* 111, as having been found to the north of the north *peribolus* wall in Mahomet's field (to the west of the Imam's field). Cf. case no. 245.

Dimensions. H. $1 \cdot 37$ m. L. $0 \cdot 75$ m. W. at shoulders (as preserved) $0 \cdot 35$ m. W. of face at eyes $0 \cdot 33$ m; of each eye $4 \cdot 1$ cm.

Marble. White, fine-crystalled.

Preserved is the head, chest, and right shoulder, to which a separate fragment of the right foreleg has been added. There is damage to the tip of the nose, and to the front of the lower jaw.

The lion is of type II, with right foreleg advanced, and head turned to the left at 45 degrees. The eyes are deep-set and create a pathetic expression, and there is an emphatic vertical groove in the forehead. Within the mouth, teeth and tongue are carved. The flews at the corner of the mouth are worked in a hard and angular fashion, as on 411. Surrounding the face is a halo of mane, with two unusually prominent tufts in the centre

of the forehead. There are twelve locks on the left side of the head, and fourteen on the right side. From behind this first row of locks the two ears protrude. The remainder of the mane is of the conventional arrangement, the hairs of the locks being quite sharply carved, as on 401–402.

The carving is competent, but rather mechanical. For the angularity of the flews, cf. 411. The style is quite close also to that of 401 and 402.

Newton, *HD* 111, pl. XV, below, first on left; *MRG* 101; Smith, *BM Cat.* 1076; Picard, *Manuel*, iv. 1 (1954), fig. 54; Jeppesen, *Paradeigmata*, 42, fig. 30.

413. Head and shoulders (pl. 39)
BM 1079; *MRG* 106; Reg. 1857.12–20.251.

Removed by Newton from the walls of the castle at Bodrum.

Dimensions. L. 1·01 m. H. 0·91 m. W. at shoulders 0·48 m; of face at eyes 0·305 m; of each eye 4·25 cm.

Marble. White, fine-crystalled.

Reconstructed from two main fragments which are horribly mutilated, particularly the head, which must have been used for target practice, since the surface is pocked with bullet marks. The left foreleg has been cut just below the body, cf. 404, 405. Yellow-brown paint remains on the right flank.

The lion is of type II, with right foreleg advanced, and head turned to the left at 45 degrees. The slender proportions of both body and head, the slightly upward pose and sideways tilt of the head, the deeply carved mane, and, especially, the prominent tufts of the mane on top of the spine, recall very much the style of 405. On that lion, however, the turn of the head was more than 45 degrees, so it is unlikely that they would have formed a pair. On the left lower flank is a large forking vein.

Newton, *MRG* 106; Smith, *BM Cat.* 1079; Jeppesen, *Paradeigmata*, 42, figs. 22 L, 32.

414. Head (pl. 40)
BM 1082; *MRG* 115; Reg. 1857.12–20.253.

Found by Newton built into the stone wall of a field, some way to the north of the north *peribolus* wall (*Papers*, ii. 9; *HD* 116, 231; cf. Invoice of cases, no. 281).

Dimensions. H. 0·58 m. W. 0·42 m. L. 0·36 m. W. of face at eyes 0·335 m; of each eye 4·1 cm.

Marble. White, fine-crystalled.

Preserved is the head and a small part of the mane. The left side of the lower jaw has been broken and rejoined. Enough of the mane survives to show that the head was turned to its left at 45 degrees, and that the lion to which it belonged was therefore of type II.

In style this head differs markedly from the other extant heads. The eyes are round, rather prominent, and are carved without tear-ducts or lids. The vertical groove on the forehead is broad and deep, and the forehead over each eye is very bulbous. The treatment of the nose and nostrils has more in common with the leopards' heads, 371 and 372, than with the other lions' heads. The tongue protrudes from the mouth, to produce a smiling, dog-like expression. This is the only head where this is so, and is perhaps the result of influence from the lion's-head waterspouts. Within the mouth the teeth are very peculiar, being more like those of a horse. At the back on each side there are large molars at top and bottom; then a gap (as if for a bit?); and then a rounded set of teeth at the front of the jaw, flanked by canines at top and bottom. At the corners of the mouth the flews are small and well-rounded, but protrude considerably to either side, almost to the maximum width of the face.

The arrangement of the mane around the head is more lively, the carving deeper and more vigorous, than on other heads. Some of this liveliness is imparted by the transverse curl at the end of each lock. There are only ten locks to the right of the face, and nine to the left. The ears would have been very large, but are now broken.

Newton, *HD* 231, praises the boldness of the carving of this head and reckons it to be the finest of all the lions' heads. While admitting the vigour of the execution, it must be said that the physiognomy is of a very peculiar character, which is inferior to that of the other heads. The predominant horse-like features, especially in the teeth, might suggest a link between this head and the hindquarters 416, below, which are also of a most original, and somewhat horse-like, design. The sculptor was evidently an individualist.

Newton, *Papers*, ii. 9; *HD* 116, 231; *Travels*, ii (1865), pl. 17; *MRG* 115; Smith, *BM Cat.* 1082.

415. Forepart (pl. 40)
BM 1078; *MRG* 105; Reg. 1857.12–20.247.

Removed by Newton from the walls of the castle at Bodrum.

Dimensions. L. 1·46 m. H. 1·06 m. W. at shoulders 0·51 m; of face at eyes 0·325 m; of each eye 4·3 cm.

Marble. White, fine-crystalled.

Missing. The hindquarters from behind the end of the mane on top of the back; both forelegs from just below the body (they have been cut, cf. 404, 405, 413). There is damage to the right ear, to the tip of the lower jaw, and to the forehead.

Body and head are considerably weathered.

The lion is of type II, with right foreleg advanced, left foreleg set back, and head turned at 45 degrees to the left. The eyes are quite deeply set, nostrils heavily drilled, the carving of the mane somewhat mechanical, but competent. The two rows of locks along the spine are broadly spreading, but lie rather flat. A neat parting which separates them runs up the neck to the crown of the head, where it meets the vertical groove in the forehead. On either side of the lower abdomen is a long vein.

On the top right side of the back, close to the rear break, is carved the letter Λ, each stroke of which measures 4·75 cm. Weathering has made the grooves faint, but they show clearly in a side light. For another *lambda* lion, see above, 408.

In style this lion is very similar to 404 of type I, and is very likely from the hand of the same sculptor. The similarity extends to the proportions of body, shape of head, treatment of eyes, nostrils and lower jaw, arrangement and execution of mane, and veins on lower abdomen. It is unlikely, however, that the two lions formed a pair, since the head of 404 is turned at 90 degrees.

Newton, *MRG* 105; Brunn-Bruckmann, no. 73; Smith, *BM Cat.* 1078; Jeppesen, *Paradeigmata*, 42.

416. Hind part (pl. 40)
BM 1085; *MRG* 109; Reg. 1857.12–20.250.

According to *HD* 232 (no. 250), found on the north side of the Mausoleum. The finding-place is more closely located by the invoice for case 76, which must refer to this piece, and which reads: 'Hind half of Lion, marked Δ, north side of Mausoleum, Omer's field.' Omer's field was at the east end of the north side, and also produced fragment 29.

Dimensions. L. 1·015 m. H. 0·915 m. W. at front break 0·40 m. H. of body in front of rear legs 0·44 m. Fur on back stops 13·5 cm before base of tail.

Marble. White, fine-crystalled.

Preserved is most of the body from behind the forelegs, the right hindleg to above the hock, and the left hindleg to below the hock. A small fragment, initialled C.T.N. (red), has been joined to the lower right hindleg. The tail is missing. The condition of what remains is good.

The positions of the hind legs, right advanced, left set back, show that the lion was of type II, and that its head would have been turned to the left. The proportions of body and hind quarters are massive and square, and are very reminiscent of the hind part of the chariot horse, 2. There is a marked hollow behind the rib-cage on the right flank.

Most unusual is the carving of the mane on top of the back, for there are three rows of tufts instead of the usual two. The tufts are neatly regimented and fairly prominent, and extend much nearer towards the base of the tail than on other lions. Unusual also are the groups of locks which spread out across the top of the back from the spinal mane, close to the front break. The fur on the backs of the upper legs and on the underside of the body, close to the rear legs, is more carefully and more vigorously carved than on most of the other lions. The variation in the lie of the tufts is reminiscent of the mane of 414. On the lower belly are large forked veins.

On the right side of the back, beyond the end of the mane, is inscribed a letter Λ. The upright strokes measure 6·15 cm and 5·4 cm, while the cross stroke, which joins the lower point of the left-hand stroke, is 5 cm long, as preserved. It does not appear to join the right-hand stroke, but the marble here is slightly damaged. Newton first read this letter as a *delta* (Invoice of cases), later as an *alpha* in *MRG*, while in *HD* 231 note q, he takes it to be a *lambda*. While it may be tempting from the point of uniformity to regard it as a *lambda*, because of the existence of other *lambda* lions (cf. Jeppesen, *Paradeigmata*, 43), the cross stroke cannot be disregarded, nor can it be dismissed as a scratch, since it is quite straight, is V-shaped in section (that is, it was cut by chisel), and it adjoins the lower point of the left-hand upright. In all probability the letter should be read as an *alpha* (cf. above, pp. 32–3, 62).

In the broken base of the tail is the bottom of a dowel hole, measuring 1 cm H. × 2 cm W. × 5 cm D, in which traces of the dowel remain. Since on no other lions were the tails carved separately, this is likely to be an ancient repair (cf. Adam, *TGS* 66).

Colour remained on the body when the lion was found. According to *HD* 232, 'the inside of the thigh, which had been protected by the weather, still retained the colour with which it had been painted, which was a dun red'. Traces of this colour (yellow-ochre rather than dun red) still remain on the inside of the upper right thigh.

The individual character of the carving of this lion, particularly apparent in the unusual and vigorous treatment of the mane, makes an association with the equally individual head, 414, likely. If the two fragments are not from the same lion (both are of type II), they are probably from the hand of the same sculptor. The horse-like features which both fragments display suggest the sculptor was more at home in carving horses; and the similarity of this hind part with the rear of the colossal chariot horse, 2, does not make it seem too far-fetched to attribute this fragment, 416, the head, 414, the hind part of the chariot horse, 2, and perhaps even the forepart, 1, to the hand of a single sculptor: one of the two who carved the chariot group.

Newton, *HD* 231–2; pl. XV, below, second from right; *MRG* 109; Smith, *BM Cat.* 1085; Jeppesen, *Paradeigmata*, 43, figs. 22 J, 33.

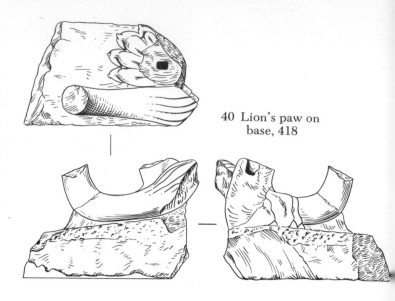

40 Lion's paw on base, 418

FRAGMENTS OF PAWS

Square bases

418. Right rear paw and tail on base

(pl. 40; fig. 40)

MRG 133. Reg. 1857.12–20.255. Numbered 64 (red).

Finding-place not known.

Dimensions. L. 0·46 m. W. 0·28 m. H. (max.) 0·32 m. Th. of base varies from 12–16 cm. Max. W. of paw 16·5 cm.

Preserved is the paw of a right rear leg and the end of a curving lion's tail, set on a large fragment of base. A separate fragment of tail has been rejoined. The original edge of the base remains on three sides, being broken only in front of the paw. Behind the paw the edge is rounded and rather irregular, and is chamfered in profile. The two edges either side of the paw are vertical. Surface, edges and underside have been worked with the point. On each of the two long edges there is a horizontal ridge, *c.* 9·5–10·5 cm above the bottom of the base, which must indicate the amount let into a plinth. Above this line the marble is considerably weathered, below it much less so.

The carving of the paw is broad but competent. Each of the four toes has its claw indicated. From the profile of the paw and the angle of the part of the lower leg which remains, and from the position of the paw relative to the tail, it is clear that the leg to which the paw belonged was set back. Since it is a right leg, the lion to which it belonged must have been of type I, with its head turned to the right.

417. Hind quarters

MRG 113; Reg. 1857.12–20.254.

According to the base on which it is mounted, it was 'discovered on the site of the Mausoleum'. Perhaps it is one of the fragments of hind quarters found in the south-west corner (*HD* 89, 99), or on the north margin, of the Quadrangle (*HD* 100). Cf. case no. 104.

Dimensions. L. 0·57 m. H. 0·49 m. W. of front break 0·42 m. Fur on top of back stops 26 cm before base of tail. Break of tail 11 × 11 cm.

Marble. White, fine-crystalled.

Preserved is only the upper part of the hind quarters. Both rear legs are broken off level with the lower part of the body. The surface is much weathered.

The left hind leg appears to have been set back, the right advanced, so that the lion would have been of type II. These leg positions are confirmed by the more prominent pelvis on the left side.

On top of the back the end of the double row of tufts remains. There appear to be traces of a letter on the left side of the top of the back: >. Each stroke measures 5·2 cm. Newton, *MRG,* read it confidently as A, but it looks more like a Λ set sideways, or else part of a Z, the latter being perhaps more likely. But there is an added difficulty in that the letter, however it is read, is on the wrong side of the back for a lion of type II.

Newton, *MRG* 113; Jeppesen, *Paradeigmata*, 43–44.

In the broken upper surface of the paw, there is a rectangular cutting for a dowel, measuring 2·5 × 3 × 14·5 cm deep, as preserved. This cutting is certainly ancient, since it is mentioned by Newton in *MRG*, and it presumably served to attach the leg to the paw. Since no other paws or lower legs have dowel holes for separate attachment, it is probable that this paw was accidently broken in the process of carving, and had to be repaired with a dowel.

The hairs on the end of the tail are carved only in very summary fashion.

Newton, *MRG* 133.

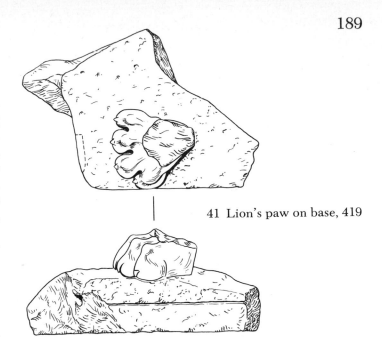

41 Lion's paw on base, 419

419. Left paw on base (fig. 41)
Reg. 1972.4–10.3.

No other number, but clearly from the Mausoleum stylistically.

Dimensions. L. 0·615 m. W. 0·425 m. H. 0·275 m. Th. of base varies from 10–17·5 cm. Max. W. of paw 21·5 cm.

Preserved is a paw, set on an irregular, coarsely pointed base, a substantial amount of which remains. On one side is a long straight edge (40 cm long), close to which the paw has been set, angled slightly outwards. On this edge is a horizontal groove, 7·5 cm from the bottom of the base, indicating the amount let into a plinth. The marble above this line is considerably more weathered than that below it. Another edge is preserved about 8 cm in front of the paw, roughly at right angles to the long straight edge. Within this edge is a recess, 9·5 cm W. × 3 cm H. × 2·5 cm D., which runs horizontally at the same level as the groove on the adjacent edge. This recess may have provided purchase for levering the lion's base into position on the building. Beyond this front edge, and to the right of the paw, the base continues forward in fragmentary condition for a short way.

It is not clear whether this is a forepaw or hind paw. If, as is more likely, it is a forepaw, then it must have belonged to a lion of type II, since the forward continuation of the base must have picked up with the base around a right forepaw that would have been set forward (see fig. 6). If it were a hind paw, then it would have belonged to a lion of type I, since it must have been set forward, and there is no tail present as on 418. Interpretation as a hind paw would imply that the base had at least one indentation in the side, and was possibly of H-clamp shape. Since there is otherwise no evidence for a lion's base of this shape, a forepaw is perhaps more likely.

420. Forepaw on base (pl. 41; fig. 42)
Reg. 1868.4–5.31.

From Biliotti's excavations at Bodrum. Lions' paws are recorded in his diary as having been found on 3 May 1865 (built into a garden wall of Mehmeda's property, south of the Mausoleum Quadrangle) and on 2 August 1865 (two paws, built into the wall of a house on Hagi Imam's property, east of the Mausoleum Quadrangle).

Dimensions. L. 0·37 m. W. 0·255 m. H. 0·26 m. Th. of base, 15 cm below paw; 12 cm behind paw. Max. W. of paw 21 cm.

The front upper edge of the base is damaged.

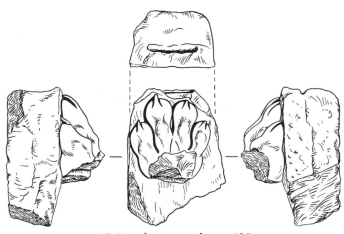

42 Lion's paw on base, 420

Preserved is the front part of a paw set on a large piece of base. The four toes are plump and well splayed, and the claws are large and sharply carved. Probably this is a forepaw. Three original edges of the base remain, in front of the paw, to the left, and to the right, all straight and running close to the limits of the paw. In the right edge there is a groove, 9 cm above the bottom of the base, indicating the amount let into a plinth, and in the front edge, at the same level, there is a recess, 13 cm W. × 2 cm H. × 2 cm D., probably for levering the lion into position (cf. 419). The finish of the base is rough.

For the individual base around the paw, cf. 418.

421. Left forepaw (fig. 43)
MRG 117. Reg. 1972.4–10.4. Numbered 128 (red).

Finding-place not known.

Dimensions. L. 0·29 m. W. 0·165 m. H. 0·205 m. Th. of base, as preserved, 8 cm.

Preserved is the left side of a paw, resting on a base of which parts of the front and left edges remain, running close to the paw. The edges are straight, set at right angles to one another, and their faces are smoothly dressed (unlike most of the other bases). Traces of a recess remain on the left edge.

Newton, *MRG* 117.

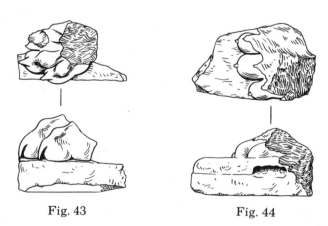

Fig. 43 Fig. 44

422. Left paw (fig. 44)
Reg. 1972.4–10.5. Numbered 64 (red), 281 (black).
Finding-place not known.

Dimensions. L. 0·32 m. W. 0·205 m. H. 0·18 m. Th. of base 9·5–10·5 cm.

Preserved are the front parts of the three left-most toes of a lion's paw, probably a left one, set on a piece of

base, of which the straight left edge remains. In this edge there is a horizontal ridge, 6 cm from the bottom, indicating the amount let into a plinth, and, at the same level below the paw, a recess, 8·5 cm L. × 3 cm H. × 2 cm D. Surface, edge, and underside of the base are neatly carved with the point. The large amount of base remaining in front of the paw may suggest that this is a rear paw.

423. Fragment of paw (fig. 45)
Reg. 1972.4–10.6. Numbered B.66.1 (black).

For the paws found by Biliotti, see 420 above.

Dimensions. L. 0·155 m. W. 0·20 m. H. 0·155 m. Th. of base 6·5–7·5 cm.

The surface of the marble is severely weathered. There remain the tips of the three left-most toes of a paw, resting on a small fragment of base, of which some of the left and front edges are preserved. These edges are straight, and meet roughly at a right angle.

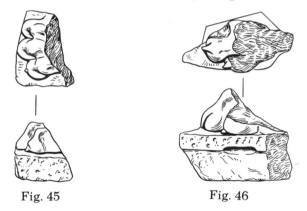

Fig. 45 Fig. 46

424. Fragment of paw (fig. 46)
MRG 118. Reg. 1972.4–10.7. Numbered 156 (red), 287 (black).

Finding-place not known.

Dimensions. L. 0·29 m. W. 0·135 m. H. 0·24 m. Th. of base 12–13 cm.

Preserved is a fragment of base with the two left toes and part of the third toe of a lion's paw, much damaged. The straight left edge of the base remains, with a horizontal groove, 7·5 cm above the bottom, and, at the same level, a recess, 9 cm L. × 2 cm H. × 3 cm D. Cf. 419–422. A small fragment of the front edge of the base may also be preserved.

Newton, *MRG* 118.

Rounded bases

425. Right paw on base (fig. 47)
MRG 122. Reg. 1972.4–10.8. Numbered 282 (black).

Finding-place not known.

Dimensions. L. 0·255 m. W. 0·24 m. H. 0·30 m. Th. of base 15–16·5 cm. Max. W. of paw 20 cm.

A well-preserved right paw, set on a thick base, with a rounded front edge, running close to the claws, and a straight right edge. The front edge is strongly undercut or chamfered (cf. 418). For the thick base, cf. 418–420. That it is a right paw is shown by the thumb claw which remains on the left side, just below the break.

Newton, *MRG* 122.

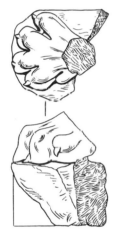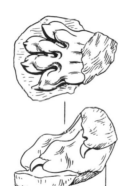

Fig. 47 Fig. 48

426. Right paw on base (pl. 41; fig. 48)
MRG 131. Reg. 1972.4–10.9. Numbered 290 (black).

Found by Newton on the south side of the Mausoleum Quadrangle (*HD* 129, no. 3). Cf. Invoice of cases, no. 238.

Dimensions. L. 0·27 m. W. 0·225 m. H. 0·215 m. Th. of base 3–4·5 cm. Max. W. of paw 18 cm.

A well preserved right paw, broken off at the fetlock, set on a base with a rounded front edge. The paw, which is shown to be a right one by the thumb claw on the left side, is lean and sinewy in treatment, and is unusual in that its left-most claw is fully advanced from its sheath in menacing fashion: so much so that the claw is carved completely in the round. Another unusual feature is the very thin base on which the paw is set. On the left side of the paw, the curving front edge gives way to a more irregular edge, which looks as if it may have been recut in antiquity, perhaps to fit the lion better into the place reserved for it. The surface and edges of the base have been roughly worked with the point, but are now much weathered.

This paw has a touch of individuality to it, similar to that of the head 414, and the hind part 416. In view of the finding-place on the south side, it is perhaps to be assigned to a different workshop from the other paws, the majority of which must come from the north side of the Mausoleum.

Although Newton described it as a hind paw (*MRG* 131), the menacing way in which the left claw is bared might rather suggest a forepaw.

Newton, *HD* 129, no. 3; 231–2; *MRG* 131.

427. Paw on base (fig. 49)
Reg. 1972.4–10.10. Numbered B.66.1 (black).

For paws found by Biliotti, see 420 above.

Dimensions. L. 0·25 m. W. 0·155 m. H. 0·205 m. Th. of base, as preserved, 9·5 cm.

The tips of the two left-most toes are missing. Otherwise the paw is in quite good condition. The toes are carved in a spare, sinewy fashion that recalls 426, but the base of this lion was obviously thicker than that of 426. Parts of the right, front, and left edges remain. The right edge is straight, the front edge curves closely round the paw, undercutting the toes in places, while the part of the left edge which remains, curves only slightly, and had an irregular recess in the face, little of which now remains.

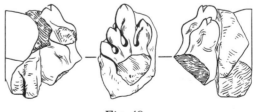

Fig. 49

428. Fragment of paw on base (fig. 50)
MRG 124. Reg. 1972.4–10.11. Numbered 199 (red).

Perhaps from the Imam's field: the inventory for case 199 dittoes 198, which contained fragments from there.

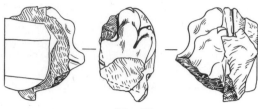

Fig. 50

Dimensions. L. 0·25 m. W. 0·155 m. H. 0·215 m. Th. of base, as preserved, 8·5–9 cm.

Two toes and part of a third from the right side of a lion's paw, set on a base with a rounded edge preserved on the right side, running close to the paw. The two toes which remain have a well-preserved surface that retains traces of the rasp. In the edge of the base there is a horizontal drilled groove, *c.* 1·5–2 cm below the top, and part of a deeper recess, the bottom of which comes 5·5 cm below the top.

Newton, *MRG* 124.

429. Fragment of paw on base (fig. 51)
Reg. 1972.4–10.12. Numbered 254.9 (red).

No precise finding-place is given, but most of the other fragments in case 254 seem to have come from the south side of the Quadrangle.

Dimensions. L. 0·105 m. W. 0·21 m. H. 0·225 m. Th. of base 13 cm.

Three toes and part of the fourth of a lion's paw, set on a base with a rounded edge that runs close to the paw. The edge of the base is vertical for the upper 3 cm, but below this point it is stepped inwards by 1·5 cm and then tapers inwards slightly. The upper 3 cm may represent the amount exposed above the plinth which received the paw.

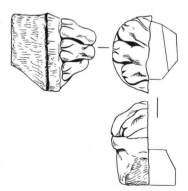

Fig. 51

430. Fragment of paw on base (fig. 52)
MRG 136. Reg. 1972.4–10.13. Numbered 109 (red), 267 (black).

Finding-place not known.

Dimensions. L. 0·13 m. W. 0·205 m. H. 0·215 m. Th. of base 12 cm.

Preserved are the foreparts of the three right-most toes of a lion's paw, set on a base with a rounded edge, running *c.* 2·5 cm in front of the claws of the toes. In the edge of the base there is a roughly drilled line, *c.* 5·5–6·5 cm above the bottom. The surface and edge of the base was finished with the point, but is now considerably weathered.

Newton, *MRG* 136.

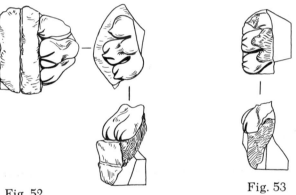

Fig. 52 Fig. 53

431. Fragment of paw on base (fig. 53)
MRG 123. Reg. 1972.4–10.14. Numbered 253 (red), 280 (black).

Finding-place not known.

Dimensions. L. 0·105 m. W. 0·175 m. H. 0·18 m. Th. of base as preserved 9·5 cm.

There remain the tips of the three right-most toes, and part of the fourth, of a lion's paw, set on a base with a curving edge that runs close to the paw. In the edge of the base there is a horizontal line *c.* 3·5 cm below the top, beneath which the edge tapers inwards quite sharply. For this style of base cf. 425 and 429.

Newton, *MRG* 123.

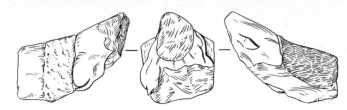

Fig. 56

432. Fragment of paw on base (fig. 54)

Reg. 1972.4–10.15. Numbered 189 (red), 268 (black).

According to the Invoice of cases, found in the Imam's field on the north side of the north *peribolus* wall. Cf. 439.

Dimensions. L. 0·14 m. W. 0·15 m. H. 0·145 m. Th. of base, as preserved, 7·5 cm.

A small fragment from the left side of a paw, preserving the tip of the left toe and part of the toe next to it. The paw was set on a base of which some of the left edge remains, curving closely around the paw. The upper 4–5 cm is more weathered than the rest, and probably indicates the amount exposed to the elements.

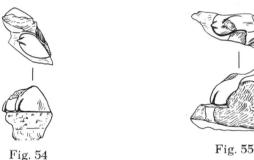

Fig. 54 Fig. 55

433. Fragment of paw on base (fig. 55)

Reg. 1972.4–10.16. Numbered 132 (red), 279 (black).

Finding-place not known.

Dimensions. L. 0·215 m. W. 0·10 m. H. 0·185 m. Th. of base as preserved 6 cm.

Preserved are parts of the two left-most toes of a lion's paw, set on a fragment of base which appears to have had a curving left edge. About 3·5–4 cm below the top of the edge there is a deeply cut recess that runs the full length of the base, as preserved.

434. Right paw on base (fig. 56)

Reg. 1972.4–10.17. Numbered 208 (red), 265 (black).

According to the Invoice for case 208, from either the north or the east side of the Mausoleum.

Dimensions. L. 0·245 m. W. 0·20 m. H. 0·295 m. Th. of base: 14·5–15 cm.

Preserved is the back of a paw, and a considerable amount of the lower leg, including the thumb claw on the left side, which shows the paw to be a right one. Of the front of the paw only the right toe remains. The paw rests on a thick base, the original edge of which remains only on the right side, where it curves closely round the paw, slightly undercutting the right toe. The upper 8 cm of the edge is severely weathered, suggesting that it was only the lower 7 cm which was let into a plinth. The paw is probably, though not certainly, a forepaw. From the angle of the lower leg, it looks as if the paw would have been set forward, in which case it would have belonged to a lion of type II.

Paws on irregular bases

435. Left rear paw on base

(fig. 57)
Reg. 1972.4–10.18. Numbered 283 (red), 284 (black).

Found in Mehemet Ali's field at the north-east angle of the *peribolus* wall (Invoice for case 283; *HD* 117).

Dimensions. L. 0·425 m. W. 0·33 m. H. 0·25 m. Th. of base: 10–12·5 cm. Max. W. of paw 18 cm.

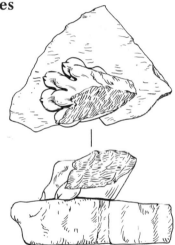

Fig. 57

Preserved is most of a left paw, set on a large fragment of base, the original left edge of which remains. The steep angle of inclination of the toes and the line of the back of the paw suggest that it is a rear paw. The left edge of the base is remarkable for the extreme irregularity of its line. It undercuts the paw below the left toe, but projects beyond the line of the paw in front of it and behind it. The reason for this irregularity is not apparent. It can hardly have been for fitting the lion in place, for the edge is fully weathered from top to bottom, a fact which suggests that the base did not fit flush into the plinth which received it. The top of the base is also much weathered, but the underside is well preserved and exhibits neat and even pointwork.

Apart from the irregularity of the left edge, the fragment is closely comparable with 419, and is quite probably from a lion of type I.

Newton, *HD* 117.

436. Fragment of right forepaw on base

(fig. 58)

MRG 126. Reg. 1972.4–10.19. Numbered 79 (red), 288 (black).

Finding-place not known.

Dimensions. L. 0·135 m. W. 0·27 m. H. 0·205 m. Th. of base: 11–12·5 cm. Max. W. of paw, as preserved, 21 cm.

The tips of three toes and part of the fourth remain, set on a fragment of base, the irregular edge of which is preserved on the right and in front of the paw. The paw is unusual in having curious fur pads carved immediately above the claws of the two inner toes, the fur indicated by means of light incision. In the edge of the base, in front of the paw, there is a recess 4 cm below the top, 9 cm long, as preserved, × 3 cm H. × 1 cm D. The surface of the base has been roughly picked, but is now much weathered.

The splayed toes suggest this is a forepaw, the line of the edge of the base that it is a right forepaw, and possibly one which was set back, i.e. from a lion of type I.

Newton, *MRG* 126.

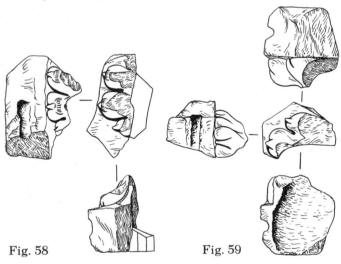

Fig. 58 Fig. 59

437. Fragment of paw on base

(fig. 59)

Reg. 1972.4–10.20. Numbered 128 (red), 286 (black).

Finding-place not known.

Dimensions. L. 0·195 m. W. 0·15 m. H. 0·21 m. Th. of base: 13 cm.

The foreparts of two toes of a lion's paw remain, set on a thick base, of which some of the front edge is preserved.

In this edge is a horizontal recess, 4 cm below the top, 9 cm W. as preserved, 3–4 cm H. and 2·5 cm D. The treatment of the base is similar to that of 436, but this paw does not have fur pads above the claws. The surface is much weathered, the underside of the base dressed with the point.

438. Fragment of paw on base

(fig. 60)

Reg. 1972.4–10.21. Numbered 271 (black).

Finding-place not known.

Dimensions. L. 0·27 m. W. 0·45 m. H. 0·16 m. Th. of base: 8–15·5 cm.

A large piece of base on one side of which is set part of the right paw of a lion. Of the paw only the tips of the two left-most toes remain. The right side and all the upper part of the paw are missing. Immediately in front of the paw, a small section of the edge of the base is preserved, its surface showing marks of the claw chisel. The base is unusual, because although it is 15·5 cm thick on the left break, it is only *c.* 8 cm thick below the paw, which accordingly is set on a considerable slant. Cf. 419, which is also set aslant, but not so much as this.

The surface of the base is coarsely pointed, but the underside is neatly dressed with the claw chisel.

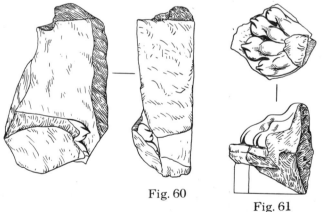

Fig. 60

Fig. 61

439. Fragment of paw on base

(fig. 61)

Reg. 1972.4–10.22. Numbered 189 (red), 269 (black).

According to the Invoice of cases, found in the Imam's field on the north side of the north *peribolus* wall. Cf. 432, above.

Dimensions. L. 0·225 m. W. 0·20 m. H. 0·24 m. Th. of base: 12·5–13 cm. Max. W. of paw: 18·5 cm.

Preserved is most of a paw, set on a thick base. Some of an irregular edge remains in front of the left side of the paw, also a small part of the underside.

440. Paw on base (fig. 62)
Reg. 1972.4–10.23.
Numbered 79 (red), 272 (black).
Finding-place not known. Cf. 436
for invoice number.

Dimensions. L. 0·26 m. W. 0·22 m.
H. 0·19 m. Th. of base: 9·5–10 cm.
Max. W. of paw: 14·5 cm.

Fig. 62

The paw is completely preserved, except for slight damage to the upper parts of the two middle toes. It is carved in the same style as the other paws, but is somewhat smaller in size: 2 cm narrower than the next smallest, 418, and 7 cm narrower than the largest, 419. For this reason, one wonders if it did not perhaps belong to a lion from a hunting group, rather than to one of the architectural lions. On the other hand, the break above the paw, *c.* 10 cm × 10 cm, is probably large enough for the leg of an architectural lion, and the base is certainly thick enough for this.

Two original edges of the base remain. There is a straight edge immediately to the left of the paw, and an irregular edge some 8 cm to the right of it, running at an angle to the left edge. The surface and edges of the base were roughly pointed, and are much weathered.

Small fragments of paws

441. Reg. 1972.4–10.24. Numbered 117 (red), 289 (black).

Dimensions. L. 0·16 m. W. 0·15 m. H. 0·115 m.

A fragment of paw with one well-preserved toe, and parts of two others. Some of the base remains.

442. Reg. 1972.4–10.25. Numbered 253 (red), 276 (black).

Dimensions. L. 0·125 m. W. 0·12 m. H. 0·10 m.

The forepart of two toes and a fragment of a third, broken from a base.

443. Reg. 1972.4–10.26. Numbered 79 (red), 277 (black).

Dimensions. L. 0·145 m. W. 0·115 m. H. 0·145 m.

Parts of three toes of a paw, broken from a base.

444. Reg. 1972.4–10.27. Numbered 63 (red), 278 (black).

Dimensions. L. 0·17 m. W. 0·09 m. H. 0·13 m.

Two toes of a lion's paw, broken from a base. Very worn.

445. Reg. 1972.4–10.28. Numbered 75 (red), 265 (black).

Dimensions. L 0·095 m. W. 0·095 n. H. 0·10 m.

Parts of three toes of a lion's paw, broken from a base.

446. Reg. 1972.4–10.29. Numbered 253.20 (red), 283 (black).

Dimensions. L. 0·15 m. W. 0·10 m. H. 0·12 m.

Parts of two toes of a lion's paw.

447. Reg. 1972.4–10.30. Numbered 176 (red), 275 (black).

Found in the Imam's field on the north side of the north *peribolus* wall.

Dimensions. L. 0·065 m. W. 0·04 m. H. 0·09 m.

The tip of a toe with a claw, broken from a base.

448. Reg. 1972.4–10.31. Numbered 67 (red), 273 (black).

Dimensions. L. 0·09 m. W. 0·06 m. H. 0·075 m.

One toe from a lion's paw.

449. Reg. 1972.4–10.32. No other number.
Dimensions. L. 0·085 m. W. 0·06 m. H. 0·05 m.

Part of a toe from a lion's paw.

450. Reg. 1972.4–10.33. Numbered 92 (red).
Dimensions. L. 0·045 m. W. 0·10 m. H. 0·095 m.

A very worn fragment that may be the front part of two toes of a lion's paw.

FRAGMENTS OF LEGS

Hind legs

451. Left hind leg (pl. 41)
MRG 134. Reg. 1972.4–10.34. Numbered B.66.1 (black).

Possibly the 'lion's hinder thigh' found by Biliotti on 2 March 1865 in Hadji Nalban's house near the south-east corner of the Quadrangle.

Dimensions. H. 0·665 m. W. at top (side view) 0·33 m. Th. at top 0·225 m.

Two adjoining fragments which make up most of a left hind leg from just below the body to a point just above the paw. A fracture on the surface of the right side above the stifle shows where the curving tail was attached, proving that this leg was set back, and therefore that the lion to which it belonged was of type II.

Newton, *MRG* 134.

452. Reg. 1972.4–10.35. Numbered 207 (red).

According to the invoice of cases, found in the Imam's field, north side.

Dimensions. H. 0·28 m. W. (side) 0·30 m. Th. 0·20 m.

A fragment from the central part of a left hind leg, including the knee. Fur remains at the upper part of the back.

453. Reg. 1972.4–10.36. Numbered 207 (red), 303 (black).

Found in the Imam's field, north side. Cf. 452, above.

Dimensions. H. 0·22 m. W. as preserved 0·20 m. Th. 0·25 m.

A fragment of an upper hind leg, possibly a left one.

454. Reg. 1972.4–10.37. C.T.N. (red), 317 (black).
Dimensions. H. 0·31 m. W. 0·29 m. Th. 0·215 m.

A fragment from the middle of a left hind leg. Coarse rasp marks remain on the inner right side.

455. Reg. 1972.4–10.38. Numbered 209 (red), 303 (black).

According to the invoice of cases, from either the north or east side of the Mausoleum.

Dimensions. H. 0·28 m. W. 0·26 m. Th. 0·19 m.

A fragment from just below the knee of a right hind leg.

456. Reg. 1972.4–10.39. Numbered 199 (red), .83 (black).

Probably from the Imam's field, north side (case 199 dittoes 198, which contained fragments from there).

Dimensions. H. 0·27 m. W. 0·28 m. Th. 0·21 m.

A fragment from the upper hind leg of a lion, broken on the inside and behind. Probably a right leg.

457. Reg. 1972.4–10.40. Numbered 157 (red).
Dimensions. H. 0·16 m. W. 0·25 m. Th. 0·18 m.
A section through a hind leg, about half-way up. Fur remains at the back.

458. Reg. 1972.4–10.41. Numbered 261 (red).

Case 261 contained fragments from under Mehemet Ali's house at the north-east angle of the *peribolus* wall, and Newton, *HD* 117, mentions that among them was a lion's leg. This is probably the fragment in question.

Dimensions. H. 0·21 m. W. 0·20 m. Th. 0·14 m.

A fragment from the rear part of a lion's leg, probably a left hind leg. There is fur at the back.

459. Reg. 1972.4–10.42. Numbered 158 (red).
Dimensions. H. 0·22 m. W. 0·23 m. Th. 0·15 m.

A fragment from the middle part of a hind leg, probably a left one. There are traces of fur on the upper part of the back.

460. Reg. 1972.4–10.43. Numbered 182 (red).
Dimensions. H. 0·26 m. W. 0·25 m. Th. 0·145 m.

A fragment of a hind leg. Yellow-brown paint remains on the surface.

461. Reg. 1972.4–10.54. Numbered 17. (red), 300 (black).

Dimensions. H. 0·26 m. W. 0·20 m. Th. 0·13 m.

A fragment of a lower left hind leg, the surface much weathered on the left, outer side.

462. Reg. 1972.4–10.44. Numbered B.66.1 (black).

From Biliotti's excavations.

Dimensions. H. 0·245 m. W. 0·20 m. Th. 0·15 m.

A fragment of a lower hind leg, including the attachment for the tail. If, as seems likely, it was a right leg, then the lion to which it belonged would have been of type I.

463. Reg. 1972.4–10.45. Numbered 253 (red), 295 (black).

Dimensions. H. 0·23 m. W. 0·16 m. Th. 0·19 m.

A fragment of hind leg, including some of the attachment for the tail.

464. Reg. 1972.4–10.46. Numbered 189 (red), 309 (black).

From the Imam's field, north side.

Dimensions. H. 0·215 m. W. 0·17 m. Th. 0·12 m.

A fragment probably from a lower hind leg of a lion, one side of which has been much less well finished than the other.

465. Reg. 1972.4–10.47. C.T.N. (red), 335 (black).

Dimensions. H. 0·14 m. W.·0·17 m. Th. 0·14 m.

Part of the lower leg of a lion. The strong curve suggests it is from a hind leg.

Upper forelegs

466. Reg. 1972.4–10.48. Numbered 174 (red), 338 (black). (pl. 41)

From the Imam's field, north side.

Dimensions. H. 0·28 m. W. 0·23 m. Th. 0·20 m.

An upper right foreleg and a small part of the lower body, in very fine condition. There is fur at the back of the leg. Clear traces of the rasp remain on the inner surface, while the outer right side is smoothly finished.

There appear also to be traces of brownish paint remaining.

467. Reg. 1972.4–10.49. Numbered 109 (red), 323 (black).

Dimensions. H. 0·355 m. W. 0·18 m. Th. 0·17 m.

Part of an upper right foreleg, with fur at the back. There are rasp marks on the inner, left side.

468. Reg. 1972.4–10.50. Numbered 21 (red), 342 (black)

Dimensions. H. 0·32 m. W. 0·17 m. Th. 0·145 m.

Part of an upper foreleg, with fur at the back. The treatment is extremely sinewy, and there are veins marked on the surface. Probably a right leg.

469. Reg. 1972.4–10.51. Numbered 193 (red), 315 (black).

Dimensions. H. 0·31 m. W. 0·24 m. Th. 0·15 m.

Part of an upper left foreleg, with fur at the back. From the angularity of the bone at the top of the leg, it looks as if this leg was set forward, in which case it would have belonged to a lion of type I.

470. Reg. 1972.4–10.52. Initialled C.T.N. (red).

Dimensions. H. 0·305 m. W. 0·22 m. Th. 0·19 m.

Part of an upper left foreleg, with fur at the back. The outer left surface is weathered, while traces of the rasp remain on the inside of the leg.

471. Reg. 1972.4–10.53. Initialled C.T.N. (red).

Dimensions. H. 0·335 m. W. 0·19 m. Th. 0·15 m.

Part of a left foreleg, with fur at the back.

472. Reg. 1972.4–10.92. Numbered 200 (red) + C.T.N. (red).

From the Imam's field, north side.

Dimensions. H. 0·285 m. W. 0·17 m. Th. 0·18 m.

Two closely adjoining fragments of an upper foreleg, from close to the join with the body. Probably a left leg.

473. Reg. 1972.4–10.55. Numbered 3 . . (black).

Dimensions. H. 0·24 m. W. 0·19 m. Th. 0·175 m.

Part of an upper foreleg, with fur indicated at the back. To judge from the weathering of the left side, and the rasp marks on the right side, it is probably from a left leg.

474. Reg. 1972.4–10.56. Numbered 161 or 191 (red), 313 (black).

In either case, from the Imam's field, north side.

Dimensions. H. 0·205 m. W. 0·205 m. Th. 0·17 m.

Part of an upper foreleg.

475. Reg. 1972.4–10.57. Numbered 120 (red).

Dimensions. H. 0·285 m. W. 0·14 m. Th. 0·135 m.

Part of the foreleg of a lion.

476. Reg. 1972.4–10.58. Numbered 127 (red), 321 (black).

Dimensions. H. 0·25 m. W. 0·155 m. Th. 0·14 m.

The middle part of a foreleg, with fur indicated at the back. The treatment is muscular, and prominent veins are marked.

477. Reg. 1972.4–10.59. Numbered B.66.1 (black).

From Biliotti's excavations.

Dimensions. H. 0·195 m. W. 0·125 m. Th. 0·107 m.

Part of the foreleg of a lion. Veins are prominently marked.

Lower forelegs

478. Lower left foreleg (pl. 42)
Reg. 1972.4–10.60. Numbered 111 (red), 293 (black).

Dimensions. H. 0·29 m. W. (side) 0·20 m. Th. 0·145 m.

A fragment of a lower left foreleg, broken off just above the paw. Traces of fur remain at the back, just below the upper break.

479. Reg. 1972.4–10.61. Numbered 117 (red), 311 (black).

Dimensions. H. 0·145 m. W. 0·16 m. Th. 0·13 m.

A fragment of a lower left foreleg, broken off just above the paw. The thumb claw which remains on the right side shows it to be a left leg. There is severe weathering on the front right side.

480. Reg. 1972.4–10.62. Numbered 117 (red), 299 (black).

Dimensions. H. 0·16 m. W. 0·115 m. Th. 0·13 m.

A fragment of a foreleg, broken off just above the paw.

481. Reg. 1972.4–10.63. Numbered 117 (red), 292 (black).

Dimensions. H. 0·17 m. W. 0·145 m. Th. 0·12 m.

A fragment probably from the lower foreleg of a lion.

482. Reg. 1972.4–10.64. Initialled C.T.N. (red).

Dimensions. H. 0·16 m. W. 0·135 m. Th. 0·13 m.

A fragment from the lower foreleg of a lion, broken off just above the paw. On one side is a thumb claw. Cf. above, 479.

483. Reg. 1972.4–10.65. C.T.N. (red), 305 (black).

Dimensions. H. 0·12 m. W. 0·10 m. Th. 0·08 m.

A fragment from the back of a lower foreleg of a lion.

484. Reg. 1972.4–10.66. Numbered 200 (red), 296 (black).

From the Imam's field, north side.

Dimensions. H. 0·19 m. W. 0·12 m. Th. 0·13 m.

Part of a lower foreleg, in good condition. Clear traces of the rasp remain on the surface.

485. Reg. 1972.4–10.67. Numbered 253.20 (red), 337 (black).

Dimensions. H. 0·165 m. W. 0·09 m. Th. 0·115 m.

A fragment from the back of a lower foreleg.

486. Reg. 1972.4–10.68. Numbered 254.9 (red), 332 (black).

Dimensions. H. 0·25 m. W. 0·15 m. Th. 0·12 m.

Part of a lower left foreleg, from just above the paw.

487. Reg. 1972.4–10.69. Initialled C.T.N. (red), numbered 297 (black).

Dimensions. H. 0·20 m. W. 0·14 m. Th. 0·08 m.

A fragment from the foreleg of a lion.

488. Reg. 1972.4–10.70. Numbered 61 (red), 291 (black).

Dimensions. H. 0·20 m. W. 0·14 m. Th. 0·13 m.

A fragment from the lower part of a lion's foreleg.

Other fragments of legs

489. Reg. 1972.4–10.71. Numbered 111 (red), 316 (black).

Dimensions. H. 0·22 m. W. 0·215 m. Th. 0·13 m.

A fragment of a sharply bent lion's leg, perhaps a hind leg.

490. Reg. 1972.4–10.72. Numbered 254.9 (red).

Dimensions. H. 0·28 m. W. 0·17 m. Th. 0·115 m.

A fragment of a sharply bent lion's leg, perhaps a lower hind leg.

491. Reg. 1972.4–10.73. Initialled C.T.N. (red), numbered 326 (black).

Dimensions. H. 0·22 m. W. 0·14 m. Th. 0·12 m.

A fragment of the lower leg of a lion, possibly a foreleg.

492. Reg. 1972.4–10.74. Initialled C.T.N. (red).

Dimensions. H. 0·21 m. W. 0·14 m. Th. 0·155 m.

Part of a sharply bent lion's leg, perhaps from a hind leg.

493. Reg. 1972.4–10.75. Numbered 125 (red).

Dimensions. H. 0·21 m. W. 0·175 m. Th. 0·12 m.

A fragment of a lion's leg, probably a hind leg.

494. Reg. 1972.4–10.76. Initialled C.T.N. (red).

Dimensions. H. 0·17 m. W. 0·17 m. Th. 0·13 m.

A fragment from the lower leg of a lion.

495. Reg. 1972.4–10.77. Numbered 253.9 (red).

Dimensions. H. 0·225 m. W. 0·15 m. Th. 0·105 m.

A fragment of the lower leg of a lion, perhaps a hind leg.

496. Reg. 1972.4–10.78. Numbered 195 (red), 325 (black).

This is perhaps the fragment described in the invoice for case 195 as: 'piece of Lion, from road north of north-east corner of Mausoleum'.

Dimensions. H. 0·15 m. W. 0·14 m. Th. 0·14 m.

Part of the lower foreleg of a lion, perhaps a left leg.

497. Reg. 1972.4–10.79. No other number.

Dimensions. H. 0·155 m. W. 0·133 m. Th. 0·107 m.

Part of the foreleg of a lion, with veins carved on the left side.

498. Reg. 1972.4–10.80. Numbered 112 (red), 330 (black).

Dimensions. H. 0·205 m. W. 0·15 m. Th. 0·105 m.

Part of the lower leg of a lion, with veins indicated on the surface.

499. Reg. 1972.4–10.81. Numbered 79 (red), 318 (black).

Dimensions. H. 0·29 m. W. 0·135 m. Th. 0·055 m.

A fragment of a lion's leg, probably a foreleg. Veins or sinews are indicated on the surface.

500. Reg. 1972.4–10.82. Numbered 85 (red), 270 (black).

Dimensions. H. 0·175 m. W. 0·19 m. Th. 0·065 m.

A fragment of a lion's leg, perhaps a hind leg.

501. Reg. 1972.4–10.83. Numbered 121 (red).
Dimensions. H. 0·13 m. W. 0·08 m. Th. 0·035 m.

A fragment of a lion's leg, with fur indicated at the back.

502. Reg. 1972.4–10.84. Numbered 71 (red).
Dimensions. H. 0·115 m. W. 0·074 m. Th. 0·05 m.

A fragment of the back of a lion's leg, with fur indicated.

503. Reg. 1972.4–10.85. Numbered 117 (red).
Dimensions. H. 0·175 m. W. 0·11 m. Th. 0·17 m.

A fragment of lion's leg, with sinewy surface.

504. Reg. 1972.4–10.86. Numbered 117 (red).
Dimensions. H. 0·19 m. W. 0·15 m. Th. 0·085 m.

A fragment of a lion's leg, perhaps a foreleg.

505. Reg. 1972.4–10.87. Numbered 117 (red).
Dimensions. H. 0·175 m. W. 0·08 m. Th. 0·135 m.

A fragment probably from a lion's leg.

506. Reg. 1972.4–10.88. Numbered 117 (red), 294 (black).
Dimensions. H. 0·14 m. W. 0·11 m. Th. 0·11 m.

A fragment of an animal's leg, in all probability from a lion.

507. Reg. 1972.4–10.89. Numbered B.66.1 (black).
Dimensions. H. 0·105 m. W. 0·18 m. Th. 0·10 m.

A fragment of lion's leg, with fur at the back.

508. Reg. 1972.4–10.90. No other number.
Dimensions. H. 0·125 m. W. 0·105 m. Th. 0·12 m.

A fragment of a lion's leg, with fur at the back.

509. Reg. 1972.4–10.91. Numbered 78 (red), 319 (black).
Dimensions. H. 0·26 m. W. 0·20 m. Th. 0·06 m.

A fragment sliced from the outer part of a lion's leg.

510. Reg. 1972.4–10.93. Initialled C.T.N. (red).
Dimensions. H. 0·27 m. W. 0·16 m. Th. 0·11 m.

A fragment perhaps from a lion's leg.

511. Reg. 1972.4–10.95. No other number.
Dimensions. H. 0·24 m. W. 0·18 m. Th. 0·14 m.

A fragment of an animal's limb, probably from the hind leg of a lion.

512. Reg. 1972.4–10.96. Numbered 195 (red).

Perhaps from the road north of the north-east corner of the Mausoleum. Cf. 496, above.
Dimensions. H. 0·20 m. W. 0·22 m. Th. 0·17 m.

A fragment of a lion's leg, with sinewy surface.

513. Reg. 1972. 4–10.97. Numbered B.66.1 (black).
Dimensions. H. 0·12 m. W. 0·06 m. Th. 0·065 m.

A small fragment of a lion's leg, with traces of fur.

FRAGMENTS OF BODIES

514. Reg. 1972.4–10.98. No other number.
Dimensions. H. 0·60 m. L. 0·26 m. Th. 0·33 m.

A large fragment from the right side of a lion, at a point just behind the right shoulder. There is almost a full section through the body, although none of the surface of the left flank remains. On top there is a broad area of mane, where the two rows of locks along the spine widen into the mane that covers the neck.

515. Reg. 1972.4–10.99. Initialled C.T.N. (red).
Dimensions. H. 0·55 m. L. 0·21 m. Th. 0·33 m.

Part of the right side of a lion's body. Some of the locks of mane are preserved on top of the back.

516. Reg. 1972.4–10.100. Numbered B.66.1 (black).
Dimensions. H. 0·55 m. L. 0·25 m. Th. 0·30 m.

A large fragment probably from the body of a lion. Some of the surface of the underbelly remains. Condition generally poor.

517. Reg. 1972.4–10.101. Numbered 253.15 (red).
Dimensions. H. 0·54 m. L. 0·30 m. Th. 0·21 m.

Part of the flank of a lion.

518. Reg. 1972.4–10.102. Initialled C.T.N. (red).
Dimensions. H. 0·415 m. L. 0·32 m. Th. 0·17 m.

A fragment from the right shoulder of a lion, including the upper part of the right foreleg, and, on the upper break, a few locks of mane. The surface of the marble is severely weathered.

519. Reg. 1972.4–10.103. Numbered 253 (red).
Dimensions. H. 0·37 m. L. 0·37 m. Th. 0·19 m.

A fragment from the right shoulder of a lion, including the top of the right foreleg.

520. Reg. 1972.4–10.104. Numbered 140 (red).
Dimensions. H. 0·23 m. L. 0·29 m. Th. 0·15 m.

A fragment probably from the upper leg of a lion where it adjoins the body. The carving of the surface of leg and body is rather rough.

521. Reg. 1972.4–10.105. Numbered B.66.1 (black)
Dimensions. H. 0·46 m. L. 0·31 m. Th. 0·21 m.

Part of the left flank and underside of the body of a lion, from just in front of the left hind leg, the topmost part of which remains. Rasp marks remain on the underside, but the side is badly weathered into holes.

522. Reg. 1972.4–10.106. C.T.N. (red), 324 (black).
Dimensions. H. 0·40 m. L. 0·15 m. Th. 0·33 m.

A fragment from the hindquarters of a lion, including the upper part of a left hind leg, on the back of which there are indications of fur, and, on the right break, part of the genitals.

523. Reg. 1972.4–10.107. Initialled C.T.N. (red).
Dimensions. H. 0·26 m. W. 0·16 m. Th. 0·10 m.

A fragment probably from the hind quarters of a lion. There is a ridge covered in fur, as if from the back of a hindleg, and there are more traces of fur on the left break.

524. Reg. 1972.4–10.108. Numbered B.66.1 (black).
Dimensions. H. 0·44 m. L. 0·30 m. Th. 0·17 m.

A fragment from the rear flank of a lion. Three ribs are indicated through the flesh.

525. Reg. 1972.4–10.109. Numbered 190 (red).
From the Imam's field, north side.
Dimensions. H. 0·323 m. L. 0·22 m. Th. 0·06 m.

Part of the curving flank of a lion. The surface is much weathered.

526. Reg. 1972.4–10.110. Initialled C.T.N. (red).
Dimensions. H. 0·29 m. L. 0·18 m. Th. 0·05 m.

A fragment with undulating surface from a lion's body, probably from the region of the rear flank.

527. Reg. 1972.4–10.111. Initialled C.T.N. (red).
Dimensions. H. 0·205 m. L. 0·215 m. Th. 0·10 m.

A fragment of a lion's body with a slightly concave surface, probably from the rear flank between hind legs and rib-cage.

528. Reg. 1972.4–10.112. Numbered 262 (red).
Dimensions. H. 0·17 m. L. 0·17 m. Th. 0·055 m.

A curving fragment probably from a lion's body. The surface is weathered into holes along the grain of the marble.

529. Reg. 1972.4–10.126. Initialled C.T.N. (red), numbered 366? (black).
Dimensions. H. 0·25 m. L. 0·14 m. Th. 0·165 m.

A fragment with curving outer surface, probably from the body of a lion, weathered into holes along the grain of the marble.

530. Reg. 1972.4–10.113. Numbered B.66.1 (black).
Dimensions. H. 0·28 m. L. 0·15 m. Th. 0·07 m.

Two adjoining fragments from the body of a lion.

531. Reg. 1972.4–10.114. Numbered B.66.1 (black).
Dimensions. H. 0·28 m. L. 0·085 m. Th. 0·12 m.

A fragment probably from a lion's body.

532. Reg. 1972.4–10.115. Numbered B.66.1 (black).
Dimensions. H. 0·23 m. L. 0·08 m. Th. 0·11 m.

A curving fragment probably from a lion's body.

533. Reg. 1972.4–10.116. Numbered 123 (red), 347 (black).
Dimensions. H. 0·165 m. L. 0·15 m. Th. 0·075 m.

A curving fragment probably from a lion's body.

534. Reg. 1972.4–10.117. Numbered B.66.3 (black).
Dimensions. H. 0·15 m. L. 0·075 m. Th. 0·07 m.

A small fragment probably from a lion's body.

535. Reg. 1972.4–10.118. Numbered B.66.1 (black).
Dimensions. H. 0·155 m. L. 0·09 m. Th. 0·06 m.

A fragment probably from the body of a lion.

536. Reg. 1972.4–10.119. Numbered B.66.1 (black).
Dimensions. H. 0·235 m. L. 0·155 m. Th. 0·10 m.

A fragment probably from the body of a lion.

537. Reg. 1972.4–10.120. Numbered B.66.1 (black).
Dimensions. H. 0·17 m. L. 0·12 m. Th. 0·05 m.

A fragment probably from the body of a lion.

538. Reg. 1972.4–10.121. Numbered B.66.1 (black).
Dimensions. H. 0·16 m. L. 0·14 m. Th. 0·045 m.

A rounded fragment probably from the body of a lion.

539. Reg. 1972.4–10.122. Numbered B.66.1 (black).
Dimensions. H. 0·23 m. L. 0·17 m. Th. 0·23 m.

A fragment on which there remains a small part of a rounded surface, probably from the body of a lion.

540. Reg. 1972.4–10.123. No other number.
Dimensions. H. 0·305 m. W. 0·16 m. L. 0·11 m.

A fragment of a lion's body with schematically carved locks of mane near one break, and traces of a limb near another. Probably from the underside between the legs.

541. Reg. 1972.4–10.124. Numbered B.66.1 (black).
Dimensions. H. 0·32 m. W. 0·32 m. Th. 0·16 m.

Part of the shoulder of a lion. On the upper break is a single lock of the mane.

542. Reg. 1972.4–10.125. Numbered B.66.1 (black).
Dimensions. H. 0·16 m. W. 0·105 m. Th. 0·045 m.

A fragment of a lion, on one edge of which there remain slight traces of fur.

FRAGMENTS OF MANES

543. Reg. 1972.4–11.1. Numbered 168 (red). (pl. 42)
Dimensions. H. 0·40 m. W. 0·36 m. Th. (L.) 0·10 m.

A fragment from the chest of a lion, below the throat and above the forelegs, on which a considerable amount of mane is preserved, running down to a point.

544. Reg. 1972.4–11.2. Numbered 160 (red).
Dimensions. H. 0·32 m. W. 0·25 m. Th. (L.) 0·125 m.

Several locks of mane from the chest of a lion, just below the throat.

545. Reg. 1972.4–11.3. Numbered 262 (red).
Dimensions. H. 0·17 m. W. 0·11 m. Th. 0·075 m.

A curving fragment from a lion's body, on one edge of which there are the ends of locks of mane.

546. Reg. 1972.4–11.4. Numbered 256 (red).
Dimensions. H. 0·15 m. W. 0·20 m. Th. 0·07 m.

A fragment with straggling locks of mane, probably from the lowest part of the chest between the forelegs.

547. Reg. 1972.4–11.5. Numbered 124 (red).
Dimensions. H. 0·36 m. L. 0·29 m. Th. 0·24 m.

A fragment of mane, probably from the region of the right shoulder.

548. Reg. 1972.4–11.6. Numbered 125 (red).
Dimensions. H. 0·42 m. W. 0·33 m. Th. (L.) 0·18 m.

On the small area of original surface which remains, there are locks of mane from the lower part of the neck.

549. Reg. 1972.4–11.7. Numbered 107 (red).
Dimensions. H. 0·28 m. W. 0·11 m. Th. 0·17 m.

A fragment on which are several locks of mane.

550. Reg. 1972.4–11.8. Initialled C.T.N. (red).
Dimensions. H. 0·315 m. W. 0·115 m. Th. 0·10 m.

Three closely adjoining fragments of mane.

551. Reg. 1972.4–11.9. Initialled C.T.N. (red), numbered 308 (black).
Dimensions. H. 0·22 m. W. 0·115 m. Th. 0·117 m.

A fragment on which are several locks of mane.

552. Reg. 1972.4–11.10. Numbered B.66.1 (black).
Perhaps from Hadji Nalban's house, to the west of the Quadrangle of the Mausoleum (cf. Biliotti's diary, 6 March 1865).
Dimensions. H. 0·22 m. W. 0·28 m. Th. 0·43 m.

Two closely adjoining fragments from the neck of a lion. The surface is exceedingly worn, but locks of mane are visible on it.

553. Reg. 1972.4–11.11. Numbered B.66.1 (black). Cf. 552 for possible finding-place.
Dimensions. H. 0·215 m. W. 0·085 m. Th. 0·095 m.

Two closely adjoining fragments of lion's mane.

554. Reg. 1972.4–11.12. Numbered 150 (red).
Case 150 contained the lower part of 'Artemisia', from the Imam's field, north side.
Dimensions. H. 0·195 m. W. 0·125 m. Th. 0·075 m.

A fragment on which there are two large locks of mane.

555. Reg. 1972.4–11.13. Initialled C.T.N. (red).
Dimensions. H. 0·197 m. W. 0·093 m. Th. 0·08 m.

A fragment on which there are several locks of lion's mane.

556. Reg. 1972.4–11.14. Numbered 83 (red), 307 (black).
Dimensions. H. 0·213 m. W. 0·075 m. Th. 0·103 m.

A fragment of lion's mane, in extremely poor condition.

557. Reg. 1972.4–11.15. Numbered B.66.1 (black).
Cf. 552 for possible finding-place.
Dimensions. H. 0·11 m. W. 0·125 m. Th. 0·045 m.

Two adjoining fragments of lion's mane.

558. Reg. 1972.4–11.16. Numbered 86 or 98 (red).
Dimensions. H. 0·165 m. W. 0·11 m. Th. 0·05 m.

A fragment on which there are several locks of lion's mane.

559. Reg. 1972.4–11.17. Numbered 79 (red).
Dimensions. H. 0·165 m. W. 0·085 m. Th. 0·05 m.

A fragment on which there are several locks of lion's mane.

560. Reg. 1972.4–11.18. Numbered 253 (red).
Dimensions. H. 0·14 m. W. 0·12 m. Th. 0·047 m.

A fragment of lion's mane.

561. Reg. 1972.4–11.19. Numbered 76 (red).
Dimensions. H. 0·176 m. W. 0·055 m. Th. 0·09 m.

A fragment with two locks of a lion's mane.

562. Reg. 1972.4–11.20. Numbered 189 (red).

From the Imam's field, north side.

Dimensions. H. 0·26 m. W. 0·21 m. Th. 0·10 m.

A fragment of a lion, on which only a small area of the surface remains, including a lock of mane.

563. Reg. 1972.4–11.21. Numbered 73 (red), 379 (black).

Dimensions. H. 0·165 m. W. 0·115 m. Th. 0·053 m.

A fragment with two locks of a lion's mane.

564. Reg. 1972.4–11.22. Numbered 79 (red), 362 (black).

Dimensions. H. 0·105 m. W. 0·13 m. Th. 0·05 m.

A fragment on which are two locks of a lion's mane.

565. Reg. 1972.4–11.23. Numbered 261 (red).

Case 261 contained fragments 'chiefly from the north side'.

Dimensions. H. 0·13 m. W. 0·08 m. Th. 0·055 m.

A fragment of lion's mane.

566. Reg. 1972.4–11.24. Numbered 264 (red).

Dimensions. H. 0·09 m. W. 0·07 m. Th. 0·04 m.

A fragment with a single lock of lion's mane.

567. Reg. 1972.4–11.25. Numbered B.66.1 (black).

Cf. 552 for possible finding-place.

Dimensions. H. 0·045 m. W. 0·07 m. Th. 0·185 m.

On the small area of original surface which is preserved there is a single lock of a lion's mane.

568. Reg. 1972.4–11.26. Numbered 152 (red).

Dimensions. H. 0·145 m. W. 0·276 m. Th. 0·09 m.

A fragment of mane from the forehead of a lion.

569. Reg. 1972.4–11.27. No other number.

Dimensions. H. 0·105 m. W. 0·095 m. Th. 0·06 m.

A lock of mane, carved in the round, from the top of a lion's forehead.

570. Reg. 1972.4–11.28. Initialled C.T.N. (red), numbered 380 (black).

Dimensions. II. 0·11 m. W. 0·10 m. Th. 0·26 m.

A fragment with only a small area of the original surface preserved, on which there is a single lock of lion's mane.

571. Reg. 1972.4–11.29. Initialled C.T.N. (red), numbered 314 (black).

Dimensions. H. 0·175 m. L. 0·33 m. Th. 0·16 m.

A fragment of a lion's mane.

572. Reg. 1972.4–11.30. Numbered B.66.1 (black).

Dimensions. H. 0·115 m. W. 0·075 m. Th. 0·04 m.

A fragment probably from a lion's mane.

573. Reg. 1972.4–4.86. Numbered B.66.1 (black).

Cf. 552 for possible finding-place.

Dimensions. H. 0·095 m. W. 0·085 m. Th. 0·035 m.

A fragment of lion's mane.

574. Reg. 1972.4–11.31. No other number.

Dimensions. H. 0·145 m. W. 0·18 m. Th. 0·06 m.

Four closely adjoining fragments from the body and mane of a lion. The surface is much weathered.

575. Reg. 1972.4–11.32. No other number.

Dimensions. H. 0·18 m. W. 0·135 m. Th. 0·065 m.

A fragment preserving some of the chest and mane of a lion.

FRAGMENT OF HEAD

576. Lower jaw of a lion
Reg. 1972.4–11.34. Numbered B.66.1 (black).

Possibly one of the 'two pieces from lower jaw of lion' found by Biliotti on 1 March 1865 when demolishing the Vakuf's house, near the south-west corner of the Mausoleum.

Dimensions. L. 0·105 m. H. 0·11 m. W. 0·13 m.

Preserved is most of the lower jaw of a lion, including the teeth on the right-hand side, and the rounded tongue which has a groove carved down the middle of it. Some

of the front and left underside of the jaw has been broken away.

This fragment was previously mounted on the same base as the horse's upper jaw, *MRG* 38a, fragment 35, above, and erroneously interpreted as the lower jaw of a horse. The extant lions' heads to which it could conceivably have belonged are 403 or 406.

Newton, *MRG* 38a; Smith, *BM Cat.* 1046, 1.

FRAGMENTS OF TAILS

577. Tip of tail on base (pl. 42)
Reg. 1972.4–11.35. Numbered 253 (red).

Dimensions. L. 0·14 m. W. 0·29 m. H. 0·145 m. Th. of base 9·5 cm.

A fragment of base on which remains the tip of a feline tail, the hairs of which are indicated by shallow, chiselled grooves. Unlike the ends of other lions' tails, which are raised clear from the ground (cf. 418 above, 578 below), this tip rests flat upon the ground. An irregular edge of the base is preserved to the left of and behind the tail, with a horizontal groove cut in it, as on some of the bases below lions' paws. The surface of the base is roughly finished with the point.

578. Reg. 1972.4–11.36. Numbered 253.9 (red).

The Invoice for case 253.9 reads 'indid.', referring to the previous entry (253.8), which came from 'Mahomet's Field, Mausoleum'. It is probable, although not certain, that this tail and the following which are numbered 253.9 also came from Mahomet's field, to the north of the north *peribolus* wall, opposite the north-west corner of the Mausoleum. (Cf. 30; and p. 7, above.)

Dimensions. H. as restored (incl. base) 0·40 m. L. 0·27 m. W. 0·10 m.

Reconstructed from two fragments which do not closely adjoin, and which probably do not belong together, one being the tip of a tail set on a portion of base, the other the lower curving part of a tail. The tip of the tail is raised from the ground (cf. 418). In the rear edge of the base which is preserved, there is a horizontal recess *c.* 3 cm below the top, as on other lions' bases.

579. Two fragments of tail (pl. 42)
Reg. 1972.4–11.37. Numbered 253.9 (red).

Dimensions. H. 0·40 m. Diam. varying between 7 and 7·5 cm.

Two adjoining fragments of lion's tail, probably from the upper part. The outer surfaces of both fragments are considerably weathered.

580. Reg. 1972.4–11.38. Numbered 253.9 (red).
Dimensions. H. 0·355 m. Diam. 7 × 8 cm (cross-section oval).

Two closely adjoining fragments of lion's tail.

581. Reg. 1972.4–11.39. Numbered 253.9 (red).
Dimensions. H. 0·265 m. Diam. 7 × 8 cm.

A single large fragment of lion's tail.

582. Reg. 1972.4–11.40. Numbered 253.9 (red).
Dimensions. H. 0·245 m. Diam. 7 × 8·5 cm.

A sharply curving fragment, probably from the lower part of a lion's tail. The outer surface is severely weathered.

583. Reg. 1972.4–11.41. Numbered 253.9 (red).
Dimensions. H. 0·21 m. Diam. 6·5 × 8 cm.

A fragment of lion's tail.

584. Reg. 1972.4–11.42. Numbered 253.9 (red).
Dimensions. H. 0·195 m. Diam. 7 × 7·8 cm.

Surface much weathered.

585. Reg. 1972.4–11.43. Numbered 253.9 (red).
Dimensions. H. 0·195 m. Diam. 8 × 8·5 cm.

586. Reg. 1972.4–11.44. Numbered 253.9 (red).
Dimensions. H. 0·18 m. Diam. 8 cm.

587. Reg. 1972.4–11.45. Numbered 253.9 (red). *Dimensions.* H. (L.) 0·145 m. Diam. 8 × 8·5 cm.

A fragment perhaps from near the base of the tail.

588. Reg. 1972.4–11.46. Numbered 253.9 (red). *Dimensions.* H. 0·135 m. Diam. 7 × 7·7 cm.

589. Reg. 1972.4–11.47. Numbered 253.9 (red). *Dimensions.* H. 0·12 m. Diam. 7·3 × 8 cm.

590. Reg. 1972.4–11.48. Numbered 253.9 (red). *Dimensions.* H. 0·11 m. Diam. 6·5 × 6·7 cm.

The surface is much pitted through weathering.

591. Reg. 1972.4–11.49. Numbered 8 (red). *Dimensions.* H. 0·105 m. Diam. (upper) 6·7 × 7 cm; (lower) 5·5 × 6·7 cm.

The fragment tapers slightly, and its diameter is a little on the small side compared with other tails, but it is not necessarily to be excluded on these grounds. The surface is severely weathered.

592. Reg. 1972.4–11.50. Numbered 43 (red). *Dimensions.* H. 0·125 m. Diam. 6·5 × 7·5 cm.

593. Reg. 1972.4–11.51. Numbered 48 (red). *Dimensions.* H. 0·14 m. Diam. 7 cm.

The outer surface is slightly broken.

594. Two fragments of tail (pl. 42)
Reg. 1972.4–11.52. Numbered 61 (red) + 186 (red).

The fragment numbered 186 was found in the Imam's field, north side.
Dimensions. H. 0·325 m. Diam. 6·2 × 7·2 cm.

Two adjoining fragments of lion's tail. Both inner and outer surfaces are pitted by weathering.

595. Reg. 1972.4–11.53. Numbered 61 (red). *Dimensions.* H. 0·065 m. Diam. 6·9 cm.

A small fragment of tail, of which only half the thickness is preserved.

596. Reg. 1972.4–11.54. Numbered 64 (red). *Dimensions.* H. 0·12 m. Diam. 7·6 × 7·8 cm.

Sent in the same case as the hind paw and tail, 418.

597. Reg. 1972.4–11.55. Numbered 64 (red). Cf. 596. *Dimensions.* H. 0·12 m. Diam. 7 × 8 cm.

598. Reg. 1972.4–11.56. Numbered 64 (red). Cf. 595–6. *Dimensions.* H. 0·125 m. Max. diam. 8·7 cm.

The outer part of a curving lion's tail, probably from close to the body, on account of the thickness.

599. Reg. 1972.4–11.58. Numbered 68 (or 89) (red). *Dimensions.* H. 0·13 m. Diam. 7 cm.

600. Reg. 1972.4–11.59. Numbered 68 or 89 (red). *Dimensions.* H. 0·093 m. Diam. 6·1 × 6·3 cm.

The diameter is a little on the small side for the architectural lions.

601. Reg. 1972.4–11.61. Numbered 69 (red). *Dimensions.* H. 0·145 m. Diam. 7 cm.

602. Reg. 1972.4–11.62. Numbered 73 (red). *Dimensions.* 0·135 m. Diam. 6·5 × 7 cm.

603. Reg. 1972.4–11.63. Numbered 79 (red). *Dimensions.* H. 0·11 m. Diam. 6·1 × 7·1 cm.

There is a slight ridge on the inner surface.

604. Reg. 1972.4–11.64. Numbered 80 (red).
Dimensions. H. (L.) 0·10 m. Diam. 6·7 × 7·8 cm.

A curving fragment of tail with a protrusion on one side where the tail was attached to a rear leg.

605. Reg. 1972. 4–11.65. Numbered 82 (red).
Dimensions. H. 0·09 m. Diam. 7 cm.

Half only of a short length of tail.

606. Reg. 1972.4–11.66. Numbered 83 (red).
Dimensions. H. 0·125 m. Diam. 7·9 cm.

Half only of a curving portion of tail.

607. Reg. 1972.4–11.67. Numbered 86 or 98 (red).
Dimensions. H. (L.) 0·10 m. Diam. 7 × 7·6 cm.

At one end is a protrusion where the tail was attached to a rear leg.

608. Reg. 1972.4–11.68. Numbered 90 (red).
Dimensions. H. 0·105 m. Diam. 6·5 × 7·8 cm.

609. Reg. 1972.4–11.69. Numbered 95 (red) + 164 (red).
Dimensions. H. 0·41 m. Diam. 7 × 8 cm.

Two adjoining fragments of lion's tail.

610. Reg. 1972.4–11.70. Numbered 110 (red).
Dimensions. H. (L.) 0·11 m. Diam. 7·5 cm.

A strongly curving fragment of tail, perhaps from between the legs.

611. Reg. 1972.4–11.71. Numbered 111 (red).
Dimensions. H. 0·082 m. Diam. 7 cm.

612. Reg. 1972.4–11.72. Numbered 111 (red).
Dimensions. H. (L.) 0·12 m. Diam. 7·1 × 7·3 cm.

At one end is a protrusion where the tail was attached to a rear leg. Cf. 604, 607.

613. Reg. 1972.4–11.73. Numbered 117 (red), 242 (black).
Dimensions. H. 0·16 m. Diam. (upper) 13·8 × 12·2 cm; (lower) 11 × 9·7 cm.

A fragment of a huge tail. It almost seems too large for the architectural lions, but could possibly have come from the very top, close to the body. From the number in black, Newton appears to have considered it to be a human arm or leg, but the curve is too regular for this.

614. Reg. 1972.4–11.74. Numbered 117 (red).
Dimensions. H. (L.) 0·185 m. W. 0·115 m. Diam. of tail 7 × 8 cm.

Part of a straight length of tail with a protrusion on one side showing where it was attached to a hindleg.

615. Reg. 1972.4–11.75. Numbered 175 (red).
From the Imam's field, north side.
Dimensions. H. 0·09 m. Diam. 8·5 cm.

616. Reg. 1972.4–11.76. Numbered 190 (red).
From the Imam's field, north side.
Dimensions. H. 0·25 m. W. 0·14 m. Th. 0·08 m. Diam. of tail 7 cm.

Part of a lion's tail resting on a fragment of base. Some of the underside of the base remains.

617. Reg. 1972.4–11.77. Numbered 195 (red).
Perhaps from north side (case 195 contained fragments from there).
Dimensions. H. 0·18 m. Diam. 6·5 cm.

618. Reg. 1972.4–11.78. Numbered 195 (red).
Dimensions. H. 0·17 m. Diam. 6·5 × 7·5 cm.

619. Reg. 1972.4–11.79. Numbered 195 (red).
Dimensions. H. 0·155 m. Diam. 7 × 7·5 cm.

The surface is much pitted by weathering.

620. Reg. 1972.4–11.80. Numbered 195 (red).
Dimensions. H. 0·14 m. Diam. 7 × 7·7 cm.

621. Reg. 1972.4–11.81. Numbered 195 (red).
Dimensions. H. 0·13 m. Diam. 6·8 × 7·5 cm.

The outer surface is severely weathered.

622. Reg. 1972.4–11.82. Numbered 195 (red).
Dimensions. H. (L.) 0·11 m. Diam. 6·5 × 7·8 cm.

At one end is a protrusion where the tail was attached to a rear leg. The exposed side is severely weathered.

623. Reg. 1972.4–11.83. Numbered 195 (red).
Dimensions. H. 0·105 m. Diam. 6·5 × 8·4 cm.

There is a bulge at one end, perhaps where the tail widened to adjoin the body (or a hindleg).

624. Reg. 1972.4–11.84. Numbered 195 (red).
Dimensions. H. 0·07 m. Diam. 6·2 × 7·4 cm.

The outer surface is severely weathered.

625. Reg. 1972.4–11.85. Numbered 198 (red).
From the Imam's field, north side.
Dimensions. H. 0·14 m. Diam. 6·3 × 7 cm.

The surface is severely weathered.

626. Reg. 1972.4–11.86. Numbered 208 (red).
From the north or east side of the Mausoleum.
Dimensions. H. 0·135 m. Diam. 6·2 cm.
The surface is very much weathered.

627. Reg. 1972.4–11.87. Numbered 99–96 or 96–66 (red).
Dimensions. H. 0·115 m. Diam. 7·5 × 8·5 cm.

Surface much weathered.

628. Reg. 1972.4–11.88. Numbered S.C.66 (red).
Dimensions. H. (L.) 0·07 m. Diam. (upper) 6·5 × 9·5 cm; (lower) 6 × 8·5 cm.

A small, tapering fragment of tail, perhaps from close to the body.

629. Reg. 1972.4–11.89. Initialled C.T.N. (red).
Dimensions. H. 0·165 m. Diam. 7 × 8 cm.

The outer surface is much weathered.

630. Reg. 1972.4–11.90. Initialled C.T.N. (red).
Dimensions. H. (L.) 0·20 m. Diam. 7 × 8 cm.

Part of a protrusion remains where the tail was attached to a rear leg.

631. Reg. 1972.4–11.91. Initialled C.T.N. (red).
Dimensions. H. 0·165 m. Diam 7·1 × 7·6 cm.

Some of a protrusion remains where the tail was attached to a hindleg.

632. Reg. 1972.4–11.92. Initialled C.T.N. (red).
Dimensions. H. (L.) 0·135 m. Diam. 7·5 cm.

The surface is much weathered.

633. Reg. 1972.4–11.93. Initialled C.T.N. (red).
Dimensions. H. 0·132 m. Diam. 6·3 × 6·9 cm.

The inner surface of the curve is pitted by weathering.

634. Reg. 1972.4–11.94. Initialled C.T.N. (red), numbered 449 (black).
Dimensions. L. 0·11 m. Diam. 8·5 × 11 cm.

A fragment of tail from close to the join with the body.

635. Reg. 1972.4–11.95. Initialled C.T.N. (red).
Dimensions. H. 0·12 m. Diam. 7 × 7·3 cm.

636. Reg. 1972.4–11.96. Initialled C.T.N. (red).
Dimensions. H. 0·095 m. Diam. 6 × 7 cm.

637. Reg. 1972.4–11.97. Initialled C.T.N. (red).
Dimensions. H. 0·085 m. Diam. 7 cm.

638. Reg. 1972.4–11.98. Initialled C.T.N. (red).
Dimensions. H. 0·083 m. Diam. 6·5 cm.

639. Reg. 1972.4–11.100. Numbered B.66.1 (black).
Dimensions. H. 0·16 m. Diam. 7·5 × 8 cm.

640. Reg. 1972.4–11.101. Numbered B.66.1 (black).
Dimensions. H. 0·155 m. Diam. 7·5 × 8 cm.

The surface is much worn.

641. Reg. 1972.4–11.102. Numbered B.66.1 (black).
Dimensions. H. 0·135 m. Diam. 8 cm.

The surface is much worn.

642. Reg. 1972.4–11.103. Numbered B.66.1 (black).
Dimensions. H. 0·13 m. Diam. 6·5 × 7 cm.

643. Reg. 1972.4–11.104. Numbered B.66.1 (black).
Dimensions. H. 0·12 m. Diam. 8·7 cm.

Probably from a lion's tail.

644. Reg. 1972.4–11.105. Numbered B.66.1 (black).
Dimensions. H. 0·09 m. Diam. 7·5 × 8 cm.

The surface is worn.

645. Reg. 1868.4–5.6.

From Biliotti's excavations at Bodrum.

Dimensions. H. 0·172 m. Upper diam. 10 × 9·5 cm; lower 9 × 8·5 cm.

Probably from a lion's tail.

646. Reg. 1868.4–5.7.

From Biliotti's excavations at Bodrum.

Dimensions. H. (L.) 0·12 m. Upper diam. 10 × 7·5 cm; lower 7 × 7 cm.

Probably from a lion's tail where it widens to join the body.

647. Reg. 1868.4–5.30.

From Biliotti's excavations at Bodrum.

Dimensions. H. 0·063 m. Upper diam. 10 × 8 cm; lower 8·5 × 7 cm.

Perhaps from the upper part of a lion's tail.

648. Reg. 1972.4–11.60. Numbered 68 or 89 (red).

Dimensions. H. 0·093 m. Upper diam. 6·5 × 5·5 cm; lower 6 × 5·2 cm.

A small fragment of tail, possibly a little too small for the architectural lions, for which the medium-crystalled marble also seems wrong.

649. Reg. 1972.4–11.99. Numbered 262 (red).

Dimensions. H. 0·11 m. Diam. 6 × 5·8 cm.

A much damaged and weathered fragment of tail which is perhaps too small for the architectural lions. The medium-crystalled marble also seems wrong.

RECLINING LION

650. Forepaw
Reg. 1972.4–11.106. Numbered 253.20 (red), 204 (black) (probably 304 is intended ?).

Dimensions. H. 0·205 m. L. 0·10 m. W. 0·095 m. Th. of base 10 cm.

Marble. White, fine-crystalled.

The tip of a lion's forepaw set on a base. There remains most of four toes, and the front and left edges of the base. The angle of the toes shows that the lion was in a reclining position and not standing. The marble is the same as that used for the majority of the free-standing sculptures.

Fragments of Supports for Statues

651. Tapering pillar on base (pl. 43)
Reg. 1972.4–17.4. Numbered 168 (red).

Finding-place not known.

Dimensions. H. 0·485 m. L. 0·415 m. W. 0·23 m. Th. of base 15–21 cm.

Marble. White, fine-crystalled.

From a fragment of rugged base there rises up part of a large support for a statue, triangular in plan, which tapers gradually upwards. L. of sides of pillar *c.* 25 cm at base, *c.* 22 cm at upper break (corners rounded). The sides of the pillar have been roughly worked with great sweeping strokes of the point. This is perhaps a support for the belly of a horse; it cannot, however, have belonged to the Persian rider, 34, whose support was rectangular, although the thickness of base is similar to that below the hind hoof, 37. It could have belonged to one of the life-sized horses, of which several fragments remain.

652. Reg. 1972.4–17.5. Numbered B.66.4 (black).
Found by Biliotti.

Dimensions. H. 0·61 m. W. 0·405 m. Th. 0·16 m.

Marble. White, fine-crystalled.

Part of a large support, now much damaged, which looks as if it may have been roughly oval in section. The side which is preserved is convex, its surface coarsely dressed with the point, and it appears to have met the other convex side at an angle. One end has been lightly hollowed out with the point. Biliotti's numbering suggests he may have associated it with the chariot group, but there seems little reason for so doing. The type of support for the horses is known, as is also a probable support for part of the chariot.

653. Reg. 1972.4–17.6. Numbered 120 (red).

Dimensions. H. 0·285 m. W. 0·20 m. Th. 0·125 m.

Marble. White, fine-crystalled.

A fragment of a tall, rounded object, almost semicircular in section as preserved, that is probably part of a support for a statue, or a tree trunk. The sides do not appear to taper. The surface is badly weathered, but traces of the claw chisel remain.

654. Reg. 1972.4–17.81. Numbered B.66.4 (black).

Dimensions. H. 0·185 m. W. 0·19 m. Th. 0·095 m.

Marble. White, fine-crystalled.

A fragment with tapering sides and a flat end, that is most probably part of the support for a statue. The surface is weathered but still shows traces of the claw chisel.

Other Fragments of Sculpture: Miscellaneous and Unidentified

655. Fragment from chariot? (pl. 43)
Reg. 1972.4–17.7. Numbered 136 (red).

Dimensions. L. 0·27 m. H. 0·16 m. Th. 0·097 m.

Marble. White, fine-crystalled.

Part of a thin slab of marble, both sides of which have been dressed with the claw chisel. Two edges remain. One has been rounded to a semicircular cross-section, also with the claw chisel. The other, which meets the first edge at right angles, is flat. From this flat edge there protrudes a circular arm or pole, the end of which is slightly hollowed out, and roughly chiselled, as if for a joint. The projection of the pole is 2·5 cm, diameter 7·7 cm. In one side of this projection is a small cutting, 1 cm W. × 1 cm D., as if for a clamp. Clear traces of lead remain around the base of the projection.

Interpretation of this curious fragment is difficult. It clearly stood or hung free. It may perhaps have formed part of the front of a chariot, the circular protrusion being a base for the chariot pole; or it may have been part of the bodywork of a chariot, the protrusion being for the support of a chariot rail which was added separately. The working with the claw chisel is reminiscent of the finish of much of the chariot group. For a similar fragment, see 656.

656. Fragment from chariot? (pl. 43)
Reg. 1972.4–17.8. Numbered 138 (red).

Dimensions. L. 0·105 m. H. 0·09 m. Th. 0·055 m.

Marble. Blue-grey, crystalline.

A fragment from the corner of a stone identical in style and dimensions to 655. It is not, however, from the same stone, since the marble is different, being blue-grey in colour, and similar to that used for the Amazon frieze.

All that remains is a small part of a flat surface, and two adjacent edges, one semicircular and worked with the claw chisel, the other flat. On the flat edge, there is a circular protrusion, 7·7 cm in diameter, which projects 3 cm. In one side of this protrusion there is a square cutting, 1 cm W. × 1 cm D. The projection is slightly greater than on 655 because the end is not hollowed out, but is flat and worked with the claw chisel.

Clearly this fragment served a similar purpose to 655. Newton's case numberings suggest that both fragments came from the same area. The variation in marbles is interesting, considering that in respect of carving and dimensions the fragments are identical. See above, p. 14.

657. Reg. 1972.4–17.9. Initialled C.T.N. (red).

Dimensions. L. 0·235 m. Diam. 8·5 × 7 cm.

Marble. White, fine-crystalled.

A cylindrical fragment, broken at both ends, and with another break on one side. Clear traces of red-brown paint are preserved on the surface. The fragment seems too long and straight to be part of a lion's tail, for which the diameter would otherwise be suitable. It may perhaps be part of a chariot pole.

658. Reg. 1972.4–17.10.

No other number, but hitherto stored with the Mausoleum fragments.

Dimensions. L. 0·185 m. W. 0·083 m. D. 0·083 m.

Marble. White, fine-crystalled.

A fragment of marble beam, square or rectangular in section. Flat, dressed surfaces remain on three sides. The marble is of finer crystal than that used for the architectural stones of the Mausoleum. It may perhaps have been connected with the chariot on the summit of the building, although it is not, apparently, from one of the chariot wheels.

659. Reg. 1972.4–17.12. Numbered 94 (red).

Dimensions. H. 0·22 m. W. 0·145 m. Th. 0·055 m.

Marble. White, fine-crystalled.

A fragment on which there are long, sweeping strands of hair, rather coarsely worked with the running drill, and now considerably weathered. Beside the hair there is also an area of skin or flesh preserved. In the broken surface of the back are the lowest parts of two drill holes, spaced some distance from each other, each being 7·5 mm in diameter and 2·75 cm deep, as preserved. They suggest that the hair was worked separately and then added to a figure. Whether the hair is human or equine is hard to say.

660. Reg. 1972.4–17.13. Numbered B.66.1 (black).

Dimensions. H. 0·05 m. W. 0·065 m. Th. 0·11 m.

Marble. White, fine-crystalled.

A fragment with a grooved surface, that is probably hair. Cf. the hair of 'Maussollos', 26.

661. Reg. 1972.4–17.14. Numbered B.66.1 (black).

Dimensions. H. 0·06 m. W. 0·045 m. Th. 0·05 m.

Marble. White, fine-crystalled.

A small fragment with a grooved surface and a flat underside. Probably it is hair, and perhaps from a human head. Cf. the hair of 'Maussollos', 26, where it rests on the shoulder.

662. Reg. 1972.4–17.15. Numbered B.66.1 (black).

Dimensions. H. 0·115 m. W. 0·035 m. Th. 0·08 m.

Marble. White, fine-crystalled.

A fragment whose curving surface has grooves chiselled in it. Probably hair.

663. Reg. 1972.4–17.85. Numbered 261 (red).

Case 261 contained fragments 'chiefly from the north side'.

Dimensions. H. 0·09 m. W. 0·11 m. Th. 0·05 m.

Marble. White, fine-medium crystal.

A fragment with a curving surface on which there are fine grooves of hair, as if from the crown of a head. If so, the style looks too archaic for the Mausoleum.

664. Reg. 1972.4–17.16. Numbered 261 (red).

Perhaps from the north side of the Mausoleum.

Dimensions. H. 0·115 m. W. 0·07 m. Th. 0·035 m.

Marble. White, fine-crystalled.

A fragment on which there are locks of hair, too small for those of a lion, and rendered in different fashion, with deeply drilled grooves between the individual locks. One side of the fragment has been cut smooth. In the other side there are the remains of two drill-holes, running adjacently to one another. Significance uncertain.

665. Reg. 1972.4–4.105. Initialled C.T.N. (red).

Dimensions. H. 0·032 m. W. 0·062 m. Th. 0·034 m.

Marble. White, fine-crystalled.

A fragment with a grooved surface, probably hair.

666. Reg. 1972.4–17.17. Numbered B.66.1 (black).

Dimensions. H. 0·10 m. W. 0·05 m. Th. 0·045 m.

Marble. White, fine-crystalled.

A fragment of hair or drapery. Surface worn.

667. Reg. 1972.4–17.18. Numbered 181 (red), 226 (black).

Dimensions. H. 0·07 m. W. 0·057 m. Th. 0·095 m.

Marble. White, fine-medium crystal.

A curling lock of hair, with a few more strands of hair behind it. It looks as if it may come from the top of a lion's head, but the marble differs from that of the architectural lions, and the curl is greater.

668. Reg. 1972.4–11.33. Numbered 261 (red).

Perhaps from the north side of the Mausoleum.

Dimensions. H. 0·155 m. W. 0·04 m. Th. 0·135 m.

Marble. White, medium-crystalled.

A fragment with a curling lock, probably from a lion's mane. The marble disqualifies it from the architectural lions, also the excessive curl of the lock. For the style, cf. 667.

669. Reg. 1972.4–17.19. Numbered 181 (red).

Dimensions. H. 0·17 m. W. 0·12 m. Th. 0·045 m.

Marble. White, fine-crystalled.

A fragment with a convex surface on which there are several worn strands of hair (?), running horizontally and parallel to one another, divided by drilled grooves. Below (or above) these are traces of vertical strands of hair. The working is reminiscent of the mane and tails of the chariot horses. Possibly, therefore, also from a horse.

670. Reg. 1972.4–17.20. Numbered 125 (red).

Dimensions. H. 0·12 m. W. 0·105 m. D. 0·15 m.

Marble. White, fine-crystalled.

A fragment that may be half of the neck of a human statue, where it broadens out to join the shoulder. The scale is roughly that of 52, 54, 55 (life-size, III).

671. Reg. 1972.4–17.21. Numbered 261 (red).
One of several fragments 'chiefly from the north side'.

Dimensions. H. 0·095 m. W. 0·12 m. Th. 0·095 m.

Marble. White, fine-crystalled.

Part of a rounded, tapering limb, probably human. The surface was once finely finished.

672. Reg. 1972.4–17.22. Numbered 264 (red).

Dimensions. H. 0·05 m. W. 0·105 m. Th. 0·05 m.

Marble. White, fine-crystalled.

A fragment of a limb.

673. Reg. 1972. 4–17.23. Numbered 115 (red).

Dimensions. H. (L.) 0·09 m. W. 0·10 m. Th. 0·06 m.

Marble. White, fine-crystalled with brown patina.

A fragment of a tapering limb, perhaps a lower arm.

674. Reg. 1972.4–17.24. Numbered 206 (red).

Found in the Imam's field, north side.

Dimensions. H. 0·17 m. W. 0·16 m. Th. 0·092 m.

Marble. White, medium-large crystal.

A half-section through a rounded limb, on one side of which is a muscular depression. Probably human. The marble differs from that used for the majority of the sculptures in the round.

675. Reg. 1972.4–17.25. Numbered 69 (red).

Dimensions. H. 0·15 m. W. 0·11 m. Th. 0·07 m.

Marble. White, fine-crystalled.

A fragment that may be from the front of a lower leg.

676. Reg. 1972.4–17.26. Numbered 127 (red).

Dimensions. H. 0·18 m. W. 0·15 m. Th. 0·07 m.

Marble. White, fine-crystalled.

A fragment of a limb, probably human, perhaps from the region of the knee or ankle.

677. Reg. 1972.4–17.27. Numbered 85 (red), 349 (black).

Dimensions. H. 0·17 m. W. 0·135 m. Th. 0·10 m.

Marble. White, fine-crystalled.

A fragment of a limb, probably human to judge from the finely finished surface. Perhaps from a thigh.

678. Reg. 1972.4–17.28. Numbered B.66.1 (black).
Dimensions. H. 0·14 m. W. 0·12 m. Th. 0·04 m.
Marble. White, fine-crystalled.

A fragment with a polished convex surface, probably from a human statue.

679. Reg. 1972.4–17.29. Numbered B.66.1 (black).
Dimensions. H. 0·09 m. W. 0·13 m. D. 0·14 m.
Marble. White, fine-crystalled.

A fragment of a rounded limb, with a smooth outer surface. The upper edge has been slightly hollowed out with the point.

680. Reg. 1972.4–20.14. Numbered 124 (red).
Dimensions. L. 0·173 m. H. 0·12 m. Th. 0·06 m. H. of base 9·2 cm.
Marble. White, fine-crystalled.

Part of the edge of a base on which rests the tip of some object. Possibly it is the end of a drapery fold. The edge of the base is straight and has been dressed with the point.

681. Reg. 1972.4–17.83. Initialled C.T.N. (red).
Dimensions. H. 0·115 m. W. 0·14 m. 0·10 m.
Marble. White, fine-crystalled.

A fragment of limb, perhaps a lower leg.

682. Reg. 1972.4–17.84. Numbered B.66.1 (black).
Dimensions. H. 0·13 m. W. 0·045 m. Th. 0·065 m.
Marble. White, fine-crystalled.

A fragment of curving limb or body.

683. Reg. 1972.4–17.86. Numbered 14 (red).
Dimensions. H. 0·16 m. W. 0·10 m. Th. 0·045 m.
Marble. White, fine-crystalled.

A fragment of rounded limb, perhaps of an animal.

684. Reg. 1972.4–17.87. Numbered 195 (red).
Possibly from the Imam's field, north side.
Dimensions. H. 0·05 m. W. 0·10 m. Th. 0·07 m.
Marble. White, fine-crystalled.

A fragment of a tapering limb.

685. Reg. 1972.4–17.88. Numbered 261 (red).
One of several fragments 'chiefly from the north side'.
Dimensions. H. 0·055 m. W. 0·10 m. D. 0·09 m.
Marble. White, medium-crystalled.

A fragment of a limb.

686. Reg. 1972.4–10.94. Numbered B.66.1 (black).
Dimensions. H. 0·205 m. W. 0·125 m. Th. 0·09 m.
Marble. White, medium-crystalled.

A fragment of limb, much weathered, probably from an animal.

687. Reg. 1972.7–14.57. Numbered B.66.1 (black).
Dimensions. H. 0·085 m. W. 0·08 m. Th. 0·073 m.
Marble. White, medium-crystalled.

A fragment of a leg, possibly belonging to a lion, but too small for the main series, and of different marble.

688. Reg. 1972.4–17.89. Numbered 181 (red).
Dimensions. H. 0·08 m. W. 0·08 m. Th. 0·07 m.
Marble. White, fine-crystalled.

A fragment with a smooth surface, either drapery or a limb.

689. Reg. 1972.4–17.31. Numbered B.66.4 (black).
Dimensions. H. 0·23 m. W. 0·19 m. Th. 0·08 m.
Marble. White, fine-crystalled.

A fragment of a large limb, possibly belonging to a horse. Biliotti's numbering suggests he associated it with the chariot group. The scale would allow this, but it is impossible to be certain.

690. Reg. 1972.4–17.32. Numbered B.66.1 (black).

Dimensions. H. 0·35 m. W. 0·185 m. Th. 0·18 m.

Marble. White, fine-crystalled.

A fragment of a colossal leg, possibly belonging to a horse. The scale would be large enough for the chariot group.

691. Reg. 1972.4–17.33. Numbered 254 (red).

Dimensions. H. 0·145 m. W. 0·215 m. Th. 0·12 m.

Marble. White, fine-crystalled.

A fragment of the leg of an animal from close to the join with a body. It seems too narrow for a lion. Possibly from a horse.

692. Reg. 1972. 4–8.40. Initialled C.T.N. (red), numbered 327 (black).

Dimensions. H. 0·21 m. W. 0·14 m. Th. 0·12 m.

Marble. White, medium-crystalled.

A fragment of a leg with a division into two parts. Not from a lion or human figure. Possibly from a horse.

693. Reg. 1972.4–8.39. Initialled C.T.N. (red).

Dimensions. H. 0·20 m. W. 0·18 m. Th. 0·11 m.

Marble. White, fine-crystalled.

Part of an animal's limb, possibly from a horse.

694. Reg. 1972.4–17.34. Numbered 181 (red), M.12 (black).

Dimensions. H. 0·07 m. L. 0·085 m. Th. 0·092 m.

Marble. White, fine-crystalled.

A fragment from the back of an animal's leg, possibly from a lion.

695. Reg. 1972.4–2.131. Numbered B.66.1 (black).

Dimensions. H. 0·155 m. W. (front) 0·115 m. Th. (side) 0·135 m.

Marble. White, medium-crystalled.

A fragment of leg at the back of which are rough strokes of the point. Likely to be from an animal rather than from a human figure. The marble is wrong for the architectural lions.

696. Reg. 1972.4–17.35. Numbered 130 (red).

Dimensions. H. (L.) 0·315 m. W. 0·21 m. Th. 0·115 m.

Marble. White, fine-crystalled.

A large fragment from an animal of some kind. The surface is rounded and only roughly finished. Traces of the flat chisel and rasp remain. There is also part of a straight edge with a drilled groove. Not obviously from a lion. Possibly from a horse.

697. Reg. 1972.4–17.36. Numbered 128 (red).

Dimensions. H. 0·14 m. W. 0·12 m. Th. 0·085 m.

Marble. White, fine-crystalled.

A fragment from the body of an animal.

698. Reg. 1972.4–17.38. Numbered 92 (red).

Dimensions. L. 0·13 m. W. 0·125 m. H. 0·065 m.

Marble. White, fine-crystalled.

A fragment with a smooth, rounded outer surface, perhaps from the body or neck of a lion.

699. Reg. 1972.4–17.39. Initialled C.T.N. (red).

Dimensions. H. 0·11 m. L. 0·23 m. Th. 0·165 m.

Marble. White, fine-crystalled.

A fragment of limb or body, possibly from a lion. Traces of the flat chisel are visible on the surface.

700. Reg. 1972.4–17.40. Initialled C.T.N. (red), numbered 386 (black).

Dimensions. L. 0·12 m. W. 0·087 m. Th. 0·056 m.

Marble. White, medium-crystalled.

A fragment which appears to be part of a lion's mane. The marble differs from that used for the architectural lions.

701. Reg. 1972.4–17.41. Numbered 157 (red).

Dimensions. H. 0·072 m. W. 0·082 m. Th. 0·05 m.

Marble. White, fine-crystalled.

Part of a rounded object, the surface of which has been finished with light strokes of the point. In one place is a shallow drill-hole, 5 mm in diameter. Possibly from the genitals of a horse.

702. Reg. 1972.4–17.42. Numbered 91 (red).
Dimensions. H. 0·105 m. W. 0·115 m. Th. 0·045 m.
Marble. White, medium-crystalled.

Half of a semispherical object, perhaps to be interpreted in the same way as 701.

703. Reg. 1972.4–17.43. Numbered B.66.3 (black).
Dimensions. H. 0·315 m. W. 0·21 m. Th. 0·09 m.
Marble. White, medium-crystalled.

A much-damaged fragment with a rounded outer surface, possibly even from the back of a draped figure.

704. Reg. 1972.4–17.44. Numbered 262 (red).
Dimensions. H. 0·075 m. Diam. 6–6·5 cm.
Marble. White, medium-crystalled.

A fragment of a small rounded limb, probably from an animal.

705. Reg. 1972.4–17.45. Numbered 96 (red).
Dimensions. H. 0·225 m. W. 0·16 m. Th. 0·085 m.
Marble. White, fine-crystalled.

A fragment of the curving limb of an animal, the surface of which shows traces of the claw chisel.

706. Reg. 1972.4–17.46. Initialled C.T.N. (red).
Dimensions. H. 0·23 m. W. 0·16 m. Th. 0·085 m.
Marble. White, fine-crystalled.

A fragment of a limb.

707. Reg. 1972.4–17.47. Numbered 186 (red).
Found in the Imam's field, north side.
Dimensions. H. 0·17 m. W. 0·10 m. Th. 0·07 m.
Marble. White, fine-crystalled.

A fragment of a limb.

708. Reg. 1972.4–17.48. Numbered 88 (red).
Dimensions. H. 0·085 m. W. 0·08 m. Th. 0·04 m.
Marble. White, fine-crystalled.

A fragment of a small limb or tail. Could be from a lion.

709. Reg. 1972.4–17.49. Numbered B.66.1 (black).
Dimensions. H. 0·075 m. Diam. 8·5 × 9·5 cm.
Marble. White, fine-crystalled.

A much-damaged fragment from a limb of some kind.

710. Reg. 1972.4–17.50. Initialled C.T.N. (red).
Dimensions. H. 0·132 m. W. 0·12 m. Th. 0·045 m.
Marble. White, fine-crystalled.

A fragment with a rounded surface. Near one break is a trace of a raised ridge. From a limb, or possibly a draped figure.

711. Reg. 1972.4–17.51. Numbered B.66.1 (black).
Dimensions. H. 0·11 m. W. 0·125 m. Th. 0·065 m.
Marble. White, fine-crystalled.

A fragment of body or limb.

712. Reg. 1972.4–17.52. Initialled C.T.N. (red).
Dimensions. H. 0·08 m. W. 0·10 m. D. 0·20 m.
Marble. White, fine-crystalled.

A fragment on which a small area of smooth surface remains.

713. Reg. 1972.4–17.53. Numbered 264 (red).
Dimensions. H. 0·19 m. W. 0·18 m. Th. 0·07 m.
Marble. White, medium-large crystal.

A fragment of a limb, possibly human.

714. Reg. 1972.4–17.54. Numbered 193 (red).
Dimensions. H. 0·21 m. W. 0·13 m. Th. 0·07 m.
Marble. White, fine-crystalled.

A fragment of a limb.

715. Reg. 1972.4–17.55. Numbered 253.20 (red).
Dimensions. H. 0·16 m. W. 0·09 m. Th. 0·05 m.
Marble. White, fine-crystalled.

A fragment of a limb.

716. Reg. 1972.4–17.56. Initialled C.T.N. (red).

Dimensions. H. 0·21 m. W. 0·235 m. Th. 0·08 m.

Marble. White, fine-crystalled.

A fragment with rounded surface, perhaps from the body of an animal.

717. Reg. 1972.4–17.57. Numbered 69 (red), 298 (black).

Dimensions. H. 0·147 m. W. 0·122 m. Th. (as preserved) 0·057 m.

Marble. White, fine-crystalled.

A fragment of a limb. It seems too thin for a lion's foreleg, but could possibly be from a horse.

718. Reg. 1972.4–17.58. Numbered 92 (red), 328 (black).

Dimensions. H. 0·165 m. W. 0·125 m. Th. 0·06 m.

Marble. White, fine-crystalled.

A fragment of a rounded limb. Whether from lion or horse or human is hard to say.

719. Reg. 1972.4–17.59. Numbered 235 (red), 145 (black).

Dimensions. H. 0·15 m. W. 0·22 m. D. 0·25 m.

Marble. White, fine-crystalled.

A fragment that might be thought to be from a rounded base from which rises up a circular support, were it not that the 'base' has overlapping locks of hair on it, as if of a lion. But it is not obviously from a lion statue. Newton's number in black suggests he interpreted it as part of a neck.

720. Reg. 1972.4–17.60. Numbered 81 (red).

Dimensions. H. 0·12 m. W. 0·112 m. Th. 0·06 m.

Marble. White, fine-crystalled.

A fragment of a limb.

721. Reg. 1972.4–17.61. Numbered 122 (red).

Dimensions. H. 0·155 m. W. 0·115 m. Th. 0·08 m.

Marble. White, fine-crystalled.

A fragment of a limb.

722. Reg. 1972.4–17.62. Numbered 158 (red).

Dimensions. H. 0·215 m. W. 0·115 m. Th. 0·055 m.

Marble. White, fine-crystalled.

A fragment of a limb, or possibly drapery, with a smooth, rounded surface.

723. Reg. 1972.4–17.63. Numbered 13 (red).

Dimensions. H. 0·24 m. W. 0·08 m. Th. 0·155 m.

Marble. White, fine-crystalled.

A fragment perhaps of a draped limb.

724. Reg. 1972.4–17.64. Initialled C.T.N. (red).

Dimensions. H. 0·19 m. W. 0·145 m. Th. 0·08 m.

Marble. White, fine-crystalled.

A fragment with an undulating surface, perhaps drapery.

725. Reg. 1972.4–17.65. Numbered 126 (red).

Dimensions. H. 0·115 m. W. 0·11 m. Th. 0·09 m.

Marble. White, fine-crystalled.

A fragment perhaps of drapery.

726. Reg. 1972.4–17.66. Numbered 128 (red), 329 (black).

Dimensions. H. 0·215 m. W. 0·175 m. Th. 0·10 m.

Marble. White, fine-crystalled.

A fragment that appears to be from the edge of a base (Th. 12 cm), on which rests an object. Not a lion's paw or a sandal.

727. Reg. 1972.4–17.67. Numbered 117 (red).

Dimensions. H. 0·195 m. W. 0·135 m. Th. 0·08 m.

Marble. White, fine-crystalled.

A fragment of rounded limb or body, with traces of what appears to be hair at one end, in which is a drill hole, 6 mm in diam. and 1·5 cm deep. It is not impossible that this may be a fragment of a colossal ram's head, like that which Jeppesen has found in Bodrum, the 'hair' being part of a horn curving across the face.

728. Reg. 1972.4–17.68. Initialled C.T.N. (red).
Dimensions. H. 0·095 m. W. 0·105 m. Th. 0·015 m.
Marble. White, fine-crystalled.

A small fragment which may have an original surface preserved on one side.

729. Reg. 1972.4–17.69. Numbered 41 (red).
Dimensions. H. 0·045 m. W. 0·05 m. Th. 0·07 m.
Marble. White, fine-crystalled.

A chip of marble with a smooth, flat surface.

730. Reg. 1972.4–17.70. Numbered B.66 (black).
Dimensions. H. 0·16 m. W. 0·095 m. D. 0·125 m.
Marble. White, fine-crystalled.

A fragment of limb or drapery.

731. Reg. 1972.4–17.71. Numbered 124 (red).
Dimensions. H. 0·165 m. W. 0·095 m. Th. 0·06 m.
Marble. White, fine-crystalled.

A fragment which looks as if it may be part of a female sandal on a statue base. The thickness of the base is 7·7 cm, the height of the sandal sole is 4 cm. Cf. 90–93 and 228, above.

732. Reg. 1972.4–17.72. Numbered B.66.1 (black).
Dimensions. H. 0·125 m. W. 0·137 m. Th. 0·077 m.
Marble. White, fine-crystalled.

A fragment in poor condition, perhaps from where a lion's tail touches a base. Cf. 577, 578, and 616, above.

733. Reg. 1972.4–17.73. Numbered 117 (red).
Dimensions. H. 0·17 m. W. 0·10 m. Th. 0·105 m.
Marble. White, fine-crystalled.

A fragment perhaps of a tail or limb.

734. Reg. 1972.4–17.74. Numbered B.66.1 (black).
Dimensions. H. 0·075 m. W. 0·125 m. Th. 0·07 m.
Marble. White, fine-crystalled.

A fragment of a limb.

735. Reg. 1972.4–17.75. Numbered B.66.1 (black).
Dimensions. H. 0·09 m. W. 0·152 m. Th. 0·06 m.
Marble. White, fine-crystalled.

A worn fragment with a rounded outer surface.

736. Reg. 1972.4–17.76. Numbered B.66.1 (black).
Dimensions. H. 0·13 m. W. 0·15 m. Th. 0·13 m.
Marble. White, fine-crystalled.

A worn, incrusted fragment of uncertain significance.

737. Reg. 1972.4–17.77. Initialled C.T.N. (red).
Dimensions. H. 0·20 m. W. 0·245 m. Th. 0·135 m.
Marble. White, fine-crystalled.

A worn fragment, possibly of drapery.

738. Reg. 1972.4–17.78. Numbered 50 (red).
Dimensions. H. 0·115 m. W. 0·123 m. Th. 0·047 m.
Marble. White, fine-crystalled.

A fragment of a limb or drapery.

739. Reg. 1972.4–17.79. Numbered 162 (red).
Dimensions. H. 0·28 m. W. 0·27 m. Th. 0·113 m.
Marble. White, fine-crystalled.

A fragment on which only a small area of original surface remains. Possibly from an animal's limb or drapery.

740. Reg. 1972.4–17.80. Numbered B.66.1 (black).
Dimensions. H. 0·175 m. W. 0·11 m. Th. 0·175 m.
Marble. Grey-white, large-crystalled.

A rounded fragment with a smooth surface in which is a groove. Possibly from drapery stretched taut over a limb.

741. Reg. 1972.4–17.82. Numbered B.66.1 (black).
Dimensions. H. 0·295 m. W. 0·19 m. Th. 0·10 m.
Marble. White, fine-crystalled.

A fragment from the body of an animal.

742. Reg. 1972.4–20.20. Numbered B.66 (black).
Dimensions. H. (L.) 0·09 m. W. 0·115 m. Th. 0·06 m.
Marble. White, fine-crystalled.

A fragment of a limb.

743. Reg. 1972.4–17.90. Numbered 111 (red).
Dimensions. H. 0·15 m. W. 0·09 m. Th. 0·075 m.
Marble. White, fine-crystalled.

A fragment possibly of a limb, with a strong taper. The smaller end has been smoothed for a join, and there are two dowel holes in it, set side by side, each measuring 8·5 mm in diameter, and 1·4 cm deep.

744. Reg. 1972.4–20.2. Numbered 105 (red).
Dimensions. H. 0·18 m. W. 0·16 m. Th. 0·11 m.
Marble. White, fine-crystalled.

A fragment of an animal's limb. Not from a lion; possibly from a horse.

745. Reg. 1972.7–14.82. Numbered B.66 (black).
Dimensions. L. 0·10 m. W. 0·075 m. Th. 0·045 m.
Marble. White, fine-crystalled, with brown patina.

A fragment with a rounded surface, the upper part of which is recessed. Possibly drapery.

746. Reg. 1972.7–14.80. Numbered B.66 (black).
Dimensions. L. 0·085 m. W. 0·07 m. Th. 0·055 m.
Marble. White, fine-crystalled.

A small fragment, three surfaces of which are worked. Possibly drapery.

747. Reg. 1972.7–14.64. Numbered 123 (red).
Dimensions. H. 0·165 m. W. 0·17 m. Th. 0·05 m.
Marble. White, fine-crystalled.

A fragment either of a muscular limb, or drapery.

748. Reg. 1972.7–14.104. Numbered 146 (red).
Dimensions. H. 0·14 m. W. 0·145 m. Th. 0·045 m.
Marble. White, fine-crystalled.

A fragment with two adjacent worked surfaces, one smooth and convex, the other with a deep hollow, in which are marks of a rasp. Probably drapery.

749. Reg. 1972.7–14.66. Numbered 60 (red).
Dimensions. H. 0·145 m. W. 0·14 m. Th. 0·05 m.
Marble. White, fine-crystalled.

A fragment with two adjacent surfaces, irregularly worked. Perhaps drapery.

750. Reg. 1972.7–14.50. Numbered 78 (red), 501 (black).
Dimensions. H. 0·135 m. W. 0·12 m. Th. 0·07 m.
Marble. White, fine-crystalled.

A fragment with an irregularly worked surface, of uncertain significance.

751. Reg. 1972.7–14.63. Numbered B.66 (black).
Dimensions. H. 0·095 m. W. 0·13 m. Th. 0·045 m.
Marble. White, fine-crystalled.

A fragment with a rounded surface, irregularly worked.

752. Reg. 1972.7–14.58. Numbered 67 (red), M 11 (black).
Dimensions. H. 0·09 m. W. 0·06 m. Th. 0·035 m.
Marble. White, fine-crystalled.

A finely worked fragment that may possibly be part of a lower thumb. Not apparently from one of the friezes.

Fragments perhaps from Mausoleum

753. Reg. 1972.4–20.1.

Dimensions. H. 0·345 m. W. 0·37 m. Th. 0·37 m.

Marble. White, medium-crystalled.

A fragment of a figure wearing close-fitting drapery, probably from the region of the waist or hip. The underside is smooth, but may have been sawn. The back shows marks of the point, and there is no sign of drapery here. From a figure about life-size.

754. Reg. 1972.4–20.3.

Dimensions. H. 0·18 m. W. 0·115 m. Th. 0·14 m.

Marble. White, medium-crystalled.

A fragment of a limb.

755. Reg. 1972.4–20.4.

Dimensions. H. 0·145 m. W. 0·075 m. Th. 0·115 m.

Marble. White, fine-crystalled.

A fragment with long, flowing strands of hair.

756. Reg. 1972.4–20.5.

Dimensions. H. 0·10 m. W. 0·065 m. Th. 0·065 m.

Marble. White, fine-crystalled.

A fragment with finely chiselled grooves on the surface, probably hair.

757. Reg. 1972.4–20.13.

Dimensions. H. 0·35 m. W. 0·23 m. Th. 0·12 m.

Marble. White, fine-crystalled.

A fragment from the body of an animal, perhaps a lion or horse.

758. Reg. 1972.4–20.6.

Dimensions. H. 0·06 m. W. 0·21 m. D. 0·115 m.

Marble. White, fine-crystalled.

A fragment with a rounded surface, either limb or drapery.

759. Reg. 1972.4–20.7.

Dimensions. H. 0·095 m. W. 0·115 m. Th. 0·062 m.

Marble. White, fine-crystalled.

A fragment of a limb, perhaps human.

760. Reg. 1972.4–20.8.

Dimensions. H. 0·15 m. W. 0·115 m. Th. 0·11 m.

Marble. White, fine-crystalled.

A fragment of a limb, perhaps a human leg.

761. Reg. 1972.4–20.9.

Dimensions. H. 0·222 m. W. 0·115 m. Th. 0·12 m.

Marble. White, fine-crystalled.

A fragment that may be drapery. In the broken surface of the back has been carved a small Maltese cross, presumably by one of the Knights of St John.

762. Reg. 1972.4–20.10.

Dimensions. H. 0·165 m. W. 0·10 m. Th. 0·08 m.

Marble. White, fine-crystalled.

A fragment that may be part of a limb or tail.

763. Reg. 1972.7–14.98.

Dimensions. H. 0·225 m. W. 0·117 m. Th. 0·07 m.

Marble. White, fine-crystalled.

A fragment with a broadly worked, undulating surface. Perhaps a piece of drapery from a large statue.

Fragments of Marble Bowls and Urns

764. Fragment of lid of urn (?) (pl. 44)
 MRG 159. Reg. 1857.12–20.343. Numbered 262 (red).

Found in Mahomet's field, some way to the north of the north wall of the *peribolus* (Invoice for case 262; *Papers*, i. 44; *HD* 112).

 Dimensions. Radius 0·36–0·37 m. Th. of wall of lid: 2·5 cm at rim, 4·5 cm in centre.

 Marble. White, medium-crystalled. The inside has been worn into deep holes by the action of water.

Preserved is about one-third of a circular lid, or shallow bowl (Newton considered it to be a phiale). The convex outer surface has been finished with the claw chisel, and has an offset rim consisting of two elements, divided by scored lines. In the centre is a raised boss, 10 cm square, projecting 1 cm above the surface, and only roughly finished with the point. The inside appears to have been smoothly finished, although it is now much worn. The precise significance of this fragment is not easy to assess. Most probably it is the lid of a large marble urn, in which case the central boss would have served for the addition of an ornamental knob. It is just possible that Newton may have been correct in regarding it as a shallow bowl, or phiale, in which case the raised boss would have acted as a support, but the fact that the ornamental rim on the outside is invisible when the object is set up as a bowl tends to go against this interpretation. It is even possible that the object is not part of an urn or bowl at all, but is a fragment of shield from a life-sized group, in which case the central boss might have served for the addition of a heraldic device in plaster. This interpretation is not helped by the fact that the marble differs from that used for most of the free-standing figures, and also by the fact that this fragment was found with several other fragments which are certainly from marble bowls.

765. Fragment of lid of urn (?) (pl. 44)
 Reg. 1857.12–20.338.

The three adjoining fragments are all numbered 262 (red). Found together with 764 in Mahomet's field, to the north of the north wall of the *peribolus* (Invoice for case 262; *Papers,* i. 44; *HD* 112).

 Dimensions. Diameter 0·70 m. Central boss 9 × 8·5 cm; projects 1·5 cm.

 Marble. White, medium-crystalled. The inside has been worn into holes by the action of water.

About half of a circular lid, reconstructed from three fragments, similar in style to 764. It differs from 764 in being slightly smaller in diameter, and in having a smoothly finished external surface and central boss. Probably, like 764, it is the lid of an urn, but it could perhaps be a shield.

766. Reg. 1972.4–4.116. Numbered 64 (red).
 Dimensions. H. 0·22 m. W. 0·11 m. Th. 0·045 m.
 Marble. White, medium-crystalled.

A fragment of lid or bowl, with an off-set rim. There are saw marks on the inner side. The style differs slightly from 764–765.

767. Reg. 1972.4–20.12. Numbered 117 (red).

Dimensions. H. 0·10 m. L. 0·105 m. W. 0·10 m. Th. of wall 2·5 cm.

Marble. White, medium-crystalled.

A fragment of a deep bowl, including one handle or lug at rim-level. The outside has been roughly finished with the point.

768. Reg. 1857.12–20.339. Numbered 67 (red).

Dimensions. H. 0·06 m. W. 0·10 m. L. 0·16 m.

Marble. White, medium-crystalled.

A fragment of a large, round, shallow dish with offset rim, the outer side of which has a double moulding.

769. Reg. 1972.7–14.55. Numbered 127 (red).

Dimensions. H. 0·12 m. W. 0·145 m. Th. 0·155 m.

Marble. White, fine-medium crystal.

A much damaged fragment of a marble bowl or urn. Parts of the foot, the underside, and the inside surface remain.

770. Reg. 1857.12–20.341. Numbered 262 (red).

One of the fragments found in Mahomet's field, north side. Cf. 764–765.

Dimensions. L. 0·105 m. W. 0·095 m. D. 0·065 m. Th. of wall 2 cm.

Marble. White, medium-crystalled.

A fragment of a dish or bowl. The rim has elaborate moulding on both inside and outside.

771. Reg. 1857.12–20.342. Numbered 262 (red).

Found in Mahomet's field, north side. Cf. 770.

Dimensions. H. 0·055 m. W. 0·095 m. L. 0·147 m. Th. of wall 1·5 cm.

Marble. White, medium-crystalled.

A fragment of dish or bowl, with moulding on both inside and outside.

772. Reg. 1857.12–20.340. Numbered 262 (red).

From Mahomet's field, north side.

Dimensions. L. 0·18 m. W. 0·12 m. Th. 0·05 m.

Marble. White, medium-crystalled.

A fragment probably from a shallow bowl, with moulding on the outside of the lip.

773. Reg. 1972.4–20.11. Initialled C.T.N. (red), numbered 190 (black).

Dimensions. L. 0·14 m. W. 0·04 m. Th. of wall 1·3 cm.

Marble. White, medium-crystalled.

A curving fragment with a rim and a narrow wall. The number in black suggests that Newton took it to be a fragment of drapery, but it is perhaps rather from a marble vessel.

Fragments to be rejected from the Mausoleum

774. Rear paw and lower leg of lion on base
(pl. 44)

MRG 137. Reg. 1865.12–12.14.

Found by Biliotti, but according to the Register it is from 'either Rhodes or Bodrum'.

Dimensions. L. 0·39 m. W. 0·23 m. H. 0·20 m. Th. of base: 5·5–6·5 cm. Max. W. of paw 9·5 cm. Dimensions of break of leg: 10 × 8·2 cm.

Marble. White, medium-crystalled, weathered to a gritty texture.

The paw is rather sinewy in treatment, and is considerably smaller than the paws of the architectural lions. It stands on a roughly dressed base, the original right edge of which is preserved immediately to the right of the paw.

Although included by Newton in *MRG*, it is by no means certain that this paw came from the Mausoleum. The imprecise entry in the Register, the small scale, and the crystalline marble, which differs markedly from that used for the rest of the lions, would tend to suggest that it did not.

Newton, *MRG* 137.

775. Fragment of draped figure

MRG 67. Numbered 96 (red). Reg. 1972.4–20.16.

Dimensions. H. 0·42 m. W. 0·38 m. Th. 0·28 m.

Marble. White, fine-crystalled.

A fragment from the upper part of a draped figure in which is part of a socket to receive a head. The lines of drapery are schematically worked, and not easy to understand. The style suggests a date later than the Mausoleum.

776. Fragment of draped figure

Reg. 1972.4–2.35. Numbered B.66.3 (black).

Dimensions. H. 0·455 m. W. 0·41 m. D. 0·30 m.

Marble. White, medium-large crystal.

A fragment of a large draped figure, probably from the left side just below the waist. The upper edge has been worked smooth as if for a join, and there is an area of coarse pointwork on the left side. The drapery, which hangs in heavy folds, appears to be a himation. A seam is preserved, running around the left side.

Marble and style do not favour attribution to the Mausoleum.

777. Fragment of draped figure

Reg. 1972.4–4.20. Numbered 168 (red).

Dimensions. H. 0·17 m. W. 0·16 m. Th. 0·115 m.

Marble. White, large-crystalled, weathered to coarse texture.

The underside has a smooth, flat surface, the folds of drapery run horizontally, but marble and style seem wrong for the Mausoleum.

778. Reg. 1972.4–20.17. Numbered 167 (red).

Dimensions. H. 0·26 m. W. 0·205 m. Th. 0·25 m.

Marble. White, medium-crystalled.

A fragment with locks of hair, over which runs the edge of a piece of drapery. Harsh work, probably Hellenistic or Roman. Could be from a figure of Pan.

779. Fragment of draped figure

Reg. 1972.4–20.18. Numbered B.66.3 (black).

Dimensions. H. 0·285 m. W. 0·32 m. Th. 0·185 m.

Marble. White, large-crystalled.

A fragment with rather hard drapery folds and part of a socket worked with a point. The marble and style seem wrong for the Mausoleum.

780. Fragment of draped figure

Reg. 1972.4–2.41. Numbered B.66.3 (black).

Dimensions. H. 0·11 m. W. 0·265 m. D. 0·205 m.

Marble. White, medium-large crystal.

A fragment of drapery from the side and front of a statue. The marble seems wrong and the style too hard for the Mausoleum.

781. Fragment of draped figure

Reg. 1972.4–4.14. Numbered B.66.3 (black).

Dimensions. H. 0·25 m. W. 0·125 m. Th. 0·145 m.

Marble. White, large-crystalled.

A fragment from the lower part of a draped figure, wearing a heavy garment, probably a himation, of which a seam is preserved, running around the side of the figure. Cf. 776.

782. Draped right arm

Reg. 1972.4–2.85. Numbered 79 (red).

Dimensions. L. 0·40 m. W. of arm 0·13 m. Th. 0·07 m.

Marble. White, medium-large crystal.

A right arm wearing a tight-fitting sleeve, preserved from just below the shoulder to about mid-forearm. Above the forearm a portion of drapery from the body of the figure remains. If this fragment is from a statue in the round, the arm must have been drawn closely across the body. The flatness of the modelling suggests, however, that it may rather come from a large relief. The style seems too hard for the Mausoleum.

783. Fragment of drapery

Reg. 1972.4–4.42. Numbered B.66.3 (black).

Dimensions. H. 0·18 m. W. 0·13 m. Th. 0·07 m.

Marble. White, large-crystalled.

A fragment of drapery with a single fold on the front and coarse strokes of the point on the back. The marble almost certainly disqualifies from the Mausoleum.

784. Fragment of drapery

Reg. 1972.4–4.65. Numbered B.66.3 (black).

Dimensions. H. 0·22 m. W. 0·125 m. Th. 0·07 m.

Marble. White, large-crystalled.

The style seems too hard for the Mausoleum.

785. Fragment of drapery

Reg. 1972.4–4.111. Numbered B.66 (black).

Dimensions. H. 0·23 m. W. 0·11 m. Th. 0·042 m.

Marble. White, large-crystalled.

A fragment of a draped limb. Marble and style seem wrong for the Mausoleum.

786. Fragment of drapery

Reg. 1972.4–4.110. Numbered 83 (red).

Dimensions. H. 0·14 m. W. 0·095 m. Th. 0·045 m.

Marble. White, medium-crystalled.

The marble probably disqualifies from the Mausoleum.

787. Fragment of drapery

Reg. 1972.4–4.112. Initialled C.T.N. (red).

Dimensions. H. 0·14 m. W. 0·15 m. Th. 0·04 m.

Marble. Grey-white, large-crystalled.

The marble seems wrong for the Mausoleum.

788. Fragment of drapery
Reg. 1972.4–4.109. Numbered B.66.3 (black).

Dimensions. H. 0·19 m. W. 0·16 m. Th. 0·07 m.

Marble. Grey-white, large-crystalled.

A fragment of a small figure wearing chiton and himation. Neat work. The scale seems too small for the free-standing sculptures, but too large for the friezes. The running drill was used in the folds of the chiton.

789. Fragment of elbow
Reg. 1868.4–5.5.

From Biliotti's excavations at Bodrum.

Dimensions. H. 0·17 m. W. 0·09 m. Th. 0·08 m.

Marble. White, large-crystalled.

An upper arm, preserved down to the elbow. The arm was bent, and was fitted to the shoulder by means of a dowel, the hole for which remains: D. 4 cm, L. 3 cm, W. 1·5 cm. The style differs markedly from that of other arms. Probably late Hellenistic or Roman work.

790. Reg. 1868.4–5.2.
From Biliotti's excavations at Bodrum.

Dimensions. H. 0·14 m. W. 0·095 m. Th. 0·12 m.

Marble. White, fine-crystalled.

A fragment of a draped statuette. There is a dowel hole for the addition of a separately worked piece.

791. Fragment of limb
Reg. 1972.4–20.19. Numbered B.66.4 (black).

Dimensions. H. 0·18 m. W. 0·20 m. Th. 0·185 m.

Marble. White, large-crystalled.

A fragment of a huge limb. Biliotti's numbering suggests he attributed it to the chariot group, but the marble differs markedly from that used for the colossal horses.

792. Reg. 1972.7–21.45.
Dimensions. H. 0·165 m. W. 0·06 m. Th. 0·05 m.

Marble. White, fine-medium crystal, brown patina.

A neatly worked lower left leg, broken above the knee and above the ankle. Not apparently from one of the friezes, and too small for the smallest scale of sculpture in the round.

793. Reg. 1972.4–20.22. No other number.
Dimensions. H. 0·165 m. W. 0·105 m. Th. 0·07 m.

Marble. Grey-white, large-crystalled.

A fragment with a rounded surface.

794. Reg. 1972.4–20.23. No other number.
Dimensions. H. 0·18 m. W. 0·24 m. Th. 0·16 m.

Marble. White, large-crystalled.

A rounded fragment with the remains of a flat underside, worked with the point. Possibly from a leg or support.

Fragments from a Wall on Cos, previously confused with the Mausoleum Sculptures

795. Fragment of draped figure
MRG 57. Reg. 1972.4–20.26. Numbered 253.12 (red).

The Invoice for this number reads: 'Five pieces of draped statue from same wall', referring to the entry for 253.11, which makes it plain that the wall was on the island of Cos. This seems to have been forgotten when MRG was drawn up nearly thirty years later.

Dimensions. H. 0·30 m. W. 0·24 m. Th. 0·175 m.

Marble. White, fine-crystalled, with brownish patina.

A fragment from the upper part of a male figure wearing a cloak. The bottom of a socket to receive a head remains on the upper break.

Scale. About life-size. Were it not for the information in the Invoice, it is doubtful if this fragment would have been disqualified from the Mausoleum sculptures on grounds of marble or style.

The whereabouts of the other four pieces of this statue is unknown.

Newton, MRG 57.

796. Back and shoulders of naked male figure
Reg.. 1972.4–20.27. Numbered 253.11 (red), C.T.N. 3 (black).

The Invoice for 253.11 reads: 'Torso of naked male figure in Parian marble, found in a wall, Cos'.

Dimensions. H. 0·185 m. W. 0·23 m. Th. 0·16 m.

Marble. White, fine-medium crystal.

Preserved is the upper left part of the torso, the bottom of a socket to receive a head, and part of a joint and dowel hole at the left shoulder for the addition of a separately worked arm.

Scale. Considerably less than life-size.

797. Elbow of right arm　(pl. 44)
Reg. 1972.4–20.28. Numbered 253.13 (red), 261 (black).

The Invoice for 253.13 reads: 'Three fragments of Sculpture, indid.', the 'indid.' referring to the same wall on Cos as was mentioned in the entry for 253.11. The number in black suggests Newton forgot or ignored this, and catalogued it with the other Mausoleum fragments.

Dimensions. H. 0·283 m. L. 0·26 m. Th. 0·125 m.

Marble. White, large-crystalled.

There is a wedge-shaped dowel hole at about mid-bicep, for the addition of the arm to a body. The lower forearm is missing.

Scale. Over life-size, verging on colossal. The marble confirms the Invoice and favours the rejection of this fragment from the Mausoleum.

798. Elbow and forearm

Reg. 1972.4–20.29. Numbered 253.13 (red), 260 (black).

From a wall on Cos. Cf. 797.

Dimensions. H. 0·18 m. L. 0·165 m. Diam. of lower break 10 cm.

Marble. White, large-crystalled.

There is a joint at the biceps, with a dowel hole for the addition of the arm to a body. Marble and style are similar to that of 797; the scale is slightly smaller, although still over life-size.

799. Left elbow and lower arm

Reg. 1972.4–20.30. No other number.

Dimensions. H. 0·12 m. L. 0·265 m. W. 0·105 m.

Marble. White, large-crystalled.

Reconstructed from three fragments. Broken above the elbow. Very similar in scale, style and marble to 798, and so, despite the absence of a number, probably from Cos.

APPENDIX I

Newton's Invoice of packing-cases of sculptures from the Mausoleum

Reproduced from *Papers*, i. 24–27 and *Papers*, ii. 35–38. An attempt to reconstruct the contents of each packing-case has been made in the list following on pp. 239–40. Since the sequence of case numbers reflects the progress of the excavations, it is likely that cases 61–144 contained the mass of broken sculptures from the Quadrangle of the Mausoleum. Cf. above, pp. 3, 12–13.

I particularly mention this point, because I consider that it is to the good discipline of the crew of the "Gorgon," not less than to their general efficiency, that I owe much of the success of this expedition, in which, at the outset, the prejudices of a Mussulman population had to be overcome.

I have only to add that my personal intercourse with Commander Towsey has been marked by the greatest courtesy and kindness on his part, and that, throughout the period during which we have acted together, the most entire unanimity and good understanding has existed between us.

No. 11.

Vice-Consul Newton to the Earl of Clarendon.--(Received July 20.)

My Lord, *Budrum, June 24, 1857.*

I HAVE the honour to inclose herewith an inventory of 218 packages, which I have shipped on board Her Majesty's ship "Gorgon," and consigned to the Trustees of the British Museum.

It has been impossible for me to make complete lists of the objects contained in each case, on account of the great number of fragments.

I have, however, drawn attention to the objects of the greatest value and interest, both in the inventory and in the lists inclosed in the several cases.

I have not hesitated to send home every fragment of sculpture from the Mausoleum, however minute or defaced, because it is only by a careful collation of these that we can hope to form an idea of the whole design of this celebrated edifice.

I am not without hope that, if examined by a competent sculptor, many of these fragments may be fitted together, and it is possible that some of the detached heads and limbs from the frieze, of which I send a very large collection, may be adjusted to figures in the frieze from the Castle, now in the British Museum.

In the case of the sculptures found north of the Hellenic wall, I have little doubt that the fragments will be found to belong to the statues and lions there discovered, and that they can be rejoined.

I have, therefore, packed the whole of these fragments separately from the rest, distinguishing them in the inventory as "Fragments from the Imaum's Field and North Wall."

I trust that the whole of the objects now sent will arrive safely at their destination. I have personally superintended the whole of the packing, and every case containing sculpture has been most carefully inspected before it was closed.

I have, &c.
(Signed) C. T. NEWTON.

Inclosure in No. 11.

List of Cases shipped in Her Majesty's ship "Gorgon."

MOSAICS.

(1.) Lion A.
(2.) 41, 43, C.
(3.) 29, 34, C.
(4.) 31, 33, C.
(5.) 14, 17, 19, C.
(6.) 14, 4, C.
(7.) Fragments C and A.
(8.) 44, 42, C.
(9.) 2, 5, fragments.
(10.) 37, 39, C.
(11.) Amphitrite, C.
(12.) 1, 25, 30, 36, C.
(13.) 8, 22, fragments, C.
(14.) 28, 15, Amphitrite, C.

(15.) 10, 11, 2, C.
(16.) 38, 40, C.
(17.) Lion, A.
(18.) Amphitrite, C.
(19.) 22, 3, C.
(20.) 18, 16, C.
(21.) 27, 33, C.
(22.) 9, 22, 6, C.
(23.) 26, 32, C.
(24.) Dolphin, A.
(25.) Dog, A.
(26.) Amphitrite, C.
(27.) 45, 47, C.
(28.) 46, 52, C.
(29.) Halicarnassus, E.
(30.) Atalanta, B.

(31.) Meleager, B.

(32.) Goat, A.

(33.) Halicarnassus, Head of Summer, E and D.

(34.) Medallion, D (east end).

(35.) Medallion, D (east end).

(36.) Medallion D (east end).

(37.) 48, 50, 57, C.

(38.) Fragments, Meleager, B.

(39.) Three Medallions, north side of D.

(40.) 48, 50, C ; fragments, border, east end of B.

(41.) Three Medallions, D (north side).

(42.) Europe, two pieces, and fragments, D.

(43.) Head of Sun, Medallion, D (south side).

(44.) Border of the same head.

(45.) Wreath, D (west gallery), broken.

(46.) Wreath, D ; fragments of Dido and Æneas, border (east end), B.

(47.) Corner border, A (broken).

(48.) Fragments, A ; ornaments, D ; Æneas, B.

(49.) Border (north-west corner), B.

(50.) Idem. (at side).

(51.) Circle round the Head of Sun, D (east side).

(52.) Head of Sun, with border, D (west side).

(53.) Dionysos, Nymph on Hippocamp, D.

(54.) Figure of Amphitrite, C.

CASKS.

(55.) Terra-cotta Figures, from Field of Chiaoux.

(56.) Painted Stucco, from Spratt's Platform.

(57.) Mosaics, from idem.

(58.) Painted Stucco, from idem.

(59.) Idem.

(60.) Terra-cotta Figures and Lamps, from Field of Chiaoux.

CASES.

(61.) Head from Well in Hadji Captan's Field ; nine Legs from Frieze, Mausoleum.

(62.) Fragments of Amphitrite, Mosaic.

(63.) Female Figure, Hadji Captan's Field.

(64.) Draped Male Figure, Mausoleum ; various fragments, idem.

(65.) Piece of Beam, idem.

(66.) Bust of Female Figure, Hadji Captan's field ; small fragments, Mausoleum.

(67.) Small fragments, Frieze of Mausoleum.

(68.) Idem.

(69.) Piece of Horse, Mausoleum, south-western side, corner of Ismail's house.

(70.) Architrave, not packed.

(71.) Part of Body of Draped Figure, Mausoleum ; various small pieces from Frieze.

(72.) Lion (lowest of the two at the north-west angle of the Castle).

(73.) Part of Draped Figure, piece of Cornice, pieces of Lion, pieces of Frieze, Mausoleum.

(74.) Piece of Body, Lion, Mausoleum.

(75.) Hind half of Lion, marked Γ, north side of Mausoleum, Mahomet's field.

(76.) Hind half of Lion, marked Δ, north side of Mausoleum, Omer's field.

(77.) Hind half of Lion.

(78.) Lion's Paw, many small fragments.

(79.) Three Lions' Paws, various fragments of Lions.

(80.) Piece of Frieze, various small fragments.

(81.) Three pieces of frieze, various small fragments.

(82.) Three pieces of Cornice, of which one is an angle-piece ; fragment of Lion's Mane.

(83.) Three pieces of Frieze, fragments.

(84.) Two pieces of Frieze, fragments of Lion.

(85.) Piece of Cornice with Lion's head, fragments of Cornice.

(86.) Three pieces of Frieze, of which one is the upper half of an Amazon, from Sulimon's house ; another is an Amazon, which has been photographed.

(87.) Cask, Inscribed Handles of Amphoræ, Terra-cottas.

(88.) Cask, fragments of Frieze and of Architecture.

(89.) Part of Inscription from Well south of Spratt's Platform, fragments of Frieze.

(90.) Part of Draped Figure, piece of Frieze, Foot and Base of Statue, various fragments.

(91.) Part of a Sepulchral Relief from the wall of a house on south of Theatre Hill.

(92.) Cask, fragments, chiefly from Lions' Heads in the Cornice.

(93.) Figure in a Chariot, from Frieze.

(94.) Horses, from Frieze.

(95.) Idem.

(96.) Piece of Frieze, Shoulder of Draped Figure, piece of Cornice.

(97.) Piece of Horse, from Frieze.

(98.) Piece of Lion, of smaller size than the rest.

(99.) Figure in a Chariot.

(100.) Piece of Shoulder of the Lion marked Γ (see No. 75, *ante*).

(101.) Tail of Colossal Horse, found in the modern boundary-wall between Imaum's and Omer's field, near Colossal Horse from the Pyramid.

(102.) Piece of Horse, Frieze.

(103.) Idem.

(104.) Hind quarter of Lion (west side).

(105.) Upper part of a Draped Statue, piece of Cornice ; fragments of Frieze ; Colossal Wrist, fragment of Limb.

(106.) Inscription from Cubical Block excavated in Field of Chiaoux, east side (see Plan).

(107.) Half of Inscription from the Well south of Spratt's Platform (see No. 89, *ante*).

(108.) Stone from the field of Hadji Ali, with Inscription relating to Priapus.

(109.) Piece of Lion, various fragments of Architecture and Sculpture.

(110.) Cask, chiefly Legs of Statues.

(111.) Cask, Legs and Arms of Statues and Lions.

(112.) Cask, fragments of Statues and Frieze.

(113.) Cask, fragments of Statues.

(114.) Cask, various fragments.

(115.) Two pieces from Lions, Figure from Frieze.

(116.) Piece of Marble, with Bronze Socket, from foundations, west side, Mausoleum, at the foot of the staircase.

(117.) Cask, various fragments of Sculpture.

(118.) Figure in a Chariot, from Frieze ; fragments of two Feet, in Sandals.

(119.) Bodies of two Dogs, fragments of Sculpture.

(120.) Cask, various fragments of Sculpture.

(121.) Piece of Marble, with Bronze Socket (see *ante*, No. 116).

(122.) Two fragments of Lion ; architectural fragments.

(123.) Two pieces of Lion ; fragment of figure from Frieze.

(124.) Cask, various fragments of Sculpture.

(125.) Idem.

(126.) Relief of Bacchus and Ariadne, from field near supposed site of Palace of Mausolus.

(127.) Cask, various fragments.

(128.) Idem.

(129.) Fragment of Lion ; fragment of Lioness ; Architectural fragments ; fragment of figure from Frieze.

(130.) Cask, various fragments.

(131.) Fragments from Frieze; arm from Statue; two Hands; fragments of Frieze; small figure purchased at Budrum durng visit of the "Medusa."

(132.) Piece of Cornice; fragment of ditto; piece of Lion's Claw; various fragments of Frieze; Eagle, presented by G. A. Masters, Esq., Her Majesty's ship "Gorgon."

(133.) Lion from castle, inside battlements.

(134.) Idem, from north side Mausoleum (see Nos. 75, 100, *ante*).

(135.) Leopard, from Castle.

(136.) Fragment of colossal Female figure, from waist to hips, from near the well, Omer's field, Mausoleum.

(137.) Hind-quarters of Lion, north side of Mausoleum.

(138.) Cask, various fragments, chiefly architecture.

(139.) Cask, various fragments, Frieze and Architecture.

(140.) Cask, various fragments, Sculpture.

(141.) Idem.

(142.) Mounted Amazon, Frieze, east side of Mausoleum.

(143.) Cask, various fragments.

(144.) Cask, various fragments, Frieze.

(145.) Colossal Female Head, Mahomet's field, north side of the Mausoleum.

(146.) Lion, from west wall, Castle.

(147.) Idem.

(148.) Capital of Column, north side of Mausoleum.

(149.) Slab of Frieze, three figures, east side of Mausoleum.

(150.) Lower half of Female figure (No. 1), Imaum's field, north wall of Mausoleum.

(151.) Various fragments of Frieze, Sculpture, and Architecture.

(152.) Various fragments, Frieze, Lions, Architecture.

(153.) Piece of Fold from statue, in Imaum's field, north side.

(154.) Various fragments, Lions and Frieze.

(155.) Various fragments, Lions, Architecture.

(156.) Various fragments, Lions, Sculpture, Architecture.

(157.) Various fragments, including several Heads and Extremities; pieces of Frieze; specimens of coloured Architectural Ornaments.

(158.) Various fragments, Frieze and Architecture, coloured.

(159.) Various fragments, Frieze and Architecture, including coloured specimens.

(160.) Piece of Lion; various fragments of Architecture and Sculpture.

(161.) Lion, from Imaum's field, north side of Mausoleum.

(162.) Cask, various fragments.

(163.) Idem.

(164.) Idem.

(165.) Part of Statue No. 2, Imaum's field, north side.

(166.) Cask, fragments, chiefly from Capitals.

(167.) Cask, various fragments.

(168.) Idem; Inscription to Priapus (see No. 108, *ante*).

(169.) Idem.

(170.) Part of Statue No. 2, Imaum's field, north side of Mausoleum.

(171.) Cask, seven pieces from Statue No. 2, Imaum's field, north side.

(172.) Statue No. 1, Imaum's field.

(173.) Cask, fragments of Statue No. 2, Imaum's field, north side.

(174.) Cask, fragments of Lion, Imaum's field, north side.

(175.) Horse's Head; various fragments of Sculpture and Architecture, from Imaum's field.

(176.) Head of Apollo, in four pieces, Imaum's field, north side; various small fragments from the same place.

(177.) Ionic Capital from Castle, supposed to be from Mausoleum.

(178.) Inscription from Temple of Apollo, Calymnos.

(179.) Piece of Statue No. 2, Imaum's field.

(180.) Idem.

(181.) Metallic objects and Sculpture, chiefly from Mausoleum.

(182.) Three pieces of Base of Column, pieces of Egg-and-tongue Moulding.

(183.) Piece of Cornice, fragment of Lion, piece of Egg-and-tongue Moulding.

(184.) Three pieces of an Inscription from Well in Saleh Bey's garden, east of Field of Chiaoux.

(185.) Arm of Statue No. 1, Imaum's field; Leg of Lion, from idem.

(186.) Two pieces of Frieze, fragments of Statue in Imaum's field.

(187.) Two fragments from Great Equestrian Figure.

(188.) Alabaster Vases, from west side of the Mausoleum; Terra-cottas from ditto.

N.B. This case, containing the *alabastrum* with the name of Xerses, has been consigned to the special care of Commander Towsey.

(189.) Cask, fragments of Colossal Horse and Lion, Imaum's field, including Horse's Hoof.

(190.) Cask, fragments of Sculpture from Imaum's field; one piece from Hadji Captan's field, marked H. C.

(191.) Case, various small fragments, among which are two portions of a Female Head, Imaum's field.

(192.) Several Lions' heads from Cornice, Imaum's field; various fragments, including a Bearded Head, found in a shaft, west side of the Mausoleum.

(193.) Various fragments, Frieze.

(194.) Idem.

(195.) Piece of Cornice, Imaum's field; piece of Lion, from road north of north-est corner of Mausoleum.

(196.) Two Feet, in Sandals; various fragments; Imaum's field.

(197.) Half of Horse's Head, with Bronze Bit, from *quadriga* on Pyramid east of Imaum's field (for the other half of this Head, see *ante*, No. 175).

(198.) Piece of Lion, various fragments of Lion, Imaum's field.

(199.) Piece of Lion, various fragments of ditto.

(200.) Foot of Colossal Horse, various fragments of ditto (see *ante*, Nos. 197, 175, and 189), Imaum's field.

(201.) Head of Lion, fragment of Lion, from idem.

(202.) Piece of Frieze, east side of Mausoleum; fragments, Imaum's field.

(203.) Fragments of Frieze, several fragments, east side of Mausoleum.

(204.) Slab of Frieze. east side of Mausoleum. This case contains a fragment of a Horse's Foot, from next slab.

(205.) Slab of Frieze, east side of Mausoleum.

(206.) Cask, fragments of Statues, Imaum's field, including Hand of Colossal Figure.

(207.) Fragments, chiefly of Lions, from idem.

(208.) Two Lions' Feet, various fragments from east and north sides of Mausoleum.

(209.) Two fragments of Draped Figures, various fragments from north and east sides of Mausoleum.

(210.) Fragments of Frieze, Architectural Mouldings, from north and east sides of Mausoleum.

(211.) Colossal Head, smaller Bearded Head, from east side of Imaum's field.

(212.) Cask, Inscribed Handles of Amphoræ, and small Terra-cotta Figures.

(213.) Cask, Hand and Arm, in three pieces, from Temple of Apollo, Calymnos; piece of Inscription from same Temple; three fragments of an Amazon, from Mausoleum Frieze, found near slab of Frieze No. 205, east side; various fragments, east end, north side of Mausoleum.

MARBLES, WITHOUT CASES.

(214.) Colossal Equestrian Figure, Mausoleum, centre.

(215.) Colossal Seated Female Figure, Mausoleum, east side.

(216, 217.) Two Halves of the Body of Colossal Horse, Mausoleum.

(218.) Portion of Ionic Column next the Base, Mausoleum.

(Signed) C. T. NEWTON.

No. 12.

Vice-Consul Newton to the Earl of Clarendon.—(Received August 23.)

My Lord, *Budrum, July* 15, 1857

IN the letter in which I had the honour to submit to your Lordship the first project of an excavation here, I stated that there were at Budrum two localities, both of which presented claims to be considered the site of the Mausoleum; one of these being the platform surveyed by Captain Spratt, and marked Mausoleum in his chart, the other, a much larger platform, surrounded on the east and south sides by a terrace-wall, and situated in the square C, D, 7, 8, of the chart, very near the northern wall of the ancient city.

This platform, from its extent, commanding position, and the massiveness of the terrace-wall which bounds it, has attracted much notice from travellers. Mr. William Hamilton and, more recently, Dr. Ross, a distinguished German archæologist, considered this as the most probable site for the Mausoleum. Captain Spratt, on the other hand, marks it in his chart as the site of the Temple of Mars, mentioned by Vitruvius in his description of Halicarnassus, and I have expressed the same opinion in my Memoir on the Mausoleum, published in the Classical Museum some years ago.

On examining the site itself, it was evident to me that an Ionic edifice of considerable dimensions had once stood in the centre of the platform.

Several *frusta* of Ionic columns of fine white marble, and 4 feet in diameter, were lying on the surface in this part of the platform. I have the honour to inclose a photograph of one of these. A little west of the same spot the outlines of the foundations of an oblong edifice were indicated by ridges in a field planted with figs, which is marked in Spratt's chart, the foundations being laid down in dotted lines.

After making the discovery that the site of the Mausoleum was not on this platform, but lower down the hill, in square F, G, 6, 7, of the chart, I was confirmed in my original opinion that the Temple of Mars must be looked for where it is placed by Captain Spratt, that is to say, on the upper platform, C, D, 7, 8, of the chart. With a view of ascertaining this fact, I detached a small party in February last to dig that part of the platform where the dotted lines of foundations are marked in the chart, and which lies immediately west of the *frusta* of Ionic columns.

The result of this excavation was as follows: the upper surface of the ground was covered with small splinters of fine white marble, below which the soil principally consisted of boulder stones and decayed rock, evidently brought down by torrents from the heights above. Digging through this mass of rubble we found below it, at a depth varying from 8 to 12 feet, the native rock cut into beds and levels to receive the foundation walls and pavement of a large building. As the ground was cleared away, massive foundation-walls were laid bare, of which I inclose a plan, reduced by photography from the original drawing by Lieutenant Smith. The foundations are those of an oblong edifice, which has been traced from west to east for 57 feet, and, probably, extended originally about 20 feet further in an eastern direction towards the *frusta* of columns already mentioned. The width of these foundations is 35 feet. At the western end is a line of wall, 8 feet in width, composed of large oblong blocks of coarse freestone rock, such as were used by the Greeks for the foundations of their temples, and were, in this instance, quarried out of the stratum in the

F 2

Inclosure in No. 9.

Invoice of Antiquities shipped on board Her Majesty's steam-ship "Supply," from June 24, 1857, to September 26, 1858.

[The numbers in this invoice are continued from the last number in the previous invoice sent home with Her Majesty's ship "Gorgon."]

(219.) Piece of Architrave, north side of Mausoleum.

(220.) Idem.

(221.) Idem.

(222) Step from Mausoleum Pyramid, north side of Mausoleum.

(223.) Drum of Mausoleum Column, Imaum's Field, north side of Mausoleum.

(224.) Idem.

(225.) Inscription on Limestone Slab, road at foot of Theatre Hill, north-east of Mausoleum.

(226.) Part of Pedestal of a Colossal Figure, elliptical marble, both from Imaum's Field, piece of panel which has contained a relief, Mausoleum.

(227.) Marble, with a hollow square cut in it, perhaps from apex of Pyramid, Imaum's field, Mausoleum.

(228.) Step from Pyramid, indidem.

(229.) Square marble, with step cut in it, perhaps from apex of Pyramid; marble in form of tile, indid.

(230.) Square marble, with fine joint, perhaps from apex of Pyramid, indid.

(231.) Piece of Architrave, indid.

(232.) Marble step, indid. eastern side.

(233.) Idem.

(234.) Idem.

(235.) Part of a draped Female Figure, Imaum's field, Mausoleum.

(236.) Inscription from Turkish House, west side of Budrum, near the Lazaretto.

(237.) Colossal Female Head, found in chimney of Imaum's house, north side of Mausoleum.

N.B.—As this head is veiled, it may belong to the female figure found under the Pyramid stones at the side of the male figure, supposed to be Mausolus.

(238.) Head in Phrygian cap; Lion's Paw; Hadji Nalban's field, south side of Mausoleum.

(239.) Inscription from Koja Mahomet's field, Eastern Cemetery, Budrum.

(240.) Sepulchral Inscription from a Turkish house, west side of Budrum.

(241.) Inscription relating to Stoa of Ptolemy, and Apollo, from house below Eastern Peribolus wall, Mausoleum.

(242.) Fragment of Inscription, No. 241, *supra*.

(243) Angle Pyramid Step, Imaum's field.

(244) Leopard, Mahomet's field, north side of Mausoleum.

(245.) Lion's head, indid.

(246.) Marble beam, north side of Mausoleum.

(247.) Idem.

(248.) Inscription, Epitaph of the Physician Melanthios, from field near north wall of ancient city, Budrum.

(249.) Part of Draped Female Figure, Hadji Nalban's field, north side of Mausoleum.

(250.) Piece of Capital, Mahomet's field, north side, indid.

(251.) Part of Capital, indid.

(252.) Upper piece of Architrave, indid.

(253.) Contains the following :—

1. Male Torso, Parian marble, found in a garden wall, Cos.

2. Marble Casket, Mahomet's field, north side of Mausoleum.

3. Piece of marble, with mitre joint, Mausoleum.

4. Piece of Capital, north side, indid.

5. Part of Stèlè, with relief representing Apollo Musegetes, Ishmael's house, south-west angle of Mausoleum.

6. Angle of sunk panel, with Foot in relief, Mausoleum.

7. Part of Horse's Hoof, indid.

8. Piece of Base Moulding, unfinished, Mahomet's field, Mausoleum.

9. Various fragments of Lion's tails, indid.

10. Various fragments, Frieze and Lions.

11. Torso of naked male figure in Parian marble, found in a wall, Cos.

12. Five pieces of Draped Statue, from same wall.

13. Three fragments of Sculpture, indid.

14. Piece of Lion's Shoulder, Mausoléum.

15. Piece of Body of same, indid.

16. Part of Base of Female Figure, indid.

17. Part of Draped Female Figure, indid.

18. Part of Lion's Back, indid.

19. Piece of Lion's Shoulder, with mane, indid.

20. Fragment of Frieze, indid.

21. Piece of Drapery, indid.

22. Part of Head, indid.

(254.) Contains the following :—

1. Nave of Chariot Wheel, Mausoleum Quadriga.

2. Several pieces of Spoke of same Wheel.

3. Hough joint of Colossal Horse, from Quadriga. (All the above fragments were found in Hadji Nalban's field, on the south side of the Mausoleum.)

4–7. Three Mouldings, Mausoleum.

8. Several Lion's Heads, from cornice, indid.

9. Several Lion's Legs, indid.

10. Two fragments from Frieze.

11. Sheep's Head, south side of Mausoleum.

12. Part of Face, with Eye, indid.

(255.) Youthful Male Head, indid.

(255.) Contains the following :—

1. Piece of Capital, Mahomet's field.

2. Youthful Female Head in Phrygian cap, indid.

3. Neck of Statue, Hadji Nalban's field, south side.

4. Angle fragment of Cornice, Mahomet's field.

5. Neck, Mausoleum.

6. Piece of Draped Shoulder.

7. End of Leopard's Tail on base.

8. Piece of Felloe of Wheel from Mausoleum Quadriga, from north-east angle of Peribolus.

(257.) Cask, Inscribed Handles of Diotæ, coarse Terra-cotta Heads; Mausoleum, Peribolus.

(258.) Female Statue, purchased at Smyrna for the British Museum, found near Clazomenæ

(259.) Inscribed Base, found with the above statue.

(260.) Part of the same.

(261.) Cask containing various fragments of the Mausoleum, chiefly from the north side, including two Necks found under Mehemet Ali's house, north-east angle of Peribolus.

(262.) Contains various fragments, including

pieces of Marble Phialæ, and of a Bowl, found in Mahomet's field, north side; and part of the Cheek of a Statue, life size, Hadji Nalban's field, south side Mausoleum.

(263.) Cask, Handles of Diotæ, inscribed with magistrates' names, from Mausoleum, Peribolus.

(264.) Various fragments of Sculpture and Architecture from the Mausoleum, including fragment of an Inscription from Salik Bey's garden, No. 184, *supra*; Head of Hercules, purchased at Budrum; two small Statues from Cos.

(265.) Various Terra-cottas, from Mausoleum and Budrum diggings; metallic objects; two Bronze Dishes, found with Marble Phialæ in Mahomet's field, north side of Mausoleum; fragments of Inscription relating to Stoa of Ptolemy, No. 241; fragments of Statues.

(266.) Cask, Handles of Diotæ.

(267.) Cask, Lamps from Tombs, Cnidus.

(268.) Idem.

(269.) Upper part of Statue of Demeter, found in Tomb of Lykœthios, Cnidus; small terminal figure, indid.

(270.) Term, found in Temenos of Persephone, Cnidus, with Nos. 271, 278, 280, 282.

(271.) Seated Female Figure, indid.

(272.) Fragment of Draped Statue, from Temple supposed to be of Bacchus, Cnidus.

(273.) Inscribed Base, back of Lower Theatre, Cnidus.

(274.) Inscribed Base, found at entrance to Lower Theatre, indid.

(275.) Inscription, with names of two artists, back of Lower Theatre, indid.

(276.) Head of Statue, from Tomb of Lykœthios; fragments of Inscriptions, indid; fragments of Sculpture from Temenos of Persephone, viz.: one Arm, two pieces of Drapery, a small Term, a Ram's Head, Base of Neck, three fragments.

(277.) Group of Eros and Psyche, embossed on bronze handle of vase; two Bronze Vases, said to have been found with the handle in a tomb in the Island of Telos.

(278.) Base inscribed with metrical dedication to Persephone, from Temenos of Persephone, Cnidus.

(279.) Body of Figure from Tomb of Lykœthios.

(280.) Base inscribed with dedication to Persephone, Temenos of Persephone, Cnidus.

(281.) Lion's Head from Mausoleum, found in garden wall, north of north side of Peribolus.

(282). Female Head; small figure of Persephone, and fragments as follows: Female Arm and Hand, two pieces; Female Hand in two pieces; Female Arm and Hand, in three pieces; part of Female Foot; part of several Female Hands; various fragments; all from Temenos of Persephone, Cnidus.

(283.) Lion's Head; fragments of Lion; fragments of Frieze in panels, from Mehemet Ali's field, north-east angle of Mausoleum, Peribolus; Box containing specimens of Building Materials used in Mausoleum; Inscribed Handles of Vases.

(284.) Pyramid Step, Mehemet Ali's field, north-east angle of Mausoleum, Peribolus.

(285.) Fragment of Draped Colossal Figure, east side of Mausoleum; various fragments from idem; inscribed Handles of Vases.

(286.) Head of Demeter, from Temenos of Demeter and Persephone, Cnidus.

(287.) Legs of Draped Female Figure, found in the town of Cos.

(288.) Two Marble Footstools, inscribed with dedication to Persephone, Temenos of Persephone.

(289.) Inscription from Temenos of Temple of Apollo, Calymnos.

(290.) Cask, Inscribed Handles of Diotæ, Cnidus and Budrum.

(291.) Various antiquities:—

First Division.—Antiquities of the Roman period, found in a tomb at Carpathus, purchased at Rhodes for the British Museum:

1. Large Hydria of coarse drab-coloured ware.
2. Two Oinochoæ, same kind of ware.
3. One small two-handled Glass Cup, broken.
4. One Glass Alabastron.
5. One Saucer, red varnished ware.

Second Division.—Carpathos Antiquities:

6. Small Marble Figure of Venus.
7. One Bronze Mirror.
8. Two broken ditto.
9. One broken ditto.
10. One Bronze Handle.
11. One Bronze Ring.

Third Division.—Antiquities from Temenos of Demeter and Persephone, Cnidus.

Ten small Terra-cotta Figures of Hydrophori.
Eleven Lamps, one broken.
Shell, found in a tomb.
Fragments of a Glass Vase.
Two specimens of Cement, coloured blue, from niche in rock.

(292.) Ridge Tile, from grave, Temenos of Persephone, Cnidus.

Fragments of Leaden Plates, found near Statue, idem.

Six Terra-cotta Bulls, found at Datcha, near Cnidus.

Fifteen Lamps, from tomb of Lykæthios, idem.

(293.) Contains—

1. Angle from Chair of seated Female Figure. Temenos of Persephone.

2. Figure of Demeter (?), in two portions, found in a Roman building supposed to be baths, Cnidus.

3. Marble sculptured, in form of a vase, with inscription and wreath in relief, from Rhodes.

4. Breast of Male Figure, Budrum.

5. Part of Head in relief, indid.

6. Two Fragments, perhaps of Terms, Temenos of Persephone.

7. Fragment of Leg, in high relief, basalt (?), found in excavation, Cnidus. (K of Index Chart.)

8. Fragment of Hand, Temenos of Persephone.

9. Two Fragments of Inscription, No. 295.

10. Fragment of Archaic seated Figure (?), Cnidus.

11. Base of Figure of Hekate Triformis, Temenos of Persephone.

12. Breast of small Statue of Archaic seated Figure, indid.

13. Fragment of Head, Elliptical Chamber, indid.

14. Fragment of Inscription, No. 295.

15. Five Pieces of Bases, Elliptical Chamber, Temenos.

16. Sandalled Foot, indid.

17. Pieces of Veneered Marble, from Tomb of Lykæthios.

(294.) Eight Skulls, indid.

(295.) Inscription, found near supposed Temple of Venus, Cnidus.

(296.) Miscellaneous Antiquities, as follows:—

1. Terra-cottas; six Heads, two Feet, one Arm, one Fragment of Lyre, all found in deep diggings, Mausoleum, Peribolus.

2. Terra-cotta Head, found in mine under Hadji Nalban's house, south side of Mausoleum.

3. Small Ivory Pendant, in the form of an Elephant, found on the top of the eastern wall of the Peribolus, Mausoleum; four Ornaments, found in a tomb at Carpathos, with the objects specified *supra*, No. 291, Second Division. They consist of the following:—One plain

Gold Earring; two Hooks of Gold Earrings; one Gold Ring, with intaglio representing a Raven; one plain Gold Ring, with carbuncle (?), uncut; one Carnelian Intaglio, representing warrior seated to left; one Intaglio, representing a Lion galloping to the right; three Roman third Brass Coins, one of which is struck by Septimus Severus. The above objects, with those in No. 291, from Carpathos, were purchased for the British Museum.

4. Four Terra-cotta Heads, found in deep diggings, within Mausoleum Peribolus; circular Onyx for broach, found in north-west gallery, Mausoleum; small Leaden Ornament, representing a mounted figure, found in chamber, south side, Mausoleum.

5. Part of small Ivory Box, found within Peribolus of Mausoleum.

6. Part of Jade (?) Handle, found in north-west gallery, Mausoleum; part of Byzantine Fibula, with Winged Monster in relief, purchased at Cnidus; Ivory Ring, Bronze Key, two Bronze Ornaments, Fragments of Inlaid Glass; all found in excavations.

7. Part of Dionysiac Mask, in copper; part of Circular Bronze Fibula, Leaden Face in relief, found in Peribolus of Mausoleum; Ivory Counter, from Theatre, Cnidus; small piece of Gold, Bronze Ring, Glass Bead, Crystal Pendant; two Bronze Studs, or Bullæ.

8. Eight Bronze objects.

9. Bronze Armlet, found in excavations, Cnidus.

10. Small Figure of Dionysos, cast in bronze, purchased at Budrum.

11. Iron Key, excavations, Cnidus.

12. Head of Bronze Nail, indid.

13. Packet of Coins, 1 to 93, as follows :—

1. Alexander III, Æ, purchased at Lagina.
2. Philip III, Æ, purchased at Eski Hissar.
3. Idem.
4. Cassander, Æ, indid.
5. Philip III, Æ, indid.
6. Antigonus, Æ, indid.
7. Bœotian, Æ, purchased at Calymnos, said to have been brought from Thoriko, near Oropo.
8. Mytilene, Æ.
9. Erythræ, Æ.
10—17. Miletus, Æ, purchased at Geronta.
18. Miletus, Tiberius (?) indid.
19. Chios, Æ.
20. Alabanda, Æ.
21. Aphrodisias, Æ.
22. Cnidus, Æ.
22—33. Cnidus, Æ.
34. Cnidus, Æ, found in Temenos of Persephone.
35—47. Halicarnassus, Æ.
48. Halicarnassus, Æ, found in Mausoleum.
49—54. Mylasa, Æ.
55. Myndus, Æ, not in Mionnet.
56—8. Myndus, Æ.
59. Myndus, Nero (?) Æ.
60. Idem, Sept. Severus and Julia Domna, Æ.
61—79. Stratonicæa, Æ.
80. Idem, Antoninus, Æ.
81. Idem, Sept. Severus and Julia Domna.
82. Mausolus, plated.
83. Cos, Æ.
84. Idem.
85. Cos, Augustus, Æ.
86. Calymna, Æ, purchased at Calymnos.
87. Electrum, unascertained, purchased at Budrum.
88. Unascertained Lycian or Carian.
89. Unascertained, Æ, purchased at Budrum, from Kerowa.
90. Patara (?) Æ.
91. Unascertained Ptolemy.
92. Impression in lead, Byzantine die.
93. Leaden coin or token.
94. Eleven unascertained coins, Æ, purchased in Caria.
95. Fifteen ditto.
96. Four unascertained Coins, purchased at Eski Hissar.
97. One Turkish coin; one Venetian ditto, Æ.

14. Small Glass Pendant, Mausoleum; piece of inlayed Glass from excavation; Colour from flute of column, Mausoleum.

15. Bottle containing blue colour, from moulding, Mausoleum.

16. Head of Mule, Terra-cotta, Vomitory of Lower Theatre, Cnidus.

17. Fragment from Mane of colossal Lion, Cnidus.

18. Mould in Vomitory of Lower Theatre, Cnidus, perhaps for striking tickets.

19. Comic Mask, Terra-cotta, Lower Theatre, Cnidus.

20. Grotesque Terra-cotta Head, Lower Theatre, Cnidus.

21. Fragment of Roman Phiala in red glazed ware, on which has been a group in relief, probably Hercules taking the golden apples of Hesperus, Cnidus.

22. Honeysuckle ornament, Handle of Terra-cotta Lamp, Cnidus.

23. Grotesque head of Ape, Lower Theatre, Cnidus.

24. Terra-cotta Hand.

25. Fragment of marble Phiala, Temenos of Persephone, Cnidus.

26. Forty-four fragments of Pottery from Vomitory of Lower Theatre, Cnidus.

(297.) Inscription from Lower Theatre, Cnidus.
(298.) Idem.
(299.) Fragment of an Inscription in elegiac verse, indid.
(300.) Colossal Lion; Tomb on Promontory; Cnidus.
(301.) Sepulchral Cippus, with Snake in relief, Cemetery outside Eastern wall, Cnidus.
(302.) Inscribed base of same.
(303.) Byzantine inscribed base, indid.
(304.) Two marble Pigs; fragments of their Legs and Snouts; a fold of Drapery and several other fragments; Elliptical Chamber, Temenos of Persephone.
(305.) Two Calves; several fragments of base from Elliptical Chamber; fragment of Drapery from north of Tomb in western part of Temenos, Cnidus.
(306.) Inscription - Dedication by Diokleia; three fragments of the same; base of term; three fragments of the same—Elliptical Chamber, Temenos.
(307.) Two small Pigs; one base, probably of figure of Hekate Triformis; base of term, with dedication by a priestess; lower part of same term limestone base, with dedication by Xeno to Demeter and Persephone—Elliptical Chamber, Temenos.
(308.) Head of Aphrodite (?) found in Western part of Temenos of Persephone, at the side of the square foundation; marble Calathus; long piece of term; hind legs of Calf; small female Head; piece of base—all from Elliptical Chamber, Temenos.
(309.) Three fragments of Inscription No. 295; fragments of a neck and face—west side of Temenos. Base of Pig; piece of Drapery; three fragments of bases; head of term; fourteen pairs of breasts; one pair of Cupid's heads—Elliptical Chamber, Temenos.
(310.) Forty-four Glass Bottles, bottom of Elliptical Chamber, Temenos.

(311.) Seated Male Statue, inscribed "Chares," from Sacred Way, Branchidæ (Geronta).

(312.) Lion, inscribed, indid.

(313.) Female Figure, indid.

(314.) Small Female Figure, in a later style of sculpture, indid.

(315.) Seated Female Figure, inscribed at back of chair ΝΙΚΗ ΓΛΑΥΚΟΥ, indid.

(316.) Sphinx, indid.

(317.) Seated Male Figure, inscribed with the name of an artist, partly effaced, indid.

(318.) Small seated Female Figure, with traces of an inscription on the back, indid.

(319.) Seated Male Figure, differing from the rest in the arrangement of the drapery, indid.

(320.) Seated Male Figure, the chair anciently mended with lead.

(321.) Inscription, in very Archaic characters, recording the dedication, by the sons of Anaximander, of some work of art made by Terpsikles. From south-east extremity of Sacred Way at Geronta, near the last seated figure in his direction.

(322.) Cube of Marble, with Agonistic inscription, from field a little to south-east of Sacred Way, Geronta.

(323.) Door-jamb, or Parastas, inscribed, from ruins at Kara Köi, near Geronta.

(324.) Similar Door-jamb.

(325.) Marble, with inscription, recording the bringing of an ivory door from Alexandria as an offering in the Temple of Apollo at Branchidæ; from ruined Church of Panagia, on road from Geronta to Kara Köi.

(326.) Agonistic Inscription, recently discovered in Byzantine foundations outside the village of Geronta, to the south-east of the Temple.

(327.) Head from Statue of Demeter, Temenos, Cnidus.

(328.) Statue of Demeter, Temenos, Cnidus, discovered with Head No. 327.

(329.) Base of Statue of Demeter, No. 328, with votive inscription, recording dedication by Nikokleia, the daughter of Nikokoros.

(Signed) C. T. NEWTON.

Also, 160 Marble Blocks, from north wall of Mausoleum, Peribolus.

C. T. N.

Ruins of Cnidus, September 26, 1858.

No. 10.

Vice-Consul Newton to the Earl of Malmesbury.—(Received November 13.)

My Lord, *Ruins of Cnidus, October* 1, 1858.

AFTER the removal of the colossal lion in the month of June last, as reported in my despatch of the 1st of July, we proceeded to clear out the tomb near which the lion was discovered, and from the summit of which it had evidently fallen.

As an immense mass of ruins had to be removed, this operation occupied a large force from July 1 to August 15.

I have already, in previous despatches, described this tomb generally. As it has been now completely explored, I am enabled to present a more exact report on its design, and the details of its architecture.

The tomb, as I have previously stated, originally consisted of a basement surmounted by a pyramid, the inner structure of both of which is built of blocks of travertine resting on a foundation of travertine and marble intermixed.

Externally this core of travertine masonry has been faced with marble.

Within the basement is a circular chamber, 17 feet 7 inches in diameter, which had been originally covered over with a vault laid in horizontal courses. The greater part of this roof had fallen in, and, at the commencement of our operations, choked up the chamber with its ruins.

The apex of this vault had been bridged over by an immense circular stone, an outline and section of which are given, Fig. 3 of the tracings and drawings of Mr. Pullan, which I have the honour to inclose.

This stone measures 6 feet 3½ inches in its greatest diameter, and 2 feet 2 inches in thickness; its smaller diameter being 5 feet 4 inches.

In its original position on the crown of the arch its greatest diameter must have been lowermost, so that its form would be that of a bung inverted. In the account by Pausanius, of the Treasury of Minyas, at Orchomenos, he seems to describe such a structure of roof—

" Λίθου μέν εἴργασται, σχῆμα δὲ περίφερές ἐστιν αὐτῷ, κορυφὴ δὲ οὐκ ἐς ἄγαν ὀξὺ ἀνηγμένη, τὸν δὲ ἀνωτάτω τῶν λίθων φασὶν ἁρμονίαν παντὶ εἶναι τῷ οἰκοδομήματι.—(ix, 38, 2.)

The present height of the walls of the chamber is 17 feet; the height of the horizontal vault which rested on these courses cannot now be ascertained.

Up to the height of 4 feet from the ground, the wall is composed of large

Reconstruction of contents of cases

Case no.	Catalogue nos	Case no.	Catalogue nos	Case no.	Catalogue nos
(8.)	591	(80.)	188, 372, 391, 406, 604	(117.)	113, 117, 126, 137, 169, 176, 186, 189, 441, 479, 480, 481, 503, 504, 505, 506, 613, 614, 727, 733, 767
(13.)	723	(81.)	720		
(14.)	343, 345, 683	(82.)	178, 605		
(21.)	468	(83.)	121, 284, 556, 606, 786		
(23.)	270				
(24.)	283				
(41.)	729	(85.)	182, 500, 677	(118.)	59, 96, 209, 210, 309
(43.)	592	(86.)	175, 558, 607	(120.)	60, 139, 161, 190, 193, 274, 275, 381, 475, 653
(47.)	336	(88.)	220, 708		
(48.)	593	(90.)	198, 608		
(50.)	738	(91.)	702		
(60.)	749	(92.)	450, 698, 718	(121.)	183, 501
(61.)	214, 488, 594, 595	(93.)	241	(122.)	721
(63.)	42, 444	(94.)	659	(123.)	533, 747
(64.)	127, 196, 418, 422, 596, 597, 598, 766	(95.)	609	(124.)	173, 547, 680, 731
		(96.)	66, 705, 775	(125.)	105, 181, 339, 493, 548, 670
(66.)	384, 396	(98.)	372		
(67.)	153, 233, 448, 752, 768	(100.)	411	(126.)	81, 148, 725
		(101.)	2	(127.)	41, 133, 197, 230, 255, 476, 676, 769
(68.)	379, 599, 600, 648	(105.)	11, 62, 307, 744		
(69.)	221, 299, 385, 386, 601, 675, 717	(107.)	549	(128.)	134, 314, 338, 341, 421, 437, 697, 726
		(109.)	256, 305, 430, 467	(129.)	374
(71.)	330, 502	(110.)	115, 119, 168, 170, 178, 180, 191, 610	(130.)	235, 253, 323, 696
(73.)	68, 91, 563, 602			(131.)	145, 146
(75.)	266, 411, 445	(111.)	40, 125, 147, 269, 375, 478, 489, 611, 612, 743	(132.)	433
(76.)	416, 561			(134.)	411
(78.)	509, 750			(135.)	247, 371
(79.)	399, 436, 440, 443, 499, 559, 564, 603, 782	(112.)	163, 179, 217, 498	(136.)	29, 106, 655
		(115.)	315, 377, 673	(137.)	316
				(138.)	656

Case no.	Catalogue nos	Case no.	Catalogue nos	Case no.		Catalogue nos
(139.)	11, 317	(189.)	6, 16, 199, 432, 439, 464, 562		11.	796.
(140.)	520				12.	795
(141.)	16, 18, 20, 263	(190.)	525, 616		13.	797, 798
(143.)	264	(191.)	74		15.	517
(145.)	30	(192.)	47		18.	408
(146.)	82, 748	(193.)	469, 714		19.	376
(149.)	84	(195.)	149, 223, 320, 337, 496, 512, 617–624, 684		20.	361, 446, 485, 650, 715
(150.)	27, 36, 116, 232, 554					
(152.)	12, 21, 568				21.	308
(154.)	69, 90	(197.)	1		22.	52, 63
(156.)	101, 424	(198.)	625	(254.)		270, 691
(157.)	311, 457, 701	(199.)	342, 428, 456	(254.)	1.	24a
(158.)	35, 261, 359, 378, 459, 722	(200.)	8, 15, 472, 484		2.	24b, d, e, f, g
		(202.)	136		3.	10
(160.)	544	(203.)	124, 132, 143	4–7.		370
(161.)	257, 474	(206.)	26, 142, 166, 172, 211, 358, 363, 674		9.	429, 486, 490
(162.)	95, 205, 234, 369, 739				10.	254
(163.)	131	(207.)	24k, 452, 453		12.	57
(164.)	102, 104, 219, 609	(208.)	202, 357, 434, 626	(255.)		46
(165.)	26, 287, 288	(209.)	455	(255.) (sic)		546
(167.)	778	(211.)	26, 45		2.	50
(168.)	543, 651, 777	(213.)	67		5.	55
(170.)	26	(214.)	34		6.	160
(171.)	26, 78, 332	(215.)	33		8.	24c
(172.)	27	(216–17)	1, 2	(260.)		26
(173.)	26, 245, 271	(226.)	23, 25	(261.)		53, 129, 228, 301, 333, 346, 458, 565, 663, 664, 671, 685
(174.)	466	(235.)	43, 719			
(175.)	1, 280, 615	(236.)	216			
(176.)	48, 447	(237.)	31, 329	(262.)		58, 259, 300, 528, 545, 649, 704, 764, 765, 770, 771, 772
(177.)	208	(238.)	49, 426			
(179.)	26, 28	(244.)	360			
(180.)	26, 312	(245.)	412	(264.)		344, 400, 566, 672, 713
(181.)	34, 111, 144, 151, 158, 669, 688, 694	(249.)	44			
		(250.)	244	(281.)		414
(182.)	460	(253.)	152, 174, 194, 218, 394, 431, 442, 463, 519, 560, 577	(283.)		364, 403, 435
(183.)	389			(285.)		64, 203
(184.)	122					
(186.)	594, 707	(253.)	7. 107			
(187.)	34		9. 128, 495, 578–590			

APPENDIX II

Extracts from Lieutenant R. M. Smith's diary concerning the sculptures in the round

Numbers in parentheses refer to the present catalogue.

1856

December

Mon. 29. Discovered a lion's mane in the wall of a house in Smith's platform.

1857

January

Week ending Sat. 10th. Discovered statue of a female figure, and a Colossal Equestrian Statue. (42 and 34)

Week ending Sat. 17th. Discovered a marble head in the passage, and pieces of a lion and an architrave. (47?)

Tues. 20th. Piece of a lion found.

March

Mon. 2nd. Found some fragments of the Equestrian Statue at the Mausoleum. (34 et seq.)

Sat. 14th. Found half a lion at the Mausoleum. (411? Cf. case no. 75)

Tues. 17th. Found half a lion—very fine—on north side of Mausoleum. (416, cf. case no. 76)

Thurs. 19th. Taking out the lions in the castle.

20th. Ditto.

21st. Got out the last of the lions in the castle.

Tues. 31st. Forepart of a lion found at the Mausoleum. (411. Case no. 100; cf. 134)

April

Thurs. 2nd. Found Colossal marble statue of a female figure sitting in a Chair, at the Mausoleum. (33)

Thurs. 16th. Filling in at the Mausoleum the central area being all dug. Laying down the N. & E. sides of the excavations.

Fri. 17th. At Mausoleum discovered the head of a large female Statue in a very good state of preservation. It was lying just above the newly found Greek wall on the north side. (30)

Mon. 20th. Found part of the head of a statue. (26?)

Tues. 21st. Found some other pieces of the head. (26?)

Thurs. 23rd. Found a lion almost perfect, behind the marble wall on the North side of the Mausoleum. . . . Part of another Statue showing on the surface. (401 and 27)

Fri. 24th. At the Mausoleum found that what showed above ground was a splendid female figure. From the neck to the knees almost entire. (27)

Sat. 25th. Near the same place at the Mausoleum found the lower part of the figure found yesterday. (27)

Mon. 27th. Taking out another statue of a female figure at the Mausoleum. Discovered a colossal horse near the same place, also a lion's head and some fragments. (26, 2, and 406?)

Tues. 28th. Commenced clearing out for the large horse. Took out and brought down half the female figure found yesterday. (2, 26)

Wed. 29th. Clearing out the horse. Took out and brought down two pieces of another Statue. (2, 26?)

Thurs. 30th. Clearing out the large horse. Got him ready for slinging. (2)

May

Fri. 1st. Got the large horse slung and the way cleared. Commenced pulling down Ahmet's second house on the East side of the road. (2)

Thurs. 7th. Found the forequarters of the large horse. (1)

Fri. 8th. Uncovering the forequarters of large horse at North side of Mausoleum. (1)

Sat. 9th. Got out the fore quarters of the large horse, and found part of a lion, the head and neck, near the same place. (1, 402)

June

1st. At the Mausoleum found the fore part of the head of the large horse and the head of the figure in the quadrangle. (1, ?)

Thurs. 9th. Found a head, the face almost perfect, under the Kodja Kare's house. (45)

Tues. 30th. Found head, part of a statue, and a lion's claw at the Mausoleum.

July

Wed. 1st. Found a rough Greek male on the north side close to the road.

August

Fri. 7th. Found a tiger or leopard in Mehemet's field. (360)

Sat. 8th. Found a lion's head and shoulders in Mehemet's field. (412).

APPENDIX III

Extracts from Biliotti's diary of the Mausoleum excavations, 1865, concerned with sculptures in the round

Numbers in parentheses refer to the present catalogue.

1865

1st. March: Pulling down the Vacouf's house (S.W. corner of Mausoleum): 2 pieces from lower jaw of lion. (576) Some fragments of lions, and of other pieces of sculpture.

2nd. March: From Hadji Nalban's house nr. S.E. angle of Quadrangle: lion's hinder thigh (451). Several small fragments from drapped (*sic*) statues, lions and cornices, some of these last bearing traces of red painting.

3rd. March: Mehmeda's property. Two pieces belonging to the body of a lion found in the garden walls.

6th. March: Hagi Nalban's house W. of Quadrangle: Several fragments from lion's mane have been discovered among the stones. (cf. 552, 553, 557, 567, 573)

13th. March: Excavating below the Vakuf's house: Foot of a marble statue, larger than life size—it is broken a little lower than the instep and adheres to part of the pedestal—it is the right foot (200). Lion's head very mutilated, and hardly to be known as such. Fragment of lion's leg.

14th. March: Near SW. angle of Vakuf's house just around bed rock (?): Horse, fragment. As far as I can judge it is the left side of the breast, and the upper part of the thigh belonging to one of the quadriga horses. (5)

15th. March: Same place W. of Mausoleum: A piece from the base of a statue, on which are visible the marks of the sole of a foot. (201)

23rd. March: From well nr. Medmeda's property. From sides are extracted several fragments more or less damaged of large draped statues.

24th. March: Excavated to bottom of well. We discover more fragments similar to those mentioned yesterday.

27th. March: No fragments found so far in soil: all from walls of houses demolished.

28th. March: Hadji Nalban's house nr. S.W. angle of quadrangle, pulled down: Yielded: lower part of the leg of a statue, in very bad condition, & hardly made out as such.

29th. March: Discovered in garden wall nr. S.W. angle of quadrangle: a Head larger than life size, but so defaced that it can hardly be recognised as such. (56?)

4th. April: From the walls of Hadji Nalban's house (S.W.): the elbow of a marble statue, larger than life size. (110)

6th. April: From the door of Imam's property situated in the street passing north of the Mausoleum and at about 100 yards from it, the half of a man's head, the left side belonging to a marble statue.

22nd. April: Excavation S. of Ashlar wall (S. side of quadrangle): a fragment from a lion's face, the right eye with part of the cheek.

3rd. May: Mehmeda's property: demolition of garden wall. Several lion frags. found: paw, two pieces of leg, two from the body.

4th. May: Mehmeda's property. Among the stones of the

wall we find of a statue, the fragments of a leg large size, another fragment of a large draped statue, together with some other smaller fragments of drapery.

12th. May: W. side of Mehmeda's property. The only thing discovered is a fragment from a Colossal draped statue. It seems to be part of the breast. This piece is cut at one end and was joined, very likely at the waist, to another piece of marble forming the lower part of the statue. There is here as well as on our side a hole for an iron pin (?).

18th. May: Demolishing Mehmeda's property. A few pieces from marble statues of different sizes are only discovered.

19th. May: Same work contd. Discovered are: Horse fragment thigh—it was built in the chimney and is black on one side. (13) Several small fragments from statues.

In walking with Mr. Newton in the gardens occupying the lower ground E. of the Mausoleum platform, we found a sculptural fragment, which Mr. Newton recognized at once to be part of a Horse's tail (19).

20th. May: Demolition of Mehmeda's house contd. Horse fragment from lower part of leg (17). Some fragments of lion and statues.

22nd. May: We discover in the foundation of the house. Lion. part of the body, near forelegs. Large piece. Statue. left leg up to knee, large size. Statue. right leg and foot of draped human figure larger than life size (165). Some other small fragments.

23rd. May: Statue: fragment from leg of large statue. Several other small pieces of sculptured marble.

24th. May: Mehmeda's house, contd. Some fragments of sculptured marble are discovered amongst which that of a Leg from a human statue.

30th. May: We clear today part of the foundations of the house which had not been entirely excavated. The objects discovered are: Statue—fragment of drapery from large statue and several smaller pieces. Statue—heel. fragment on which the sandal strings are visible (229). Lion—of limestone—three fragments. two of them belonging to the paw, and one to the leg.

2nd.–3rd. June: Mehmeda's property. Lion. Large fragment of body near the neck. Discovered near the foundation of the house.

14th. June: From the garden wall dividing Mehmeda's property from Ahmed Bey's.
Statue: Heel under which is inscribed the letter Σ.

15th. June: Sculpture from walls of Ahmed Bey's garden: Lower part of large draped statue, and also a piece of leg of another marble statue.

20th.–23rd. June: Demolition of Hagi Imam's property (E. of Mausoleum): The hoof of a colossal horse with part of the pedestal (7).

21st. July Digging on Hagi Imam's property between Mausoleum quadrangle and peribolus wall. A very small marble fragment, an arm, or leg and another sculptured piece are discovered.

31st. July: Among stones of foundations (of Hagi Imam's house), a marble fragment, roughly rounded, which is very likely part of the body of an animal, perhaps a horse, altho' it appears to me to be of rather small size.

2nd. August: In wall of house on Hagi Imam's property: Lion's paw, in the earth outside the wall. Lion's paw, with part of the pedestal.

Excavations closed on 2nd. September 1865.

INVOICE
Fragments of Sculptures from the Mausoleum

Nos

1–4	Casks containing all friezes.
5–17	Casks containing sundry frags., statues, horse, lion, &c.
18	Case containing Terra-cotta fragments
19–23	Case containing Inscriptions
24–25	Case containing Lions and sundries
26	Case containing Earthenware vessel (broken crater)
27	Case containing Marble slab and cornices
28	Case containing horses
29–30	Case containing Sundries
31	Case containing Lion
32	Case containing Horse's thigh, lion, &c.

Fragments of Sculptures not belonging to the Mausoleum

Nos

33–43	Casks and Cases containing antiquities offered for sale.
44	Tin case containing impression of: inscriptions and coins.

APPENDIX IV

Notes to Plates Appendix

Plate 45, 1
Complete architrave beam, re-used as door lintel in Bodrum castle, from which Jeppesen has calculated the intercolumniation of the order. Cf. above, p. 55 and n. 153.

Plate 45, 2
Fragment of pyramid step with cutting for lion of type II. Some of the front edge of the step remains. Max. D. of block 68 cm. Max. W. of cutting 45 cm. D. of cutting originally *c.* 8 cm.

The part of the cutting which remains is for the base beneath the forelegs. After running parallel to the front of the step, from which it is set inward *c.* 7 cm, the cutting curves around in front of where the left forepaw would have been, and then returns on the far side of the lion, having presumably run around the extended right forepaw on what is now the broken left edge of the step. Cf. reconstructed base of lion of type II, above p. 31, fig. 6.

Plate 45, 3
Pyramid step with cutting for lion of type II. Step almost complete: L. 95 cm, D. 94 cm, Th. 30 cm. A clearly visible setting line, 60 cm inwards from the front edge, indicates the width of the surface of the step. Dowel holes and a raised rim at the back of the step are in order to interlock with the step above.

The cutting, which runs in from the left side of the step, can only be for the left rear leg and attached tail of a lion of type II. It is set *c.* 9 cm in from the front edge, is 35 cm W., 24 cm L. as preserved, and *c.* 6·5 cm D. Bruising around the edge of the cutting suggests that the upper sides of the lion's base veered out and rubbed against it. Cf. above, p. 188, fig. 40; p. 192, fig. 51, for types of base which would have fitted.

This particular step may provide a clue to the spacing of the lions, since there is a clear distance of 70 cm behind the paw.

Plate 45, 4
Pyramid step with cutting for lion of type I. The front edge is broken, but parts of the rear and right edges remain.

The cutting is for a left rear leg (set forward) and for part of a tail and right rear leg (set back) of a lion of type I. Cf. above, fig. 5, for the shape of the base. The edge of the cutting turns at sharper angles than that of Plate 45, 3.

L. of cutting, as preserved, 86 cm. W. 37 cm. D. 7·5 cm. Traces of a setting line remain on the left of the cutting,

c. 3–4 cm inward. This narrow margin, when taken with the margins of 7–9 cm left at the front of the steps (Plates 45, 2–3, above), and deducted from the known width of the surface of the step of 60 cm, gives a width for the lions' bases of *c.* 47–50 cm, which agrees with the widths of the lion statues themselves. Cf. above, pp. 27–8.

Plate 46, 1–2
Blue limestone step from podium with cutting for statue. There is a moulded front edge, consisting of cavetto plus ovolo and astragal. Part of a straight edge with *anathyrosis*, which remains at the back, provides the important evidence of the original projection of the step: 72 cm on the underside, and 83 cm on the upper side, which includes the moulding. Th. of block *c.* 20 cm. The surface has been dressed with the claw chisel.

Part of an oval cutting remains for a life-size statue, obliquely aligned at *c.* 60 degrees to the front edge, which suggests it was for a figure in action. D. of cutting *c.* 5·5–6 cm.
Cf. above, p. 57, and n. 160.

Plate 46, 3
Blue limestone step from podium with two cuttings for statues. Probably from the same course as the above stone. Broken at the back and each end, but the moulding is well preserved at the front. L. of block 85 cm D. 51 cm (upper side). Th. 20·2 cm.

The two cuttings appear to have been oval in shape, and are obliquely aligned relative to the front of the step, so as to form an angle of *c.* 120 degrees to each other. Most likely they are for two confronting lifesize figures in action. The cutting on the right is 3·5–4 cm deep, that on the left 5·8 cm deep.

Plate 46, 4
Blue limestone step with cutting for frontally placed statue. Probably, though not certainly, from a step on the podium, since no moulded edge survives. Max. L. of block 61 cm. Th. *c.* 20 cm. Some of the left edge of the block is preserved, with *anathyrosis*. From the line of this, relative to the axis of the cutting for the statue, it is evident that the statue was not set at an angle, but was squarely placed, probably with its back to the building. The cutting is also less ovoid in shape than those of Plate 46, 1–3, and, to judge from the dimensions preserved, W. 25 cm, D. 42 cm, may well have been for a heroic-sized standing figure. There is a space of 41 cm to the left of where the figure would have stood.
Cf. above, pp. 49, 60.

NOTES AND REFERENCES

1. For C. T. Newton's excavations see his *Papers*, i and ii (1858/9); *HD* (1862); *Travels and Discoveries* (1865). Although excavations on the site of the Mausoleum continued on into 1858, almost all the sculptures in the round were found between January and September 1857.

2. An account of Biliotti's excavation survives in his diary in the Greek and Roman Department at the British Museum, which is to be published in full by Jeppesen and Zahle. Extracts concerned with sculptures in the round are to be found in Appendix III (p. 243).

3. Biliotti papers.

4. The diary, which is deposited in the National Library of Scotland in Edinburgh, will be published in full by Jeppesen and Zahle. The few entries relevant to the sculptures in the round are published in Appendix II by kind permission of the owner of the diary, Lt-Col. H. M. Harvey-Jamieson.
For the part played by Murdoch Smith in the excavations, cf. W. Dickson, *Life of Major-General Sir Robert Murdoch Smith* (1901).

5. According to R. M. Smith's diary, three lions came from the Imam's field: 401 (23 April); 402 (9 May); and a lion's head and some fragments (27 April), which, by a process of elimination, seems likely to be 406. See Catalogue entry for 406 and Appendix II (p. 241).

6. The distance between the two is only 3·35 m.

7. So Jeppesen, *Paradeigmata*, 21 n. 43.

8. Cf. *AJA* 79 (1975) 68.

9. See below, pp. 32–4.

10. Cf. Ashmole, *BSA* 65 (1970), 1–2 for differences between marbles used for the relief sculptures of the Mausoleum.

11. See Catalogue entry 48 for the opinion of P. Gardner on the marble of the head of Apollo.

12. Cf. J. B. Knowlton Preedy, *JHS* 30 (1910), 136.

13. Pliny, *NH* xxxvi.31. See below, p. 54, for full text.

14. Above, p. 5.

15. For the reason stated above, p. 5.

16. See above, pp. 10–12.

17. Cf. Alexander's clipping of horses' tails on the death of Hephaestion, which has a Persian precedent: R. L. Fox, *Alexander* (1973), 434.

18. See above, p. 15.

19. For a detailed comparison, see pp. 38–9.

20. See Preedy, op. cit. 146–8; and especially J. K. Anderson, *Ancient Greek Horsemanship* (1961), 18, 21, 22, 26–27, 31, and 82, for the types and sizes of Asiatic and Nisaean breeds.

21. Cf. in particular the chariot horse led by an attendant on the fifth-century Lycian relief, BM B.312: Anderson, op. cit., pl. 13b; Bernard, *Syria* 42 (1965), 279 ff. For other examples, see below, pp. 67–8.

22. Anderson, op. cit. 18, warns against over-estimating the size of ancient draught horses, maintaining that their greater size compared with riding horses related to weight and massiveness rather than increased height. The Lycian relief BM B.312, on which Preedy, op. cit. 148, based his arguments for the proportion of man to draught-horse, may be misleading, for as Anderson points out in his notes to pl. 13b, the attendant who leads the horse may be a boy.

23. *'Maussollos' und die Quadriga* (1931), 18–21.

24. *Paradeigmata* 41.

25. Borchhardt, *Ist. Mitt.* 18 (1968), 171 ff., pls 40–50.

26. Above, n. 23.

27. *Het Reconstructieplan* (1942), 247, fig. 55, no. 40 on p. 180 (drawing inaccurate).

28. Nike inscriptions of this type, generally of Roman date and carved on architectural stones, are common in south-west Asia Minor. For comparable examples from Halicarnassus, see *SEG* xvi. 658–63; for those from Didyma, cf. Rehm, *Inschriften von Didyma*, 509–16 (reviewed by Robert, *Gnomon* [1959], 670); and cf. in general Hula, *Festschrift für Benndorf* (1898), 237–42. I am grateful to Mr A. G. Woodhead for drawing my attention to some of these references.

29. It is possible that fragments 655–658 belong to the chariot group, but because of the element of uncertainty they are best left out of the discussion.

30. According to Aeschylus, *Persae* 47, chariots with two or three poles were used by the Lydians.

31. This is the height of the attendant leading the chariot horse on the Lycian relief BM B.312. Cf. however n. 22, above. The more normal ratio in Greek art between a man and a horse bred for riding is for the man's head to be as high as the horse's. If, as suggested on p. 39, the chariot group was of twice life-size, then a figure standing in it ought to have been 3·60 m high.

32. *MRG* A21: Jeppesen, *Paradeigmata*, fig. 13E.

33. As, for example, in the reconstructions by Krischen and Law. Jeppesen, *AJA* 79 (1975), 76, suggests most persuasively that the Centaur frieze may have been placed around this base.

34. For further discussion see below, pp. 67–8.

35. Cf. G. Hafner, *Viergespanne in Vorderansicht* (1938); J. White, *Perspective in Ancient Drawing and Painting* (1956), 11 ff.

36. Jeppesen, *Mélanges Mansel* (1974), 738 ff.; Jeppesen and Zahle, *AJA* 79 (1975), 78–79. Although the propylon and *peribolus* wall may never have been completed, it was evidently the intention of the architect to have the main entrance at the east.

37. For the approximate distances at which the various sculptural groups would have been visible, see below, p. 61.

38. P. 20. Cf. also below, p. 39.

39. *JHS* 30 (1910), 146–8.

40. Of the type that is found, for example, on the Chariot frieze of the Mausoleum.

41. See above, n. 17.

42. So P. Gardner, *JHS* 13 (1892/3), 188; Preedy, *JHS* 30 (1910), 133 ff.; Lethaby, *The Builder*, 5 April 1929; Lippold, *GrPl.* 255; Picard, *Manuel*, iv.1 (1954), 71. Cf. Ashmole, *Architect and Sculptor*, 162, who suggests that the chariot represented transportation from this world to the next, although he does not commit himself on whether or not it was occupied.

43. Cf. Preedy, op. cit.

44. Frova, *Arti Figurative*, 1 (1945), 105–22; Verdiani, *AJA* 49 (1945), 402–15; Picard, *Manuel*, iv.1 (1954), 64, n. 1; Villard, in Charbonneaux *et al.*, *Hellenistic Art* (1974), fig. 111, p. 113; R. F. Hoddinott, *Bulgaria in Antiquity* (1975), 97–103.

45. Above, n. 25.

46. Von Lorentz, 30 ff.

47. *Viergespanne in Vorderansicht* (1938), 110 ff.

48. Op. cit. 439.

49. Cf. E. Panofsky, *Tomb Sculpture* (1964), 24; Borchhardt, *Ist. Mitt.* 18 (1968), 198; Demargne, *FdX* v (1974), 76, n. 42. Cf. Plato, *Phaedrus*, 246a–248c, for the image of the soul striving for apotheosis in a winged chariot.

50. *JdI* 43 (1928), 52.

51. *Reconstructieplan*, 248. The possibility had already been considered and rejected by Oldfield, *Archeologia*, 55 (1896), 357.

52. *Life of Aratos*, 13.

53. For this type of scene, cf. the vase in the Louvre by the Suessula painter, *ARV²* 1344,1. Side A. Pfuhl, *MuZ*, fig. 584.

54. For Nike on the obverse of Carian coins of 450–30 BC, cf. Kraay, *Greek Coins*, nos 636–7, pl. 187.

55. See above, p. 19.

56. Metzger, *Représentations* (1951), 210–12, 216–18. Cf. Demargne, *FdX* v (1974), 76, n. 42.

57. For Theodektes' play, cf. Aulus Gellius, *Noctes Atticae* x.18; Laumonier, *Les Cultes Indigènes en Carie* (1958), 637 n. 5. For Nike crowning a deified emperor, cf. for example the panel in the Arch of Titus, Strong, *Roman Imperial Sculpture*, fig. 59.

58. *HD* 249–50.

59. *Archeologia*, 55 (1896), 354–73.

60. Cf. Tarn, *Hellenistic Civilisation*, 138; Laumonier, op. cit. 636–8.

61. Op. cit. 34.

62. For the close link between Helios and Apollo cf. A. B. Cook, *Zeus*, i.241, 744; ii.253, 729. Note also the tall draped statue of Helios-Apollo represented on Halicarnassian coins of Roman Imperial date: A. B. Cook, *Zeus*, ii.872, figs 807–11; Laumonier, op. cit. 630, pl. XVI, 5–15. For the worship of Helios in Caria, cf. Fraser and Bean, *The Rhodian Peraea* (1954), 130–2; Laumonier, op. cit. 683–5.

63. Ἰνδὸς ποταμός ἐστι τῆς Ἰνδίας, ῥοίξῳ μεγάλῳ καταφερόμενος εἰς τὴν τῶν Ἰχθυοφάγων γῆν. ἐκαλεῖτο δὲ πρότερον Μαυσωλός, ἀπὸ Μαυσωλοῦ τοῦ Ἡλίου.

I am grateful to Mr S. Hornblower for drawing my attention to this and to some of the following references.

64. This would not be beyond the bounds of possibility if, as has been suggested by Atenstädt, *Hermes*, 57 (1922), 219–46, a source for the *De Fluviis* was Alexander Polyhistor, a Milesian who wrote volumes on Caria. The Carian Indus is mentioned by Livy, xxxviii.14.2, who has a curiously comparable story to that of the *De Fluviis* for the origin of the river's name: ad Thabusion castellum imminens flumini Indo ventum est, cui fecerat nomen Indus ab elephanto deiectus.

65. H. Metzger, *CRAI* (1974), 82–93. The inscription is datable to 358 BC. Cf. *AJA* 79 (1975), 212.

66. Metzger, op. cit., lines 32–35 and p. 91, for links with Nymphs.

67. A. B. Cook, *Zeus*, ii.1145–6.

68. A. B. Cook, *Zeus*, i.230 ff., 571, 625–6, 748–9.

69. A. B. Cook, *Zeus*, ii.920–1. Note especially the row of Archaic lions dedicated to Apollo on Delos; and the statues of Zeus and Apollo, accompanied by lions, supposedly made by Bryaxis, which stood at Patara in Lycia (Clement of Alexandria, *Protrepticus*, iv.47.4). The division of the Mausoleum lions between male and female may also accord with the male–female aspect of a ruler/fertility cult that identified itself with Apollo and Artemis.

70. A. B. Cook, *Zeus*, ii.163–4; iii.1120.

71. Cf. the pyramid which appears on the reverse of some fifth-century Carian coins: Robinson, *Num. Chron.* (1936), 265–80; Kraay, *Greek Coins* (1966), nos 636–7, pl. 187.

72. Pliny, *NH* xxxiv.61; Picard, *Manuel*, iv.2 (1963), 519–34.

73. Picard, *Manuel*, iv.2 (1963), 1270 ff. He has also suggested, *Manuel* iv.1 (1954), 205–6, that the Mourning Women on the sarcophagus of that name may be Heliades, sisters of Phaethon.

74. Bieber, *The Sculpture of the Hellenistic Age*[2] (1961), 124, fig. 488; Fuchs, *Die Skulptur* (1969), 423, fig. 482.

75. For further discussion cf. von Lorentz, op. cit. 26 ff.

76. The last person to accept the attribution, in print at least, was Krischen, *JdI* 40 (1925), 22 ff. Richter, *Portraits*, ii (1965), 161, does not entirely reject the possibility.

For the history of the controversy over the statues, see Neugebauer, *JdI* 58 (1943), 48 ff.

77. Se pp. 21–2, 39.

78. *Sic* MSS: In summo est quadriga marmorea quam fecit Pytis. For the full text, see p. 54.

79. For the text of Vitruvius, see p. 79.

80. For example, i.1.12; iv.3.1.

81. H. Diels, *Abh. Akad. Berlin* (1904), ii.7 ff. Cf. Jeppesen, *Paradeigmata*, 57, n. 66; Riemann, P-W, 371.

82. Marcadé, *Recueil des Signatures*, i (1953), no. 93; Bieber, *Anthemon, Scritti in Onore di Carlo Anti* (1955), 67 ff.

83. So Jeppesen, *Paradeigmata*, 57.

84. Pp. 79–84.

85. Above, p. 18.

86. This is slightly longer than the 1·40–1·45 m estimated by Jeppesen, *Paradeigmata*, 42, 50, and followed by Riemann, P-W, 452.

87. Möbius, *Bonner Jahrbücher*, 158 (1958), 217–18. See below, p. 68.

88. *HD* 232–3; Mendel, *Catalogue*, i, no. 3.

89. Möbius, op. cit. 215, n. 3.

90. It is speculatively suggested above, p. 24, n. 69, that the presence of lions and lionesses may accord with the joint male–female rule and cult of the Hecatomnid dynasty.

91. So Jeppesen, *Paradeigmata*.

92. So Möbius, op. cit. 215–21.

93. *AJA* 77 (1973), 338; *AJA* 79 (1975), 77–78.

94. *MRG* A.19: drawings published by Möbius, op. cit. 219, fig. 1; and Jeppesen, *Paradeigmata*, fig. 13A.

95. *AJA* 77 (1973), 338; cf. his paper in the *Report of the Tenth International Congress of Classical Archaeology*, Izmir, 1973.

96. Cf. R. Martin, *Manuel d'architecture grecque*, i (1965), 234–8.

97. See below, p. 61.

98. For the removal of the lions from the castle walls, see Newton, *Papers*, i.10; and R. M. Smith's diary for 19–21 March 1857 (Appendix II).

99. See above, p. 8.

100. Cf. Jeppesen, *Paradeigmata*, 43–44; Riemann, P-W, 452. It seems highly unlikely that the letters are the initial ones of any of the sculptors involved in the carving of the sculptures.

101. It is a lettering system rather than a strict architectural numbering system, for which see Tod, *BSA* 45 (1950), 126–39; Martin, op. cit. 221–31; Shear, *Hesperia*, 39 (1970), 167.

102. For the possible consequences of such an interpretation, see below, pp. 62 and 82–3.

103. See Catalogue for the possibility that this lion may in fact have been found in the Imam's field.

104. On this and other dimensions, see below pp. 54 ff.

105. It is possible that the pyramid steps with cuttings recently found by Jeppesen may throw some light on this question.

106. See above, p. 18, nn. 20–22.

107. Cf. above, pp. 20, 21–2.

108. P. 25.

109. Pp. 35–6.

110. From Jeppesen's excavations, and not yet published.

111. Above, pp. 5–7.

112. To judge from other evidence, notably the Ada and Idrieus relief from Tegea, male undergarments like that worn by 26 normally had short sleeves. See below, pp. 69–70.

113. See below, p. 70.

114. For numerous parallels, particularly among statues of Alexander the Great, see von Lorentz, 49 and n. 104.

115. See below, pp. 71–2.

116. See below, p. 72, nn. 247–9.

117. See below, pp. 70–71.

118. Above, p. 15

119. *AJA* 77 (1973), 338; *AJA* 79 (1975), 77–78.

120. There were also statues between columns on the Great Altar of Pergamon and the Altar of Artemis at Magnesia: Martin in Charbonneaux *et al.*, *Hellenistic Art* (1974), 50. Cf. M. Ç. Şahin, *Die Entwicklung der griechischen Monumentalaltäre* (1972), 114–15. For examples of Roman Mausolea, see J. M. C. Toynbee, *Death and Burial in the Roman World* (1971), 118 ff.

121. Above, p. 30.

122. As, for example, Sisyphos II was included amongst the statues of his ancestors in the Daochos group at Delphi.

123. For the idea of the participation of a monarch's ancestors in the glory of his achievements, cf. Pindar, *Pythians*, v. 96–104; *Ol.* viii.77 ff.
For comparable family monuments, see below, p. 78.

124. Herodotus, v.118.2. Cf. Bockisch, *Klio* li (1969), 124, 175.

125. Cf. in this respect the fragments of the chariot group and the lions.

126. Cf. Homer, *Odyssey*, xi.30, for Poseidon; Diodorus, iv.39, for Heracles.

127. Below, pp. 72–3. For variations in the animals offered, see Eustathius on Homer, *Odyssey*, xi.30. The main variants seem to have been: two sheep and a cow; cow/ox, goat and sheep; boar, ram, bull.

128. I. Scott-Ryberg, *MAAR* 22 (1955), 1 ff.; M. J. Vermaseren, *BaBesch*, 32 (1957), 1–12.

129. Van Breen, 229, fig. 63.

130. For parallels, see below, p. 72.

131. Cf. M. Reinhold, *History of Purple as a Status Symbol in Antiquity* (1970).

132. See below, pp. 73–4.

133. For details of scales, see above pp. 38–9.

134. 388 could perhaps have belonged to the chariot group. See Catalogue, *ad num.*, and above, p. 16.

135. Schefold, *Der Alexandersarkophag* (1968), figs 32–46.

136. See below, p. 60.

137. For parallels, see below, pp. 74–5.

138. For the relative dimensions of the scale, see above pp. 36–7.

139. Below, pp. 75–6.

140. Above, pp. 36–7.

141. Below, pp. 57, 245.

142. Arnold, *Die Polykletnachfolge* (1969) for the Delphi groups; also Will, *BCH* 62 (1938), 289–304, Adam, *TGS* 97–102, and Dohrn, *AP* viii (1968), 33–53, for the Daochos group.
Cf. also the Monument of the Eponymous Heroes in the Athenian Agora: Shear, *Hesperia* 39 (1970), 145–222; datable in the form discovered to 'shortly after 350 BC' (p. 196).

143. See above, p. 24.

144. See below, p. 60.

145. Below, p. 77.

146. See Catalogue, *ad num.*, for examples.

147. Above, pp. 30, 49.

148. Above, pp. 7–8.

149. For recent discussions of this passage, see Jeppesen, *Paradeigmata*, 4–10, and Ashmole, *Architect and Sculptor*, 151–2.

150. For the new evidence see Jeppesen, *AJA* 77 (1973), 336–8; and Jeppesen and Zahle, *AJA* 79 (1975), 67–79.
 A summary of the architectural evidence from the excavations of Newton and Biliotti is given by Jeppesen in *Paradeigmata*.

151. *AJA* 77 (1973), pl. 63; *AJA* 79 (1975), 70, fig. 2.

152. Cf. *Paradeigmata*, 58; *AJA* 79 (1975), 78.

153. *AJA* 77 (1973), 338, pl. 64, fig. 3; *AJA* 79 (1975), 76–78, figs 6–7. See also below, p. 245, pl. 45, 1.

154. For example, von Lorentz, 58.

155. *Acta Archaeologica*, 38 (1967), 36 ff.; *Mélanges Mansel* (1974), 738–41; *AJA* 79 (1975), 78–79.

156. *Inferiorem*, p. 54, line 17 of text; and cf. Jeppesen, *Paradeigmata*, 8.

157. For Guichard's account, see Newton, *HD* 76 ff.; Jeppesen, *Paradeigmata*, 12; cf. *AJA* 77 (1973), 337.

158. *AJA* 77 (1973), 338; *AJA* 79 (1975), 75, fig. 4. These fragments were found 'all over the site'. Cf. below, p. 245, and pl. 46.

159. The depth of the statue bases of the Daochos group, which supported eight frontally placed life-size statues and one over life-size statue of a deity, is on average 65–66 cm. Cf. Will, *BCH* 62 (1938), pl. XXX.

160. *AJA* 79 (1975), 75, fig. 4. Cf. below, p. 245, and pl. 46, 1–2.

161. A suitable candidate to have occupied such a cutting would be 198.

162. Jeppesen, *Paradeigmata*, 29, fig. 11E.

163. See above, p. 34.

164. See Guichard's account, above, p. 56. The 'stone for making lime', i.e. marble, apart from being the facing of the podium, is likely to have included marble statuary.

165. Above, pp. 36–7, 47.

166. Above, pp. 51–2.

167. Above, p. 53.

168. Reuterswärd, *Studien zur Polychromie der Plastik* (1960), 60–62.

169. Above, pp. 32–3.

170. *Papers*, i.13.

171. Adam, *TGS* 53, 66, 80–81, 99; Ashmole, *JHS* 71 (1951), 19 n. 40; G. Merker, *The Hellenistic Sculpture of Rhodes* (1973), 8–9.

172. For this practice, compare the colossal portrait statue, Vatican, Belvedere 9. See below, p. 69.

173. Dohrn, *AP* viii (1968), 39, pls 30–32; Adam, *TGS* 80.

174. I owe this information to Mr A. F. Stewart.

175. Ashmole, *JHS* 71 (1951), pl. IV.

176. Cf. Ashmole, op. cit. 19.

177. For the use of iron dowels, cf. Adam, *TGS* 81.

178. Cf. Adam, *TGS* 81, who suggests the join must have been secured with cement or mortar.

179. See Catalogue.

180. Above, p. 30.

181. For this feature, cf. the base of Aknonios from the Daochos group at Delphi: Adam, *TGS* 100.

182. This is found also on the pedimental sculptures of the Scopaic temple of Athena at Tegea (information of A. F. Stewart).

183. See above, pp. 20–1.

184. Pausanias, vi.10.6–8.

185. Pausanias, v.12.5; vi.4.10; vi.9.4–5 (Gelon's team of 488 BC by Glaukias of Aegina); vi.10.8; vi.12.1 (Hieron's team by Onatas of Aegina, post 467 BC); x.10.2; x.15.4.
 Bronze chariot groups are attributed to the following late fifth- and fourth-century sculptors by Pliny: *NH* 34.64–5, Lysippus; *NH* 34.67, Euthycrates, son of Lysippus; *NH* 34.72, Aristides, pupil of Polyclitus; *NH* 34.78, Euphranor, including four-horse chariots in which stood Alexander and Philip; *NH* 34.81, Pyromachus's group of Alcibiades driving a four-horse chariot; *NH* 34.88, Menogenes (date uncertain).

186. Merker, op. cit. 17.

187. Bol, *Die Skulpturen des Schiffsfundes von Antikythera* (1972), 84–91, pls 50–55. See also above, p. 21, n. 1.

188. Picard, *Manuel*, iv.2 (1963), 1270 ff., cf. Keil, *Führer durch Ephesos* (1957), 137–42.

189. Brommer, *Die Skulpturen der Parthenon-Giebel* (1963), 38, pl. 64.

190. Treu, *Olympia*, iii (1897), 53; Ashmole and Yalouris, *Olympia* (1967), 14, figs 28–30, 53–54.

191. Above, p. 18, nn. 20–22.

192. Pryce, *BM Cat*. B.312; Bernard, *Syria*, 42 (1965), 279 ff.

193. Hamdy Bey-Reinach, *Une Nécropole Royale à Sidon* (1892), pl. IX; Picard, *Manuel*, iv.2 (1963), 205 ff., pl. VII.

194. See above, n. 44.

195. Schmidt, *Persepolis*, i (1953), pl. 52; Anderson, *Ancient Greek Horsemanship* (1961), pl. 8.

196. Above, pp. 18–19, 22.

197. A useful general survey has been made by C. Vermeule, *AJA* 76 (1972), 49–59.

198. *Die Löwenkopf-Wasserspeier* (1959), 130. Cf. the strictures of Möbius, *Bonner Jahrbücher*, 158 (1958), 218 n. 21a, on Willemsen's list.

199. *Clara Rhodos*, viii, 19, 203–5.

200. Op. cit. n. 39. The fairly upright lion on the relief, NM 2966, Svoronos, pl. 194, is not really comparable, since it is being hunted.

201. A. W. Lawrence, *Greek and Roman Sculpture* (1972), 72–73.

202. Sarre, *Die Kunst des alten Persien* (1922), 27, pl. 55; A. B. Cook, *Zeus*, i.749–50.

203. Keil, *ÖJh* 29 (1935), Beibl. 103–41; *ÖJh* 30 (1937), Beibl. 173–93.

204. Diodorus, xvii.115.1–5.

205. Luschey, *D. arch. Mitt. aus Iran*, NS i (1968), 115–22, pls 45–50.

206. Schefold, *Der Alexandersarkophag* (1968), figs 32–34, 40, 42; von Graeve, *Der Alexandersarkophag und seine Werkstatt* (1970), pls 38–39.

207. Cf. also the lion in Kansas City, Vermeule, op. cit. 50, pl. 11, fig. 3; and the lion from Marathon, op. cit., pl. 12, fig. 4.

208. Waldhauer, *JHS* 44 (1924), 51, fig. 5; idem, *Hermitage Catalogue*, i (1927), no. 36, pl. XVIII; Lippold, *GrPl*. 259, n. 5. 2 m high without the head and lower legs.

209. For the pose of 29, with its arm akimbo, cf. the fourth-century statue of Asclepios at Eleusis, Adam, *TGS* 102–4, pls 50–51; also statues attributed to Timotheos, such as the Artemis on the Sorrento base (Schlörb, *Timotheos* [1965], 67), and the Athena Rospigliosi type (*BSA* 66 [1971], 377, 381, pl. 71b).

210. *IG* ii.² 212; Tod, *GHI* ii, no. 167; Br.Br. 475B; Svoronos 590–2, pl. 104; Diepolder 45 ff.; Speier, *RM* 47 (1932), 59–60, pl. 22.1; Binneboessel, no. 53; Süsserott 58–59, pl. 4.3; Picard, *Manuel*, iv.2 (1963), 1257 ff., fig. 494; Karouzou, *Guide* (1968), p. 130; Brown, *Anticlassicism* (1973), fig. 82.

211. Amelung, *Vatican Cat*. ii.21, no. 4, pl. 4; Helbig-Speier, *Führer*,⁴ i (1963), no. 252.

212. Delphi Museum, inv. 1819; *FdD* iv (1926), pls 69, 71; Kabus-Jahn, *Studien zu Frauenfiguren* (1963), 43, 46–48; Poulsen, *BCH* 70 (1946), 497, pl. 24; Pouilloux, *FdD* ii, 'La Région nord du Sanctuaire' (1960), 49; Fuchs, *Die Skulptur* (1969), 132, fig. 119; A. W. Lawrence, *GRS* 204.

213. Hekler, *Die Sammlung antiker Skulpturen* (1929), no. 26; Picard, *Manuel* iv.2 (1963), 1306, fig. 513.

214. Tsirivakos, *AAA* 1968 (2), 35 ff. and 108–9 (for statue); cf. *BCH* 92 (1968), 749 ff.; *Archaeological Reports*, 1968–9, p. 6; and Tsirivakos, *AAA* 1971 (2), 108–10. The Heroon must date from before Demetrios of Phaleron's anti-luxury decree of 317 BC.

215. Inv. 2767. Lawrence, *LGS* 29, pl. 52; Carpenter, *Greek Sculpture*, 215, pl. 38. Carpenter claims this Pergamene statue as evidence to support his dating of 'Maussollos' to the second century BC. Yet a comparison of sandal types alone demonstrates the chronological gulf between the two statues. The sandals of the Pergamene statue, with their indented sole, are typical of the second century BC. Those of 'Maussollos' are undoubtedly of fourth-century type (see p. 69). Carpenter's eccentric dating of 'Maussollos' has been followed by Havelock, *Hellenistic Art* (1968), 35–36; and eadem, *Studies presented to G. M. A. Hanfmann* (1971), 55 ff. For a detailed refutation, see Ashmole, *Festschrift für Brommer*, forthcoming.

216. Richter, *Portraits*, ii, figs 1397–1400; cf. also fig. 1408.

217. H. Thompson, *Eph. Arch.* 1953/4, iii (1961), 32, 41; Adam, *TGS* 96.

218. Pouilloux, *loc. cit.*, above n. 212.

219. Kraay, *Greek Coins* (1966), no. 638, pl. 187.

220. BM 1914.7–14.1. A. H. Smith, *JHS* 36 (1916), 65 ff.; A. B. Cook, *Zeus*, ii.593 ff.; Tod, *GHI* ii, no. 161; Picard, *Manuel*, iv.1 (1954), 75–76, fig. 32; Brown, *Anticlassicism* (1973), 30.

221. Borchhardt, *AA* 1968, 202, fig. 21; *Ist. Mitt.* 19/20 (1969/70), 204–5, pl. 39.2. Cf. also the priest on the Salas monument, *AA* 1968, 178–9, figs 6–7.

222. See above, n. 44.

223. Collignon, *Statues Funéraires*, 285, fig. 178; Heuzey, *Histoire du Costume antique* (1922), 99, fig. 52.

224. Lippold, *Gr. Pl.* 258, pl. 93.3; Picard, *Manuel*, iv.2 (1963), 871 ff.

225. *Clara Rhodos*, v.2, 186–9; Lippold, *Gr. Pl.* 259, n. 1; R. Kabus-Preisshofen, *AP* xv (1975), 56–60, pls 27–28, figs 3, 14–16.

226. A. B. Cook, *Zeus*, ii.881, pl. 39. Possibly based on a statue by Bryaxis (so Lippold, *Gr. Pl.* 259, n. 2); cf. deity on NM 1486, Svoronos, pl. 112.

227. Walter, *ÖJh* 31 (1938/9), 53–80.

228. D. E. L. Haynes, *The Arundel Marbles* (1975), pl. 4.

229. Richter, *Portraits*, ii.211, fig. 1368. Cf. similar statues in the Vatican, Sala della Biga, inv. 2340: Helbig-Speier, *Führer*,[4] no. 505; and Marbury Hall, *EA* 3105.

230. Richter, *Portraits*, ii.213, fig. 1369.

231. *FdD* iv, pl. 71.2.

232. Op. cit. 52–53.

233. Conze no. 1084; Diepolder 54; Lippold, *Gr. Pl.* 271, pl. 87.4; Fuchs, *Die Skulptur*, fig. 579.

234. Demargne, *FdX* v (1974), 61–87, pls XXV–XXIX, 27–45. For date, cf. esp. pp. 85–87.

235. Above, n. 210.

236. Lippold, *Gr. Pl.* 259, pl. 95.2.

237. Ibid. 258, pl. 95.3.

238. Above, n. 224.

239. Wallis, *Catalogue* (1893), no. 832; Amelung, *Ausonia*, iii (1908), 117–19, fig. 18; Buschor, *MuA* 21–22, 38.

240. Richter, *Portraits*, ii, fig. 680.

241. Conze no. 1173, pl. 251; Johannsen, *AGR* 52, 163.

242. For Attic grave reliefs with related figure types, see Kabus-Jahn, op. cit. 26.

243. For a discussion of the possible participation of Praxiteles on the Mausoleum, see below, pp. 71, 79–84.

244. Jongkees, *JHS* 68 (1948), 29–39; Kabus-Jahn, op. cit. 65–70, pls 9–10; Fuchs, *Die Skulptur*, 213, fig. 229.

245. NM 743. Conze no. 410, pl. 97; Diepolder 49; Johannsen, *AGR* 46 ff., fig. 24. Datable *c.* 375–350 BC.

246. Pausanias, iii.11.3; Vitruvius, i.1.6.

247. Richter, *Portraits*, i.70–72.

248. Mobius, *AM* 53 (1928), 7, Beil. III.2–3. For Neo-attic copies, cf. Fuchs, *Die Vorbilder der neuattischen Reliefs* (1959), 6, pl. 1. *Sakkoi* are also worn by some of the females on the 'Graces of Socrates' and Maenad reliefs: Fuchs, op. cit., pls 12b, 15–19.

249. Conze no. 1213, pl. 269.

250. Caskey, *Boston Catalogue*, no. 39; Richter, *Animals in Greek Sculpture* (1930), fig. 141.

251. Richter, *Animals*, fig. 143.

252. Cf. Arnold, *Die Polykletnachfolge*, 126 ff.

253. For other unpublished free-standing statues of bulls, some found quite recently, see Vermeule, *AJA* 76 (1972), 52 n. 10 and 56 n. 34.

254. Frickenhaus, *AM* 36 (1911), 123 no. 7; Brendel, *RM* 45 (1930), 215, pl. 82; Helbig-Speier, *Führer*,[4] ii (1966), no. 1908.

255. Borchhardt, *AA* 1968, 202, fig. 21; idem, *Ist. Mitt.* 19/20 (1969/70), 204–5, pl. 39.2.

256. Diodorus, xvii.115.1–5. Cf. above, p.24, n. 2.

257. Ashmole, *Br.Br.* 768.

258. Brown, *Anticlassicism* (1973), 9, fig. 8; cf. also the corner acroteria, op. cit. figs 17, 19, 20.

259. Picard, *Manuel*, iv.2 (1963), 741–50.

260. Picard, op. cit. 703 ff.

261. Benndorf-Niemann, *Heroon* (1889), 168–70, pl. XVII, A.12–19.

262. Hamdy Bey-Reinach, pl. X; Mendel, *Catalogue*, i, no. 10, 55–57; Borchhardt, *Ist. Mitt.* 18 (1968), pl. 56,1–2.

263. Wolters, *Führer* (1935), nos 495–6; Richter, *Animals*, 10, fig. 33; Ohly, *Guide* (1975), 32.

264. C. Vermeule, *AJA* 76 (1972), 58.

265. Richter, *Animals*, fig. 116; Picard, *Manuel*, iv.1 (1954), 166 ff., fig. 78.

266. For a discussion of the date of the Tegea pedimental sculptures, see most recently, Brown, *Anticlassicism* (1973), 29–31.

267. Adam, *TGS* (1966), 97–102; T. Dohrn, *AP* viii (1968), 37–52; Arnold, *Polykletnachfolge* (1969), 210–12; Brown, *Anticlassicism* (1973), 36, figs 50–56; S. Lattimore, *AJA* 79 (1975), 86–88.

268. Sichtermann, *AP* iv (1965), 72; Dohrn, op. cit. 47.

269. Hamdy Bey-Reinach, pls VI–VII; Picard, *Manuel*, iv.1 (1954), 225, fig. 99; Lawrence, *GRS* (1972), pl. 50b.

270. Picard, *Manuel*, iii (1948), 653 ff.; Lippold, *Gr. Pl.* 252, n. 5, pl. 91.3; Mansuelli, *Uffizi Cat.* (1958), nos 31–32; Helbig-Speier, *Führer*,[4] ii (1966), nos 1392, 1644.

271. Schlörb, *Timotheos* (1965), 66, fig. 54.

272. Schuchhardt, *Die Epochen* (1959), 116, figs 92–93; Sichtermann, op. cit. 71–85.

273. Cf. for this feature, the Lateran statue of Sophocles (Richter, *Portraits*, fig. 680) and two figures on the tomb of Payava (Demargne, *FdX* v (1974), pl. 45.2–3).

274. Cf. Adam, *TGS* 100.

275. Adam, loc. cit.

276. Arnold, *Polykletnachfolge*, 210-13; cf. Dohrn, op. cit. 48–49.

277. Caskey, *Boston Catalogue* (1925), no. 25, pp. 59–61; Picard, *Manuel*, iv.2 (1963), 896–8, pl. XXIII, fig. 368; Pollitt, *Art and Experience in Classical Greece* (1972), 100, fig. 44.

278. Picard, *Manuel*, iv.2 (1963), 1011 ff., fig. 399; Helbig-Speier, *Führer*,[4] iii (1969), no. 2271; cf. Pfeiff, *Apollon* 124, pl. 50; Lippold, *Gr. Pl.* 264, pl. 96.2; and for other versions in Rome, Helbig-Speier, op. cit. nos 1249, 1460, 2091, 2280.

279. Tölle, *JdI* 81 (1966), 142; K. Schefold, *Basler Antiken im Bild* (1958), 37, pl. 28.

280. *New Chapters in Greek Art* (1926), 99–116; cf. Lippold, *Gr. Pl.* 311, pl. 110.3; Helbig-Speier, *Führer*,[4] i (1963), no. 82.

281. Above, n. 270.

282. Pausanias, iii.11.3; Vitruvius, i.1.6.

283. NM 215. Lippold, *Gr. Pl.* 238, pl. 85.3; Fuchs, *Die Skulptur*, fig. 530. Cf. also the Atthis on the Venice relief, Linfert, *AA* 1966, 496, fig. 2; Fuchs, op. cit., fig. 627.

284. Keil, *ÖJh* 29 (1935), Beibl. 139–40, fig. 54. The seated Persian figure in Izmir Museum from the Mausoleum will be discussed in association with the fragments from Bodrum in a subsequent volume.

285. Met. Museum. Richter, *Catalogue* (1954), p. 72, no. 118, pl. 91; A. W. Lawrence, *BSA* 26 (1923–5), 67, pl. VIII; Frel, *Ist. Mitt.* 21 (1971), 121–4, pl. 42.

286. Copenhagen no. 262. *RM* 2 (1887), 159 ff., pls 7, 7a; Poulsen, *Catalogue* (1951), no. 262; Frel, op. cit. 124, pl. 38.2.

287. Cf. in general, U. Süssenbach, *Der Frühhellenismus im griechischen Kampfrelief* (1971).

288. NM 738. Conze no. 1151, pl. 245; Diepolder pl. 50.

289. Conze no. 1152, pl. 246; Diepolder, pl. 28.2.

290. Above, p. 75,

291. For further discussion of this question, see below, pp. 79–84.

292. For a recent discussion of the problem, see Brown, *Anticlassicism* (1973), 54–56.

293. Overbeck, *Schriftquellen* (1868), no. 1314; Loewy, *Inschriften*, no. 83; *IG* ii/iii.[2] 3829; Picard, *Manuel*, iv.2 (1963), 771.

293a. Pseudo-Plutarch, *Vit. X Orat.*, *Isokrates* 837C; Pausanias, i.37.3; Drexel, *AM* 37 (1912), 119 ff.; Richter, *Portraits* i.45, ii.224.

294. Above, n. 81.

295. The likelihood of the delegation of much of the carving of the relief sculptures to assistants has been emphasised by Ashmole, *JHS* 71 (1951), 17; and *Architect and Sculptor*, 167.

296. Jeppesen, *Paradeigmata*, 55–58.

297. Homolle, *BCH* 23 (1899), 383; Picard, *REA* 44 (1942), 5 ff.; Tod, *GHI* ii (1948), no. 161; Bieber, *Anthemon, Scritti in Onore di Carlo Anti* (1955), 67 ff.; Marcadé, *Recueil des Signatures*, i (1953), 93; Picard, *Manuel*, iv.1 (1954), 70 ff., 235; Jeppesen, *Paradeigmata*, 57; Riemann, P-W, 508.

298. Above, n. 220.

299. Clement of Alexandria, *Protrepticus*, iv.47.4.

300. Pliny, *NH* xxxvi.22.

301. Pliny, *NH* xxxiv.42.

302. *JHS* 71 (1951), 13–28.

303. Pliny, *NH* xxxvi.20.

304. Steph. Byz., *s.v.* Alexandreia.

305. Ashmole, *Architect and Sculptor* (1972), 22–23.

306. Cf. Schlörb, *Timotheos* (1965), 71.

307. *FdD* iv.2 (1928), 112 ff., 143 ff.; Lippold, *Gr. Pl.* 70.

308. See above, pp. 36–7.

309. P. 62.

310. See above, pp. 61–2.

PLATES

The numbers preceding the captions
refer to the catalogue entry

A VIEW OF BODRUM (ancient Halicarnassus) FROM THE ACROPOLIS

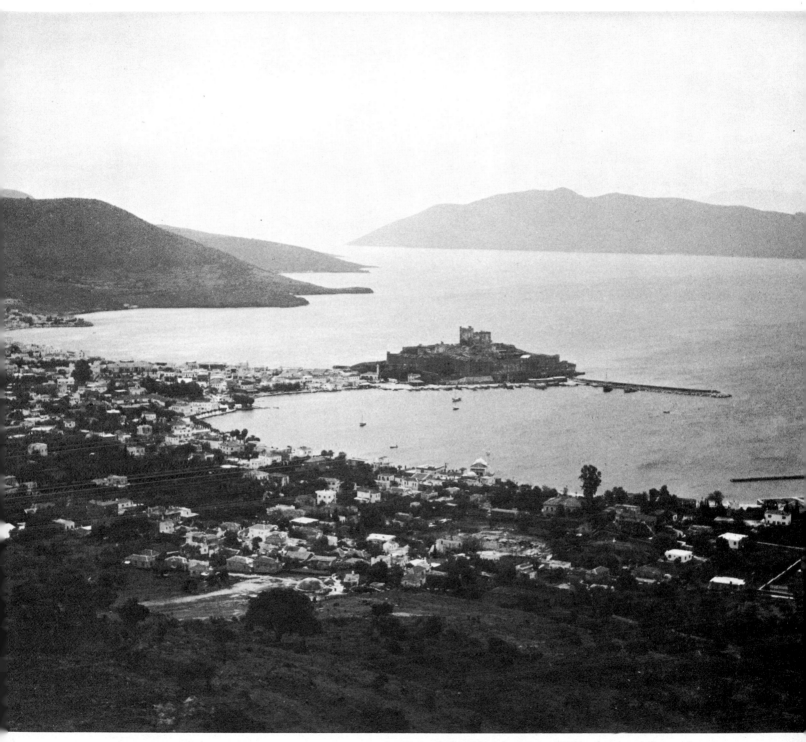

A view of Bodrum (ancient Halicarnassus) from the acropolis. The site of the Mausoleum is in the foreground in the open space in front of the minaret of the mosque. Dominating the harbour is the Castle of St Peter, constructed largely from stones taken from the Mausoleum by the Knights of St John in the fifteenth century AD.

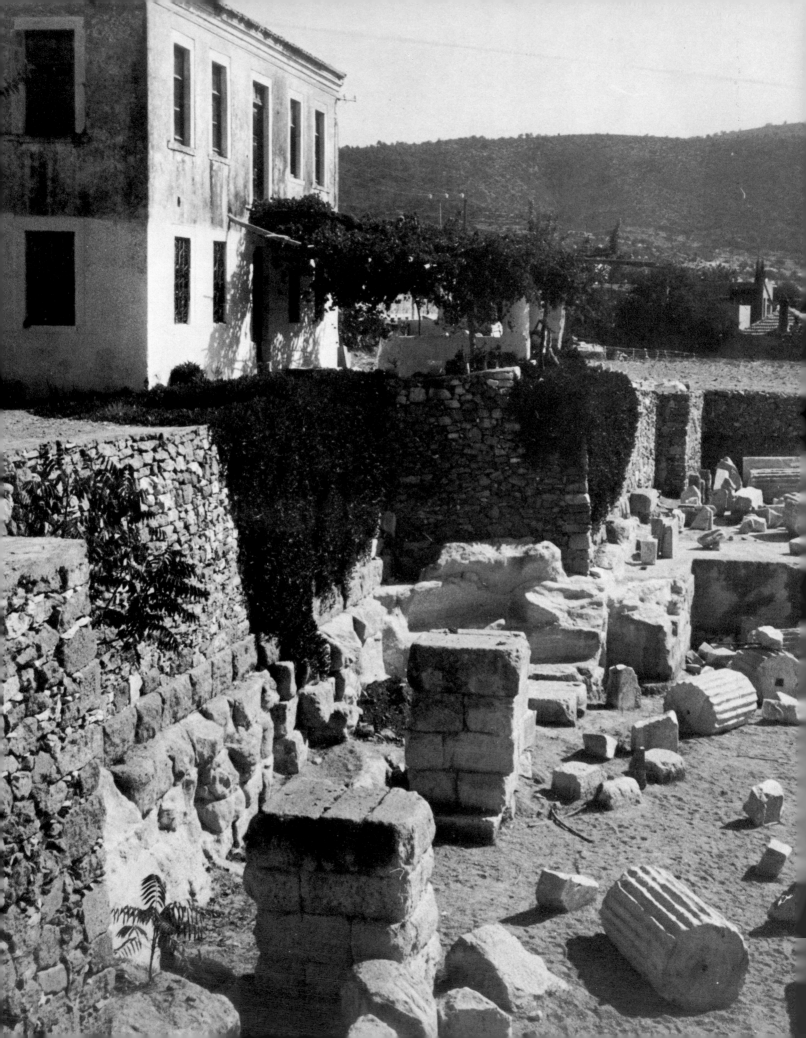

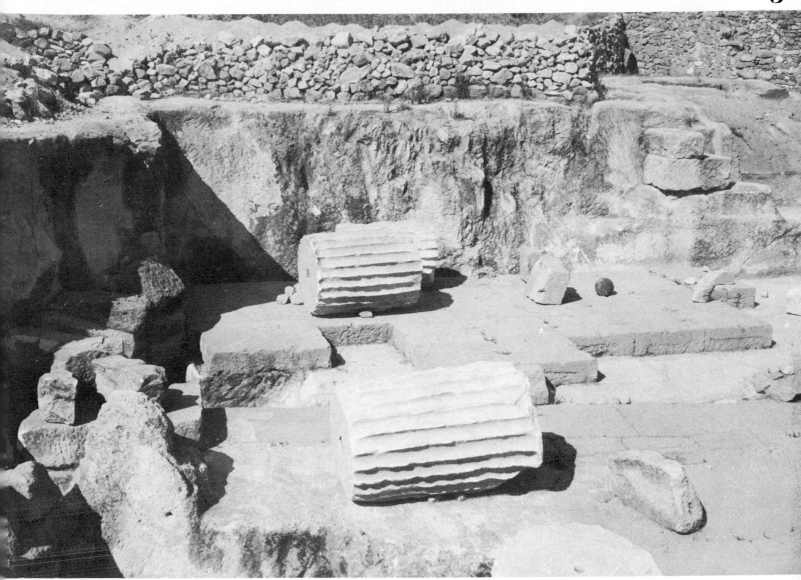

Above: The south-west corner of the Quadrangle showing greenstone blocks from the core of the Mausoleum *in situ.*

Opposite: The north side of the Quadrangle of the Mausoleum and the foundations of the north *peribolus* wall. Beneath the modern house was found the main deposit of sculptures in the Imam's field.

Overleaf: Two views across the area of the burial chamber, from the east and west respectively. *Above,* in the background is the western staircase giving access to the burial chamber. *Below,* the burial chamber seen from the west, with the overturned greenstone plug-block in the foreground.

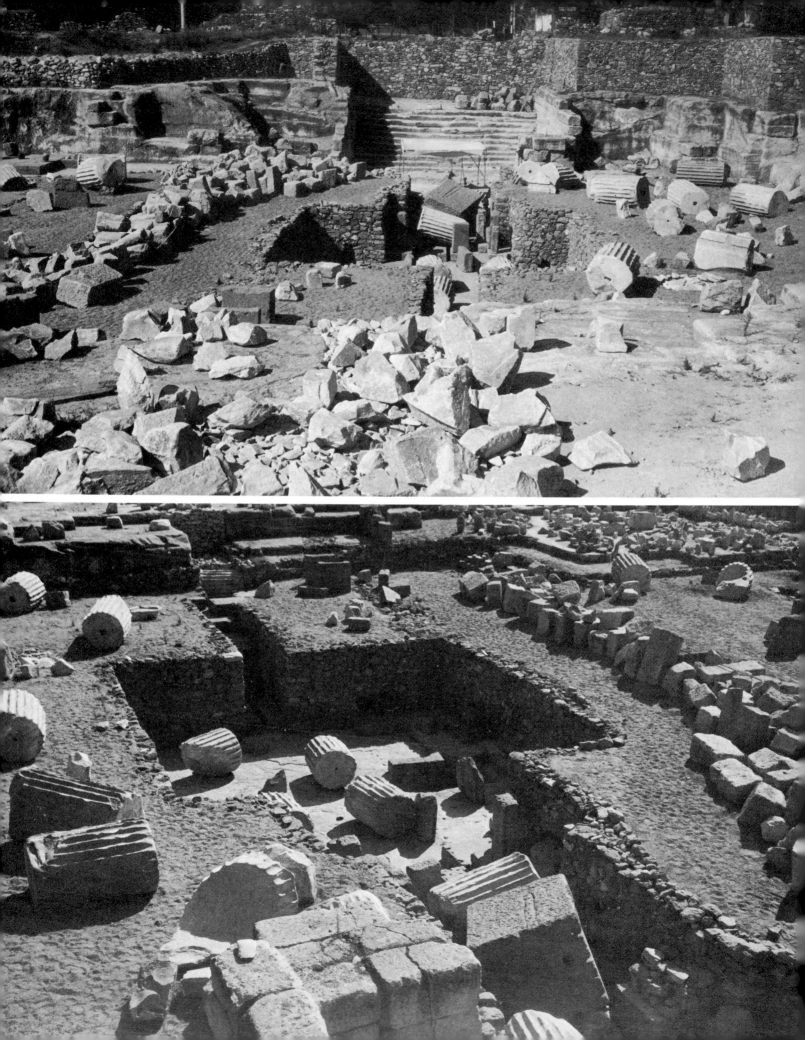

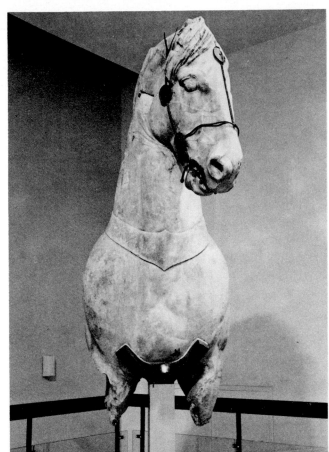
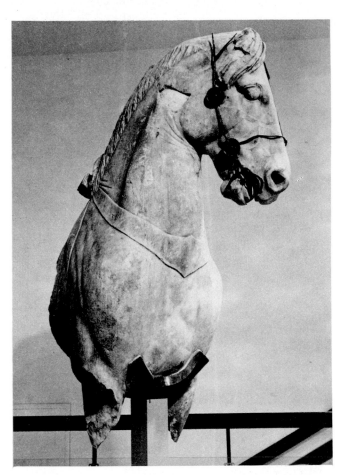
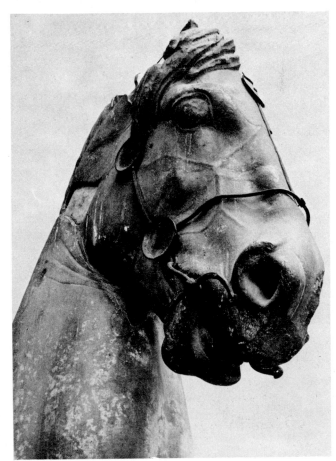
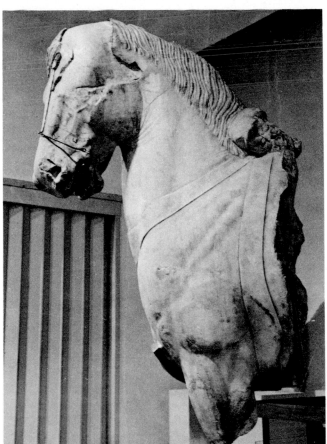

1 Forepart of a horse.

CHARIOT GROUP

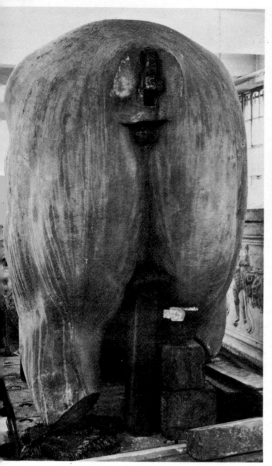

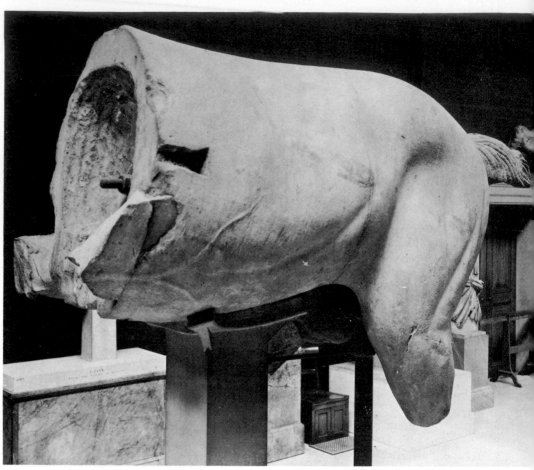

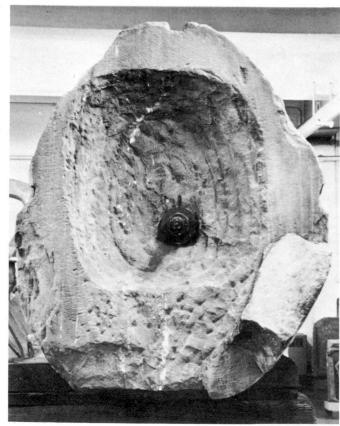

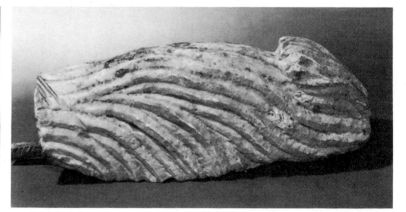

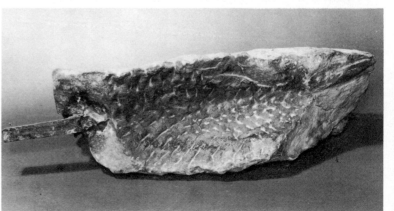

2 Rear part of body and tail of a horse.

3 Fragment of forepart of a horse.

4 Fragment of forepart of a horse, showing part of the girth.

5 Front and profile views of forepart of a horse.

8

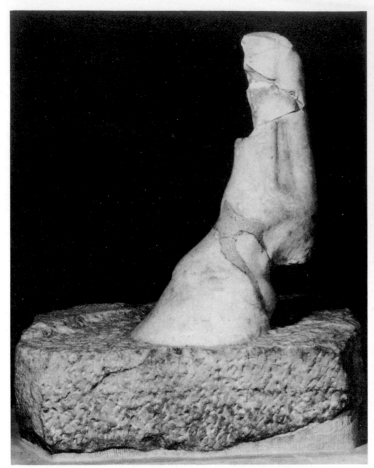

6 Left hoof and foreleg of a horse on a base.

7 Right hoof on base.

9 Fragment of hoof.

8 Fragment of hoof on base.

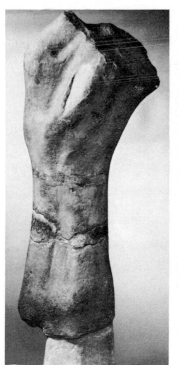

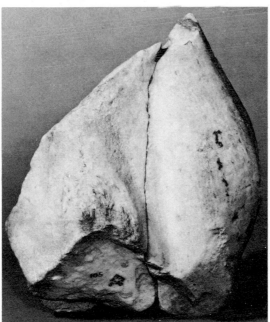

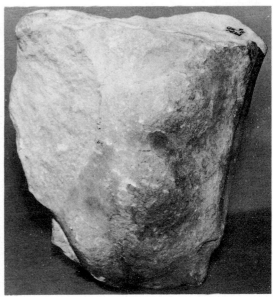

12 Fragment of the lower hind leg of a horse.

11 Hock from a hind leg of a horse.

10 Hind leg of a chariot horse.

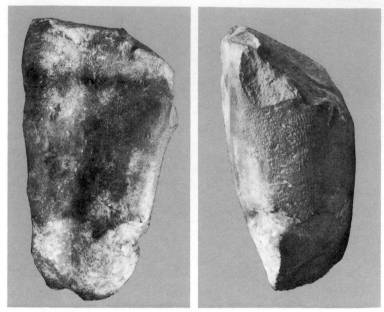

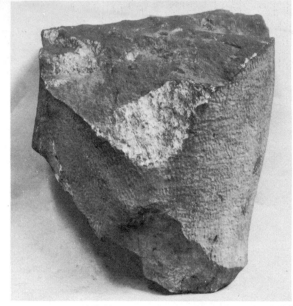

13 Fragment of an upper foreleg of a horse.

14 Fragment of an upper foreleg of a horse.

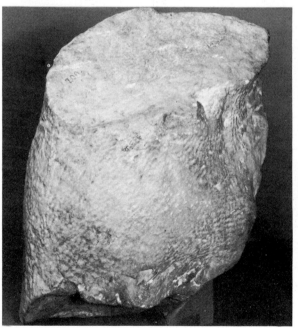

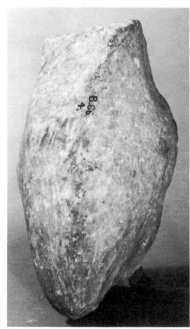

15 Fragment of a foreleg.

16 Fragment of lower foreleg.

17 Fragment of fetlock.

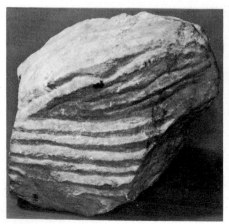

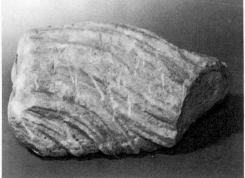

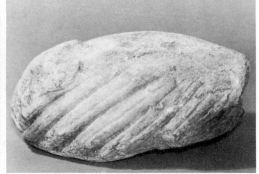

18, 19, 20 Fragments of tails from three different horses.

21 Fragment of genitals of a horse.

22 Fragment of a bronze bridle.

24 Chariot wheel as reconstructed by C. T. Newton.

23 Two views of half a marble support for a chariot horse.

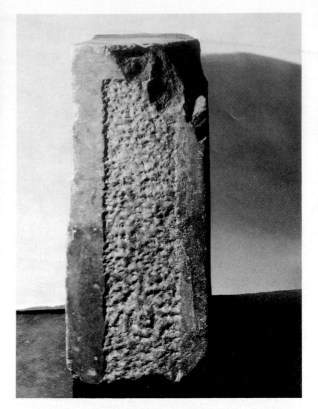

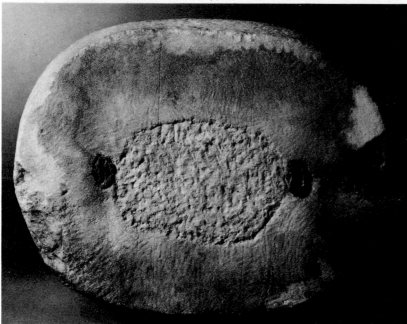

25 Oval drum, probably from chariot support.

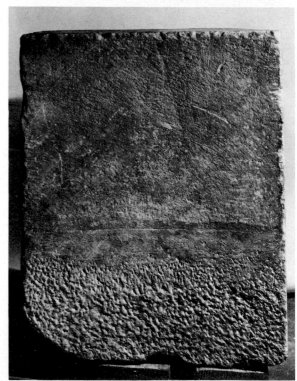

Left and above: Three views of a curved stone found by C. T. Newton. Possibly part of an exedra, it has a Nike inscription on the upper edge.

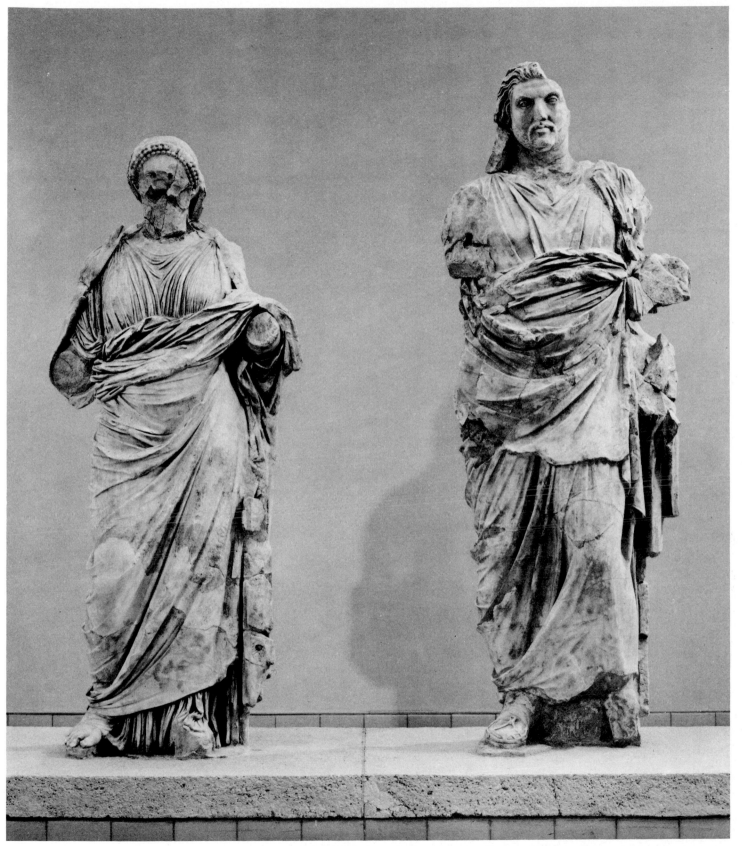

26, 27 Colossal statues traditionally identified as Maussollos and Artemisia.

MAIN FRAGMENTS OF STATUARY

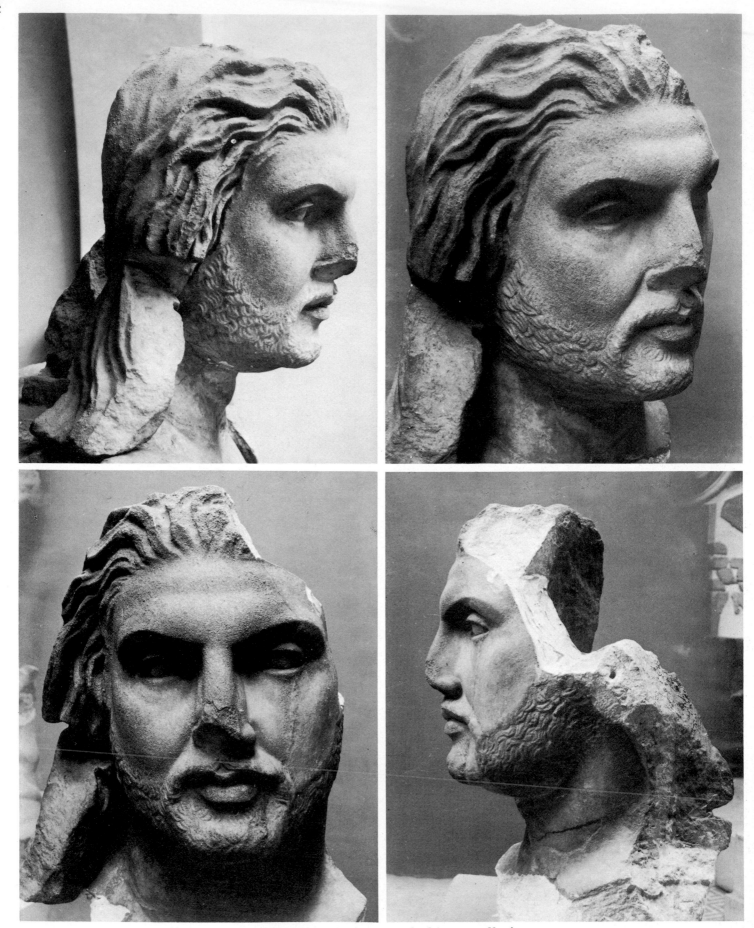

26 Four views of the head of 'Maussollos'.

26 Three views of the tenon and socket attachment for the head.

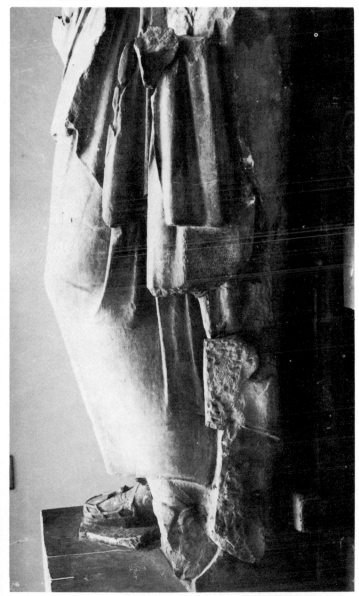

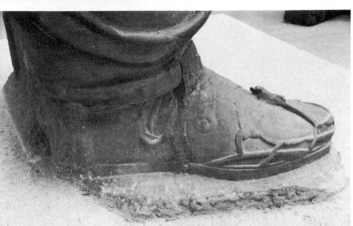

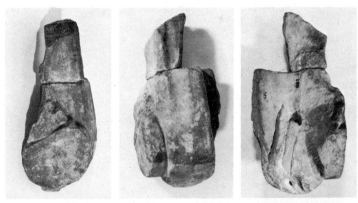

26 *Above:* Detail of cutting on the lower left side of 'Maussollos'.

26 *Right:* Detail of right sandal, and scabbard fragments from 'Maussollos'.

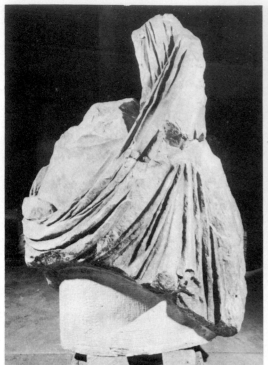
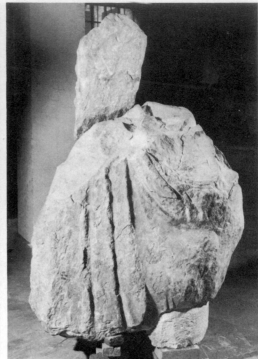
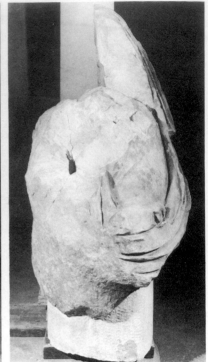

29 Colossal standing male figure.

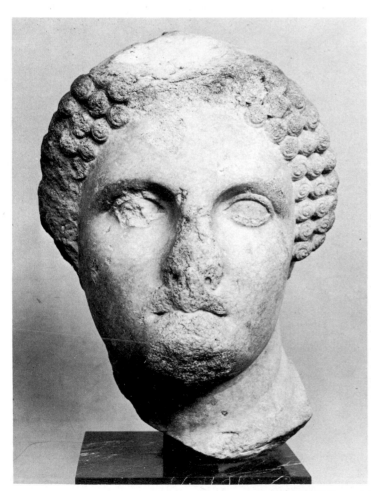
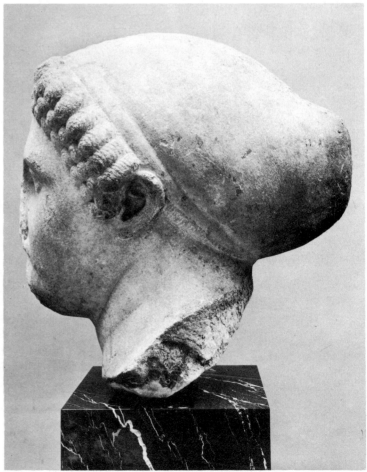

30 Colossal female head.

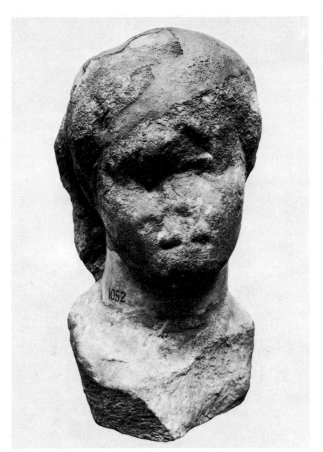

31, 32 Two colossal female heads.

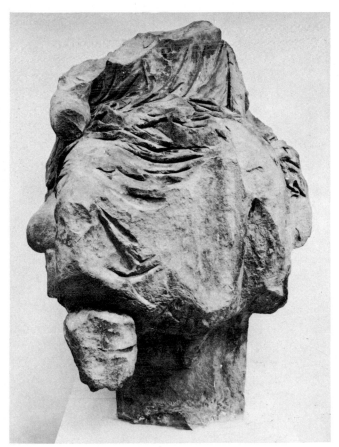

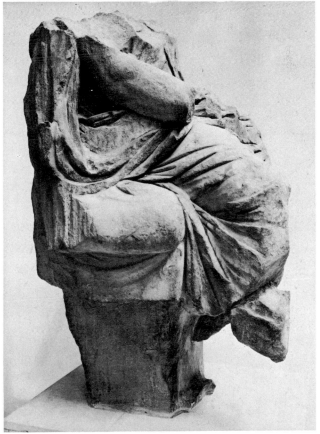

33 Colossal seated male figure.

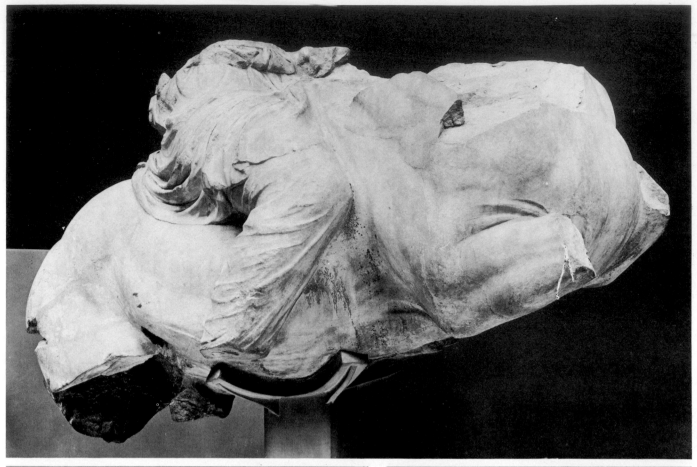

34 *Top:* Fragment of colossal Persian rider and horse.

35, 36, 37 Fragments of nose, raised forehoof, and hind hoof on base from Persian rider's horse.

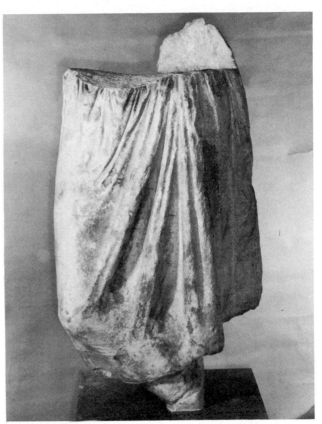

39 Fragment of upper hind leg of colossal horse.

42 Lower part of draped, standing male figure.

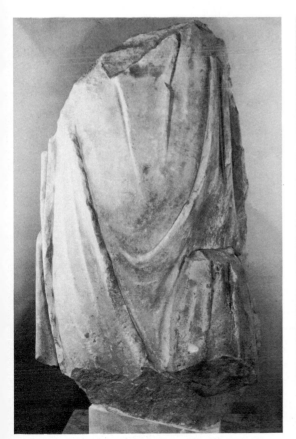

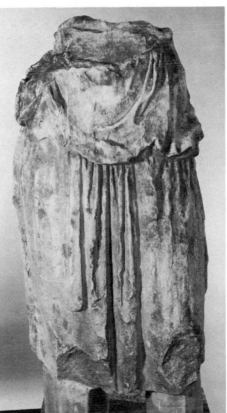

43 Fragment of draped, standing male figure.

44 Lower part of standing male figure wearing Persian dress.

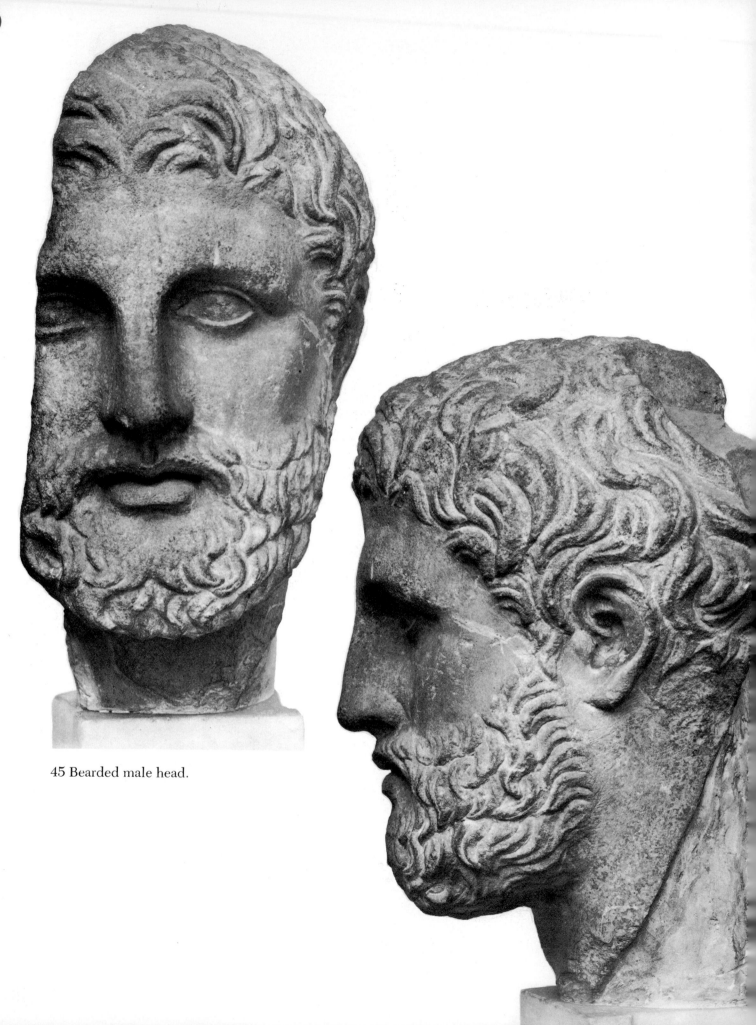

45 Bearded male head.

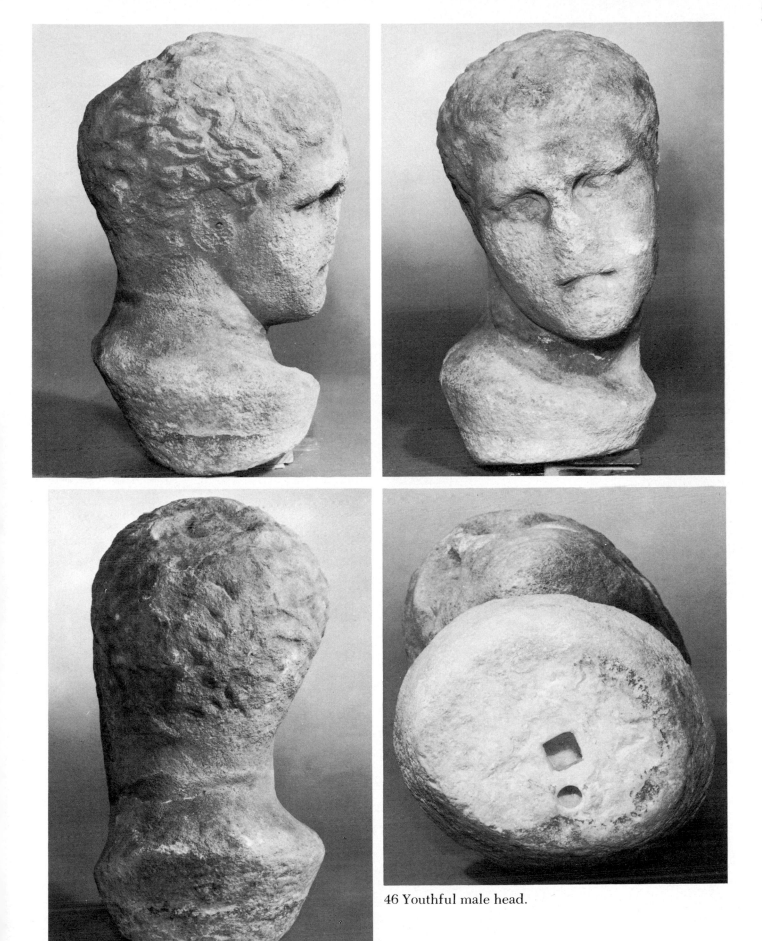

46 Youthful male head.

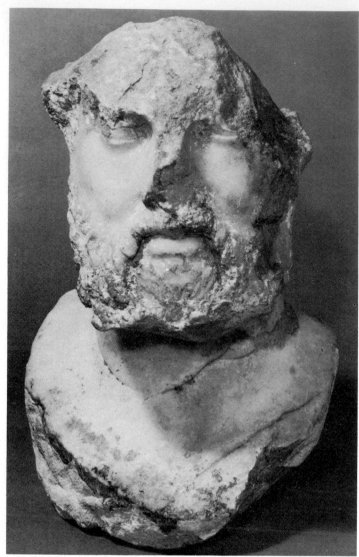

47 Bearded male head,
possibly not from the Mausoleum.

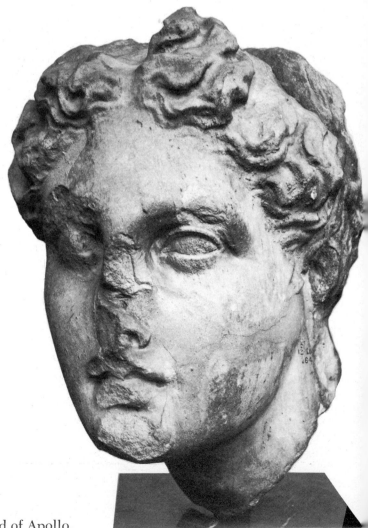

48 Head of Apollo.

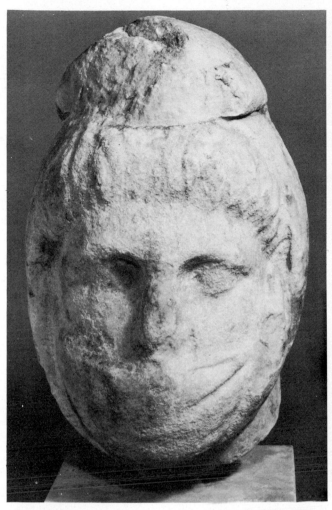

49 Head of a Persian.

50 Head wearing a Phrygian cap.

51 Back of male head.

52 Neck and tenon of head.

53 Neck fragment.

55 Lower neck and tenon.

57 Face fragment with left eye.

63 Part of upper back of colossal draped figure.

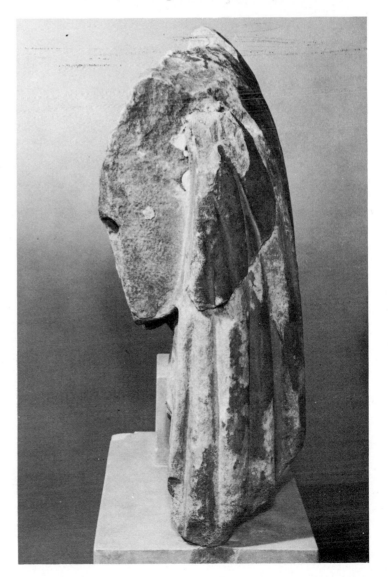

65 Fragment of colossal draped figure.

66 Fragment of right shoulder of draped figure.

68 Left shoulder and body of draped male figure.

71 Fragment of body and shoulder of draped figure.

85 Left shoulder and breast of nude male figure.

85A Fragment of draped, male standing figure.

87 Fragment of draped figure.

89 Fragment of small figure in Persian dress.

90 Base of draped female figure.

91 Lower back of draped female figure.

104 Fragment of draped torso with arm-joint.

98 Fragment of right arm of colossal standing
female figure.

111 Elbow of left arm.

139 Wrist
fragment
with Persian
sleeve.

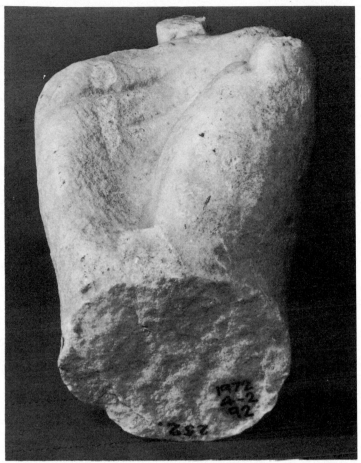

142 Colossal right hand.

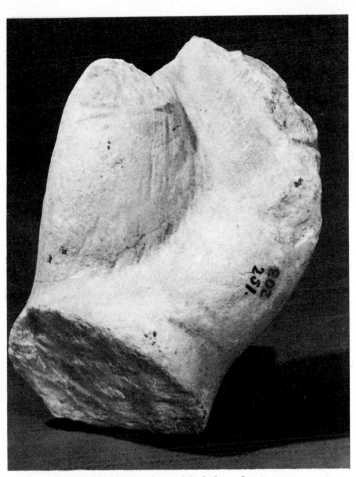

143 Colossal left hand.

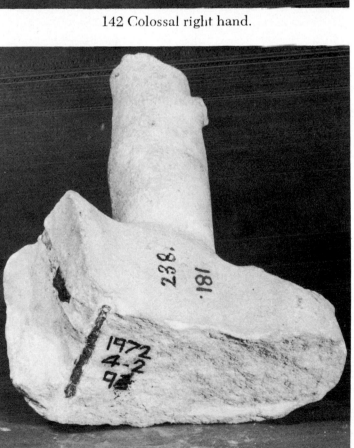

144 Fragment of colossal left hand.

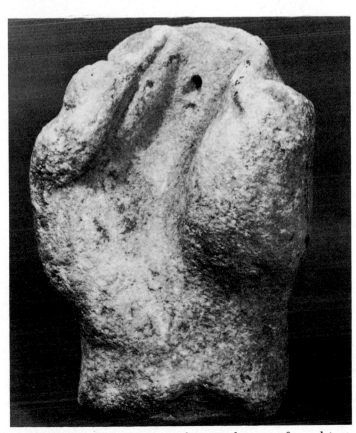

145 Right hand with groove for attachment of an object.

155 Finger tip.

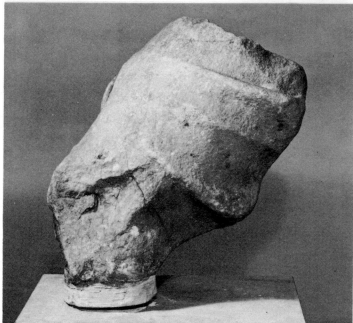

159 Left thigh of
striding draped statue.

165 Draped lower right leg with sandal strapping.

168 Draped leg
wearing boot.

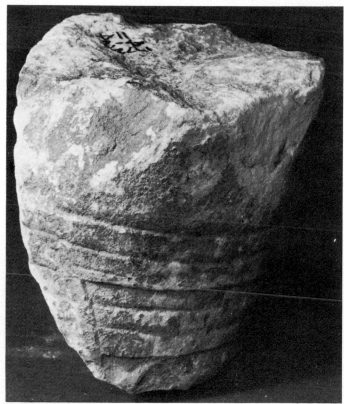

169 Fragment of leg with sandal strapping.

170, 178, 193 Fragments of bare leg, ankle, and heel on base.

200 Bare right foot on base.

211 Tip of sandalled foot of colossal male figure.

209 Fragment of colossal female sandalled foot on base.

212 Fragment of colossal foot in sandal.

213 Male right foot in sandal.

214 Left heel of sandalled foot.

216 Sandalled foot on base.

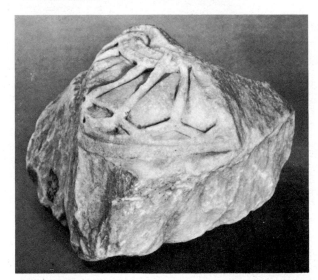

217 Sandalled left foot on base.

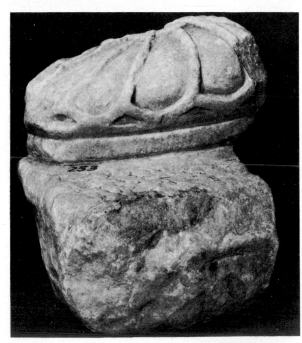

218, 221 Fragments of sandalled left feet.

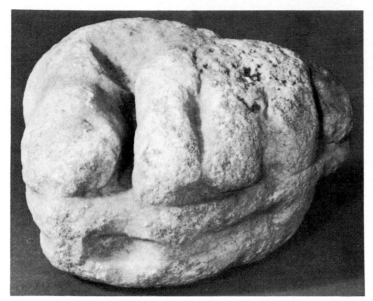

228 Toes of female foot in sandal.

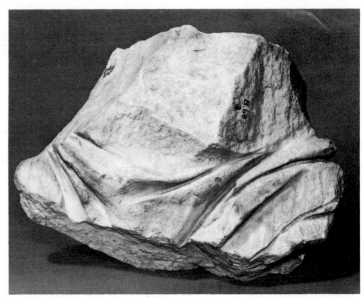

231 Fragment of colossal draped figure.

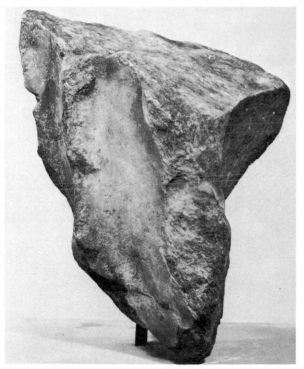

306 Fragment of drapery from a large statue.

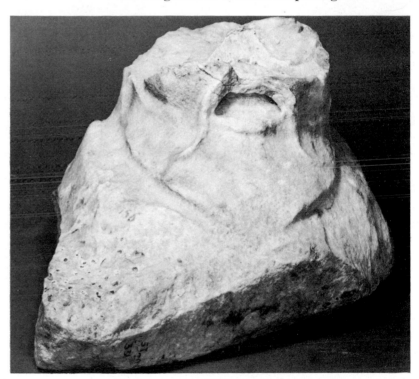

358 Fragment of helmet on base.

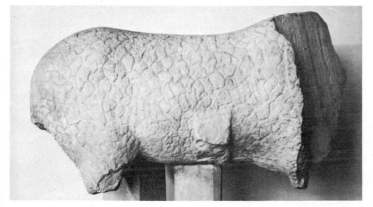

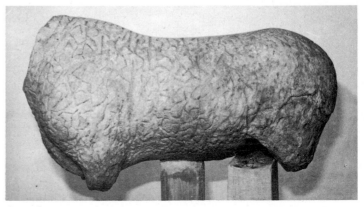

360 Body of colossal ram.

FRAGMENTS OF ANIMALS FROM SCULPTURAL GROUPS

362 Hoof of
bull or ox.

364 Fragment of
shoulder and foreleg
of bull.

365 Forepart of a boar.

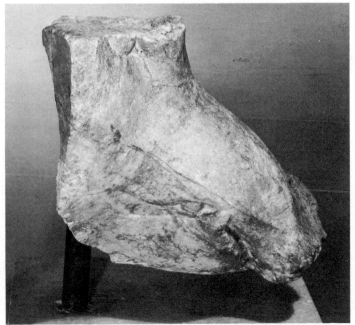

367 Boar's head fragment.

368 Head of boar with right side finished in detail.

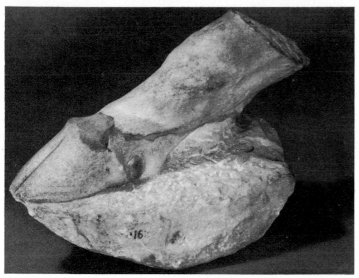

369 Leg and hoof of boar on base.

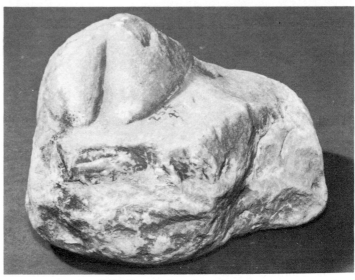

370 Boar's hoof on base.

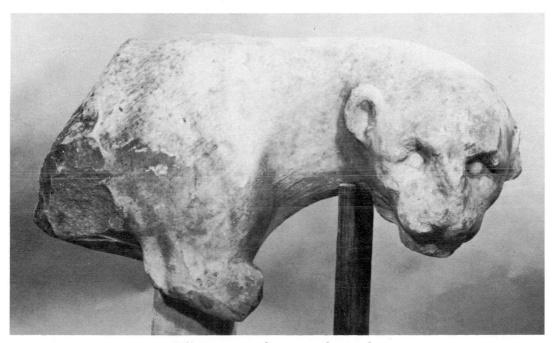

371 Forepart of running leopard.

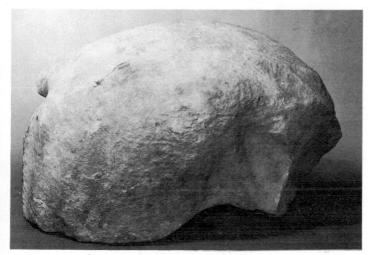

373 Rear part of a leopard.

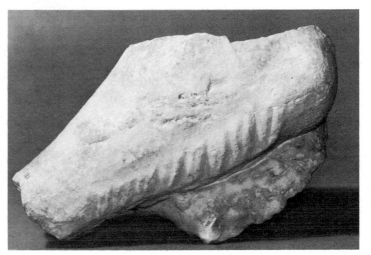

375 Left foreleg of feline.

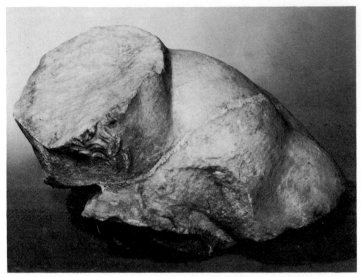

376 Forepart of a muscular animal, possibly a mastiff.

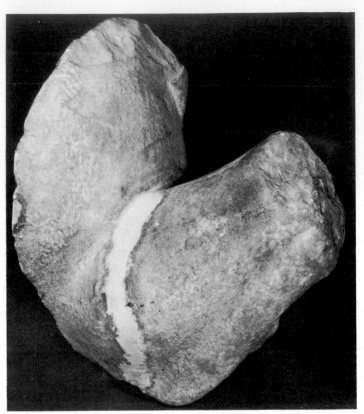

390 Fragment of raised foreleg and body of a horse.

392 Raised foreleg of a prancing horse.

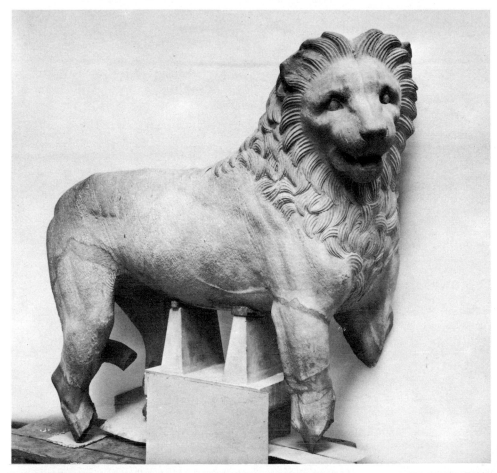

401 Most complete remaining lion of type I.

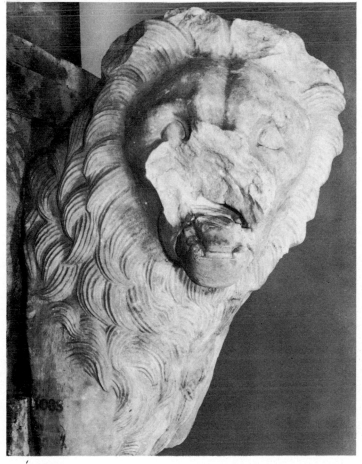

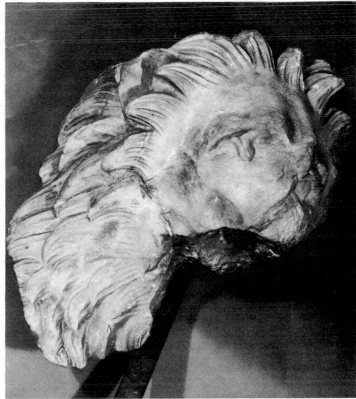

402, 403 Fragments of lions' heads of type I.

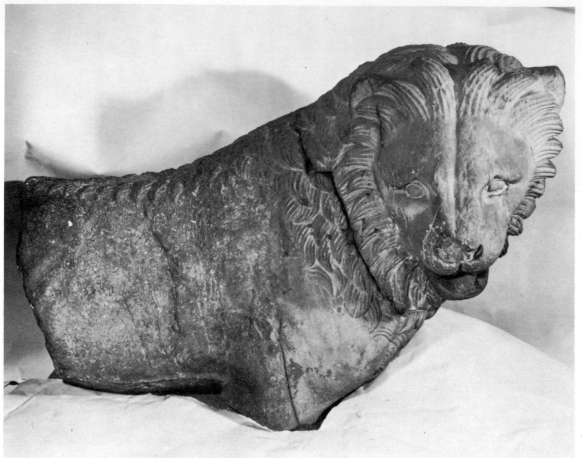

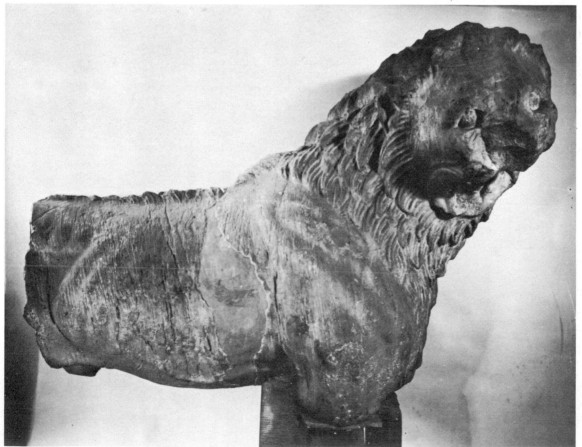

404
Foreparts of lions of
type I with sharply
turned heads.
405

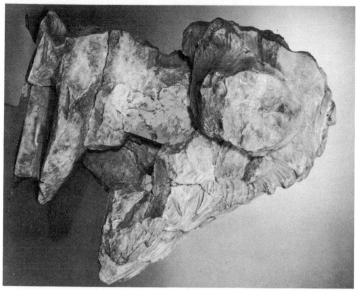

406 Fragmentary head and mane of lion of type I.

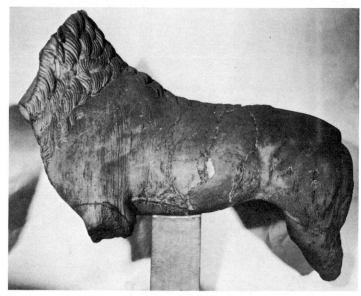

410 Most complete lion of type II.

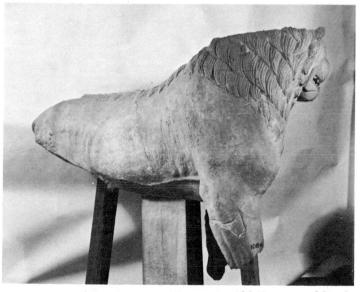

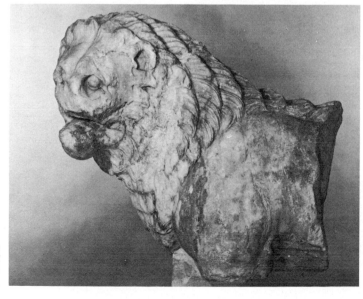

411 Front and back views of lion of type II.

412 Head and foreleg of lion of type II.

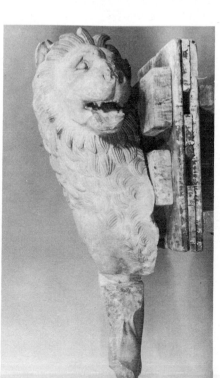

413 Head and shoulder of lion of type II.

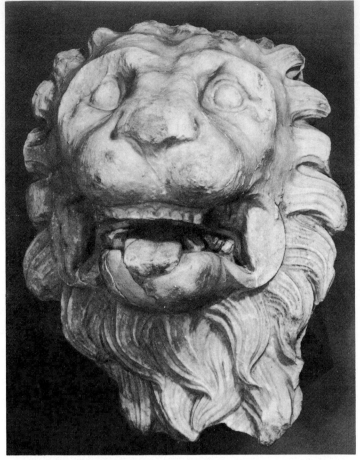

414 Head of lion of type II, with lolling tongue.

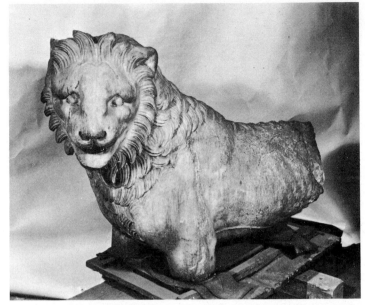

415 Head and forepart of lion of type II.

416 Hind part of lion of type II.

418 Right rear paw and tail of lion of type I on base.

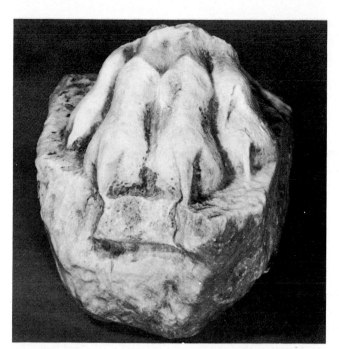
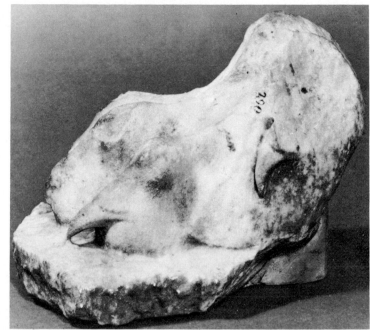

420, 426 Fragments of forepaws of lions on bases.

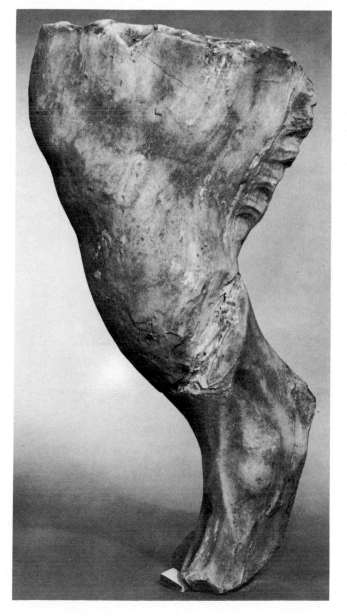
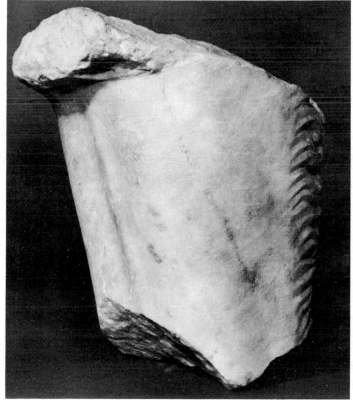

466 Upper right foreleg of lion.

451 Left hind leg of lion of type II.

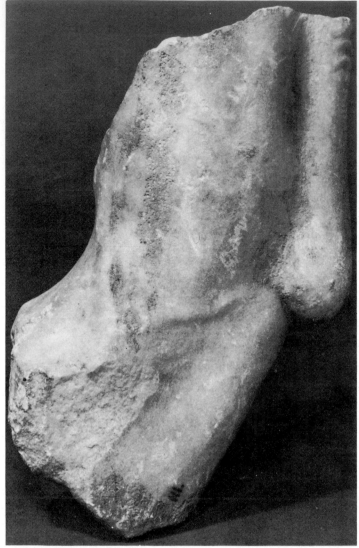

478 Lower left foreleg of lion.

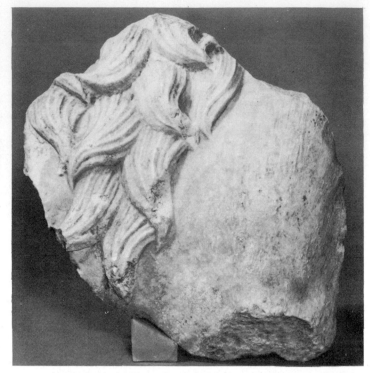

543 Fragment of mane and chest of lion.

579, 594 Two fragments of lions' tails.

577 Tip of lion's tail on base.

651 Fragment of tapering
pillar on base.

**MISCELLANEOUS
FRAGMENTS**

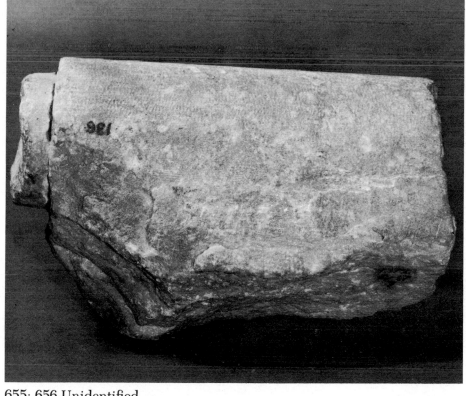

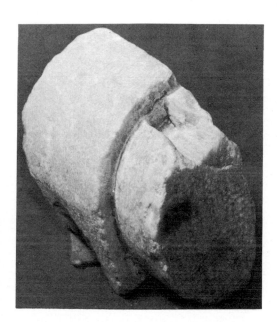

655; 656 Unidentified
fragments, possibly from
a chariot.

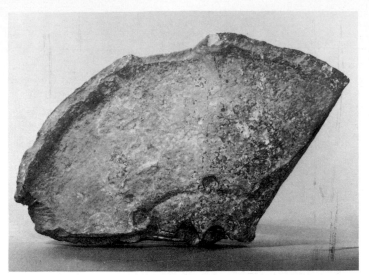
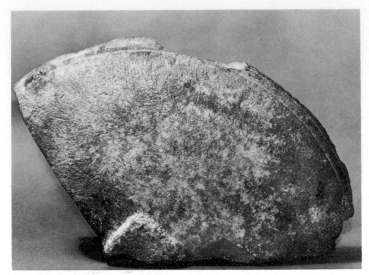

764 Fragment of lid of marble urn.

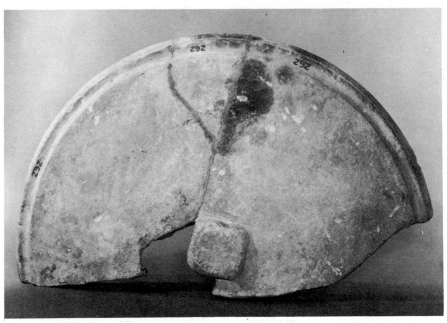

765 Fragment of the outer side of the lid of a marble urn.

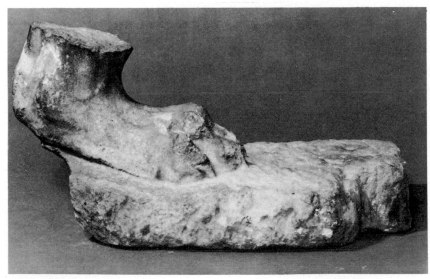

774 Rear paw of lion on base; not from the Mausoleum.

797 Elbow of a right arm from a wall on Cos.

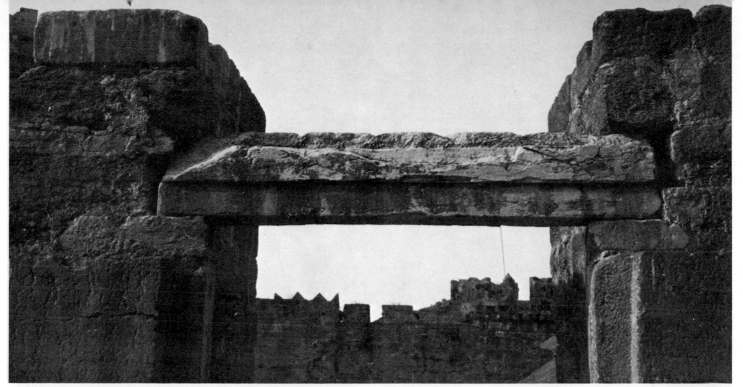

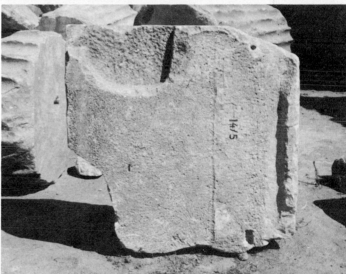

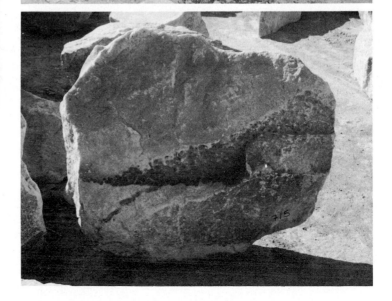

45, 1 Complete architrave beam from the Mausoleum built into Bodrum castle.

45, 2, 3 Fragments of pyramid steps with cuttings for lions of type II.

45, 4 Fragment of pyramid step with cutting for lion of type I.

PLATES APPENDIX

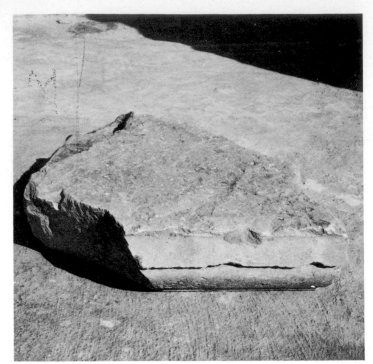

46, 1, 2 Blue limestone step from podium with cutting for statue.

46, 3 Blue limestone step from podium with two cuttings for statues.

46, 4 Blue limestone step with cutting for frontally placed statue.

CONCORDANCE I

With A. H. Smith, BM Cat., vol. ii (1900)

BM nos	This Cat.	BM nos	This Cat.	BM nos	This Cat.	BM nos	This Cat.
1000	26	1046,2	36	1058	48	1080	405
1001	27	1046,3	37	1059	358	1081	410
1002	1	1047	33	1060	50	1082	414
1003	2	1048	42	1061	66	1083	402
1004	24	1049	44	1062	86	1084	411
1005,1	6	1050	43	1063	87	1085	416
1005,2	7	1051	30	1064	89	1086	407
1005,3	23	1052	31	1065	85	1095	371
1005,4	10	1053	32	1075	401	1096,1	367
1005,5	8	1054	45	1076	412	1096,2	365
1005,6	25	1055	47	1077	404	1096,3	369
1045	34	1056	46	1078	415	1097	360
1046,1	35	1057	49	1079	413		

CONCORDANCE II

With C. T. Newton, A Guide to the Mausoleum Room (1886)

MRG nos	This Cat.	MRG nos	This Cat.	MRG nos	This Cat.	MRG nos	This Cat.
34	26	44	30	71*	85	114	408
35	27	45	31	72	198	115	414
36	1	46	32	73	199	116	403
36 a	2	47	45	74	203	117	421
36 b	6	48	46	75	204	118	424
36 c	7	49	49	76	205	119	?
36 d	23	50	48	77	206	120	?
36 e	10	50*	358	78	193	121	?
36 f	8	51	50	79	207	122	425
36 g	25	51 a	51	80	213	123	431
36 h	11	51 b	52	80*	214	124	428
36 i	19	51 c	53	81	218	125	?
36 k	18	51 d	54	82	215	126	436
36 l	14	51 e	55	83	219	127	?
36 m	15	51 f	+ 48	84	221	128	?
36 n	16	52	66	84*	222	129	?
36 o	12	53	65	85	216	130	?
36 p	13	54	71	86	217	131	426
37	24	55	63	87	?	132	?
38	34	56	67	88	208	133	418
38 a	35	57	795	89	209	134	451
38 b	36	58	69?	90	226	135	?
38 c	37	59	68	91–99	?	136	430
38 d	+26	60	70?	100	401	137	774
38 e	?	61	86	101	412	138	371
38 f	?	62	159	102	402	139	366
38 g	?	62*	160	103	411	140	374
38 h	38	63	87	104	404	141	390
38 i	?	64	90	105	415	142	365
38 j	?	65	89	106	413	143	367
38 k	?	66	?	107	405	144	369
38 l	?	66*	?	108	410	145	360
39	29	67	775	109	416	146	370
40	33	68	?	110	407	147	361
41	42	69	?	111	406	152	47
42	44	70	91	112	409	159	764
43	43	71	?	113	417	160	765?

CONCORDANCE III

With Registration numbers

Reg.	Cat. no.	Reg.	Cat. no.	Reg.	Cat. no.	Reg.	Cat. no.
1857.12–20.232	26	1857.12–20.262	50	1868.4–5.2	790	1972.3–30.15	21
233	27	263	49	4	281	16	22
234	34	264	48	5	789	17	32
235	33	265	46	6	645	18	35
236	29	266	47	7	646	19	36
237	42	267	45	8	118	20	37
238	1	279	44	19	150	21	40
239	2	280	90	27	326	22	41
240	401	281	43	28	282	23	38
241	405	282	68	29	250	24	39
242	404	283	6	30	647		
243	402	284	8	31	420	1972.4–2.1	51
244	403	285	23	148	155	2	52
245	407	286	10	149	154	3	53
246	408	287	365	150	157	4	54
247	415	288	25			5	55
248	410	327	24(a)	1972.3–30.1	2	6	56
249	411	328	24	2	3	7	57
250	416		(b)–(d)	3	5	8	58
251	413	329	24	4	7	9	59
252	412		(e)–(k)	5	11	10	60
253	414	330	358	6	12	11	62
254	417	338	765	7	13	12	63
255	418	339	768	8	14	13	65
256	371	340	772	9	15	14	66
257	376	341	770	10	16	15	67
258	360	342	771	11	17	16	69
259	30	343	764	12	18	17	70
260	27			13	19		
261	31	1865.12–12.14	774	14	20		

Reg.	Cat. no.	Reg.	Cat. no.	Reg.	Cat. no.	Reg.	Cat. no.
1972.4–2.18	71	1972.4–2.68	117	1972.4–2.118	173	1972.4–2.168	224
19	72	69	119	119	174	169	225
20	74	70	120	120	184	170	226
21	75	71	121	121	175	171	227
22	76	72	122	122	176	172	228
23	77	73	123	123	177	173	229
24	78	74	124	124	178	174	230
25	79	75	125	125	179	175	149
26	80	76	126	126	185	176	220
27	81	77	127	127	180	177	200
28	82	78	128	128	181	178	85A
29	84	79	129	129	182		
30	83	80	131	130	183	1972.4–4.1	237
31	85	81	132	131	695	2	238
32	86	82	133	132	186	3	239
33	87	83	134	133	187	4	240
34	88	84	135	134	188	5	241
35	776	85	782	135	189	6	242
36	89	86	136	136	190	7	243
37	232	87	137	137	191	8	244
38	234	88	138	138	192	9	245
39	235	89	139	139	193	10	246
40	236	90	140	140	194	11	247
41	780	91	141	141	195	12	248
42	91	92	142	142	196	13	249
43	92	93	143	143	197	14	781
44	93	94	144	144	198	15	253
45	94	95	145	145	199	16	254
46	306	96	146	146	201	17	256
47	95	97	147	147	202	18	257
48	96	98	148	148	203	19	255
49	97	99	151	149	204	20	777
50	98	100	152	150	205	21	258
51	99	101	153	151	206	22	259
52	100	102	156	152	207	23	261
53	101	103	158	153	208	24	262
54	102	104	159	154	209	25	263
55	103	105	160	155	210	26	264
56	105	106	161	156	211	27	266
57	106	107	162	157	212	28	267
58	107	108	163	158	213	29	268
59	108	109	164	159	214	30	269
60	109	110	165	160	215	31	270
61	110	111	166	161	216	32	271
62	111	112	167	162	217	33	272
63	112	113	168	163	218	34	273
64	113	114	169	164	219	35	274
65	114	115	170	165	221	36	275
66	115	116	171	166	222	37	276
67	116	117	172	167	223	38	277

Reg.	Cat. no.	Reg.	Cat. no.	Reg.	Cat. no.	Reg.	Cat. no.
1972.4–4.39	278	1972.4–4.89	333	1972.4–8.8	369	1972.4–10.18	435
40	279	90	334	9	370	19	436
41	280	91	335	10	372	20	437
42	783	92	336	11	373	21	438
43	284	93	337	12	374	22	439
44	285	94	338	13	375	23	440
45	286	95	339	15	377	24	441
46	287	96	340	16	378	25	442
47	288	97	346	17	379	26	443
48	265	98	348	18	380	27	444
49	289	99	349	19	381	28	445
50	291	100	350	20	382	29	446
51	292	101	351	21	383	30	447
52	293	102	352	22	385	31	448
53	294	103	353	23	386	32	449
54	295	104	354	24	387	33	450
55	296	105	665	25	388	34	451
56	297	106	355	26	389	35	452
57	298	107	356	27	9	36	453
58	299	108	357	28	390	37	454
59	300	109	788	29	391	38	455
60	301	110	786	30	393	39	456
61	302	111	785	31	392	40	457
62	303	112	787	32	394	41	458
63	304	113	26	33	395	42	459
64	305	114	359	34	396	43	460
65	784	116	766	35	397	44	462
66	307	117	231	36	398	45	463
67	308	118	251	37	399	46	464
68	309	119	252	38	400	47	465
69	310	120	260	39	693	48	466
70	311	121	290	40	692	49	467
71	312	122	318			50	468
72	313	123	347	1972.4–10.1	406	51	469
73	314	124	321	2	409	52	470
74	315	125	323	3	419	53	471
75	316	126	341	4	421	54	461
76	317	127	342	5	422	55	473
77	319	128	343	6	423	56	474
78	320	129	283	7	424	57	475
79	322	130	344	8	425	58	476
80	324	131	345	9	426	59	477
81	325			10	427	60	478
82	327	1972.4–8.1	361	11	428	61	479
83	328	2	362	12	429	62	480
84	329	3	363	13	430	63	481
85	330	4	364	14	431	64	482
86	573	5	366	15	432	65	483
87	331	6	367	16	433	66	484
88	332	7	368	17	434	67	485

Reg.	Cat. no.	Reg.	Cat. no.	Reg.	Cat. no.	Reg.	Cat. no.
1972.4–10.68	486	1972.4–10.118	535	1972.4–11.41	583	1972.4–11.91	631
69	487	119	536	42	584	92	632
70	488	120	537	43	585	93	633
71	489	121	538	44	586	94	634
72	490	122	539	45	587	95	635
73	491	123	540	46	588	96	636
74	492	124	541	47	589	97	637
75	493	125	542	48	590	98	638
76	494	126	529	49	591	99	649
77	495			50	592	100	639
78	496	1972.4–11.1	543	51	593	101	640
79	497	2	544	52	594	102	641
80	498	3	545	53	595	103	642
81	499	4	546	54	596	104	643
82	500	5	547	55	597	105	644
83	501	6	548	56	598	106	650
84	502	7	549	57	384		
85	503	8	550	58	599	1972.4–17.1	64
86	504	9	551	59	600	2	73
87	505	10	552	60	648	3	104
88	506	11	553	61	601	4	651
89	507	12	554	62	602	5	652
90	508	13	555	63	603	6	653
91	509	14	556	64	604	7	655
92	472	15	557	65	605	8	656
93	510	16	558	66	606	9	657
94	686	17	559	67	607	10	658
95	511	18	560	68	608	11	61
96	512	19	561	69	609	12	659
97	513	20	562	70	610	13	660
98	514	21	563	71	611	14	661
99	515	22	564	72	612	15	662
100	516	23	565	73	613	16	664
101	517	24	566	74	614	17	666
102	518	25	567	75	615	18	667
103	519	26	568	76	616	19	669
104	520	27	569	77	617	20	670
105	521	28	570	78	618	21	671
106	522	29	571	79	619	22	672
107	523	30	572	80	620	23	673
108	524	31	574	81	621	24	674
109	525	32	575	82	622	25	675
110	526	33	668	83	623	26	676
111	527	34	576	84	624	27	677
112	528	35	577	85	625	28	678
113	530	36	578	86	626	29	679
114	531	37	579	87	627	30	4
115	532	38	580	88	628	31	689
116	533	39	581	89	629	32	690
117	534	40	582	90	630	33	691

Reg.	Cat. no.	Reg.	Cat. no.	Reg.	Cat. no.	Reg.	Cat. no.
1972.4–17.34	694	1972.4–17.60	720	1972.4–17.85	663	1972.4–20. 20	742
35	696	61	721	86	683	22	793
36	697	62	722	87	684	23	794
38	698	63	723	88	685	26	795
39	699	64	724	89	688	27	796
40	700	65	725	90	743	28	797
41	701	66	726			29	798
42	702	67	727	1972.4–20.1	753	30	799
43	703	68	728	2	744		
44	704	69	729	3	754	1972.7–14.50	750
45	705	70	730	4	755	55	769
46	706	71	731	5	756	57	687
47	707	72	732	6	758	58	752
48	708	73	733	7	759	60	28
49	709	74	734	8	760	63	751
50	710	75	735	9	761	64	747
51	711	76	736	10	762	66	749
52	712	77	737	11	773	76	233
53	713	78	738	12	767	80	746
54	714	79	739	13	757	82	745
55	715	80	740	14	680	98	763
56	716	81	654	16	775	104	748
57	717	82	741	17	778	119	130
58	718	83	681	18	779		
59	719	84	682	19	791	1972.7–21.45	792

Index